Photo & Digital Imaging

by

Jack Klasey
Writer/Editor/Photographer
Kankakee, Illinois

Publisher
The Goodheart-Willcox Company, Inc.
Tinley Park, Illinois

Library of Congress Card Catalog Number 2001033404

International Standard Book Number 1-56637-879-6

3 4 5 6 7 8 9 02 05 04

Library of Congress Cataloging in Publication Data
Klasey, Jack
 Photo & digital imaging / by Jack Klasey
 p. cm.
 Includes index.
 ISBN 1-56637-879-6
 1. Photography. 2. Photography – Digital techniques. I. Title.
TR145 .K53 2001
771—dc21

 2001033404

Introduction

Photo & Digital Imaging has been designed for use as a first course in the basics of photography with the extension of those principles into the growing field of digital imaging.

The first five chapters will provide you with a knowledge base that includes development of the photographic medium and the essential tools of the photographer: cameras, lenses, light, and film. While these chapters present a fair amount of theory, practical "hands-on" elements (such as proper use of the hand-held light meter) are included wherever they are appropriate.

Chapters 6–10 are highly practical in nature, presenting many specific techniques in the use of the camera, film development, darkroom setup and operation, printmaking, and the finishing and mounting of prints. Since basic darkroom skills are usually easiest to acquire and master when working with monochrome materials, the emphasis in these chapters is on black-and-white. In most programs, color processing and printing is an advanced course, so it is touched on only briefly in this text (as part of the color photography chapter).

Chapters 11–14 form an overview of areas that allow the beginning photographer to build upon and expand the basic skills introduced in the first ten chapters. Introduced in this section are the use of large format cameras, color photography, the use of artificial light sources for location and studio photography, and a variety of specialized or advanced techniques for use in both the field and the darkroom.

Finally, *Photo & Digital Imaging* covers the extension of photographic principles into the digital realm in a pair of chapters that blend theory and practice. The first of these chapters is devoted to the various methods of capturing and storing digital images, including original image capture with digital cameras and the conversion of conventional prints, negatives, and transparencies to digital form by scanning. Image editing software and the "digital darkroom" techniques for correcting and enhancing images are thoroughly covered in the final chapter. Also covered are the many types of image manipulation and combination that can be carried out to realize the photographer's artistic vision, and an overview of the devices and methods used for digital-image output.

While the continuing development of digital cameras and related equipment and software will give beginning photographers ever-better and more convenient tools to use, the basic skills of photography will always be essential to the effective use of those tools. The photographer's need to produce a meaningful photograph that is well composed, properly lighted, and correctly exposed is constant — whether the capture device uses a glass plate covered with wet collodion, film with a highly sensitive emulsion on a flexible plastic base, or an array of millions of tiny electronic sensors.

Jack Klasey

Table of Contents

Acknowledgments

A textbook of this type is always a collaborative effort, requiring the assistance of many individuals, organizations, and companies during the process of researching, organizing, writing, and illustrating the final product. Those who contributed to the development of *Photo & Digital Imaging* in some way are listed below.

Charles Beseler Company

Canon USA, Inc.

Meghann Carlile

Ed Cayot

Cokin Filters/Minolta Corporation

Bob Condra (Porter's Camera Store)

Crescent Cardboard Co.

Daige Products, Inc.

Delkin Devices

Sha'Nia Dickerson (Eastman Kodak Company)

Digi-Frame, Inc.

Eastman Kodak Company

Epson America, Inc.

Bonnie Ford

Foveon, Inc.

Scott Gauthier

Valerie Gibbons

Deborah Gordon

Rob Gorham

Gossen/Bogen Photo Corporation

Joe Hall (Jobo Fototechnic, Inc.)

Hass Manufacturing Company

Heidelberg

Hunt Corporation

IFF Repro-System/Bogen Photo Corp.

Illinois Film Office

Jobo Fototechnic, Inc.

Kankakee County Historical Society

Kinesis

Glory Klasey

John, Kevin, Katie, Marcia, Jack, and Caroline Klasey

Kyocera Optics, Inc.

Tory Lepp Productions

Library of Congress

Linhof/H.P. Marketing Corp.

LPA Designs/Bogen Photo Corp.

Manfrotto/Bogen Photo Corp.

Microtek

Anne, Tony, and Matthew Milaneses

Miller Electric Mfg. Company

Minds@Work, Inc.

Larry Morris

Museum of Broadcast Communications, Chicago

National Aeronautics and Space Administration

National Pork Producers Council

Nikon, Inc.

Norman Enterprises, Inc. Division of Photo Control Corporation

Michelle Nguyen

Olympus America, Inc.

Tony Panozzo

Bianca Parra

Pentax

PhotoTherm

Polaroid Corporation

Porter's Camera Store

Quantum Instruments, Inc.

Regal/Arkay

Sanovia Reynolds

Roland DGA

Rollei Fototechnic

Leonard Rue Jr. (Leonard Rue Enterprises)

Prof. Paul Schranz (Governors State University)

Midj Scudella

Sekonic Professional Division, Mamiya America Corp.

Silicon Film Technologies, Inc.

Sinar Bron Imaging

Smith-Victor Corporation

Stroboframe

Sunpak/ToCAD America, Inc.

Suzanne Silagi

Patrick Tezak

Toyo Professional Camera Division, Mamiya America Corp.

Wacom

Johnny Wade

Walgreen Company

Nicole Wallon (Jobo Fototechnic, Inc.)

Dr. Norman Weinberg (Berg Color Tone)

Alan Wendt

Photography:
The act of "drawing with light," or
capturing reflected light to form an
image. From the Greek roots *photos*
(light) and *graphos* (drawing).

Chapter 1

Catching a Shadow

When you have finished reading this chapter, you will be able to:

➡ Identify the significance of photography in our visual society.

➡ Describe the development of the photographic process.

➡ Compare and contrast silver-based and digital photography.

➡ Discuss the future roles of both silver-based and digital methods.

We live in a visual society. From the time we get up in the morning until the time we fall asleep at night, we are surrounded by imagery — monochrome or color, still or moving, entertaining or instructional, ugly or beautiful. Some of that imagery is painted or drawn, but a large proportion is *photographic:* light and shadow captured on a silver-gelatin emulsion or an electronic array. Although its history of less than 200 years is far shorter than that of the other visual arts, photography has become the dominant means of visual expression in our world.

Photography is everywhere

When a food company wants to introduce a new item to consumers, one of the first priorities is a *photograph*: a carefully arranged, beautifully lighted picture bursting with highly saturated colors. See **Figure 1-1.** By wordlessly conveying the

message, "This is delicious ... you have to try it!," the photo will become the centerpiece of the advertising campaign. It will appear in

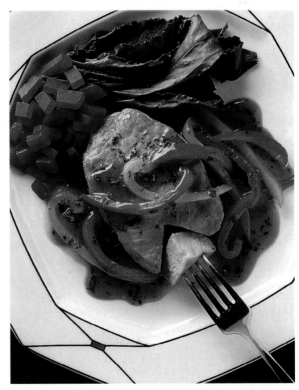

Figure 1-1. *A compelling photograph is the key item for an advertiser introducing a new product or building consumer awareness of a particular category of food. This photo was used to promote the use of pork products.*
(National Pork Producers Council)

many different contexts — on billboards, in magazine and newspaper advertisements, in television spots, on packaging and point-of-purchase displays, or on coupons. If the company maintains a Web site, it will be seen there as well.

Illustration

Advertising and packaging are among the major uses of photographic *illustration,* and provide a livelihood for a large number of photographers who specialize in such areas as food, new automobiles, health and fitness equipment, or clothing. The rapid growth of mail order buying has created new opportunities for studios specializing in catalog illustrations. In addition to photos aimed at consumers, a large volume of advertising photography is done each year to sell products to business clients. In producing photos for brochures or trade magazine advertisements, industrial and commercial photographers often deal with more challenging situations than those found in photography aimed at consumers. Their subject matter may be a highly complex machine, a sprawling production operation, or a process taking place under hazardous conditions, **Figure 1-2.**

The other major area of photographic illustration is editorial use in newspapers, magazines, and books. *Photojournalists* produce thousands of pictures each day to meet the demand for news ranging from political events and international conflicts to auto accidents and local charity events. For television audiences, *ENG (Electronic News Gathering)* camera operators perform the same function in both motion and still video.

Beyond the "breaking news" area, a great deal of photography is used to illustrate informational articles. Newspapers often use multiple photos for full-page features in their travel, food, business, and "lifestyle" sections, **Figure 1-3.** Magazines are even more photography-intensive, with content ranging from celebrity fashion

photos to adventure travel illustrations to power tool product pictures. While most of the photos in these publications are done by staff photographers, many magazines also welcome the work of freelancers.

Nonfiction books are often extensively illustrated with photographs; some, in fact, consist primarily of pictures. "How-to" books rely upon photos to show the different stages of a project; cookbooks often have photographic illustrations of the finished recipe. Textbooks use photographs to introduce students to subjects that range from unfamiliar cultures to complex technologies, **Figure 1-4.** Textbook publishers, advertising agencies, magazine publishers, and others make use of *stock photography.* A number of large and small stock photo agencies offer the work of many different photographers on a huge variety of

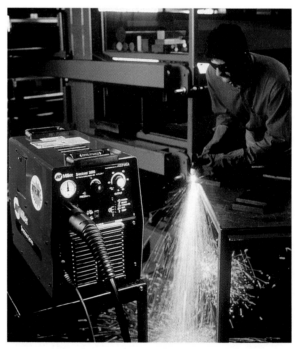

Figure 1-2. *Industrial and commercial firms, as well as consumer product companies, use photographic illustrations to reach their customers. This photo was taken to illustrate a machine and process of interest to potential buyers of welding and cutting equipment. (Miller Electric Mfg. Company)*

subjects. Typically, the user arranges with the agency for a specific use (such as a book cover) at a flat licensing fee, or *royalty,* that is split between the agency and photographer. Additional uses of the same illustration (on a CD accompanying the book, for example) would require payment of another fee. The rapid growth of desktop publishing has given rise to a different type of stock photo distribution, ***royalty-free image collections.*** These are groups of photos on specific themes (business, medicine, leisure activities, travel, and so on) that are packaged on CDs and sold outright, **Figure 1-5.** The end user pays a price for the CD that is usually less than a stock photo royalty for a single

Figure 1-3. *Photographs are extensively used to illustrate newspaper and magazine articles, providing visual appeal and reinforcing the written information.*

Figure 1-4. *Textbooks may use photographs to help illustrate complex operations, to introduce students to people of different cultures, or to help clarify unfamiliar subjects. In recent years, changes in printing processes have made it economical to print most textbook illustrations in full color.*

Figure 1-5. *Collections of stock photographs on particular themes, such as transportation, business, or people at work or play, can be purchased for a flat fee and used as needed for illustration.*

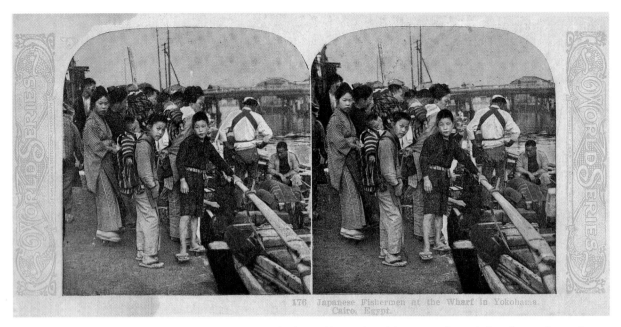

Figure 1-6. *Stereo cards provided viewers with three-dimensional images of exotic locales and people from various cultures. Early cards were in black-and-white and had actual photographs pasted to them. The photos were sometimes hand-colored for added realism. This 1905 card, showing a fishing wharf in Japan, makes use of color lithography — the original images (probably hand-colored) were photographed as color separations and reproduced with a printing press.*

image. For that price, the user gets one hundred or more photos to use whenever and wherever he or she wishes.

Entertainment

The first form of photographic entertainment to achieve wide popularity was the stereoscope. Invented during the 1860s, the *stereoscope* was a handheld device used to view pairs of photographs, giving the viewer the illusion of depth or three-dimensional space. The photographs were taken using a camera with two lenses spaced approximately two inches apart to mimic the spacing of human eyes. The resulting photographs were mounted side-by-side on a card for use in the viewer. By the late 1800s, many publishers were marketing series of cards on travel subjects and similar topics, often with colored images, **Figure 1-6.** In a time before television and the widespread use of photographs in newspapers and magazines, "stereo cards" introduced viewers to natural wonders and to exotic locales and peoples.

Today's dominant forms of entertainment — television and motion pictures — rely upon moving photographic images to convey their messages. Even though electronic methods of capturing, recording, and processing images have made inroads in motion picture production, most movies continue to be shot on silver-based film, **Figure 1-7.** The finished product (the "release print" projected in theaters) is still on physical film, as well. Many cinematographers and directors maintain that there is a distinctly different "look" to scenes photographed on traditional film, as compared to scenes recorded electronically.

Television has been an electronic medium from the time that it was first demonstrated successfully in 1932 by Philo T. Farnsworth. In the earliest days of commercial programming, however, television had to rely upon film as a means of recording programs for later broadcast. During the 1940s, 1950s, and the early 1960s, recordings called *kinescopes* were made by photographing the image on a television cathode ray

tube. These contrasty, grainy, black-and-white images, **Figure 1-8,** were the only method available for recording a program.

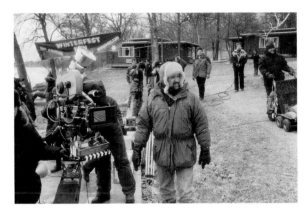

Figure 1-7. *Most Hollywood movies continue to be shot on silver-based film, since it is believed to provide a distinctive "look" that is not captured by electronic recording methods. In this photo, the director (center, in parka), cinematographer, and other crew members prepare to film a location shot for the movie* Chain Reaction. *(Illinois Film Office)*

Figure 1-8. *Until the video tape recorder was introduced in the mid-1950s, virtually all television shows were broadcast in live performance. Film copies called kinescopes were used to record shows for distribution or rebroadcast. This is a frame from a kinescope of the drama "Night Panic," starring Marion Ross and Cloris Leachman. The drama was presented on* Kraft Mystery Theater *on July 18, 1962. (Museum of Broadcast Communications, Chicago)*

The days of the kinescope were numbered once the first commercial videotape recorder was introduced by Ampex in 1954. Within two years, programs recorded on tape were being broadcast. Eventually, programs recorded on videotape for later broadcast became the norm. With the exception of news shows, "live" programs (those broadcast as they occur) have become a rarity in television.

Books remain an important entertainment medium. While fiction forms the largest category of "entertainment" books, a visit to a bookstore will turn up many examples of the large-format (so-called "coffee table") books, **Figure 1-9.** These books are filled with photos organized on a theme or specific subject. Some display the work of a single photographer; others are compiled from photographs taken by a number of individuals and may include both contemporary and historic images. Sometimes, a single volume will capture the popular imagination and become a springboard for an entire series of books. One such series consists of aerial views of major cities; another focuses upon the varied aspects of life in a given country during a single 24-hour period.

Figure 1-9. *Large-format books with numerous photographic illustrations remain popular, even in an age when television is the dominant medium of entertainment.*

Scientific and technical applications

In the scientific realm, photography has been a useful investigative tool for dealing with subjects as small as molecules and as large as entire galaxies. With the use of scanning electron microscopes, scientists have been able to investigate the structure of the very building blocks of matter. At the other end of the scale, astronomers have used photography as an aid to forming theories on the development of the universe, **Figure 1-10.**

One of the first to use the camera as a scientific tool was an English-born American photographer, Eadweard Muybridge, who began photographing sequences of motion in the 1870s. Using a battery of cameras with electrically operated shutters, he photographed a trotting horse at a California track on June 19, 1878. That sequence of pictures settled for once and all the question of whether all four feet of a trotting horse are off the ground at the same time (they are). Muybridge's long-term project was to create an artist's reference, or "visual dictionary," of animals and human beings in motion. In 1887, his book *Animal Locomotion* was published with nearly 800 illustrations, including many action sequences with human models. See **Figure 1-11.**

Even earlier, in the 1860s, physician Oliver Wendell Holmes had begun closely studying street scenes taken by various photographers. By examining the positions of pedestrians whose motions were frozen in the photographs, Holmes (who was also the inventor of the stereoscope) hoped to design

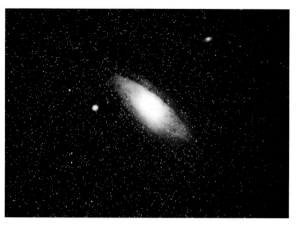

Figure 1-10. *Photography has been a vital tool for astronomers as they investigate the origin and development of the universe. This astro-photograph shows the Andromeda galaxy, the nearest large galaxy to our own (the Milky Way). The light rays that made this exposure left the Andromeda galaxy approximately two million years ago.*
(National Aeronautics and Space Administration)

better artificial legs for soldiers who suffered amputation during the Civil War.

Scientific and technical uses of photography form an almost endless list, ranging from aerial mapping photos to time-lapse pictures to crime scene evidence photographs to diagnostic X-rays. A major step forward for scientific photography, as well as photography in general, occurred in 1931, when Harold Edgerton of the Massachusetts Institute of Technology devised the electronic flash. The brilliant burst of light, lasting a tiny fraction of a second, was capable of "freezing" a bullet as it burst

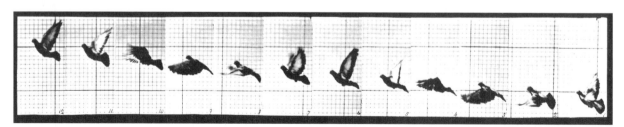

Figure 1-11. *The pioneering work of Eadweard Muybridge provided the first visual record of how humans and other animals move. This panel from Muybridge's book,* Animal Locomotion, *shows consecutive images of a pigeon in flight. (Courtesy of the Library of Congress)*

through a playing card or the splashing of a single drop of milk in the shape of a crown. When fired in rapid (*stroboscopic*) sequence while the camera's shutter remains open, the electronic flash allows a scientist to record movements as a series of "stop-action" images on a single frame of film. In addition to its value as a scientific tool, Edgerton's development freed photographers from dependence upon the slower, more cumbersome, and less efficient flashbulb method of illumination.

Documentation

The overwhelming number of photographs that are taken can be classified as *documentation:* pictures taken "for the record." Literally millions of snapshots each year document such family events as birthday parties, graduations, weddings, and vacation trips. Each records a bit of history and documents the people, places, and events that have meaning to the photographer, **Figure 1-12.** The entire consumer photographic industry, from camera and film manufacturers to retailers to photofinishers, is built upon the public's fascination with recording events on film.

Beyond snapshots, many families and individuals "sit" for professionally taken portraits as a more formal photographic record. The early years of childhood and such milestones as graduations account for a large share of portrait photography, **Figure 1-13.**

"Record shots" are also the staple of photojournalism, with newspaper and magazine photographers constantly chronicling events that range from the mundane to the momentous. The majority of journalistic photographs are of limited interest — promotional pictures for local charitable events, features on people or places, the doings of public figures, or such accidental occurrences as fires and automobile collisions, **Figure 1-14.**

At times, however, journalistic photos go far beyond being mere record shots. Through the decades, individual photographs have

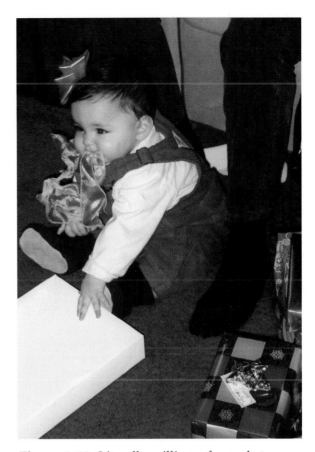

Figure 1-12. *Literally millions of snapshots are taken to document such events as graduations, birthdays, holiday parties, or everyday family activities. Vacation trips or special occasions such as parades or performances are also frequently documented.*

become icons, summing up the emotions or events of a particular period. Joe Rosenthal's tableau of soldiers planting the American flag on Mount Suribachi, Iwo Jima, epitomizes World War II for many persons, just as John Filo's picture of a screaming girl kneeling next to a fallen student at the Kent State massacre summed up the era of Vietnam War protests. Astronaut Neil Armstrong's photo of Edwin Aldrin, Jr. walking on the moon, **Figure 1-15,** not only records a moment in history but carries a full load of associations with the changes in American society as a result of competition with the Russians following their launching of the Sputnik space satellite in 1957.

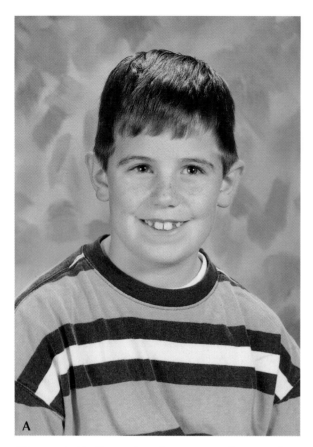 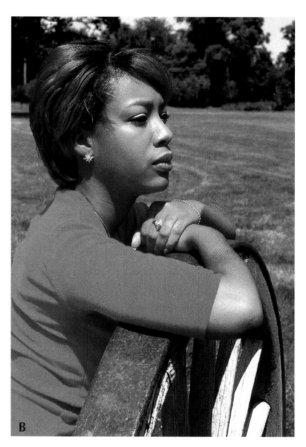

Figure 1-13. *Portraits of young people at various points in their school years account for a large percentage of all portrait photography. A—A formal "studio portrait" of a grade-school student. B—An informal portrait made outdoors, often called an "environmental portrait." This style is popular with high school seniors and other young adults.*

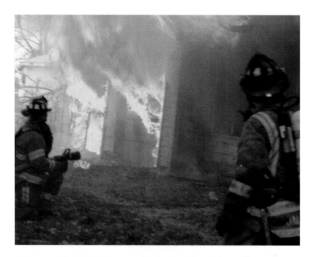

Figure 1-14. *Many photographs taken for newspaper or magazine use are "record shots," such as this scene of firefighters preparing to enter a burning building.*

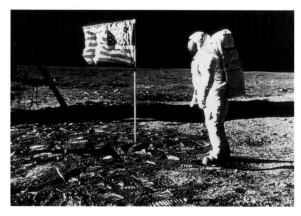

Figure 1-15. *A single photograph may capsulize an event or an entire era. The decade-long American effort to place astronauts on the Moon before Russia could do so is summed up in this photograph taken on July 20, 1969. (National Aeronautics and Space Administration)*

Documentary photography, usually in the form of a series of photographs or a "picture story," has functioned as a mirror held up to our society for nearly 100 years. From the 1930s through the 1960s, popular magazines such as *Look* and *Life* provided a steady weekly diet of photographic essays on topics as wide-ranging as the impoverished life of southern sharecroppers and the working conditions in the steel mills of Pittsburgh. Sometimes, such photo essays became a catalyst for social change, in much the same way as Lewis Hine's images of young children working in factories in the early 1900s resulted in the passage of child labor laws. See **Figure 1-16.**

The photo-based weeklies fell victim to the rise of television and the changing

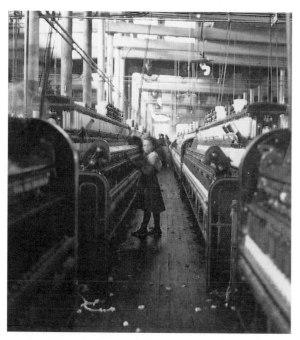

Figure 1-16. *Photographer Lewis W. Hine documented the exploitation of children as laborers in industrial plants early in this century. Views such as this one from 1908, showing a very young girl working as a spinner in a South Carolina textile mill, were used to convince lawmakers of the need for legislation restricting the use of child labor. (Courtesy of the Library of Congress)*

economics of the magazine business, eliminating a major outlet for the work of documentary photographers. Today, most documentary work is being published in book form.

Art

The use of the photograph as a form of artistic expression — and the continuing debate over whether photography is art or craft — dates almost to its beginnings. The earliest practitioners were most concerned with merely obtaining a recognizable and permanent image. Initially, the content of that image was less important than the mere *existence* of the image. Once perfected, however, photography was put to use as a tool for the traditional artist. In the mid-1840s, Scottish painter David Octavius Hill, with the aid of David Adamson (a practitioner of the photographic calotype process) began a massive project. They began making portraits of more than 400 persons as models for a huge painting planned by Hill. In the process, they developed many of the basic principles of portrait photography.

From being used as an artist's tool, photography evolved within a decade into an imitation of painting. In the 1850s, photographs conveying sentimental or morally instructive themes were devised in an attempt to mimic the popular taste in painting. Described by the term *pictorialism*, or pictorial photography, this movement remained strong from the late 1850s until well into this century. The trendsetter in pictorialism was the English painter turned photographer Henry Peach Robinson, whose 1858 composition "Fading Away" was widely acclaimed. Robinson's composition depicts two female family members hovering over the bed of a dying young woman while a male figure (presumably her physician) stands dejectedly peering out a window in the background. The final picture was achieved by multiple printing from the negatives of five separate, carefully posed photographs.

In opposition to the pictorialist philosophy was the work of photographers such as Peter Henry Emerson, who termed his approach *naturalistic photography.* Emerson, an Englishman who was active from 1870s to the 1890s, was a believer in "straight" photography that did not attempt to imitate painting. He maintained that photography was, in itself, an art form and should attempt to show natural subjects in their actual surroundings.

A later development within the naturalistic, or "straight photography," tradition was the growth of *abstractionism.* By selecting or "abstracting" one characteristic or element of a subject and making it the main focus of the image, abstractionism places strong emphasis on forms and their relationships. An abstraction based on an unrecognizable or greatly distorted and altered subject is referred to as *nonrepresentational.* Early in this century nonrepresentational photographic abstracts were being produced by artists such as Alvin Langdon Coburn, Francis Bruguiere, and Man Ray. Abstract composition emphasizing some aspect of a recognizable object or objects is most commonly described as *realistic abstraction,* **Figure 1-17.** Alfred Stieglitz, Paul Strand, Minor White, Edward Weston, Aaron Siskind, and many other important photographers of the twentieth century have produced powerful abstracted compositions.

The advent of digital image manipulation has opened new avenues of expression for the photographer/artist. Whether the work begins with an image captured on film and scanned into digital form or an image captured in digital form directly, the artist has almost limitless capabilities for realizing his or her vision. With the appropriate computer software, such processes as combining, abstracting, distorting, emphasizing, texturizing, or recoloring image elements can be achieved relatively easily.

Today, many museums and galleries have accorded photographs the same artistic status as paintings, prints, and other visual

Figure 1-17. *A single detail or characteristic of an object can be emphasized or "abstracted" to make a striking image. Forms and their relationships are emphasized in abstract photographs.*

media. Fine art photographers are seeing their work hung in both public and private collections.

Development of photography

For years, instructors have introduced their students to the world of photography by teaching them to make a simple pinhole camera. Typically constructed from a light-tight cardboard container such as a cereal box, the camera consists of nothing more that a tiny covered opening in one wall and a sheet of film or photographic paper attached to the opposite wall. The camera is placed on a firm surface, pointed at a well-lighted subject, and the covering is removed from the pinhole. Minutes or hours later (depending upon the lighting and other variables), the pinhole is covered to end the

exposure. The film or paper is developed to reveal a picture of the scene that is often surprisingly good.

The basic principle of the pinhole camera — that light rays reflected from a subject will pass through the tiny opening and form an exact (though inverted) image on the other side — has a history far longer than photography itself. See **Figure 1-18.** The first recorded observation of an image formed by a pinhole is in the writings of Mo Ti, a Chinese philosopher who lived in the fifth century B.C. The ancient Greeks and Arabs were familiar with the principle as well, but the first practical applications were not made until the 1500s, when the *camera obscura* came into use.

The name, which means "dark chamber" or "dark room," was literally true in the earliest days of its use by artists. By making use of an actual room or a room-sized box or tent, the artist could bring the image to focus on a movable screen or wall and trace it onto a piece of paper or canvas. The tracings would then form the basis for a painting.

A simple lens eventually replaced the pinhole, providing a brighter and sharper image. By the 1700s, the "dark room" had shrunk to the size of a large tabletop box. A mirror inside the box, angled at 45°, reflected the image upward onto the underside of a sheet of ground glass, **Figure 1-19.** This arrangement permitted the artist to lay a piece on paper on the glass and easily trace the image.

The *camera lucida,* invented in the early 1800s in England by William Hyde Wollaston, did away with the box. The device, consisting of a prism mounted on a stand, was placed above a sheet of drawing paper. When the artist looked downward through the prism, he or she would see the scene in front of the camera lucida projected onto the paper. Tracing was a relatively quick and easy matter.

Neither of these methods, of course, involved *photographic* principles. Both the camera obscura and the camera lucida displayed the scene as a pattern of light and shadow that could be preserved by tracing. These devices could not "catch a shadow" in permanent form, in the sense that a modern camera is used to record a scene on film or an electronic medium.

The development of the recording *medium* (film) ran parallel to the evolution of the recording *device* (camera). When the two came together, photography was born. The

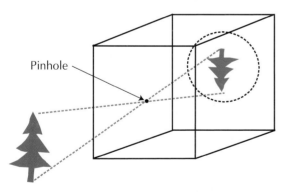

Figure 1-18. *Rays of light entering a darkened space through a tiny opening form an image that is inverted in relation to the actual scene. This principle was the basis of the drawing aid called the camera obscura. Photographs of surprisingly good quality can be taken with a pinhole camera, which is based on the principle shown in this illustration.*

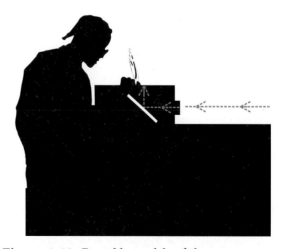

Figure 1-19. *Portable models of the camera obscura could be placed on a tabletop or similar support for convenience in tracing an image. An angled mirror bounced the light upward, forming the image on a ground glass surface.*

Milestones in Photography

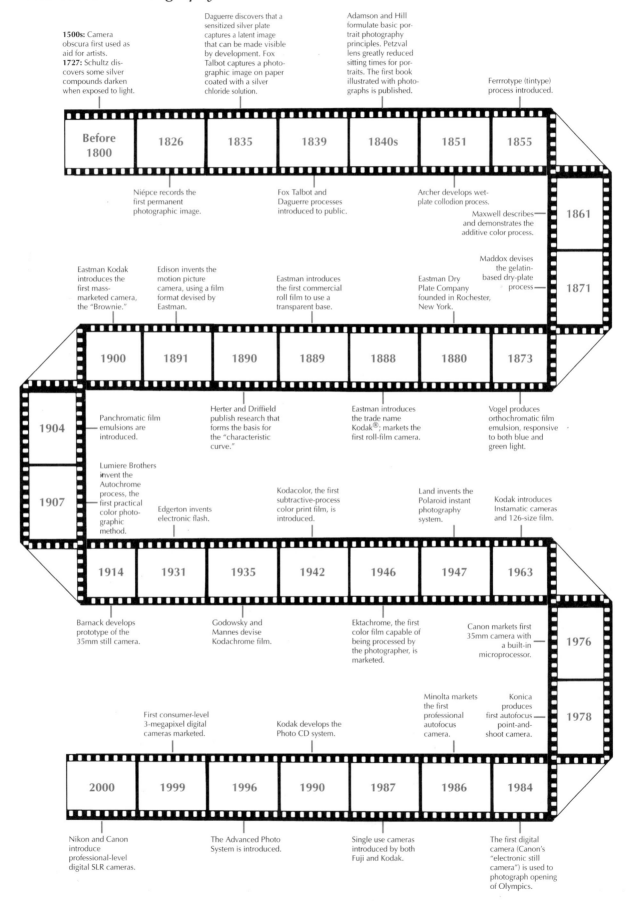

1500s: Camera obscura first used as aid for artists.
1727: Schultz discovers some silver compounds darken when exposed to light.

Daguerre discovers that a sensitized silver plate captures a latent image that can be made visible by development. Fox Talbot captures a photographic image on paper coated with a silver chloride solution.

Adamson and Hill formulate basic portrait photography principles. Petzval lens greatly reduced sitting times for portraits. The first book illustrated with photographs is published.

Ferrrotype (tintype) process introduced.

| Before 1800 | 1826 | 1835 | 1839 | 1840s | 1851 | 1855 |

Niépce records the first permanent photographic image.

Fox Talbot and Daguerre processes introduced to public.

Archer develops wet-plate collodion process.

Maxwell describes and demonstrates the additive color process.

| 1861 |

Maddox devises the gelatin-based dry-plate process

| 1871 |

Eastman Kodak introduces the first mass-marketed camera, the "Brownie."

Edison invents the motion picture camera, using a film format devised by Eastman.

Eastman introduces the first commercial roll film to use a transparent base.

Eastman Dry Plate Company founded in Rochester, New York.

| 1900 | 1891 | 1890 | 1889 | 1888 | 1880 | 1873 |

| 1904 |

Panchromatic film emulsions are introduced.

Herter and Driffield publish research that forms the basis for the "characteristic curve."

Eastman introduces the trade name Kodak®; markets the first roll-film camera.

Vogel produces orthochromatic film emulsion, responsive to both blue and green light.

| 1907 |

Lumiere Brothers invent the Autochrome process, the first practical color photographic method.

Edgerton invents electronic flash.

Kodacolor, the first subtractive-process color print film, is introduced.

Land invents the Polaroid instant photography system.

Kodak introduces Instamatic cameras and 126-size film.

| 1914 | 1931 | 1935 | 1942 | 1946 | 1947 | 1963 |

Barnack develops prototype of the 35mm still camera.

Godowsky and Mannes devise Kodachrome film.

Ektachrome, the first color film capable of being processed by the photographer, is marketed.

Canon markets first 35mm camera with a built-in microprocessor.

| 1976 |

Minolta markets the first professional autofocus camera.

Konica produces first autofocus point-and-shoot camera.

| 1978 |

First consumer-level 3-megapixel digital cameras marketed.

Kodak develops the Photo CD system.

| 2000 | 1999 | 1996 | 1990 | 1987 | 1986 | 1984 |

Nikon and Canon introduce professional-level digital SLR cameras.

The Advanced Photo System is introduced.

Single use cameras introduced by both Fuji and Kodak.

The first digital camera (Canon's "electronic still camera") is used to photograph opening of Olympics.

first important step toward a recording medium was the discovery, in 1727, that certain silver compounds would darken when exposed to light. Johann Heinrich Schultz observed that opaque objects, by blocking the light rays, would form stencil images on the surface of a container of silver chloride. The images were not permanent, however.

More than 70 years later, in 1802, the English scientists Thomas Wedgwood and Humphrey Davy applied a silver chloride solution to paper, placed opaque objects on it, and exposed the paper to light. They obtained the same stencil-like results as Schultz, creating a photographic form known as the *photogram*, **Figure 1-20.** Wedgwood and Davy attempted to carry the process a step further by placing the sensitized paper in a camera obscura and trying to record a scene. The results were not satisfactory, since the medium was apparently not sensitive enough to capture the image.

The first permanent image

Joseph Nicéphore Niépce, a French experimenter, achieved the goal of making a permanent photographic image in 1826. Using a pewter plate with a light gray coating of an asphaltic material (bitumen of Judea) and a camera with a simple lens, he made an eight-hour exposure of the scene outside the window of his home.

The bitumen of Judea was light-sensitive, hardening in proportion to the amount of light striking it. A solvent called *oil of lavender* was used to process the exposed plate. In areas with little or no exposure (shadows), the bitumen was dissolved completely, revealing the dark surface of the pewter. Highlight areas — those exposed to the most light — resisted the action of the solvent, remaining light gray. Varying degrees of exposure (and thus, capability of being dissolved) provided the middle tones. The positive image, while faint and low in contrast, was *permanent*; it remained unchanged when further exposed to light.

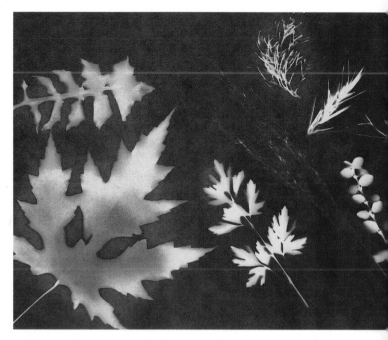

Figure 1-20. *Opaque objects placed on a sensitized material will form stencil-like images when the material is exposed to light. A number of photographic artists have produced works using the photogram, either alone or in combination with other processes.*

Several years later, Niépce refined his process by using silver for his plates. He found that, after using the oil of lavender solvent, he could darken the shadow areas with iodine. Then, he was able to remove the hardened bitumen from highlight areas to reveal the bright silver metal beneath them.

Louis Jacques Mandé Daguerre, a painter of theater scenery and huge tableaus who regularly used the camera obscura in his work, became Niépce's partner in 1829. Together, they continued to experiment with ways to achieve better images from the process.

Following Niépce's death in 1833, Daguerre continued to work on perfecting the process with the aid of Niépce's son, Isidore. A major breakthrough came in 1835, when Daguerre found that a silver plate sensitized (made light-sensitive) by iodine fumes and then exposed in the camera held a *latent* (invisible) image. That image, he

discovered, could be made visible, or *developed,* by exposing it to the fumes from a heated container of mercury.

The final element that made Daguerre's method a practical means of photography was a means of *fixing* the image to prevent further darkening of the silver by exposure to light. At first, he used a hot solution of common salt to wash the plate after development. This removed enough of the unexposed silver iodide to prevent darkening by exposure to light. A more effective fixing method became available in late 1839. The English astronomer John Herschel (who had coined the term "photography") described the use of hyposulfite of soda, or "hypo," to make photographic images permanent. Hypo, now called sodium thiosulfate, achieves this fixing action by dissolving the unexposed silver on the plate's surface. Daguerre quickly adopted that method.

Word of Daguerre's success in producing permanent photographic images reached the scientific world on January 7, 1839. On that date, Francois Arago, director of the Paris Observatory, made Daguerre's work the subject of his lecture to the French Academy of Sciences. Arago did not reveal technical details, but suggested that the process should be purchased by the French government. Slightly more than six months later, the government acted upon Arago's suggestion, awarding lifetime pensions to Daguerre and to Isidore Niépce in return for public disclosure of the process. On August 19, 1839, a joint meeting of the Academy of Sciences and the Academy of Fine Arts heard a detailed description of how *daguerreotypes* were made. The announcement took not only France, but the entireWestern world, by storm. Before the year was out, a small handbook written by Daguerre was on the market, and daguerreotypes were being made in a number of countries. See **Figure 1-21.**

At first, the need for very long exposures made the process somewhat impractical for portraits: few people were willing or able to

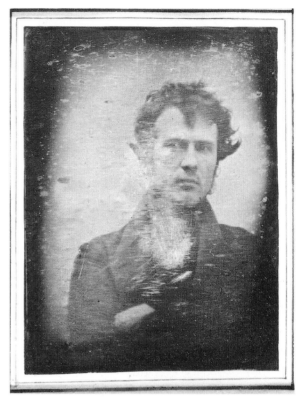

Figure 1-21. *One of the first daguerreotype images made in the United States was this self-portrait of Robert Cornelius of Philadelphia. The image was made in October or November, 1839, only months after Daguerre's process was described in detail for the first time. Written on the paper backing of the image (presumably by Cornelius himself) are the words, "The first light picture ever take. 1839."*
(Courtesy of the Library of Congress)

sit perfectly still for up to twenty minutes. Within a year of Daguerre's announcement, however, a new camera lens was introduced that reduced exposures to a much more practical length of a minute or less. The lens was built by Peter W.F. Voigtlander in Vienna, Austria, from a design by the Hungarian mathematician Josef Petzval. Compared to the simple meniscus lens then in use, the Petzval lens was four stops faster (transmitted 16 times more light). Once sitting time was drastically reduced by the adoption of the Petzval lens, daguerreotype portrait studios became common.

Each daguerreotype image was unique, a "one-of-a-kind" picture. The only way to obtain an additional copy was to photograph the original image. Eventually, the daguerreotype would be supplanted by the more flexible negative/positive system.

Discovery of the negative

In the early 1830s, William Henry Fox Talbot, an English scientist and "gentleman inventor," began experimenting with methods to permanently record a photographic image. Rather than using metal plates, Fox Talbot worked with paper that he coated with various silver compounds. In 1835, he succeeded in capturing a quite detailed image of his home's leaded glass window on paper that had been coated first with a solution of common salt, then with silver nitrate. The resulting silver chloride compound was sufficiently light-sensitive to record an image. Following a long exposure, a visible negative image appeared on Fox Talbot's sensitized paper. A paper upon which the image appears without the use of a developer, as in this case, is called **printing out paper.** The paper used for photographic prints today is known as **developing out paper,** since the latent image must be brought out through use of a developer.

When Fox Talbot learned of Daguerre's work through a report of Arago's January 7 speech, he was anxious to announce his own process. His paper, *Some Accounts of the Art of Photogenic Drawing,* was read at a meeting of the Royal Society on January 31, 1839. Like the first description of the daguerrotype process, Fox Talbot's initial announcement did not provide specific technical details. Less than a month later, on February 20, a second paper was presented with a complete description.

The "photogenic drawings" were negative images—reversed both in tones and in orientation (left-to-right). In his February paper, Fox Talbot described what is to this day the basis of chemical-based photographic printing: the **negative/positive system,**

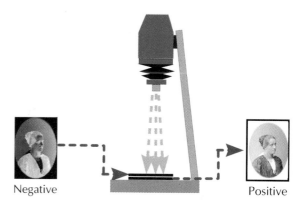

Figure 1-22. *The negative/positive system invented by Fox Talbot made it possible to reproduce a photographic image in any quantity the photographer desired. In the most basic form of the negative/positive system, the original (negative) is placed against a sheet of sensitized paper and exposed to a light source. After chemical development, a same-size contact print (positive) results. Later, it became possible to expose enlarged copies called projection prints.*

Figure 1-22. (The terms *positive* and *negative* were another contribution by John Herschel.) Fox Talbot noted that the original reversed image, the negative, could be placed atop another sensitized sheet and the sandwich exposed to strong light. The resulting print would be a positive version with both tones and orientation matching the photographed scene.

By discovering and refining the negative/positive system, Fox Talbot altered the direction taken by photography. Instead of being limited to unique, one-at-a-time images, photographers could now make as many copies as they wished from each negative. A whole new kind of photography was born.

Continued experimentation by Fox Talbot resulted in the **calotype,** a paper negative material that could be exposed in a fraction of the time needed for his original process. This process produced an image that had to be developed to make it visible. The finished paper negatives were coated with wax to make them more translucent, allowing a shorter printmaking exposure and improving the amount of detail visible in the print. The

calotype (later renamed the "talbotype") process was used to produce the first book illustrated with photographs. Fox Talbot's *Pencil of Nature*, published in 1844, was illustrated with 24 photographs that were individually printed and adhered to the pages.

Even with the improved quality provided by the waxed calotype negatives, images produced by the daguerreotype process remained superior in detail and contrast. The problem, of course, was in the negative material: the fibrous nature of paper images introduced a texture that masked fine detail and lowered contrast. What was needed was a negative material as clear as glass — which was not long in coming.

Plate-based photography

By 1848, a method of adhering a light-sensitive coating to a sheet of glass was devised by Abel Niépce de Saint-Victor in France. He used albumen prepared from the whites of eggs. The clear and smooth glass base of the negative permitted the making of prints rivaling the appearance of the daguerreotype. The major drawback of the albumen plate was low sensitivity to light, requiring lengthy exposure times. This factor limited its usefulness. Albumen emulsions for printing paper were introduced in 1850, allowing the photographer to retain the full quality of the glass plate negative.

An improved coating process using *collodion* (a viscous liquid that dries to form a clear, tough layer) was devised in England in 1851 by Frederick Scott Archer. The *wet-plate collodion process* quickly replaced the use of albumen plates. Within a matter of years, it drove both the daguerreotype and the talbotype out of the marketplace.

The collodion plate was much faster (more light-sensitive) than the albumen plate, and provided a photographic quality equal or superior to any other process. It did, however, have its drawbacks. The major weakness of the method was the cumbersome sequence of steps needed to prepare, expose, and develop the plate.

The liquid collodion, mixed with iodide, was flowed onto the surface of a carefully cleaned sheet of glass. The glass was then tilted in different directions to achieve an even coating. Within a few minutes, the collodion surface became tacky. The plate was then plunged into a silver nitrate solution to sensitize it. This step, and all succeeding ones until the negative was developed and fixed, had to be carried out in darkness or under dim red or orange light. A light-sensitive silver bromide emulsion was formed.

The sensitized plate was placed in a holder covered with an opaque lid (**dark slide**). Since the sensitivity of the emulsion would be lost if the emulsion was allowed to dry, the plate had to be exposed quickly. It would be inserted in an already positioned and focused camera, the dark slide removed, and the camera shutter opened. After an exposure of up to 15 seconds, the shutter was closed and the dark side replaced. The holder was carried quickly to the darkroom and the plate developed immediately in an open tray. After fixing and washing, the plate was air-dried in a rack.

Because of the complexity of the process, wet plate collodion photography typically required at least two persons: the photographer to set up and operate the camera, and an assistant to prepare and develop plates. It also needed, for location photography, a wagon or tent that could be made essentially light-tight to handle the plate chores. See **Figure 1-23**. Since emulsions of that time were not sensitive to red light, a tent made from orange or red canvas could be used. The glass plates were fragile and relatively heavy, especially in the larger sizes (16" × 20" plates were not uncommon).

Despite these drawbacks, the wet plate collodion method was the primary photographic process for nearly three decades (1850–1880). In both the field and the studio, it permitted photographers to produce images of a quality that would have been virtually impossible with any of the preceding photographic processes.

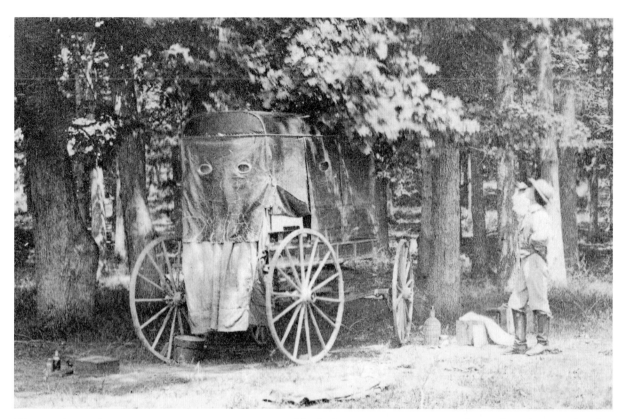

Figure 1-23. *A tent or wagon to serve as a portable darkroom was a necessary item of equipment for the field photographer using the wet-plate collodion process. This wagon, parked in a grove of trees near the Manassas battlefield in Virginia, was used by Timothy O'Sullivan, one of Matthew Brady's staff of photographers. The photo was taken July 4, 1862. (Courtesy of the Library of Congress)*

Collodion also made possible the ambrotype and ferrotype processes. The *ambrotype* was simply a glass negative placed over a black backing material and enclosed in a decorative case. The black backing changed the appearance of the negative into a positive; the result resembled a daguerreotype. *Ferrotype* was the formal name for the highly popular *tintype* process for quick and inexpensive portraiture, **Figure 1-24.** It consisted of a wet collodion emulsion applied to a thin iron plate that had been painted with a black or brown enamel. The material was low in cost and the picture processed in a matter of minutes, resulting in a positive-appearing image because of the dark background material. Some cameras were constructed to allow a sequence of exposures to be made on a single large plate. After processing, tin snips were used to cut apart the individual pictures. The ferrotype process was introduced into the United States (where it would achieve its widest use) in 1855, and would continue to be popular into the twentieth century. A few practitioners still produce tintypes in nostalgic settings, such as Civil War reenactments or historical village restorations.

With the invention of the *dry plate process* in 1871, the chains binding the photographer to the darkroom were broken. A British physician, Richard Leach Maddox, made the discovery that gelatin could be substituted for collodion when coating glass plates. Unlike the collodion-based emulsion that lost its light sensitivity if allowed to dry, gelatin emulsions remained light-sensitive after drying. In fact, the silver bromide emulsions used in dry plates were much more light-sensitive than those used in

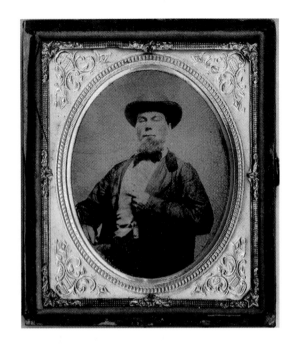

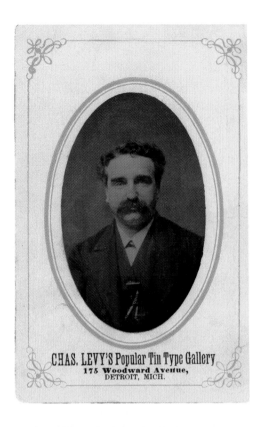

Figure 1-24. *The ferrotype, or tintype as it was known, became "the people's photograph" after its introduction in the mid-1850s. Its low cost compared to the daguerreotype and other processes made it popular with individuals and families of limited means. The completed tintype might be presented to the customer in unadorned form, like the two examples at bottom. Often, however, they were placed in a printed paper folder advertising the photographer's studio (top right). Some were packaged in a form that emulated the daguerreotype, sandwiched in glass and a metal foil frame, then placed in a wood and leather case. The example at top left is missing the lid half of its case.*

wet-plate photography. Dry plates could be prepared and stored for months before being exposed; development could be delayed until convenient. Dry plates could also be manufactured under controlled conditions to produce consistent results. The "one-at-a-time" preparation of wet collodion plates introduced many variables that could affect the final result.

Commercial production of dry plates began in England in 1876; in the United States, Carbutt of Philadelphia began offering dry plates in 1879, and George Eastman founded his Dry Plate Company in 1880. See **Figure 1-25.** The immensely greater convenience of the dry plate, and the greater light-sensitivity that permitted much shorter exposure times, soon ended the general use of the wet-plate method.

Introduction of roll film

The dry plate was a major step toward making photography available to a wider audience. With the ability to keep a stock of

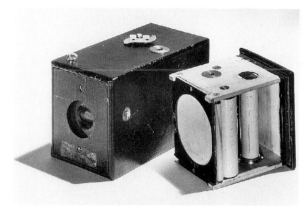

Figure 1-26. *George Eastman's roll film snapshot camera made photography a popular pastime, since it was simple to use and eliminated the need for developing and printing by the photographer. His slogan, "You press the button, we do the rest," pointed the direction that the consumer photographic industry would take. (Eastman Kodak Company)*

plates and use them as needed, it became possible for photography to become a hobby, rather than the exclusive province of the professional. Though far easier to use than wet plates, the new dry plates still required access to a darkroom for developing and printing. They also retained the drawbacks of the glass support: fragility, bulk, and weight. These problems were resolved in the late 1880s, when sheet films (gelatin emulsions adhered to a flexible, transparent base) came onto the market.

The true solution to making photography a widespread and popular activity was achieved in 1888, when George Eastman began marketing the first self-contained camera to use roll film, **Figure 1-26.** While some professionals had been working with roll films for several years, Eastman targeted his roll-film camera squarely on the amateur. The box-type camera was extremely simple to operate: the user pulled a string to cock the shutter, pressed a button to release it, then turned a keylike knob to advance to the next frame. Sealed inside the camera was a roll of gelatin-emulsion film sufficient for 100 exposures, each 2 1/2" in diameter,

Figure 1-25. *The invention of the dry plate process allowed photographers to carry a ready-to-use supply of plates, rather than having to prepare each plate just before exposure. A number of manufacturers offered dry plates in sizes to fit 4" × 5", 8" × 10", and other popular camera formats. Dry-plate emulsions were more sensitive than wet-plate coatings, permitting photography of action scenes or in low-light conditions. (Kankakee County Historical Society)*

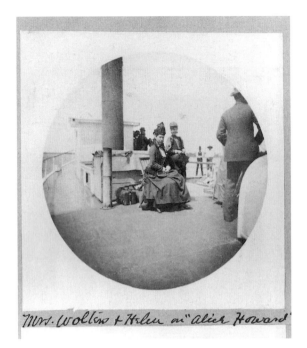

Figure 1-27. *When the photographer sent in a Kodak camera for developing, he or she received back the prints and negatives, plus a freshly reloaded camera. The camera produced up to 100 small circular prints. This snapshot of two women on a boat deck in Florida was taken by Joseph J. Kirkbride in 1889.*
(Courtesy of Library of Congress)

Figure 1-27. The Kodak system eliminated the need for a darkroom. When all 100 exposures had been made, the entire camera was sent back to the company. For a $10 fee, the film was developed and printed, and a new roll of film loaded into the camera. Camera, negatives, and prints were returned to the photographer.

Eastman's earliest roll film consisted of a gelatin emulsion applied to a paper backing. After development, the emulsion was separated from the paper and sandwiched between two layers of clear gelatin. This method provided a clear base for print-making, and additional support for the somewhat delicate negative. Within a year of introducing the roll-film camera, Eastman adopted a simpler and better system of supporting the emulsion. The light-sensitive material was coated onto backing of clear

celluloid (*cellulose nitrate,* one of the earliest plastics), rather than the paper support. With the exception of changes in the type of plastic used for the base (flammable cellulose nitrate was replaced by *cellulose acetate* in the 1920–1940 period, and polyester was introduced in the 1990s), the roll film form devised by George Eastman remains the standard for both still photography and motion pictures.

The motion picture industry, in fact, owes its very existence to Eastman's film. The use of a strong, flexible, transparent base for the light-sensitive emulsion made possible Thomas Edison's development of the first motion picture camera in 1891. See **Figure 1-28.** Interesting enough, the film that evolved as the standard for motion pictures — 35 millimeters in width and perforated with holes to accept the drive sprockets of the movie camera — became the most widely used format for still photography more than a half-century later. From the 1890s through

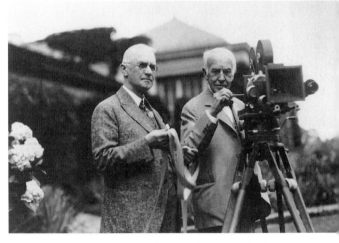

Figure 1-28. *These two men made possible the existence of the motion picture industry. The prolific American inventor Thomas Edison developed the motion picture camera in 1891. It used the roll film introduced two years earlier by George Eastman. An unknown photographer captured the two men together with a current model of the camera during the 1920s. Edison is behind the camera.*
(Courtesy of the Library of Congress)

the middle years of the twentieth century, roll films used by both professionals and amateurs were what would be referred to today as "medium format." Many of these films were 2 1/4" wide, like the still-available 120 size, but others were as much as 3 1/2" in width. Like today's medium format roll films, the strip of unperforated film was taped to a paper backing material. The tough, opaque paper was used to carry the film through the camera, and also provided protection against stray light.

Although 35mm motion picture film had been used by several experimenters for still photography, the "father of the 35mm camera" was Oskar Barnack, a machinist for the German optical firm of Ernst Leitz and Co. In 1914, Barnack developed a prototype still camera that could be used with the small film format. The design made use of the perforations to pull the film through the camera, one frame at a time, eliminating the paper backing used with other film sizes. The film was loaded into a small, light-tight metal can or *cassette*, and rewound into that container when all frames had been exposed. By 1924, the Leitz firm was manufacturing and marketing Barnack's camera under the name Leica, which it still bears today. For many years after the Leica's introduction, the use of 35mm cameras was known as "miniature photography," **Figure 1-29.**

Like the Eastman roll-film camera of 1888, the 35mm camera created a photographic revolution. The introduction of the roll-film camera had produced an almost immediate effect, making photography a popular pastime. Its "point and shoot" simplicity and elimination of the need for a darkroom created a market for photographic products almost overnight. The 35mm revolution took place at a considerably slower pace. For many years, "miniature photography" appealed primarily to the adventurous person who was already involved with photography. As more and more 35mm cameras (most of them rangefinders with a single fixed lens) came

Figure 1-29. *Fifteen years after their introduction, 35mm cameras were still being referred to as "miniature cameras," as shown in this portion of a 1939 Kodak advertisement. While the $33.50 price seems a bargain by today's standards, it was actually the most expensive of the nearly 30 cameras listed in the advertisement. A "Brownie Junior" box camera sold for $2, while a "Jiffy Kodak" folding camera was priced at $7.50. Both produced 2 1/4" × 3 1/4" negatives.*

on the market, they began to be purchased as primary photo equipment, **Figure 1-30.**

Single-lens reflex (SLR) cameras with interchangeable lenses became more widely available in the late 1950s and 1960s. Their flexibility, light weight, and ability to take photographs under almost any conditions

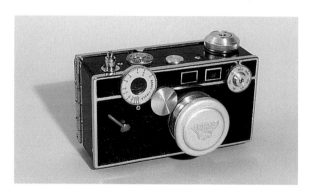

Figure 1-30. *One of the most popular of the 35mm rangefinders from its introduction in 1939 until its last production model in 1966, the Argus C-3 camera introduced many people to "miniature photography." The camera's size, shape, and 1 1/2 pound weight earned it a descriptive nickname: "The Brick."*

greatly accelerated the trend toward 35mm. Automatic exposure and autofocus features, especially in the simple point and shoot cameras intended for general "snapshot" use, solidified the position of 35mm as the dominant film format. Other formats, such as disc film and the 126 and 110 Instamatic films were introduced, but eventually faded out or declined to form only a minuscule portion of the market. The Advanced Photo System (APS), introduced in 1996, experienced moderate success but failed to have much effect upon the 35mm market.

Part of the success of 35mm photography can be attributed to the growth of its support system. Cameras are readily available in almost every setting from specialty photo shops to the corner drugstore. Extraordinary growth has been registered in the sales of 35mm single-use cameras, **Figure 1-31.** Like the original Kodak, these cameras are sold already loaded with film, and are sent in — camera and all — for processing. In this modern version, the prints and negatives are returned, but the plastic camera is ground up and recycled. The overwhelming proportion of

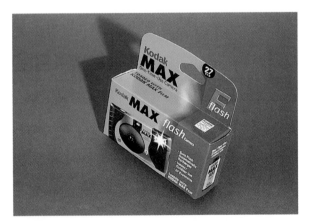

Figure 1-31. *Sales of 35mm single-use cameras have grown to tens of millions annually as a result of convenience and low cost. Versions are available with and without built-in flash; some models are sealed for use underwater or in adverse conditions of dust, snow, or dampness. Packages with multiple units are marketed for group activities such as wedding receptions or parties.*

film produced, exposed, and developed is color negative ("print") film. It can be readily purchased almost everywhere, and developed and processed nearly as universally. Overnight film processing, once considered an extra-cost "rush" option, is now standard. Even that standard is rapidly being superseded by the explosive growth of one-hour processing minilabs in shopping centers and retail stores.

Color photography

While practical methods of capturing and displaying a black-and-white photographic image were being developed and refined in the mid-to-late nineteenth century, some experimenters were also working to achieve photography in full color. The first to produce viewable photographic images in color were an Irish experimenter, John Joly (in 1893) and an American, Frederick Ives (in 1894).

Joly's method involved exposing a plate through a fine line screen checkered with tiny red, green, and blue squares. After the photographic plate was developed and fixed, the line screen was laid over the plate, brought into register with the image, and fastened in place. The sandwiching of the two elements allowed the image to be seen in color.

Ives developed a more complex system that required the use of a special viewer that he called a *Photochromascope*. The key to the Ives system was a camera he invented that produced three color-separation negatives. After the negatives were processed, they were used to make positives that could be viewed with the Photochromascope, which recreated the full-color original scene.

Neither system achieved commercial success, however. It was not until 1907, when the *Autochrome process* was introduced, that color photography became a practical reality. Brothers Louis and Auguste Lumiére of France found that applying fine grains of colored potato starch to a plate, then coating the plate with an emulsion,

would produce a colored image. The starch grains were dyed three different colors (cyan, magenta, and yellow), then thoroughly mixed together to achieve a uniform distribution. The resulting powder, which appeared gray to the naked eye, was dusted in a thin layer onto a plate covered with wet varnish. A second coat of varnish was applied, and another layer of starch powder added. Finally, very finely ground charcoal powder was applied to fill any spaces between the starch grains in the second layer. The light-sensitive emulsion was coated over the top starch layer. The emulsion used by the Lumiére brothers was *panchromatic*, meaning that it responded with adequate sensitivity to all colors of light. The earliest film emulsions were primarily responsive to blue light; *orthochromatic* emulsions, introduced in the 1870s, were responsive to both blue and green light. "Red-blindness," the inability to respond to red wavelengths of light, was overcome in 1904 with the addition of special dyes to the emulsion, making it panchromatic.

During exposure and later, during viewing, the two starch layers worked together as a filter to condition light by the *additive color process*. To reach the emulsion, light had to pass through the starch-grain layers. The colors were produced by the effect of the colors of the tiny grains in the two layers. Light passing through a yellow grain, then a cyan grain (or vice versa), produced green; cyan and magenta yielded blue; magenta and yellow made red. After development, the plate was viewed from the emulsion side, so that light passed through both the starch grains and the emulsion to the eye. The result was a surprisingly natural-looking color image, **Figure 1-32.**

Like the daguerreotype, each Autochrome image was essentially "one-of-a-kind." Despite this limitation, the process became popular and was used extensively until the mid-1930s. Autochrome and similar additive color processes were made obsolete by the introduction of subtractive color films,

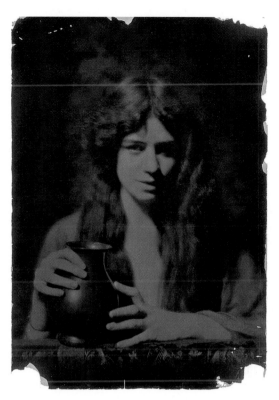

Figure 1-32. *Until it was supplanted in the 1930s by subtractive color process films, the Autochrome process was the most successful method of achieving color in photography. This portrait of a woman with red hair was made by San Francisco photographer Arnold Genthe in the early 1900s.*
(Courtesy of the Library of Congress)

beginning with the invention and marketing of Kodachrome in 1935.

In the *subtractive color process,* dyes are used to subtract or block specific colors from the white light that is used to view the image. A cyan dye absorbs red light and passes blue and green; a magenta dye absorbs green and passes blue and red; a yellow dye absorbs blue and passes red and green.

The subtractive color process eliminated the complex mechanical masking involved in Autochrome and similar additive color processes — dye formation was done chemically during processing of the exposed film. Kodachrome®, invented by Leopold Godowsky Jr. and Leo Mannes, is a color

reversal (transparency) film; Kodacolor, the first color negative film using the subtractive process, was introduced in 1942.

"Instant" photography: the Polaroid process

Photographers have always been eager to see the results of their efforts as quickly as possible. For those without darkroom facilities, this once meant a wait of several days for the material to be returned by the processor. It has only been in the last decade that overnight and even one-hour film development became commonly available.

This impatience contributed to the initial and continuing success of a unique photographic system introduced in 1947 by American inventor Edwin H. Land, **Figure 1-33.** The Polaroid process (named for Land's company, which was originally

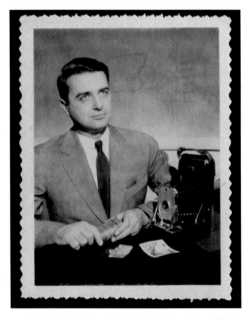

Figure 1-33. *Edwin H. Land introduced his Polaroid Land camera in 1947. Land's system made possible, for the first time, an immediate assessment of photo results. Development of the photo initially took one minute; later refinements reduced the time to only ten seconds. (Courtesy of the Polaroid Corporation archives)*

formed to market sheet polarizing materials he had invented) allowed the photographer to view a fully developed picture only one minute after exposure. This rapid development time, later reduced to ten seconds, was achieved by incorporating a small packet of chemicals in each sheet of film. After exposure, the sheet passed through a set of rollers while being ejected from the camera. Roller pressure broke open the packet of chemicals and spread the mixture evenly over the film surface. At the end of the development period, a cover sheet was peeled off the film, revealing the finished photograph. In the earliest form of the process, a special applicator was used to apply a material that helped neutralize any remaining chemical, and served as a protective coating. Improvement in the one-step developing/fixing chemicals later eliminated the coating step.

A color version of the Polaroid process began to be marketed in the early 1960s. A new camera and film combination, the SX-70 system, was introduced in 1972. The SX-70 camera, after exposure, ejected a one-piece photograph with a clear top layer. The photographer was able to watch the picture develop, with no need to remove and discard a cover sheet.

Although it has never achieved the widespread acceptance of conventional-film-based photography, the Polaroid process has filled several market niches. It continues to appeal to consumers who wish to see almost instant results (although digital cameras are eroding this market segment). Studio photographers with large format equipment have long relied on Polaroid materials to quickly check lighting setups and composition. Fine art photographers use a variety of Polaroid materials for such alternative processes as emulsion transfer and mechanical manipulation of images during development. A number of photographers make use of a Polaroid film that produces both a positive and a negative, **Figure 1-34.**

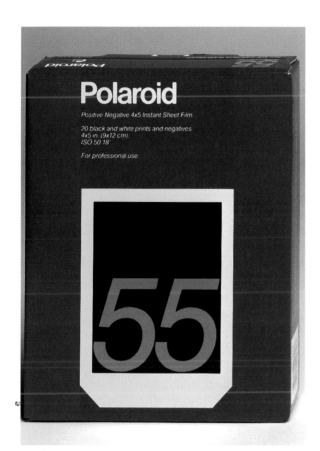

Figure 1-34. *Polaroid's Type 55 P/N film produces both a positive and a usable negative. The negative must be processed for permanence, but then can be used to make conventional prints. (Polaroid Corporation)*

The growth of digital photography

Photography without film seemed to burst upon the public's consciousness in the late 1990s, although digital photography can be dated to 1984, when Canon introduced what it called an "electronic still camera." The device was actually used by Japanese photojournalists to document the opening of the 1984 Olympic Games in Los Angeles, California. Through the remainder of the 1980s, various Japanese cameramakers and Eastman Kodak introduced digital products. The high cost and low resolution of the images restricted the market initially. Most of the products released in that period were actually still video cameras that recorded the electronic images on videotape.

In the early 1990s, however, *digital photography* began to be a serious competitor to film in some forms of studio photography. Digital cameras specifically designed for large format product photography began to be seen in the studios of catalog and advertising photographers. Also available to photographers were **digital backs** (arrays of charge-coupled devices, or CCDs) that could be mated with large format cameras. These digital cameras and backs could be used only for photos of stationary objects, since each scene was literally scanned three times (once for red, once for blue, and once for green). The very large arrays used to capture the subject, however, resulted in a high quality image rivaling traditional film. In recent years, digital backs also have been developed for medium format equipment. See **Figure 1-35.**

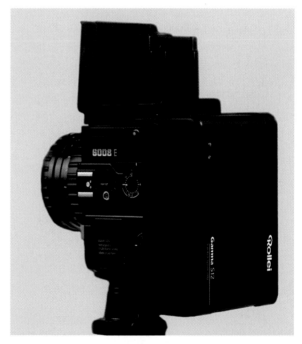

Figure 1-35. *While digital scanning backs were originally available only for large format cameras, they now can be used with medium format equipment as well. This back is designed for use with Rollei 6 × 6 cameras, and takes three minutes to make a scan at the highest resolution setting. (Rollei Fototechnic)*

For the photographer, the digital approach offered several advantages. He or she was able to use (in the case of digital backs) all of the traditional movements of a familiar studio camera and the high optical quality of existing lenses. Since the digital back was linked electronically to a computer, composing the shot was done on a computer monitor. Continuous and constant lighting was needed through the complete scanning sequence, so all lighting decisions could be made and evaluated before exposure. Once the exposure was made, the digital file could be called up on the computer screen and examined. Any problems could be corrected and the scene exposed again.

Photojournalists and other photographers working with live subjects or in the field, however, needed a camera that could capture an image instantly. They also needed a camera that was flexible and portable, rather than being literally tethered to a computer. Some form of "on board" storage of completed images was needed. Those requirements would be the key to making digital photography a part of the consumer market, as well. The digital camera would have to retain most of the attributes of the 35mm conventional camera (light weight, ease of use, acceptable picture quality, affordability), while providing the highly desirable feature of instantly visible results.

Cameras for professional use, especially for photojournalism, developed somewhat along the lines of the studio digital back systems: a digital array and associated electronic components were "married" to an existing professional-level 35mm SLR. See **Figure 1-36.** As in the case of the digital back, this arrangement allowed the photographer to work with a familiar system and take full advantage of an array of quality lenses. A major difference from the studio camera, of course, is that the image is captured instantaneously, rather than in three separate scans.

A number of image storage systems based on cards that could be inserted in the

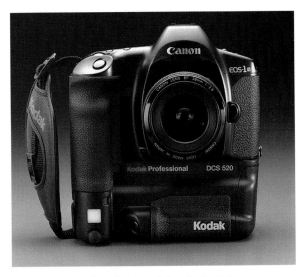

Figure 1-36. *Professional-level digital cameras often consist of the digital sensors and circuitry added to a top-of-the-line 35mm camera. Photojournalists and others using such a camera would gain the benefits of digital image capture while retaining familiar camera controls and functions. (Eastman Kodak Company).*

camera were developed. The equivalent of "digital film," the card could be removed from the camera when filled, and a new one inserted. By using a special adapter, the stored image files on a card could be transferred to a computer's memory, **Figure 1-37.** Storage capacity of the different cards, and thus their cost, varied greatly. Most could hold a small number of very large (high resolution) images, or a larger number of images at a lower resolution.

The surge in consumer acceptance of digital cameras paralleled the great expansion of home computer use and the explosive growth of the Internet. In the late 1990s, literally dozens of digital cameras designed for consumer use came onto the market. The cameras varied widely in capabilities and price, appealing to different market segments. Most shared a common characteristic, however: they were the digital equivalent of the 35mm "point-and-shoot" snapshot camera. Other than zoom lenses on some models, most offered the user limited capability for making decisions about the

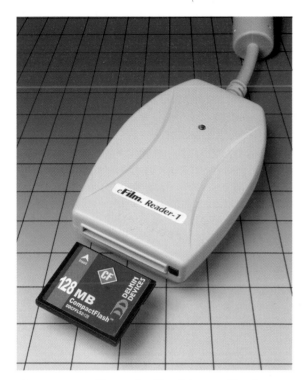

Figure 1-37. *"Downloading" image files from the digital camera's interchangeable memory cards is done by using a special adapter that accepts the card and plugs into the computer. The stored images can be transferred fairly rapidly to computer memory, and the memory card reused for new images. (Delkin Devices)*

image. Focus, aperture, and shutter speed all were automatically set by the camera's electronics. More sophisticated models allowed the photographer to manually set exposure controls.

At the low end of the price spectrum were (and still are) cameras capable of producing low-resolution images suitable for use on a computer screen, in a newsletter printed on an inkjet or laser printer, and similar applications. At the opposite extreme are the *megapixel cameras*, **Figure 1-38.** These have CCD arrays containing in excess of a million (three million or more in some models) sensors to instantly capture images with moderately high resolution. Megapixel cameras are capable of producing printed images that begin to approach the quality of those made with conventional film.

The future of photography

As noted in the preceding section, digital imaging saw its most significant growth in the mid-to-late 1990s. Its continuing growth is most likely to depend upon the relationship of resolution and price. If the digital camera market follows the pattern set by computers in the last decade of the twentieth century — continuing increases in capability with a relative decrease in prices — rapid and continued growth seems likely. If the available resolution fails to rise steadily and prices do not decrease (relative to improved resolution), the rate of increase in digital camera sales may stagnate.

Digital applications

On a professional level, digital image capture has achieved a reasonable amount of acceptance in several fields. One of the largest of these is product illustration, especially for the mail-order catalog industry. With most catalogs being created using electronic page layout systems, the ability to import an original digital image, without the cost and delay associated with scanning of

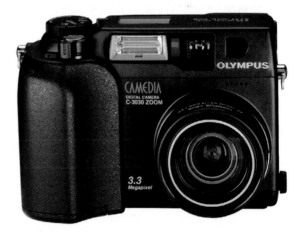

Figure 1-38. *The consumer-level megapixel digital cameras introduced in the late 1990s and early 2000 had CCD sensors arrays including as many as three million pixels. Images captured at the highest resolution were suitable for quality printed reproduction. (Olympus)*

conventional slides or prints into digital files, is an important advantage.

The speed with which a digital photograph can move from camera into the printed page is also an important factor for newspapers and magazines. A picture of a news event taken on the other side of the world can be on file in a newspaper's computer system and available for publication literally minutes after the occurrence. Using telephone lines and satellite technology, the photographer can transmit the image from camera to newspaper at high speed.

In scientific/technical fields, the advantage of being able to examine an image immediately after it is taken makes digital capture a valuable tool for many disciplines. The relative ease of copying and transmitting electronic files simplifies dissemination of information resulting from research, or sharing of material with other researchers. Compared to physical photographic products, such as slides and prints, digital photos take up little space and do not require special environmental conditions for safe storage. Duplicate copies are easily created and moved off-site for security.

Digital image capture and subsequent manipulation are a fruitful field for artistic exploration. Image editing programs are extensively used by photographers in a "digital darkroom" context, **Figure 1-39.**

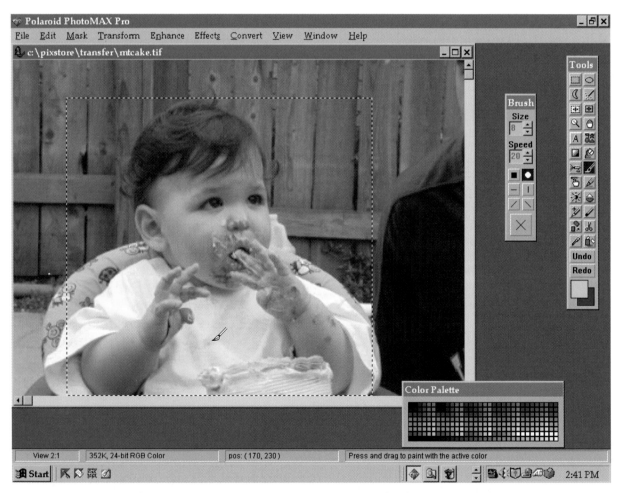

Figure 1-39. *Images from digital cameras, or from conventional film that has been scanned into a digital file, can be retouched or otherwise manipulated by the use of image editing software on a personal computer. Editing software varies from simple consumer-level programs with limited capabilities to highly complex programs used by professional photographers and graphic artists. (Rob Gorham)*

Beyond the electronic equivalents of the traditional local exposure adjustments (dodging and burning in) and contrast adjustments, these programs allow the repair of defects such as scratches and visual "cleanup," such as eliminating unfortunately placed telephone wires. Through such techniques as combining multiple images or parts of images, altering colors and textures, or applying various distortions, the photographer can exercise a considerable degree of artistic freedom. See **Figure 1-40.**

Whether digital cameras will sooner-or-later replace traditional cameras in the broad consumer market is an open question. A huge number of traditional cameras are currently in use — in developed nations, few families do not have at least one camera; many have several. Most of these cameras are as simple, or even simpler, to use than their would-be digital replacements. The explosive growth of the "disposable," or single-use, camera segment of the market is also a factor. Purchase of these low-cost, impulse-driven or special-occasion-driven cameras seems unlikely to be affected by the availability of digital cameras.

Most often cited by those who predict a digital revolution among consumers is the cost savings from eliminating the purchase of film and film processing. The digital camera, however, cannot produce pictures (at least in the print form favored by most consumers) without some fairly costly accessories. The costs of the camera, memory cards, a computer, and a printer and printer supplies add up to a total that would purchase a significant supply of film and processing. Of course, other than printer supplies, these are one-time expenses, rather than the continuing costs of film and processing. A recent development has been the marketing of printers that can be used to produce prints directly from the camera, without the use of a computer. See **Figure 1-41.** Continuing development in that direction should overcome at least one of the roadblocks to digital acceptance.

Figure 1-40. *Photo-based illustrations made by combining a number of images are becoming common for advertising and magazine editorial use. Many photographers are exploring the creative freedom that digital image manipulation makes possible.*

Will silver-based photography survive?

Compared to the almost overnight demise of the 8mm home movie camera as a result of the introduction of the video camcorder, the move by consumers from conventional photo equipment to digital cameras is likely to be more gradual. The change will be more of an evolution than a revolution. The ability to achieve almost instant results does not seem as compelling to the consumer in still photography as it apparently was with motion video. Had it been, Edwin Land's 1947 Polaroid instant camera would have driven conventional cameras off the market by now.

Even though digital image capture seems likely to become the standard practice for a large segment of the advertising and commercial photography market in the near future, silver-based photography is expected

Figure 1-41. *Some ink jet printers permit insertion of a digital camera memory card, so that images can be printed without the need for a computer. The printer also can be connected to a computer for conventional use. (Eastman Kodak Company)*

to remain a significant process. Serious amateurs and professionals dedicated to fine art photography can be expected to remain with silver-based methods as a creative tool. The process of capturing the image on film and producing it with traditional darkroom practices will allow the artist to present a subject in a way very different from the same subject captured and presented by digital methods. The evolution of silver-based photography from a broad popular form of expression to a narrow fine-art specialization is likely to take a very long time.

Questions for review

Please answer the following questions on a separate piece of paper. Do not write your answers in this book.

1. Industrial and commercial photography is often more challenging than photography aimed at _____.
2. A flat fee, or _____, is charged for each separate use of a stock photograph.

3. _____ conducted pioneering photographic studies of animal motion in the late 1800s.
 a. Holmes
 b. Farnsworth
 c. Muybridge
 d. Daguerre
4. What social change resulted from the publication of photographs taken by Lewis Hine in the early 1900s?
5. The term _____ is used to describe an early approach to photography that attempted to imitate painting.
 a. abstractionism
 b. naturalism
 c. dadaism
 d. pictorialism
6. The name "camera obscura" literally means _____ chamber.
7. Why was neither the camera obscura nor the camera lucida a "camera" as we know it?
8. The first person to permanently capture an image by photographic means was _____.
 a. Niépce
 b. Fox Talbot
 c. Daguerre
 d. Wedgwood
9. A _____ photographic image must be developed to become visible.

For Questions 10–16, match each of the discoveries with its inventor on the right.

10. daguerreotype
11. calotype
12. wet-plate process
13. dry plate process
14. roll film
15. Autochrome process
16. Polaroid process

a. Eastman
b. Lumiére brothers
c. Daguerre
d. Land
e. Fox Talbot
f. Maddox
g. Archer

17. What was the significance of the invention of the negative/positive system?

18. The popular term for the product of the ferrotype process was _____.

19. Describe the photographic product introduced by George Eastman in 1888 and its significance to the growth of photography.

20. The _____ process was the first practical method of producing color photographs.
 a. Orthochrome
 b. Autochrome
 c. Kodachrome
 d. Photochrome

21. Digital cameras that are described as "megapixel" have _____ or more sensors in their CCD array.

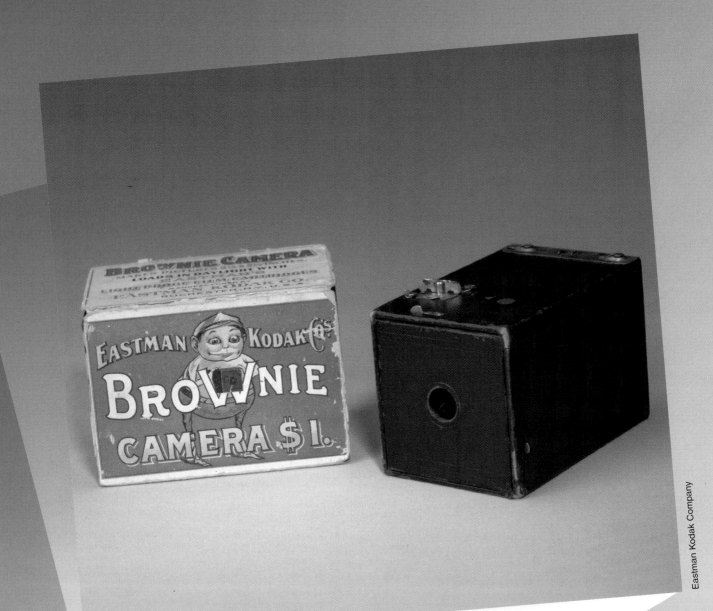

Eastman Kodak Company

Box camera:

The earliest form of roll-film camera —
a light-tight box with a lens and
shutter at one end and film stretched
across the opposite end.

Chapter 2

The Camera System

When you have finished reading this chapter, you will be able to:

⇒ Identify the three interactive systems of the camera.

⇒ Describe the differences between manual focus and autofocus methods.

⇒ Explain the light control functions of the aperture and shutter.

⇒ Distinguish between the various film-holding methods.

⇒ List the characteristics of the major camera types.

In its most basic form, a *camera* is a light-tight box with a closable hole at one side and a light-sensitive material on the opposite inside surface. The hole may be fixed in size or variable, and the method for opening and closing it might range from a simple flap of paper or tape to a tiny electrical impulse from a computer chip. Light-sensitive materials might be a sheet of film or paper coated with a silver halide emulsion, or an array of thousands or millions of tiny "electronic eyes" (*charge-coupled devices*, or CCDs).

Whether extremely simple or highly sophisticated, a camera must accomplish one basic task: *getting the picture.* To do so, it must gather the light rays reflected from an object or scene and focus them on the light-sensitive material. That material, in turn, will be affected by the light rays and capture a representation of the scene. The silver halide material records the scene as a latent image, while the CCD array records it as a digital pattern of voltages (on/off or high/low) that can be stored on a magnetic medium. Later, the silver halide latent image can be developed and fixed for permanence; the stored electronic image can be displayed on a computer screen or printed to paper.

The camera can be thought of as a device made up of three interacting systems: a viewing/focusing system, a light control system, and a film-holding system.

Viewing/focusing system

The simplest pinhole camera has no viewing system — it is merely pointed at the general scene you wish to record — and has no means of adjusting focus, since the tiny pinhole aperture results in a moderately sharp image. All other cameras, however, feature some method of viewing the scene to be photographed; many also allow you to adjust the focus of the image.

Viewing methods

Many of the cameras used today are of the *single-lens reflex (SLR)* design, in which the photographer views a scene or subject through the same lens that will be used to take the picture. In other cameras, however, some type of separate viewfinder is employed.

Through-the-lens viewing systems are straightforward: what you see in the viewfinder is what you will get on film . . . *almost*. Actually, with the exception of a few professional models, **Figure 2-1,** cameras with through-the-lens viewfinders show less of the scene than will actually be recorded on the film. Although the amount of "viewfinder masking" varies from manufacturer to manufacturer and camera model to camera model, a loss of 5% to 8% is not uncommon. In other words, what you see in the viewfinder may be only 92% to 95% of what the film records. Although the loss may not be critical for most photographs, it could allow a distracting element to appear at the edge of a carefully or critically composed picture. Information on the percentage of the scene actually shown by the viewfinder can usually be found in the manual or specification sheets for a specific camera. Magazine reviews of camera models also normally include this information.

The simplest form of *separate viewfinder* is a plain wire frame called a "sports finder." Although seldom used today, the sports finder allowed a photographer working with

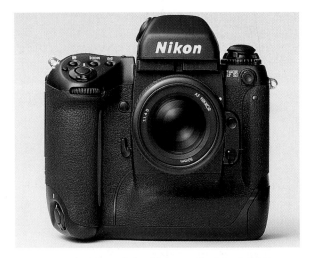

Figure 2-1. *Top-of-the-line professional SLR cameras, such as the Nikon F5, have viewfinders that show close to 100% of the scene being photographed. Most cameras using through-the-lens viewing show significantly less than 100% of the image that will be captured on film. (Nikon, Inc.)*

a cumbersome large format press camera to quickly compose an action shot.

Much more common is the separate viewing window used in cameras ranging from inexpensive single-use models to both classic and modern rangefinder models. Another form of separate viewfinder is used on twin-lens reflex (TLR) cameras, which have one lens for viewing and focusing and another for taking the photo. See **Figure 2-2.**

Separate viewfinders work well for many situations, but can cause a problem when taking closeup photos. The problem is called *parallax error* and is a mismatch in what the photographer sees though the viewfinder and what the camera's taking lens actually sees. As shown in **Figure 2-3,** the slight difference in what is "seen" can result in cutting off part of a subject. Some viewfinders have *parallax correction marks* to allow the photographer to compensate for the offset image.

On cameras that have both interchangeable lenses and a separate viewfinder, a different problem occurs: matching the field of view to the lens. A "normal" lens has a field of view that is approximately the same as human vision, while a telephoto lens sees a narrower slice of the scene and a wide-angle lens sees a wider slice. If the same viewfinder is used with all three lenses, it would be accurate for the normal lens, but see only part of the scene that the wide-angle lens would reproduce, and much more of the scene than the telephoto lens would capture. The simplest way of compensating for this is showing different-size frame lines in the viewfinder. A method used on more expensive and sophisticated cameras is a viewfinder that changes to show the matching field of view when a different lens is installed.

Many of the cameras designed for the *Advanced Photo System (APS)* introduced in the mid-1990s have viewfinders that change to match the photo format selected, **Figure 2-4.** This is basically a form of masking or cropping, since the field of view remains the

Figure 2-3. *Parallax error, resulting from the distance between the viewing and taking lenses of a TLR, can cause part of a subject to be lost when taking a close-up photo. The red line shows the subject as seen through the viewing lens. The black line frames the view that will be captured on film through the taking lens.*

Focusing methods

As in the case of viewing systems, focusing with a through-the-lens camera is a matter of approximately "what you see is what you get." To manually focus one of these cameras, the photographer rotates the lens barrel while looking through the viewfinder. As the lens barrel rotates, the image in the viewfinder will become either sharper or more diffused (softer). When the image is at maximum sharpness, it is said to be *in focus*, resulting in a picture that is sharp as well.

Manual focusing aids

Some cameras use a plain focusing surface, called a **ground glass**, requiring the photographer to judge whether the subject is in focus. Others use *focusing aids* to simplify the task. There are two major types of focusing aids, the split prism and the micro-prism. Some cameras have one or the other, but many use both, **Figure 2-5.**

- *Split-prism* focusing aids are usually circular, and are divided by a horizontal line. The image in the upper and lower halves of the prism will be misaligned if

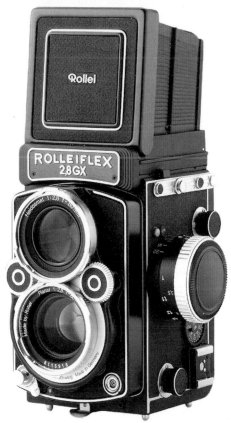

Figure 2-2. *Viewing systems. A—Rangefinder and simple cameras use a separate viewing window, rather than seeing the scene through the lens. B—On twin-lens reflex cameras, viewing and focusing are done using a separate lens above the lens that is used to take the photograph. (Rollei Fototechnic)*

same. Models equipped with zoom lenses, however, have viewfinders that change to match the wider or narrower view.

Figure 2-4. *The viewfinder of an APS camera uses masks to show the format selected for a photograph. Top—Classic, the traditional 2:3 proportion. Middle—HDTV, with a 9:16 ratio. Bottom—Panoramic, with a ratio of approximately 1:3.*

Figure 2-5. *Many cameras with through-the-lens focusing have a viewfinder combining two focusing aids, a split prism surrounded by a microprism.*

models that have interchangeable focusing screens overcome this problem by offering one screen with a split prism for large aperture lenses and another screen with a split prism for smaller-aperture lenses.

- *Microprism* focusing aids appear to be made up of small diamond-shaped elements that "break up" the image when it is out of focus. As the lens barrel is rotated and the image comes into focus, the image becomes smooth and whole. Some cameras use a small

the subject is out of focus. As the lens barrel is rotated, the two image halves shift left or right. When they are aligned, the subject is in focus. The easiest method of using the split prism to focus accurately is to find and use a straight vertical line in the subject. A common problem encountered in using the split prism focusing aid is the "blacking out" of one or both halves of the circle, **Figure 2-6**. This normally occurs when using a lens with a large aperture (typically f/2.8 or greater). Some camera

Figure 2-6. *Split-prism viewfinders often will "black out" when used with apertures of f/2.8 or larger.*

rectangular panel microprism by itself, but most combine it with the split prism. In such combinations, a narrow ring of microprism material surrounds the split prism. One drawback to microprism focusing is that it requires some judgment (like the ground glass) of whether the subject is properly in focus.

Rangefinder focusing

A number of cameras that have separate viewfinders are of the *rangefinder* type. They are focused by finding the distance from the camera to the subject. This is done by using a method similar to the split-prism focusing method. The viewfinder might have a split image, or overlapping images. When the split image comes together, or the overlapped images are perfectly aligned, the distance to the subject can be read from a scale. See **Figure 2-7.**

Rangefinder focusing may be a one-step or a two-step process. The older of the methods is the two-step process, in which a rangefinder reading is made, then the distance transferred to a pointer and scale arrangement on the camera. When the pointer is aligned with the indicated distance on the scale, the subject is in focus. Some older cameras have a built-in rangefinder; others require use of a separate instrument.

Coupled rangefinders, **Figure 2-8,** provide a much more convenient, one-step process. They are mechanically connected to the lens, so that as the split or overlapped images are aligned, the subject is brought into focus. One feature of the rangefinder that appeals to some photographers is a brighter viewfinder image than through-the-lens focusing systems. This is an advantage in low-light situations.

Ground glass focusing

As noted earlier, **ground glass focusing** requires the photographer to make a judgment of when the image is in sharp focus. This makes using a ground glass more open to error than other focusing methods. Some users of 35mm and medium format cameras prefer a viewfinder with plain ground glass, considering it faster and easier to use than split prisms or other focusing aids. Large format camera users have no choice: ground glass focusing is the only method available. Large format users have another hurdle to overcome in focusing, since the image they are viewing is upside-down and reversed from left to right.

Autofocus systems

Today, some medium format cameras, most 35mm cameras, and all APS cameras

Figure 2-7. *Rangefinder cameras are focused by bringing together overlapped or split images. When the images are perfectly aligned, the camera is focused.*

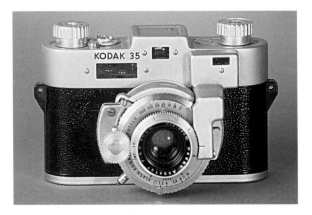

Figure 2-8. *Coupled rangefinders, like this early Kodak 35mm model, allowed single-step focusing. Turning the gear-like focusing wheel caused the lens to rotate and bring the subject into focus.*

have autofocus capability. Using one or more sensors built into the camera's viewing system, they are able to bring the image into sharp focus before the shutter is released. There are two broad categories of autofocus systems: active and passive.

Active autofocus

This system is used most extensively in highly automated "point-and-shoot" cameras designed primarily for snapshots. The term *active autofocus* is based on the method used to achieve focus: a beam of infrared light is emitted to bounce off the subject, **Figure 2-9.** The system times the interval between the departing and returning burst of light, calculates the distance, and focuses the camera to that distance.

One problem with this focusing system is *selectivity*: if the subject is not centered in the viewfinder, the infrared "echo" selected for focusing distance may be bouncing off something else. Some cameras overcome this by offering *focus lock* capability. This means that the subject first can be centered in the viewfinder and proper focus established. The focus distance can then be "locked in," and the picture recomposed.

A difficulty that is less easily overcome is the slowness of the active autofocus system. Frequently, there is a perceptible (sometimes even measurable) lag between the time the

Figure 2-9. *In active autofocus, a beam of infrared light is bounced off the subject to establish camera-to-subject distance. The camera then focuses to that distance.*

shutter release is pressed to activate the autofocus system and the actual opening of the shutter. The length of the autofocus lag varies greatly depending upon the camera, the lighting situation, the state of charge of the camera's batteries, and other factors. At times, the lag is long enough that the subject has moved out of focus before the shutter opens.

Passive autofocus

More sophisticated cameras use various versions of the *passive autofocus* system. These systems evaluate incoming light, allowing them to react much more rapidly than systems that send out a beam and must wait for its return. Some systems read changing energy levels as the image is brought into focus, while other systems use the electronic equivalent of split-image focusing.

The earliest passive autofocus systems suffered from the same selectivity problem as the active systems — if the subject was not centered, the focus point would be on whatever *was*. Even if the subject was properly centered, the system frequently would "hunt," continually attempting to focus without success. This problem resulted from the orientation and sensitivity of the sensors, which required a fairly well-defined vertical line to focus on. Low-light situations and low-contrast subjects also caused problems with these early systems.

The passive autofocus systems used in today's SLRs make use of multiple sensors and computer circuitry to quickly and precisely achieve focus under almost any conditions. See **Figure 2-10.** The user can select which sensor or combination of sensors should be dominant in focusing under given conditions. In one cameramaker's system, the photographer can select a sensor by merely focusing his or her eye on it in the viewfinder. The ability of computer circuits to make decisions and order actions rapidly led to the development of *predictive autofocus.* With a fast-moving subject, the system continually calculates speed and direction and makes adjustments to ensure that the focus will be precise at the instant the exposure is made.

Figure 2-10. *Multiple sensors are used in the passive autofocus systems of many current camera models. The photographer can select one or more sensors to be dominant for specific situations.*

For greatest flexibility, a camera should include capability for switching off the autofocus system and performing manual focusing. This is very important when making creative decisions involving selective focusing. In such instances, the photographer's desire for placement of in-focus and out-of-focus scene elements will most likely differ from the decisions made by the camera's computer chip. If the photographer is moving up from a manual-focus camera to one with autofocus, the ability to use his or her current manual-focus lenses on the new camera might also be a consideration.

Light control system

The amount of light reaching the film's emulsion to record an image is governed by the camera's light control system. This system consists of two parts, the lens aperture and the shutter. The two can function together or independently to regulate how much light strikes the surface of the film. The varying relationship between the aperture and the shutter speed affects the ability to stop subject motion and dictates how much of the scene will be in sharp focus.

Aperture

The word *aperture* means "opening," and is typically used in photography to describe the size of the hole through which light passes to expose the film. Depending upon the age, type, and complexity of the camera, the aperture may be fixed or variable. It can be located in the camera body or the lens assembly. The simplest example of a fixed aperture is the tiny opening used on a *pinhole camera.* To vary exposure, or the amount of light reaching the film, the opening is left uncovered for varying amounts of time. Some very simple "point-and-shoot" cameras have both a fixed aperture and a fixed-speed shutter. To provide acceptable pictures, they must be used in bright lighting conditions, preferably with subjects that hold still.

Methods for varying aperture

There are two basic methods of varying the aperture: a series of different fixed-size openings, or an adjustable device that can be opened or closed to provide openings of various sizes. Early box cameras (and even some later "snapshot" cameras) were equipped with a plate that had two or more openings of different sizes. By pivoting or rotating the plate, the photographer moved the desired-size opening into the light path, **Figure 2-11.**

A similar method was used with the large "view cameras" operated by nineteenth century photographers. They carried a set of *Waterhouse stops,* which were individual brass plates, each containing a single precisely-sized hole. After selecting the plate with the desired size hole, the photographer slipped it into a slit cut in the lens barrel. A later development was a single long plate containing the full range of openings. By sliding the plate from side to side, the desired opening was placed in the light path.

The *diaphragm,* or *iris,* is a variable-aperture device consisting of an assembly of thin, overlapping metal blades, **Figure 2-12.** On modern SLR cameras, the diaphragm is mounted in the interchangeable lenses, rather than in the camera body, and is controlled by a movable ring on the lensbarrel. Rotating the ring causes the blades to move inward or outward, varying the size of the opening they create. The aperture can range from a pinhole

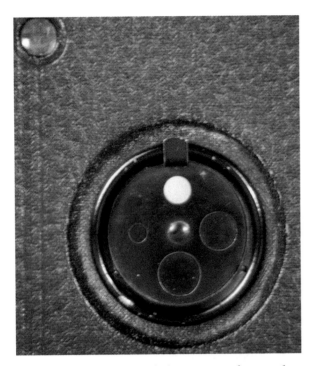

Figure 2-11. *This simple box camera from early in the twentieth century has a rotating plate with four different apertures. The desired aperture was simply moved into the top position for use. The shutter and the camera lens are located behind the aperture plate.*

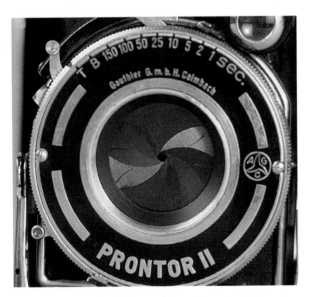

Figure 2-12. *An iris consists of overlapping metal plates that can form round openings of various sizes. A series of specific-sized openings, or f-stops, makes it possible to consistently regulate the amount of light reaching the film.*

size to the full width possible inside the mounting ring. Although the diaphragm could provide an almost infinite number of different-size openings, the ring on the lens barrel is marked with a number of specific-size openings called f-stops. The sizes of the f-stops have a constant relationship: each opening is half as large in area as the preceding one, and twice as large as the one following it. This means that adjoining stops will admit twice as much or half as much light, respectively. The f-stop system, with its numbers that get larger as openings get smaller and vice versa, is explained in detail in Chapter 3.

Aperture and depth of field

The size of the opening has a direct relationship to how much of the picture will be in sharp focus. The size of this zone of sharp focus, called *depth of field*, becomes greater as the aperture size decreases, and shrinks as aperture size increases. At the smallest opening available on a given lens, a flower located three feet from the camera and a mountain miles away may both be in focus (along with everything in-between). At the largest, or "wide open" setting, the depth of field might be a matter of inches: only the flower itself will be sharp and everything else will be soft or "out-of-focus."

Shutter

The role of the *shutter* in the camera system is to act like a valve or faucet, opening and closing to allow or prevent the flow of light to the film. While the aperture controls the amount of light through changes in size, the shutter regulates light by the length of time it remains open.

For practical purposes, shutters can be divided into two categories, based on their location. Those that are part of the lens assembly are referred to as *between-the-lens shutters;* those located in the camera body, just in front of the film, are called *focal plane shutters.* Between-the-lens shutters are used in simple and inexpensive small cameras, some medium format cameras, and virtually

all large format field and studio cameras. Focal plane shutters are almost universally used in 35mm SLR cameras.

Between-the-lens shutters

Many older camera designs and some of today's simpler models use a rotating or pivoting disk with a hole in it. See **Figure 2-13.** The action of pressing the shutter release first tensions a spring, then releases it to rapidly move the shutter opening past the aperture. The length of exposure with this type of shutter is subject to many variables, but is roughly 1/40 second.

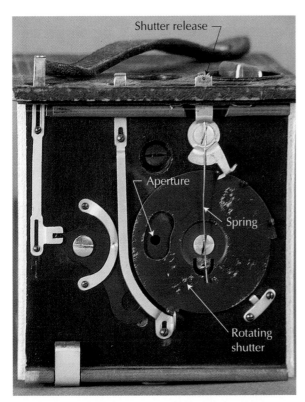

Figure 2-13. *This century-old camera has a spring-operated shutter and three different apertures arranged on a pivoting plate. The shutter could be locked in an open position (as done here to show the aperture) to take time exposures. Unlike later cameras where the shutter is located between lens elements, this one has the lens located behind the shutter and aperture plate. The outer shell of the camera was removed to show the shutter and aperture plate.*

A much more complex mechanism, which makes it possible to vary shutter speeds, is called the leaf shutter. In appearance, it is quite similar to the diaphragm used to vary apertures. Unlike the diaphragm, however, it has only two positions: open and closed. When the release is pressed, the shutter snaps to the fully open position. At the end of the preset exposure time, it snaps back to the fully closed position. At shutter speeds of 1/30 second and faster, the open/close sequence seems almost instantaneous. At slower shutter speeds, however, the lag between opening and closing is perceptible to both the eye and ear.

Shutter speeds are usually set by rotating a ring around the lens and moving a pointer to the desired speed setting. This movement changes the tension on the shutter spring. As shutter speed settings go higher (providing shorter exposures), the spring tension increases; decreasing the speed setting (lengthening exposure time) decreases spring tension. The spring-drive mechanism, combined with friction in the mechanical system, sets a practical limit on shutter speeds. For smaller cameras, maximum speed of the between-the-lens shutter is typically 1/500 second (1/1000 in a few cases). As shutters become physically larger, maximum speed decreases. A large view camera shutter may have a top shutter speed of only 1/60 second.

Some leaf shutters are actuated in the same way as the simple rotating shutter: pressing the shutter release first tensions the spring, then releases it to actuate shutter movement. Other leaf shutters have a cocking lever separate from the shutter release. The cocking lever is moved to place tension on the spring, then tension is released by pressing the shutter lever or button. See **Figure 2-14.**

Camera movement caused by pressing the shutter release can blur a picture. The separate cocking mechanism helps eliminate this problem, since the amount of effort

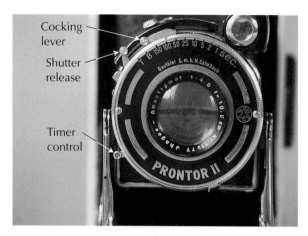

Figure 2-14. *Leaf shutters used in view cameras and many of the once-popular folding cameras had a cocking lever that set spring tension for the shutter release.*

needed to press the shutter release is less. This is a particular advantage when a time exposure is being made and the shutter must be pressed twice. With the shutter set to the *T* mark, the first press opens the shutter, the second closes it. With less effort needed, the likelihood of camera movement is decreased.

Focal plane shutters

By cutting a thin slit in an opaque card and moving the slit rapidly across the surface of a piece of film, you could "paint" light onto the film to expose it. If the card movement was at a steady rate, each point on the film surface would be exposed to light for the same amount of time. Although the process has been greatly refined in today's focal plane shutters, this basic principle remains the same.

The first focal plane shutters were made with a curtain of thin, tough cloth fastened to two rollers equipped with spring drives. Spring tension was varied to move the narrow slit past the film at different rates, or shutter speeds. A later development was a curtain with slits of several different widths. These slits were located on the curtain so that only one would be in position for exposure at a given time. The larger or smaller area of the individual slits allowed an increased or decreased amount of light to reach the film.

In effect, this provided additional shutter speeds. Combining the various slit sizes with different spring tensions broadened shutter speed selection still further.

Two-piece curtains of fabric or flexible metal are used in modern 35mm and medium format cameras to achieve a wide range of shutter speeds. The two curtains are driven independently to form a moving slit of the desired width at shutter speeds higher than 1/60 second. At speeds of 1/60 second or slower, the first curtain will typically move all the way across the film before the second curtain begins its travel, **Figure 2-15.** The delay between first-curtain and second-curtain movement is the *exposure time.* Depending upon camera design, the shutter curtains may travel horizontally or vertically. A variant is the Copal square shutter, with four blades opening from the center, much like a leaf shutter.

In recent years, spring drives for focal plane shutters have been replaced by tiny electronically controlled motors. This has made possible more consistent control of shutter speeds, as well as making an almost infinite variety of shutter speed/aperture combinations available when the camera is used in an autoexposure mode. Electronic control has also permitted higher flash synchronization speeds, as discussed later in this section.

Figure 2-15. *At a shutter speed of 1/60 second or slower, the first curtain of a focal plane shutter is completely open before the second curtain begins its travel.*

Selecting the shutter speed on a camera equipped with a focal plane shutter is usually a simple matter of rotating a dial to the proper setting, or pressing a button or other control until the desired speed is shown on an LCD display. On some older cameras, especially the larger format ones like the Speed Graphic press camera, it is necessary to wind up a spring, using a knob or key, until the desired speed is shown in a small window. Some press cameras are equipped with both between-the-lens and focal plane shutters. The two shutters offer different speed ranges and other differing advantages that make each more suitable for various situations.

Available shutter speeds vary widely, depending upon the type and age of the camera. Older 35mm cameras, with mechanical or electromechanical operation, generally included shutter speeds ranging from 1/1000 second to 1 second in length. The newest fully electronic models stretch the range in both directions, with exposures as long as 30 seconds and as short as 1/8000 second. Many cameras also have *T* (time) and *B* (bulb) settings to allow longer, manually controlled exposures. As described earlier, the *T* setting requires the shutter release to be operated twice — once to open the shutter and once to close it. The *B* setting will hold the shutter open as long as the shutter release is being pressed. When the pressure is removed, the shutter closes. (The *bulb* reference doesn't refer to a lightbulb, but to a rubber squeeze-bulb and hose arrangement used to actuate the shutter release by applying air pressure. Although they are still available, squeeze-bulb devices are seldom used today.)

Shutter speeds have a constant relationship, just like the f-stops that are used to indicate aperture. Each shutter speed is twice as fast as the preceding one, and half as fast as the one following it. This means that the adjoining speeds will admit half as much or twice as much light, respectively. Shutter speeds and their relationship to f-stops will be covered in detail in Chapter 4.

Shutter speed and motion control

Aside from its role in controlling light to help achieve proper exposure, shutter speed is the primary means of controlling *camera* and *subject* motion. Blurring of a photograph caused by camera motion is almost always undesirable, while blurring that results from subject movement has both negative and positive aspects.

Camera shake (involuntary movement of the camera during exposure) typically occurs when hand-holding a camera at shutter speeds slower than 1/60 second, **Figure 2-16.** Although the use of techniques such as bracing against a tree or other support make it possible for some photographers to hand-hold successfully at slower shutter speeds, a minimum of 1/60 second is usually recommended.

Subject blur occurs when a person or object is moving too fast for the selected shutter speed to stop its motion, **Figure 2-17.** Often, an artistic decision is involved: you may want to "freeze" a ballerina in mid-leap, but capture some blur in a shot of windblown flowers to convey motion. Finding the proper shutter speed to stop motion or allow a desired degree of blur for a given situation is usually a matter of

Figure 2-16. *Hand-holding a camera at shutter speeds slower than 1/60 second can produce a blurring due to camera shake. The blurring affects the entire picture, unlike the blur caused by subject movement.*

Figure 2-17. *A subject moving too rapidly for the selected shutter speed will be blurred, while the rest of the picture is sharp. Blur may be introduced intentionally for creative effect, such as conveying motion.*

experience and experimentation. The speed at which a subject is moving, the direction of movement in relation to the camera, and the subject's distance from the camera are all factors that must be weighed (in addition to overall exposure questions). Refer to Chapters 6 and 14 for more information on this topic.

Shutter types compared

The between-the-lens and the focal plane shutter types each have advantages and disadvantages:

- A between-the-lens shutter synchronizes with an electronic flash at any speed, since the shutter opens fully at all settings. A focal plane shutter, as noted above, can be synchronized only at speeds where the film frame is fully uncovered. For most cameras, "synch speed" is 1/60 second, but electronics technology has raised synchronization speeds to as high as 1/250 second.

- The moving slit of the focal plane shutter, when combined with the motion of the subject, can cause distortion. This distortion takes the form of a skewing of the image, and is especially noticeable with circular shapes. The round tire of a swiftly moving motorcycle, for example, may assume an elliptical shape. Like subject-motion blur, distortion may sometimes be desirable as a creative tool. Between-the-lens shutters, since they open fully during exposure, do not create distortion.

- A focal plane shutter permits easy interchangeability of lenses.

Film-holding system

For proper and undistorted exposure to the light rays being transmitted by the camera lens, a photographic film must be held perfectly flat in the plane where the light rays are focused. The film also must be kept absolutely perpendicular to the axis, or centerline, of the lens. The plane where the film is located and the light rays are focused is called the *film plane,* or the focal plane. The *focal plane shutter,* interestingly enough, is not located in the focal plane but very slightly ahead of it to leave space for the film.

There are two basic mechanical systems for holding film in position, and for exchanging an exposed piece of film with an unexposed one to take another picture. For large format film in individual sheets, a holder system allows an exposed sheet to be removed from the camera and a fresh piece of film inserted. For medium format and smaller cameras, film is in strip form, and is advanced with a roller system that moves the exposed frame out of the light path and positions a fresh frame.

Sheet film

Many types of color and black-and-white film are available in sheet form. Although sheet film is manufactured in sizes ranging from 2 1/4″ × 3 1/4″ to 11″ × 14″, it is most often used in the 4″ × 5″ and 8″ × 10″ sizes.

For use, sheet film must be loaded in a light-tight device that can be inserted in the camera and opened to permit an exposure to

be made. The *film holder* rigidly supports the sheet in the film plane. Various types of magazines exist that can hold multiple sheets of film, but the most common form of film holder accommodates only two sheets, one on each side. This simple device, **Figure 2-18,** consists basically of a body and two removable *dark slides.*

The holder body has slots that create a light-tight seal when the dark slide is fully closed. Film is loaded (under conditions of complete darkness, of course) by withdrawing the dark slide most of the way from the body, then opening a hinged lower lip. This permits the film sheet to be slid, emulsion side up, into the body. Channels along either side hold the edges on the film flat. Once the sheet is fully inserted, the bottom lip can be returned to its normal position, and the dark slide closed. The holder is turned over, and the process repeated with a second sheet of film.

Cameras are equipped with a spring-loaded back that allows a filmholder to be inserted and held firmly in place. Focusing (on a ground glass with its rear surface just in front of the film plane) is done before the film holder is inserted. With the shutter closed, the dark slide on the forward-facing side of the film holder is pulled out. This uncovers the emulsion side of the film sheet, which is exposed when the shutter opens.

After an exposure is made, the dark slide is fully closed, and the holder removed from the camera. By reversing the holder, back-to-front, and reinserting it in the camera, the second sheet of film can be exposed in the same way.

Working with a large camera and a half-dozen or more loaded film holders is a cumbersome business. To overcome this problem, various types of magazines have been developed to hold multiple sheets of film, **Figure 2-19.** Typically, these use some type of push/pull mechanism to "shuffle" exposed sheets of film from the front to the back of the "deck." Unlike conventional holders, the magazine does not have to be removed and turned over between exposures. Most hold a half-dozen sheets of film.

A more recent development are individual sheets of film in sealed, light-tight packets that are used with a special holder inserted in the camera back. These packets (called "Readyload" by Kodak, and similar names by other film manufacturers) represent a considerable savings in bulk. A somewhat similar approach is the Polaroid back, which accepts multiple-sheet packs of the self-developing film. Polaroid film is typically used to check lighting and exposure, particularly in studio situations.

Figure 2-18. *A sheet film holder is designed for two sheets of film, one on each side. Dark slides cover the film to exclude light. Once the holder is clamped into the camera back, the slide is withdrawn so that light can strike the film when the shutter is operated.*

Figure 2-19. *This film magazine for a press camera holds six sheets of 4" × 5" film. It is much less bulky than the three conventional holders needed to accommodate six sheets of film.*

Roll film

The *roll films* used in medium format cameras consist of a strip of film taped at one end to an opaque paper backing and rolled up with the paper. The film has smooth, unperforated edges. Once made in many different widths and lengths, roll film today is readily available only in the 120 and 220 sizes. Both consist of a strip of film 2 1/4" wide, attached to a paper backing that is 2 3/8" in width. In the 120 size, the strip of film is approximately 2 1/2' in length, yielding 8 exposures in the 6cm × 9cm format, 10 exposures in the 6cm × 7cm format, 12 exposures in the square 6cm × 6cm (also referred to as 2 1/4" × 2 1/4") format or 15 exposures in the 6cm × 4.5cm format.

The 220 size differs from 120 only in the length of the strip of film. It is double the length of the 120 size, and thus yields twice as many exposures in each format. The longer 220 rolls are used almost exclusively by professional photographers, who prefer the convenience of fewer roll changes while shooting a wedding or sporting event.

The 620 film size, once used in many cameras, is identical to 120 film, but is mounted on a spool with a narrower center and ends that are slightly smaller in diameter. See **Figure 2-20.** The 620 film is no longer available commercially. Photographers who collect and use older cameras commonly "respool" 120 film onto 620 spools so that it will fit in their models.

Roll film cameras use a two-spool system to position film for exposure and advance it from frame to frame. A full roll of film, wrapped around its spool, is inserted at one side of the camera back. A second, empty spool is positioned on the opposite (take-up) side. After removing a narrow paper band sealing the full roll, several inches of the paper backing are pulled out. The paper is laid across the full width of the camera back, and its narrowed "tongue" inserted in a slot on the take-up spool. Using a winding knob or lever, usually located on top or side of the camera, the spool is rotated several turns to take up slack, **Figure 2-21.** The camera is

Figure 2-21. *Roll film is loaded by inserting the tongue of the paper backing into the slot of the take-up spool. A winding knob is used to take up slack. After the camera is closed, the film is wound until the first frame is in position for exposure.*

Figure 2-20. *The difference between 120 film and 620 film is the size of the spool's center. The diameter of the ends is slightly smaller on the 620 spool, as well.*

closed, then the winding knob or lever is used to pull the paper backing and film from the supply spool onto the take-up spool.

While newer medium format cameras have film counters similar to those on 35mm models, most older equipment uses the "red window" method. Numbers printed on the paper backing are visible through a hole in the camera's back. When the numeral *1* appears in the window, the film is positioned for the first exposure. The simplest roll film camera advance systems require the user to merely stop winding when the frame number appears. Other cameras have a positive stop mechanism that "clicks" into place when the film has been advanced a sufficient distance. Often, it is necessary to press a release button or lever to permit winding to the next frame. On some cameras, the shutter release also unlocks the frame advance. *Double-exposure prevention* is a feature of some cameras: once the shutter release has been pressed, it can only be activated (cocked) by winding the film to the next frame.

When all frames on the roll have been exposed, no rewinding is necessary. The film is merely advanced until the paper backing is free of the supply spool and fully wound onto the take-up spool. The camera is opened and the full take-up spool removed. The last few inches of paper backing are folded under, and an attached gummed paper band moistened and sealed around the roll. The empty film spool is removed from the supply side and moved to the take-up side of the camera. The camera is then ready for reloading.

Cassette

An easier method of handling and loading film is the *cassette,* a light-tight canister of metal or plastic that holds and protects a long strip of film. When the first "miniature cameras" (as 35mm models were then called) were introduced in the 1920s, however, using a film cassette was anything but easy. The early cassettes had to be loaded, in full darkness, with strips of 35mm motion

picture negative film. Typically, the strips were cut to approximately 5 1/2′ in length, yielding 36 exposures. Later, factory-loaded cassettes became available, in either 18-exposure or 36-exposure lengths. Still later, the 24-exposure length replaced the 18-exposure package. Today, different manufacturers offer a variety of quantities ranging from 10 to 40 exposures, but 24 and 36 remain the most common.

The cassette is fairly simple in construction, with a plastic spool inside a three-piece shell (usually metal) consisting of a body and two caps or ends. See **Figure 2-22.** The film is attached to the spool at one end and tightly wrapped onto it. One end of the film is left extending through a slit in the shell body. This slit is lined with strips of felt material to form a *light trap* that protects the film inside from accidental exposure.

35mm cassette

Many 35mm cameras have hinged backs that are swung open to load film. Typically, a rewind knob is pulled upward, allowing the cassette to be inserted on the supply side. When the rewind knob is lowered into position again, a stem extends downward to engage the spool of the cassette. This permits film to be rewound into the cassette after all frames have been exposed.

Figure 2-22. *A 35mm film cassette consists of a body, a spool, and two endcaps. Film is attached to the spool and extends through a light trap slit in the body.*

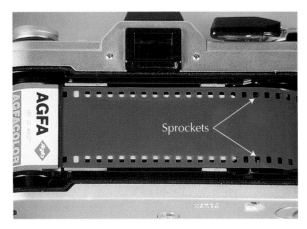

Figure 2-23. *When properly engaged in the take-up spool, perforations of the 35mm film will be positioned over two sprockets. The sprockets pull the film out of the cassette, one frame at a time, as the film advance lever is operated.*

Once the cassette is in the camera, the film extending from the light trap (called the **leader**) is pulled out several inches. The film is laid across the width of the camera and the leader inserted into the take-up spool. Doing so also engages the perforations (holes) along the two film edges with a pair of **sprockets, Figure 2-23.** The film advance lever and shutter release are operated several times to ensure that the film is properly engaged, then the camera back is closed. The film advance is operated until the counter shows a numeral *1,* indicating that the first frame is in position.

The sprocket holes on the film edges provide a very positive, slip-free method of film advance. Advance levers and the drive sprockets are designed to move the film forward eight holes (one frame) each time. Most cameras are designed so that the film advance lever cocks the shutter as it is operated. The lever then locks, and cannot be moved again until the shutter release is pressed. This prevents leaving blank frames by advancing film without operating the shutter. To avoid accidental double exposures, the shutter will not operate after an exposure until it is cocked by using the film advance lever. Some cameras have a release

mechanism that permits intentional double exposure by allowing the shutter to be cocked without advancing the film.

Many newer 35mm SLR cameras, and most of the "point-and-shoot" models, have a motor-driven film advance that automates the loading process. The camera back is opened and the cassette placed in the supply side, with no need for pulling up a rewind knob. Several inches of film are pulled from the cassette, and the leader is laid in place, with its end extending into the take-up area. When the back is closed, the leader is automatically engaged with the take-up spool and the film advanced to the first frame. Some models actually roll all the film out of the cassette and onto the take-up spool, then rewind it into the cassette one frame at a time as it is exposed.

For most cameras, however, rewinding is necessary after all frames have been exposed. Motor-driven camera models may rewind film automatically or at the touch of a button. *Manual rewinding* is usually a two-step process. First, a release mechanism (usually a small button on the base of the camera) must be pressed to disengage the sprockets. Then, the rewind knob is turned to move the exposed film back into the cassette. For easier rewinding, most knobs are fitted with a small folding crank. Once film has been fully rewound, either manually or by a motor, the camera back is opened and the cassette removed.

APS cassette

Cameras designed for the Advanced Photo System (APS) accept only the special APS film cassette, **Figure 2-24.** APS film is slightly narrower than 35mm film. The resulting frame is 16.7mm × 30.2mm, compared to the 24mm × 36mm frame size of 35mm film. Cassettes holding either 25 or 40 exposures are available. The design and characteristics of APS film will be discussed more extensively in Chapter 5.

A specific goal in the design of APS (a development carried out jointly by a group

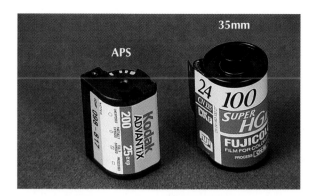

Figure 2-24. *The Advanced Photo System uses a cassette with a shape and size slightly different from the 35mm cassette. The cassette is designed for drop-in loading. It also serves as the storage container for negatives after film processing.*

of major film and camera manufacturers) was ***drop-in loading.*** The cassette and cameras were designed to work together so that all the user has to do is open a film door, insert the cassette, and close the door. The film is then automatically loaded and advanced to the first frame. After the final exposure, the film is rewound into the cassette.

One unique feature of the APS cassette is easy ***mid-roll film change.*** Film that has been partly exposed (for example, 17 of 25 exposures) can be rewound into the cassette and removed from the camera. This allows different film speeds and types to be interchanged as needed for changing conditions or other reasons. When the partly exposed cassette is inserted in the camera again, sophisticated electronics allow it to be automatically advanced to the next unexposed frame. Technically, mid-roll film change is possible with both roll film and 35mm cassettes. Because the film must be manually rewound and later advanced to the next unexposed frame, the process is cumbersome and must be done carefully to prevent the loss or double-exposure of one or more frames.

Cartridge films

Over the years, various types and sizes of drop-in film cartridges have been developed. The most widely adopted cartridges,

and the only ones still readily available in stores, are the 126 and 110 film sizes introduced by Kodak for use in its Instamatic snapshot cameras. See **Figure 2-25.** While the cartridges provide drop-in loading convenience, film advance is totally manual. Rewinding is not necessary, since both the supply and take-up spools are fully enclosed in the cartridge.

Camera varieties

Since the first practical cameras were introduced in the late 1800s, many different designs have developed. Most of the designs, however, are variations in size or complexity on a few basic types.

One method of classifying cameras is by their format, or size of film that they use. The traditional format classes are small, medium, and large:

- ***Small format cameras*** are those that use films in 35mm size or smaller (all the way down to the tiny subminiature or "spy" cameras, **Figure 2-26,** that use 9.5mm or 16mm film).
- ***Medium format cameras*** all use 2 1/4" wide (120- or 220-size) roll film, but produce negatives in one of five different formats: 6cm × 4.5cm, 6cm × 6cm, 6cm × 7cm, or 6cm × 9cm, or 6cm × 12cm.

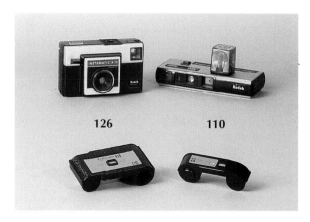

Figure 2-25. *Cartridge films in the 126 and 110 sizes are still available for Instamatic snapshot cameras.*

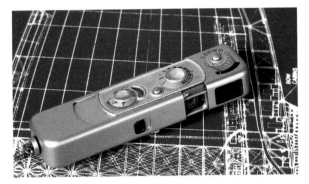

Figure 2-26. *Subminiature cameras, such as the Minox, are often referred to as "spy cameras" because of their small size. Despite the tiny film size, the quality of the camera's lens permits the making of sharp enlargements up to snapshot size.*

- *Large format cameras* expose individual sheets of film, most commonly in $4'' \times 5''$ or $8'' \times 10''$ sizes. Cameras and sheet film in a number of larger sizes are available for special applications.

Another method of grouping cameras is by the type of viewing and/or focusing system they employ. These range from the "window" viewfinders of simple snapshot cameras to the split-image rangefinders to the plain ground glass of view cameras to the complex mirror systems of the SLRs.

Simple cameras

Cameras in this group are, as the name suggests, the least sophisticated in construction. *Simple cameras* are basically "point-and-shoot" units requiring little of the user other than framing the desired subject matter in the viewfinder window.

The many variations of the *single-use camera* are in this category, as are the reloadable point-and-shoot models. See **Figure 2-27.** A few simple reloadable cameras have been made that accept 120 film, but the majority of these cameras are in the 35mm and APS formats. A few cameras in this category use the gradually disappearing 110 and 126 film sizes.

Rangefinder cameras

Focusing by means of bringing together two overlapping images (or two halves of a

split image) has long been a popular system for cameras. Most of the *rangefinder cameras* in use today accept 35mm film, and virtually all are of the *coupled rangefinder* type. This means that, as the image is brought into focus in the rangefinder, a gearing arrangement moves the lens as well. While the use of rangefinders has declined with the surge in single-lens reflex models, a number continue to be popular. See **Figure 2-28.**

Reflex cameras

Cameras in this category are in two distinct groups, but both use a mirror to reflect a scene onto a viewing screen. The *twin-lens reflex (TLR)* camera has two lenses positioned one above the other, **Figure 2-29.** The lower lens is the "taking lens" which

Figure 2-27. *Simple cameras. A—Single-use cameras are sent in to have the film developed. Varieties with and without flash are available, as are models with zoom lenses and those for underwater use. B—Reloadable, fully automated "point-and-shoot" cameras are popular in both Advanced Photo System and 35mm formats. (Nikon, Inc.)*

Figure 2-28. *Rangefinder cameras are quiet in operation and offer a bright viewfinder image. They enjoy continued popularity. (Kyocera Optics, Inc.)*

actually admits light to the film, while the upper lens is used for focusing. A fixed mirror is set at a 45° angle behind the focusing lens to reflect the scene onto a ground glass screen. The reflected image is large and fairly bright, but is reversed left-to-right. The separation of the two lenses makes critical focus on close-up subjects

difficult due to parallax. TLR cameras typically use 120-size (2 1/4") film.

The 35mm *single-lens reflex (SLR)* camera began coming into wide use in the late 1940s and 1950s, and remains one of the most popular types of camera, **Figure 2-30.** Like the TLR, it makes use of a mirror to reflect an image onto a viewing screen, but there, the resemblance ends. In the single lens reflex camera, the *same* lens is used for focusing and for taking the picture. Light reflected from the subject passes through the lens, strikes the angled mirror, and is reflected upward onto a screen. The light then passes through a five-sided prism **(pentaprism)** that corrects the inverted and reversed image for viewing through the eyepiece. See **Figure 2-31.** When the shutter release is pressed after focusing, the hinged mirror flips upward, allowing light to reach the film.

Since both viewing and picture-taking are done through the same lens, there is no parallax problem with the SLR. This arrangement also permits selective focusing and depth-of-field preview, and allows easy interchangeability of different focal length lenses. A minor drawback, in most applications, is the momentary "blackout" of the

Figure 2-29. *In the twin-lens reflex, the viewing and focusing lens is positioned above the "taking" lens. This can cause parallax problems when attempting close-ups.*

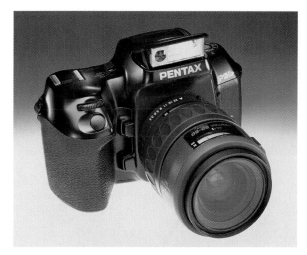

Figure 2-30. *The single-lens reflex (SLR) camera uses the same lens for composing, focusing, and taking the picture. This eliminates the problem of parallax error. (Pentax)*

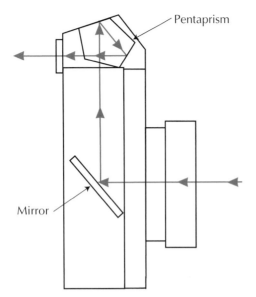

Figure 2-31. *In a single-lens reflex camera, light entering the lens bounces off an angled mirror, then through a pentaprism to the viewfinder, so the picture can be composed and focused.*

scene when the mirror flips up. In sports and other types of action photography, however, this can be a serious problem. Also, at shutter speeds slower than 1/30 second, the movement of the mirror can cause a vibration that affects sharpness of the image.

View cameras

The large and cumbersome wooden contraptions that provided us with scenes from Civil War battlefields and the first pictures of the Grand Canyon and other impressive western locales were called *view cameras.* They were given this name because the photographer composed and focused the scene on a ground glass *viewing surface* at the back of the camera. Once this was done, a glass plate (later, a sheet of film) could be slipped in place behind the ground glass, and the picture exposed.

Today's view cameras are essentially unchanged from those of a century ago, except in the materials from which they are made. Today's view cameras are more likely to be constructed of metal and plastic than of wood (although a number of wooden cameras

are still made). Most often used today with film in 4"× 5" or 8"× 10" sheets, view cameras have been built to accept much larger film sizes. The typical view camera, **Figure 2-32,** consists of a lens and shutter mounted in a lensboard, a flexible bellows, and a film back with a ground glass for focusing and some means of clamping a filmholder in place.

To focus, the lensboard is moved backward or forward along a support (camera bed or rail), then locked at the desired point. Although the capabilities vary from camera model to camera model, the lensboard and film back often can be raised or lowered, pivoted, or tilted. These adjustments, or *movements,* allow correction of various kinds of distorted perspective. A drawback of the view camera, aside from its awkward size, is the need to use a hood or focusing cloth for proper viewing of the ground glass while

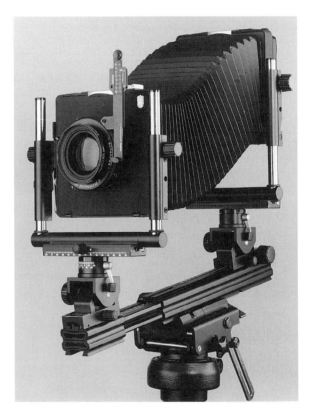

Figure 2-32. *View cameras are used with sheet film loaded in holders. This rail-mounted view camera is used primarily in studio situations. (Linhof/HP Marketing Corp.)*

focusing. A further problem is the double inversion of the image on the ground glass: it is both upside-down and reversed left-to-right.

View cameras mounted on a focusing rail are best used under controlled studio conditions, where a heavy, solid tripod provides a firm base. For outdoor or other location work where portability and ease of use are desirable, a variation of the view camera called the *field camera* is typically chosen, **Figure 2-33.** Field cameras are more compact than rail cameras and have a flat bed for support. The front portion of the bed can be folded upward to protect the retracted bellows and lens during transport. Movements on field cameras are usually fewer than on the studio-type rail cameras. While there may be a full range of front movements, the back seldom will have rise/fall or shift capability. Even fewer movements are found on the *press camera,* which is similar in appearance to the field camera. These cameras, most often in the 4″ × 5″ film size, were commonly used by newspaper photographers until the 1950s. View cameras and their operation are discussed more fully in Chapter 11.

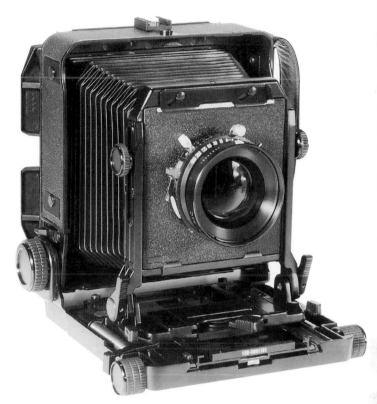

Figure 2-33. *Field cameras are a more rugged and compact version of the studio view camera. (Toyo Professional Camera Division, Mamiya America Corp.)*

Questions for review

Please answer the following questions on a separate piece of paper. Do not write your answers in this book.

1. A camera must gather light rays and _____ them on a light-sensitive material.
2. A _____ camera does not have a viewing/focusing system.
 a. rangefinder
 b. pinhole
 c. large format
 d. twin-lens reflex
3. Why is parallax a problem with cameras that have a viewfinder separate from the taking lens?
4. Does "blacking out" of a split-prism focusing aid usually occur when using a lens with an aperture larger or smaller than f/2.8?
5. The _____ autofocus system uses a beam of infrared light to calculate the camera-to-subject distance.
6. To adjust the aperture on their view camera lenses, nineteenth century photographers used a set of _____.
 a. Windisch shutters
 b. aperture plates
 c. adjustable diaphragms
 d. Waterhouse stops
7. Depth of field _____ as the aperture becomes larger.

8. Describe the difference between focal plane shutters and between-the-lens shutters in terms of using electronic flash.

9. Film holders for large format cameras typically hold _____ sheet(s) of film.
 a. 1
 b. 2
 c. 4
 d. 6

10. What was the basic difference between 120 film and the now-obsolete 620 film?

11. Each frame of 35mm film has _____ sprocket holes along its edges.

12. Which of the following is *not* a feature of the Advanced Photo System?
 a. drop-in loading
 b. larger frame size
 c. 25 or 40 exposure cassettes
 d. mid-roll film change

13. The 110 and 126 cartridge film sizes were developed for use in Kodak's _____ snapshot cameras.

For Questions 14–19, match each of the items with the phrases on the right.

14. medium format camera
15. rangefinder camera
16. SLR camera
17. TLR camera
18. field camera
19. simple camera
 a. viewing lens above taking lens
 b. "point-and-shoot" operation
 c. 120 and 220 film
 d. through-the-lens focusing
 e. separate viewfinder
 f. compact, folding view camera

20. Rail-mounted view cameras are most suited to _____ photography.

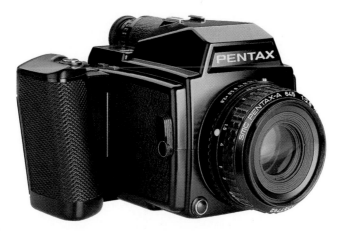

A

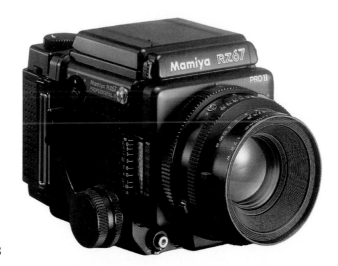

B

C

In addition to the traditional 6cm × 6cm frame, medium format cameras are offered in other frame sizes (all based on 120-size roll film). A—The 6cm × 4.5cm camera is widely used. (Pentax Corporation) B—A 6cm × 7cm camera. (Mamiya America) C— This camera produces 6cm × 12cm images. (Linhof/HP Marketing Corp.)

Selective focus:

A method of emphasizing a subject by holding it in sharp focus, while shifting the background out of focus.

Chapter 3

Lenses

When you have finished reading this chapter, you will be able to:

⇒ Explain how a lens focuses an image on film.
⇒ Describe the relationship of focal length to image size.
⇒ List the characteristics of the various types of lenses.
⇒ Explain functioning of the f-stop system.
⇒ Discuss how aperture affects depth of field.

As a device for making small objects appear larger or distant objects look closer, the lens has been in use for thousands of years. Archaeologists have unearthed crudely made glass magnifying lenses on the island of Crete that are believed to have been made about 4000 years ago. It was not until the late 1500s and early 1600s, however, that the magnifying power of lenses was put to practical scientific use with the invention of the microscope and the telescope.

The photographic applications of the lens began well before the first permanent photographic image was taken by Niepce in about 1826. The camera obscura, described in Chapter 1, was a large box or even a small portable "room" with a tiny hole in one wall, used as a drawing aid by artists. The pinhole projected a scene onto the opposite blank wall inside the darkened space, allowing the artist to trace it on paper or canvas. Later, a

simple biconvex lens (the familiar "magnifying glass" lens) replaced the pinhole. It provided a far brighter image, but one that was distorted at the edges.

The first lens developed specifically as a *camera lens* was introduced in 1812 by William Hyde Wollaston, an English scientist and inventor. Wollaston's **meniscus lens,** **Figure 3-1,** was designed to improve the image projected by the camera obscura. By changing the shape of the lens, Wollaston was able to project a flatter image, eliminating much of the distortion that was a problem with the biconvex lens.

How a lens works

Ever since the introduction of the meniscus lens, the goal of lens designers has been to produce an ever-sharper, more distortion-free image. They have done so by combining different-shaped lenses (called "elements") in varying numbers, by using improved glass formulations, and by adding special surface coatings. A brief discussion of how lenses work will be useful in understanding how a choice of lens affects the final photograph.

Lens shapes and light

Simply stated, a lens *bends* light through a process called **refraction.** As shown in

Meniscus Biconvex

Figure 3-1. *The meniscus lens was the first lens designed for camera use. It projected a less distorted image than the biconvex lens.*

Figure 3-2, a light ray passing from air into glass changes direction. The change occurs because glass is more dense than air, and slightly slows the speed of the light ray, causing its path to bend. When the light ray emerges from the other surface of the glass, it again changes speed (and thus direction). Because lenses are curved shapes, the rays of light entering them are bent to different angles by different parts of the curved surface. If the lens shape is *convex* (curved

Figure 3-2. *Light rays are bent, or refracted, as they pass from a material of lesser density, such as air, to a material of greater density, such as glass. Rays are bent again as they pass from glass to air.*

outward), the emerging light rays will *converge,* or be brought together. If the lens is *concave* (curved inward), the rays will be spread apart, or *diverge.* Rays that enter the lens perpendicular (at a 90° angle) to its surface pass straight through and are not refracted.

Figure 3-3 illustrates the action of simple convex and concave lenses on light. In the convex lens, light rays entering the different areas of the curved surface are bent

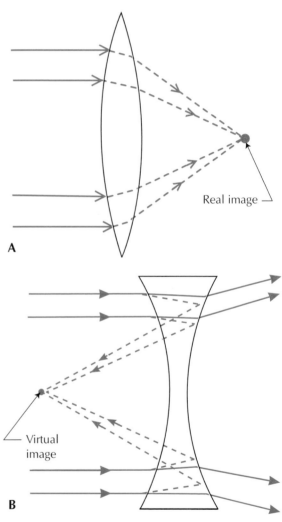

Figure 3-3. *Convex and concave lenses. A—Light rays passing through a convex lens converge to focus at a common point, forming a real image. B—The concave lens diverges light rays, spreading them out. A virtual image is formed on the same side of the lens as the subject.*

at different angles to converge on a common point called the *focal point.* The convex lens produces a *real image* at its focal point. The image can be seen or, if projected onto a piece of film or sensitized paper, photographed.

The concave lens, on the other hand, diverges light rays that pass through it. This lens also forms an image, but on the same side of the lens as the object reflecting the light. This type of image, called a *virtual image,* can be seen only by looking through the lens. By itself, a concave lens has no photographic use, since it does not form a real image.

Lens aberrations

When a convex lens is used alone, optical problems called *aberrations* can cause blurred, color-distorted, or shape-distorted images. *Compound lenses*, **Figure 3-4**, are combinations of convex and concave lenses designed to overcome some of these optical problems. The major types of aberrations are:

- *Spherical aberration* occurs in simple *biconvex* lenses (those with both sides curved outward). The light rays entering the outer edges of the lens are bent more sharply than those entering closer to the center. As a result, these outer rays come to a focus at a point closer to the lens,

Figure 3-4. *Concave and convex lens elements are combined in a compound lens, helping to correct some aberrations.*

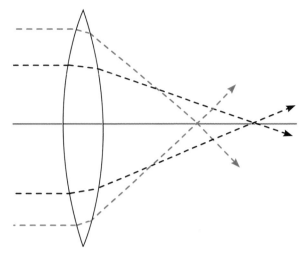

Figure 3–5. *In spherical aberration, light rays do not come to a common focal point, resulting in a "soft" image.*

Figure 3-5. The result is an overall softness of focus, or "fuzziness" of the image. It is corrected by making the curvatures different on the two sides of the lens, bringing light rays to focus at a common point. This type of lens is called an **aplanatic** lens.

- *Chromatic aberration* is similar to spherical aberration, in the sense that the light rays do not come to a focus at a common point. In chromatic aberration, however, the problem is the different *colors* of light, which refract differently when passing through a lens. Like the visible spectrum formed when light passes through a prism, the lens separates light into its different wavelengths (colors). As shown in **Figure 3-6,** each of these wavelengths focuses at a slightly different distance behind the lens. The correction for chromatic aberration was actually discovered in the 1700s by an English experimenter, Charles Moor Hall. He found that two types of glass (crown glass and flint glass) refracted light slightly differently. By combining a convex lens of crown glass and a concave lens made from flint glass, the different colors of light could be brought to a common focus. Hall's was the first

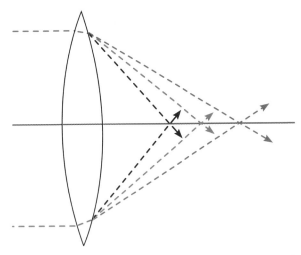

Figure 3-6. *The different wavelengths (colors) of light are refracted differently in chromatic aberration. They do not come to a common focus.*

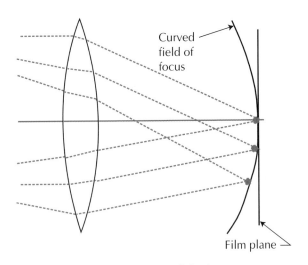

Figure 3-7. *Only one part of the image, center or edges, will be in focus when a lens exhibits curvature of field.*

achromatic lens (one designed to minimize or eliminate chromatic aberration). Later, apochromatic lenses were developed to further overcome the problem of chromatic aberration. An *apochromatic lens* is corrected to provide precise convergence of the primary wavelengths of light (red, blue, and green).

- *Curvature of field* is a failure of light rays to focus at a common point, and occurs because most convex lenses are spherical (like a section of a ball) in shape. The curved surface of the lens causes an image that would be in perfect focus on a matching spherical field. On a flat surface, however, only one portion of the image will be in focus. See **Figure 3-7.** The projected image will either be in focus at the center and out-of-focus at the edges, or vice versa, depending on which focal point is chosen. The meniscus lens was developed to minimize this problem. This is one of the problems that *aspheric lenses* (those with surfaces that are not a section of a sphere) were designed to overcome.

- *Astigmatism* is a by-product of spherical aberration, resulting in the inability of the lens to bring horizontal and vertical lines in the subject into sharp focus at the same time. If you were taking a photo of a cross-shaped object with a lens that was not corrected for astigmatism, either the horizontal or the vertical arms of the subject would be out of focus, **Figure 3-8.** The first major step in correcting astigmatism occurred in the 1880s with the development of a new optical glass that included the elements boron, barium, and phosphorus. This new glass, called *Jena glass* for its origin at the Schott Glassworks in Jena, Germany, made possible the development of *anastigmatic lenses.*

- *Coma* occurs when light rays that are not parallel to the lens axis create a series of overlapping circles of decreasing size.

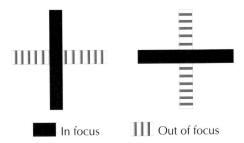

Figure 3-8. *Astigmatism makes it impossible to obtain sharp focus simultaneously on the horizontal and vertical lines of the subject.*

Figure 3-9. *In coma, points of light from the edge of an image are distorted into a series of overlapping circles, forming a teardrop (comet) shape.*

These circles gives the appearance of a comet with a tail, thus the name "coma," **Figure 3-9.** Lenses are corrected for coma by the use of elements with coma aberrations that cancel each other out.

- *Distortion* involves a change in the shape of a rectangular image projected by a lens. It is one of the several effects related to spherical aberration. As shown in **Figure 3-10**, the distortion may take the form of outward-bulging sides (*barrel distortion*) or sides that are pushed inward (*pincushion distortion*). With a single convex lens, barrel distortion occurs if the diaphragm or lens aperture is placed between the subject and the lens. Pincushion distortion results when the lens is between the

Barrel Pincushion
distortion distortion

Figure 3-10. *In barrel distortion, the sides of a square object would appear to bulge outward. In pincushion distortion, the sides appear to be squeezed inward.*

subject and the diaphragm. Correction for distortion is done by the use of a *symmetrical lens*, which consists of two groups of lens elements with the lens diaphragm placed between them.

Virtually all lenses on the market today make use of the corrective methods described, to a greater or lesser degree. Even the least-expensive photographic lens is anastigmatic and achromatic. More expensive lenses are apochromatic, often are aspheric, and are made with special low-dispersion glass.

Lens coatings

In addition to refracting light, lenses also *reflect* some light from their surfaces. This reflection of light has two negative effects on lens performance. First, light reflected from the lens is lost — it cannot be focused on the film to help make an image. Second, light reflecting off multiple surfaces (today's camera lenses often have more than a dozen lens elements) inside the lens housing can cause flare and ghost images. Manufacturers apply nonreflective coatings to lenses to lessen or eliminate these problems.

The loss of light from reflection can be severe: if a lens had six elements with light-reflecting surfaces, total light transmission could be cut by almost *one-third* (loss due to reflection is estimated at 5% from each uncoated lens surface). This means that only 70% of the incident light is reaching the film. The transmission loss due to reflection is making the lens *slower*: it has only about two-thirds the light-gathering power that it should provide.

Problems caused by ghost images and flare can degrade picture quality. If the sun or another bright light source shines directly into the lens, one or more distracting bright spots can show in the photo. In 35mm SLR cameras, these often take the form of reflections of the pentaprism used in the viewfinder. See **Figure 3-11.** The problem of *flare* may be less immediately noticeable,

Figure 3-11. *Ghost images can be formed when the camera is aimed so that the sun or another bright light source shines directly into the lens. In this photo, the sun is just outside the frame on the upper-right corner.*

depending on its degree. The stray light bouncing around inside the lens housing will cause decreased contrast in the photo. This may be a mild effect, with colors or shadow values appearing less intense than expected, or may create a severe "washed out" appearance that mimics overexposure.

Coatings were initially applied to lens elements as a single, extremely thin (0.000004") layer. Single-layer coating greatly improved lens performance, reducing flare significantly and increasing light transmission into the 90% range. Later, multiple coatings with as many as ten layers were applied to lens elements, raising light transmission levels to as high as 99%.

Focal length

As shown in **Figure 3-12**, the *focal length* of a lens is the distance, with the lens focused at infinity, from the optical center of the lens to the point where the light rays converge on the film plane. Although focal lengths may be stated in inches or in millimeters, the general practice is to refer to a "50mm lens," rather than a "2" lens." An exception is large format work, where some older but still-used lenses are referred to by their focal length in inches.

Only a few years ago, a well-equipped photographer carried a camera bag filled with as many as a half-dozen lenses in a variety of fixed focal lengths. For a photographer with a 35mm SLR camera, the lens selection might include focal lengths of 28mm, 50mm, 70mm, 105mm, 150mm, and 200mm. If specializing in wildlife or sports photography, he or she might pack along a separate 500mm or even 1000mm lens (either would have been too large to fit in the average camera bag).

Today's well-equipped 35mm shooter is more likely to cover the same range of focal lengths, or an even wider one, with only two variable-focus (zoom) lenses. Although individual selections would vary by personal taste or preferred type of shooting, the two lenses would probably be a wide-angle to short telephoto model zooming from 28mm to about 100mm, and a short to moderate telephoto covering a 100mm to 300mm range. Zoom ranges continue to lengthen, with 28mm–200mm, 35mm–300mm, and even 170mm–500mm lenses offered by various manufacturers.

For many years after they were introduced, zoom lenses were considered to be

Figure 3-12. *The focal length of a camera lens is measured from the optical center of the lens to the film plane. The focal length is usually given in millimeters, but some large format lenses are still described in inches.*

optically inferior to *prime lenses,* which are those with a fixed focal length. Zoom lenses were also considered more subject to flare, since they had a larger number of elements. Advances in materials, manufacturing techniques, and especially design (with the aid of the computer), have made the best zoom lenses of today equivalent to comparable prime lenses. Many professionals use both prime lenses and zooms, depending upon the work being done.

Lenses with very short or very long focal lengths present problems. If built with the normal construction, a very short-focus lens, such as a 20mm, would leave no room for the camera mirror. At the other extreme, a conventional 1000mm lens would be an unwieldy 39″ (one full meter) in length.

By arranging groups of convex lenses (which converge light rays) and groups of concave lenses (which diverge light rays), designers can shorten or lengthen the actual physical distance traveled by the rays. By lengthening the distance the rays travel, for example, a 20mm lens can be moved forward enough to permit mirror operation without giving up the 20mm focal length. On a long-focus lens, such as the 1200mm, the distance traveled by the light rays can be shortened, permitting the lens to be shortened physically, as well. The physical size of a long-focus lens can also be changed by using mirrors to "fold" and shorten the light path, **Figure 3-13.**

Focal length and image size

The focal length of the lens directly affects the size of the image projected onto the film plane — the shorter the focal length, the smaller the image, and vice versa. As the focal length becomes shorter, the lens becomes (in effect) more convex. As a result, light rays are bent at a sharp angle, converging a short distance behind the lens and producing a small image. As the focal length becomes longer, the lens design becomes progressively less convex. Light rays are bent less sharply, and converge a greater distance behind the lens, resulting in a larger image. See **Figure 3-14.**

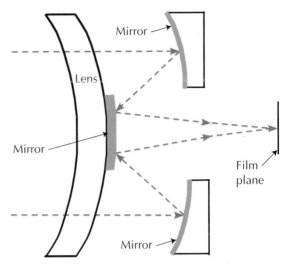

Figure 3-13. *The light path of a long focal length lens can be "folded" with the use of mirrors, allowing a physically shorter lens. The most common mirror lens focal length is 500mm.*

Directly related to the image size is the field of view, or *angle of view*, of the lens. The image projected by a short focus lens covers a wide area, with objects in the scene relatively small in relation to the overall view. A 28mm lens, for example, has an angle of view of 76°, about one-third wider than the 45° angle of view of the "normal" 50mm lens. As the focal length increases, the angle of view becomes progressively more narrow. The 100mm lens has a 22° angle of view — half as wide as the 50mm. The 200mm lens

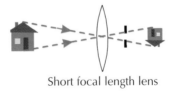

Short focal length lens

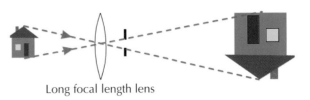

Long focal length lens

Figure 3-14. *Long focal length lenses bend light rays less sharply than short focus lenses, providing a larger image at the film plane.*

shows an angle of just over 11°, while a 500mm telephoto lens would show a very narrow slice of the scene, since its angle of view is only 5°. **Figure 3-15** shows the relationship between angle of view and object size for several focal lengths.

Focal length also affects *perspective*, the relative size of objects in a scene and how they are aligned. A view made with a 50mm lens presents near and far objects in a size relationship that is very close to what we are used to seeing in everyday life. In a print made from a shot taken with a short focus lens, such as a 20mm, distant objects look smaller and farther apart than they would to the naked eye. The short lens exaggerates depth and width — room interiors, for example, seem more spacious. Long-focus lenses are described as "compressing" perspective, making distant objects appear larger and closer together, **Figure 3-16.**

Camera lens types

Based generally upon their angle of view, fixed-focal length lenses have traditionally been grouped into three categories, normal, wide-angle, and telephoto (narrow angle). Zoom lenses cover *ranges* of focal lengths, but often can be broadly classified as wide-angle or telephoto.

Normal lenses

In the preceding section, the 50mm lens was described as "normal," since it provides an angle of view and a perspective close to that of the unaided human eye. Actually, the focal length that provides the most distortion-free "normal" view is considered to be one that is equal to the diagonal of the film. In the case of a camera using 35mm film, the diagonal measurement of the frame is 43mm, so 43mm is *theoretically* the normal

Figure 3-15. *The angle of view of a lens decreases as the focal length increases. These four views of the Madison, Wisconsin, skyline were taken using a tripod-mounted camera with only the focal length of the lens changed for each view. As a reference point, observe the domed State Capitol building in each view. A—28mm (76° angle of view). B—50mm (45°). C—100mm (22°). D—200mm (11°).*

100mm 200mm 300mm

Figure 3-16. *The compression effect of long lenses is seen in this series of views taken from the same position with 100mm, 200mm, and 300mm lenses. Note how distant objects seem to be made larger and brought closer to the foreground objects.*

focal length. In practical terms, lenses with focal lengths of 40mm to 55mm approximate human vision closely enough to be classified as normal. Until recent years, when it was replaced by a short zoom lens, the 50mm lens was typically supplied by camera manufacturers as the standard or normal lens on a new camera.

Since the definition of *normal* is based on the diagonal of the film size, the focal length of the normal lens is different for medium format and large format cameras. For square-format (6cm × 6cm) cameras using 120 film, the normal lens focal length is 75mm; for the popular 6cm × 7cm medium format, an 85mm lens is normal. In large format cameras, 150mm is normal for 4″ × 5″ film, and 300mm for 8″ × 10″. **Figure 3-17** is a table showing equivalent focal lengths for various film formats.

Wide-angle lenses

A lens with an angle of view from about 55° to as much as 180° is considered a **wide-angle lens.** In terms of focal length, wide-angle lenses range from about 35mm down to 8mm, although special lenses with

an angle of view greater than 180° are made. Lenses with an angle of view of 100° or more show considerable spherical distortion. For this reason, and because of the round image they produce, such lenses are usually referred to as "fish-eye lenses."

As noted earlier, the focal length of a short-focus lens may be too short to allow room for the hinged mirror of an SLR camera. To avoid this problem, most wide-angle lenses are of the **retrofocus** design,

Equivalent Lens Focal Lengths

	35mm	6cm × 6cm	6cm × 7cm	4″ × 5″	8″ × 10″
Wide	28mm	54mm	60mm	105mm	210mm
Normal	43mm	75mm	85mm	150mm	300mm
Tele	105mm	190mm	210mm	370mm	740mm

Figure 3-17. *When changing film formats, choosing a lens of equivalent focal length will produce photos of approximately the same magnification and perspective. Equivalents for various film formats are shown.*

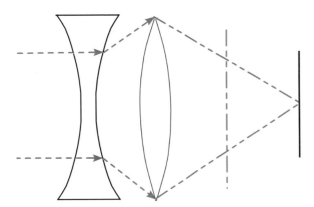

Figure 3-18. *A retrofocus lens design lengthens the light path within the lens, moving the point of measurement for focal length (shown as the green dashed line) backward, so that it is actually located in mid-air behind the rear lens element.*

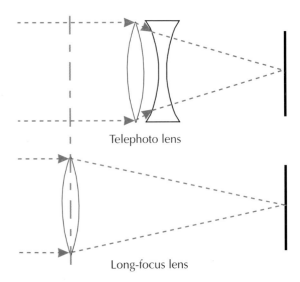

Figure 3-19. *Telephoto lens design shifts the point of measurement for focal length (shown as the green dashed line) forward, out in front of the lens itself. This front-focusing telephoto design (top) makes it possible to produce a physically shorter lens with the same focal length as a traditional long-focus lens (bottom).*

Figure 3-18. In this design, also called an "inverted telephoto," the front element group is composed of negative (concave) lens elements that cause light rays to spread or diverge. The rear elements are positive (convex), causing the light rays to converge. The design "stretches" the light path within the lens to provide sufficient back focus (distance from the rear element of the lens to the film plane) for mirror clearance, while maintaining the focal length of the lens.

Telephoto lenses

A lens with a longer-than-normal focal length is commonly referred to as a *telephoto*. While this is correct for most of the lenses made today (especially zoom lenses), there are long-focus lenses that are *not* telephoto lenses.

The distinction is a difference in design, as shown in **Figure 3-19**. A 300mm lens of conventional design for a 35mm camera would require a distance of slightly less than a foot from the optical center of the lens to the focal plane. While a length of one foot is not unmanageable, something shorter and more compact would be easier to hold and use. A more compact lens is possible with the *front-focusing design* used in the true **telephoto lens.** In

this type of lens, the front element group has a positive (converging) design, and the rear elements have a negative (diverging) design. This combination *shortens* the light path, making a larger image possible at the film plane with less physical distance between the front lens element and the film. The focal length of the lens is still 300mm, but the point from which the distance to the film plane is measured has been moved forward. Since the point is actually located out in the space in front of the first lens element group, the lens is referred to as "front-focusing."

Zoom lens

Convenience of use, coupled with improved optical design, have made zoom lenses the choice of many photographers in recent years. The major attraction of the **zoom lens** is its variable focal length, allowing the photographer to change composition without physically changing lenses or position. She or he can *zoom out* for a

Figure 3-20. *With a zoom lens, the photographer can choose an overall view, or extract a detail of the scene, without changing lenses or camera position. A—View at 100mm setting on a zoom lens. B—View at the 300mm setting on same lens.*

broader view of the scene, or *zoom in* to focus on a detail, quickly and easily. See **Figure 3-20.**

The zoom lens operates on the principle of lens groups moving varying distances within the housing to provide the different focal lengths. As shown in simplified form in **Figure 3-21,** a negative (diverging) lens is placed between two positive (converging) lenses. As the negative lens moves forward,

Figure 3-21. *Moving groups of lens elements are used to provide the varying focal lengths in the zoom lens. The principle is shown here in simplified form. A—As the negative element moves closer to the front positive element, focal length of the lens becomes shorter. B—As the negative element moves toward the rear positive element, a longer focal length is achieved.*

the focal length of the zoom lens is shortened; as it moves backward, the focal length becomes longer. An actual zoom lens would use *groups* of lens elements, with a number of the groups moving varying distances as the focal length is changed.

The *zoom range*, or ratio of shortest focal length to longest focal length, may be as low as 1.5 (800–1200mm, for example) or as high as 5 (60–300mm or 100–500mm), but most fall into the range of 2 or 3. Very common zoom ranges are 28–70mm, 70–210mm, or 100–300mm.

Most zoom lenses have different maximum apertures at the two extremes of the zoom range, with a difference of 2/3 stop to one full stop most common. A typical 70–300mm lens often will have a wide-open aperture of f/4 at the 70mm end, and f/5.6 at the 300mm end. Some zoom lenses feature a *constant* maximum aperture. These lenses are typically more expensive than zooms with differing maximum apertures, due to their greater complexity.

Macro lenses

Photographing objects so that they are "larger than life" is technically called *photomacrography.* In common usage, however, the elements of the word are reorganized into the easier-to-pronounce phrase, "macrophotography," or avoided altogether and called "close-up photography."

Derived from the Greek word *makros*, meaning large, the label *macro* is usually applied to a lens that can focus more closely than a typical lens of the same focal length. Since it is able to focus more closely, the macro lens can provide a larger image of an object on film. The relationship between the actual size of an object and the size that object is physically recorded on the film is called the *reproduction ratio*, or magnification. If the actual size of an object is 1/4" (6.3mm) and the image on the film is also 1/4", a 1:1 *reproduction ratio* has been achieved. If the film image of that same 1/4" object is only 1/8" (3.1mm), the reproduction

ratio is 1:2, or "half life-size." In the ratio, the first number represents the object's size on film; the second number represents the actual size. If the image on film is *larger* than the real object, the number for the film size is the larger of the two. If an object is 1/2" long on film, but only 1/4" long in real life, the reproduction ratio is 2:1.

Most normal lenses will only focus close enough to provide a 1:7 or 1:8 reproduction ratio. When first introduced for use on 35mm SLR cameras, macro lenses were available only in 50mm focal length and typically provided a "half life-size" (1:2) image. Today, macro capability is built into lenses of a number of fixed focal lengths, often providing 1:1 reproduction ratios. Zoom lenses, especially those with manual focus, frequently claim macro capability, but most provide only a 1:4 (one-quarter life-size) reproduction ratio. The majority of those lenses allow macro-focusing only at the long end of their zoom range; a few are close-focusing at the wide end, instead.

Tele-extenders

The focal length of a telephoto lens can be increased by placing a diverging (negative) lens between the lens and the film plane. The diverging lens in this case is contained in an accessory called a tele-converter or *tele-extender* that is mounted between the lens and the camera body, **Figure 3-22.** Tele-extenders are usually available in two different degrees of magnification, 2× or 1.4×. The 2× extender doubles the focal length of the lens, while the 1.4× extender increases focal length by 1.4 times. Thus, a 300mm lens becomes a 600mm with the 2× extender, or a 420mm lens with the 1.4×. General-purpose tele-extenders (those not designed for a specific lens) often cause a noticeable loss of sharpness and contrast, especially if used with a zoom lens. A tele-extender made specifically for use with a given lens is another story. These multiple-element lenses are designed to work together optically with the prime lens, maintaining image quality while increasing focal length.

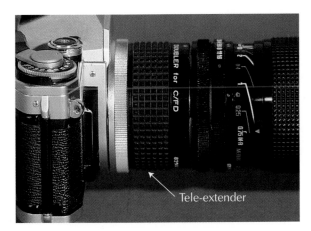

Figure 3-22. *The focal length of a lens can be increased by 1.4 or 2 times by adding a tele-extender between the camera and lens.*

The f-stop system

The numbers *0.7, 1, 1.4, 2, 2.8, 4, 5.6, 8, 11, 16, 22, 32, 45,* and *64,* called **f-stops,** probably create more confusion among beginners than any other aspect of photography. First, the mix of whole numbers and decimals is harder to remember than a simple 1, 2, 3 numeric sequence. Second, and more perplexing, is that as f-stop numbers become *larger,* the opening (aperture) that they represent becomes *smaller.*

The f-numbers themselves are calculated by dividing the focal length of the lens by the diameter of the aperture. For a 50mm lens with an aperture of 25mm, the f-number is 2. If the aperture is 12mm, the f-number is 4. In the first example, the aperture is 1/2 the focal length; in the second, it is 1/4 the focal length. Thus, an f-stop can be thought of as a fraction: f/8 is an aperture 1/8 the focal length, f/22 is an aperture 1/22 the focal length, and so on. See **Figure 3-23.**

Aperture size and light transmission

More important than the method of calculating f-stops, however, is the relationship of the stops to each other. In the series of f-stops listed above (from 0.7 to 64), the area of the diaphragm opening is either halved or doubled from one to the next,

depending on whether the number is larger or smaller. The effect of this is to allow either half as much or twice as much light to reach the film (at the same shutter speed).

The diaphragm opening (aperture) sizes are the reverse of the f-stops: as the f-numbers get larger, the area of the opening gets smaller. **Figure 3-24** shows the relationship between f-stops and diaphragm openings. The opening at f/16 is half as large as the opening at f/11; f/22 is half as large as f/16. Moving in the opposite direction has the corresponding result: the opening at f/16 is twice as large as at f/22, and f /11 is twice as large as f/16. Some people find it easier to remember the difference by remembering that the f-numbers are *fraction*s. Thus, f/16 is a smaller fraction (1/16) than f/11 (1/11), so the diaphragm opening is smaller, as well.

Relative aperture

The sequence of f-stop numbers is the same, regardless of the focal length of the lens, but the *size of opening* that a given stop

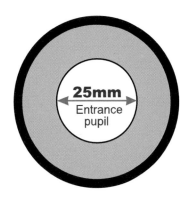

Aperture ÷ Focal length = f/stop
25mm ÷ 50mm = f/2
f/2 = 1/2 focal length

Figure 3-23. *The diameter of the aperture used in calculating focal length is actually the diameter of the "entrance pupil," which is the diaphragm diameter as seen through the front lens element. Because it is magnified by the lens, the entrance pupil's diameter is larger than that of the actual opening in the diaphragm.*

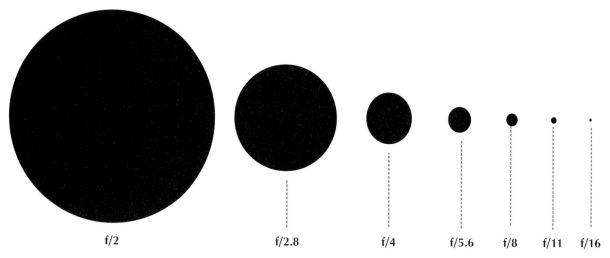

Figure 3-24. *F-stop relationships are based on halving or doubling of the aperture area. Going one stop higher (f/8 to f/11, for example) cuts the aperture area—and thus the light passing through it—in half. Going one stop lower (f/8 to f/5.6) will double aperture area, and thus the light.*

represents changes with the focal length. This is called *relative aperture,* and is important to being able to obtain consistent photographic results. Imagine what would happen if f/2 represented an aperture of 25mm for any lens, regardless of focal length. An exposure that was correct for a 50mm lens would be two stops underexposed (receive only one-fourth as much light) if a 100mm lens was used.

As described earlier, the f-number is calculated by dividing the focal length by the aperture. For this reason, a lens with twice the focal length of another lens would have an aperture twice as large for a given f-stop. If f/2 represents an aperture of 25mm on a 50mm lens (50 ÷ 25 = 2), then f/2 on a 100mm lens would require an opening of 50mm (100 ÷ 50 = 2). The difference in aperture compensates for the difference in the intensity of the light reaching the film because of the increased focal length. This is demonstrated in **Figure 3-25,** which shows that both the 50mm and 100mm lenses transmit the same amount of light reflected from the subject. The image of the ball projected onto the film by the 100mm lens is twice as large as the image of the ball from the 50mm lens. The light reflected from the

ball is spread over an area four times as large with the 100mm lens. The aperture of the 100mm lens at f/2 is twice the diameter (four times the area) of the same f-stop of the 50mm lens, so the film receives the same exposure. The apertures are different physical sizes, but the same *relative* size.

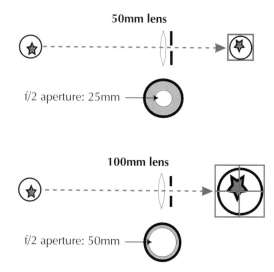

Figure 3-25. *Relative aperture ensures that the film receives the same exposure from lenses of two different focal lengths. As focal length increases, the aperture also becomes larger for a given f-stop, and vice versa.*

Lens speed

To shoot a speeding motorcycle at noon, you aren't likely to need a fast lens, but to take a photo of a tortoise at dusk, you probably will. Does that seem like a contradiction? Not when you realize that the descriptive term "fast," when applied to a lens, has nothing to do with the *motion* of the subject.

A *fast lens* is one that has a large maximum aperture, giving it great light-gathering power. A fast lens can be "opened up" to allow relatively short exposures in low-light conditions. With the speeding motorcycle at noon, plentiful light would allow exposure at smaller apertures; the fading light at dusk (especially with a dark-colored subject like a tortoise) would require a large aperture.

The fastest lenses for 35mm SLRs are typically 50mm "normal" lenses with maximum apertures greater than f/2. On many 50mm lenses, a fractional stop such as 1.7 or 1.8 (one-third stop faster than f/2) is the maximum; f/1.4 , f/1.2, and even f/0.7 lenses are available, but tend to be costly. Many wide-angle lenses have a maximum aperture of f/2.8; so do a large number of mid-range (between 70mm and 100mm) lenses.

Zoom lenses typically have a maximum aperture of f/3.5 or f/4 at their shortest focal length, and f/4.5 or f/5.6 at the long-focus end. A relatively small number of more expensive zooms have a constant maximum aperture, usually f/2.8, regardless of focal length. Fixed focal length lenses over 100mm have smaller maximum apertures — some are f/4, many are f/5.6, and others are f/8. There is a mechanical reason why longer lenses are slower than shorter-focus lenses: greater speed would require larger-diameter diaphragms than are practical for most users. The very large 1200mm f/5.6 lenses used by professional sports photographers are almost three feet in length and 8 inches in diameter, **Figure 3-26.**

Effect of aperture on depth of field

Most lenses offer a range of six or seven f-stops. In most situations, the photographer can choose among several f-stop/shutter speed combinations that will provide equivalent amounts of exposure. Which stop is selected is frequently determined by how much *depth of field* is desired or required for the photograph.

Depth of field is the distance from the nearest object that appears to be in sharp focus to the farthest object that appears to be in sharp focus. When photographing a mountain landscape, the depth of field may be measured in miles, while in close-up flower photography, it may be in millimeters.

Technically, only a single plane of a scene, the *plane of focus,* can be in sharp focus; parts of the scene closer to or further from the camera will be progressively more "fuzzy" or out of focus, **Figure 3-27.** That is why the term "appears to be in sharp focus"

Figure 3-26. *Very long lenses, like this 1200mm telephoto, are relatively slow because of the large aperture required to produce larger f-stops. Physical size and weight are also a problem: this lens weighs more than 36 pounds. (Canon USA, Inc.)*

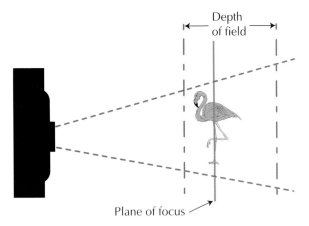

Figure 3-27. *Only one plane can actually be in absolutely sharp focus. Areas for a limited distance in front of and behind the plane of focus, however, appear to be sharply focused enough to provide a "zone" of acceptable focus, or depth of field. Traditionally, the zone of acceptable sharpness is considered to be divided one-third in front of the plane of focus and two-thirds behind it.*

was used when defining depth of field. The limited resolving power of the human eye will find focus to be apparently sharp in a zone extending some distance in front of and behind the plane of focus.

Sharpness of focus results from the way light rays reflected from the subject are refracted by the lens and projected onto the film plane. As shown in **Figure 3-28,** each point of light on the subject has a corresponding point on the film plane. Points from the *plane of focus* are represented as points on the film plane, but points in front of or behind the plane of focus appear as small circles on the film. The circles become larger as the distance of the originating point from the plane of focus increases. The size of these circles, called ***circles of confusion***, determines sharpness of the image on the film. As noted earlier, the human eye has limited resolving power. This means that up to a certain diameter, a circle is seen as a point, and thus appears to be sharp. The size of the ***permissible circle of confusion*** varies, depending upon individual eyesight and other factors, but is generally considered to be 1/100″ on a 6″ × 8″ print when viewed from a distance of 10″.

Factors controlling depth of field

How much or how little depth of field is present in a specific photographic situation is governed by three factors: the distance of the subject from the camera, the f-stop used, and the focal length of the lens. Since the photographer often can alter one, two, or all three factors, he or she is able to exert considerable control.

- **Subject distance.** The further the subject is from the camera, the greater the depth of field, and vice versa. If you focus on a subject 5′ away from the camera, your depth of field might be from about 4′ to 7′. When you take a few steps backward, so the subject is 10′ away, then refocus, your depth of field increases dramatically. By doubling the distance to the subject, you increase depth of field by *four* times. Now, objects in the scene will be in acceptable focus from about 6.5′ to almost 18′ away. See **Figure 3-29.**

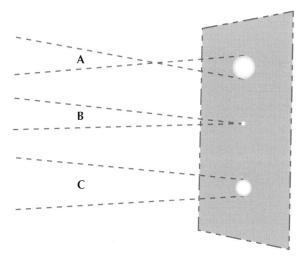

Figure 3-28. *When rays of light striking the film plane are not perfectly focused, they form small circles called "circles of confusion." If the circles are small enough, the human eye sees them as acceptably sharp points. Larger circles are seen as a softness of focus, or fuzziness. A—Light rays from object farther away than the plane of focus. B—Light rays from object at plane of focus. C—Light rays from object nearer than the plane of focus.*

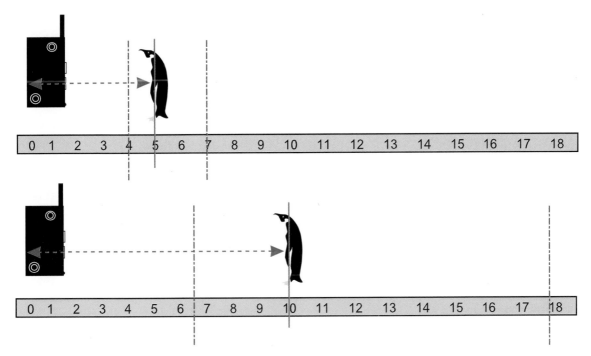

Figure 3-29. *Distance of the subject from the camera is a factor in depth of field. Doubling the distance between the camera and the subject will increase depth of field by four times. Distances shown are in feet.*

- **f-stop.** For convenience, this is the control factor most-often used by photographers to alter depth of field. The relationship of f-stops to depth of field is the same as their relationship to exposure, but in reverse — "stopping down," or decreasing the aperture size, *increases* depth of field; "opening up" (increasing aperture size) *decreases* depth of field. For example, focusing at f/8, then changing the aperture to f/11, doubles the depth of field; going from f/8 to f/5.6 cuts it in half. See **Figure 3-30.** By adjusting shutter speed to compensate, the photographer can adjust depth of field while maintaining correct exposure. (The subject of *equivalent exposure* is covered in detail in Chapter 4).

- **Focal length.** The choice of lens has a considerable effect upon depth of field, since focal length and depth of field are *inversely proportional*. In other words, increasing focal length decreases depth of field, and vice versa. While maintaining the same f-stop and subject distance from the camera, changing from a 50mm lens to a 100mm lens cuts depth of field in half; moving from the 50mm to a 24mm doubles depth of field. This change in depth of field does *not* take place, however, if the camera is moved to keep the image the same size with the two lenses. If the photographer focuses with 24mm lens, then changes to the 50mm lens and moves the camera back until the subject is the same size in the viewfinder as with the 24mm lens, the depth of field will be *exactly the same*.

To obtain maximum depth of field, make use of all three control factors: focus on a subject that is reasonably distant from the camera, use the smallest practical f-stop, and select a wide-angle lens.

Depth of focus

The terms *depth of field* and *depth of focus* are sometimes confused, since they sound like the same thing. While both relate to sharpness of the image, they are considerably different. As described in the preceding

Figure 3-30. *"Stopping down" the lens increases depth of field. The point of focus, in all three examples, was on the face of the statue. The building is approximately 80' behind the statue. Only the f-stop (and equivalent shutter speed for proper exposure) was changed. A—Aperture set at f/5.6. B—Aperture set at f/11. C—Aperture set at f/32.*

paragraphs, depth of field is the zone of apparent sharpness in front of and behind the subject. In effect, it is the space in which the subject could move around and still be in acceptable focus. ***Depth of focus*** is the distance that the film can move toward or away from the lens without the image losing sharpness. Since modern cameras are designed to hold the film firmly in place in the film plane, depth of focus is not something the photographer need worry about.

Questions for review

Please answer the following questions on a separate piece of paper. Do not write your answers in this book.

1. The _____ lens, developed by Wollaston in 1812, was the first lens developed specifically for camera use.

2. Why does a lens refract (bend) light rays?

3. Light rays passing through a convex lens are bent at different angles and come together at a common _____.

4. Which of the following types of lens was designed to correct the aberration known as curvature of field?
 a. achromatic
 b. aplanatic
 c. aspheric
 d. apochromatic

5. Coatings are applied to lenses to reduce _____ and increase light _____.

6. Define the term *focal length*.

7. Assuming that you are using a 35mm SLR camera, which of the following lenses would you choose to provide an angle of view and a perspective most similar to unaided human vision?
 a. 28mm
 b. 50mm
 c. 80mm
 d. 105mm

8. What problem is solved by applying *retrofocus* design to a wide angle lens?

9. In a true telephoto lens, where is the point from which distance to the film plane is measured to determine focal length?

10. Your macro lens permits you to make closeups at a reproduction ratio of 1:3. If you are making a closeup of a flower that is 3/8" across, how wide will the flower's image be on film?

11. If you use a 1.4× tele-extender with your 135mm lens, what is the focal length of the combination?

12. In this sequence of numbers — 1, 1.4, 1.8, 2, 2.8, 4, 5.6 — which does not represent an interval of full f-stop from its neighbors?

13. Explain why the actual size of a given aperture (such as f/8) is larger for a 200mm lens than it is for a 28mm lens. Calculate the physical size of the aperture at f/8 for the two lenses.

14. The sharpness of the image on the film plane is determined by the size of the

 _____.

 a. circles of confusion

 b. silver molecules in the emulsion

 c. points of parallax

 d. lens element groups

15. What are the three factors controlling the depth of field exhibited in a photograph?

Diffused light:
Light that is reflected in many
directions and has a soft, almost
shadowless, unfocused quality.

Chapter 4

Light and Exposure

When you have finished reading this chapter, you will be able to:

➠ Discuss the basic characteristics of light as they affect photography.

➠ Explain how filters are used to control light.

➠ Describe the operation of a photoelectric light meter.

➠ Demonstrate proper light metering techniques.

➠ Describe the use of the Zone System.

Photography is the act of capturing patterns made by light, or put another way, "drawing with light." The word was coined in 1839 by English astronomer Sir John F. W. Herschel, who combined the Greek roots *photos* (light) and *graphos* (drawing). Herschel did more than give a name to photography — he made important chemical contributions. These included the discovery of the first fixing agent ("hypo") to make photographs permanent, and the development of the cyanotype, or blueprint, process.

The description "drawing with light" is an appropriate one, since light rays entering the camera create a latent image on film by chemically changing its silver coating. In a digital camera, the entering light rays cause electrical changes on an array of electronic sensors. Through photographic or electronic processing, these "light drawings" can be given permanent form and reproduced for viewing.

Basic light theory

Every aspect of photography is somehow intertwined with light: we use natural or artificial light to make pictures, we measure light with meters to determine proper exposure, and we control the quantity of light reaching the film by choosing apertures and shutter speeds. We also moderate or intensify light reaching the subject with diffusers and reflectors and use filters to change the color for effect or to suit different films.

Because it is so central to photographic success, some understanding of light and its physical properties is important. Being aware of how light behaves often can help you overcome problems and capture the scene as you visualized it.

Light is defined as a form of electromagnetic radiation, or radiant energy, that is visible to the human eye. The largest producer of this radiant energy, of course, is the sun. On a smaller scale, both heat energy and light energy are given off by fire. Artificial sources of radiant energy are lamps that produce light through discharge, fluorescent, or incandescent means.

An electronic flash is an example of light emitted by *discharge*. The flash tube is filled with xenon, an inert gas. Xenon emits a short and very intense burst of light when a high-voltage electrical discharge takes place inside the tube. In a *fluorescent* light source,

a discharge of electrical energy causes a gas, usually mercury vapor, to emit ultraviolet radiation. This radiation, in turn, causes a coating inside the glass tube to glow and emit light. *Incandescent* light sources consist of a metal element with high electrical resistance inside a sealed glass container or bulb. When an electric current is passed through the element, resistance causes it to heat rapidly to the point where it glows white-hot and emits light. The atmosphere inside the bulb is either a vacuum or an inert gas, otherwise the element would quickly be consumed (burned up).

Movement of light

When light is emitted from a source, it moves away (radiates) in straight lines in all directions, **Figure 4-1.** The light *rays* move in the form of a wave, vibrating at right angles to the direction of travel. The waves move away from the source very rapidly: the *speed of light* is 186,000 miles per second. This is why a room appears to instantly fill with light when you press a wall switch.

Two characteristics of the light wave can be measured, as shown in **Figure 4-2.** The *wavelength* is the distance from the crest of one wave to the crest of the next, while the *frequency* is a measure of the number of waves (cycles) passing a given point in a given amount of time. Actually, light makes

Figure 4-1. *Light radiates from a source in all directions, moving in straight lines.*

Figure 4-2. *Measuring a wave. Wavelength is measured from one wave crest to the next. The number of waves passing a point in one second is the frequency.*

up only a tiny portion of the entire spectrum of electromagnetic radiation. The full *electromagnetic spectrum* ranges from gamma rays with extremely high frequency and extremely short wavelengths to radio waves with wavelengths measured in miles and frequencies of 10,000 cycles per second or less. The unit of measure for frequency is the **hertz** (one cycle per second = 1 Hz), while the unit of measure for wavelength is the **nanometer**, which is equal to one-billionth of a meter (0.000000001m = 1nm).

Visible spectrum

The portion of the electromagnetic spectrum that can be seen by the human eye is referred to as the *visible spectrum.* It consists of waves with frequencies ranging from about 400nm to about 700nm. Our eyes see different wavelengths of light as different colors, **Figure 4-3.** Structures in the human eye called *cones* are receptive to essentially three ranges of wavelengths: 400nm–500nm (blue), 500nm–600nm (green), and 600nm–700nm (red). Each type of cone is receptive to only one range of wavelengths, but the combined effect of the cones is to provide a full rainbow of colors blending from red to violet. Although we may be able to distinguish as many as 100 different colors within the red-to-violet spectrum, it is divided traditionally into seven: red, orange, yellow, green, blue-green, blue, and violet.

The wavelengths for some distance on either side of the visible spectrum are not normally visible to the eye, but can be

The Visible Spectrum

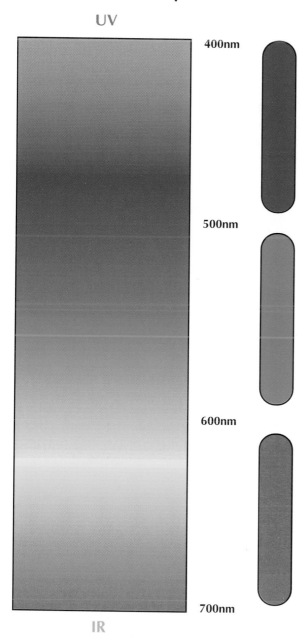

Figure 4-3. *The wavelengths from approximately 400nm to 700nm make up the visible spectrum. The human eye perceives the different wavelengths as colors ranging from red to orange to yellow to green to blue-green to blue to violet.*

recorded on film. *Infrared* wavelengths are longer than 700nm, so they are below red (infra means "below") on the spectrum, while *ultraviolet* ("beyond violet") wavelengths are shorter than 400nm. Film can be made sensitive to infrared radiation with special dyes added in manufacture, and is normally quite sensitive to ultraviolet (UV) wavelengths. In fact, many photographers routinely use a UV ("haze") filter, especially when photographing landscapes. Short wavelengths (such as ultraviolet) are scattered more readily in the atmosphere than longer wavelengths. This creates a haze effect that obscures details in the distance. The UV filter absorbs the short-wavelength radiation, eliminating the haziness.

The color of light

When light is composed of red, green, and blue wavelengths in approximately equal proportions, it is said to be "white light." Such a light is produced by the mid-day sun on a clear and cloudless day. In contrast, the warm light of early morning and late afternoon is strongly red-orange in color. Different types of artificial light have different colors (although the human vision system adjusts to the differences and sees them as generally "white" light.). Ordinary incandescent lightbulbs emit a light that is heavily balanced toward the red/orange/yellow end of the spectrum, while electronic flash tubes are balanced toward the opposite (blue-violet) end of the spectrum.

The effect of the color of light on film is more obvious with color emulsions, since film doesn't adjust like the human eye to see a range of colors as "white." For this reason, color film emulsions are *balanced* for the type of light in which they will be used. Film that is *daylight-balanced* renders colors normally when exposed with natural light or electronic flash, while *tungsten-balanced* film reproduces colors realistically when the light is provided by incandescent bulbs. Daylight film used under tungsten lights produces pictures with a strong cast of red-yellow. Tungsten film exposed under daylight conditions shows an overall cold blue shade.

The effect that the color of light has on black-and-white films is very slight today, but this was not always the case. See **Figure 4-4.**

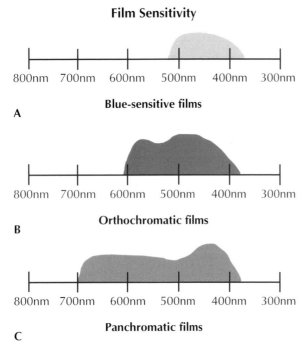

Figure 4-4. *Sensitivity of black-and-white films to different wavelengths of light. A—The earliest film emulsions responded only to the shorter blue wavelengths. B—Orthochromatic films are "red-blind." They are sensitive to the blue and green wavelengths, but not to red. C—Modern emulsions are panchromatic, responding to almost the full 400nm to 700nm visible spectrum.*

The earliest films were ***blue-sensitive*** — they responded only to wavelengths in the blue/violet/ultraviolet end of the spectrum. In the 1870s, it was discovered that adding a pink dye to the photo emulsion would make it sensitive to the green wavelengths of light. Even though it responded to only two-thirds of the visible spectrum (it was still "red-blind"), this film produced tones in the black-and-white print that more closely matched what the human eye saw. For this reason, it was known as "corrected," or ***orthochromatic,*** film. The addition of a green dye to the film emulsion finally made it able to respond to more or less the full visible spectrum. Today's ***panchromatic*** films are sensitive to light in the blue, green, and red wavelengths.

Even though panchromatic films are able to respond to light across the entire visible spectrum, they do not "see" various

colors in the same way that the human eye sees them. As shown in **Figure 4-5,** human vision is very sensitive to green wavelengths, and about equally sensitive to blue and red wavelengths. Panchromatic film, by contrast, is very sensitive to blue wavelengths and has approximately equal sensitivity to green and red (red-sensitivity declines as wavelengths approach the infrared).

This difference in sensitivity often results in colors that appear quite different to our eyes being reproduced on black-and-white film as almost identical gray tones. This is especially true for the colors red and green: when you look at a red flower against green leaves, it stands out in strong contrast. In a black-and-white photographic print, however, it may almost disappear. The solution is to use a *contrast filter* that makes the film emulsion render the colors as distinctly different. See **Figure 4-6.**

Controlling light with filters

Except on those rare occasions when we include the sun or another light source in a picture, all our photographs are made with ***reflected light***. Light rays from the source bounce off an object and pass through the camera lens to be focused on the film plane. How the film *records* those reflected rays of light can be controlled to a great extent by the use of filters. Before moving on to filters

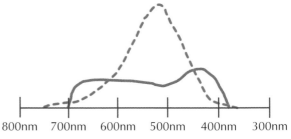

Figure 4-5. *The human eye responds to colors differently from panchromatic film. The eye (dashed line) is most sensitive to green light, while film (solid line) is most sensitive to blue. Green and red objects, in particular, are likely to be recorded on film as similar shades of gray.*

Figure 4-6. *Rendering red and green. A—A red flower on green leaves, as the human eye would see them. B—Print from panchromatic film, with flower and leaves rendered almost identical shades of gray. C—A contrast filter lightened the red flowers and darkened the green leaves to separate the two tones.*

and how they work, a brief discussion of how light rays are absorbed and reflected will be useful.

Light absorption/reflectance from objects

To better understand what happens when light rays strike an object, visualize directing a stream of water from a garden hose at a brick wall. Some of the water will soak into the brick, or be *absorbed*, but most of it will bounce off, or be *reflected*. If you directed the hose stream at another surface, such as a patch of dry earth, most of it would be absorbed, and a small amount reflected. A third possibility can be illustrated by directing the water stream at a piece of wooden latticework. Some of the water would be absorbed and some reflected, but most of it would be passed on (*transmitted*) through the diamond-shaped openings of the lattice. See **Figure 4-7.**

How much of the light is absorbed, reflected, or transmitted depends upon the material from which the object is made, the type of surface finish, and the object's color.

Material that is transparent or translucent (milky in color) reflect very little light—most is either transmitted or absorbed. Opaque materials, those than do not transmit light, absorb or reflect light in different proportions, depending on their surface finish. A dull or rough surface absorbs a high percentage of the light rays. The reflections from such a surface are *diffuse*

(reflected in many directions). A surface that is smooth and polished, such as chrome metal, reflect a very high percentage of the light, and will reflect the rays in an orderly and concentrated manner. Such reflections appear as bright spots of light and are referred to as *specular reflections.* Even materials that transmit most of the light that strikes them, such as glass or water, produce specular reflections from their smooth surfaces.

Objects that are white or light-colored reflect light rays readily; black or dark-colored objects absorb most light rays. Our perception of an object's color is based upon the wavelengths of light that are reflected

Figure 4-7. *Depending upon the material and its surface finish, a light ray striking it might be absorbed, transmitted, or reflected.*

Figure 4-8. *Color perception. A—Red and blue wavelengths of white light are absorbed by the lime, while green wavelengths are reflected. The lime is seen as green. B—Blue light is absorbed by the lemon's skin, while red and green wavelengths are reflected, providing the yellow color.*

from that object. As shown in **Figure 4-8,** white light (an equal mixture of the red, green, and blue wavelengths) strikes the surface of a lime. The red and blue wavelengths of light are absorbed by the fruit's surface, but the green wavelengths are reflected back to the viewer's eye. The lime is seen as *green.* If a lemon is viewed under white light, the *yellow* color seen by the eye results from the blue wavelengths being absorbed, and equal amounts of red and green wavelengths being reflected.

How filters work

Filters placed in front of the camera lens, or between the lens and the film, may reflect a small percentage of the light, but primarily transmit it or absorb it. The *contrast filters* mentioned earlier are made in deep shades of red, green, and blue. Each of these filters transmits light of its own color, but absorbs light of the other two colors.

The major use of the contrast filter is to help differentiate between colors when they are rendered as gray shades on black-and-white film. The effect is to lighten objects of the same color as the filter and darken objects of other colors; thus, a blue filter lightens a blue object and darkens red and green objects. What about objects of other colors? Since all colors are combinations of two or all three of the primary colors in different proportions, they are affected according to their makeup.

The Maxwell triangle, **Figure 4-9,** is a guide to how different colors are affected by filters. The primaries (red, green, blue) are at the points, and the secondary colors (yellow, cyan, magenta) are along the three sides. The secondary colors result from mixing light of the adjoining primary colors in equal proportions. Thus red and green produce yellow, blue and red create magenta; and green and blue form cyan. The lightening and darkening of colors described in the last paragraph is done in groups of three. If a green filter is used, it lightens green objects, but also lightens objects of the adjoining

Figure 4-9. *Use this triangle to predict how a contrast filter will affect the colors recorded on black-and-white film. A filter of a given color will lighten objects of the same color and of the colors to either side of it on the triangle. The color directly opposite, and its adjoining colors, will be darkened.*

colors on the triangle: cyan and yellow. It darkens objects of the opposite color, magenta, and the two adjoining colors, red and blue.

Using filters for emphasis

With their ability to lighten and darken the way colors are represented on film, contrast filters can be used creatively to emphasize certain colors and deemphasize others. The most frequent use for filters in black-and-white photography is darkening the sky. Since film is very sensitive to the blue wavelengths, skies tend to photograph as white. Unless clouds are quite dark, they almost disappear in the white of the sky. A *yellow* filter absorbs some of the blue light, darkening the sky and allowing the clouds to stand out better. A deep yellow or orange filter darkens the sky even more; a red filter gives an almost "night" effect. See **Figure 4-10.**

The effect that a filter has on a given color will vary, depending upon the wavelengths of the light being reflected. For

example, some reds are lightened more than others by a red filter. The effect of the filter can usually be seen by looking at the scene through it.

Filters are also used to correct the way color is represented on the film. A *light* yellow filter, for instance, darkens a clear blue sky just enough to match it to what the eye actually sees. This is less darkening than is done for creative effect with yellow, orange, or red filters. Another correction is the use of a light green filter when shooting panchromatic film with tungsten lighting. The green filter slightly darkens reds and blues, which would otherwise appear too light on film.

Filters are also used for correction when shooting color film. That topic, and other uses of filters, will be covered in Chapter 12.

Using filters to reduce light

Sometimes, you can have *too much* light to work with, creating an overexposure condition beyond the control capability of available shutter/aperture combinations. An example might be having a high-speed film loaded in your camera and finding yourself in a brightly lighted situation with the need to maintain a shallow depth of field to eliminate a distracting background. When you meter the situation, you find that even your fastest shutter speed would result in overexposing by two stops.

The solution is the **neutral density (ND)** filter, which reduces the light reaching the film without affecting the way various colors are recorded. Neutral density filters are available for various degrees of light reduction. Typically, ND filters offer a 1-stop, 2-stop, or 3-stop reduction, but can be stacked to provide more extreme results. With sufficient light reduction using ND filters, it is possible to photograph a busy street scene and eliminate all the moving autos and pedestrians. The long exposure time means that any moving object will not be in the scene long enough to be recorded on film.

Figure 4-10. *Using filters to darken the sky. A—No filter. Sky is white and clouds barely visible. B—Yellow filter. Sky darkened, making clouds more visible. C—Orange filter. Sky is darkened even more, and clouds stand out more strongly. D—Red filter. Most dramatic contrast between dark sky and bright clouds. The orange and red filters darken the overall scene. In printing C and D, the foreground area was dodged (given less exposure) to maintain approximately the same appearance as in A and B.*

Using filters to control reflection

When light is reflected as glare (a bright, unwanted reflection) from a shiny non-metallic surface like glass or water, it becomes *polarized.* This means that the light waves become lined up in a single plane. The glare obscures what is behind the glass or beneath the surface of the water.

The glare can be minimized or even eliminated by using a polarizing filter on the camera lens. The filter, when rotated to the proper angle, absorbs the polarized light that forms the reflection. As shown in **Figure 4-11,** use of the filter reveals what had been hidden by the glare.

There are two types of polarizing filters: linear and circular. The effect and the method of use are the same, but it is important to select the right type for use with a given camera. Linear polarizers create problems with autofocus systems, so only circular polarizers should be used with autofocus cameras. Most manual-focus cameras can use either type. Those that use a beam-splitter in their light-metering system require use of a circular polarizer, however.

Using filters for special effects

There are many kinds of *special effects* filters available to enhance, distort, or otherwise affect the image captured on film. Some common special effects filters used with black-and-white film include:

- Soft-focus filters are often used in portrait work. Various degrees of softening are available.

Figure 4-11. *Polarizing filter. A—Glare reflecting from the glass surface of an aquarium obscures details. B—With a polarizing filter absorbing the reflected light, the scene behind the glass is revealed. (Cokin Filters/Minolta Corporation)*

- Star filters produce radiating rays from light sources in the photograph. Different filters produce four, six, or eight rays from each source.

- Multiple image filters arrange two, three, four or more images of the subject in the frame.

- Graduated filters are half-clear and half-ND or a color. The transition from color to clear is smooth and gradual. Graduated ND filters are used to balance scenes with widely varying brightness levels (such as a snowy foreground or a bright sky with darker areas below the horizon).

Filters come in two basic forms: the round screw-in type that fits over the lens, and square type that is used in a special holder that attaches to the lens, **Figure 4-12.** Each type has a disadvantage. The holder for square filters is somewhat cumbersome, especially in the field. Round filters must be mated to a lens with matching threads. To avoid purchasing multiple filters, many photographers buy one for their largest-diameter lens, then use special adapters (*step-down rings*) to mount them on smaller-diameter lenses.

Filter factors

Almost any filter placed on a lens will reduce the amount of transmitted light.

Sometimes this loss, called a *filter factor,* is negligible; but it is often equivalent to 2 stops or even more. The filter factor is important information when exposure must be calculated and set manually, as it is with all large format and many medium format cameras. With SLR cameras, no adjustments are necessary. The camera's built-in meter takes its reading through the already-mounted filter, automatically including the additional exposure required by the filter.

The factor is normally stated as a number by which normal exposure must be multiplied to correct for the light loss. As might be expected, filter factors increase as the filter colors get darker. Thus, a UV filter,

Figure 4-12. *Round filters screw into the front of the lens and are made in a number of diameters. Square filters are used with a special holder that can be attached to the lens.*

which is essentially clear glass, has a filter factor of 1, a yellow No. 8 filter has a factor of 2, and the dark red No. 25 filter has a factor of 8.

Calculating exposure with filter factors is easier if you remember that "opening up" one f-stop doubles the amount of light reaching the film. A filter factor of 2 means that you must provide for twice as much exposure as you would normally. This can be done by a one f-stop increase in exposure. If the filter factor is 4, you must double the exposure, then double again. In other words, you open up by *two* f-stops. In the same way, a factor of eight would require doubling exposure, doubling again, and then doubling a third time: an increase of *three* f-stops. To further complicate the matter, filter factors for daylight and for tungsten lighting often differ. **Figure 4-13** lists filter factors and exposure compensations for a number of contrast filters.

Measuring light

To properly expose film, you need some means of measuring light to help make decisions on your camera settings. Before exposure meters (usually called "light meters") came into common use, photographers had to rely upon experience, a good eye for lighting conditions, and some "rules of thumb" to determine exposure.

The basic exposure guide was termed the "sunny 16" rule: *when shooting in bright sunlit conditions, set the aperture at f/16 and the shutter speed to the nearest reciprocal of your film speed.* If you are using film with a speed of ISO 100, the reciprocal would be 1/100, and the shutter speed nearest that reciprocal would be 1/125 second. With ISO 400 film, the nearest shutter speed would be 1/500 second, and so on. Experienced photographers would make further adjustments, based on their results under various lighting conditions; for example, opening up 3 stops under cloudy conditions. A carryover from those premetering days are the suggested exposure charts still printed on or inside most film boxes, **Figure 4-14.**

Virtually all 35mm SLR cameras sold today have a built-in light meter that can be used to indicate exposure when operating manually, or to determine and control exposure for automatic operation. Also available are various types of hand-held meters that can be used to determine proper exposure. Hand-held meters are preferred over built-in camera meters by some photographers; others use either or both, depending upon the situation. Photographers working with medium format and large format cameras generally must rely on hand-held meters for exposure determination.

Filter Factor Adjustments

Filter	Daylight Factor	Increase f-stop by:	Tungsten Factor	Increase f-stop by:
#6 Light Yellow	1.5	2/3	1.5	2/3
#8 Yellow	2	1	1.5	2/3
#11 Yellow-Green	4	2	3	1 2/3
#15 Deep Yellow	2.5	1 1/3	1.5	2/3
#25 Red	8	3	5	2 1/3
#47 Blue	6	2 2/3	12	3 2/3
#58 Green	6	2 2/3	6	2 2/3

Figure 4-13. *Filter factors and f-stop compensation for contrast filters used with black-and-white film. Note that filter factors may vary, depending on whether light is daylight or from a tungsten source.*

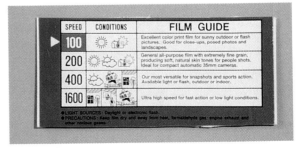

Figure 4-14. *Suggested exposures for a number of common photographic situations are printed on or inside most film packages.*

How exposure meters measure light

A *photoelectric light meter* uses electrical changes caused by different light intensities to indicate various levels of illumination. These indications, in turn, can be used to determine the exposure needed for a scene. The electrical changes (either a generated current or a change in resistance) can be used to drive a pointer against a scale, or to provide an LCD (liquid crystal display) readout.

There are two basic forms of photoelectric meter, those using selenium cells and those using cadmium sulfide (CdS), silicon blue (Sbc), or gallium-arsenic phosphide (GAP) cells. The Sbc and GAP cells are less widely used than the CdS cell.

Selenium cell meters were once the most common type, but are used much less frequently today. The selenium cell in these meters is photosensitive and generates a tiny electrical current whenever it is struck by light (no batteries are required). The strength of the current generated is proportional to the intensity of the light—the stronger the light, the larger the current, and vice versa. The current is used to move a pointer across a scale to indicate an exposure value. See **Figure 4-15.**

Cadmium sulfide cell meters, or CdS meters, also react to light but use a different approach. A battery generates a small electrical current through the meter circuit. The intensity of the light striking the CdS cell causes a change in its *electrical resistance*. The increase or decrease in resistance is directly reflected as a change in the current flowing through the circuit. The changing current is translated into exposure values indicated on a scale or a display. The CdS cell provides a more precise reading than the selenium cell, especially under low-light conditions.

Meter displays

The way that the exposure values are displayed by a meter may be either indirect

Figure 4-15. *Selenium cell exposure meter. A—Back of meter, with cell partly exposed. Pivoting shutter arrangement was used to set the film speed. B—Current generated by intensity of light falling on the cell moves the pointer across a scale calibrated in f-stops. Setting the shutter speed on the rotating selector dial brings a matching f-stop scale onto the display.*

or direct. Indirect-reading meters provide an index number that must be related to an f-stop/shutter speed combination, while *direct-reading meters* give a specific f-stop/shutter speed combination. Older hand-held meters usually are of the indirect type, with a needle moving over a scale; newer meters typically provide a direct reading on an LCD. See **Figure 4-16.**

The TTL, or *through-the-lens,* meters used in cameras are direct-reading, although the reading is presented in a number of different ways in the viewfinder. Some use blinking LEDs (light-emitting diodes) on a scale of shutter speeds or apertures; some display both aperture and shutter speed in numerals; still others require matching two needles or indicators by changing aperture or shutter speed. Because of the great variety of systems used, the use of TTL meters will be covered only in general terms. For specific information, consult the owner's manual for your camera.

Types of meter readings

In-camera meters can only be used to read *reflected light,* or light that enters the lens after bouncing off the subject. Virtually all hand-held meters make reflected light readings, but many also can be used to read *incident light,* or light that is falling on the subject.

Reflected light readings are made with the meter facing the subject. Most often, readings are made from the camera position. Readings sometimes are made close to the most important part of the subject to avoid having the meter influenced by adjacent brighter or darker areas.

Incident light readings must normally be taken from the subject's position, with the meter facing toward the light source, *since the light falling on the subject* is being measured. Sometimes, an incident light reading can be made from other positions, so long as the light being measured is the same as that falling on the subject. Meters used for incident light readings have a translucent cover

A

B

Figure 4-16. *Types of meter displays. A—Indirect reading. The needle moves across a scale of index numbers. The dial is then rotated to set the index number opposite a pointer. Various f-stop/shutter speed combinations can be read at the top of dial. B—Direct reading. An LCD panel shows recommended f-stop/shutter speed. (Gossen/Bogen Photo Corp.)*

over the light-sensitive cell to diffuse the light rays. This helps the meter take an average reading, rather than being more strongly affected by the concentrated brightness of the light source. Meters that can be used for both types of readings typically have a translucent plastic dome that can be slid over the cell for reading incident light, **Figure 4-17.**

There are two specialized types of light meters in use: spot meters and flash meters. A *spot meter*, **Figure 4-18,** is used to take reflected light readings from very tiny areas and distant subjects. The spot meter has an angle of view as narrow as 1°, even narrower than a 1000mm telephoto lens. By comparison, a typical hand-held light meter has an angle of view of 30° to 50°, approximately the same as a 50mm lens. Some meter manufacturers offer attachments that can narrow the hand-held meter's angle of view to 7.5°, making it function somewhat like a spot meter. A number of 35mm SLR cameras allow the user to select among various metering patterns, including a spot meter mode. Spot metering, whether done with a hand-held meter or a camera, is used to make very precise readings to compare light reflected from different areas of the subject.

A *flash meter* can be used to make reflected or incident light readings, just like a normal hand-held meter. Its special

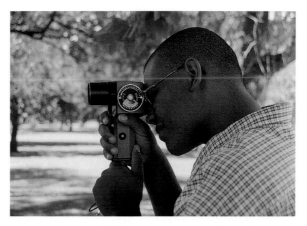

Figure 4-18. *The spot meter can make reflected light readings from distant subjects or tiny areas of closer subjects, allowing precise calculation of exposure.*

application, though, is making an accurate reading of the bright, extremely short pulse of light produced by electronic flash equipment. Flash meters are used most often for studio photography or special field applications such as weddings. Depending upon the situation, the flash meter can be used to make either an incident or a reflected light reading. Flash meters are typically of the direct-reading type.

A recent introduction by one manufacturer is an "all-in-one" model that can be used as an incident meter, a flash meter, or a spot meter with zoom capability. The zoom feature allows the angle of view to be varied from 1° to 4°. The spot meter can be used for ambient light, flash, or mixed light readings. Readings are displayed on a large LCD panel, **Figure 4-19.**

Making a light reading

To obtain an accurate meter reading that will result in proper exposure, a number of specific actions must be performed. First, before any reading can be made, the meter must be programmed with the speed (ISO rating) of the film being used, **Figure 4-20**. (For a variety of reasons, a photographer may choose to set the meter to an ISO rating different from the one suggested by the manufacturer. This practice is covered in

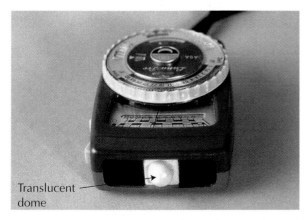

Translucent dome

Figure 4-17. *A translucent dome that can be slid over the light-sensitive cell permits a reflected light meter to make incident light readings.*

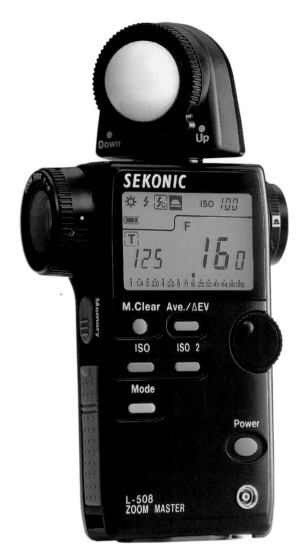

Figure 4-19. *This multifunction meter can be used to make reflected light, incident light, or flash readings. The spot meter has a zoom function allowing a variable angle of view from 1° up to 4°. (Sekonic Professional Division, Mamiya America Corp.)*

Chapter 5.) The shutter speed/aperture setting recommendations resulting from the meter reading are *for the film speed programmed into the meter*. If the film in the camera has a different ISO rating, it will be exposed incorrectly. For example, if the meter is programmed for ISO 100 film, and the camera is loaded with ISO 400 film, the meter's recommended settings will cause pictures to be overexposed by two full stops. For most in-camera meters, this problem will

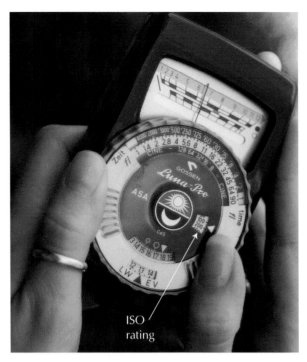

Figure 4-20. *To obtain accurate exposure readings, the meter must be programmed with an ISO rating matching that of the film in the camera.*

not occur. Today's 35mm and APS cameras read a form of bar code (the DX code) printed on the film cassette, **Figure 4-21.** This ensures that the meter is basing its readings on the speed of the film actually being used.

The meter's battery check function should be used at the beginning of a photo

Figure 4-21. *The use of DX coding on 35mm and APS film cassettes permits the camera to automatically set the film ISO rating for metering. Older cameras without the ability to read the DX code must still have the ISO rating set manually.*

session to be sure power is being supplied to the metering circuit. Meter batteries typically quit working abruptly, rather than slowly declining like batteries in some other applications. Thus, the difference is usually between a meter making proper readings and one making no readings at all. Photographers who rely on hand-held meters make it a policy to always carry replacement batteries.

Correct metering technique

Using proper metering techniques — selecting the right areas to meter and using the correct methods to get consistent and accurate readings — are vital to taking pictures that are well-exposed. The following sections will concentrate on using a hand-held meter effectively.

Making averaged readings

For many photographs, an overall reflective light reading, or *averaged reading,* is sufficient. This is a reading made by pointing the meter at the main subject, **Figure 4-22A.** Since the hand-held meter has about the same angle of view as the normal lens, it is affected by light that is reflected from the same area that appears in the photo. Most often, the scene will include a range of tones from those that reflect a great deal of light *(highlights)* to those that reflect little or no light *(shadows).* The meter reading will fall somewhere in the middle, averaging out the reflected light. This reading allows the film to properly expose most of the tones present in the scene, from fairly dark shadows through fairly bright highlights. In a scene photographed in brilliant sunlight, some detail is lost at both the shadow and highlight extremes, due to the limited ability of film to reproduce an extreme range of brightness.

An *incident light reading* accomplishes the same purpose as an averaged reflective reading for scenes with a wide range of tones. Since the incident meter is pointed at the light source from the subject's position, it measures the light falling on the subject,

Figure 4-22B. The photograph is *taken,* of course, by reflected light. The average of that reflected light is equivalent to the incident light reading.

What averaged reflective readings and incident readings actually produce is an exposure value for *middle gray,* equivalent to a tone that reflects 18% of the light that falls upon it. The standard **gray card** that is often used to take light readings under studio conditions has 18% reflectance. By properly exposing for the middle gray value in a scene, the darker and lighter tones in the scene will generally reproduce properly.

A more precise technique, used when it is important to keep detail in specific

Figure 4-22. *Overall light readings. A—Pointing the meter at the main subject provides an averaged reading of reflected light from all the tones in the scene. B—An incident reading measures the light falling on the subject, providing the same result as an averaged reflective reading.*

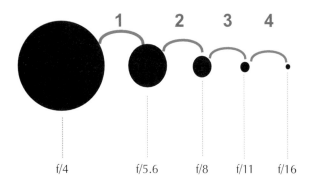

Figure 4-23. *A scene with a shadow reading of f/4 and a highlight reading of f/16 would have a range of four stops, as shown.*

shadow or highlight areas, involves the use of two meter readings. First, select the shadow area in which you want to preserve detail and take a meter reading from that area. Next, repeat the process with the selected highlight area, and then find the exposure *midway between* the two readings. For example, if the shadow reading indicated an exposure of f/4 at 1/60 second, and the highlight reading was f/16 at 1/60 second, the brightness range that you metered would be four stops (f/4, f/5.6, f/8, f/11, f/16), **Figure 4-23.** The midway point in that range is f/8. By using an exposure of f/8 at 1/60 second, you would be fairly

certain of keeping the desired detail in the shadow and highlight areas you selected.

Metering subjects that aren't "average"

Problems occur when the object or portion of a scene that is metered is not "average," but much darker or lighter than middle gray. The meter provides an exposure reading that, if used, results in a picture that is seriously overexposed or underexposed. As shown in **Figure 4-24**, exactly following the meter readings taken from the black or the white squares will result in pictures that are too dark or too light. *Why?* Because the meter always makes a middle gray reading — if a large amount of light is being reflected (as from the white square), the meter will adjust the exposure reading downward to avoid the "overexposure." As a result, the photo will be *under*exposed. In the same way, the meter will react to the small amount of light reflected from the black square by adjusting the exposure reading upward to prevent "underexposure." In this case, the photo actually will be *over*exposed. To photograph the white square as white, more exposure is needed than indicated by the meter; to show the black square as black, less exposure is necessary.

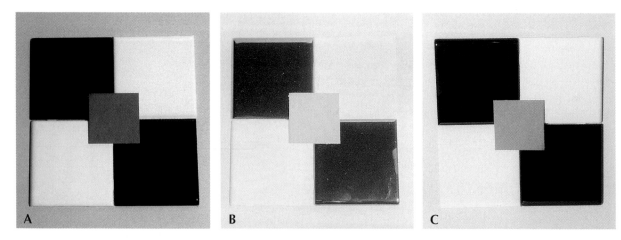

Figure 4-24. *Incorrect meter readings. A—A meter reading taken from the white square will cause the photograph to be underexposed. B—Using the reading taken from the black square produces a photo that is overexposed. C—With the exposure taken from the middle gray square, the black-and-white squares reproduce properly.*

Compensating for the meter's behavior in situations that are not "average" is a matter of experience. As a general rule, however, an adjustment of 1 to 1 1/2 stops (2 stops in extreme cases) usually provides a good exposure. For example, when photographing a winter snow scene, opening up 1 1/2 stops from the meter's recommended exposure will reproduce the snow as white instead of gray. At the opposite extreme, making a black cow *appear* black in a photo would require stopping down 1 or 1 1/2 stops from the meter's reading.

The meter can provide an incorrect reading even when making an overall reading of a scene if you are not careful about where you point it. A typical situation would be a scene that includes a bright sky or water area. If the meter is pointed at the bright area, the less reflective parts of the scene will be severely underexposed. A meter reading should be made from the part of the scene that you want to be properly exposed (possibly with adjustments made, as described in the preceding paragraph).

The same kind of underexposure problem can occur when a subject is *backlighted* (has most of the light coming from behind it). As shown in **Figure 4-25,** a meter reading influenced by the bright light will underexpose the subject, creating (in extreme cases) a silhouette. This is a valuable creative technique, but it should be done deliberately, not by accident. To prevent unplanned silhouettes, move in to take a reading directly from the subject, **Figure 4-26.** If a close-up reading can't be made, increase

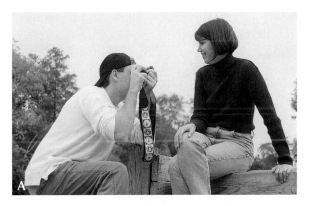

Figure 4-25. *An overall meter reading made when a subject is backlighted turns the subject into a silhouette, eliminating most or all detail.*

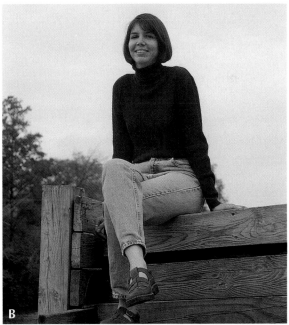

Figure 4-26. *Metering a backlit subject. A—Move in close to the subject so that the meter reading is not influenced by the strong backlight. B—Close-up metering results in the subject being properly exposed.*

your exposure by 1 1/2 stops over the meter reading. If time allows, you may want to try several different exposures to see which provides the best results. Shoot three exposures: one that is 1 stop over the meter reading, one that is 1 1/2 stops over, and one that is 2 stops over.

Reading the meter

In the preceding examples, exposures have generally been given as a specific aperture and shutter speed combination ("f/8 at 1/60 second"). Newer hand-held meters display such readings directly on an LCD panel. So do many in-camera meters. Older hand-held meters, however, typically use an index number that is manually translated into exposure recommendations by moving a dial.

As shown in **Figure 4-27,** the meter is pointed at the desired subject and a button or switch is pressed to activate the metering circuit. A needle moves against a scale of index numbers to show the strength of the reflected light reaching the meter's photo-electric cell.

A dial is then rotated to align an indicator mark with a number matching the index number indicated by the needle. This action aligns an f/stop scale with a shutter-speed scale to provide recommended exposures.

Each of the combinations presented by the paired f/stop and shutter speed scales will result in the same amount of light reaching the film. This is an illustration of the *reciprocity law,* which describes the relationship of light intensity and time on exposure. For example, f/5.6 at 1/125, f/8 at 1/60, and f/11 at 1/30 are equal in exposure value. For this reason, they are known as *equivalent exposures.* For the photographer, the value of equivalent exposures is flexibility and creative control. He or she can choose a combination with a high shutter speed (f/2 at 1/1000) to stop action, or a small aperture pair (f/16 at 1/15) to maximize depth of field.

The relationship described by the reciprocity law has its limitations, however.

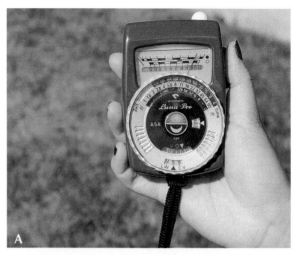

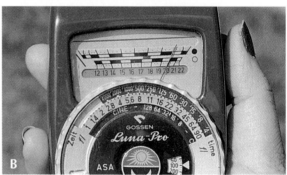

Figure 4-27. *Light meter. A—The needle indicates the proper index number on the scale. The dial is then rotated until the indicator mark points to the same number. B—Equivalent exposures can be read directly from the f/stop and shutter speed scales.*

When very long or very short exposures are being made, the time/light intensity relationship doesn't remain constant: longer exposure times or larger apertures are needed. This is known as reciprocity law failure or, more commonly, *reciprocity failure.* The times at which the reciprocity law fails vary from film emulsion to film emulsion, but are typically 1 second and 1/1000 second. Film manufacturers provide information on the time or aperture changes needed to compensate for reciprocity failure.

Calculating equivalent exposures

While the different combinations are easily read from the scales of many light

meters, it is useful to know how to quickly calculate equivalent exposures. The key is remembering that a one-stop change in aperture will either double the amount of light reaching the film or cut it in half. The same relationships apply to changing shutter speeds.

Assume that you are starting with an exposure of f/5.6 at 1/125, but need a shutter speed of 1/250 to counteract the slight motion of a flower caused by a gentle breeze. Moving from 1/125 second to 1/250 will *cut in half* the amount of light admitted while the shutter is open. To have the same amount of light reach the film (an equivalent exposure), you will have to *double* the size of the aperture. This can be done by opening up one stop to f/4. The combinations f/4 at 1/250 and f/5.6 at 1/125 are equivalent.

In practical terms, there's no need to keep track of "doubles and halves." Instead, all you have to do is count stops or shutter speed units *in opposite directions.* Thus, if you make your aperture smaller by two stops (from f/5.6 to f/8 to f/11), you will move two shutter speed units in the opposite direction (from 1/125 to 1/60 to 1/30) so the shutter is open longer. The same principle applies if you increase your shutter speed by three units (1/15 to 1/30 to 1/60 to 1/125). To achieve an equivalent exposure, you will have to open up by the same number of stops (f/16 to f/11 to f/8 to f/5.6). If you memorize the sequence of f-stops and shutter speeds found on your cameras and lenses, you will find that determining equivalent exposures becomes simple and almost effortless.

The Zone System

The *Zone System* is a photographic method designed to produce consistent, predictable results through careful control of exposure, development, and printing. As devised by Ansel Adams and Fred Archer in 1939, the system uses a 10-step scale of image values (tones) from pure black to pure white to allow precise description and control. Although its original use was with large format black-and-white sheet film, most of the techniques and principles of the Zone System can be applied to 35mm and medium format photography in both color and black-and-white.

Through the years, a number of other photographers have developed modifications and further refinements of the basic system. The Zone System and all its variants have been covered at length in numerous books and articles. Due to the space limitations of a general text like this one, it is only possible to provide a brief overview; for simplicity, the discussion will center on the system as devised by Adams and Archer.

The ten-step scale of values

Adams' goal in developing the Zone System was to provide the photographer with a means of creative control that would consistently produce a final print that matched his or her visualization of the scene. Sometimes, that final print would be a literal rendering or reproduction of the scene. At other times, however, the finished product would have a far different range of tones or contrasts from what the eye had literally seen. See **Figure 4-28.**

Potentially, any photograph could have a range of tones from absolute black to absolute white, with an almost infinite gradation of values in-between. Adams reduced this unmanageable number to only 11 specific tones numbered in Roman numerals. This provided for a progression of 10 steps from the darkest tone (0) to the lightest (X). See **Figure 4-29.**

Adams distinguished between the term *zone,* used to describe exposure, and the term *value,* used to describe the result of that exposure as seen on the negative and print. The zones are equivalent to f-stops, and have the same halving and doubling relationship — moving from a given zone to the next lighter one on the scale (VI to VII, for example) represents twice as much exposure, while moving to the next darker zone (VI to V, for instance) represents cutting the exposure in half.

Figure 4-28. *Different visualizations. A—A scene that the photographer chose to render "as seen," or a literal representation of what was viewed through the camera's viewfinder. B—The same scene, visualized by the photographer as a much more dramatic, higher-contrast photograph. To achieve these results, both exposure and darkroom techniques were adjusted.*

Three of these zones have particular importance: Zone V represents the middle of the exposure scale, equivalent to the gray card with its 18% reflectance; Zone III is an exposure that yields a dark (shadow) print

| 0 | I | II | III | IV | V | VI | VII | VIII | IX | X |

Figure 4-29. *The Zone System provides ten steps (0 to I, I to II, etc.) of gradation from black to white. Zone V is "middle gray," representing 18% reflectance.*

value with texture and detail just visible, and Zone VIII is an exposure that yields a light (highlight) print value in which texture and detail is just visible.

Unless you are photographing a gray card or similar monochrome object, any subject that you photograph presents a variety of *luminances* (percentages of reflected light) or tones. Parts of the scene are of low luminance, reflecting only a small percentage of the light falling upon them and thus appearing dark in color. At the opposite extreme are high luminance areas, reflecting a large percentage of the light. Between the two extremes are a variety of luminances. In other words, the scene is made up of shadows (low-luminance areas), highlights (high-luminance areas) and middle tones (luminances between the extremes). As shown in **Figure 4-30**, these luminances in the subject are reproduced in a photographic print as values correlated with the exposure zones.

An average sunlit outdoor scene typically produces a range of luminances equivalent to nine stops, or Zones I to IX on the scale. This is known as the *dynamic range* or *subject brightness range (SBR)* of the scene. Some scenes may have a wider SBR, from Zone 0 to X and actually beyond, but most will have a narrower range of three to seven stops. That range of stops may be located anywhere on the scale. A predominately dark-toned subject with a three-stop range might have values equivalent to Zones II, III, and IV. A light subject with the same range of three stops could have values equivalent to Zones VII, VIII, and IX. A subject made up of middle tones with a range of three stops might have values that are equal to Zones IV, V, and VI.

Placing an exposure value

The metered values may be shifted up or down the scale to provide an exposure that matches the photographer's visualization of the scene. A significant shadow area in a scene may be selected, for example, and a meter reading taken. The reading will

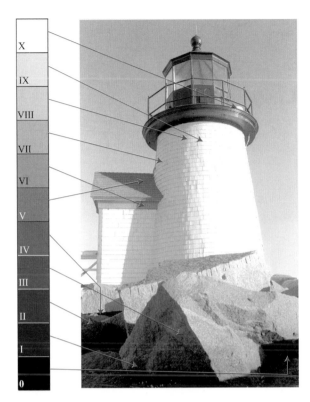

Figure 4-30. *Values corresponding to the exposure zones can be identified in a photographic print. Each value represents the luminance of a specific area of the subject.*

indicate the exposure required to yield a middle gray (18% reflectance) or Zone V value for that area. If the photographer visualizes that shadow area as dark enough so that texture and detail will be just visible in the resulting print (Zone III), the exposure can be adjusted to record that shadow area with the desired value. By giving the scene two stops less exposure, the shadow area will be exposed at Zone III instead of Zone V.

This is called "placing a value"—the shadow has been *placed on Zone III* by the photographer as a result of selecting the desired exposure. Other values in the scene will *fall* on the remaining Zones within the subject brightness range, *in relation to the Zone III placement*. Thus, a light area of the scene that originally would have been a highlight (Zone VII) will now fall on Zone V, and thus be a middle tone. A shadow area that would have been Zone III (shadow

with some visible detail) becomes Zone I (featureless black). **Figure 4-31** illustrates this.

Whether a shadow or a highlight is chosen as the value to be placed may depend upon the subject matter, but in most situations, it is determined by the type of film you are using. With negative film (black-and-white or color), the shadow values are controlled by exposure and the highlight values by development (or printing controls). Thus, the value selected for placement will most often be a shadow. With positive (transparency/slide) film, the relationship is reversed: exposure controls the highlights, while development controls the shadows. When shooting positive film, the value selected for placement would normally be a highlight.

Using a simplified Zone System exposure method

The strict application of the Zone System to fully control the photographic process, as described by Adams and later practitioners such as Fred Picker and Phil Davis, is a complex and time-consuming endeavor. It involves testing and calibration to precisely tune the process to the individual photographer's equipment, materials, and working methods. The results, as seen from work produced by dedicated Zone System practitioners, are clearly worth the effort.

If you are interested in the detailed methods used for film and paper testing and other aspects of the Zone System, a number

Figure 4-31. *When a value in a scene is placed on a specific Zone, all the remaining Zones shift along with the value that has been placed.*

of excellent books are available. The starting point for many photographers is Ansel Adams' three-volume set consisting of *The Camera, The Negative,* and *The Print*.

Many beginning and intermediate photographers have seen improvement in their work by applying a simplified form of the Zone System that concentrates on better control of exposure. Earlier, a method of taking highlight and shadow readings to obtain average exposure was described. A similar method is used for the simplified Zone System. It is most applicable to black-and-white photography, but can also be used to some benefit with color print film. It consists of basically three steps:

- Metering significant shadow and high-light areas of the scene.

- Adjusting the selected shadow reading to place it on desired Zone.

- Determining processing and/or paper grade adjustment for best rendition of highlights.

Metering shadows and highlights. To identify the subject brightness range of the scene, first meter the darkest shadow area in which you want to retain some detail and texture in the final print. Note the reading. Next, meter the lightest highlight in which you want to retain detail and texture in your print. Note that reading. Both readings should be for the same shutter speed, such as 1/60 second or 1/125 second. If necessary, determine an equivalent exposure for one of the readings, as described earlier.

By counting the number of stops between the shadow reading and the high-light reading, the SBR of the scene can be determined. For example, if the shadow reading was f/4 at 1/60 and the highlight reading was f/22 at 1/60, you would have a 5-stop range of brightness in the photo ($4 \rightarrow 5.6 \rightarrow 8 \rightarrow 11 \rightarrow 16 \rightarrow 22$). If you exposed this scene at the shadow reading (f/4 at 1/60), the resulting photograph would have middle-gray shadows and featureless "burned out" white highlights

(Zones V through X). On the other hand, if you exposed at the highlight reading (f/22 at 1/60), your photo would range from a middle-gray highlight down to featureless black shadows.

Placing a Zone value. To achieve a photograph in which the significant shadow area shows just a trace of detail and texture, that area should be placed on Zone III. Since your meter reading of f/4 at 1/60 would result in a Zone V value for the shadow, it is necessary to reduce exposure by two stops (and thus two Zones). An exposure of f/8 at 1/60 would place the shadow area on Zone III. If you visualized a less dense and more detailed shadow area, the shadow could be placed on Zone IV by reducing exposure by only *one* stop to f/5.6 at 1/60.

Assuming that you did place the shadow on Zone III, all other values would be two Zones lower. This means that your highlight value would then fall on Zone VIII, exactly where it needs to be so that it will show slight texture and detail. An exposure of f/8 at 1/60 thus would result in a photo exposed properly to print on normal contrast paper.

Adjusting for highlights. When the subject brightness range is greater than seven stops, you usually can salvage what would otherwise be blank, white, "blocked up" highlights by adjusting film development to reduce contrast. If all the frames on a roll were taken under the same high-contrast (wide SBR) conditions, reducing the development time will make the highlight values (dark areas on the negative) less dense than they would be with normal-length development. This prevents the highlights from "blocking up" or becoming so dense that no light will come through when making a print. The reduction in development times for a given situation usually must be established by trial and error, but may be as great as 30%.

When printing a negative with a wide contrast range, highlights often can be improved by using a "softer" (lower contrast) paper grade or lower-number variable con-

trast filter. Reducing the paper contrast grade or filter from the "normal" #2 to #1, for example, will result in increased exposure for the highlight areas without appreciably affecting the shadow areas. This subject will be covered in greater detail in Chapter 9.

Questions for review

Please answer the following questions on a separate piece of paper. Do not write your answers in this book.

1. By what three means do artificial light sources produce radiant energy?

2. The unit of length commonly used to measure the wavelength of light is the _____.

 a. manometer
 b. kilometer
 c. barometer
 d. nanometer

For Questions 3–7, match each of the wavelengths with the correct name on the right.

3. shorter than 400nm
4. 400nm–500nm
5. 500nm–600nm
6. 600nm–700nm
7. longer than 700nm

 a. green light
 b. infrared radiation
 c. ultraviolet radiation
 d. red light
 e. blue light

8. What does the term *panchromatic* mean when used to describe a black-and-white film?

9. Briefly explain why we perceive an object as a particular color (for example, blue).

10. The major use of the _____ filter is to differentiate between colors when they are rendered as gray tones on black-and-white film.

11. Which of the filters below would bring out (emphasize) clouds most strongly when using black-and-white film?

 a. #6 light yellow
 b. #8 yellow
 c. #15 deep yellow
 d. #25 red

12. How does a neutral density filter make it possible to eliminate all the cars from a photograph of a busy street?

13. Autofocus cameras require the use of _____ polarizing filters for proper operation of the focusing system.

14. The amount of additional exposure that must be calculated when using most filters on a large-format camera is called the _____.

15. What is the "sunny 16" rule?

16. Briefly explain how a selenium cell meter works. How is this different from the way a cadmium sulfide cell meter works?

17. Averaged reflective light meter readings produce an exposure value for _____.

18. To avoid silhouetting a backlighted subject, _____ the meter's exposure recommendation by 1 1/2 stops.

19. In the Zone System, there are three Zones with particular significance. List and describe them.

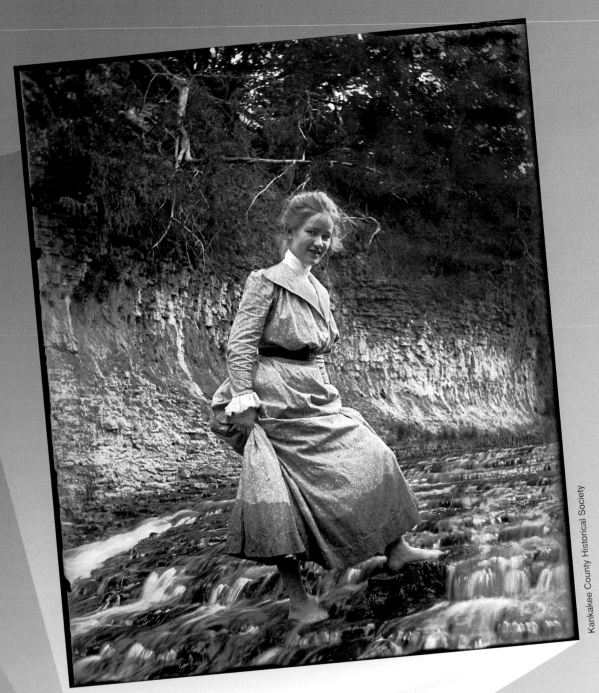

Dry plate:
Glass plate, coated with gelatin-based photosensitive emulsion, that could be prepared and stored for months before being exposed and developed.

Chapter 5

Film

When you have finished reading this chapter, you will be able to:

➡ Distinguish between the physical structures of black-and-white film and color film.

➡ Explain the method by which a latent image is formed.

➡ Describe the film speed rating system as a measure of sensitivity to light.

➡ List the various types and forms of film.

➡ Demonstrate the loading procedures for common types of cameras.

Imagine being one of Matthew Brady's photographers during the 1860s in the American Civil War. Before you could make an exposure, you would have to go through a lengthy process of preparing your "film" to accept an image.

The "film" was a sheet of glass onto which you flowed a coating of *collodion* (cellulose nitrate dissolved in ether and alcohol) containing a dissolved halogen salt such as potassium iodide. Once the collodion coating became tacky as a result of the ether and alcohol evaporating, it had to be *sensitized*. This was done by dipping the plate for a minute or two in a silver nitrate solution. The sensitizing step, performed in total darkness, converted the halogen salt in the coating into a light-sensitive *silver halide salt*. The sensitized plate was next placed in a light-tight holder for insertion in the camera.

Since the coating on the plate remained light-sensitive only while wet, the exposure had to be made in a matter of minutes. If allowed to dry, the coating would not accept an image. Processing of the exposed plate was done immediately, using a solution of ferrous sulfate as developer, and potassium cyanide, sodium cyanide, or sodium thiosulfate as a fixing agent to make the image permanent.

Obviously, such a lengthy preparation process, coupled with the relatively long exposure times required, meant that capturing action was not an option. Photographs showed the aftermath of battle, **Figure 5-1,** rather than the battle raging. Despite the limitations of the process, photographers using the wet-plate collodion process created a large body of memorable and historically valuable photographs.

Photography became less cumbersome with the introduction of the dry emulsion silver bromide plate in the 1870s. In addition to eliminating the time and bother needed to prepare the wet collodion plate, dry plate photography did away with the need for immediate exposure. So long as they were protected from the light, dry plates could be exposed literally months after they were manufactured. Although prompt processing was recommended, developing did not have to be performed within minutes of making the exposure, as was the case with wet plates.

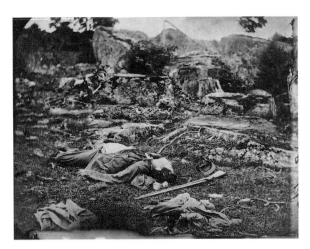

Figure 5-1. *Long plate preparation times and lengthy exposures meant that photos made with the wet-plate collodion process would involve static subjects. Civil War photographs, for example, typically showed preparations for battle or the aftermath, rather than the battle itself. This photo was taken by Alexander Gardner after the Battle of Gettysburg in July, 1863. (Courtesy of the Library of Congress)*

The dry plate increased the popularity of photography, but truly widespread acceptance as a hobby did not occur until 1888, when George Eastman began selling a camera that used film in roll form. Roll film had actually been introduced to the marketplace four years earlier, in 1884. Roll film was first sold with adapters to allow use with different types of plate cameras. But the key to making photography a truly popular pastime was *ease of use* — packaging a 100-exposure roll of film in a simple "point-and-shoot" box. The slogan that Eastman created for his Eastman Kodak Company, *"You press the button, we do the rest,"* said it all.

The physical structure of film

While glass plates and early roll films consisted simply of a layer of emulsion on a support material or **base,** modern film structure is much more complex. Black-and-white film typically consists of five layers of material; color film can have nine or more.

The base material used to support the emulsion has evolved through the years from metal, paper, and glass to modern plastics. Early photographs made by the daguerreotype and tintype methods involved light-sensitive materials applied to metal bases. Henry Fox Talbot, the inventor of the photographic negative, used paper as a base. Glass was used to support the light-sensitive layer in the ambrotype, wet collodion, and dry emulsion forms.

For roll film, a flexible base material was needed. Eastman's first roll film used paper as a base. After processing, the emulsion layer was stripped off the paper and bonded to a layer of clear gelatin. In 1889, Eastman began producing roll film with the emulsion applied to a base of cellulose nitrate (dried collodion) material. Cellulose nitrate was flexible and quite durable, but had one drawback: it was highly flammable. This problem was overcome by the introduction of a base made from cellulose acetate, which began to be used in the 1920s. Since it was not flammable, cellulose acetate was promoted as "safety film." The term can be seen in the edge marking of older film negatives, **Figure 5-2.**

The progression from cellulose nitrate to cellulose acetate was also made in sheet films, although glass plates continued to be used for specialized applications well into

Figure 5-2. *Cellulose acetate "safety film" was first produced in the 1920s, but did not begin replacing significant amounts of flammable cellulose nitrate film until the 1950s. (Courtesy of Alan Wendt)*

the twentieth century. In the graphic arts and other fields where dimensional stability was important, polyester base films replaced acetate base materials. A polyester base is used for some generally available sheet films, and also was chosen for the new Advanced Photo System (APS) films. Acetate, however, is still the most popular base material for motion picture and still photography films.

Black-and-white film

While the base provides support, the critical layer in any film is the *emulsion*, a thin coat of clear gelatin in which silver halide crystals are suspended. Although they are much smaller and more numerous, the silver halide crystals could be visualized as the seeds in a slice of poppyseed cake. Just as the seeds are separated and held in place by the cake, the crystals are supported by the gelatin. Over the years, film emulsions have been applied in thinner and thinner layers to reduce film curling and other problems. The thinning of the emulsion layer has been achieved primarily by reducing the ratio of gelatin to silver halide crystals.

As shown in **Figure 5-3,** a typical black-and-white film has three additional layers, one on the bottom side of the base material, one between the base and emulsion, and one on top of the emulsion. The layer between base and emulsion is called the *subbing layer.* It is very thin and is usually composed of pure gelatin without silver halide crystals. In effect, the subbing layer is a "glue" that helps bond the emulsion to the base.

The layer on the bottom of the film is designed to balance the curling tendency of the emulsion, so the film stays relatively flat. This layer also serves as an *antihalation layer,* absorbing light rays that have passed through the base. This prevents the light rays from being reflected back through the base and emulsion to form halos (halation) around bright objects in the photograph.

The topmost layer, referred to as the *surface coating* or *supercoat,* is very thin but has a number of functions. Its primary purpose is to protect the emulsion from abrasion during exposure and processing. This layer may contain a number of additives, such as hardeners, antistatic agents, preservatives, and antifogging chemicals. To improve processing, a wetting agent, or *surfactant,* may be incorporated in the coating. The surfactant promotes more even absorption of processing chemicals to help ensure even development.

Color film

As many as nine layers may be present in a subtractive color film, often referred to as an *integral tri-pack film.* In color film, **Figure 5-4,** there are three separate emulsion layers (the "tri-pack"). One is sensitive to blue light, the second to red light, and the third to green light. A layer of yellow material separates the blue-sensitive and green-sensitive

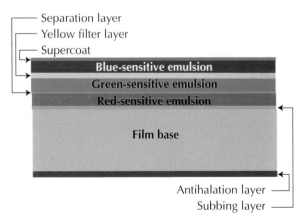

Figure 5-4. *Color film is more complex than black-and-white film and has more layers.*

Figure 5-3. *Black-and-white film typically consists of five layers, as shown.*

layers. This thin layer is used to "trap" any blue light that has not been absorbed by the blue-sensitive emulsion. Sometimes, another thin layer of material separates the green-sensitive and red-sensitive emulsion layers. Depending upon the design of the film, this layer may improve image quality, or may merely be a physical separator between the two emulsion layers.

An antihalation layer may be located on the bottom side of the film base (as in black-and-white film), or it may be positioned between the subbing layer and the adjoining (red-sensitive) emulsion layer. In some film designs, antihalation material might be used in both locations.

How light affects film

As described in the preceding section, the film emulsion can be visualized as similar to a slice of poppyseed cake, with the "poppyseeds" (the light-sensitive silver halide crystals) dispersed in a "cake batter" layer (the gelatin carrier). The shape and size of the silver halide crystals, and how densely they are packed in the gelatin layer, all play a role in how the crystals are affected by light.

The halides used in photography include chlorine, bromine, and iodine. While silver chloride and silver iodide are typically present in small amounts in an emulsion, silver bromide is by far the largest halide present. For that reason, the following discussion will use silver bromide as the example. Crystals of silver bromide consist of pairs of silver and bromine atoms arranged in a lattice form, as shown in **Figure 5-5.** The silver and bromine atoms are in a form called *ions*, which means that they carry an electrical charge. Each silver ion has one less orbiting electron than the number of protons in its nucleus, and thus has a positive electrical charge. Each bromine atom has an *extra* electron, so it carries a negative charge. The opposing charges hold, or *bond*, the pairs of ions together. In addition to the

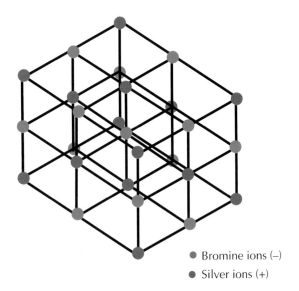

● Bromine ions (–)
● Silver ions (+)

Figure 5-5. *Silver and bromine ions have opposite electrical charges, which hold them together in pairs on the lattice of the silver bromide crystal. Free silver ions and impurities called "sensitivity specks" are scattered through the crystal.*

paired ions forming the lattice, a silver bromide crystal typically contains a number of free silver ions (atoms not paired with bromine atoms). It also contains impurities referred to as *sensitivity specks*. These specks are believed to play the important role of focal points, or sites, for the formation of the silver clumps making up the latent (undeveloped) photographic image.

Creation of a latent image

When a particle of light (*photon*) strikes one of the bromine ions in the silver bromide crystal, it increases the energy level of the "extra" electron in the ion. This allows the electron to break free. With the loss of one electron, the bromine atom becomes electrically neutral. This in turn creates a free silver ion, since there is no longer the positive-negative attraction holding the pair together. The sensitivity specks serve as gathering points for negatively charged electrons that have broken free of the bromine ions. The negatively-charged electrons gathered on the specks attract the positively-charged free silver ions. See **Figure 5-6.** As more light

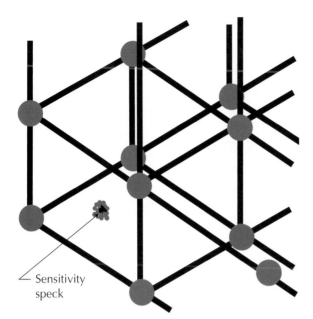

Sensitivity
speck

Figure 5-6. *A latent image is formed by free silver ions gathering as clumps of silver around sensitivity specks. The ions are freed from their chemical bonds by the action of photons (light particles) striking the crystal. The energy imparted by the photon of light allows an electron to break free of a bromine ion, changing the ion's electrical charge from negative to neutral. Without the negative charge to hold the silver-bromine pair together, the positively charged silver ion is free to move around within the crystal. Free electrons (negatively charged) that have gathered around the sensitivity speck attract the free silver ions (positively charged) to form clumps of silver.*

strikes the crystal, more electrons and silver ions are freed from the lattice to form "clumps" of silver metal on the sensitivity specks. These clumps constitute the **latent image** — an image that will not become visible until developing chemicals are used to bring it out and make it permanent.

Density is proportional to light

The **density** (the darkness, or light-blocking ability, of the developed image) that is created on the film in any given area is proportional to the amount of light striking that area. For example, a deeply

shadowed area of the subject will reflect only a small amount of light. When this tiny amount of light strikes a particular area of the film, the latent image in that area will consist of clumps of silver metal that are small and relatively far apart. In the developed negative, that area of the film will exhibit *very low density* — it will be clear or very nearly so. The reverse is true of an area that has received a large amount of light from a bright (highlight) part of the subject. When the film is developed, that part of the negative will exhibit *very high density* — it will appear black and opaque. Between these two extremes, the negative will have varying densities, exhibited as different shades of gray. These densities will be in proportion to the amount of light that has been reflected from the corresponding areas of the subject. See **Figure 5-7.**

When the negative is printed, the values are *reversed* to reflect the actual scene. The low-density (clear) areas of the negative allow light to pass through freely, resulting in a deep black shadow area on the print. The densest areas of the negative will allow little or no light to pass, resulting in a light-colored highlight area in the print. Depending upon the amount of density in the negative, highlight areas may show some detail and/or texture, or may be "blocked," showing on the print as a featureless white that is identical to the paper base.

The characteristic curve

Although the concept of density increasing as the amount of light increases is true in the general sense, the buildup of density is not strictly proportional to the amount of light, or *exposure*. If the two were strictly proportional, the relationship could be shown with a graph that would appear like the one in **Figure 5-8.** On that graph, movement from left to right is a diagonal straight line — each increase in exposure generates a corresponding increase in density.

In the real world of photography, however, exposure and density are not so neatly

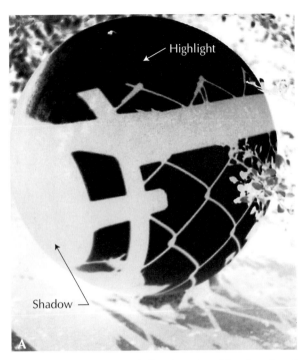

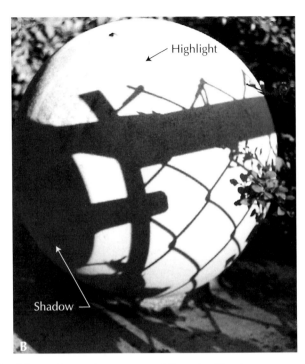

Figure 5-7. *Light and density. A—The density that builds up in various areas of the negative is proportional to the amount of reflected light striking those areas. A small amount of light will form little silver, resulting in a virtually clear section of the negative, while a large amount of light will create a black area of high density. Other degrees of density will form in proportion to the light striking the film. B—The positive, or print, will have areas ranging from black to white, as a result of the varying densities in the developed negative. Low-density areas of the negative will allow a large amount of light to pass, resulting in a dense black shadow area in the print. Very dense areas of the negative will permit little or no light to pass, resulting in a white highlight area in the print.*

Figure 5-8. *If the relationship between exposure increase and density increase was perfectly reciprocal, a straight-line graph like this could be plotted. In such a situation, each increase in exposure would cause an exactly equal increase in density.*

paired. The relationship between exposure and density increase is typically plotted in the S-shape shown in **Figure 5-9.** This is called a *characteristic curve,* and serves as a "snapshot" of a given film's reaction to light. While the general shape of the curve remains the same, its details will differ for each film.

The characteristic curve is formed by plotting density increase (on the vertical axis) against exposure increase (on the horizontal axis). The curve is traditionally divided into four major sections: film base plus fog, toe, straight line, and shoulder.

The first section, *film base plus fog,* is short and horizontal. It represents the minimal amount of density resulting from the base material of the film plus a very small density increase caused by action of the

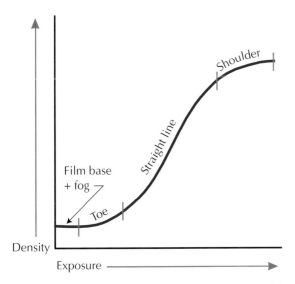

Figure 5-9. *The characteristic curve is a graphic representation of the relationship between exposure and density increase for a specific film. Density is plotted on the vertical axis, exposure on the horizontal axis.*

developer. Typically, this is the density of the clear areas between frames on roll film.

Density begins to increase fairly quickly in the *toe* section of the curve. The sharply curved line indicates that density is increasing at a faster rate than exposure — each exposure increase results in a proportionately greater density increase. The toe is the low-density, or *shadow,* portion of the curve.

In the **straight-line section,** or *middle-density section,* of the characteristic curve, the density/exposure relationship is most nearly proportional. In other words, each increase in exposure will cause a corresponding and approximately equal increase in density. If one step on the exposure scale is a doubling of the amount of light, the density will also double. The steep slope of the typical straight-line portion of the curve also shows that the contrast, or separation, of tones is greatest in this area: the steeper the slope, the higher the film's contrast.

At the right end, or **shoulder,** portion of the curve, exposure changes make progressively less difference in density. This is the high-density portion of the curve, representing the *highlights* of a scene.

Film sensitivity

The way in which a film emulsion reacts to light is described as its *sensitivity.* Actually, the term can be used to describe two different qualities: **color sensitivity** and **light sensitivity.**

For black-and-white films today, *color* sensitivity is not the issue it once was. All of the emulsions in general photographic use are **panchromatic,** which means that they are (more or less) equally sensitive to all the colors of light. See **Figure 5-10.** The earliest emulsions were extremely blue-sensitive, which caused them to overexpose sky areas to a blank white expanse. This can be seen in some of the great scenic photos of the American West, taken by O'Sullivan and others, in the years immediately after the Civil War. This problem was overcome in the 1870s with the addition of a dye to make the emulsion more sensitive to green light, resulting in **orthochromatic** film. The word *orthochromatic,* which can be loosely translated as "correct color," indicated that photographs taken with this film would reproduce tonal values of scenes more like those seen by the human eye. (Human vision is most sensitive to greens and yellows.)

More recently, other dyes were added to emulsions to make them sensitive to red light, which neither blue-sensitive nor orthochromatic films reproduced. This

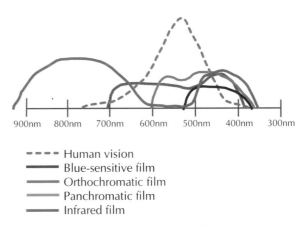

Figure 5-10. *Color sensitivity of human vision compared to different black-and-white film types.*

resulted in today's panchromatic emulsions. Even though panchromatic films are sensitive to virtually all colors, they remain somewhat oversensitive to *blue* wavelengths. For this reason, a yellow filter is often placed over the lens when shooting scenes with large areas of sky. The yellow filter absorbs some of the blue light, slightly darkening the sky and making clouds stand out more.

Infrared films are sensitized with dyes to reproduce light beyond the red end of the spectrum. Since these emulsions are also extremely sensitive to blue light, the camera must be loaded and unloaded in total darkness. To minimize the effect of blue and ultraviolet light, photographers normally use a deep red (#25) filter on the camera lens when shooting infrared film. The red filter absorbs blue and ultraviolet wavelengths. See **Figure 5-11.**

Film speed ratings: a measurement of sensitivity

The concept of "speed" is often confusing to beginning photographers, since it is used in at least three different contexts, *all* relating to exposure. *Shutter speed*, of course, is fairly obvious: the amount of time the shutter is open to admit light can be relatively fast (1/2000 second) or slow (1/2 second). *Lens speed* is sometimes mystifying because the smaller the number (2.8 vs. 5.6, for example), the larger the maximum aperture and thus, the faster the lens.

Film speed is a measure of sensitivity to light — the higher the number, the less light is needed to create a latent image on the emulsion. Thus a "100-speed" film is much less sensitive to light than a "3200-speed" film. The speed rating for each specific type of film is determined by its manufacturer,

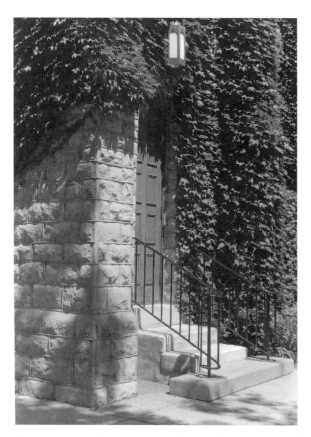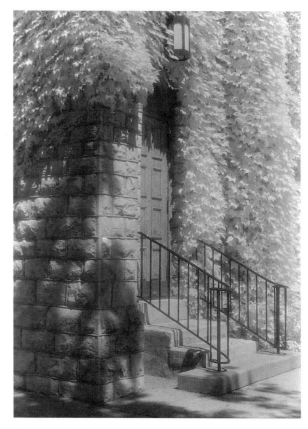

Figure 5-11. *Compare the photo at left, taken with panchromatic film, with the one at right, showing the same scene taken on infrared film. Note the way each film "sees" the different elements of the scene.*

Figure 5-12. *The ISO rating of film speed includes both the arithmetic value used in North America and the logarithmic value used in Europe. In this case, the film is rated as ISO 100/21°; 100 is the arithmetic (ASA) value; 21° is the logarithmic (DIN) rating.*

based on a standard set of requirements published by the ***International Standards Organization (ISO)***. This ensures that 100-speed film produced by different manufacturers in different countries will have essentially the same sensitivity. The published speed is considered a recommendation or "starting point," since the film is most likely to be used under conditions different from those used in the ISO standards. Standard testing requirements govern the type of light, exposure time, developer, developing time, and several other factors. Under other conditions, film is likely to have a higher or lower sensitivity than its rating. Many photographers test the film types they use regularly to establish a personal *exposure index*, or speed rating, that matches their equipment and type of photography. For example, one photographer may find that a 100-speed film gives him or her the best results when exposed as if it were rated at a speed of 50; another might rate it at 200.

A film's official speed rating is properly referred to by preceding the number with ISO (ISO 100, ISO 400) to indicate that it was established using the International Standards Organization requirements. You may hear

(especially from older photographers) a film's speed referred to as its "ASA rating." This is a reference to the *American Standards Association*, whose standard was previously used for film manufactured or used in North America. In practical terms, ASA 100 and ISO 100 ratings are identical.

Technically, the full ISO identifier on a film has two parts, as shown in **Figure 5-12**. The identifier consists of the arithmetical rating previously used by the ASA and a logarithmic rating based on the German DIN system that was used in Europe. Thus, the full ISO identifier for a 100-speed film is ISO 100/21°.

Sensitivity doubles/halves with each ISO step

Although the standard ISO film speeds are calculated in increments of 1/3 stop, **Figure 5-13,** the film speeds that are commonly available represent differences of one stop in exposure. Each of the popular film speeds — 100, 200, 400, 800 — represents a sensitivity to light that is double that of the next-lower speed, and half the sensitivity of the next higher speed.

As you will remember, this is the same doubling/halving relationship found in lens apertures (f/5.6, f/8, f/11, f/16) and in shutter speeds (1/15, 1/30, 1/60, 1/125). Thus, changing from an ISO 100 film to an ISO 200

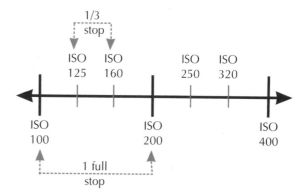

Figure 5-13. *Standard ISO film speeds are calculated in 1/3 stop increments. The films in general use—100, 200, 400, 800—are one stop apart in sensitivity.*

film has the same effect upon exposure as opening up one stop (f/16 to f/11) or using the next-slower shutter speed (1/125 to 1/60). In the case of both aperture and shutter speed, the effect is to double the *amount* of light falling on the film. When film speed is doubled, however, the amount of light remains the same, but the silver halide emulsion is *twice as sensitive* to it.

Interrelationship of film speed/aperture/shutter speed

For the photographer, the various relationships of film speed, aperture, and shutter speed provide the tools needed to successfully capture images under a wide variety of conditions. An example might be photographing a track and field meet on a fairly dark and cloudy day. The photographer meters the situation and finds that with her standard ISO 100 film and her lens at its widest aperture (f/4), the fastest shutter speed possible is 1/60 second. To stop the motion of high-hurdlers under the dim lighting conditions, however, the photographer needs a shutter speed of 1/250 second. A lens that is two stops faster (f/2) would allow the desired shutter speed, but she doesn't have such a lens available. What she *does* have in her camera bag is a selection of films in different speeds. By loading ISO 400 film into her camera, she can gain the equivalent of two stops exposure, or in this case, two steps in shutter speed.

If a faster film is not available, the same benefits can be realized by rating the film at the higher speed (i.e., 400 instead of 100), then adjusting development to compensate for the underexposure. To rate film at a higher speed, move the film speed control to the desired setting. This will trick the camera's meter, so that it provides exposure readings based on an ISO 400 film, instead of ISO 100. In processing, the development time also must be adjusted (lengthened) to treat the film as 400 instead of 100. This is called **push processing**, and the film is said in this case to be "pushed two stops" (if it

had been rated at ISO 200, it would be "pushed one stop").

The penalty for pushing film to a higher speed is increased contrast and increased grain. This is especially true when a push of two or more stops is attempted. Except in extreme cases (such as films used for low-light surveillance work that may be pushed three to four stops), the increase in grain will often not be objectionable until enlargements of 8" × 10" or larger are made from a 35mm negative. The contrast increase from over-developing can normally be compensated for by using contrast filters or paper grades in printing.

Film speed/grain relationship

Film emulsions can be categorized into four speed groups: low, medium, high, and very high. Although some authors select different points for dividing the categories, the traditional divisions have been:
- *Low:* ISO 50 or below.
- *Medium:* ISO 64 to ISO 200.
- *High:* ISO 250 to ISO 640.
- *Very high:* ISO 800 and above.

As film speed increases, so does **grain** (the clumps of metallic silver visible on the film or print). Traditionally, low speed has implied fine, virtually invisible grain, while high speed meant grain that was distinctly noticeable. The speed/grain relationship results from the traditional method of increasing film speed: making the silver grain larger. A physically larger silver grain presents more surface area to be affected by light, and thus makes the emulsion more light-sensitive. When the film is developed, these larger grains also form bigger, more-easily seen clumps of metallic silver than the finer grains of slow films.

While the speed/grain relationship remains true in the general sense, improvements in film emulsions in recent years have moved the realm of fine grain higher on the speed scale. Tabular grain technology, originally developed for color film to allow an

increase in film speed without a correspon-
ding increase in grain, has been applied to a
number of black-and-white films. *Tabular
grains* are thinner and flatter than conven-
tional silver halide grains, **Figure 5-14.** As a
result, the clumps of metallic silver formed by
these grains are smaller and less noticeable.
Tabular grain technology allows medium-
speed ISO 100 films to have a grain structure
as fine as many traditional low-speed films.
Tabular grain ISO 400 films approach tradi-
tional ISO 100 films in the amount of grain
visible in enlargements.

Film size is also a factor in the visibility
of grain — the larger the film, the smaller
the relative size of the grain. Although the
clumps of silver metal are the same physical
size on a 35mm negative, on 6cm × 6cm
negative, and on a 4″ × 5″ negative, the size
of a silver clump *relative to the film size* is far
different. This is most noticeable when the
image on the film is enlarged, since the
smaller negative must be magnified more
than a large negative for a given size print.
To obtain a common size of enlargement
(8″ × 10″), a 4″ × 5″ negative must be magni-
fied only twice its original size, while a
35mm negative (roughly 1″ × 1 1/2″ in size)
must be magnified approximately 8 times

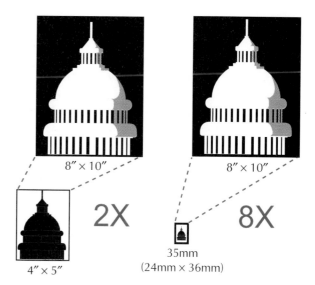

Figure 5-15. *A 4″ × 5″ negative must be enlarged
only twice actual size to make an 8″ × 10″ print,
but a 35mm negative must be magnified about
8 times for an 8″ × 10″. Grain is enlarged
proportionally.*

original size. See **Figure 5-15.** Since the
physical size of the "grain" (silver clumps)
on the two negatives is the same, it will be
magnified in the same proportion and thus
will be much more visible in the enlarge-
ment from the 35mm negative.

One specialized type of black-and-white
film produces an essentially grainless image,
regardless of film speed. *Chromogenic film* is
developed using the same C-41 process as
color negative film, but produces a black-
and-white image composed of dyes rather
than silver.

Film types, forms, and sizes

Film is available in an almost bewildering
variety of types, forms, and sizes. The rapid
growth of "filmless" digital photography,
however, will undoubtedly reduce the market
for film in coming years. Despite this, the
varied photographic applications using tradi-
tional film should ensure a broad offering of
materials for the foreseeable future.

Currently, the largest segment of the
film market is 35mm color negative, the
format and type used by millions of

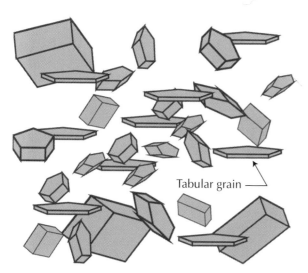

Figure 5-14. *Conventional silver halide grains are
irregular and thicker than the flat, thin shape of the
tabular grains used in newer film emulsions.*

"snapshooters" as well as by professionals and serious amateurs. The smallest segment is large format sheet film, used almost exclusively by professionals. A growing, though still relatively small, percentage of the market is the Advanced Photo System (APS) film introduced in 1996. APS was a joint development by five major film and camera manufacturers: Canon, Fuji, Kodak, Minolta, and Nikon. The APS film and cameras introduced a number of features aimed at capturing a strong share of the consumer photo market.

Film types

All film can be classified into three categories: reversal (transparency), negative/positive (print), and instant-print (Polaroid). Reversal film produces a positive image on a transparent base, while negative/positive film produces a negative, or reversed, image on a transparent base. The negative can be used to create a positive image, usually in the form of a paper-based print. Instant-print film, as the name indicates, results in a print (one related product produces both a negative and a print, another is used to make rapidly processed transparencies).

Reversal film

The transparency produced by *reversal film* is an original, or "first generation," image, **Figure 5-16.** If correctly developed, a transparency shows precisely the exposure selected by the photographer or automated camera system. This makes it valuable for assessing technique and/or equipment — overexposure or underexposure by as little as one-third stop can be detected, especially in a bracketed series of exposures. Reversal films are available in both color and black-and-white, with color film accounting for the vast majority of sales.

In development, a black-and-white reversal film first goes thorough the same negative-forming process as a negative/positive film. A bleach step is then performed to dissolve and remove all of the

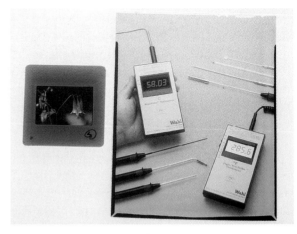

Figure 5-16. *Reversal film provides a positive transparent image, or transparency. The transparency is an original, or "first generation," image. While 35mm reversal film images are technically transparencies, they are commonly referred to as "slides."*

metallic silver image formed in the negative stage. Next, the remaining (previously unexposed) silver halides are exposed by means of a chemical fogging agent, and a second development takes place. This results in the reversed or positive final image. Fixing and washing complete the process.

Color reversal film follows a similar development sequence. The first developer forms a negative silver image in each of the three (blue-, green-, and red-sensitive) film layers. A chemical fogging agent then is used to expose the remaining (previously unexposed) silver halides in the three layers. During the second development, color dyes form in the three layers, corresponding to the positive images. A bleaching agent then is used to remove both the negative and positive silver images, leaving only the dyes that form the final positive image. The process is carried to completion by fixing and washing the film.

Until recent years, transparencies — from 35mm to 8″ × 10″ — were strongly preferred for reproduction in magazines, books, and other printed matter. Since they are original, or "first generation" materials, editors and art directors felt that they

produced the best-quality reproduction. The increasing use of electronic scanners and the availability of image manipulation software to adjust color and repair defects has opened the door to wider use of film negatives and prints for reproduction.

Negative/positive films

When most people think of photographic film, they envision a film that yields snapshots or positive prints that can be readily viewed and shared with others. The overwhelming majority of film manufactured and used worldwide is "print," or more properly, *negative/positive film.* These films produce a negative original that is then used to make a positive print. In a negative, the dark and light values of the original scene are reversed — light tones in the scene record as dark areas on the negative and vice versa. When a print is made from the negative, tones are reversed again, back to the relationship they had in the original scene. See **Figure 5-17.**

Negative/positive films are popular for a number of reasons:

- Virtually universal availability.
- Wide range of film speeds in most formats.
- "Forgiving" exposure latitude, especially in color films.
- Rapid and easily accessible processing.
- Ease of handling and displaying prints.
- Fast, simple, and relatively low-cost production of multiple copies.

At the consumer level, the entire system — from camera design to processing methods and equipment — is optimized for the use of negative/positive color film. Professionals also use negative/positive color film extensively, especially when the final product is a portrait or other type of display item. Photojournalism, especially at the newspaper level, still makes considerable use of negative/positive film (in both color and black-and-white forms), but that use is declining in favor of images created with digital equipment.

Color negatives. Like color reversal film, color negative film has three light-sensitive layers. Production of the final image is simpler, however, since the reversal step to produce a positive image is not needed. Color negatives are hard to "read" directly to make judgments on exposure and color quality, since they display subtractive primary colors (cyan, magenta, yellow) and have an overall orange dye mask that is used to properly balance colors in printing. See **Figure 5-18.**

When a print is made from a color negative, the cyan, magenta, and yellow dyes *subtract* their complementary colors

Figure 5-17. *In the negative/positive process, the original ("first-generation image") is a negative, which is then used to produce a print ("second-generation image").*

Figure 5-18. *Color negative film, after development, has an overall orange tint resulting from a mask that improves color balance during printing. The colors in the negative are cyan, magenta, and yellow, known as the "subtractive" primary colors.*

(red, green, and blue) from the white light produced by the enlarger or other light source. As shown in **Figure 5-19,** this means that the cyan areas of the negative will block the red wavelengths of light, but allow the blue and green wavelengths to pass through. The magenta areas of the negative will pass red and blue light, but block the green wavelengths, and yellow areas will block blue but pass red and green light. Since the color print paper consists of layers sensitive to red, green, and blue light, the developed and fixed print will reproduce the colors of the original scene.

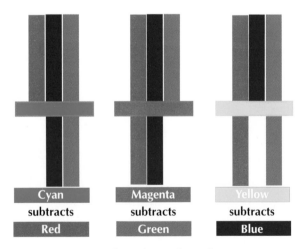

Figure 5-19. *In the subtractive color system, each of the primary colors (cyan, magenta, yellow) subtracts its complementary color (red, green, blue) from white light.*

Black-and-white negatives. Although all black-and-white negative/positive films produce a **monochrome** (single-color) image, there are several variations within the category. Most common are the silver halide films, which are developed to yield a negative image composed of metallic silver. In the developing process, the small amount of metallic silver that makes up the latent image is greatly amplified to form the visible image. This is done by the **developer,** a powerful *reducing agent* that converts exposed silver halides to metallic silver. The metallic silver particles forming the latent image serve as sites for the formation of additional molecules of metallic silver. The developer has little or no effect, however, on the silver halides in areas that have not been exposed to sufficient light to form a latent (metallic silver) image. Once the image is developed, *fixing* is necessary to dispose of these unexposed silver halides, which would otherwise darken upon exposure to light. The fixer is a powerful solvent that dissolves the unexposed silver halide particles and allows them to be washed away.

The chromogenic films, as noted in a preceding section, form a virtually grainless image using dye clouds. They are developed using the same process used for color negative films, but have only one dye-forming layer (compared to the three in color film).

A special type of negative/positive film is *high-contrast,* or **lithographic,** film. Used primarily in the graphic arts industry, this *orthochromatic* film is sensitive primarily to blue and green wavelengths of light. It provides an image without graduated tones: the film is either black or clear. See **Figure 5-20.** This allows it to be used for masking and other special photographic effects. There are a number of high-contrast film brands, but the most widely used is Kodak's *Kodalith®.* Although conventional film developers can be used with high-contrast films, the best results are obtained with special developers designed for that application.

Figure 5-20. *A high-contrast, or lithographic film, negative shows no gradation of tone. Compare it with the conventional negative that shows a full tonal range.*

Figure 5-21. *Peel-apart instant-print films use the diffusion transfer process to create a positive image.*

Instant-print films

This special category of films was introduced in 1947 by Dr. Edwin H. Land, inventor of the Polaroid® process. In its original black-and-white form, Polaroid instant-print film consisted of a sandwich of negative and positive sheet materials and a pod of developing agent. After exposure, the sandwich was pulled out of the camera between a pair of pressure rollers. The pressure broke open the pod of developer and spread it evenly between the positive and negative sheets. As development progressed, the exposed silver halides migrated from the negative to the positive sheet. After 60 seconds, the sheets were peeled apart to reveal a visible image on the positive sheet, **Figure 5-21.** The developing agent also acted as a fixer to make the image permanent (in some early versions of the process, a plasticized coating was wiped onto the print manually to neutralize any remaining chemicals and form a waterproof layer). The negative sheet was discarded.

A color version of the peel-apart instant-print film was introduced by Polaroid in 1963. Ten years later, a one-step color system was announced. This system was self-contained, with all the materials for each print in a single sealed unit. The camera ejected a color print that developed fully as the photographer watched, **Figure 5-22.**

Polaroid also markets several specialized products that meet specific photographic needs. Although most of the peel-apart films have a negative component that is discarded, the *Type 55 P/N film* produces both a positive and a usable negative. The negative must be processed for permanence, but then can be used to make conventional prints. *Polachrome* is referred to as a "rapid access" film rather than an instant film, but can produce usable color transparencies in a matter of minutes. The exposed film is fed into a special processor and completely processed within two to three minutes. In addition to color transparency material, Polaroid transparency

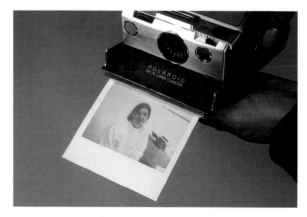

Figure 5-22. *The one-step instant-print system produces a dry, fully developed color print directly from the camera. There is no peel-apart material to dispose of, and no need to time the development.*

films are also available in black-and-white and in a version that produces a white image on a blue background (often used for text slides in audiovisual programs).

Forms of film

Film is available to today's photographer in four basic forms: sheets, paper-backed rolls, plastic or metal cassettes, and drop-in plastic cartridges. Although not readily available, coated glass plates are still made for specialized applications, such as astrophotography, that require an extremely stable base material.

Sheet film

Sheet film is on a somewhat heavier, stiffer base than roll or cassette films, since its larger area must remain flat during exposure. In the most-common sheet sizes (4″ × 5″, 5″ × 7″, and 8″ × 10″), the widest variety of film speeds and types is available. The selection becomes more restricted for smaller and larger size sheets. Packaging of sheet films is typically in boxes of 10, 25, 50, or 100, **Figure 5-23**. Several manufacturers offer packets of 4″ × 5″ film for use in special film holders. The light-tight packets, each holding one or two sheets of film, can be loaded and unloaded from the holder under daylight conditions in the field. They eliminate the inconvenience of darkroom-loading and

transporting multiple standard two-sheet film holders.

Roll film

Once available in a number of different sizes, paper-backed roll film is now sold only in the 120 and 220 sizes for use in medium format cameras. Both 120 and 220 film is 2 1/4″ in width; the difference is in the length of the strip of film material. In the 120 size, the strip of film is approximately 2 1/2 feet long; 220 is 5 feet in length. A paper backing is attached to the film for protection and economy (no film is wasted as exposed "leader"). See **Figure 5-24**.

The medium format cameras using roll film yield one of four common negative sizes: 6cm × 4.5cm, 6cm × 6cm, 6cm × 7cm, or 6cm × 9cm. A 6cm × 12cm size is produced by at least one camera. A roll of 120

6cm × 4.5cm 6cm × 7cm

6cm × 6cm 6cm × 9cm

Figure 5-24. *Roll film. A—The strip of film is attached to a paper backing for protection and economy. B—The four common negative sizes used in medium format roll-film cameras.*

Figure 5-23. *Sheet film is packaged in various quantities ranging from 10 to 100 sheets.*

film will provide 15 exposures in the 6cm × 4.5cm format, 12 exposures in the square 6cm × 6cm (often referred to as 2 1/4"× 2 1/4") format, 10 exposures in the 6cm × 7cm format, or 8 exposures in the 6cm × 9cm format. Since the 220 strip of film is double the length of the 120 size, it yields twice as many exposures in each format. This appeals to professional photographers, who prefer the convenience of fewer roll changes while shooting a wedding or sporting event.

Film in cassettes

The most popular film-packaging method is the **cassette**, a light-tight metal or plastic container holding enough film for as few as 10 or as many as 40 exposures. Typically, the film is pulled out of the cassette as it is exposed, one frame at a time, and then rewound into the cassette to protect it until it is processed. Some cameras first wind all the film onto a take-up spool, then pull it back into the cassette one frame at a time as exposures are made. The principle is the same.

Cassettes are used by two similar, but not interchangeable, film sizes: 35mm and APS (Advanced Photo System), **Figure 5-25.** The *35mm cassette,* usually made of metal, is cylindrical in shape and holds a strip of film 35mm wide by up to 5 1/2' (36-frames plus leader) in length. The film is removed from the cassette for processing, then cut into individual slides (reversal film) or short strips of several negatives for ease of storage. The empty cassette is typically discarded.

The *Advanced Photo System cassette* has the shape of a slightly flattened cylinder, and holds either 25 or 40 exposures (compared to 24 and 36 for 35mm). APS film is slightly narrower than 35mm film, with a frame size of 16.7mm × 30.2mm, compared to the 24mm × 36mm frame size of 35mm film. Exposure data and other information is electronically coded onto APS film at the time of exposure, providing useful information for processing adjustments. The system allows photos to be taken or reprinted in any of three frame proportions, from traditional 3 1/2" × 5" to a 4" × 11 1/2" panoramic. The cassette is made from fairly heavy plastic to serve as a storage container for the processed film. An *index print* showing small reproductions of each frame on the roll is produced at the time the film is processed. A major convenience feature of the APS cassette is ***drop-in loading.*** All the user has to do is open a film door, insert the cassette, and close the door. The film is automatically loaded and advanced to the first frame. It is rewound into the cassette after the final exposure. APS cassettes have an indicator on the bottom to show the status (unexposed, partly exposed, fully exposed, processed) of the film, **Figure 5-26.**

The 35mm film system is a long-established film format that has literally

Figure 5-25. *Cassettes for 35mm and APS film are similar in size, but cannot be interchanged.*

Figure 5-26. *Status of the film inside an APS cassette is shown by the indicator on the bottom of the cassette. The numbered indicators are: 1–Unexposed, 2–Partly exposed,; 3–Fully exposed., 4–Processed.*

millions of cameras capable of using it. It offers users the greatest variety of film speeds and types. APS was initially restricted to color print film in a few popular speeds. Offerings have broadened as the format gains popularity, with a black-and-white emulsion and a reversal film now on the market.

Cartridge film

Probably the smallest segment of the consumer film market, and one that is continuing to decline, is 110- and 126-size film cartridges. Introduced in 1963 for use in Kodak's new Instamatic® line of cameras, the 126-size film produces a square 26.5mm negative. A later development, in 1972, was 110-size film, with a rectangular 13mm × 17mm negative, for use in the small Pocket Instamatic cameras. See **Figure 5-27.** The major selling point of the Instamatic cameras was ease of loading and use — the plastic film cartridges were merely dropped into place and the camera was ready to "point and shoot." Cartridges for either size are available only in a few color print films and a narrow range of film speeds, and are becoming more difficult to find.

Figure 5-27. *Film cartridges for Instamatic cameras, in 126- and 110-size, are gradually disappearing from the market. The 126-size camera is no longer made, and only a few 110-size models are available.*

Loading a camera

Getting film into the camera and ready to shoot ranges in difficulty from the ease of APS and cartridge "drop-ins" to the rather complex sequence of activities involved in preparing to take a photo with large format sheet-film.

Cartridge and APS film

As noted earlier, loading cartridge film is a simple matter: open a loading door on the Instamatic camera, drop the cartridge in place (it only fits one way), close the door, and operate the manual film advance until the first frame locks into place. See **Figure 5-28A.** Advanced Photo System loading is *even easier,* as shown in **Figure 5-28B:** open the door, insert the cassette, close the

Figure 5-28. *Drop-in loading. A—Manually advancing an Instamatic cartridge to first frame. B—Once the APS camera door is closed, a built-in motor drive will advance the film.*

door, and listen to the whir of a tiny motor advancing the film.

35mm cassettes

Most newer 35mm cameras are motorized and feature essentially automatic film loading. The film cassette is inserted, and the film leader extended across the back of the shutter to the film take-up area. When the camera back is closed, the leader is captured and the film advanced by motor drive until the first frame is in position for exposure.

Traditional manual loading is only slightly more complicated. As shown in **Figure 5-29,** the leader is extended across the shutter area and inserted in the slot or other capture device of the take-up spool. The film should be positioned so that the sprocket teeth engage the perforations on the two film edges. Operating the film advance lever will pull the film taut and begin wrapping the leader around the take-up spool. Once it is clear that the film is winding properly, the camera back may be closed. Operating the film advance lever and firing the shutter several times will bring the first frame of film into proper position (as indicated by the film counter).

Some photographers, especially those who do their own film processing, find advantages in loading their own film cassettes rather than buying factory-loaded film. The major advantage is flexibility —

the photographer is not restricted to the standard 12, 24, or 36 exposures per roll. He or she can load as few or as many frames as desired (although approximately 40 is a practical upper limit because of the physical size of the cassette). Many photographers like to load a number of "short rolls" containing 5–15 frames for testing, experimenting, or use in situations where only a few exposures are needed. Another advantage can be cost, since buying film in 50- or 100-foot bulk rolls and loading reusable cassettes can significantly reduce the "per cassette" price.

Film loading does require time and some investment in equipment and supplies, however. At minimum, you will need a *film loader,* a light-tight device that holds the roll of bulk film and allows a desired number of frames of film to be wound into a cassette, and a number of reusable cassettes. You will also need tape, scissors, labels, and a pen or marker. See **Figure 5-30.**

Reusable cassettes should be discarded after being loaded three times to avoid the possibility of light leaks or scratches from foreign matter. Some people obtain emptied cassettes at no cost from one-hour film processors. The method the processor uses to unload the cassettes leaves a short stub of film extending through the light trap. Bulk film can be taped to this stub and wound into the cassette in the same way as reusable cassettes. These cassettes are discarded after

Figure 5-29. *Loading 35mm cassette film. A—The film leader is inserted in a slot or other capture device on the take-up spool. B—The film advance lever is used to begin winding leader onto the take-up spool. Sprocket teeth must engage the film perforations. C—With camera back closed, film is advanced until the counter shows the first frame is in place for exposure.*

Figure 5-30. *Loading your own film cassettes, using the tools and supplies shown, can be convenient and can reduce film costs somewhat.*

Figure 5-31. *The paper backing of the roll film is secured in the slot of the take-up spool so that it can be wound smoothly onto the spool as the film is exposed.*

a single use. The major drawback to using emptied commercial cassettes is that the tape bond sometimes doesn't hold, preventing rewinding of the film and making it necessary to unload the camera in the darkroom. Also, if your camera sets film speed by reading the DX code on the cassette, you have to load a cassette that has the proper code, or apply one of the commercially available labels with the right DX code.

Roll film

Loading paper-backed roll film is similar to manually loading a camera with a 35mm cassette. The major difference is that roll film is wound *off* one spool and *onto* another, instead of being rewound into the cassette like 35mm film.

The first step in loading most roll-film cameras (or the interchangeable magazines used by some more sophisticated models) is to remove the empty spool from the supply side and place it on the take-up side. The empty spool was left behind on the supply side when the last roll of film was wound onto the take-up spool.

A fresh roll of film is then placed on the supply side, and the small paper band closure is removed. This will allow the tongue of the paper backing to be unfolded, as shown in **Figure 5-31.** The paper is then stretched across the back of the camera and

the tongue inserted in the slot of the take-up spool. A knob attached to the take-up spool is rotated to begin winding the backing around the spool. Once it is established that the backing is winding properly, the camera back is closed. The take-up spool knob is rotated until the first frame is in position. On some cameras, this will be indicated by the knob "locking up" (operating the shutter to make an exposure will release it), or by a frame number printed on the backing paper becoming visible in a small window. After the last frame is exposed, the film is advanced until the take-up knob rotates freely, indicating the film and backing have all been wound onto the take-up spool. The camera back is opened, and a small strip of gummed paper is used to hold the roll of film and backing paper tightly around the spool until it is processed.

Sheet film

If conventional film holders are used with a large format (4″ × 5″ or larger) camera, they first must be loaded with the desired sheet film in a darkroom or changing bag. Film holders may be made of wood, metal, or plastic (often, all three in combination) and are designed to protect the film from unwanted light or dust, as well as holding

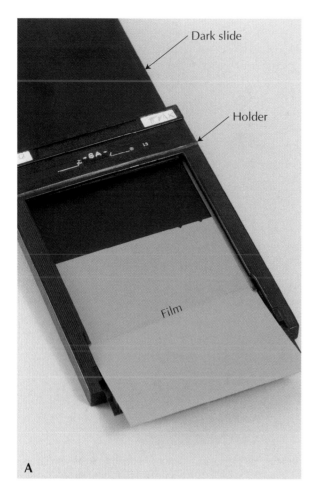

Figure 5-32. *Loading sheet film. A—The film is slipped into the holder with the emulsion facing outward. It will be covered by the dark slide until the holder is placed in the camera, ready for exposure. B—When the film's code notches are in the upper right corner, the emulsion side of the film is facing toward you.*

the film flat during exposure. As shown in **Figure 5-32,** the film sheet is slipped — emulsion outward — into channels that will hold it in place. A removable dark slide is then slid into another set of channels over the film to seal out light and dust. When loaded, a film holder will have one sheet on each side.

The camera is aligned and focused, using a ground glass focusing screen at its back end, before the film holder is inserted. A spring-loaded back plate presses the film holder firmly against the ground glass to exclude any stray light from the sides that would cause unwanted exposure. With the camera's shutter closed, the dark slide is removed from the side of the film holder nearest the front of the camera, **Figure 5-33.** This will permit light to reach the film and expose it when the shutter is opened. After the exposure is made, the dark slide is re-inserted to again cover the film. If another exposure is to be made, the film holder is removed from the camera back, rotated 180°, and reinserted. The second sheet of film is now positioned behind the ground glass, and the exposure sequence can be repeated.

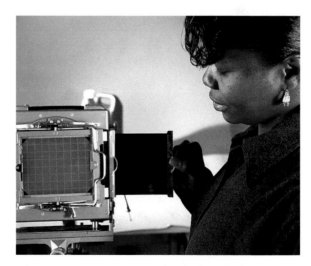

Figure 5-33. *Removing the dark slide from the film holder uncovers the film so that it can be exposed when the camera's shutter opens. After exposure, the dark slide is replaced to cover the film until it can be processed in the darkroom.*

Questions for review

Please answer the following questions on a separate piece of paper. Do not write your answers in this book.

1. Photography achieved wide acceptance when the _____ camera was introduced, providing ease of use.

2. Which of the following prevents light from being reflected back through the film base and emulsion?

 a. subbing layer

 b. emulsion

 c. antihalation layer

 d. supercoat

3. Color film may have as many as nine layers,. including _____ separate emulsion layers

4. Briefly describe the role of sensitivity specks in forming the latent image on film.

5. The _____ of any part of the image on the film is proportional to the amount of light striking that area at the time of exposure.

6. The _____ portion of the characteristic curve represents the low-density, or shadow, values.

 a. film base plus fog

 b. toe

 c. straight line

 d. shoulder

7. Since _____ films are extremely blue-sensitive, they must be loaded and unloaded in total darkness.

8. A film's rated "speed" is a measure of its _____ to light.

9. Film rated at ISO 800 is _____ times faster than a film rated at ISO 100.

 a. 2

 b. 4

 c. 6

 d. 8

10. What is the undesirable result of push-processing film two or more stops?

11. Why is grain likely to be less noticeable in enlargements made from a 4" × 5" negative than one made from a 35mm negative?

12. All film can be classified into three categories. Name them.

13. Which type of film would be the best choice to test a camera's metering system? Why?

14. Both cartridge and APS films offer the same convenience feature, _____.

15. When loading sheet film into a holder, the emulsion will be facing you when the film's code notch is in the _____ corner.

*Films with higher ISO ratings can produce acceptable photographs
even under dimly lit conditions. An ISO 800 film was used for
this hand-held shot taken inside England's Canterbury Cathedral.*

Camera angle:
Point of view (such as a high or low angle) chosen for its effect on a picture's composition and visual impact.

Chapter 6

Camera Technique

When you have finished reading this chapter, you will be able to:

➡ Describe the proper techniques for supporting different types of cameras.

➡ Explain the advantages and disadvantages of using a tripod.

➡ Select appropriate aperture/shutter speed combinations for different situations.

➡ Demonstrate the effective use of various compositional techniques.

Think about this photographic situation: you want to take a picture of a lighthouse across the bay in the fading light of early evening. Your 100-300mm zoom lens, at full extension, lets you frame up the shot nicely. You have ISO 100 film in the camera, and your meter tells you that the top shutter speed available is 1/60 second (with the lens wide open at f/5.6). Unfortunately, you didn't bring a tripod along on your stroll down to the harbor.

Given these conditions, what are your chances of obtaining a well-composed, properly exposed, sharply focused photograph? Your chances are pretty good of making two out of the three (composition and exposure), but missing on the third count (sharpness) essentially negates the other two. If a photo is well-exposed and sharp, flawed *composition* might be tolerated

to some extent, or even adjusted by cropping when making the final print. A sharp photo with good composition might have been given less-than-ideal *exposure*, but film latitude will often allow making an acceptable print. However, a photo that is blurry and out of focus — no matter how good the composition and exposure — cannot be redeemed. (You might try claiming the blur was intentional and artistic, but you probably won't convince anyone knowledgeable about photography.)

Unless you possessed Superman's nerves and muscles of steel, or just happened to be carrying a gyroscopic stabilizer, your photo of the lighthouse was doomed to fuzziness by the circumstances. No matter how steady-handed you are, it is impossible to avoid some degree of motion-induced blur when hand-holding a 300mm telephoto lens at a shutter speed of 1/60 second.

What could you have done to overcome the problem of unsharpness? Three possibilities present themselves:

• *Find a support to steady the camera.* Rest it on a wall, a post, the top of a car. Use a cable release or the camera's self-timer to further reduce possible movement.

• *Use a faster film.* This will permit a shutter speed that more closely matches the focal length of the lens. Moving from ISO 100 to ISO 400 film would allow

you to change the shutter speed by two increments (from 1/60 second to 1/250 second). An ISO 800 film would let you shoot at 1/500 second, almost certainly fast enough to eliminate "camera shake."

- *Change the film speed setting.* By "fooling" your meter into believing you are using ISO 400 film, you can use a shutter speed of 1/250 second. The film will then have to be "push-processed" (as described in Chapter 5) to compensate for two stops underexposure.

A fourth possible solution — but one of limited availability — is to use an image-stabilizing lens. Makers of these lenses claim the design will allow you to hand-hold a camera without detectable shake at two shutter speed increments less than normally recommended.

All of the items discussed so far fall into the broad category of *camera technique,* which could be defined as "using your camera and its capabilities to greatest advantage to obtain photos that are technically correct and esthetically pleasing." To put it a bit more bluntly, camera technique is "making the camera do what you want it to do."

Beginning photographers, especially those whose interests are artistic rather than commercial, are often impatient when it comes to learning technique. They fear that concentrating on technique will diminish creativity or distract them from making their desired artistic statement. To an extent, they are *right* — some photographers become so caught up in seeking technical perfection, they forget that a photo should have something to *say* in addition to saying it well. A technically perfect photograph without meaning is an exercise in futility.

That is not to say technique, in the sense of mastering your tools and materials, is not important. A photograph that is both meaningful and executed with good technique is a stronger visual experience than the same subject rendered with poor technique.

Figure 6-1. Migrant Mother, *taken by Dorothea Lange in 1936 for the U.S. Farm Security Administration, depicts the plight of migrant farm families during the depth of the Great Depression. Its strong emotional content is given greater visual impact by the use of good photographic technique.*
(Courtesy of the Library of Congress)

Consider a photo such as Dorothea Lange's *Migrant Mother,* **Figure 6-1.** If it had been overexposed so the furrows of the woman's forehead and other highlight details were burned out, would it still be a meaningful photograph? If the plane of sharp focus were further forward so the woman's arm was sharp but her face and the strands of the girl's hair were soft, would it still be a photo with great emotional impact? If the whole scene had been rendered in a flat, gray, low-contrast manner, would it still be a memorable picture? In all cases, of course, the answer would be "*yes,*" because the content — the meaningful nature of the photograph — would transcend any technical flaws. Because Dorothea Lange was an artist who had perfected her craft by

mastering its tools and materials, her technique reinforced and enhanced the meaning of her photograph.

A thorough grounding in technique has another major benefit from an artistic standpoint: it frees you to devote full attention to the creative aspects of making the photograph. Once basic technical skills have been learned and used until they become virtually automatic, you are able to concentrate on matters like composing the picture, or waiting for precisely the right expression or capturing the peak of action.

Supporting the camera

There are two kinds of blur that can be seen in photographs: those caused by *subject motion* and those caused by *camera movement*. While the first type of blurring is often acceptable for artistic reasons (such as conveying the idea of speed), blurring caused by camera motion is usually considered a defect. There are successful photos that incorporate *deliberately caused* camera motion, particularly the technique known as *panning,* but they are exceptions to the general practice.

Photographers make use of a variety of methods and devices, all aimed at properly supporting a camera and holding it motionless during the vital period when the shutter is open. That period may range from a fraction of a second to literally minutes. The camera to be supported might be a tiny point-and-shoot weighing a few ounces or a large studio view camera weighing several pounds.

Hand-holding a camera

Most instances of blur due to camera movement are the result of poor technique when hand-holding the camera. When proper methods are used, the human body can be an effective camera support, allowing photos to be taken at fairly slow shutter speeds. Effective hand-holding technique begins with using the correct grip.

The camera should be held with both hands, using a firm but relaxed grip (clenching the camera body too tightly is tiring and more likely to make your hands shake). While there are a number of minor variations, most professionals recommend holding a 35mm camera as shown in **Figure 6-2.**

Figure 6-2. *Holding a 35mm camera, using two hands and the head for support. The right hand is positioned to permit operating the shutter release with the index finger. The left hand cradles the camera's baseplate for support, leaving the fingers free to operate a manual-focus lens. A—Horizontal camera position. B—Vertical camera position.*

- Use the fingers and palm of your right hand to grip the right end of the camera, leaving the index finger free to press the shutter release. This positioning of the right hand also permits the thumb to be used to operate the manual film advance lever if the camera has one. (Camera designers apparently believe that all photographers are right-handed — controls are seldom conveniently placed for left-handed users.)

- "Cradle" the lens with the fingers of your left hand, allowing the left side of the camera's baseplate to rest on the heel of your left palm. This provides support for the weight of the camera, and allows you to use your fingers to rotate the lens barrel for manual focusing or zooming. You can also rotate the aperture ring to change lens settings when shooting manually.

Your head is also part of the camera support system. When the camera is held horizontally, as depicted in Figure 6-2A, the back should be pressed lightly against your nose and cheek as you look through the viewfinder. In the vertical position, Figure 6-2B, your forehead and nose help to hold the camera steady.

Additional steadiness can be gained by proper positioning of your arms, and by good breath control. **Figure 6-3** shows the recommended arm positions. When holding the camera horizontally, tuck your elbows in against your sides. Like your handgrip on the camera, elbow pressure should be firm but light — pressing too hard can actually cause you to shake. If you are using the vertical position, only one elbow will be tucked into your side.

When you are ready to make an exposure, take a deep breath, and then exhale about half of it. Hold your breath and press the shutter release with a light, steady movement of your index finger. Never "jab" the shutter release with a quick, sharp movement. "Jabbing" the shutter release is an almost guaranteed method of causing camera movement.

Figure 6-3. *Arm positions used to hold a 35mm camera steady. A—In the horizontal position, both elbows are pressed lightly against your side. B—When the camera is held vertically, one elbow is pressed against the body and the other is "locked" at a right angle.*

Medium format cameras of the twin-lens reflex type are usually held at waist or chest level, rather than eye level. While the method of breathing and pressing the shutter is the same as used for 35mm cameras, the grip and steadying methods differ. As shown in **Figure 6-4,** the camera is grasped at both sides and pulled downward to place tension on the neck strap. This tension helps hold the camera steady during exposure.

In addition to standing, you may be taking photos from a sitting, kneeling, or lying position. **Figure 6-5** shows methods of supporting the camera when using these positions to achieve more creative camera

Figure 6-4. *Holding a medium format twin-lens reflex camera with viewfinder used at a waist level or chest level involves pulling downward on the camera to place tension on the camera neckstrap. The shape and shutter release position on other medium format cameras may require a grip different from the one used on this twin-lens reflex.*

angles. Avoid positions that are unbalanced or cause muscle strain, since fatigued muscles can cause trembling that will be transmitted to the camera.

Shutter speeds for hand-holding

Improved steadiness will come with practice, allowing you to greatly reduce the number of photos that are ruined by camera movement. Even the steadiest and most experienced photographer is faced with physical limits to his or her ability to hand-hold the camera. The slowest practical shutter speed for most people is 1/30 second; a few can achieve acceptable results at 1/15 second.

Those speeds, however, are with 50mm or shorter lenses; as focal lengths increase, shutter speeds for hand-holding become

faster. Practical experience has shown that the *denominator* (bottom number) of the shutter speed fraction should be larger than the focal length of the lens to decrease the chance for camera movement. If you are using a 100mm lens, your shutter speed should be 1/125 second or higher. With a 300mm lens, shoot at 1/500 second or faster. (The same speed could be used with a 500mm lens, but 1/1000 second would be safer.)

The reasons for this practice are both physical and optical. The physical reason is fairly obvious: longer focal length lenses extend further from the camera and are often heavier than short lenses, making them harder to hold steady. Optically, you are dealing with a magnified image of a distant object, so any movement is exaggerated, **Figure 6-6.** To illustrate this, imagine holding a typical wooden pencil horizontally by the eraser end and trying to insert the sharpened end into a socket with a diameter that's only slightly larger than the pencil. Since the pencil is only about eight inches long, it's not too hard to hold steady and insert in the hole. Now imagine trying to do the same thing with a pencil eight *feet* long. Every tiny movement at your end would make the other end wag up and down a distance of several inches — inserting it in the socket would be very difficult.

By selecting a shutter speed to match the focal length, you are improving your chances of overcoming the effects of lens weight and exaggerated movement. The faster shutter speed is a thinner slice of time, capturing the image before movement is detectable. Even with the advantage of a faster shutter speed, however, there's still need to practice proper holding and support techniques to avoid camera movement.

Camera support devices and methods

Going beyond the body alone as a support system, there are many other ways to steady a camera. Some of these provide greater convenience or comfort, while others

Figure 6-5. *Holding a 35mm camera in various positions. A—When sitting, chair arms can be used for support. B—Elbows placed on a table or other support can be used when sitting, standing, or kneeling. C—When kneeling, sit back on your heels and rest your elbow on the heavy muscle of your thigh. D—Lying on your stomach lets your chest and elbows act as the three legs of a "tripod."*

permit shooting at shutter speeds one or two increments slower than body support alone. A few methods approach the tripod in steadiness as a support for long exposure times.

Monopods

The *monopod* is a "one-legged tripod" that combines improved camera support with good mobility, especially when using telephoto lenses. This makes the monopod a

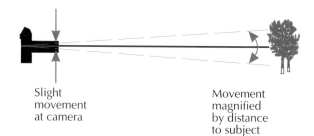

Slight movement at camera

Movement magnified by distance to subject

Figure 6-6. *When a telephoto lens is focused on a distant object, the slightest movement of the camera is greatly magnified.*

favorite for those who shoot sports and similar activities. A typical monopod has three to four telescoping sections, allowing it to extend to about 5' for use and collapse down to about 18" for storage. All have some sort of nonslip tip at the bottom and a method of mounting a camera at the top. Ideally, the camera-mounting device should swivel and tilt to adjust the angle of the camera, and be capable of being locked in place. Most often, the device is a *ballhead* (described in detail in the tripod section that follows).

In use, the monopod works in combination with the photographer's body to provide a quite firm and steady support. As shown in **Figure 6-7,** the monopod should extend far enough to put the camera at eye-level. By

Figure 6-7. *By forming a three-point support with the monopod and her two legs, the photographer can provide a steady camera platform. This is a particular advantage when using a longer lens, which magnifies unwanted movement.*

spreading his or her feet apart slightly, then "leaning into" a slightly angled monopod, the photographer can create a firm three-point (tripod) support for the camera. Unlike the more cumbersome tripod, the monopod can be quickly picked up, relocated, and set up again at a different location to follow action.

A variation on the monopod that is inexpensive, easily made, and surprisingly effective is the *"stringpod."* It consists of nothing more than three items easily found at a hardware store: a length of strong, thin string (mason's line works well), an inch-long bolt with 1/4-20 thread to fit the camera's tripod socket, and a heavy nut or washer. As shown in **Figure 6-8,** the bolt is tied to one end of the string, and the nut or washer to the other. The length of the string used depends upon the height of the photographer. It should be adjusted so that, when the camera is at eye level, the nut or washer just touches the ground. The stringpod is used by placing a foot on the nut or washer to anchor it, then pulling upward on the camera. The tension placed on the string will help hold the camera steady. A major advantage of the stringpod is its small bulk, allowing it to be easily carried in a pocket or a corner of the camera bag.

Shoulder stocks

Wildlife photographers, especially those whose subjects move rapidly and unpredictably (such as birds), frequently mount their cameras on a *shoulder stock,* **Figure 6-9.** Since these photographers typically use lenses of 300mm and longer, the rifle-like stock helps them to better "track" their target and steady the camera during exposure. Although designs vary slightly, the key features of the shoulder stock are a means of firmly attaching the camera and lens to the support and a method of conveniently and smoothly releasing the shutter. This is usually accomplished by using a cable release long enough to be easily operated by the photographer while he or she is holding the stock.

Figure 6-8. *Stringpod camera support. A—Strong string is fastened to a bolt at one end and a heavy nut or washer at the other. Light chain can be used in place of the string, but is bulkier. B—With a foot anchoring the string, the photographer merely pulls upward on the camera to provide enough tension for steadiness.*

Clamping devices

A variety of camera support devices based on *clamping* action are available commercially, and many others have been devised and made by photographers for their own use. One of the most widely used types is the *window clamp,* **Figure 6-10,** which allows the camera to be firmly attached to a vehicle window that is partly open. Since

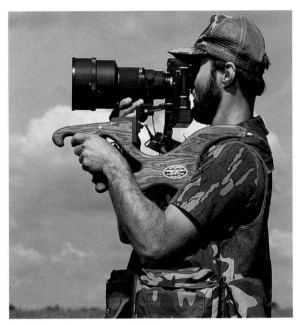

Figure 6-9. *When a camera with a long telephoto lens is used to photograph birds and similar types of fast-moving subjects, the shoulder stock is a handy accessory. It steadies the lens and makes tracking the moving subject easier. (Leonard Rue Enterprises)*

wild creatures frequently will allow a car or truck to approach them more closely than a human on foot, window clamps are the mount of choice for this type of photography. Before shooting, the vehicle engine must be shut off to eliminate vibration.

Other clamps come in different sizes and have jaws of different shapes. These variations permit mounting them on various supports ranging from table edges and chair backs to fence rails, pipes, or tree limbs. Similar devices include spikes that can be stuck in the ground and mounts with threads like a large woodscrew. To be useful, each of these devices must include some form of camera mount that can be rotated and adjusted for proper leveling.

Beanbags and "on site" supports

A *beanbag* is a small pillow-shaped cloth bag filled with dry beans, rice, or similar materials. It is a useful support that can be placed on a table or other surface and

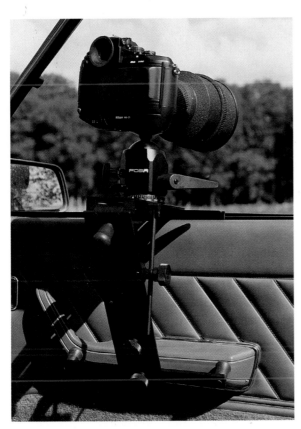

Figure 6-10. *The window clamp is one of a variety of devices that can be used to hold a camera steadier than is possible when hand-holding. This device, called the Groofwin Pod™, is designed to be used as a ground-level camera support, as a window clamp, or as a support on a car or truck roof for large animal photography. (Leonard Rue Enterprises)*

will conform to the shape of the camera or lens. The beanbag is light and small enough to carry in a pocket or equipment bag. Although they are available commercially, many photographers who use beanbags make their own. The camera support provided is firm enough that even a time exposure can be made if a cable release or the camera's self-timer is used to trip the shutter. **Figure 6-11** shows the beanbag in use, as well as a selection of typical "on-site" supports. These are surfaces that can be used to rest the camera upon (such as a garden wall or windowsill) or against (such as a tree or door frame) to provide extra support and steadiness.

A

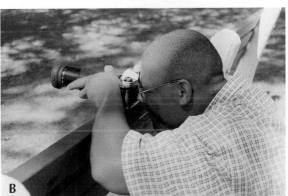

B

C

Figure 6-11. *Camera support techniques. A—The beanbag is a simple device that will hold a camera steady enough to make a time exposure. This one can be filled with beans, polystyrene beads, sand, or water. (Kinesis) B—Resting a camera on a firm surface will help avoid movement. C—Extra support can be obtained by pressing the camera against a solid structure, such as a door frame, wall, or tree.*

Tripods

A ***tripod***, if sturdy and well-made, is the best type of camera support. The three-legged design, with each leg's length independently adjustable, allows it to be firmly set in place on almost any kind of terrain. When mounted atop the tripod, the camera can be adjusted to the desired orientation and locked in position. Exposures of any length can be made with little danger of camera movement. Tripods are manufactured in many sizes, from small tabletop models to large, heavy units suitable only for studio use.

Basic components of the tripod are identified in **Figure 6-12.** They consist of:

- *telescoping leg sections* that can be extended independently to various lengths.

- *a leg locking mechanism* for each section to hold it at the desired amount of extension.

- *nonslip feet* for use on smooth or hard surfaces. Some feet include spikes that can be extended for a better grip on soft surfaces.

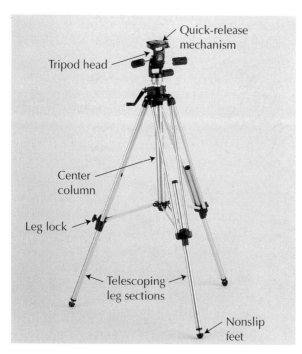

Figure 6-12. *A sturdy tripod is the best camera support available. Basic parts of the tripod are shown. (Manfrotto/Bogen Photo Corp.)*

- *center column* or *centerpost* (not used on all tripods) that may be extended to various heights and locked in place. Some models have a crank and gear teeth for raising and lowering the column.

- *tripod head* for mounting a camera. Ballheads are common, but other types of heads are used.

- *quick-release mechanism* that allows rapid dismounting and remounting of the camera on the tripod head. The mechanism, which is part of the tripod head, consists of a spring or manual latch that holds a special mounting plate in position. The plate is attached to the camera body.

Traditionally, tripods have been made of aluminum or well-seasoned wood to strike a balance between sturdiness and weight. The major advantage claimed for wooden tripods is the ability of wood to "damp" (prevent transmission of) vibrations. In recent years, the trend has been toward the use of a carbon fiber-reinforced composite, a material with an excellent strength-to-weight ratio. Due to the relatively high cost of that material, however, the majority of tripods continue to be made from aluminum.

Tripod legs

Better-quality tripods are typically sold as legs-only, **Figure 6-13,** since photographers have different needs and tastes in tripod heads. Although there are several leg patterns, the most common type is three or four tubular sections nesting inside each other. The locking mechanism usually is either a lever-type or a collar that is rotated to lock or release the section. When fully closed, legs are usually 18" to 24" in length, although some large, heavy-duty tripods may be more then 3' long when closed. Fully extended, the tripod may be less than 5' in height, or more than 8'. A practical height for most photographers is between 5 1/2' and 6', without the centerpost extended. This allows the camera to be placed at a comfortable eye-level position.

Figure 6-13. *This set of tripod legs is made of strong, lightweight carbon fiber. The center column can be pivoted (as shown here) to serve as a horizontal arm allowing the camera to shoot straight down without tripod legs showing. (Manfrotto/Bogen Photo Corp.)*

Some tripod designs allow the angles of the legs to be varied individually. Usually, there are three latching positions: normal, horizontal (at a 90° angle to the centerpost), and midway between. This capability comes in handy in certain situations, such as working in a stairwell or on rocky, uneven ground. On some tripods intended to support heavier cameras, the three legs are connected to the center column with braces that provide greater rigidity. The braces are adjustable to permit some changes in leg angle.

Tripod heads
The device attached to the tripod legs to allow mounting and positioning of a camera is typically referred to as a *tripod head.* Depending upon the method used for positioning the camera, tripod heads can be classified into one of two general categories: pan heads and ballheads.

A *pan head* allows you to move the camera in either two or three axes. As shown in **Figure 6-14,** a two-axis head can tilt the camera forward or backward, or pan from

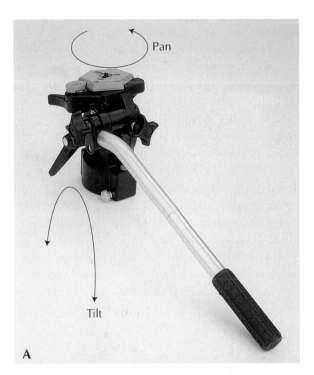

Figure 6-14. *Pan head operation. A—The two-axis head is able to pan (turn horizontally) and tilt forward or backward. Usually, a single handle is used to control movement in both axes. B—The three-axis head (in this case, a gear head) can move in a third plane, tilting from side-to-side. Separate controls are used to adjust and lock each axis. (Manfrotto/Bogen Photo Corp.)*

side to side. Often, a single long handle controls movement in both axes. It can be twisted one way to allow movement for adjustment, and the other way to lock the camera in place. A three-axis head, often referred to as a *pan-tilt head,* allows tilting from side-to-side, as well as forward and back. This more flexible type of head usually has three controls (handles, knobs, or levers) to permit individual adjustment and locking in each axis. Bubble levels are built into many pan-tilt heads to aid in camera alignment. A variation of the pan-tilt head, the *gearhead,* uses gears rotated with cranks or knobs to achieve even greater precision of movement.

Although they provide excellent control of the camera's positioning, pan-tilt heads are rather cumbersome and slow to operate. Many photographers have switched to a *ballhead,* which uses a single control to lock the camera in position, **Figure 6-15.** A typical ballhead has a camera platform attached to a highly polished metal sphere contained in a housing. When a locking device (lever or knob) is released, the ball can be rotated 360° and tilted through an arc of 180°, providing quick and almost infinitely adjustable positioning. When the camera is oriented as desired, the locking device is operated. A friction mechanism holds the camera in the position set by the photographer. One variation on the ballhead resembles a computer joystick and operates with a squeeze grip. Operation is simple: squeezing the grip unlocks the ballhead, allowing the camera (mounted atop the grip handle) to be positioned as desired. Releasing the grip locks the ballhead in the new orientation. Some ballheads are "double-action" — they have a second locking lever, which allows the entire ballhead and housing assembly to rotate horizontally (pan).

Quick-release systems are built into many tripod heads. They are a major convenience for the photographer, since they allow a camera to be quickly mounted or dismounted, without changing any position adjustments. An example of this advantage would be a situation in which the photographer is shooting the same scene in both color and

A

B

Figure 6-15. *Ballheads. A—A ballhead can be quickly and easily adjusted in all three axes of movement and locked in position with a single control (in this case, the large knob). This model can also be rotated horizontally and locked in position with the smaller knob. The view at right shows the notch in the housing that allows the camera to be shifted to a vertical position. (Linhof/H.P. Marketing Corp.) B—This ballhead variation uses a squeeze handle to control movement. When pressure is released, the head locks in position. (Manfrotto/Bogen Photo Corp.)*

black-and-white, or with transparency and print films. Two camera bodies, each loaded with a different type of film, can be "swapped" easily with the quick-release system to record the scene with precisely the same camera positioning.

Figure 6-16. *Quick-release systems consist of a mounting plate that attaches to the camera body and fits into a latching mechanism on the tripod head. This allows the camera to be rapidly attached or removed from the tripod. A common system is the hexagonal mounting plate and corresponding latching mechanism shown here on a three-axis pan-tilt head. Many other types are available, including mounting plates custommade for use with specific camera models. (Manfrotto/Bogen Photo Corp.)*

The two components of the quick-release system are a special mounting plate fastened to the camera and a latching mechanism that is attached to the tripod head. See **Figure 6-16.** The latching mechanism, which may be a part of the tripod head's design or an "add-on," is matched to the shape of the mounting plate and locks it in place on the head. A lever or spring control on the latching mechanism allows the mounting plate and camera to be quickly installed or released.

Many of the mounting plates used with different systems are *universal* — they can be attached to virtually any camera by means of the tripod screw socket on the baseplate. There are also custom-made mounting plates that are designed for use with specific camera bodies. They typically have pins or other features to help lock the plate in place on the camera. This prevents the weight of a long lens from causing the camera body to rotate on the plate when the camera is positioned for a vertical composition.

Tripod "plusses and minuses"

Some photographers make virtually every exposure with a camera mounted on a tripod; others use tripods rarely, if at all. The type of camera and the type of photography that you do will often determine whether you use a tripod. For the large format photographer, camera size alone makes a tripod a virtual necessity (old-time photojournalists regularly made hand-held exposures with 4″ × 5″ Speed Graphic cameras, but few photographers do so today). Medium format camera owners doing studio work or landscape photography normally use a tripod; those shooting weddings or doing general photography, such as photojournalism, seldom use one. A major advantage of the 35mm format is the small size, lightness, and mobility of the camera; attaching it to a tripod would seem to negate those advantages. Again, the type of photography you are doing will usually determine whether use of the tripod will be an advantage or disadvantage.

Major reasons for using a tripod include:
- improved image sharpness through elimination of "camera shake."
- precision in camera positioning for better composition.
- long-exposure capability due to rigid and steady support.
- freeing the photographer's hands to shade the lens or hold a reflector, **Figure 6-17.**

Major reasons for *not* using a tripod include:
- weight and cumbersome shape, especially when tripod must be carried some distance.
- time-consuming setup and resulting lack of mobility.
- possible hazard to others in confined areas (many museums ban tripods for this reason).

Selecting a tripod

As in the case of deciding whether or not to use a tripod, the factors of camera

Figure 6-17. *Among other advantages, placing the camera on a tripod leaves the photographer's hands free for other tasks, such as shading the lens to prevent flare from the sun or other light source. A card, hand, or cap can be positioned to keep light from falling directly on the lens. With a wide-angle lens, use care to stay "out of the shot."*

type and the kind of photography you do will play major roles in *selecting* a tripod. Here are several points to consider:

How much weight must it support? A tiny APS camera weighs only a few ounces; most modern 35mm cameras with a zoom lens attached weigh a pound or more. Many medium format cameras will be in the 4 lb. to 6 lb. range, while the large format field and studio cameras may weigh as little as 8 lb. or more than 20 lb., depending on size and materials.

How much does the tripod itself weigh? If you are carrying your tripod any distance at all, its weight can be a major consideration (especially in combination with a heavy camera bag). See **Figure 6-18.** Aluminum tripods suitable for use in the field typically weigh from 3 lb. to 10 lb., while carbon fiber units with matching capacities will be approximately 30% lighter. For a photographer using 35mm or medium format equipment, a tripod in the 5-lb. to 6-lb. range is usually a good choice. It represents a good compromise between sturdiness and weight. The lighter (3 lb.–4 lb.) tripods are a good choice for photographers who backpack for considerable distances. The tradeoff, of course, is that they are less sturdy as a support.

How well made is the tripod? To provide a solid support for your camera, the tripod must be strong and rigid, even when fully extended. Most aluminum tripod legs are round or rectangular tubes and have sections of different diameters that telescope (slide into) each other for height adjustment. Usually, tripod legs with an open-channel (U-shaped section) design should be avoided — they are less rigid than tubular designs. Leg-locking mechanisms should operate smoothly, but provide a secure locking action. Avoid locks that appear flimsy and likely to break off under pressure. If the tripod has a centerpost (geared or sliding), it should move up and down smoothly, without binding, and lock firmly in position. The tripod should have nonslip feet of rubber (not plastic); retractable spikes for soft surfaces are a desirable feature. The tripod head should meet the same criteria as the legs — it should be sturdily made, and all controls should operate smoothly and positively. Ballheads should lock easily and securely, with no slippage.

Using a tripod

When setting up a tripod, it is usually first extended to full height (unless you know you will be shooting from a lower vantage point). If the tripod has three-section

Figure 6-18. *Tripod weight is a factor in selection, especially when it must be carried along with a heavy camera bag. A sling-type tripod strap can make it easier to carry.*

legs, first fully extend and lock the bottom sections. Follow suit with the middle sections, then spread the legs and stand the tripod on the ground or floor.

Position the legs so that one of the three is pointing toward the subject, **Figure 6-19.** This has two advantages: it provides the photographer with more "working room" between the two legs to the rear, and it adds some support and rigidity beneath the extended lens. One tripod manufacturer offers a brace that can be used to support a camera when a very long telephoto lens is mounted. The bottom end of the brace locks onto the tripod leg.

Make any necessary leg height or angle adjustments. Try to avoid extending the centerpost more than a few inches — the taller the centerpost extension, the greater the danger of sharpness-destroying

vibration. Adjust the ballhead or pan-tilt head as necessary to properly position the camera and frame the subject. Make exposure determinations and set the camera controls. Check focus.

Maximum sharpness in the photo is obtained by eliminating all causes of camera movement, even vibrations caused while opening the shutter. To eliminate possible vibration caused by the viewing mirror flipping up out of the light path when the shutter is pressed, some SLR cameras offer *mirror lockup.* With this feature, a control manually moves the mirror out of the way and locks it in place.

Pressing the shutter release with your finger, even using great care, can cause vibrations that affect sharpness. For this reason, a cable release or electronic remote control cord is usually used to make an

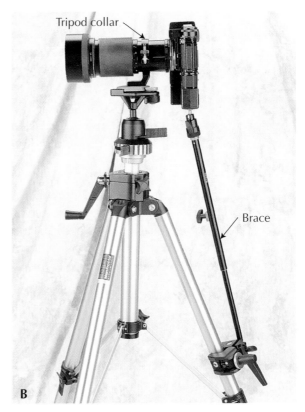

Figure 6-19. *A—When properly set up, a tripod should have one leg pointing toward the subject. This gives the photographer more room to work behind the camera and also provides some additional stability when a telephoto lens is used. B—Longer telephoto lenses are usually mounted with a tripod collar. For additional support, a brace from the camera body to a tripod leg can be used. (Manfrotto/Bogen Photo Corp.)*

exposure with a tripod-mounted camera. The manual *cable release* uses a stiff wire inside a flexible sleeve to gently press the shutter release without causing vibration. See **Figure 6-20.** The *electronic remote control cord,* used on newer cameras, sends an electronic pulse to operate the shutter. An alternative is the use of the camera's self-timer — the delay of several seconds after the shutter release is pressed allows time for any vibrations to die out before the shutter actually operates.

Camera movement can be caused by wind, especially if it comes in intermittent gusts. The problem is most severe with lightweight tripods, but even a heavy and otherwise sturdy unit can be buffeted by the wind when a large view camera is mounted atop

Figure 6-20. *A cable release can operate the camera's shutter without causing vibration. Cable releases come in various lengths, and frequently offer a locking feature that can be used to hold the shutter open for time exposures. This release has a small locking screw just below the plunger.*

it. The view camera provides a large area upon which wind can act, causing movement. The classic solution to this problem is to suspend a weight, such as a heavy camera bag, from the tripod to provide greater stability. Some photographers use a bag made from canvas or a similar strong fabric and fill it with rocks or sand at the site. When empty, the bag can be folded into a fairly small bundle for storage.

Shutter speed/aperture decisions

The use of a higher shutter speed to minimize the effects of camera movement with a longer lens was discussed earlier in this chapter. Shutter speeds can also be changed for other reasons, especially when action (subject movement) is involved. Different shutter speed/aperture combinations (*equivalent exposures,* as discussed in Chapter 4) can be selected to achieve specific effects. In broad terms, fast shutter speeds and resulting large apertures, are chosen to capture action; small apertures, and resulting slow shutter speeds, are selected to achieve greater depth of field with stationary subjects.

Higher shutter speeds to capture action

In some situations, a fast shutter speed (for example, 1/2000 second) is sufficient to stop action; in others, it may not be rapid enough to "freeze" the movement without blur. Selecting a shutter speed to stop the movement of a subject involves three factors:

- Speed of the subject's motion.

- Direction of the subject's movement in relation to the camera.

- Distance of the subject from the camera.

The rate at which your subject is moving will affect the choice of shutter speed: arresting the motion of a motorcyclist obviously requires a faster shutter speed than stopping a walker.

Direction of the subject's movement, in relation to the camera, has a major effect on

motion-stopping capability, **Figure 6-21.** If the subject is moving directly toward or away from the camera, movement may be stopped by a relatively low shutter speed. A subject moving at an angle across the camera's field of view requires a somewhat faster shutter speed. The highest shutter speeds are needed to stop motion of subjects moving directly across the field of view.

A subject that is close to the camera crosses the field of view more rapidly than a subject that is far away, so a faster shutter speed is needed. This relationship is true if a lens of the same focal length is used in both cases. If lenses of different focal lengths are involved, however, the situation changes — the field of view narrows as focal length increases. For example, a person 12′ away would cross the field of view of a 50mm lens in the same time as a person 24′ distant would cross the field of view of a 100mm lens. In the second instance, the subject was twice as far from the camera, but the field of view was only half as wide.

A distant subject that is moving slowly toward or away from the camera is easily stopped with a relatively slow shutter speed, but a very high speed would be needed for a subject that is close to the camera and moving rapidly across the field of view. See **Figure 6-22.**

In certain situations, a subject is moving too fast to be stopped by shutter speed alone. To freeze movement, the brief (often 1/30,000 second or shorter) pulse of light from an electronic flash can be used. For best results, the ambient light level should be fairly low.

The "tradeoff" of using a high shutter speed to stop action is usually a shallow zone of sharp focus (depth of field) resulting from the need to use large apertures to provide the proper exposure to the film. This may be relieved by using a faster (higher ISO) film. Each step upward in film speed will gain one stop at a given shutter speed. For example, changing from an ISO 100 film to an ISO 800 film would gain three stops. If the original reading (with ISO 100) was f/5.6

Figure 6-21. *Apparent motion. A—Subjects moving directly toward or away from the camera can be stopped with a relatively low shutter speed. B—Diagonal motion requires a higher shutter speed to halt the action. C—A subject moving across the field of view needs a high shutter speed to "freeze" the action, especially if the camera-to-subject distance is fairly short.*

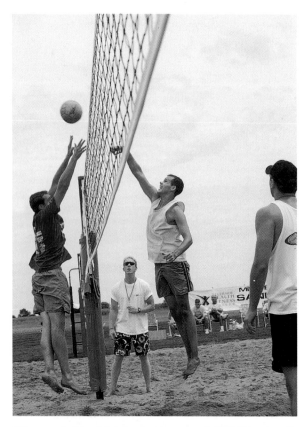

Figure 6-22. *A high shutter speed (1/500 second) was needed to stop the motion of the ball and athletes because of their direction of motion and closeness to the camera.*

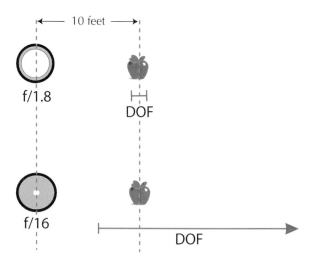

Figure 6-23. *Depth of field (DOF) increases as aperture decreases. With a 50mm lens focused on an object 10' away, depth of field at f/1.8 is measured in inches. At f/16, however, depth of field extends from approximately 6' to almost 30'.*

at 1/500 second, moving to ISO 800 film would allow you to shoot at f/16 at 1/500 second.

Smaller apertures to maximize depth of field

If motion is not a factor (for example, when photographing a landscape), aperture becomes relatively more important than shutter speed. The size of the lens opening is the major factor in controlling how much of the scene you photograph will be in focus. The distance between the nearest object that appears to be in sharp focus and the most distant object that appears to be in sharp focus is known as ***depth of field.*** As the aperture becomes *larger,* depth of field decreases; as the aperture becomes *smaller,* depth of field increases. See **Figure 6-23.**

Two other factors affect depth of field: the focal length of the lens and the distance from the camera to the nearest object that must appear to be in sharp focus. In comparison to a 50mm lens, a telephoto (long focal length) lens provides *decreased* depth of field; while a wide-angle (short focal length) lens provides *increased* depth of field. The shorter the lens, the greater the depth of field, and vice versa. Depth of field can be increased by moving farther away from the nearest object that must appear to be in sharp focus; moving closer to that object decreases the distance behind it that will appear to be in sharp focus.

In the two preceding paragraphs, you probably noted that all the depth-of-field references were to objects that "appear to be" in sharp focus. Technically, only one point or *plane* of the subject can be in precise or "razor-sharp" focus. The resolving power of the human eye, however, provides some leeway — objects for some distance in front of and behind the plane of focus will *appear to be* in focus, or "acceptably sharp." See Chapter 3 for a more detailed discussion of depth of field and related topics.

Determining depth of field

Although it is possible to calculate depth of field for a given lens, most photographers never have need to do so. Most older lenses (and some newer ones) include depth-of-field scales to permit direct reading of the distances in acceptable focus. For lenses without such scales, a depth-of-field table must be used. Tables are included in the data sheets packed with a new lens, and are also available in various reference books.

The depth-of-field scale has markings, for most or all of the apertures, on either side of the *focusing mark,* **Figure 6-24.** After focusing on the subject, the distance from the camera can be determined by noting the number on the distance scales that is aligned with the focusing mark. The distances appearing above the markings for the selected f-stop will be the nearest point in focus (left-hand mark) and most distant point in focus (right-hand mark).

Hyperfocal distance

To get the greatest possible depth of field for a given lens at a specific aperture, you can set the lens at its hyperfocal distance. The *hyperfocal distance* is the nearest point that will be in sharp focus when the lens is focused on infinity. This distance is different for each f-stop and each focal length. If the lens is set to the hyperfocal distance, focus will be sharp from one-half that distance to infinity. Finding the hyperfocal distance on a lens with a depth-of-field scale, **Figure 6-25,** is simple:

1. Align the infinity symbol (∞) on the focusing mark.

2. On the left-hand scale, note the distance (in feet or meters) shown above the mark for the appropriate f-stop. This is the *hyperfocal distance.*

A

B

Figure 6-25. *Hyperfocal focusing. A—With the infinity symbol aligned on the focusing mark, the hyperfocal distance can be read directly from the distance shown above the desired f-stop on the left-hand scale. In this example, f/11 is the desired f-stop, and the hyperfocal distance is approximately 27′ (8 m). B—Aligning the hyperfocal distance with the focusing mark will ensure that everything from half that distance to infinity will be in focus.*

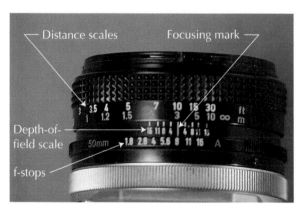

Figure 6-24. *A depth-of-field scale allows you to determine the nearest and most distant points that will be in focus. The nearest distance at which an object will be in focus is shown (in feet or meters) above the mark for the selected f-stop at left. The farthest distance that will appear to be in sharp focus is above the matching f-stop mark at right. Unfortunately, many new lenses are being made without depth-of-field scales.*

3. Rotate the focusing ring until the hyperfocal distance found in step 2 is aligned with the focusing mark.

4. Note the distance figure above the appropriate f-stop on the left-hand scale. It will be one-half the hyperfocal distance. Everything from that point to infinity will be in focus.

As noted, many new lenses are being manufactured without depth-of-field scales. To find the hyperfocal distance with these lenses, a depth-of-field chart must be used. Such charts typically provide the near-focus and far-focus points for each aperture at each distance. To use such a chart, locate the infinity focusing distance for the desired f-stop. Infinity will be the far-focus point; the near-focus point will be the hyperfocal distance. By setting the lens to the hyperfocal distance, depth of field will extend from half that distance to infinity.

The hyperfocal method can be used to advantage in landscape and nature photography, in street photography or similar situations where you wish to be unobtrusive, and in sports or action photography where focusing on a rapidly changing scene would be difficult.

Seeing the picture

For the visual artist, especially the photographer, being said to have "a good eye" is high praise. It means that she or he looks at a scene or a subject in a way quite different from the nonartist. Being aware of the relationship of masses and colors, the emotional content of the scene, the interplay of light and shadow, the meaning that goes beyond the obvious and readily apparent, are among the many elements of "seeing photographically." While the tourist marvels over the spectacular sunset, the photographer is more likely to turn his or her back to the sun to capture the warm evening light on a line of mountain peaks or an old building. Where the nonphotographer sees an unsightly auto graveyard, the photographer may see literally hundreds of patterns, relationships, and isolated details just waiting to be photographed.

Subjects are all around us. Which ones we select to photograph depends on many factors, but the first must be personal interest. We must *recognize* it as a possible subject for photography, then decide that we *want to* photograph it.

Why we want to photograph a given subject is a question with an almost infinite number of answers:

- It might be a simple and straight-forward record to show others that you have been there ("We visited Disney World.") or what the subject looked like to you. ("The old Gordon mansion was in poor condition before the restoration started.")

- It often is a subject that we have been conditioned to photograph. ("Those parade floats are so beautiful." "Don't miss Joshua blowing out the candles on his cake!" "That old barn is really picturesque.")

- It can be something that involves our emotions. ("You can see how much that the little girl loves her kitten." "His expression shows the years of rejection and disappointment he's experienced.")

- It may appeal to you aesthetically. ("The shadows of the columns form a pleasing pattern." "The relationship of the figures is perfectly balanced." "The sunlit buildings against the dark storm clouds catch your eye immediately.")

- It can even be a means of stating your political, moral, or social views. ("The wretched conditions in which these people exist conveys the repressive and uncaring regime that governs their country." "The little girls running through the mountain meadow are a statement about the freedom and innocence of childhood.")

"Taking" a picture vs "making" a picture

The commonly used term for photographic activity is "taking a picture." This implies a simple *recording* of what is in front of the camera. The vast majority of all photographs that are taken — casual snapshots — are simple record shots of places visited, children's activities, and family events.

More serious photographers often use the term "making a picture," which implies more conscious control of the process and the final result. Instead of merely recording what appears in the viewfinder, these photographers make decisions or choices that will affect what the viewer of the final product (print or slide) will see, **Figure 6-26.**

To control how the final product will appear to the viewer, the photographer must first see that desired final result in his or her own mind. A formal term for this process is **visualization.** As Ansel Adams described it in his book, *The Camera*: "To visualize an image ... is to see it clearly in the mind prior to exposure, a continuous projection from composing the image through the final print."

To capture that visualized image on film, the photographer must make a series of decisions. The most basic of these, of course, is selecting the subject, and determining how you want to portray that subject. As an example, consider an abandoned wooden building, such as an old rural schoolhouse. You could show it in many different ways. Among these might be:

- a typical architectural subject (3/4 front view of the full structure).

- a focal point in a wider landscape or "environment" photo.

- a pattern of shapes (windows or other details).

- a study of texture (weathered wood, peeling paint, curling shingles).

- a portrait of abandonment (debris-filled and battered interior of the structure).

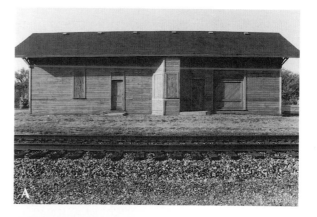

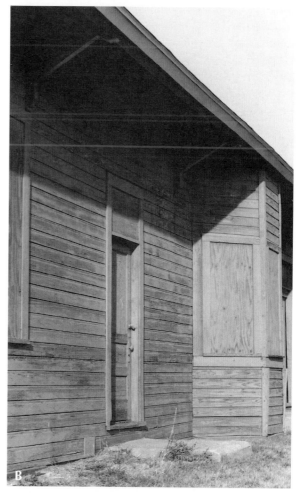

Figure 6-26. *Taking a picture vs making a picture. A—This picture of an abandoned railroad depot was taken from standing eye level, straight on, and centered in the frame. It's a competent but unexciting record shot. B—To make this more interesting picture, the photographer moved in closer to fill the frame, selected a low angle, and carefully exposed to bring out shadow detail.*

The way you choose to show the subject will influence your decisions in a number of other areas. One of these might be film type (black-and-white, color print, color slide) and film speed (low, medium, high, very high). This decision, in turn, might be influenced by the time of day (early morning, midday, dusk) and the quality of light (gloomy, cloudy but bright, light overcast, strong sunlight).

The focal length of lens that you choose will affect size of the image (magnification) and perspective. Camera orientation (horizontal, vertical, or tilted) and angle of view (high, medium, or low) will obviously have a major influence in the final appearance of the image. So will *composition,* the relative arrangement of shapes and lines within the frame of the photo.

Compositional techniques

The way that you compose your photograph — how you arrange the relative positions and sizes of the different elements — will strongly influence the message the viewer will receive. Assume that you have a dozen identically-sized balls and want to convey to the viewer that one of these is more important than the other eleven. **Figure 6-27** illustrates four compositional techniques that you could use to send that message.

- Place one of the balls nearer the camera, so it appears larger.

- Sharply focus on one ball and leave the others "soft."

- Paint one of the balls a strongly contrasting color.

- Isolate one ball from the others.

These are only a few of the many compositional techniques that experienced photographers use regularly. All techniques for composing photographs make use of a limited number of **compositional elements**.

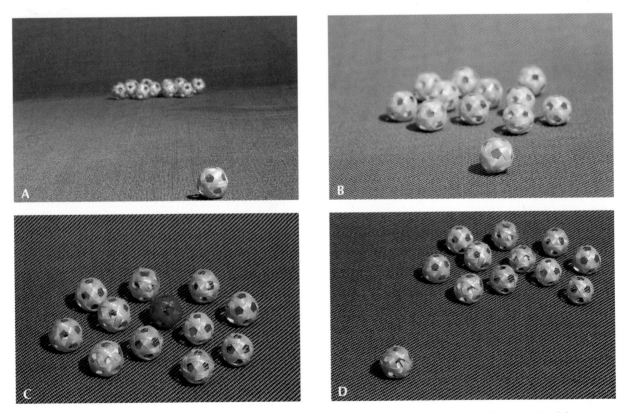

Figure 6-27. *Compositional techniques that can be used to emphasize one of the balls. A—Position (apparent size). B—Focus. C—Color. D—Pattern (isolation).*

As visual artists, both painters and photographers make use of these same elements to convey meaning. Painters are able to do so with greater freedom, however, since they can add, subtract, and rearrange the elements within the frame of the picture. The photographer is bound by physical limitations of the scene. He or she must use careful framing, changes of angle, selective focus, and other techniques to achieve the desired composition. (Manipulation of the image in the darkroom or with computer software is a separate issue and is dealt with in later chapters of this book.)

Elements of composition

Various sources cite different numbers and names for the basic elements of composition. These six include all the important topics:

- Point
- Line
- Shape or pattern
- Balance
- Emphasis
- Contrast

A *point* (sometimes referred to as a spot) is a single object, typically small in size, that attracts the eye. As such, it may serve as the center of interest in a composition, or it may be a distraction, pulling the eye away from a more important object. See **Figure 6-28.**

A *line* is a "stretched point," and typically draws the viewer's eye along its length, making it a useful tool for directing attention. The orientation and shape of a line can convey certain impressions: straight horizontal or vertical lines are static, whereas diagonal lines imply motion; gently curved lines are considered placid and restful, while sharply curved or bent lines, as well as broken lines, convey energy or strong movement.

The *shape* of an individual object, or the *pattern* made by multiple objects, are strong compositional elements. A shape may appear to be flat and two-dimensional, exhibiting only the properties of *length* and *width*. The effect of light falling on an object, creating

Figure 6-28. *Point as a compositional element. A—In this photo, the small bright spot (the tennis ball) is the center of interest, drawing the viewer's eye to the desired area of the photograph. B—The small bright area in this photo (a discarded soda can) draws the eye away from the intended center of interest.*

shadows or tonal variations, adds a third dimension, the property of *depth*. See **Figure 6-29.** A pattern may consist of repetition of identical shapes, or may have elements alternating or varying in either shape or size.

Figure 6-29. *Shape as a compositional element. A—The silhouetted objects are two-dimensional shapes. B—Light falling on this object creates tonal variation (light and shadow), giving it a three-dimensional appearance.*

Figure 6-30. *Balance as a compositional element. A—Formal balance exhibits nearly identical left and right halves. B—Informal balance. The bright color of the foreground object at left balances the larger, darker mass of the building roofs at right.*

Overall arrangement of the elements within the frame determines the compositional *balance*. The balance may be symmetrical (formal), or asymmetrical (informal), **Figure 6-30**. A composition that exhibits *formal balance* consists of matched halves — dividing the frame vertically or horizontally in the middle would produce two "mirror images." A common metaphor for formal balance is a seesaw with riders of equal weight at equal distances from the center balance point. *Informal balance* provides a feeling of visual balance, but without the "mirror image" effect. Using the seesaw example again, informal balance would involve riders of different weights with the larger of the two positioned closer to the balance point and the smaller rider farther from the balance point. In a photograph, informal balance may be achieved by the relative positions of two objects of different sizes, or by such techniques as using a smaller, brightly-colored object to balance a

larger dark object. Sometimes, a single large object may be balanced by several smaller objects.

Emphasis is used to make some element of your picture stand out and capture the viewer's attention. Refer to Figure 6-27, where four different types of emphasis are demonstrated. By emphasizing a single element of the photo, you are creating a *center of interest* to which all the other elements of the picture will relate. Without such a center of interest, or with more than one emphasized element, the photo does not send a clear message to the viewer. An old design maxim, "*All* emphasis is *no* emphasis," is illustrated in **Figure 6-31.** When every element of the photo is given equal weight, nothing stands out. The viewer receives no guidance, and will quickly lose interest in the photo.

Although it is a compositional element in itself, *contrast* is often employed to provide emphasis. Contrast is a noticeable difference between adjacent elements of a composition. These include light and shadow, large and small size, dark and light (or saturated and muted) colors, smooth and rough textures, curved and straight-edged shapes, and sharp and unsharp focus.

Using compositional elements effectively

The compositional elements just described are used in various combinations by the photographer to create an effective photograph. Although numerous "rules" of composition have been proclaimed by individuals throughout the history of photography, good composition should be almost instinctive. We live in a society that surrounds us with images. In magazines, newspapers, and books, on movie screens and on our television sets, we are constantly exposed to images that are almost invariably *well-composed.* Unconsciously, we have absorbed the principles of good composition. Even though we might not be able to pinpoint what is wrong or right, we are disturbed by a poorly-composed image and pleased by one that is well-composed.

Even so, some familiarity with accepted compositional practices will help you to make conscious decisions as you visualize a photograph you are about to make. The basis of any photographic composition is the *film frame.* Like the painter's canvas, this is the working space within which the picture is composed. All the compositional elements are employed in relation to the frame.

For example, a center of interest can be placed anywhere within the frame, but some locations are more effective than others. As a general practice, placing it in the physical center is considered rather static and boring. While there are certainly examples of effective composition with a centered object, placement elsewhere in the frame is usually more interesting visually.

Figure 6-31. *Emphasis as a compositional element. A—With all objects equally emphasized, the viewer doesn't know where to look. B—Emphasizing one element provides a center of interest to guide the viewer.*

Figure 6-32. *You can visualize a grid dividing the film frame into thirds, horizontally and vertically. Placing your center of interest at one of the four points where lines cross will result in a more interesting composition than centering the subject in the frame.*

A compositional device that has long been used is the *rule of thirds.* A "tic-tac-toe" grid can be created to divide the frame into thirds, **Figure 6-32.** The four intersections created by the crossing lines are considered the most effective spots to position the center of interest. By mentally imposing these lines in your camera viewfinder, you can see the effects of different placement.

The rule of thirds is also a useful guide when your photo includes the horizon or another dominant horizontal or vertical line (such as a desert roadway or a lighthouse). Placing the horizon on or close to the top or bottom guidelines of the grid will make for a much more interesting photo than positioning it across the middle of the frame. See **Figure 6-33.**

High Horizon

Low Horizon

Figure 6-33. *Placing the horizon on or near one of the grid lines will result in a more effective photo than centering the horizon line. Selection of the upper or lower grid line depends upon whether your sky or your foreground is most interesting.*

Changing your *camera angle,* or point of view, can have a dramatic effect on the picture's composition and visual impact. Instead of shooting from a standing position, with the camera at eye-level, you might create a more effective picture by crouching or kneeling (or even lying on the ground). Alternatively, you could stand on a chair or ladder for a high-angle approach, or even shoot from a second-story window or the roof of a building.

When working with children or animals, getting down to *their* eye level often will result in a better picture than the "birds-eye view" of shooting downward from a adult viewpoint. See **Figure 6-34.** An innovative way of photographing a field of flowers might be to lie on your back and shoot upward through blossoms that are backlighted by the sky.

Photographing from a high angle is a good way to show patterns (visualize a dozen umbrellas covering sidewalk cafe tables, as seen from a hotel balcony) or to avoid a visual obstacle such as a foreground fence. When photographing a landscape, a high angle will permit you to "tilt down" and eliminate an uninteresting expanse of cloudless sky. Several well-known landscape photographers have used platforms installed atop their vehicles so they could quickly and easily attain a high-angle viewpoint.

Inclusion and *exclusion* are important concepts in composition. By selective framing, you decide what to *include* in the frame, and what to *exclude.* Sometimes referred to as "cropping in the camera," the goal of this approach is to produce the picture you visualized, without any extraneous elements. Depending upon the situation, this may be accomplished through choice of lens (focal length), by changing angle of view, and by moving toward or away from the subject. Frequently, all three elements may be necessary to frame the photo as you desire.

Unless your subject is a hungry lion, *moving in closer* will usually help you make a better picture. (Even in the case of the hungry lion, you could move in closer *optically* with a very long telephoto lens.)

Figure 6-34. *Suit the camera angle to the subject. A—Photographing children or animals from their own eye level is more effective than shooting from adult eye level. B—Adult viewpoint diminishes shorter subjects.*

Think of the number of boring vacation pictures you've seen, like the one in which Aunt Mavis — that tiny speck in the center of the frame — is shown at the rim of the Grand Canyon. Now, think of how much better a photo would have resulted if Uncle Fred had moved in close enough so that you could actually see Aunt Mavis's features and make out some of the details of the canyon behind her.

As you compose your picture, *check all the edges of the frame* for distracting or unwanted elements. It's easy to focus all your attention on placement of the main subject or the major elements of the composition, and overlook something that is at the edge of the frame. The problem is

made worse by the fact that, in all but the most expensive professional-level cameras, the viewfinder does not show the entire scene. Usually, however, any distracting edge element will be large enough to intrude on the scene shown in the viewfinder. Make it a habit, before pressing the shutter release, to check the frame edges. If you find a problem, remove the distracting item, if possible, or recompose to avoid it.

Also check for the problem of *convergence,* where parts of the image come together in an undesirable way. The classic example of convergence, of course, is the flagpole or tree that appears to be growing out of the head of your subject. Other objects, and even background items that present strong lines, can create problems, as shown in **Figure 6-35.** Convergence of *tones* in the photograph can

be undesirable, although it can sometimes be used to good effect. In a conventional portrait, for example, poor tonal separation between the subject's hair and the background would be undesirable. When dramatic sidelighting is used, however, convergence of the deeply shadowed side of the subject's face and the background is normally a desired compositional element.

Directing the viewer's attention within the photograph can be accomplished by a number of different means. The use of various forms of emphasis (the eye is drawn to the brightest or most sharply focused element, for example) has already been covered. Another method of directing attention is the use of **leading lines.** These are pictorial elements that draw the viewer's eye from one area of the photo to another. In an outdoor scene, **Figure 6-36,** a

Figure 6-35. *Be careful to avoid convergence of objects that shouldn't come together. Sometimes, the result can be unintentionally funny; most often it merely ruins the photo.*

Figure 6-36. *Leading lines will direct the viewer's attention to the center of interest in your photo. Not all photos will employ leading lines, but they are a useful tool for composition.*

Figure 6-37. *Keeping viewer attention inside the frame. A—A moving object can lead the eye out of the frame. B—Providing some space between the object and the frame edge helps keep attention within the frame.*

leading line might be a fence, a road, a railroad track, or even a fallen tree. In a portrait, the line of the subject's arm, a shadowed fold in clothing, or an object in the environment surrounding the person might serve to lead the eye as intended by the photographer.

Leading lines are sometimes contained completely within the frame, but most often, they draw the viewer's eye from one of the edges to the intended point. Try to avoid compositions that direct the viewer's attention *out* of the frame. This is most often a problem when photographing people or moving objects. If possible, provide some additional room on the side of the frame toward which the subject is looking or moving, **Figure 6-37.** This will help to keep the viewer's attention within the frame.

You can also have a "frame within the frame." Using a foreground object or shape to partly or fully surround your main subject has two benefits: it directs attention into the frame, focusing it in the main subject, and it helps give the picture a sense of depth. Although the use of an overhanging branch or a building archway as a frame has become something of a visual cliché, the concept of the frame is still valid and useful. See **Figure 6-38.**

Figure 6-38. *An unusual framing shape can sometimes be used to focus attention on a subject. This view of visitors and the ornate front of the Mission San Xavier del Bac in Arizona was shot through an opening in the adobe wall of the church's front courtyard.*

Using visual effects

There are a number of techniques that you can use to achieve certain visual effects that will make your pictures more interesting or help to convey your intended meaning. Most of these effects can be used regardless of whether you are shooting with color or black-and-white film. A few are color-dependent.

Soft-focus. This technique is used primarily in portrait photography, since it is flattering and helps to mask minor blemishes and wrinkles. The effect, **Figure 6-39,** is subtle and is different in quality from the unsharpness caused by imprecise focusing. Several methods are used to achieve the soft-focus effect; each provides a somewhat different result. Two techniques that have been used for many years are stretching a single thickness of sheer stocking fabric (preferably black) across the lens, or smearing a thin coat of petroleum jelly on a clear (UV) filter. Special *soft-focus filters* are also available in several degrees of softness.

Selective focus. While sharp definition of objects from the near foreground to the distant background is desirable in some photographs, it is less desirable in others. **Figure 6-40** shows two versions of the same scene. With a depth of field that renders the busy background sharp enough to be recognizable, the eye is distracted from the main subject — there's too much "going on" in the picture. With a shallower depth of field that throws the background far out of focus, attention is drawn to the main subject. This technique, called *selective focus,* is used extensively in photographing flowers and small animals, especially in natural settings. In the studio, it is often used for both product photos and portraits.

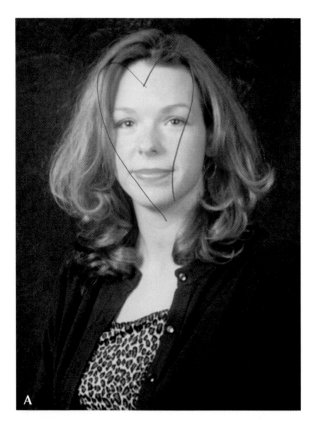 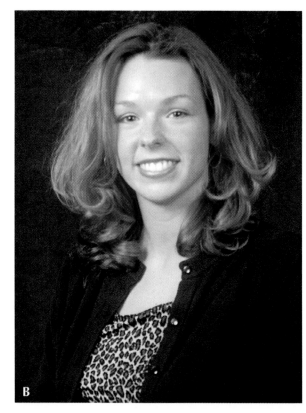

Figure 6-39. *A soft-focus effect can be pleasing and flattering, since it helps disguise small blemishes and wrinkles. In this case, soft focus was achieved with a thin coat of petroleum jelly spread on a filter. A—Soft-focus portrait. B—The same subject in sharp focus.*

Figure 6-40. *Selective focus can make a photo stronger and more dramatic. A—The busy background draws attention away from the main subject and makes it hard to distinguish. B—Using a wider aperture to throw the background out of focus isolates the main subject, capturing the viewer's attention.*

To view the degree to which the background is out of focus, or one subject is emphasized and another is de-emphasized, *depth-of-field preview* capability is a desirable camera feature. As noted in Chapter 2, SLR cameras typically use the widest aperture of the lens for composing and focusing, then automatically "stop down" to the set aperture when the shutter is pressed. This method allows the photographer to see the effects of focusing only at the widest aperture (where depth of field is shallowest). The *preview* feature permits viewing the scene at the desired aperture, so that the photographer can see the *actual* depth of field. The degree to which the background is out of focus can be judged and adjusted, either by shifting the plane of focus or changing to a higher or lower f-stop.

Without depth-of-field preview, selective focus is more difficult to achieve, but can be done by using a depth-of-field chart or the depth-of-field scale on the lens, as described earlier in this chapter.

Deliberate blurring. While blurring as a result of *camera shake* is seldom desirable, motion blur due to movement of the subject can be used creatively. Motion effects that result from manipulating a zoom lens during exposure also can be used.

As described in an earlier section of this chapter, motion blur is usually avoided by selecting a shutter speed fast enough to "freeze" the subject's movement. Sometimes, however, a certain amount of blurring is desirable to convey motion. By experimenting with subjects and shutter speeds, you can achieve different effects: the blurred but recognizable shape of a runner against a background that is in sharp focus or a tennis player who is in focus except for an arm and racquet blurred from rapid movement.

A technique called *panning* is often used to convey speed when shooting moving vehicles ranging from bicycles to racing cars. Although it takes some practice and experimentation to get acceptable results, **Figure 6-41,** the concept is a simple one. With the camera prefocused for the proper distance, the photographer frames the vehicle as it approaches, then *pans* (moves the camera laterally) to keep the vehicle properly framed as it crosses in front of him or her. At the desired point,

Figure 6-41. *Panning the camera along with the motion of the subject will produce a blurred and streaked background that will help convey the idea of motion. The effect can be varied by using different shutter speeds.*

Figure 6-42. *Dramatic streaking and contrasts of sharp focus and blur result from using the zooming technique with a static subject. Use of a tripod will keep the desired framing.*

the exposure is made, without stopping the panning movement. Continuing to pan after pressing the shutter release is an important aspect of this technique. The result is a vehicle that is sharply focused, against a background that is blurred and streaked horizontally to dramatically show movement. The technique works well with manual-focus cameras and autofocus models that are capable of "tracking" to adjust focus on a moving target. The focus-lock feature on some autofocus cameras may work for panning; other cameras may have to be switched to manual focus to use this technique.

Striking motion effects can be achieved by using a relatively slow shutter speed and *zooming out* or *zooming in* during the exposure. The camera should be mounted on a tripod to hold the desired framing on the subject during the zooming action. A typical result is shown in **Figure 6-42,** but each exposure made

with this technique will give a different effect. This occurs because the zooming rate and smoothness of the motion will be different each time. Zooming in will give a different effect from zooming out; so will the use of lenses with different ranges of focal lengths.

Special effects filters. Filters can be used to create a wide array of special visual effects ranging from diffraction ("star filters") to multiple images to various distortions to color alterations of many kinds. Most are as effective with black-and-white film as they are with color film. Warming, cooling, and color-enhancing filters are effective only with color films, of course. They can eliminate unwanted color casts, provide an overall color for a scene to convey a certain mood, or strengthen (enhance) certain colors in a scene for greater impact. **Figure 6-43** shows some examples of results gained by using special effects filters.

Figure 6-43. *Examples of results from using special effects filters. A—A diffraction filter creates multi-colored halos around light sources. B—The center spot filter diffuses the image around a sharp central area. C—Multi-image filters repeat the subject several times. D—A fog filter lends a dreamlike quality to a scene. E—The radial zoom filter mimics the effect of zooming in or out during exposure. F—Color filters provide an overall coloration when used with color film. (Cokin Filters/Minolta Corporation)*

Questions for review

Please answer the following questions on a separate piece of paper. Do not write your answers in this book.

1. Blurring in a photograph can be due to _____ or _____.

2. When hand-holding a camera with a 50mm lens, _____ second is the slowest practical shutter speed for most photographers.

3. Why is camera shake more apparent when using longer focal length lenses?

4. List at least three types of camera support, other than a tripod.

5. Tripods are made from aluminum or other metals, wood, or _____.

6. Which of the tripod heads below normally has separate controls for adjustment and locking in each axis?

 a. pan head

 b. ballhead

 c. locking lever head

 d. pan-tilt head

7. A quick-release system uses a _____ fastened to the camera and a latching mechanism on the tripod head.

8. Cite several reasons for and against using a tripod.

9. A tripod used with a large format field camera might have to support ___ pounds or more.

10. If a cable release isn't available, what shutter release option might you use to minimize camera shake?

11. For each of the situations described, indicate "low" or "high" to show the shutter speed you would need to stop motion.

 a. person running diagonally toward camera.

 b. bicyclist riding straight away from you.

 c. jogger one block away, crossing field of view.

 d. motocross rider jumping ditch, 15 feet away.

 e. trampoline user at peak of bounce.

12. Depth of field _____ as the aperture is made larger, and _____ as it is made smaller.

13. Define *hyperfocal distance.*

14. What is the *rule of thirds?*

15. The technique of making part of the picture sharp and the rest soft is called _____.

Include human figures in landscape photos to provide a sense of scale. The foreground picnic party, and the tiny figures of hikers along the clifftop, emphasize the vast scale of the Cliffs of Moher on Ireland's west coast.

Tonal range:
The spread of tones, from deepest shadows to brightest highlights, represented in a photograph.

Chapter 7

Developing Film

When you have finished reading this chapter, you will be able to:
- List the equipment and materials needed for film development.
- Explain the steps involved in developing roll and sheet film.
- Discuss the safe handling of photographic chemicals.
- Describe variations of the development process.
- Evaluate negatives for proper exposure and development.

When George Eastman introduced his Kodak camera in 1888, photography changed forever. Until then, it was a pastime limited to a relatively small number of enthusiasts willing to invest the time and effort to learn the varied skills required to expose, process, and print their photographs. Being a photographer meant you also had a properly equipped darkroom, or at least access to one.

Eastman changed all that by separating the process of exposing film from the processes of developing and printing. The photographer using a Kodak was freed from the darkroom. All he or she had to do was take the pictures (100 exposures could be made), then send the camera off to Eastman's company. By and by, the developed film and prints would be returned,

along with a reloaded camera. By eliminating the need for a darkroom and for learning the associated skills, Eastman made photography accessible to almost everyone.

Today, film processing is even more convenient. Small labs offering one-hour color processing are located in shopping malls, discount and department stores, and many drugstores, **Figure 7-1.** For those living in isolated settings, there are numerous

Figure 7-1. *The photographer who doesn't wish to develop film has many choices for processing, ranging from one-hour developing and printing operations to mail-order labs. Most such processing operations are devoted entirely to handling color negative (print) film. Transparency and black-and-white films are typically sent elsewhere or processed infrequently, and thus take longer to deliver.*

mail-order processing labs. Relatively few professional photographers do their own processing and printing today — they send their film to specialized high-quality photo labs.

Since processing is so readily available, why should any photographer even consider doing his or her own developing and printing work?

The first thought many people have is *"to save money,"* but the opposite is probably true. When you factor in the time, equipment cost, and materials, the commercial film processor can do the job more cheaply than you can (especially for color negative film). There might be a slight cost advantage for those who shoot and process many rolls of black-and-white film, but that is usually not their motivation for doing darkroom work.

Most serious photographers who develop their own film do so for reasons of *creative control* and *quality*. For the same reasons, they usually prefer to make their own prints. By using various combinations of film, developer, processing time, and solution temperature, these photographers can make adjustments to compensate for such problems as extremely flat or extremely contrasty lighting conditions at the time of exposure. They also can be sure of the strength and freshness of the developing solutions and can maintain conditions of darkroom cleanliness to avoid film contamination or damage. Darkroom work is also part of a continuous process of learning and improvement. By seeing the results of different exposure decisions or other changes in technique soon after the film is exposed, the photographer can make judgments while the experience is still "fresh in mind." This can lead to changes in technique or refinements in the way the photographer approaches certain situations.

In this chapter, the emphasis will be on processing black-and-white film. Chapter 9 deals with making black-and-white prints, while color film developing and printing are discussed in Chapter 12.

Film-developing requirements

To develop film, you need a *dark room*…but not necessarily a *darkroom.* Actually, you don't even need a *room.* All that is necessary is a means of excluding all light from a space of about one cubic foot in volume. That's the amount of space needed to remove exposed film from a cassette or roll, thread it onto a developing reel, and enclose that reel in a light-tight tank. Once that is achieved, the rest of the developing process can be carried out in normal room lighting.

Special bags or tents of tightly woven fabric are made for this purpose. (They are also used by large format photographers to load and unload sheet film in the field.) The film cassette, developing reel and tank, and a pair of scissors are placed inside the bag. By inserting your arms through elastic cuffs that maintain light-tightness, you can then perform the loading operation.

More convenient is an actual room to work in, since it is less confining. Any space that can be made light-tight will do: a closet, a windowless bathroom, or a basement storage room. The room should be as clean and dust-free as possible, and should have a horizontal surface to work on, such as a shelf, table, or counter. The door should fit tightly enough to exclude light at the top and sides. A folded bath towel can be laid across the bottom of the door to block light.

Basic equipment and chemicals

Basic equipment for film developing consists of a developing tank and reel, an opener for 35mm film cassettes, a pair of scissors, a watch or timer, and some clips for hanging the film to dry. The processing chemicals, a measuring cup or pitcher, a thermometer, and appropriate containers are also required.

The developing tank and reel may be made of stainless steel or plastic, as shown in **Figure 7-2.** Tanks are made with capacities of one to eight 35mm rolls, but the most

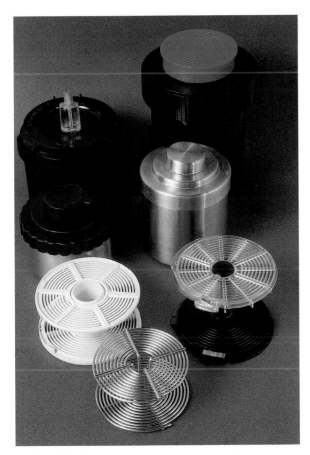

Figure 7-2. *Developing tanks are made in various capacities, and are formed from plastic or stainless steel. Developing reels are also made of either stainless steel or plastic. The "ratcheting" type of plastic reel, which simplifies film loading, is most popular. The taller of the two plastic reels is an adjustable type that has been extended for use with 120-size film. When collapsed, it is used for 35mm.*

common is the tank that can hold two rolls of 35mm or one roll of 120-size film. Normally, plastic reels are used with plastic tanks, and stainless steel reels with stainless steel tanks. While the steel tanks were originally manufactured with metal lids, most of those sold today have plastic lids, which are easier to remove. The tank lid has a *light trap,* which allows processing chemicals to be poured into and out of the tank without exposing the film to light.

There are two types of developing tanks: inversion and noninversion, based on the

type of agitation that is done while processing. *Inversion tanks* have spillproof caps, allowing them to be physically turned upside down (inverted) at intervals to agitate the chemicals. *Noninversion tanks* are intended to remain upright. Some are agitated by sliding the tank in an arc on a smooth surface. Other types are agitated by inserting a thermometer or other device into the hub of the developing reel and rotating it.

Plastic *developing reels* are made in several different styles, but the most popular allows film to be threaded onto the reel with a ratcheting action. Stainless steel reels require some practice to load properly and easily, but have the advantage of allowing loading even when damp (as when processing several rolls of film, one after the other). Moisture on plastic reels will cause the film to stick and bind.

Although special devices are made for opening 35mm film cassettes, most darkroom workers use an opener designed to remove bottle caps, **Figure 7-3**. The *film cassette opener* is hooked over one of the crimped-on ends of the cassette, then used with a prying motion. Once the end is removed, the tightly rolled film can be slipped out for threading onto the developing reel.

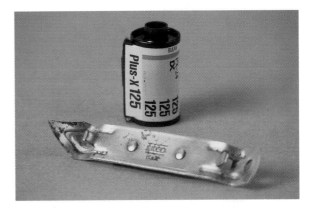

Figure 7-3. *A common bottle opener is often used in the darkroom to pry off one of the endcaps of a 35mm film cassette. This allows the film to be removed and threaded onto a developing reel.*

Scissors are needed to trim the beginning section (leader) of the film for threading onto the developing reel. After the film is on the developing reel, the end attached to the film cassette hub is cut off.

Once the developing process is complete, the strip of film is hung up to dry. Wooden clothespins or special metal *film clips* have traditionally been used to hang film. Wire spring clips coated with soft plastic are increasingly used for this purpose. Excess water may be wiped from the film with a special sponge or a squeegee-type device. See **Figure 7-4.**

Developing chemicals, at minimum, consist of a *developer* for turning the latent image into a metallic silver visible image, a *fixer* to make the image permanent, and water to stop development action and to wash residual chemicals out of the emulsion. An acid *stop bath* can be used between the developing and fixing steps, and a *washing aid* may be used to make residual fixer easier to wash away. To prevent water spots from forming on the developed film as it dries, a solution containing a *wetting agent* is normally used as a final rinse before the film is hung. See **Figure 7-5.**

Measured amounts of processing chemicals and water usually must be mixed before use. This requires a *measuring cup,* beaker, or pitcher large enough to hold the necessary

quantity of material. A stirring paddle or rod for mixing is a convenience, although some darkroom workers employ a thermometer for "double duty." The *thermometer* is needed to measure developer temperature for accurate calculation of developing time. Airtight containers of the proper volume must be used to hold and store the mixed solutions. See **Figure 7-6.**

Chemical handling and storage

Most chemicals used in darkroom work are relatively nontoxic, but a few are considered quite dangerous. As a matter of safe practice, all darkroom chemicals should be treated with caution and respect.

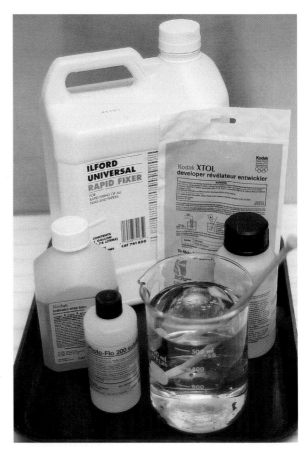

Figure 7-5. *Basic processing chemicals include developer (in either liquid or powdered form), stop bath, fixer, washing aid, and wetting agent. All must be mixed with water in the proper proportions.*

Figure 7-4. *Various types of clips may be used to hang processed film for drying. To remove excess water, a photographic sponge, or a set of tongs with soft rubber squeegee blades (like the one shown in the foreground) may be used.*

Figure 7-6. *A graduated pitcher or beaker is used for both measuring and mixing processing chemicals. Since solution temperatures are often critical, an accurate thermometer is a vital tool. A stirring paddle with a flat end is useful to break up clumps of dry chemicals so they dissolve properly. Airtight storage containers are used to store mixed solutions. Since they will not break if dropped, plastic containers are usually preferred to those made from glass.*

Appropriate protective equipment should be worn to prevent skin and eye contact with chemicals; a properly designed ventilation system should be in place to help prevent breathing fumes or dusts from chemicals. All containers must be properly labeled to identify their contents, and used chemicals must be disposed of properly.

Mixing chemicals safely and correctly

To perform their jobs effectively, chemicals must be accurately measured and prepared under the conditions specified by the manufacturer. To protect yourself from possible injury or health hazards, you must use proper equipment and procedures when preparing the chemicals.

All chemicals used in darkroom work are **solutions** (liquid or powdered materials dissolved in water). They must be mixed in the proper proportions, and often, at a specified temperature. For example, directions for a liquid chemical might be to mix it in a 1:3 ratio with water at 68°F (20°C). The 1:3 ratio means that you would use one part of the chemical (for example, 100 ml) and three parts water (3 × 100 or 300 ml). See **Figure 7-7.** Liquids are normally mixed at approximately "room temperature."

Powdered chemicals are usually packaged in units designed to produce a given volume (quart or liter; gallon or four liters, for example) of mixed solution. They are usually mixed with about 3/4 the final quantity of water until fully dissolved. More water is then added to make the full volume. For easier dissolving of the powdered chemicals, a temperature of approximately 100°F (38°C) is usually specified. Generally, the mixed solution then must cool to room temperature before use. Recently, some powdered chemicals have been introduced that are designed to dissolve easily in room-temperature water.

Whenever chemical solutions are being prepared, you must be careful to avoid contaminating one chemical with another. Most critical is the developer, which can be rendered ineffective if contaminated with stop bath or fixer. Some photographers solve the problem by reserving specific pieces of

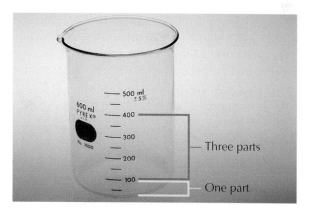

Figure 7-7. *When mixing to a ratio, such as 1:3, the first number is typically the chemical—such as developer—and the second is the diluting agent, usually water. A unit of any size can be used, depending on the amount of finished solution needed. If 100 ml of fixer is used, 300 ml of water would be added to make 400 ml of solution at a 1:3 ratio.*

measuring and mixing equipment strictly for developer. Others are careful to always thoroughly rinse and clean equipment to eliminate any possible residue of one chemical before moving on to another. When rinsing out a beaker that has held a solution, most use the scientific "triple rinse" approach — the beaker is filled with clean water and emptied three times. Mixing paddles and thermometers should also be carefully rinsed after use. One area of contamination that is sometimes overlooked is the rubber or plastic gloves worn by the photographer. When powdered chemicals are being mixed, a fine film of chemical dust may be deposited on a glove, especially if it is wet. Like beakers and mixing paddles, gloves should be thoroughly rinsed when moving from the preparation of one solution to the preparation of another.

Some photographers prefer to formulate their own developers and other solutions, working from traditional formulas. In such situations, very accurate measurement of quantities and volumes is necessary for success. It is also vital to mix ingredients in the proper order and use liquids that are at the specified temperature. Proper sequence is particularly important when mixing any acid (such as the acetic acid used for stop bath) with water to make a dilute solution. *Always pour acid into water; never pour water into acid.* This will eliminate the possibility of a violent reaction that could splatter acid onto your skin or into your eyes. For proper vision protection, *always* wear a face shield or safety glasses with side shields when mixing chemicals, **Figure 7-8**. To avoid breathing the fine dust that can rise from powdered chemicals as they are being mixed, a simple dust mask is usually sufficient. Ventilation should draw dust or fumes away from the area where you are mixing, instead of past your face.

Many photographers, especially those whose skin is sensitive to various chemicals, wear latex (rubber) or plastic gloves whenever they mix or handle chemicals.

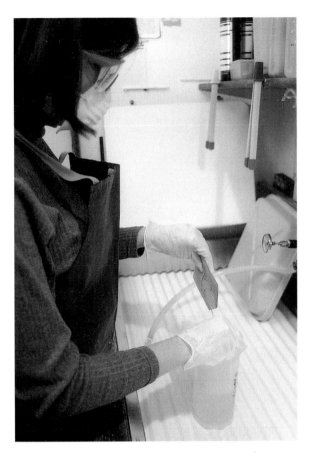

Figure 7-8. *Wearing appropriate personal protective equipment is important when working with chemicals of any kind. This photographer is wearing safety glasses with side shields to protect against solution splashes, a dust mask to avoid breathing chemical powder, latex gloves to avoid skin contact with chemicals, and an apron to prevent damage to clothing from splashed chemicals.*

Disposable latex gloves, similar to those worn by healthcare personnel, are readily available in drugstores and hardware stores. Also available are disposable gloves made from thin, clear plastic film, which are widely used in food service. These gloves are inexpensive and are typically "one size fits all." Latex gloves are usually preferred to plastic, since they allow a firmer, nonslip grip on bottles and other objects. See **Figure 7-9**.

Storing chemicals

Both for safety and to prevent a mix-up that could ruin your film, always clearly

Figure 7-9. *Skin contact with common darkroom chemicals can cause allergic reactions or irritation. In a few cases, chemicals can be toxic if absorbed through the skin. To avoid skin contact, many photographers wear gloves like those shown. The latex gloves at left and plastic gloves at center are usually discarded after a single use. Heavier rubber gloves like those at right are usually worn for kitchen and household cleaning use. They are more durable, but some darkroom workers find them hard to use because they are thicker and less flexible.*

label the contents of all chemical containers in your darkroom or storage area (if you do not have a permanent darkroom). Use a thick black marker to write directly on the container, if the background is suitable, or on a piece of white tape applied to the container. See **Figure 7-10.** Use a permanent marker, so that labels won't smear or run if you touch them with wet hands.

Many different types of chemical containers are used by photographers, depending upon personal preference and availability. Some use recycled beverage bottles of dark glass or the brown glass bottles once used by pharmacists. Even though glass poses a danger of breakage, it is preferred by some darkroom workers because they believe glass excludes oxygen better than plastic. Plastic containers are most common and range from opaque dark brown bottles made specifically for photographic use to translucent bottles normally used in household refrigerators.

Figure 7-10. *All chemical storage containers should be clearly labeled with a permanent marker ink that will not run or smear when wet. Labels should be clear and easy to read to prevent mix-ups when processing.*

No matter what type of container you choose for chemicals, it must perform two basic functions: hold the chemical without leakage and prevent oxygen and light from causing the chemical to degrade. If chemicals are to be stored in an area where the containers will be exposed to light for lengthy periods, the containers should be dark-colored or opaque — light can shorten the useful life of some chemicals. Translucent or even clear containers could be used when the storage area is normally dark.

Oxidation is a greater problem, especially for developers. Exposure to oxygen in the air will cause the developer to lose its effectiveness. To minimize oxygen contact while

Figure 7-11. *Methods of excluding oxygen contact with stored chemicals. A—Special collapsible bottles can be compressed to eliminate any air space above the chemical. B—Glass marbles can be added to the storage container to raise the level of liquid and eliminate any air space. C—An inert gas can be injected to drive out air in the space above the liquid.*

solutions are stored, there should be little or no air space at the top of the container. If the amount of chemical solution is not sufficient to completely fill the container, several methods are available to deal with the problem. As shown in **Figure 7-11,** special "accordion-pleated" collapsible bottles are available, glass marbles can be put in a bottle to raise the solution level, or air can be replaced with an inert gas.

The life of a chemical solution used in photography is limited by both time and use. All chemical solutions have a specific *shelf life,* the length of time that they will retain their effectiveness. They also have a specific *capacity,* or amount of material that they can be used to process before becoming *exhausted.*

The shelf life of a chemical depends upon its state. Powdered chemicals in sealed packages or liquids in unopened bottles have a shelf life measured in months (or in some cases, a year or more). Once the bottle is opened, or the powdered chemical is mixed with water to form a concentrated *stock solution,* shelf life becomes considerably shorter. Diluting the stock solution to form a *working solution* results in a still shorter life span (a developer in an open tray, for example, will be usable for 24 hours or less). Shelf life is shortest for developers; stop baths and fixers are less affected by oxidation and thus are longer-lived. Check a darkroom guide, the package, or directions packed with each chemical to determine its shelf life in both stock and working solution forms. Careful darkroom workers note the date when each batch of a particular chemical is prepared. Some mark the date on the container, others use a blackboard or similar method.

If you do a fair amount of film processing, *solution capacity* will be more important than shelf life — chemicals will become exhausted before they go out of date. Capacity of developers and fixers is often stated in the number of rolls or 8" × 10" sheets of film per gallon. Sometimes, the information is given in rolls or sheets per liter (one gallon is approximately 4 liters). Stop bath capacity is typically not stated in film quantities, since most photographers use a color-changing *indicator stop bath.* The normally yellow solution begins changing to a purple color as it nears its capacity.

One 8″ × 10″ sheet of film and one 36-exposure roll of 35mm film have the same surface area: 80 sq. in. A roll of 120-size film has the same surface area. Four pieces of 4″ × 5″ sheet film also have a total area of 80 sq. in. For a number of commonly used developers, capacity is 16 rolls or 8″ × 10″ sheets per gallon. Developer loses strength, however, with each roll that is processed. For this reason, the photographer must keep track of the number of rolls developed, **Figure 7-12**, and progressively increase developing time at stated intervals.

Figure 7-12. *The number of rolls or sheets of film processed in a batch of developer must be recorded so that necessary developing time adjustments can be made at intervals. This photographer is making a tally mark to indicate that the batch has been used to develop six rolls so far. Note that the date the batch was prepared is written on a label to keep track of shelf life.*

Typically, development time is lengthened by 15% after each four rolls. Thus, the first four rolls would be developed at the normal time (such as 6 minutes at 68°F); rolls 5–8 would be developed for almost 7 minutes (6 minutes, 54 seconds); rolls 9–12 almost 8 minutes (7 minutes, 56 seconds), and rolls 13–16 for just over 9 minutes (9 minutes, 7 seconds).

The need for calculating lengthened developing time can be avoided by one of two methods: replenishment or the use of "one-shot" developers. Many types of developers can be used with special *replenisher* solutions to maintain normal developer strength (and thus, developing times). A specific amount of replenisher solution is added to the developer after each 80 sq. in. of film is processed. Usually, this will approximately equal the amount of developer absorbed by the film emulsion. Replenishment can continue until the amount of replenisher added is equivalent to the original volume of the developer solution.

The other alternative is to prepare a dilute solution of developer in sufficient volume for the amount of film being developed (typically 250 ml per roll), then discard it after use. This is called "one-shot" developing. One developer that is often used for this type of development is Kodak's ascorbic acid-based developer called XTOL®, which was introduced in 1996. This developer has a capacity of 15 rolls per liter at normal strength (with time compensation after each 5 rolls). It is also designed to be diluted in 1:1, 1:2, or 1:3 ratios and used for "one-shot" developing. Increased dilution requires longer development times, since the amount of active developer in the solution is decreased.

Fixer capacity is considerably greater than developer capacity. Capacities vary by brand, but a typical capacity for a 1:3 (called "film strength") working solution is 120 rolls or sheets per gallon (or approximately 30 per liter). Careful photographers usually adopt a cautious approach, and do not try to use fixer to its full capacity. Since film that is

inadequately fixed can discolor and deter-iorate over time, they prefer to take no chances and discard fixer well before it becomes exhausted.

Disposing of chemicals properly

An often-expressed concern by those setting up a home darkroom for the first time is the proper disposal of chemical solutions after use. Large-scale users of photographic chemicals, such as commercial developing labs, must dispose of chemical wastes under Environmental Protection Agency regulations. Home darkrooms, however, produce very small volumes of used chemicals and are not subject to these regulations. Local governments, however, often have regulations that apply to any material being discharged into the sewer system. Before setting up a darkroom, check with the proper authority to be sure you are complying with disposal requirements. Practices differ on the discharge of home darkroom chemicals into the individual septic systems used in rural areas. Chemical manu-facturers generally advise against discharge of used photographic solutions into septic systems. However, many photographers with small home darkrooms have discharged to septic systems for years with no observ-able adverse effect on system operation.

Whether the darkroom is connected to a municipal sewer system or an individual septic system (in rural areas), the key to proper disposal is *dilution*. Most photographic solutions are basically nontoxic in the con-centrations normally used; further diluting them with plenty of water makes them even less likely to cause harm, **Figure 7-13.** Developers are alkaline, while stop baths and most fixers are acids. Some darkroom workers prefer to mix the used developer with stop bath or fixer to achieve a fairly neutral pH (acid/alkaline balance) before disposal. The solution is then gradually poured down the drain along with a steady flow of running water. Once all the solution has been poured out and the container

Figure 7-13. *The key to proper disposal of used chemical solutions in the home darkroom is to flush them down the drain with plenty of water for dilution. Combining acid and alkaline solutions before disposal to neutralize them is also recommended.*

rinsed, let the water continue to flow for a minute or so to clear any residue out of the sink trap.

Developing roll film

The developing process for 35mm or medium format (120-size) roll film is a relatively simple sequence of actions. It begins with loading the film onto a reel and enclosing it in a light-tight tank, moves on to a series of chemical steps (developing, stopping, fixing), then ends with washing to remove fixer residues, and drying.

Loading film onto the reel

For beginning darkroom workers, this is the step that usually creates the most anxiety, since it must be carried out in total darkness and requires some dexterity (especially when loading stainless steel reels). However, the process is basically simple; once mastered, it can be performed in a matter of a minute or so per roll.

Before turning out the lights, assemble all the equipment and materials and place them within easy reach on the working surface, as shown in **Figure 7-14.** Keep all

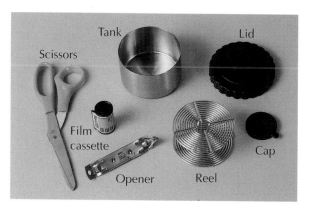

Figure 7-14. *Lay out all the materials and equipment needed to load film into the developing tank so that you can easily locate everything in the dark.*

Figure 7-15. *The film end is trimmed off squarely, just behind the beginning of the leader. This is done to make it easier to load onto the developing reel.*

items well back from the edge, so they cannot be easily dislodged and fall on the floor (making them almost impossible to find in the dark).

The basic steps in loading 35mm film onto the developing reel are:

1. Turn off the lights and make sure that there is no light of any kind leaking into your work area. Although print developing can be done under a dim "safelight," film development must be done in *total* darkness to avoid fogging and ruining the film.

2. Use the bottle opener or other device to pry one end off the film cassette.

3. Slide the cassette hub and tightly wound film roll out of the shell. Grasp the roll of film between thumb and forefinger to keep it from unrolling.

4. Unroll several inches of the film leader and use the scissors to cut the film end squarely across. Make the cut just behind the point where the leader is trimmed to narrower width, **Figure 7-15.**

5. Thread the end of the film onto the reel and feed the film into the spiral track. The method you use will differ depending on whether you are working with a plastic reel or a steel reel. See **Figure 7-16.**

6. When all but the last few inches of the film have been threaded onto the reel, use scissors to cut off the end of the film that is taped to the cassette hub. Thread the film completely onto the reel.

7. Place the full reel into the developing tank. If you are using a multiple-reel tank, load the remaining reels and place them in the tank. (*Note:* If you have a two-reel tank, but are developing only one roll of film, place an empty reel in the tank to avoid excessive movement during development.)

8. Put the lid on the tank, making sure that it seats firmly. If you are using an inversion-type tank, the cap over the pouring opening should be in place.

9. Turn on the room lights. The remaining film processing steps can be carried out in room light, since the film is inside the light-tight tank.

For medium format roll film, the major difference in the loading process is at the very beginning. The 120-size (6 cm or 2 1/4" wide) strip of film is rolled up in a strip of backing paper on an open spool. To load this film, the strip of gummed tape holding the roll closed is broken, and the paper unrolled until the free end of the film is revealed,

Figure 7-16. *Film loading methods. A—Some consider plastic reels easier to load, since film is slipped into tracks, then "ratcheted" into place by alternately moving each side of the reel. B—On the stainless steel reel, film must be "bowed" slightly with finger pressure while loading. It is first slipped into a clip at the hub, then fed into the spiral while rotating the reel. C—An aid to loading the stainless steel reel is clipped over the reel and uses a shaped metal guide to keep the film properly bowed during loading. The film feeds into the spiral as the reel is rotated. D—Once common, but now seldom used, is the "lasagna roll" method, named for its resemblance to the crinkly-edged pasta. The film and plastic strip are rolled together, then placed in the tank. The crimped edges hold successive layers apart so that solutions can flow freely around the film.*

Figure 7-17. The film is threaded onto the developing reel in the same manner as 35mm film. The end of the strip of film is taped to the paper backing, and can simply be pulled free to complete film loading. The loaded reel is placed in the tank and the cover put in place.

Determining development time

Temperature is the controlling factor in film development. For any combination of film and developer, the length of time for normal development will be determined by the temperature of the developer. For most developers, the *recommended* normal development temperature is 68°F (20°C), but Kodak recommends use of its T-Max developers at 75°F (24°C).

For a specific film, development time at 68°F can vary considerably, depending upon the developer selected. For example, the normal development time for Tri-X film in D-76 (a widely used film developer) is 8 minutes. In Microdol-X, the time is 10 minutes; in

Figure 7-17. *Medium format film loading. A—The 6cm-wide strip of film is rolled together with a paper backing. It is separated from the backing and threaded onto the developing reel. B—Some plastic reels can be adjusted in width to process either 35mm or 6cm film.*

HC-110 (Dilution B), it is 7 1/2 minutes. The recommended time with T-Max developer is 5 1/2 minutes at 75°F.

In general, the lower the temperature, the longer the developing time, and vice versa. Using Tri-X film as the example again, the development time in D-76 at 68°F is 8 minutes, but at a lower temperature (65°F or 18°C) time increases to 9 minutes. As the temperature goes up, development time gets shorter: 6 1/2 minutes at 72°F (22°C) and 5 1/2 minutes at 75°F (24°C). For many film/developer combinations, 5 minutes is a critical point in development time. If the time is shorter than 5 minutes, development may not be uniform.

Figure 7-18. *Determining the temperature of the developer is the first step in identifying the development time for your film.*

To determine the proper development time for your specific combination of film and developer, first determine the developer temperature, **Figure 7-18.** Then, check the development table to find the correct time for that temperature. Development tables can be found in various sources, such as darkroom guides and the technical data sheets available from the manufacturer of the developer. The tables will show time/temperature combinations for specific film brands and speeds for both full-strength developer and various dilutions. **Figure 7-19** is a section of one such table.

TABLE 1: Small-Tank Processing with Full-Strength Developer

Important
Development times shorter than 5 minutes may produce unsatisfactory uniformity.

ROLL FILM	FORMAT	EI	CI	DEVELOPMENT TIME (minutes)					
				65 F (18 C)	68 F (20 C)	70 F (21 C)	75 F (24 C)	80 F (27 C)	85 F (29 C)
KODAK PLUS-X Pan / PX / 5062 KODAK PLUS-X 125 Pro	135	32/64	0.52	5.75	4.50*	4.00*	3.00*	2.50*	2.00*
		125	0.58	6.50	5.25	4.75*	3.75*	2.75*	2.25*
		250	0.65	7.75	6.50	5.75	4.50*	3.50*	2.50*
		500	0.75	9.25	8.00	7.25	5.50	4.25*	3.00*
		1000	0.85	12.25	10.25	9.25	7.25	5.25	3.75*
KODAK PLUS-X Pan Professional / PXP / 6057 KODAK PLUS-X 125 Pro	120/220	32/64	0.52	5.75	4.50*	4.00*	3.00*	2.50*	2.25*
		125	0.58	6.75	5.50	5.00	3.75*	3.00*	2.50*
		250	0.65	8.00	6.75	6.00	4.75*	3.50*	2.75*
		500	0.75	11.00	8.50	7.50	5.75	4.50*	3.50*
		1000	0.85	16.00	11.50	10.00	7.75	6.00	4.50*
KODAK VERICHROME Pan / VP / 6041	120	32/64	0.52	6.25	5.00	4.50*	3.50*	2.50*	1.50*
		125	0.58	7.50	6.00	5.25	4.00*	3.00*	2.00*
		250	0.65	8.75	7.00	6.00	4.75*	3.50*	2.50*
		500	0.75	11.00	8.50	7.50	5.75	4.50*	3.00*
		1000	0.85	13.50	11.00	9.50	7.25	5.50	3.75*
KODAK TRI-X Pan / TX / 5063 KODAK TRI-X 400 Pro	135	100/200	0.52	6.50	5.50	5.00	4.00*	3.25*	2.50*
		400	0.58	6.75	6.75	6.00	4.75*	3.75*	3.00*
						7.75	7.00		
						9.0			

Figure 7-19. *This section of a development table for XTOL developer shows various time/temperature combinations for different film types.*

Development can be (and often is) done at a temperature different from the recommended one, but you will obtain the most consistent results by always processing your film at the same temperature. That temperature might be the recommended 68°F, or 66°F, or 70°F — the important thing is to use the same temperature each time you develop film.

Ideally, that temperature should be the same for any liquid that will come in contact with the film (fixer, washing aid, water), but in practice the *developer temperature* is the critical one. The other solutions can vary a few degrees without creating a problem. A *wide* variation in temperature, such as 10 degrees or more, could cause a wrinkling or cracking of the film emulsion (a condition known as **reticulation**).

To achieve the desired consistent temperature, it may be necessary to cool or warm the developer and other solutions. One method of doing so is to place beakers or other containers holding the desired amount of each solution in a **tempering bath** of water that is at the desired temperature. Commercially available tempering baths use thermostatically controlled heaters to hold the water at the desired temperature. A more common darkroom method is to adjust the supply faucet to provide water of the desired temperature, then fill a developing tray to serve as a tempering bath. Maintaining a slow, steady flow of water to the tray will hold the temperature at the desired level, **Figure 7-20.** Solutions inside the beakers will gradually stabilize at the temperature of the water.

A more rapid method of raising or lowering the temperature of a developer, or other solution, is to place ice cubes (or hot water) in a plastic bag that has a zip closure. By squeezing most of the air out of the bag, it can be submerged in the beaker of developer, **Figure 7-21.** Use of the tempering bath will then help to hold the solution at the desired temperature.

Figure 7-20. *A developing tray with slowly running water at the desired temperature can be used to bring solutions to that temperature before development begins. A thermometer placed in the container of developer will indicate when the proper temperature has been reached.*

Figure 7-21. *To rapidly cool developer by a few degrees, ice cubes can be sealed in a plastic bag and submerged in the liquid. By substituting hot water for ice cubes, the same technique can be used to raise solution temperature.*

Developing steps

Before beginning development, all needed equipment and materials should be at hand. The necessary amounts of developer, fixer, and washing aid should be measured out into beakers or similar containers for easy pouring. A timing device should be easily visible to monitor the amount of time needed for each step. A wall clock or wristwatch with a sweep second hand can be used, a stopwatch such as those used for sporting events is even better. A timer specifically made for darkroom work can be used, but many photographers have found inexpensive digital countdown timers designed for kitchen use to be ideal. They have large, easily read digits for minutes and seconds, and can be quickly reset. See **Figure 7-22.** If both a timer and a watch or clock are available, the timer can be set for the most critical step (development), then reset for a later step. The watch is used to time alternate steps.

Film development can be broken down into an eight-step process with an elapsed time of less than 30 minutes:

1. Prewetting (1 minute)
2. Developing (5–15 minutes — varies by film, temperature, and dilution)
3. Stop bath (30 seconds)
4. Fixer (typically 2–4 minutes)
5. Rinse (30 seconds)
6. Washing aid (2 minutes)
7. Wash (10 minutes)
8. Wetting agent (30 seconds)

Prewetting

Some photographers believe strongly that filling the tank with water (*prewetting*) and agitating for one minute improves developing uniformity. Others believe just as strongly that it has no beneficial effect and is unnecessary. Soaking the film in water supposedly swells and softens the gelatin emulsion, making it easier for the developer to be absorbed consistently. After the tank is

Figure 7-22. *Digital timers designed for kitchen use can be set to count down to zero from a desired time. They are inexpensive, are easily reset for a different interval, and start or stop at the touch of a button. An audible tone signals the end of the timing cycle.*

filled, you should rap it sharply on a hard surface once or twice. This will dislodge any air bubbles ("air bells") from the film surface. Such bubbles interfere with developer action, leaving blemishes on the finished film.

Development

If prewetting is used, the water is poured off, then developer is poured into the tank through a light trap opening, **Figure 7-23.**

Figure 7-23. *A light trap at the top of the developing tank allows solutions to be poured in or out without exposing the film to light. Timing of a step should start at the same time tank filling begins. Emptying of the tank should start ten seconds before time runs out.*

Figure 7-24. *To agitate an inversion-type tank, first turn it upside-down (left) than right-side-up again (right). The cycle should be completed in one second.*

The timer should be started when you begin to pour in the developing solution. When the tank is full, replace the cap on the light trap (if using an inversion tank) or insert the agitator in the reel hub of a noninversion tank.

Proper agitation is important during the development process to be sure that fresh solution is always in contact with the film. If there is no movement of the solution, the developer that is against the film surface will become exhausted in a short time, and development will stop. Proper agitation ensures that development will be consistent and complete.

Both the time and the type of agitation are important. With the developer, the agitation pattern typically used is *continuous* for the first full minute, then 5 seconds at 30-second intervals for the remainder of the developing time. A film or developer manufacturer may suggest a different pattern or interval for its product; you may wish to use that as a starting point and determine whether results are satisfactory.

As shown in **Figure 7-24,** inversion tanks are agitated by being turned upside down, then right-side-up again. Each inversion

(over and back) should be completed in about one second.

For tanks that cannot be inverted, one of two methods may be used, depending on tank design. Those that have an agitator inserted in the reel hub move the entire developing reel within the tank. The agitator is "twirled" back and forth between thumb and forefinger, causing the reel to rotate halfway around, then back again. See **Figure 7-25.** A noninversion tank that does

Figure 7-25. *The agitator is rotated one-half turn, then one-half turn back. This moves the reel inside the tank to keep fresh solution in contact with the emulsion.*

not have an agitator can be slid back and forth in a short arc to create solution movement. As shown in **Figure 7-26,** the tank is moved in an arc about 10″ long on a smooth surface. Like the inversion method, the agitation cycle should be completed in about one second.

While too little agitation can cause incomplete or uneven development, too much agitation can create problems as well. Excessive agitation can increase negative density and contrast, but more seriously, can cause *surge marks* — streaks of uneven development resulting from developer flowing back and forth through the sprocket holes of the film.

When the timer shows 10 seconds left, begin pouring the developer out of the tank. With practice, you will be able to finish pouring at the same time that the timer ends its cycle. Even though all the solution has been poured out of the tank, the residue of developer on the film will continue to work until it is *stopped*.

Stopping development

There are two different methods of stopping development of the film: using an acid stop bath or using plain water. The acid stop works very quickly by neutralizing the alkaline developer. Water doesn't neutralize the developer; instead, water dilutes it

Figure 7-26. *Moving a noninversion tank in a short arc on a smooth surface will provide sufficient agitation for development. Intervals should be the same as used for inversion tanks.*

sufficiently that developing action stops almost as quickly. Using water to stop development is a common practice, since it means the photographer has one less solution to handle. The usual procedure with a water stop is to fill and empty the tank three times. If an acid stop is used, it is continuously agitated and poured out after 30 seconds.

Fixing

The developer acts upon the latent image on the film, forming molecules of metallic silver to make the image visible. Silver halides in areas of the film that have not been exposed to sufficient light to form a latent image are not affected by the developer. *Fixing* is necessary to dispose of these unexposed silver halides, which would otherwise darken upon exposure to light. The fixer is a powerful silver solvent. It dissolves the unexposed silver halide particles and allows them to be washed away, while leaving the metallic silver (visible image) intact.

Fixing time for film is usually 2–4 minutes. The proper fixing time should be determined before beginning the development process. This is done by using a small piece of exposed but undeveloped film (the leader you cut off while loading the developing reel will do). The film is dropped into a beaker of fixer, **Figure 7-27,** and the time the film takes to turn from opaque to clear is measured. Fixing time should be *twice* this **clearing time.**

Rinsing

To stop the action of the fixer and dilute any residue remaining in the tank, a water rinse is used. The procedure is the same as that used for stopping development — filling and emptying the tank three times.

Washing aid

Use of a washing aid before washing the developed and fixed film is an optional step, but is often done because of the savings in time and water. Marketed under various names, a washing aid acts upon the fixer residues in the film's emulsion, making them

Figure 7-27. *The clearing time of film is measured by immersing a small piece of film in fixer. The time that is needed for the appearance of the film to change from cloudy to clear is measured. Doubling this time provides the proper length for the fixing step of the development process.*

dissolve more readily in water. A 2-minute immersion of the film in a washing aid can cut the time needed for washing from about 30 minutes to 10 minutes or less (follow the manufacturer's recommendation).

Washing

Film that has not had fixer residues thoroughly washed out can eventually discolor and deteriorate. A running water wash is recommended, with the flow rate sufficient to fill the film tank or other container several times in a 5-minute period. While there are a number of specially designed film washers on the market, many photographers merely remove the lid from the film developing tank to do the wash step. With the film still in place, they fill and empty the tank several times until the recommended time has elapsed. See **Figure 7-28.**

Figure 7-28. *Thorough washing of film ensures that it will not discolor in future years. Filling and emptying the tank several times over the recommended washing period will be effective. Use of a washing aid will greatly reduce the time needed for washing, and thus, minimize water use.*

Wetting agent

When washing is complete, the film should be immersed for approximately 30 seconds in a solution of Kodak Photo-Flo® or a similar wetting agent. This solution makes water drain off the film surface more readily to prevent the formation of water spots during drying. As a further precaution against waterspotting, many darkroom workers carefully remove excess water with a set of squeegee tongs, **Figure 7-29,** or a viscose sponge. The sponge or the rubber blades of the squeegee must be kept clean and free of any grit that could scratch the film emulsion.

Drying film

A dust-free atmosphere for film drying is very important, since a dust particle that becomes embedded in the emulsion is difficult or impossible to remove without visible damage. Film may be hung in the open, **Figure 7-30,** or inside a drying cabinet. Depending upon temperature and humidity, film hung in the open will dry thoroughly in 2–4 hours. Cabinets often are designed to circulate heated, filtered air over the film to speed drying.

After film is thoroughly dried, it must be placed in a protective covering for ease of

Figure 7-29. *Water remaining on the film's surface after washing can be removed by wiping carefully using a sponge or, as shown, a pair of squeegee tongs. This method also poses the danger of scratching the film, however.*

Figure 7-30. *The washed film will dry in 2–4 hours when hung in the open. Attaching a spare film clip to the bottom of the strip of film will help prevent curling.*

storage and prevention of damage due to foreign matter or handling. A common method is to cut the roll of film negative into short strips (usually 5 frames for 35mm film) and place them in a plastic storage page, **Figure 7-31.** The plastic pages have sleeves or channels to hold the negative strips, and are punched and sized to fit into a standard ring binder. The pages also simplify making contact prints of the negatives for reference (see Chapter 8).

To prevent scratching the negatives during handling, wear thin cotton gloves. They will also prevent depositing fingerprints on the film surface. The oily fingerprints will show up during printing; worse, acids in the oil can actually etch the film surface, making the marks permanent.

Figure 7-31. *Developed negatives, after drying, should be stored in a protective covering. Plastic "negative pages" allow negatives to be easily examined, and can be stored in standard three-ring binders. Wearing cotton gloves will protect the negatives from fingerprints and scratches. Some plastics can damage negatives over time; use only pages made for archival storage.*

Developing sheet film

Film in cut sheets (generally 4″ × 5″ or 8″ × 10″) is processed using basically the same steps and chemical solutions as 35mm or 120-size film. While roll films are almost universally developed using small tanks, as described in the preceding section, sheet films present more choices of processing method. These include tray or open tank development, and the use of closed drums or tubes.

Tray or open tank development

The major disadvantage of the tray or open tank methods is that they must be carried out in total darkness to prevent fogging the film. The open tank method (also called "dip and dunk") uses metal frames, called hangers, that each hold one sheet of film. The hangers are suspended from the rim of the filled tank, so that the solutions can reach all areas of the film. Agitation is accomplished by lifting the frames out of the solution, then lowering them back in (giving the process its "dip and dunk" name). Emptying and filling a tank in total darkness is impractical, so three tanks must be used: developer, stop, and fixer. Once film has been fixed, the lights can be turned on, allowing a tank to be emptied and refilled with other solutions (such as washing aid).

Open tray development uses smaller amounts of solutions than tank development, and does not require the use of hangers. It is easiest to use when only a few sheets of film must be developed. Since this method requires placing hands in the processing chemicals, the use of rubber gloves is recommended, especially for persons with sensitive skin.

Like the tank method, separate containers for developer, stop, and fixer must be used. The shallow trays should contain enough solution (about 1/2″–1″ in depth) to fully cover the sheets of film. The film sheets are slipped below the surface of the developer, one at a time. Once all of the sheets to be

developed are in the tray, they are agitated by a bottom-to-top shuffling process. As shown in **Figure 7-32,** the sheet at the bottom is slipped from beneath the pile, placed on top, and gently pressed down into the solution. The shuffling process continues through the entire development time. Sheets are transferred to the stop tray, one-by-one, until all are out of the developer. The procedures are repeated in the stop and the fixer.

Using a water presoak will prevent sheets from sticking together when first placed in the developer. A fourth tray can be used for water, but many photographers use water for the stop bath, and employ the same tray for both presoak and stop. Using water to stop development is believed to minimize the formation of pinholes on the large negatives. See **Figure 7-33.** These tiny clear spots, or holes in the emulsion, are thought to be caused by reaction of the alkaline developer to acid stop bath.

Closed tube or drum development

The use of closed tubes or drums for developing large format films has the same

Figure 7-32. *Tray development of large format negatives involves constant shuffling of the film as a method of agitation. This method is most easily used with a small number of negatives.*

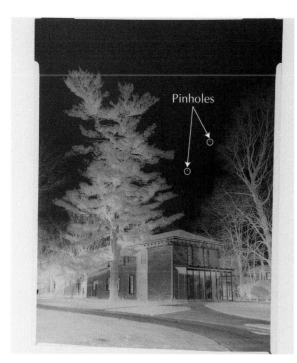

Figure 7-33. *Small holes in the emulsion of a large format negative are called pinholes. They are believed to be caused by a violent reaction between the alkaline developer and an acid stop bath. Pinholes would show as black spots on a print made from this negative.*

Figure 7-34. *Drum development can be carried out in room light. The drum is placed on a roller base like this one for manual agitation, or on a base that rotates it with a low-speed motor. Some motor bases rotate steadily in one direction; others use a reciprocating movement — first in one direction, then the opposite direction. (Jobo Fototechnic, Inc.)*

advantage as the closed tanks used for roll films: the film must be loaded in the dark, but all subsequent steps can be carried out in room light. Another advantage is use of a much smaller quantity of chemicals than either the tray or tank methods. Only a few ounces of developer, stop, and fix are needed for each sheet of film processed.

The closed tube method is manual — one sheet of film is placed in each tube, the appropriate amount of chemical is poured in, and the tube is capped. Agitation consists of continuously rotating the tube as it floats in a tray or tank of water. Subdued room light and the narrow tube form allow chemicals to be changed without fogging the film. Several tubes (and thus several sheets of film) can be managed at one time.

Drum development is usually mecha-nized, with a motorized base rotating the closed drum containing film and chemicals. One mechanized system rotates the drum in a temperature-controlled water bath. The unit has provision for chemical containers in the tempering bath, as well. Drums can also be agitated manually, by rolling them on a special base, **Figure 7-34,** or back and forth on a countertop. The drums come in various sizes, to hold different sizes of film (or paper, since they can also be used for print development). One popular size can hold a single sheet of 8″ × 10″ film, or four sheets of 4″ × 5″. The drums have a light-trap pouring spout that is used to add or empty chemicals.

Although their cost makes them imprac-tical for most home darkrooms, *automatic film processors* may be found in commercial studios, industrial or corporate photo departments, or similar settings. Processors, like the one shown in **Figure 7-35,** can handle multiple rolls or sheets of film. Once film is loaded, the process is carried out automatically through development, fixing, washing, and drying of the film.

Figure 7-35. *Automatic film processors have built-in programs for developing color slide, color negative, or black-and-white film. Sheet film, as well as roll film, can be processed. (PhotoTherm)*

Development variations

The development process can be altered in various ways to compensate for exposure or lighting problems, or to obtain certain results, such as increased or decreased contrast. The alterations may be made through choice of developer or through adjustment of developing time (or a combination of the two).

Push processing

Although you normally attempt to expose your film properly, there will be times when you underexpose by accident or by design. The first underexposure situation might occur when the ISO rating of your film is different from the film speed setting on your camera (assuming you are using a camera that doesn't read the film cassette's DX code). If you had been shooting ISO 400 film, then loaded a roll of ISO 200 without changing the speed setting on the camera, your photos on that roll would be underexposed by one stop. The second situation is one where you need to expose your film at a higher shutter speed or a smaller aperture than would be possible at the correct film speed. To gain the shutter speed increase that you need to shoot in a dimly-lighted interior, for example, you might set the camera's film speed indicator to 400, even though your actual film speed was ISO 100. In this case, you would be underexposing by two stops.

In either case, you can compensate for the underexposure by increasing the developing time. This method is called *push processing,* and can be used with both black-and-white and color films. When you push-process film, you are actually overdeveloping it, with a resulting increase in grain and contrast (see "Contrast Adjustment," later in this chapter). To minimize the effects of overdevelopment, push processing should be used only when necessary. A one-stop or two-stop push will generally provide results that are acceptable, but a push of three stops or more will cause the quality to degrade noticeably. For a surveillance photo or similar image that couldn't be obtained otherwise, or for a planned effect, such an extreme push would be justified.

The traditional "rule of thumb" for push-processing black-and-white films is to increase development time 50% for a one-stop push. For example, developing time for Ilford 100 Delta in ID-11 developer (1:1 dilution) is 10 minutes when the film is exposed at its normal ISO 100; exposing it at ISO 200 (a one-stop push) requires a 15-minute developing time.

Kodak states that a number of its black-and-white films (T-Max 100 and 400, Plus-X Pan, and Tri-X Pan) can be underexposed one stop and processed at normal times. Two-stop or three-stop underexposure, however, requires push processing. With these films, a two-stop push would require a 50% increase in development time; a three-stop push would be done by doubling normal development time. For example, Tri-X Pan (ISO 400) processed in T-Max developer would require a 5 1/2 minute developing time for normal or one-stop push development. For a two-stop push (rating at ISO 1600), the time increases by 50% to 8 1/4 minutes. A three-stop push (film rated at ISO 3200), the normal developing time of 5 1/2 minutes

would be doubled to 11 minutes. Some variation in push-processing recommendations will be found from film to film; use the manufacturer's recommendation as a starting point and test with your developer and processing conditions.

The opposite of push processing is *pull processing,* a technique that is much less commonly used. Pull processing is intentional underdevelopment of the film, and is typically employed in situations where the film has been overexposed by one or more stops. It is also used in extreme contrast situations, such as a night shot of a brightly-lighted scene (for example, an oil refinery). The amount of reduction depends upon the film and developer, but a typical starting point for a one-stop pull is a 30% reduction in developing time. One danger of pull processing is too-short developing times, which can result in uneven development. Development times shorter than 5 minutes should be avoided.

Developer type choices

Instead of push processing an underexposed negative or roll of film, some photographers prefer to use a special *high-energy developer,* also called a speed-enhancing developer. When used as directed by the manufacturer, these developers will produce somewhat less contrast increase and finer grain than processing in a standard general purpose developer for longer times.

Two other types of special developer may be selected for specific purposes; both work best with slow to medium-fast (up to ISO 400) films. *Extra-fine-grain developers* are low-energy types that tend to work slowly and produce a lower-contrast negative. They produce finer grain by preventing the formation of clumps caused by overlapping of silver grains. Some general purpose fine-grain developers, such as Kodak's XTOL, can be diluted to produce a finer-grained result. *High-acutance developers* provide an impression of greater image sharpness. They do so by concentrating development in the layer of

silver in the uppermost portion of the emulsion. This avoids the slight blurring effect that occurs when the developed image is formed by grains deeper in the emulsion.

High-contrast developers are designed for use with graphic arts (lithographic or "lith") films that are developed to show only black-and-white values, with no middle tones. High-contrast developers are sometimes used with normal films to achieve special effects.

Contrast adjustment

Adjustment of film exposure and development, similar to the push-processing approach, can be used to consciously alter the contrast of the developed negative. This is done in response to the conditions under which the film was exposed: the *subject brightness range.* If you are shooting outdoors on a day when the sky is covered with thick clouds, your subject will almost certainly exhibit a compressed subject brightness range, or *low contrast.* The resulting photo would be termed "flat," showing a limited range of gray tones, without strong blacks or whites, **Figure 7-36.** The opposite extreme would be a scene shot in bright midday sunlight, which would

Figure 7-36. *A low-contrast scene has a short tonal range and tends to look "flat" and uninteresting. This scene, photographed on a dark and foggy day, has almost all middle tones. There are no dark shadows or bright highlights.*

exhibit a wide subject brightness range, or **high contrast.** The resulting photo would have a wide range of gray tones, and would show deep black shadows and brilliant (but probably featureless) white highlights, **Figure 7-37.**

As you will remember from the discussion of the Zone System, the basic principle is to *expose for the shadows and develop for the high-lights.* In other words, the exposure you choose for the scene controls the detail and density in the shadow areas, while development you give the film controls the density and thus detail in the highlights. See **Figure 7-38.**

Figure 7-37. *A high-contrast scene has a wide tonal range and may look overly contrasty with highlights and shadows that contain little or no detail. This photo was taken in harsh midday sunlight. While it has a good range of middle tones, the extremes lack detail.*

Applying this knowledge to the low-contrast scene, you would decrease exposure and increase development. The decreased exposure decreases density in the shadow areas of the negative, making them darker when printed. The increased development gives the highlight areas of the negative greater density, making them print lighter. By making the shadows darker and the highlights lighter, this method will yield a print with a wider tonal range that has more "sparkle," or visual interest. The actual exposure and development adjustments to increase contrast are best determined by experimenting with your film/camera/developer combination. A starting point would be one-half stop under-exposure and a development time increase of 30% to 50%.

When photographing high-contrast scenes, the same technique is used but the directions are reversed: *increase* exposure and *decrease* development. By increasing exposure, shadow densities on the negative will increase, making them print somewhat lighter. Decreasing development time will decrease the density of highlight areas on the negative, making them print darker. The print resulting from a negative exposed and developed this way will have a narrowed tonal range, or decreased contrast, that will improve detail in both the shadows and the highlights. Increasing exposure by one-half stop and decreasing development time by 15% to 30% is a good starting point for decreasing contrast.

These methods of contrast control are easiest to use effectively with sheet film, since exposure and development can be adjusted for each piece of film. The application to 35mm or 120-size roll film is more limited, since the entire roll is affected by changes in development. For effective use with these films, an entire roll should be exposed under the same conditions and with the same exposure adjustment — you can't mix high- and low-contrast scenes on a roll and obtain good results from both.

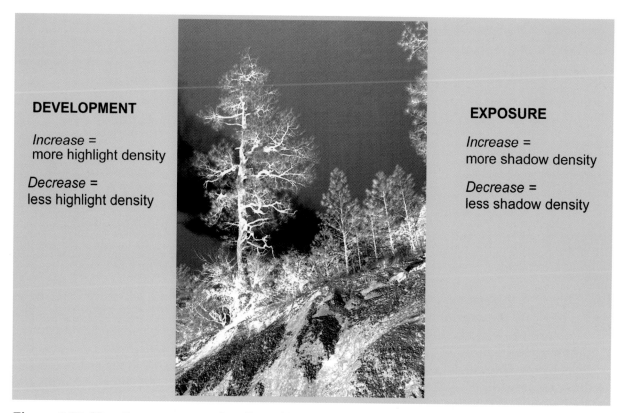

DEVELOPMENT

Increase =
more highlight density

Decrease =
less highlight density

EXPOSURE

Increase =
more shadow density

Decrease =
less shadow density

Figure 7-38. *Negative contrast can be adjusted by adjusting exposure and development in combination.*

With the introduction and widespread use of variable contrast printing papers, adjustment of contrast *while making the print* has become more common than the methods just described. As you will learn in the next chapter, an appropriate filter and corresponding change in print exposure time can be used to increase or decrease contrast. The contrast change can be applied to the entire print, or even certain areas of the print as needed.

Intensification and reduction

In extreme cases, a negative may be so underexposed or underdeveloped (or over-exposed/overdeveloped) that you will find it virtually impossible to make an acceptable print. Such negatives can be treated using chemicals called intensifiers and reducers. An *intensifier* will darken the weak image of an underexposed or underdeveloped nega-tive, making it more printable. Both grain and contrast will increase as a result. A

reducer makes changes in the opposite direc-tion: it dissolves away some of the silver to lighten the very dense negatives that result from overexposure or overdevelopment. See **Figure 7-39.** Using an intensifier or a reducer is usually considered a last resort, since you are physically altering the negative. In some cases, however, it is the only way to salvage an image.

"Reading" the negative

The interrelated effects on the negative of exposure and development are easiest to see and understand when the variations are displayed side-by-side in a form called a *ringaround*. As shown in **Figure 7-40,** a ring-around is a panel of nine developed negatives of the same subject showing all possible combinations of exposure and development. The name is derived from the fact that nor-mally exposed/normally developed negative is in the center, and all the variations form a

Figure 7-39. *Effects of reduction. A—This weak image was printed from a very dense, overexposed negative. B—A print made from the same negative after reduction with Farmer's Reducer exhibits a greatly improved tonal range. Contrast and grain have both increased as a result of reduction, however.*

ring around that negative. The three horizontal rows are the development variations (under, normal, over); the three vertical columns are the exposure variations (under, normal, over). Thus, the negative in the upper-left corner shows the effects of both underexposure and underdevelopment. The diagonally opposite negative, in the lower right corner, shows the effects of overexposure and overdevelopment. Careful examination of the negatives, and the matching set of prints in **Figure 7-41,** will help you learn how to "read" your negatives as an aid to making good prints. Examining negatives on a regular basis will also help you improve your photography by indicating problems (such as consistent underexposure) that should be corrected.

When examining a negative, first look at the overall density: is it thin and light gray in appearance (underexposed) or dense and dark overall (overexposed)? A properly exposed and developed negative of a subject with a full-range of tones will exhibit a matching range of tones, although they will be reversed in value for the scene. The highlights, which appear darkest on the negative, should exhibit detail in all but the most dense areas. In the same way, the shadows (light on the negative) should show detail or texture in all areas except those that will print pure black.

The details of the scene, when examined under magnification, should be sharply focused. If an object or detail appears soft in the negative, it will be much more obviously soft when an enlarged print is made. If your subject is a person or an animal, the eye is an area of critical focus. If the eye is not sharp, most viewers will react unfavorably to the print.

There are a number of physical faults that you should watch for when examining negatives. These include:

- *Scratches, pinholes, or dust embedded in the emulsion.* These problems can usually be avoided by careful handling and good darkroom cleanliness. Dust spots will show up as white areas on the print, while scratches or holes in the emulsion will print black. Parallel scratches running the length of the film are typically made by a burr or grit in the camera's film transport mechanism.

- Clear or *opaque patches* on the film, **Figure 7-42,** are caused by adjacent areas of film touching on the developing reel. Most often, this is caused by two turns of film wrapping into the same spiral groove on a stainless steel reel. If the film touches, the developer can't reach the emulsion. Dark round spots or *mottling* on the film can be caused by **air bells** (bubbles) that cling to the film surface and interfere with development. Dark, arc-shaped *kink marks* on the film indicate that the film was bent sharply, or kinked, during loading on the reel.

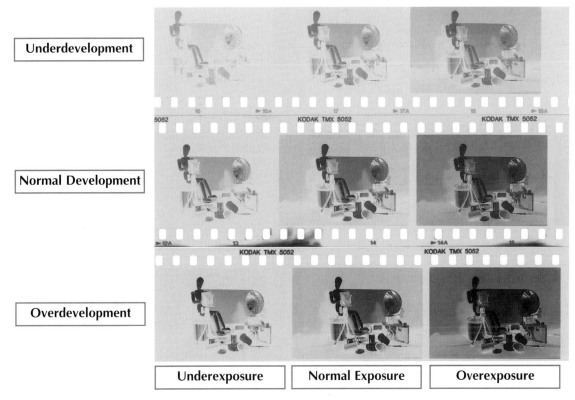

Figure 7-40. *A ringaround allows you to compare negatives side-by-side to see the effects of different exposure and development combinations.*

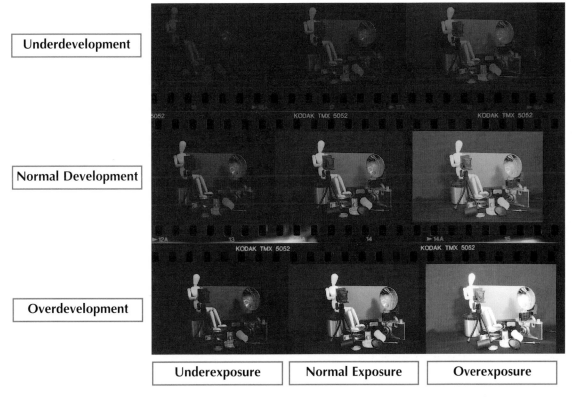

Figure 7-41. *Prints showing the result of each negative condition depicted in Figure 7-39.*

Figure 7-42. When adjacent areas of film on the development reel touch, the developer cannot reach the emulsion to act upon it. The result is an opaque or clear patch without any image. This problem occurs primarily with stainless steel reels, but can occur if plastic reels are carelessly loaded.

- If the *negative is clear* except for the manufacturer's edge printing (name and numbers), the developed film was never exposed. Clear film *without* edge printing was exposed to processing chemicals in the wrong order: fixer before developer. If the film is completely black, or has large black areas, it was *fogged* by exposure to light, either before loading into the camera, or before being sealed in the developing tank.

- *Overlapping images* can indicate a faulty film transport mechanism in the camera, or an exposed roll that was inadvertently loaded and exposed again.

- Uneven development in which one edge of the film is lighter than the other is a sign of *insufficient developer* in the tank. Solutions must completely cover the film inside the tank. Too much agitation can cause light-colored streaks across the film next to the sprocket holes. These *surge marks* are caused by extra development as the solution surges through the sprocket holes. Too little agitation will usually cause uneven development due to the developer becoming locally exhausted.

- Insufficient *fixing* can result in negatives with a milky appearance. When processing T-Max films, a purplish or pink coloration indicates that fixing time was too short or that the fixer is nearing exhaustion. See **Figure 7-43.** The color

Figure 7-43. Fixer that is nearing exhaustion, or a fixing time that is too short, can leave a pink or purple cast on T-Max negatives (bottom strip). Using fresh fixer for the proper time will correct the problem.

cast can be removed by placing the film in fresh fixer for the recommended period (twice the clearing time). The normal sequence of washing aid and wash (or longer wash if washing aid is not used) would then be followed.

Questions for review

Please answer the following questions on a separate piece of paper. Do not write your answers in this book.

1. Why was the introduction of the Kodak roll film camera an event of major significance to the development of photography?

2. Once film has been placed in a _____ tank, the developing process can be carried out in normal room lighting.

3. If you needed to process several rolls of film, one after the other, would you use a plastic or a stainless steel reel? Why?

4. Developer and _____ are both necessary for film development. An acid stop bath and a _____ may also be used, but are not required.

5. You are using a liquid developer concentrate and want to make a liter (1000 ml) of working solution. The directions tell you to mix concentrate and water in a 1:4 ratio. How much concentrate and how much water will you use?

6. When mixing photographic chemicals, always clean equipment thoroughly to avoid _____.

7. Although both light and oxygen can cause darkroom chemicals to lose their effectiveness, _____ causes the more serious threat.

8. Which of the following does not have a surface area of 80 sq. in. (the unit used to calculate developer capacity)?

 a. one sheet of 8" × 10" film

 b. one roll of 120-size film

 c. one 24-exposure roll of 35mm film

 d. four sheets of 4" × 5" film

9. _____ is the key to safe disposal of used photographic chemicals.

10. Why must film be loaded onto the developing reel in total darkness?

11. State the general relationship between developer temperature and developing time.

12. For proper fixing of developed film, first find the "clearing time," then fix for _____ times as long.

13. To compensate for underexposure, film can be deliberately overdeveloped — a method known as _____.

14. When photographing very high-contrast subjects, one method of controlling contrast in the negative is to _____ exposure and _____ development.

15. If a negative is too dense to print properly, it can be treated with a _____ as a last resort.

Wet side:
The area of a darkroom that includes the processing sink, chemical storage, and solution mixing equipment.

Chapter 8

Setting up a Darkroom

When you have finished reading this chapter, you will be able to:
➥ Describe the alternatives available when planning a darkroom.
➥ Evaluate the advantages of different types of enlargers.
➥ List the basic items of equipment for enlarging and print processing.
➥ Discuss proper storage methods for photographic solutions.

Unless all of your photographs are made on transparency (slide) film, your photographic experience is only two-thirds complete when you have exposed and processed your film. For many persons, *making prints* is the final third of the complete photo experience. Some even consider it the most enjoyable and fulfilling aspect of photography.

Photographers may have access to a well-equipped darkroom in a school or through an organization, such as a local camera club or community center. See **Figure 8-1.** Those who live in large cities may find rental darkrooms that are available by paying an hourly or daily fee. For most photographers who wish to do their own printing, however, setting up a personal darkroom is the preferred course of action.

Temporary vs permanent facilities

The ideal darkroom would have sufficient sink room and counter space to handle the largest desired print, an efficient and step-saving arrangement, plenty of storage space for materials and equipment, and excellent ventilation. It would also permit precise control of water flow and temperature, maintain a comfortable air temperature,

Figure 8-1. *Many photographers obtain their first darkroom experience in school facilities like this one. Group darkrooms are also operated by community centers and similar organizations, and can be found for rent in larger cities. (Suzanne Silagi)*

201

and have a good sound system (few dark-room workers prefer to work in silence).

Darkrooms seldom achieve that ideal, of course; compromises are almost always necessary. At the opposite extreme is the darkroom that doesn't even *exist* most of the time — a temporary arrangement that is set up as needed. There are certain "bare mini-mum" requirements. These are the capability of excluding light, adequate ventilation, enough space to set up the enlarger and processing trays, and electricity to operate the enlarger and safelight. Such items as running water and temperature control make darkroom work more convenient and efficient, but good printing work can be done without them.

Temporary facility

If you live in an apartment, or in a house or trailer with no space to spare, you will have to work in a temporary darkroom. Although temporary darkrooms have been set up in many different locations, the most common are bathrooms, laundry rooms, and kitchens. Closets, storage rooms, and spare bedrooms are also used.

The obvious advantage of a bathroom, laundry room, or kitchen is, of course, *plumbing*. Running hot and cold water and a drain system are great conveniences for the photographer. However, many highly successful photographers have not had the luxury of permanent darkrooms with running water, especially early in their careers. One example is Harry Callahan, who did not have a darkroom sink for the first 25 years of his long photographic career. As he worked, he accumulated the devel-oped and fixed prints in a tray of water. At the end of the darkroom session, he moved the tray to a bathroom or kitchen sink for the washing step.

Room selection factors

When choosing a space for a temporary darkroom, a number of considerations must be weighed:

- *Is there enough room to work?* Even very small spaces may be usable through such strategies as using a rack to stack three trays in the area normally occu-pied by one. A small enlarger, a rack of trays, and a separate tray of water for holding prints could fit into a space as small as two feet by four feet.

- *Can light be excluded?* A space with no windows and a tight-fitting door (such as some bathrooms) is almost ideal. Windows can be made light-tight with opaque black plastic taped in place or held on a removable frame. A rolled bath towel can be used at the bottom of a door to exclude light. Unless there is a street-light outside the window, some rooms can be made usable by simply working at night and pulling down shades or tightly closing blinds and/or draperies.

- *How good is the ventilation?* Although the vapors from normal darkroom chemi-cals are not considered particularly toxic, they can be unpleasant to breathe and can cause headaches or allergic reactions. If possible, an exhaust fan should be used to draw in fresh air (another advantage of using a bathroom, since many are equipped with fans). The smaller the room, and the smaller the volume of air to dilute the fumes, the more important it is to ventilate. If your darkroom is set up in a closet or similar space, it may be necessary to period-ically open the door and use a fan to circulate the air.

- *Is electrical power available?* The enlarger will require electricity to operate; so will your safelight. A "white" light for viewing prints is also a good idea, as is a fan. Most spaces (with the possible exception of a small closet) have either an electrical outlet or a light socket. For your safety, any electrical outlet in an area where water will be present must be equipped with a *ground fault circuit interrupter (GFCI)*, **Figure 8-2.** The GFCI

Figure 8-2. *Outlets equipped with ground fault circuit interrupters should be used in any location where water is present, such as temporary or permanent darkrooms. A GFCI can prevent possibly fatal electrical shocks.*

will cut off electrical power instantly if a dangerous current flow (ground fault) develops. If an extension cord is used to bring electrical power into a room from elsewhere, a cord with a built-in GFCI should be used.

- *Is use of this space practical?* A space that fits all the other requirements may not be practical to use because of other considerations. For example, in a household consisting of several people, using the only bathroom as a darkroom (even late at night) might not be a good idea.

Beyond suitability of the space, a temporary darkroom presents some problems of logistics. The darkroom equipment and materials must be stored somewhere between uses, brought out and set up for each session, then broken down and returned to storage at

the end of the session. Because of the differing requirements of each photographer and the space available for storage and for darkroom use, there is no single solution.

If possible, the equipment and materials should be stored in or near the room where they will be used. Sometimes, storage might be split: smaller items such as trays, boxes of paper, and bottles of chemicals can be kept in the room, while the enlarger is stored elsewhere. A number of enlargers designed for "entry level" darkroom use are small and light enough to be easily carried. A practical solution adopted by some photographers is a small rolling cart of the type often used for microwave ovens. The enlarger is placed on top of the cart, and most of the other equipment and materials are stored in the lower section. The cart can be easily rolled into the space used for darkroom work. Another solution is a bedroom clothes closet with bifold doors. If half (or better, all) of the closet can be devoted strictly to darkroom use, a counter and storage shelves can be built in. By opening the bifold doors and excluding light from the bedroom, the darkroom would be ready for use, **Figure 8-3.**

Figure 8-3. *There are many forms of temporary darkrooms. This modified clothes closet allows orderly storage and ease of use. The bedroom adjoining the closet must be fully darkened to allow use of the equipment.*

Somewhere between a temporary and a permanent facility is the ***dry darkroom*** that is established in a room (such as a spare bedroom) that is not used for other activities. Although finished prints must be held in a tray of water and taken elsewhere for washing, the dry darkroom has the advantage of remaining set up for use.

Permanent facility

The ideal, of course, is a space that can be used exclusively for photographic developing and printing. In addition to the convenience of having the facility always ready for use, a dedicated darkroom space can be customized to your working methods and preferences. Some photographers like a fairly large space, with plenty of room to move around; others like a more compact layout, with everything placed in easy reach. Although workable darkrooms have been set up in closet-sized spaces, a space approximately 6′ × 8′ will allow a compact but efficient layout suitable for one person. If two persons are likely to use the darkroom at the same time, or if prints larger than 11″ × 14″ may be made, a larger space (such as 10′ × 12′) will be needed. Print mounting and finishing will require additional darkroom space, unless a separate workroom area can be set up.

Darkroom layout

When planning a darkroom installation, the first step is to develop a floor plan or layout indicating the size and position of all equipment and work areas, **Figure 8-4.** If the darkroom is being fitted into an existing room, some creativity and compromise may be necessary. Greater flexibility will be available if the darkroom space is being created from a larger area (such as walling off a portion of a basement).

When alternate locations are available within the building (such as basement vs attached garage or main floor vs attic), the *working environment* should be an important consideration. An attic space or garage can become uncomfortably hot in summer or cold

Figure 8-4. *Making a layout is the first step in darkroom planning. A rough sketch can be refined on graph paper to show all the elements to scale.*

in winter. Basement areas can be excessively damp. A darkroom located on the main floor or second floor of a house may be plagued by floor vibrations as occupants move around. Each darkroom installation is unique, and typically requires compromise from the ideal.

A darkroom is traditionally divided into a *wet side* and a *dry side*. As shown in **Figure 8-5,** the ***wet side*** consists of the

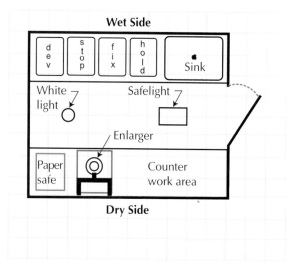

Figure 8-5. *A typical medium-size (8′ × 10′) darkroom provides ample sink and counter space for developing, printing, and related activities. The arrangement completely separates the wet side and dry side, and permits efficient processing without wasted steps.*

processing sink and areas for washing prints, viewing wet prints, and print drying. Chemical storage containers and mixing equipment are also normally kept on the wet side of the darkroom. The *dry side* contains the enlarger, counter space for such equipment as a paper trimmer, and storage for photographic paper and other materials and tools that must be kept dry. If space allows, equipment and materials for print mounting and finishing are also located on the dry side. If the darkroom is small, print mounting and finishing are usually done in a separate work space.

Ventilation and light exclusion

Two important considerations in darkroom design are *excluding light* and *providing good ventilation*. The two are related, since any vents or fans for air movement must be properly *light-trapped* (designed to prevent light from entering the darkroom). Fans and louvered vents specially designed for darkroom use can be purchased. Since light travels in straight lines, it is also possible to construct a baffle system to exclude light. A method used to provide light-excluding ventilation through a conventional partition wall is shown in **Figure 8-6.**

Ventilation should be arranged so that air movement is across the wet side, so that any chemical fumes will be drawn away from the person working at the sink. Ventilation systems can be negative or positive. In a *negative ventilation system,* an exhaust fan on the wet side draws air through the darkroom from intake vents on the dry side. In a *positive ventilation system,* the fan is placed on the dry side and blows fresh air into the room. The air exits through vents on the wet side. Either system is effective in removing chemical fumes and providing a continuous change of air in the darkroom. The negative ventilation system has one drawback that makes the positive system preferable. The negative system creates a slightly lower air pressure inside the darkroom, so that dust and lint particles

can be drawn in through small cracks. The positive system has the opposite effect, keeping the darkroom more dust-free.

Other openings in the darkroom walls — windows and doors — must be covered or sealed in a way that will prevent light from entering. Windows often can be covered with an opaque material such as black plastic, which is taped to the frame. An alternative is a piece of plywood, foamboard, or a plastic-covered framework that fits tightly into the window opening. Any gaps around the insert that show light can be sealed with an opaque tape.

The door presents a special problem, since it must be opened and closed to allow access to the darkroom. When space is available, a light-trap entrance can be used. These entrances, **Figure 8-7,** permit easy entry and

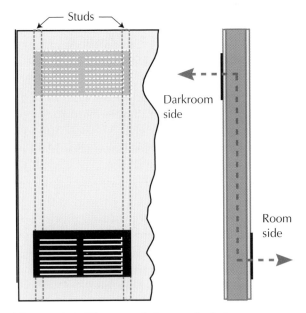

Studs

Darkroom side

Room side

Figure 8-6. *The space between studs in a conventional interior wall can be used for darkroom ventilation that will not admit light. Openings are cut through the plaster or drywall on opposite sides of the wall in the same cavity between studs. The openings should be 3' to 4' apart vertically. The wall cavity between the two openings should be sprayed with flat black paint to prevent light reflection. Louvered covers (painted black) are used to cover the opening. Power ventilation is achieved by attaching a fan to one of the openings.*

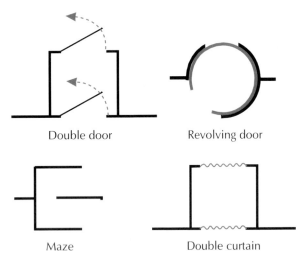

Double door Revolving door

Maze Double curtain

Figure 8-7. *Light-trap entrances for the darkroom are convenient if space is available. The commercially available rotating door requires the least room, while the maze entry allows the easiest access.*

exit without the danger of exposing photo material to light. Often, the darkroom location or available space will not permit use of such a light trap, and a single door opening directly into the darkroom must be used. In this case, special care must be taken to exclude light. The door should open outward for emergency egress, and should fit as tightly as possible in its frame. An adjustable "sweep" or weatherstrip should be attached to the bottom edge of the door to seal the opening between the door and the floor. Plastic foam weatherstrip material with a pressure-sensitive backing can be positioned on the door or the doorway moldings to form a light-tight seal when the door is closed. The material is inexpensive and is readily available in hardware stores.

To check for light leaks, sit in the closed darkroom for a few minutes. Even the smallest leak will be apparent in the otherwise total darkness. By keeping a roll of opaque tape in hand, you will be able to quickly seal these small light leaks.

Water and electricity
The darkroom should be equipped with both a cold and hot water supply, a connection to the household drainage system, and an electrical circuit with sufficient capacity to handle all lights and equipment. If the water and drain connections are already in place, they may dictate placement of the processing sink. If they are being installed, the best location for the sink should be identified first, and the plumbing located there. Installing a water filter of the replaceable cartridge type in the line will provide the cleanest possible water supply.

For most "starter" darkrooms, especially those that will be used primarily for black-and-white, separate hot and cold water valves on a mixing faucet regulate water temperature When used with an in-line thermometer, **Figure 8-8,** this system can provide fairly accurate control of water temperature. If greater precision is desired or needed (as when developing color, which requires holding some temperatures within $\pm 1/2°F$) a temperature regulating system should be installed. A number of such systems, like the one shown in **Figure 8-9,** are available commercially.

Electrical requirements of the darkroom will depend upon the number and size of

Figure 8-8. *A standard mixing faucet, when used with an in-line thermometer, provides sufficiently accurate temperature regulation for black-and-white darkroom work. It cannot compensate, however, for temperature fluctuations caused by waterflows in other parts of the system (such as a shower or automatic washer).*

Figure 8-9. *Special regulating devices can be purchased to precisely control water temperature within a fraction of a degree. Such systems also compensate for changes in pressure or temperature fluctuation caused by users of the household water system. (Hass Manufacturing Company)*

the devices used. At minimum, the circuit must be able to handle an enlarger and timer, ventilation fan, a safelight, and general (white) lighting. Additional devices that might be used include a film processor, inspection light, a motor base for processing drums, film drying cabinet, a print dryer, and a drymounting press. As noted earlier, most darkroom workers also enjoy some type of sound system: radio, cassette player, or CD player.

Separate switches should be installed on the dry side of the darkroom to control the ventilation fan, safelight, and white lights. Preferably, the white light should be in a pull-chain type fixture, which will allow it to also be controlled by a nonconductive cord. In many darkrooms, a strong string or cord is run horizontally the length of the room and connected to the light chain. This

permits the light to be safely turned on from any point in the room, even with wet hands.

Sufficient electrical outlets to meet present and future needs should be installed. Most will be on the dry side, but some may be placed on the wet side if needed. Any outlet on the wet side must be placed well above the level of the sink to avoid possible splashes of water or chemicals. All outlets in the darkroom, whether on dry side or wet side, must have GFCI (ground fault circuit interrupter) protection.

For your safety and the safety of others in the household, all plumbing and electrical installations in the darkroom must comply with local and national codes.

Sink, counters, and shelves

You may approach the "fixtures" aspects of setting up your darkroom in one of three ways: building, buying, or a blend of the two. Which one you choose will depend upon your budget, your timetable, and your carpentry skills.

The most time- and labor-intensive course, naturally, is to *build* all the necessary items. The major advantage of this approach is customization: everything will be suited specifically to your space and your needs. A smaller advantage might be reduced out-of-pocket cost.

From a carpentry standpoint, the sink is not a particular challenge: an open-topped box made from 3/4" plywood (marine-grade, preferably), approximately 6" deep with a hole cut at one end to accept a drain. It should be a minimum of 18" wide (front to back), but 24" is better. If you plan to make prints in larger sizes, such as 16" × 20", a 30" width is desirable. Length can be as short as 4' (the practical minimum for making 8" × 10" prints) to as long as the available space.

The challenge in building a processing sink, of course, is watertightness and resistance to chemical attack. Some sink builders apply several coats of epoxy finish, while others choose to build up a fiberglass and resin coating like that used in fabricating

boats and similar structures. Properly applied, either finishing material will provide long and useful service in the darkroom. The framework built to support the sink should be strong enough to give rigid support and must provide a slight slope for proper drainage.

The countertops on both the dry side and the wet side (if used) should be smooth and hard for easy cleaning. Surfacing is normally done with a plastic laminate, such as Formica® — odd lengths of prefabricated kitchen countertops are often available from building supply stores at bargain prices. Storage shelves and bins or drawers should be installed beneath the counters; shelves for chemical containers and measuring/mixing equipment are often installed above the processing sink. The prefinished shelving boards available from building supply stores have a smooth surface that is easy to keep clean.

The opposite course of action to building darkroom fixtures is to *buy* all of the items ready-made. Cabinets and countertops can be purchased at building supply stores. The cabinets can be obtained with varying combinations of drawers and doors to meet different storage needs. They can be bought already finished, or in an unfinished ready-to-paint form at a lower cost.

Processing sinks may be ordered from several different suppliers, and are typically either stainless steel or ABS plastic. Most sinks are either 24″ or 30″ wide and are offered in standard lengths of 4′, 5′, 6′, and 8′. Stainless steel sinks are also made to custom sizes. Stainless steel photographic sinks are made from Type 316 stainless, which is not affected by photo-processing chemicals. Some photographers have found used restaurant sinks at bargain prices, but the long-term durability of such sinks is unknown, since they are made from different stainless steel formulations.

When selecting a sink, two factors must be considered: the space available, and the size of the largest prints you plan to make. As noted earlier, a 4′ sink is the shortest practical for making prints up to 8″ × 10″ in size, assuming the use of four processing trays size-by-side. Larger trays can be accommodated, however, by using a stacking device that holds three trays in a "ladder" arrangement. The 6′ and 8′ lengths allow more flexibility, if space to install them is available.

Most photographers blend elements of each approach to a greater or lesser extent. They might buy a sink and some of the cabinets and build the rest, or they may build the sink and purchase all the other fixtures.

Before fixtures are built or moved into the darkroom, all floor and wall finishing should be complete. For ease of cleaning, flooring should be hard-surfaced, such as vinyl tile or seamless sheet material. For the same reason, walls should be finished with a durable and washable semigloss or flat enamel paint. Most of the walls and ceilings can be painted white, but areas behind and to either side of the enlarger should be painted flat black to absorb any stray light reflections.

Equipping the darkroom

Once the basic facilities have been completed, equipment can be gathered and moved in. The largest single item of equipment will be the enlarger. Other items related to enlarging are one or more lenses and negative carriers, a timer, a set of variable contrast filters, a focusing aid, a printing easel to hold paper in place, a paper safe (light-tight storage box) for the printing paper, and negative cleaning tools (a soft brush and can of compressed air). Processing equipment and materials include processing trays, print tongs or rubber gloves, a clock or digital timer, a print washing device, print drying equipment, chemicals, mixing tools, and appropriate storage containers.

Enlargers

There are two basic types of photographic enlargers: those with a condenser head and those with a diffusion head. There are also two different types of light sources, incandescent bulbs (used in both condenser and diffusion enlargers) and a specialized form of fluorescent bulb (called a "cold light") that is used only in diffusion enlargers. Three typical enlargers are shown in **Figure 8-10.**

In a *condenser enlarger,* light is passed through a condensing lens to make it directional and focus it on the plane where the

negative is held, **Figure 8-11.** This bright, focused beam of light permits relatively short exposure times, and provides a sharp and somewhat contrasty image. It also tends to make defects, such as dust spots or scratches on the negative, more noticeable in the print.

Many condenser enlargers use a frosted 75 W or 150 W incandescent bulb (similar to a standard household lightbulb); those intended for color enlarging typically use a quartz halogen lamp (like those used in slide projectors). The halogen lamp provides a more consistent color and intensity of light than a standard incandescent. A specialized type of condenser enlarger, called a *point source enlarger,* uses a small and very bright incandescent lightbulb. The light is highly directional and produces very sharp and contrasty images. However, it also makes negative imperfections even more noticeable than a standard condenser enlarger. Point source enlargers are rarely used for conventional photo enlarging work.

Figure 8-10. *Three enlarger types. From left to right, dichroic color head, variable contrast, and condenser. The dichroic head allows the darkroom worker to "dial in" settings for yellow, magenta, and cyan filters. The VC enlarger is a diffusion type, with the light source balanced for use with variable contrast papers. This model has settings for different paper brands. The condenser enlarger is extensively used for black-and-white printing. It has a holder that accepts filters for printing with variable contrast papers. (Charles Beseler Company)*

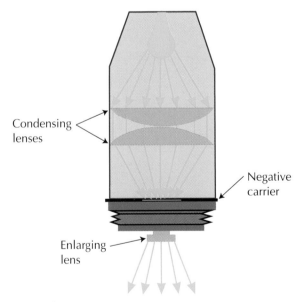

Figure 8-11. *Light from an incandescent source is focused and made more directional as it passes through the condensing lens(es) inside the enlarger. The focused beam of light passes through the negative and the enlarging lens, so that the enlarged image is projected onto the paper.*

The *diffusion enlarger,* as its name indicates, produces a soft, unfocused light for enlarging. The light from an incandescent or fluorescent source is made nondirectional by passing it through a frosted diffusing panel, as shown in **Figure 8-12,** or by reflecting it repeatedly off the walls of a "mixing chamber." The unfocused light passes through the negative and enlarging lens to make an exposure on the printing paper. In comparison to a condenser enlarger, the diffusion enlarger requires longer exposure times and produces a print that is somewhat softer in contrast. An offsetting advantage, however, is that negative imperfections — particularly scratches — are less noticeable on the print (compared to a print made with a condenser enlarger).

Although many diffusion enlargers use the same type of incandescent light source as the condenser enlarger, a significant number are equipped with fluorescent or

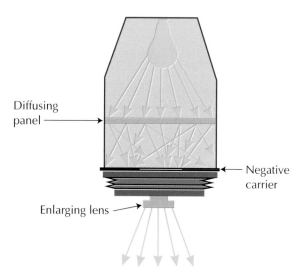

Diffusing panel

Negative carrier

Enlarging lens

Figure 8-12. *In a diffusion enlarger, the light from an incandescent or fluorescent source is softened and made nondirectional by passing through a frosted diffusing panel, as shown. Other types of diffusion enlargers use a "mixing chamber," where light rays are made nondirectional by repeatedly reflecting off the walls. The soft glow of the diffused light passes through the negative and the enlarging lens to print a projected image on the paper.*

cold-light heads. These heads consist of a grid of fluorescent tubes that emits a soft nondirectional light. The light is usually further diffused before passing through the negative. An advantage of the cold-light head, in addition to the benefits already listed for diffusion light sources, is its relatively low heat production. This advantage is primarily of interest to photographers printing from medium format and large format negatives. Heat produced by incandescent sources can cause a larger negative to expand and "pop" out of focus during longer exposure. The cold-light source eliminates that problem.

Standard cold-light heads emit light that is strongly biased toward the blue end of the spectrum (in comparison to the warmer, more red incandescent light). This creates a problem when printing with variable contrast (VC) paper, since the variable contrast is achieved by using filters to control the amounts of blue light and green light reaching the paper. One solution is to use a 40cc yellow color correction filter along with the VC filters. Better control can be achieved by using one of the special cold-light heads developed for use with VC papers.

Although it is primarily used with a diffusion light source, especially when printing color, the *dichroic filter head* can also be used in a condenser mode (in some enlarger brands). The filter head, **Figure 8-13,** permits the photographer to "dial in" the desired values of yellow, magenta, and cyan filtration when printing color. This is simpler and faster than assembling packs of sheet-type color correction filters and placing them in a filter drawer. The head can be used for printing with variable contrast black-and-white paper as well. Different yellow or magenta values are set on the controls, substituting for the sheet-type variable contrast filters used with other enlargers.

Selecting an enlarger

When selecting an enlarger, important considerations are the size of negative it will accept, the largest size print that can be

Figure 8-13. *The dichroic head enlarger permits the photographer to simply dial in the desired filtration for either color or variable contrast printing. Yellow, magenta, and cyan values can be independently controlled.*

made on the baseboard, the sturdiness of construction, and the adaptability of the design. See **Figure 8-14.**

Enlargers are available in a variety of sizes, ranging from small and inexpensive "hobby" units usable only for 35mm negatives to huge pieces of equipment capable of handling 8" × 10" negatives. Most common for use in home and small commercial or educational darkrooms are those able to be used with 35mm and medium format (120-size film) negatives. Less extensively used, but still common, are enlargers that can accept negatives up to 4" × 5" in size.

The size of the largest print that can be made on the baseboard of the enlarger is governed by the combination of the negative size, enlarging lens focal length, and height of the enlarger column. Typically, for a 35mm negative and the standard 50mm enlarging lens, an enlarger will be able to produce an 11" × 14" print with the head raised to the top of the column. Some enlargers are offered with an extended length column that permits an even larger print on the baseboard. An alternative available on many enlargers is the ability to swivel the head 90° so that the image can be projected onto an adjacent wall to make larger prints.

If the enlarger is not sturdily constructed, raising the head to maximum height can cause vibrations that result in unsharp prints. Some enlarger models use a twin-rail frame as a column, others use a heavy

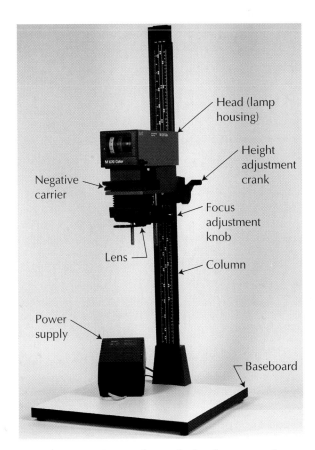

Figure 8-14. *Parts of a typical enlarger used with 35mm negatives. An enlarger should be well-made, sturdy, and adaptable to the photographer's changing needs. (Jobo Fototechnic, Inc.)*

column made with a square or triangular cross-section. On a well-built enlarger, parts will appear to be well-made and fit together properly. All movements (such as raising and lowering the head on the column or adjusting the lensboard for focusing) should be smooth and precise, without noticeable "play" or looseness. Any locking devices should operate smoothly and release easily.

Adaptability of the enlarger is important to suit your changing needs or photographic interests. It should have the capability of handling a range of negative sizes (usually 35mm to the various medium format sizes based on 120 film), provision for switching from black-and-white to color printing, and the ability to adapt to a cold-light source. Some enlargers are built on a "system" or modular approach. This allows the photographer to begin with a basic condenser design for black-and-white enlarging, then later add specialized modules, such as a cold-light head, a diffusion head, or a dichroic filter head for color.

A feature that is highly desirable in any enlarger is a *filter drawer* positioned between the light source and the negative. The drawer allows the use of inexpensive acetate or gelatin filters for either color printing or variable contrast black-and-white printing, **Figure 8-15.** Positioning of the filters *above* the negative is important, since the light is modified without optically degrading the projected image. In cases where the enlarger does not have a drawer, filters usually must be positioned between the enlarging lens and the paper. To avoid softening or distorting the image, filters used in this way must be handled very carefully to avoid fingerprints, dirt, or physical damage, such as scratches.

A well-made enlarger will last for many years with little or no need for maintenance beyond occasionally replacing a burned-out bulb. For this reason, it pays to buy a good quality enlarger, since you may never have to purchase a replacement. Since they are so durable, a good quality enlarger can be purchased used and provide years of excellent service.

Figure 8-15. *A filter drawer positioned in the light path between the light source and the negative allows use of low-cost sheet-type filters to control color or contrast. Since the filters are above the negative, they do not soften or distort the image.*

Enlarging equipment and accessories

New enlargers are often sold without a negative carrier, lensboard (for mounting the enlarging lens) or the lens itself. A used enlarger may or may not include these items, depending upon whether you buy from an individual or a photo equipment dealer.

Negative carriers are usually made in a hinged two-piece design with openings sized for a specific negative format. See **Figure 8-16.** Although a carrier with a larger opening could be masked down to accommodate a smaller negative, most photographers prefer

Figure 8-16. *Negative carriers are constructed to firmly hold a negative in place in a precisely sized opening that will allow light to pass through. This is a glassless carrier, the type normally used for 35mm and medium format negatives.*

Figure 8-17. *The lensboard, with enlarging lens attached, can be easily mounted or dismounted to permit changing formats. The most convenient method is to use a separate lensboard for each lens.*

the convenience of using a carrier for each film format they might need to enlarge. For 35mm and medium format negatives, the holders are usually *glassless,* since the carrier design holds the negative sufficiently flat for printing. Carriers for 4″ × 5″ or larger negatives usually incorporate two sheets of thin, high-quality glass to hold the negative perfectly flat. Carriers that use glass must be kept free of fingerprints and dust to avoid degrading image quality.

Lensboards are used to hold lenses so that they can be easily mounted or dismounted from the enlarger, **Figure 8-17.** This makes a change from one film format to another quicker and more convenient than unscrewing one lens from the enlarger and replacing it with one of a different focal length.

Enlarging lens

The quality of your finished print will depend to a great extent on the quality of your enlarging lens, so you should buy the best lens that you can afford. New 50mm enlarging lenses (for use with 35mm negatives) are offered in a wide range of prices. As in the case of camera lenses, higher quality optics command a greater price. Like used enlargers, used lenses can often be a good means of fitting better quality into a tight budget.

A different focal length lens is usually needed for each film format to ensure proper *covering power* (the circular area that is "seen" by the lens) for the negative size. Common focal lengths and their matching film formats are:

25mm	110 film
35mm	126 film
50mm	35mm film
75mm	6cm × 6cm (120 film)
80mm	6cm × 7cm (120 film)
105mm	6cm × 9cm (120 film)
135mm	4″ × 5″ sheet film
150mm	4″ × 5″ sheet film
180mm	5″ × 7″ sheet film
240mm	8″ × 10″ sheet film

Many enlarger lenses in focal lengths from 50mm to 150mm (those used most commonly) have a *barrel size,* or threaded diameter, of 39mm. The 39mm thread is often referred to as the *Leica thread.* Lenses with a 39mm thread are usually held in place on the lensboard with a retaining ring called a "jam nut," **Figure 8-18.** Other barrel sizes, such as 50mm, 62mm, and 72mm, are used on longer focal length lenses. They may be threaded directly into the lensboard, or held with a jam nut.

Timer

For accurately timed exposures, most darkroom workers use some form of timer

Figure 8-18. *A threaded barrel, 39mm in diameter, is common on enlarger lenses used for 35mm and medium format work. They sometimes are threaded into the lensboard, but more often are slipped through an unthreaded mounting hole and held in place with a retaining ring called a "jam nut."*

that acts as a switch to turn the enlarger bulb on and off. Both conventional dial and digital-display (LCD) timers are available, **Figure 8-19.** Dial timers are calibrated in seconds, while digital electronic timers provide more precise control, and may be set in increments 1/10 second. The ability to repeat a setting is useful when making multiple copies of a print, and is offered on many

timers. Some electronic timers have programmable memories that permit a sequence of timed events. With some timer models, a foot switch can be used to start or stop operations, leaving the photographer's hands free. Since electrical fluctuations can cause light intensity to vary during exposure, some timing systems include a *voltage stabilizer*. Highly sophisticated timing systems, called **compensating enlarging timers**, monitor any voltage fluctuations and make necessary adjustments in exposure time.

Safelight

One of the advantages of black-and-white printing is that it can be done under safelight illumination, while color printing must be done in total darkness. Although an extremely dim amber safelight *can* be used for color, most darkroom workers find it provides too little light to be of practical use. The safelight used for darkroom work with most black-and-white papers is a light amber color designated "OC." It provides enough illumination to work comfortably. For work with high-contrast orthochomatic (red-blind) materials, a red safelight (designated 1A) must be used.

Figure 8-19. *Enlarging timers. A—Dial timers have a moving hand to show elapsed time. They can be set in 1 second increments. B—Digital timers show information on a lighted digital display panel. They can be set on 1/10 second increments and often have programmable memories. (Regal/Arkay)*

The smallest and simplest safelights are 15 W units that simply screw into a socket like a lightbulb. Larger units are designed to be wall-mounted or hung from the ceiling. They use 15 W or 25 W bulbs, depending upon size. For large commercial or school darkrooms, a ceiling-hung sodium-vapor safelight can provide illumination over a large area. For darkrooms equipped with fluorescent tube ceiling fixtures, special safelight sleeves are made to fit over the tubes. **Figure 8-20** shows several types of safelights.

Proper location of the safelight is important to prevent fogging of photographic paper during exposure and processing. Paper manufacturers recommend that the safelight be located no closer than four feet from any point where paper might be exposed to its illumination. Thus, it should be at least that distance from the paper safe, the enlarger, and the tray containing developer. Even when the light source is properly located, a good practice is to avoid leaving unprocessed paper in the open (for example, on a counter) for more than a few seconds. If paper is being kept in its original box, rather than a paper safe, make it a habit to remove only one sheet at a time, and to replace the box lid. This will not only prevent safelight fogging, but the more serious loss that would occur if the white room light is accidentally turned on.

Printing easel

To hold the printing paper flat and in the desired position during exposure, a *printing easel* is normally used. Other methods, such as taping the paper to the baseboard or covering it with a sheet of glass, are possible but more cumbersome. Various types of easels are made in many sizes. They include:

- Single-size easels
- Multiple-size easels
- Two-blade easels
- Four-blade easels
- Borderless easels
- Vacuum easels

Figure 8-20. *Darkroom safelights. A—A simple unit that screws into a socket like a lightbulb. It has interchangeable filters. (Porter's Camera Store) B—A larger fixture that can be wall- or ceiling-mounted. The filters can be changed as needed. (Regal/Arkay) C—A small, battery powered unit that can be hung around the neck. It uses light-emitting diodes, rather than an incandescent bulb. (Jobo Fototechnic, Inc.)*

 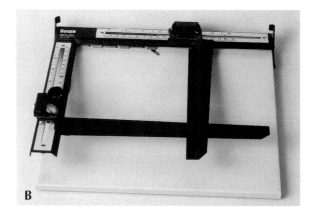

Figure 8-21. *The single-size and two-blade easels are frequently used in home darkrooms; multiple-size easels are less common. A—Single-size easel. B—Two-blade easel.*

The single-size, multiple-size, and two-blade easels are found in many home darkrooms. See **Figure 8-21.** *Single-size easels* are handy for the person who normally prints on a particular size of paper, such as 8″ × 10″ or 5″ × 7″. The easel is positioned as desired, and a sheet of paper is slipped into channels at each side of the easel. An equal-sized border is placed on all four sides. These easels are made for common paper sizes up to 11″ × 14″.

The *multiple-size easel* has preset openings for four different print sizes. One side has an 8″ × 10″ opening, while the other side has openings for 5″ × 7″, 3 1/2″ × 5″, and 2 1/2″ × 3 1/4″ prints. In use, the hinged cover of the easel is lifted and paper of the desired size is slipped into guides for the proper opening. The cover is lowered to hold the paper flat.

A *two-blade easel* is more flexible, since it can be used with paper of different sizes and the blades can be moved to change the proportions of the print. The major disadvantage of this easel is that paper must always be positioned against stops in its upper-left corner. Since this creates a border of standard width (usually 1/4″) on those two sides, it does not allow making prints with a wide border on all sides, as some photographers prefer. When making an enlargement from only part of a negative, placement of the easel may be awkward because of the fixed position of the paper.

Two-blade easels are made in several sizes to accommodate paper up to 16″ × 20″ in size.

Although it is two to three times more costly than the two-blade type, the *four-blade easel* is the choice of most serious photographic printers. As shown in **Figure 8-22,** this easel has four independently adjustable spring-steel blades. The four-blade arrangement allows almost infinite variation of print size and proportion, as well as the creation of equal-sized wide borders around the print. It also permits leaving the easel centered on the enlarger baseboard, and changing position of the paper by use of the four blades. Sizes up to 20″ × 24″ are available.

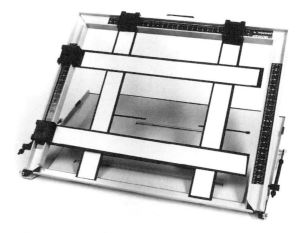

Figure 8-22. *The four-blade easel is the most versatile. It is able to handle many sizes of paper and crop the print to various proportions. (Charles Beseler Company)*

Printing an image out to the edge of the paper is possible with both the *borderless easel* and the vacuum easel. Paper is held in place on the borderless easel by retainers that have edges sloped to match the cone of light emitted by the enlarger lens. A vacuum easel uses a perforated mat or baseboard attached to a small vacuum pump. When a sheet of paper is placed on the mat, it is sucked tight against the surface to hold it in place.

Variable contrast filter set

The development of variable contrast photographic paper made it possible to work in the darkroom with one box of paper, rather than up to five boxes, each containing paper with a different contrast grade. By investing in a set of *variable contrast (VC) filters* (at a cost considerably less than a single 100-sheet box of paper), the photographer can have the equivalent of a dozen different paper contrast grades.

Filter sets are offered by Kodak, Ilford, and several other manufacturers. They typically include 12 filters in one-half grade steps. See **Figure 8-23.** Grade numbering differs from one manufacturer to another. Kodak, for example, numbers its printing filters from –1 to 5+, while Ilford's filters are numbered from 00 to 5. As a result, the filter considered the "neutral" or normal printing grade is 2 for Ilford filters and 2 1/2 for Kodak filters.

The filters intended for use in a filter drawer are thin polyester sheets in 6″ × 6″ or 3 1/2″ × 3 1/2″ sizes. Filters for use below the lens are smaller in size, and are mounted in rigid frames to fit into a special holder. Using the filters above the enlarging lens (if possible, above the negative) is the preferred method since there is less chance of optical distortion. Filters used below the lens must be handled carefully to avoid fingerprints, dirt, and scratches that would degrade the image.

Although the manufacturers claim best results are obtained by using their filters and papers together, in practical terms, filters of

Figure 8-23. *A variable contrast filter set typically consists of a dozen filters, ranging from very soft (low contrast) to very hard (high contrast). Filter sets made by one manufacturer can be used with other brands of paper, although the results will differ somewhat from brand to brand.*

one make are typically used with several different brands of paper. Some experimentation is needed, however, since different papers can give differing results with a given filter.

Focusing aid

While the projected image on the enlarging easel can be focused with the naked eye, most careful printers prefer to use a focusing aid to assure maximum sharpness. Various types of magnifying devices are made for this purpose. The *grain focuser* is widely used. It is placed on the enlarging easel, **Figure 8-24,** after the projected image has already been adjusted for size and focused as well as possible by eye. A small section of the image will be reflected from the

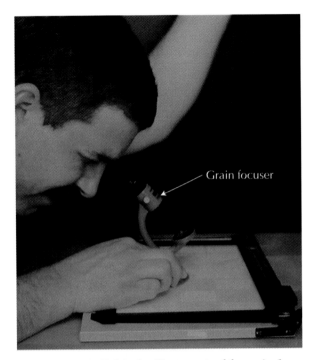

Figure 8-24. *Critical adjustment of focus is done using a grain focuser. The image is focused at the plane of the device's base, so a piece of developed photo paper of the proper thickness should be placed in the easel while using the grain focuser.*

focuser's mirror to a magnifying eyepiece. The enlarger's focus control is adjusted until the image is as sharp as possible. With some films, the clumps of silver forming visible grain can actually be seen and brought into sharp focus. With fine-grain films or larger format negatives, grain is less likely to be visible, so focusing is done on image detail. *Autofocusing* enlargers essentially eliminate the need for manual focusing, although some minor "tweaking" may be desirable. A relatively small number of the enlargers in use are of the autofocusing type.

Paper storage

Any container that is light-tight and can be easily opened and closed can be used to store unexposed photographic paper. Students and beginning darkroom workers often adopt the lowest cost storage solution: the packaging in which the paper is sold. The combination of cardboard box and opaque black plastic inner bag is definitely

light-tight when closed. Opening and closing the box and the bag each time a sheet of paper in needed is a bit cumbersome, but workable.

Various types of **paper safes** have been developed. The simplest type, shown in **Figure 8-25,** is a hinged plastic box with a small latch to help prevent accidental opening. Unlatching and opening the lid, then extracting a sheet of paper is an easy one-handed operation. Gravity causes the lid to be self-closing. Larger paper safes have several shelves for different sizes and types of paper, and typically have a spring-loaded, self-closing door on the front. Paper safes are available to hold 8″ × 10″ and larger paper sizes, and often have a capacity of 100 or more sheets.

Negative cleaning equipment

Removing any stray bits of lint or dust from your negatives before printing will avoid disfiguring white marks on the print and save the time needed to "spot" them with a fine brush and dye after drying. The traditional method of dust removal is the use of a soft brush and a jet of compressed air to clean the negative before it is inserted in the enlarger, **Figure 8-26.** The brush may be a soft artist's brush, or one of the types

Figure 8-25. *This simple paper safe is almost impossible to leave open accidentally — gravity causes the hinged lid to close automatically after a sheet of paper is removed. It is most useful for a photographer who prints primarily on one type and size of paper. (Regal/Arkay)*

Figure 8-26. *Compressed air is a useful tool, along with a soft brush or static-neutralizing brush, for removing lint and dust from negatives before developing. Dust removal should be done carefully to avoid scratching the negatives. Note that the photographer is wearing lint-free cotton gloves to avoid leaving fingerprints on the negatives.*

designed to both brush off particles and neutralize the static electricity that causes them to be attracted to film. There are also antistatic cloths and other neutralizing devices offered by different manufacturers. Aerosol cans of compressed air can be purchased in various sizes; large darkrooms may have an air supply provided by a central compressor.

To avoid placing oily fingerprints on the film, wear clean, lint-free cotton gloves whenever you handle negatives. If no gloves are available, handle the film only by its edges. Fingerprints will not only show up on prints, but can eventually damage the film emulsion physically. Any fingerprint detected on the film can be removed by using one of the chemical film cleaning products available in photo supply stores. Chemical cleaners can also be used to loosen and remove particles of foreign matter that have adhered to the *base* side of film during drying. Particles that have become embedded in the softened *emulsion* during drying are almost impossible to remove without damage to the image.

Print processing equipment

Print processing is most often done in open trays, but some photographers make use of drums, or even self-contained automatic roller processors like the one shown in **Figure 8-27.** Since these automated processors are designed for higher-volume operations, they are beyond the scope of this book. The following section will deal primarily with the tray method of development.

Trays

Basic print developing equipment consists of a set of four trays — one each for developer, stop bath, fixer, and water. The water tray may serve as a holding area for prints until they are placed in a separate print washer, or the prints may be washed in the tray itself. Additional trays are useful for use with other print treatments, such as a washing aid or toner.

Print trays are generally made of high-impact plastic, with bottoms that are either smooth or have a raised pattern. See **Figure 8-28.** The raised pattern, usually in the form of ribs, lifts prints off the tray bottom. This makes it easier to grasp the prints and transfer them to the next tray. A

Figure 8-27. *Automatic processors use a roller system to move exposed paper through a series of tanks holding the processing chemicals to provide a finished print in a matter of minutes. Some high-volume units can produce up to 100 color or black-and-white 8″ × 10″ prints per hour. (Jobo Fototechnic, Inc.)*

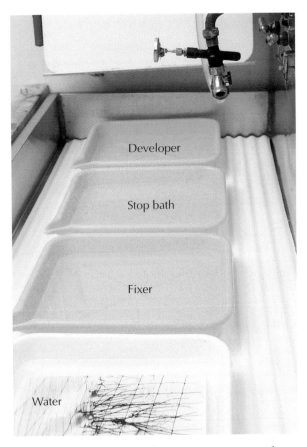

Figure 8-28. *Plastic print trays are commonly used, although stainless steel trays are also available. Individual trays are filled with developer, stop bath, fixer, and water. Developed and fixed prints are accumulated in the water tray before washing. Print trays are sized to handle all the basic photographic paper sizes.*

pouring lip formed into one corner of the tray helps avoid spills when pouring solutions back into storage containers. Stainless steel trays are also available, but are many times more costly than plastic trays. Tray sizes are designated by the largest standard print size they can hold: 5″ × 7″, 8″ × 10″, 11″ × 14″, etc. Actual inside dimensions are approximately 1″ greater in both length and width. This provides room for fingers or tongs to grip the paper edge when transferring prints from tray to tray.

Some photographers prefer to use a *drum system* for print development. The drums are rotated by a motor to provide consistent

agitation and even development. Only small amounts of chemicals are used for each print. The simplest drum systems provide only rotation, but more sophisticated units rotate the drum in a temperature-controlled water bath for processing consistency. See **Figure 8-29.**

A space-saving darkroom innovation is the *vertical slot processor*, which takes up approximately the same amount of sink space as a single tray. Sometimes referred to as a "toaster" for its resemblance to the kitchen appliance, **Figure 8-30,** the processor has two to five slots, depending on the model. Each of the slots is the opening in a narrow vertical tank that holds a chemical solution. Two-slot models hold developer and fixer, while three-slot models hold stop bath as well. Models with four slots are used for color print processing, or to hold an additional processing solution (such as a washing aid) for black-and-white. The five-slot versions have three chemical slots and two wash slots. The slots can be covered to permit storage of the chemicals between printing sessions. For color printing or critical black-and-white processing, temperatures of the solutions are thermostatically controlled. Models are available for print sizes ranging from 8″ × 10″ to 20″ × 24″.

Figure 8-29. *A temperature-regulated water bath provides processing consistency with this drum-processor. Note that the chemical containers are also immersed in the water bath. Also available are simple motor-driven drum units that do not include temperature regulation. (Jobo Fototechnic, Inc.)*

Figure 8-30. *Vertical slot processors save space in the sink, and can be covered to store chemicals when not in use. Temperature-regulated chemical slots provide accurate control for color processing. Special clips are used to lift prints out of one slot and place them in the next. Models are made in several print sizes, with two to five slots. (Jobo Fototechnic, Inc.)*

Figure 8-31. *Print tongs are used to avoid skin contact with processing chemicals. They also help to avoid contamination of chemicals, since separate tongs can be used for each tray. Note that the set of bamboo tongs is color-coded for easy identification.*

Tongs or gloves

As noted in Chapter 7, most darkroom chemicals are considered relatively nontoxic. Skin irritation due to contact with some chemicals, especially developing agents, is quite common, however. Although some photographers still use bare hands when processing prints, the use of print tongs or gloves is strongly recommended to avoid allergic reactions. Gloves of the thin latex surgical type are preferred because they provide a more positive grip on prints. To prevent contamination of solutions, a container of water should be kept at hand and used to rinse off the gloves. This is especially important to prevent fixer from being transported back to the developer tray.

More practical, in most cases, is the use of tongs to grip prints and transfer them from tray to tray. Print tongs, **Figure 8-31,** are made from stainless steel, plastic, or bamboo with rubber nonslip tips. One pair

of print tongs must be used in the developer and another in the stop bath and fixer to prevent contamination. Some darkroom workers prefer separate tongs for each of the three solutions, using color coding or other markings to avoid mixing them up.

Clock or timer(s)

Print processing steps can be timed by a number of devices, ranging from a clock or wristwatch with a second hand to a separate digital timer for each step. By placing a clock so that it is visible while facing the processing trays, each operation can be timed using the second hand. This method requires the ability to concentrate on the clock, since times longer than one minute make it easy to lose track.

Countdown timers (those that can be set for the total period, then count down to zero) are preferable, since they eliminate the need for concentrating on the time. A popular timing device is the electromechanical timer, **Figure 8-32,** which also is often used as an enlarger timer. Digital countdown timers show minutes and seconds on an LCD (liquid crystal display). A number of models are made specifically for photographic use, but small battery-operated

Figure 8-32. *Countdown timers like the dial timer model at right have been widely used in darkrooms for many years. The numerals and large second hand are easily visible under safelight conditions. An inexpensive digital kitchen timer, left, also works well in the darkroom. Since the display is not lighted, the timer must be positioned so that the numerals can be read under the safelight.*

digital timers intended for kitchen duty are inexpensive and work well. Digital timers are easily and quickly reset, but the most convenient arrangement is to use a separate timer for each of the three processing steps.

Print washer

The simplest form of print washer is a tray that is filled with water and manually emptied a number of times to remove fixer residues from the prints. Almost as simple is the use of the *tray siphon,* a device that clips to a water tray to provide a steady, continuous flow of fresh water, **Figure 8-33.** Much more complex are the various *archival print washers.* They are designed for virtually total removal of fixer residues to help ensure long print life. Both stainless steel and plastic washers are on the market, **Figure 8-34.** Archival washers have vertical compartments intended to hold a single print or two prints placed back-to-back (emulsion out), permitting free flow of water around them.

Drying equipment

Once prints are sufficiently washed, they must be dried for display or storage.

Figure 8-33. *A tray siphon mounts over the edge of a holding tray and provides a continuous flow of water into and out of the tray. Movement of the water provides agitation, moving the prints around so that all surfaces are adequately rinsed with fresh water. The siphon is one of the simplest forms of print washer. (Porter's Camera Store)*

Figure 8-34. *For greatest print permanence, an archival washer is used to remove as much fixer residue as practical from the print. Most archival washers are made from plastic; the two shown here are stainless steel, with removable plastic inserts that provide vertical slots to hold the prints. (Regal/Arkay)*

The drying method should produce a print that is reasonably flat and has a pleasingly smooth surface (unless one of the specialty textured papers is involved). Drying methods depend on whether traditional fiber-base papers or resin-coated (RC) papers are being used.

Heated dryer units, ferrotype tins (metal plates used to impart a high-gloss surface), and blotter rolls or books (absorbent sheets producing a soft matte surface on the print) were common when fiber-base papers were dominant. They are much less extensively used today. Since resin-coated papers have come into wide use, the issue of print flatness has virtually disappeared. RC papers, because of the plastic coating on both sides of the paper, dry quickly and remain flat when suspended from a line with clips. See **Figure 8-35.**

Fiberglass window screen material, stretched onto a frame, can also be used as a support for RC prints while they dry. The screening material allows proper airflow to the underside of the print, **Figure 8-36.** Fiber-base papers can be placed emulsion-side-down on the screen and will dry relatively flat. Further flattening can be achieved by placing dried prints under a stack of books.

A chemical print-flattening agent is made for use with fiber-base papers. The *print flattener* is a liquid concentrate that is mixed with water (usually in a 1:10 ratio) for use. Following washing, prints are soaked for several minutes in a tray of the flattener solution. After being blotted or squeegeed to remove excess solution, the prints are dried normally.

Processing chemicals and storage containers

Three basic chemical solutions are used for processing black-and-white prints: developer, stop bath, and fixer. The stop bath and fixer are the same solutions used for film processing, although fixer is sometimes used in a more diluted form for paper than for film. The developer must be one that is designed for use with paper, not film.

Figure 8-35. *Resin coated (RC) papers dry rapidly and exhibit little or no curl. A common method for drying RC prints is to hang them by one corner from a line stretched above the dark-room sink. Wooden spring clothespins or plastic spring clips are used to hang the prints.*

As was the case with film developers, paper developers are furnished in either liquid concentrate or powdered form. Powders are mixed with a specified amount of water to form a *stock solution.* Just before use, the stock solution (or liquid concentrate) is diluted to form a *working strength solution.* Different developers, or different dilutions of the same developer, are used to obtain prints with a cold-toned (blue-black) appearance or a warm-toned (brown-black) appearance.

The chemicals must be stored in appropriate containers, in sufficient quantity for the intended task. As noted in Chapter 7, chemical containers may be glass or plastic, opaque or translucent, with provision for excluding as much air as possible to prevent oxidation. The choice of storage container will be

Air flow

Air flow

Figure 8-36. *Fiberglass screening material can be mounted on a frame and used as a base for drying prints. Both RC and fiber-base prints can be dried on the screens, which permit free airflow to both sides of the prints. Fiber-base prints will dry relatively flat when placed on the screen emulsion-side down.*

Figure 8-37. *Large darkrooms, such as those in schools or custom labs, must be able to store larger volumes of chemicals. Storage tanks of two-gallon or greater capacity usually have a spigot for drawing off a desired amount. A dust lid keeps out foreign matter, while a floating internal lid helps prevent oxidation. (Regal/Arkay)*

determined by darkroom conditions and by the quantity of chemical that must be stored. For developing 8″ × 10″ prints in standard trays, approximately one quart (or one liter) of each solution is needed. Larger trays hold more solution, so larger storage containers are needed. Half-gallon (or two-liter) containers are typically used when the developing trays are sized for 11″ × 14″ prints. One-gallon, two-gallon, five-gallon, and even larger containers are used in darkrooms of different sizes. Storage tanks with a capacity of two gallons or more usually have a spigot for dispensing chemicals. They usually are equipped with an internal lid that floats on top of the solution to minimize oxidation. See **Figure 8-37.**

In addition to paper developer, stop bath, and fixer, containers usually must be furnished for other solutions such as washing aid or wetting agent.

Chemical safety

All chemicals should be handled with respect and proper precautions (such as the use of protective eyewear), even though they might be considered "nontoxic." Refer to Chapter 7 for a more detailed discussion of proper procedures for mixing, storing, and disposing of photographic chemicals.

Questions for review

Please answer the following questions on a separate piece of paper. Do not write your answers in this book.

1. _____ protection must be provided for all electrical outlets in a darkroom.
2. Which of the following should be considered vital when choosing space for a temporary darkroom?
 a. sufficient space to work.
 b. ability to exclude light.
 c. electrical availability.
 d. plumbing.
 e. all the above.
 f. all but d.
 g. b and c only.
3. The darkroom is typically divided into a _____ side and a _____ side.

4. Describe the difference between a positive pressure ventilation system and a negative pressure ventilation system. Why is the positive pressure system preferable?

5. The practical minimum dimensions for a darkroom sink when making 8″ × 10″ prints is:
 a. 18″ × 4′
 b. 24″ × 4′
 c. 18″ × 6′
 d. 24″ × 6′

6. The two basic types of enlargers are the _____ head and _____ head.

7. Why have manufacturers developed a special type of cold-light head for use with variable contrast papers?

8. A flimsy enlarger can permit _____, which results in unsharp prints.

9. Which focal length enlarging lens should you choose to make full-frame prints from a 6 cm × 7 cm negative?
 a. 35mm
 b. 50mm
 c. 80mm
 d. 105mm

10. Why do digital timers provide more precise control than conventional dial timers?

11. Paper manufacturers recommend that the darkroom safelight be located at least _____ feet away from any paper to prevent fogging.

12. A _____ printing easel gives the printer the greatest flexibility in print size and paper positioning.

13. For minimum optical distortion, variable contrast filters should be placed _____ the negative in the enlarger.

14. What is the major reason for using gloves or print tongs while processing prints in the darkroom?

15. _____ print washers are designed to remove virtually all fixer residues to greatly lengthen the life of the photographic print.

Sabbatier effect:
The partial reversal of tones that occurs when a print is briefly exposed to light partway through the developing process.

Chapter 9

Making Prints

When you have finished reading this chapter, you will be able to:

⮕ Compare the benefits of fiber-base and resin-coated papers.

⮕ Demonstrate making a contact print.

⮕ List the steps involved in making an enlargement.

⮕ Evaluate quality of a print and identify areas for improvement.

⮕ Adjust exposure and contrast locally with dodging and burning in.

⮕ Describe procedures for archival processing of prints.

Making your own photographic prints greatly increases your opportunities for creative expression, and makes it possible to produce the picture that you saw in your mind's eye (visualized) before you ever pressed the camera's shutter release. Ansel Adams, an accomplished musician as well as a photographer, used a musical analogy to describe the importance of printing. In his book *The Print*, Adams wrote, "I have often said that the negative is similar to the musician's score, and the print to the performance of that score. The negative comes to life only when 'performed' as a print."

A darkroom can be used for making either black-and-white or color prints using essentially the same equipment. Basic printing techniques are normally learned by making black-and-white prints, since the process is simpler and can be done under safelight illumination, **Figure 9-1.** This chapter will concentrate on black-and-white printing for that reason. Color printing must be done in total darkness and is more complex. It will be covered in Chapter 12.

Figure 9-1. *Safelight illumination can be used in the darkroom when doing black-and-white printing. This is one of the reasons why basic darkroom techniques are usually taught using black-and-white materials. Also, the process is less complex than color printing and easier to learn with only a small amount of instruction.*

227

Working in the darkroom

There are many variables that will affect the look of your prints. These include *process* variables, such as exposure time and contrast selection, and variations in *materials*: your choices of paper and developer. Additional *postprocessing* steps, such as toning or bleaching, will also change print appearance.

Beginning darkroom workers are usually advised to choose one combination of paper and developer and explore it thoroughly before moving on to other possibilities. This is sound advice, since it limits the number of variables and makes the process easier to learn. The best way to make a judgment, or to select between alternatives, is to have only *one variable* involved. For example, if you are trying to determine whether a 10-second or a 13-second exposure is best for a print, the only variable should be the exposure time. All other elements — the enlarging lens aperture, contrast filter, paper, and developing time — should be held constant. If two variables (exposure time and contrast) are changed at the same time, it will be impossible to determine whether the result is due to the exposure change, the contrast change, or *both*.

Selecting a developer

General purpose paper developers, sometimes referred to as "universal" paper developers, are used in most darkrooms. See **Figure 9-2.** They are usable with most papers to produce prints that have a neutral black tone, or a "cold" (blue-black) tone. Like film developers, paper developers are offered in either powder or liquid concentrate form. Although powder-form developers such as Kodak's Dektol® are still widely used, liquid concentrates have gained popularity in recent years. The liquid concentrates are offered by Ilford, Kodak, Edwal, and other manufacturers. They offer convenience, since they can be quickly and easily mixed with water to form a

Figure 9-2. *Developers for paper are sold in either powder or liquid concentrate form. The powder-form developers are dissolved in warm water to form a concentrated stock solution. For use, a specified quantity of stock solution is mixed with water to form a working-strength solution. Liquid concentrates are easier to use, since they eliminate the need to dissolve powder. Working-strength solutions are made from liquid concentrate and water.*

working-strength solution. Some liquid concentrates, such as Ethol LPD®, may be prepared at different dilutions to produce cold-tone, neutral, or warm-tone prints. Specialized developers to produce low-contrast or high-contrast prints are also available.

A unique type of processing chemical is the *monobath developer*. Monobaths are designed for use with resin-coated papers that have an incorporated developer, such as Kodak Polycontrast III RC®, Ilford Multigrade III RC Rapid®, or Agfa Brovira-Speed 310 RC®. The advantage of the monobath is that it permits single-tray processing, since developing and fixing is done automatically in the same tray. Completed prints are washed and dried conventionally.

Selecting a printing paper

Printing paper choices include fiber-base vs resin-coated, developer-incorporated vs nondeveloper-incorporated, variable contrast vs contrast-graded, cold-tone/neutral vs warm-tone, and glossy, satin, or matte finish. The composition of various manufacturers' lines differs — not all the alternatives are available in every line of paper.

Fiber-base (FB) vs resin-coated (RC)

Technically, all black-and-white photographic papers are "fiber-base," since the emulsion layer is coated onto a paper *substrate* (support). In resin-coated papers, however, a thin plastic resin layer is applied on both sides of the paper substrate. This limits the amounts of photographic solutions absorbed by the paper. The plastic coating shortens the washing and drying processes, and helps to keep the paper from curling as it dries. **Figure 9-3** compares the construction of the two types of paper.

For approximately 100 years, from the 1870s to the 1970s, paper substrates coated with a layer of gelatin-based, light-sensitive emulsions were the rule. Although the emulsions themselves were improved through the years (especially in terms of light sensitivity), the basic form of the fiber-base paper remained unchanged.

During the 1970s, the popularity of color negative films increased dramatically, resulting in demand for printing papers that would be easier and faster to process, especially for commercial photofinishing. Resin-coated papers were introduced in response to this demand. The technology was soon applied to black-and-white printing papers, as well.

As noted earlier, an important advantage of the resin coating is shortened washing and drying times. The paper is protected by the resin coating, and thus absorbs only small amounts of processing solutions and water. With smaller amounts of fixer to be eliminated, the prints can be washed for only a fraction of the time required by

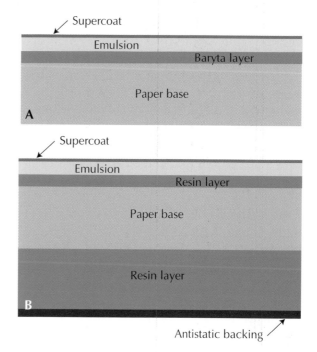

Figure 9-3. *Paper structure. A—Fiber-base papers consists of four layers, as shown. The baryta layer is a coating of the chemically inert compound barium sulfate. It provides a smooth, very white, reflective base for the emulsion. The supercoat is a thin tough layer of gelatin that protects the emulsion from scuffs and scratches during processing. B—Resin-coated papers do not have a baryta layer, but have waterproof resin (plastic) layers on both sides of the paper. The antistatic backing prevents a buildup of static electricity on the plastic bottom layer.*

fiber-base papers. For example, an RC print might be washed for 4–5 minutes, while a comparable FB print would have to wash for 20 minutes (if first treated with washing aid) or a full hour (if not treated with washing aid). Fiber-base prints require several hours of air-drying; prints on resin-coated paper will dry sufficiently to be handled in as little as 10 minutes.

Fiber-base papers are the choice of fine-art photographers, who are concerned with both the appearance and the permanence of their prints. These photographers maintain that a given print will have a different appearance on fiber-base paper than it will have on the equivalent resin-coated paper.

Although they find it difficult to describe verbally, they use terms such as "richer" or "greater range of tones."

Permanence is a greater issue, especially for photographers who sell their prints to museums and collectors. Fiber-base prints can be *archivally processed* (as described later in this chapter) with the expectation that they will remain unchanged for a century or more. The same kind of processing for permanence can be done with resin-coated paper, but no one yet knows whether a long life will result. Since RC paper has been in use for only about one-quarter century, there is no way of being sure that changes in the plastic layers will not adversely affect the image. Even with various forms of scientific testing, a definitive answer may not be available for many years.

Variable contrast vs contrast-graded paper

Until a very few years ago, the list of basic materials for a black-and-white darkroom would have included separate boxes of **contrast-graded paper** for up to five different contrast grades, **Figure 9-4.** While most printing would be done on the "normal" grades 2 or 3, some situations would call for low-contrast (Grade 1) paper, or high-contrast

Figure 9-4. *Contrast-graded printing papers vary in availability. Some brands offer a full range from grades 1–5, others are offered in only a few grades at the center of the scale. This is a high-contrast (Grade 5) paper.*

(Grades 4 or 5) paper. If the photographer used more than one brand or line of paper, at least several grades of each type would be stocked. Adding in the need to keep more than one size of paper on hand, the inventory became even larger.

The solution to keeping multiple boxes of paper was found with the introduction of **variable contrast paper** in England, by Ilford, in the 1940s. Due to performance and quality problems, and the reluctance of many photographers to change methods, variable contrast (VC) paper didn't achieve wide acceptance for a number of years. Since the 1980s, however, variable contrast paper has overtaken and passed contrast-graded paper in popularity. Its primary appeal, of course, is convenience — with the use of a set of VC filters, the darkroom worker has "all the grades in one box."

With contrast-graded papers, there are no intermediate contrast steps, such as Grade 1 1/2 or Grade 3 1/2. A slight amount of variation is possible by using different developers. A "soft-working" developer will reduce contrast somewhat, for example.

Variable contrast papers are made with a two-part emulsion. One part is sensitive to blue light and governs the paper's high-contrast response. The other part is sensitive to green light, and is responsible for low-contrast response. Contrast of the final print is governed by the proportions of green and blue light reaching the paper. If you make an enlargement from a medium-contrast negative using white light (no VC filter in place) the paper will produce a "normal" print equivalent to a Grade 2 paper. This occurs because white light has balanced blue and green components.

Variable contrast filters are offered in sets that approximate the range of contrast-graded papers, but are further divided into half-steps for more precise control. The filters range in color from a pale yellow to a deep magenta tone, **Figure 9-5.** The yellow filters block varying amounts of blue light, while the magenta filters do the same with

Figure 9-5. *The color range of variable contrast filters is from light yellow to deep magenta. Yellow filters block blue light for lower-contrast prints; magenta filters block green light for higher-contrast prints.*

green light. By selecting a VC filter, you are altering the blue/green light ratio and thus the response of the paper. With a low-numbered yellow filter (such as #1/2 or #1), the light exposing the paper will have a higher proportion of green, producing a print with "soft" or low contrast. A high-numbered magenta filter (#4 or #4 1/2) would have the opposite effect: a higher proportion of blue in the light and a print with "hard" or high contrast.

When printing black-and-white with a dichroic colorhead, the appropriate contrast value can be "dialed in," rather than inserting a VC filter in the enlarger, **Figure 9-6.** Different contrast grades are achieved by setting the cyan control to zero, then selecting the desired yellow or magenta setting. Different papers will call for different settings, since contrast grades are not consistent from manufacturer to manufacturer. The information sheet packed with the paper should be consulted for the proper settings for the brand of colorhead being used. On some colorheads, dials are calibrated from 0 to 200; others have a lower maximum number.

Contrast settings may consist of yellow values for the lower contrast grades and magenta values for the higher grades, or may be a combination of yellow and magenta

settings for each grade. For example, the recommended #1 settings for Ilford Multigrade IV paper with a Beseler color-head are 50Y or the combination 68Y/10M. For #3, recommended settings are 25M or the combination 23Y/56M. Either the single or the combination setting for a given contrast grade will achieve the same contrast. The advantage of the combined setting is the need for a smaller adjustment in exposure time when changing contrast grades.

Print contrast is not an *absolute,* but must be related to the contrast of the negative from which it is printed. A well-exposed negative with a good range of tones (medium-contrast negative) will produce a matching range of tones when printed with the #2 filter. Filters #0 and #1 will produce proportionately lower-contrast prints; filters #3, #4, and #5 will result in proportionately higher-contrast prints.

Negatives that are low-contrast or high-contrast will not have the same latitude as the medium-contrast negative. The low-contrast negative would produce a low-contrast print with a #2 (normal) filter, and a medium-contrast print with the higher-numbered

Figure 9-6. *Variable contrast papers can be exposed with a dichroic colorhead by "dialing in" the desired values. The yellow settings alone can be used for low-contrast grades, and magenta alone for high-contrast. Combinations of yellow and magenta filtration can also be used for each contrast grade.*

filters. The opposite is true with a high-contrast negative — a high-contrast print is created with the normal filter, and a medium-contrast print is produced with the lower-numbered filters.

Paper weight and finish

Papers are available in different thicknesses (weights) and with different surface finishes. Fiber-base papers have traditionally been available in a thin *single-weight* and a heavier *double-weight*. Resin-coated papers are usually described as *medium-weight:* the plastic layers on either side of the paper make them thicker than single-weight, but not as thick as double-weight. A double-weight RC paper is offered by Ilford under the name Portfolio®, while Kodak has a "premium-weight" fiber-base paper called Elite Fine Art®. Some other manufacturers also offer heavier-weight papers. The major advantage of the thicker papers is ease of handling during processing, especially when larger prints are being made.

Just as wall paints come in gloss, semi-gloss, and flat finishes, printing papers are made in gloss, semi-matte, and matte finishes. Each has its advantages, and many photographers keep a supply of at least two on hand for different purposes. A *glossy finish* paper provides the richest appearance, displaying the full range of tones available in the photo. It is especially valuable in conveying strong, deep black tones. *Matte finish* (sometimes called "satin") papers have a flatter appearance that is suited to subjects where a subtler, narrower range of tones is being conveyed. The "tooth" of the matte paper accepts paint well, making a matte finish the favorite of those who hand-color prints. A *semi-matte* finish falls between the other two and is favored by some printers as a good compromise. It is also described as a "pearl" or "fine-grain luster" finish by different manufacturers.

The degree of glossiness exhibited by a glossy FB paper is affected by the drying method. When allowed to air-dry on fiberglass screens (the method preferred by many

photographers) the paper has a distinct, but fairly low, gloss. For a highly glossy reflective finish, the paper must be *ferrotyped*. Much less popular than it once was, *ferrotyping* consists of placing the wet print facedown on a highly-polished metal plate and pressing out as much moisture as possible with a roller called a *brayer*. Prints may be left to dry naturally, or dried more quickly by placing the ferrotype plate (known as a "tin") on an electrically heated dryer. When the print is dry, it will release from the ferrotype tin.

Types of prints

Traditional prints made from negatives on photographic paper are produced by either *contact printing* or *projection printing*. The major distinction is size of the print in relation to the size of the negative. A *contact print*, made by exposing a negative that is physically laid on top of the photographic paper, is *always* the same size as the negative, **Figure 9-7**. A *projection print*, however, is an enlarged version of the negative, made by passing a beam of light through the negative and a lens and projecting it onto the photographic paper.

Until electric light sources for enlargers were introduced in the late 1800s, only cumbersome devices using daylight for illumination were available. As a result, most of the prints were of the contact type and were made from large negatives. Even

Figure 9-7. *A contact print is made by placing a negative directly on top of the photographic paper and making an exposure. As shown, the print is the same size as the negative.*

after projection printing became the rule rather than the exception, a number of photographers — such as Edward Weston — continued to prefer the contact method. They believed that a contact print provided the greatest possible sharpness and richness of tone, since it is a direct (though reversed) and same-size copy of the negative. Contact prints for display are typically made from negatives at least 4″ × 5″ in size, although most are 8″ × 10″ or larger.

The most widely used form of contact print, is a type of *proof* or trial print called a **contact sheet.** These sheets, (most often referred to as just plain *contacts*) contain same-size prints of an entire roll of either 35mm or 120 size negatives, **Figure 9-8.** A well-made contact sheet allows the photographer to assess each frame and decide which to print. Negatives and their corresponding contact sheet can be stored together for later reference and printing.

Projection prints, or enlargements, can be made from a negative of any size, if an appropriate lens, light source, and holder (negative carrier) are available. Most enlargements are made from 35mm and 120 size film, or from 4″ × 5″ negatives. Special

enlargers exist for much smaller and much larger negatives, as well.

The size of enlargement that can be made is physically limited by the height to which the enlarger head can be raised above the baseboard. On many enlargers, an 11″ × 14″ print from a full 35mm negative is the practical maximum. On some models, larger prints can be made by rotating the enlarger head 90° and projecting onto a wall, or by using an adjustable-height baseboard.

Another limiting factor is the size of the negative itself — the larger the negative, the larger the print that can be made while maintaining acceptable sharpness and grain. A 35mm negative is approximately 1″ × 1 1/2″ in size. Projecting it large enough to make an 11″ × 14″ print would involve an 11× magnification. If the negative is well-exposed and sharp, a good print is possible at that magnification (even larger prints could be made with an exceptionally sharp 35mm negative). Using the same magnification with a 120 size film (6cm × 7cm format) would yield a projected image 25″ × 30″; a 4″ × 5″ negative would yield a 44″ × 55″ image. In all three cases, assuming negatives and enlarging lenses of equivalent quality, sharpness of the image and other factors should be equal.

Preparing to print

Before a print is exposed, the darkroom must be prepared for processing. On the "wet side," trays must be set up and filled with the appropriate solutions, **Figure 9-9.** Tongs or gloves should be laid out, ready for use, and timers checked and set for the correct intervals. To protect clothing from chemical stains, an apron should be worn. On the "dry side," the enlarger and enlarger timer should be tested for proper operation. The correct lens for the film format being printed must be installed on the enlarger. The printing easel should be placed on the enlarger baseboard, ready for use. If a focusing aid such as a grain magnifier will be used, it also can be placed on the baseboard

Figure 9-8. *The contact sheet is a useful proof for the photographer. The prints, though small, can be examined closely with a magnifier to determine which should be selected for printing. Negatives and contact sheets can be readily filed together in a ring binder.*

Figure 9-9. *A left-to-right arrangement of the developer, stop bath, and fixer trays is most common. Solutions should be sufficient in volume to fill the trays to a depth of 3/4" to 1". A fourth tray is usually filled with water to serve as a holding area for prints awaiting final wash.*

for easy access. Unless contrast filtration is going to be dialed in on a colorhead, a set of contrast filters should be within easy reach. A pencil or fine black marker will be useful for making notations on the backs of prints.

Exposing the print

Whether you will be making a contact print or a projection print, the basic operations are simple and essentially the same: testing to determine proper exposure time, using that time to expose the paper, and then processing the print. One difference, when projection printing, is the need to size and focus the image on the easel before making the final exposure.

Contact printing

For most photographers, the major use for contact printing is to make proofs, or *contact sheets*, of 35mm or 120 size negatives. While special contact printing boxes containing a light source were once widely used, an enlarger is more often employed today as the light source for making contact prints. An empty negative carrier is placed in the enlarger to provide a lighted area of defined shape on the baseboard. With the darkroom lights off and the safelight on, this shape will be easy to see, **Figure 9-10.** The

Figure 9-10. *To make contact sheets using the enlarger as a light source, the enlarger head should be raised far enough to project a rectangle of light approximately 11" × 14" on the baseboard.*

enlarger is turned on, and the head is raised until the rectangle of light on the baseboard is approximately 11″ × 14″ in size. This will provide adequate coverage for the typical contact sheet. Placing a reference mark on the enlarger column will make it easy to raise the head to the proper height whenever contact prints are made.

If the negatives are stored in clear plastic pages, the entire page is usually laid atop the sheet of photographic paper to make the print. A sheet of glass is laid over the negative sheet/paper sandwich to press it tightly together. See **Figure 9-11.** Some darkroom workers prefer to use a special contact-proofing frame that has a clear, hinged lid with channels to hold strips of negative. A sheet of paper is laid face up on the base, and the lid lowered in place. An 8 1/2″ × 11″ printing paper that matches the proportion

Figure 9-11. *A sheet of window glass is an easy and inexpensive method of holding the negative storage page and photographic paper tightly together for contact printing. For safety, tape the edges of the glass or sand them smooth. Clean dust and fingermarks off the glass before each use.*

of the negative storage page is available. Most contact sheets are made on 8″ × 10″ paper, however, because it is always "on hand" in the darkroom.

Determine the proper exposure for a contact sheet by following these steps:

1. Set the enlarger lens aperture to f/5.6 or f/8. Remove any VC filters from the filter drawer or set dichroic filter controls to zero.

2. Turn off the darkroom white light and turn on the safelight.

3. Take a sheet of VC paper out of the package or paper safe. Close the lid to protect the stored paper from accidental exposure.

4. Place the paper on the enlarger baseboard, with the emulsion side facing up. The emulsion side is usually glossier than the back side.

5. Lay the negative storage page, emulsion side down, on top of the paper. The negatives are properly oriented if the film-edge numbers and words can be read normally (are not reversed).

6. Carefully lay a clean sheet of glass on top of the negative sheet and paper to press them tightly together. To avoid cutting yourself, the edges of the glass should be sanded to a rounded shape or covered with cloth tape.

7. Set the enlarging timer for 15 seconds.

8. Lay a sheet of black card stock on the glass so that it covers all but a strip approximately 1/5 the width of the negative storage page. See **Figure 9-12.**

9. Start the timer, which will turn on the enlarger light source. After 3 seconds (at the 12-second mark), move the card to expose another 1/5 of the negative page width. You may find it easiest to stop the timer to do so (some timers have a repeat feature, which would allow use of a 3-second setting).

10. Repeat the card movement at 3-second intervals. The result will be a contact sheet exposed in steps of 15, 12, 9, 6, and 3 seconds.

Figure 9-12. *To make a test contact sheet, a piece of black card stock is used as a mask to expose strips for different lengths of time. At set intervals, the card is moved to expose another strip.*

11. Develop and fix the exposed sheet (as described later in this chapter). Rinse after fixing, then wipe or squeegee off excess water.

12. Turn on the white light and examine the test contact sheet. It should show a series of strips ranging from darkest (the 15-second exposure) to lightest (the 3-second exposure). **Figure 9-13.**

13. To find the correct exposure time, look closely at the edges of the strips of film on the print. Working from the lightest-exposure strip toward the darkest, compare the *sprocket holes* to the film edge surrounding them. The strip where the sprocket holes disappear (are the same black as surrounding film edge) represents the correct exposure time for contact sheets. See **Figure 9-14.**

14. If the first contact sheet doesn't produce a dark enough exposure to make the sprocket holes disappear, make a second sheet using longer exposure times (still at 3-second intervals).

The aperture and exposure time that you establish with this test procedure can be used each time you make a contact sheet. The contact sheet that results will show distinctly how well, or poorly, each frame on the roll was exposed. At a glance, you will be able to see whether a frame is overexposed, normally exposed, or underexposed, **Figure 9-15.** This is valuable information for improving your photographic technique, and also provides needed information for making projection prints. Some photographers attempt to produce "perfect" contact sheets by giving certain frames or strips more or less exposure. While the result is a more attractive print, such a contact provides less information than one printed "straight."

Projection prints

The first step in making a projection print is to examine the contact sheet and select a negative you wish to print. Until you have acquired some basic printing skills, it will be easiest to work with negatives that are properly exposed. Using a magnifying device, if necessary, choose a frame that has a wide range of tones and is sharply focused.

Locate the strip of film containing the negative you wish to print, and remove it from the storage page. To avoid finger marks on the film, wear gloves or handle the strip of film only by its edges. Place the film strip in the enlarger's negative carrier, with the desired frame centered in the carrier opening, **Figure 9-16.** The negative is positioned with the emulsion side down. Most carriers for 35mm and medium format sizes do not use glass to hold the negative flat. If the carrier does use glass, all glass surfaces (and the negative) must be carefully cleaned before the negative is put in place.

If a glassless carrier is used, it is closed to firmly hold the negative, and then the negative is cleaned. Most careful darkroom workers use both a soft brush and compressed air to remove any dust or lint from the negative's surface. The brush is used first to gently dislodge particles, then the air

Figure 9-13. *Test exposures are cumulative, so exposures are in regular steps from darkest to lightest. The number and the length of the exposures can be adjusted to the situation or the photographer's preferences. For example, some use 3-second exposures, while others use 5-second exposures.*

Sprocket holes visible

Figure 9-14. *This section of a test contact sheet shows a strip that is slightly underexposed and one that is properly exposed. On the strip at left, note that there is a slight difference in blackness between the sprocket holes and the surrounding film edge. At right, the correctly exposed strip shows no distinct sprocket holes.*

blows them away. As shown in **Figure 9-17A,** the cleaning is done from below the carrier to avoid redepositing loosened dust or lint. After cleaning one side of the negative, the carrier is turned over and the second side is cleaned. In dry weather, static electricity can attract dust to the film surface and make it cling. To overcome this problem, various antistatic devices are made. One of the most commonly used is a brush, **Figure 9-17B,** with an element that is claimed to attract dust dislodged by the brush bristles.

Install the negative carrier in the enlarger and place your printing easel on the baseboard. If an adjustable easel is being used, its blades should be set for the desired print size, **Figure 9-18.** To make framing and focusing easier, place a sheet of processed photographic paper in the easel (the back of a discarded print or a test contact print works well).

Turn off the white light and turn on the enlarger light source. Most timers have a "focus" switch that allows you to turn on the

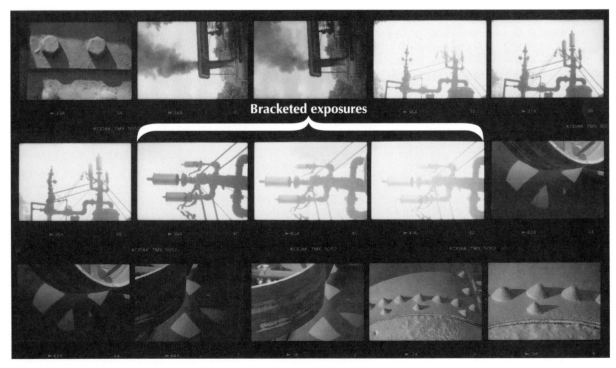

Bracketed exposures

Figure 9-15. *Exposing the contact sheet for the time established by testing will allow you to make judgments on whether each frame is properly exposed. Note the variations on this contact sheet, including the sequence where the photographer bracketed (shot at the metered exposure plus one stop under and one stop over the meter reading).*

Figure 9-16. *When placing a negative in the carrier, wear gloves or handle the film by the edge to avoid fingerprints. Position the desired negative in the opening, then close the carrier to hold the film in place.*

Figure 9-18. *Adjust the blades of the enlarging easel for the size paper you will use. The two-blade easel, shown here, will automatically provide a border of about 1/4" on the two fixed sides. The adjustable blades should be set to provide a matching border on the other two sides. Place a scrap print face down in the easel to improve visibility of the image for framing and focusing.*

Figure 9-17. *Cleaning the negative. A—Use a soft brush and can of compressed air to clean the negative from the bottom side of the carrier. Turn the carrier over to clean the other side. B—An antistatic tool that is used extensively is a brush with an element that attracts and holds dislodged particles of lint and dust.*

light without activating the timing function. Raise or lower the enlarger head until the rectangle of light projected onto the printing easel is the desired size. Since the proportion of the 35mm film frame is different from the proportions of standard paper sizes, you may choose to print the full negative, most of the negative, or a smaller part of the negative. As shown in **Figure 9-19**, a *full-frame print* on an 8″ × 10″ sheet from a 35mm negative would result in an image approximately 6 1/2″ × 9 1/2″. Printing to the full 7 1/2″ width of the paper (allowing for borders) would mean the loss of approximately 1 1/4″ of the projected image's length. Depending upon the height to which the enlarger's head can be raised, you could make an 8″ × 10″ print from one-half or less of the 35mm negative's area.

Once the print size is established, you will need to focus the image for maximum sharpness. Although there are autofocus enlargers on the market, the vast majority

are manual-focusing models. Focusing is generally done by turning a knob or handwheel that moves the lensboard up or down. Follow these steps:

1. Open the enlarging lens to its maximum aperture to obtain a bright image for focusing.
2. Rotate the focus knob or handwheel until the image on the easel appears to be as sharp as possible.
3. If focusing has caused the image size on the easel to become too large or too small, adjust the enlarger head height as necessary, then refocus.
4. Use a grain focuser for fine adjustment of focus, **Figure 9-20.** This is done by moving the control until the image just passes the point of sharp focus, then adjusting in the opposite direction until the sharpest focus is achieved. Several "back-and-forth" movements may be needed for critical focusing.

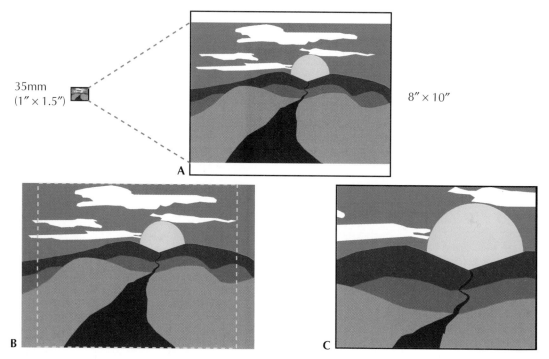

Figure 9-19. *The 35mm frame has a 2:3 proportion (1″ × 1 1/2″), while 8″ × 10″ paper has a 4:5 proportion. A—A full-frame print is narrower than paper. B—Printing the full width of the paper loses some image at one or both ends. C—Greater enlargement can be used to print only part of the 35mm frame. Printing from medium format negatives presents similar problems.*

Figure 9-20. *Critical focusing using a grain focuser. The focus control of the enlarger must be adjusted while looking through the grain focuser eyepiece. If the enlarger head is raised sufficiently high, having long arms is an advantage. In extreme cases, a second person can make the adjustments under direction of the person using the grain focuser.*

After focusing, stop down the enlarging lens to the aperture that will be used for printing. Most lenses are considered to be sharpest two or three stops down from wide-open. Thus, an enlarging lens with a maximum aperture of f/4 would be used at f/8 or f/11. By focusing wide-open, and then stopping down, you will also gain depth of field. This will help compensate for any slight shifting of the negative or the enlarger mechanism after focusing.

Insert the normal contrast (#2) filter in the filter drawer or filter holder. If you are printing with a dichroic colorhead, set the yellow and/or magenta values as suggested by the paper manufacturer for a normal contrast print.

Determining exposure time

There are several methods in general use for determining the preferred exposure time for a print. All these methods rely upon the photographer's judgment and personal preference — which is the reason "preferred" was used in the preceding sentence, rather than "correct" or "proper." Some photographers prefer to print with a darker range of tones; others prefer a lighter look. Between the extremes of obvious overexposure and obvious underexposure of a print, there is considerable latitude for conveying mood or the photographer's visualization of the subject.

When making what is referred to as a "straight" print, most people try to find an exposure that will adequately reproduce the full range of tones in the original scene. They pay particular attention to the highlights and shadows, seeking an exposure that preserves some detail in the shadows while conveying some texture and detail in the brightest highlights.

Exposure can be determined with mechanical/electronic aids, or by exposing test strips in a method similar to the one described earlier for making test contact sheets. Various forms of the electronic aid known as the ***print exposure meter*** are on the market. The general method for using these meters is to first make a print that you consider properly exposed, noting aperture and exposure time. The negative for that print and the exposure information are then used to calibrate the meter. To determine the exposure time for a different negative, a reading is made from the projected image, **Figure 9-21.** A dial with a time scale is turned until an indicator lights up on the meter. The exposure time can then be read from the dial.

Figure 9-21. *Once calibrated, a print exposure meter can be used to find the correct exposure time for a negative.*

The ***projection print scale*** is simpler to use than a meter. It is a plastic sheet printed with wedges of varying density and times in seconds. The scale is laid on top of a sheet of photo paper on the easel, and the image from the negative is printed through it. After the test print is developed and fixed, the wedge that looks best is selected. The time printed on the selected wedge is the number of seconds that the print should be exposed. See **Figure 9-22.**

The most common method of determining exposure times is the ***test strip***, a print made with a series of exposures at regularly spaced intervals. The method used is essentially the same one described for making a test contact sheet: moving a black card across the paper surface in timed steps. There are two differences: a projection print is being made, rather than a contact print, and the exposure is made with normal-contrast filtration.

A full sheet of paper may be used to make the test print. This has the advantage of making the different exposures clearly visible, but many darkroom workers consider it a wasteful practice. They feel that properly made tests on smaller pieces of

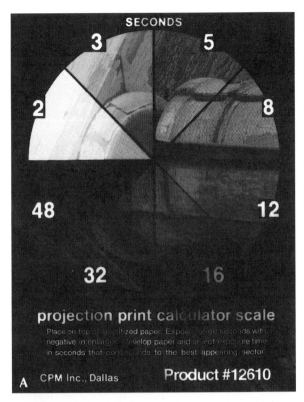

Figure 9-22. *The projection print scale is made to lay on top on the paper during exposure. A—Print made with the scale in place, showing the results that would be obtained with different exposure times. For this negative, an exposure of 8 seconds will give the best results. B—Print made with an 8-second exposure at f/8 and normal contrast.*

paper are just as informative and more economical. Often, they will make a supply of test strips by cutting an 8″ × 10″ sheet of paper into ten 1″ × 8″ strips, or four 4″ × 5″ pieces.

When making a test with a smaller piece of paper, be careful to select an area of the negative that will include all of the tones that are important. This will permit you to make a good comparison of the different exposure times. To accurately position the test strip on the easel, use the red filter on your enlarger. This filter, which is usually pivoted to swing in place under the lens, will allow you to project an image that will not expose printing paper. While viewing the image on the easel (it will be quite dim), you can put your test strip in place. Turn off the enlarger, move the red filter out of the light path, and make your series of timed exposures. Be careful that you do not cause the strip of photo paper to move when shifting the card between exposures. A device that holds the paper firmly in place and simplifies the task of producing even-width exposure increments is shown in **Figure 9-23.** This test-strip printer accepts a 4″ × 5″ piece of paper, and has five plastic shutters that can be raised or lowered separately.

With a negative that is well-exposed, a good starting point for a test strip would be to make five exposures in 5-second increments at an aperture of f/8. This would provide a strip with exposures of 25, 20, 15,

Figure 9-24. *A test strip from a medium-contrast negative, made with a condenser enlarger. With such a negative, the acceptable exposures usually will be one of the three middle strips. If five-second intervals are used, one strip may be slightly too dark, and the adjoining one slightly too light, suggesting an intermediate time for a trial exposure.*

10, and 5 seconds, as shown in **Figure 9-24.** There will be variations with different enlargers and different papers, but acceptable results using a condenser enlarger at f/8 will usually be found between 10 and 20 seconds. Using five-second increments for the test strip may result in adjoining exposures that you feel are, respectively, too light and too dark. In such a case, you could make another test strip, using only three exposures (too light, too dark, and midway between) for visual comparison. Another approach would be a single test print made at the time midway between the too-light and too-dark exposures.

Not all negatives are well-exposed, however, so you might find instances when the entire test strip is too light or too dark. An overexposed negative may produce a test in which even the longest exposure is too light; an underexposed negative may result in even the shortest exposure on the test strip being too dark. You could double the exposure times for the overexposed negative, or halve the times for the underexposed one, but *changing the aperture* is often a better choice. Opening up from f/8 to f/5.6 will double the amount of light reaching the paper at each

Figure 9-23. *Five exposure increments can be printed on a test strip with this printing device. The base accepts paper from 2″ × 5″ to 4″ × 5″.*

exposure increment. Stopping down from f/8 to f/11 will have just the opposite effect. In other words, 5 seconds at f/5.6 is equivalent to 10 seconds at f/8, while 5 seconds at f/11 is equal to 2 1/2 seconds at f/8.

An exposure-determining method that, with experience, can almost eliminate the need for test strips is finding the *minimum time for maximum black (MTMB).* In this method, a variation of the test strip is made. It is used to identify the shortest exposure time necessary to produce the deepest possible black when making a straight, normal-contrast print of a well-exposed negative.

The test strip used for this technique is exposed using a section of *clear* film — an area on the negative strip that was not exposed to light, such as the strip between frames. Such unexposed but processed film actually has a tiny amount of density, an extremely slight fogging caused by the processing chemicals (rather than light). The density of such clear film areas is characterized as *film base plus fog.*

The film should be placed in the negative carrier with the clear strip between frames centered. The enlarger head height and lens aperture should be the same settings that would be used to make the print of the size usually produced. Since this is an exposure test method, a different test must be made for *each* print size. Position the enlarging easel and focus the image (a bright stripe of light) in the normal manner.

Using the enlarger's red filter, position the test strip paper so that the projected stripe runs down its center. Turn off the enlarger and move the red filter out of the way. Set the enlarging timer for 30 seconds (or a repeating timer for 3-second intervals). Working in steps about one-half inch in length, make successive 3-second exposures, working from top to bottom of the strip.

The developed and fixed test strip should be dried before it is critically examined. By marking each exposure time change from the bottom upward, **Figure 9-25,** the time where maximum black is achieved can be identified. By ending exposure once maximum black has been achieved in a print, all the

Figure 9-25. *The minimum time needed to print maximum black is determined by making and carefully reading a variation of the test strip. This strip was made on 5" × 7" paper at f/11 with normal (#2) contrast. For those conditions, maximum black will be achieved with a 9-second exposure.*

other tones will be printed in proportion. *This means that the exposure time you have identified should give you a good "straight" print from any normal-contrast, properly exposed negative at your usual print size.* Thus, the need for test strips is essentially eliminated once you achieve enough experience to determine whether your negative is "normal contrast and properly exposed." You may still have to make test strips for negatives that are underexposed or overexposed, although some experienced printers can adjust exposure times quite accurately without testing.

Although the process can be tedious, a minimum time for maximum black test strip should be made for each size print you regularly make, and for each of the variable contrast filters (more about this later). The effort can pay off in terms of time and material savings if the method is followed consistently.

Processing the print

Like film developing, print processing consists essentially of six steps: *development, stopping development, fixing the image, treatment in a washing aid, washing,* and *drying*. Some variations exist, depending upon the type of paper used and the degree of permanence desired for the prints being made. In addition, Kodak and Ilford, two of the major manufacturers of papers and chemicals, have differing recommendations on the length of the different steps in the print developing process.

Sequence of operations

As a general rule, all of the processing steps are shorter for RC papers than for FB papers, because the plastic coating prevents penetration of solutions into the paper support. The shortened time is particularly noticeable in the washing and drying steps, which are far longer for fiber-base paper. The times noted below are general recommendations — for specific times, consult the information labels or sheets for the products you use. You may wish to use those times as a starting point, then experiment to determine what will work best in your situation.

Developer. For RC papers, Kodak recommends a range of 3/4 minute to 3 minutes; Ilford gives a 1 minute to 1 1/2 minute range. Times for FB papers are longer in both cases: Kodak's range is 3/4 minute to 4 minutes and Ilford's is 1 1/2 minutes to 5 minutes. In both cases, the variations are due to different developers and/or developer dilutions.

The exposed print should be slipped smoothly into the developer, **Figure 9-26,** so that the surface is covered immediately by solution. This will help to ensure even development. Timing should begin immediately. Whether the print should be placed in the developer faceup or facedown is an ongoing debate among darkroom workers. Advocates of the facedown approach maintain that it will prevent possible safelight fogging (and thus, lessened print quality). Proponents of the faceup method claim the slight danger of

Figure 9-26. *The print should immediately be covered completely with developer to prevent patchy, uneven development. The best way to do so is to slip the paper into the tray in one smooth motion.*

fogging is outweighed by the increased possibility of scratches or other damage from the softened emulsion rubbing on the tray bottom.

If you place the print in the tray faceup, you should see the image begin to appear in as little as 30 seconds (longer for fiber-base paper or developer that is nearing its capacity). Resist the temptation to pull the print out of the developer early, even though it appears "done." Prints that are not allowed to develop for the full time will often have a washed-out or muddy appearance.

Throughout the development period, follow a regular cycle of slightly lifting one corner of the tray, then lowering it. This continuous *agitation* sets up an ebb-and-flow of solution over the print, constantly exposing the emulsion to fresh solution to ensure even development. Approximately 10 seconds before the end of the development time, lift the print out of the developer by one corner and allow excess solution to drain back into the tray. See **Figure 9-27.** Whether you use

Figure 9-27. *Allow approximately 10 seconds of draining time for developer to run off the print. Carefully hold the print by one corner with fingers or tongs to avoid emulsion damage.*

tongs, gloves, or bare hands, try to grip the print in the border area with a firm but gentle pressure. The emulsion has softened by absorbing liquid, and can easily be marred.

When the development time is up, slip the print into the stop bath tray, being careful to prevent the tongs or your fingers from dipping into the stop. If stop bath *does* get on the tongs or your fingers, rinse it off with water immediately. Keep a clean towel near the sink to dry your hands after rinsing. This will help prevent contaminating the developer with stop bath when you handle the next print. One pair of tongs should be used only with developer. A second pair can be used in both stop bath and fixer, although separate tongs for each are most common.

Stop bath. Print development is usually halted with an acidic stop bath (unlike film development, where a water is often used as a stop). The acid chemically neutralizes the alkaline developer, halting development almost instantly. The neutralizing action helps to extend the life of the fixer, as well. A stop bath time of approximately 15 seconds is sufficient for both RC and FB papers.

Almost any mildly acid solution (even diluted vinegar) can be used as a stop, but most darkroom workers find the commercially prepared *indicator stop bath* convenient. It includes a chemical that turns the solution from yellow to purple when its capacity is near exhaustion, **Figure 9-28.**

Fixer. If they were not processed in fixer, your developed prints would begin to discolor and darken when exposed to light. This would occur because the residual silver halides in the emulsion react with the light. Fixer (either sodium thiosulfate or ammonium thiosulfate) is a solvent that removes unexposed silver halides from the emulsion.

Sodium thiosulfate fixer is typically diluted 1:3 for film and 1:7 for prints. Many darkroom workers, however, prefer to use an ammonium thiosulfate *rapid fixer*, which is diluted 1:3 for both film and prints. This dilution is used in the one-bath rapid fixing method advocated by Ilford. The theory is that the short fixing times (30 seconds for RC, 1 minute for FB) allow a sufficient interval for the fixer to do its work, but little time for the solution to soak into the paper. Kodak recommends longer fixing times (2 minutes for RC and 5–10 minutes for FB) using the 1:7 fixer dilution.

Figure 9-28. *An indicator stop bath will change from a yellow color to purple to show that it has reached its useful capacity. This means it will no longer be able to quickly neutralize the developer. The solution should be discarded and a fresh batch mixed for use.*

When fixing fiber-base paper for longer times, some photographers use the *two-bath fixing* method. Prints are fixed for half of the total time in each bath. Most of the fixing will occur in the first bath, so the second will reach exhaustion much more slowly. When the manufacturer's recommended number of prints has been processed, the first bath is discarded. The second bath then becomes the first, and a fresh batch of fixer is mixed to become the second bath. The advantages of the two-bath method are economy (more prints can be processed in a given quantity of fixer) and decreased danger of inadequate fixing due to fixer exhaustion. Fixer that has been used for more than the recommended number of prints will not remove silver halides effectively. It will also form byproducts that are insoluble in water and thus virtually impossible to wash out. Fixer can be tested for exhaustion by using a test solution, **Figure 9-29.** A few drops of solution are added to a sample of the fixer. The fixer should be replaced if a precipitate forms.

Whether a one-bath or two-bath fixing method is used, prints must be properly agitated to keep a fresh supply of fixer in contact with the emulsion. At minimum, prints should be agitated continuously for the first 15–30 seconds, then periodically

Figure 9-29. *A test solution for fixer can be used to determine whether the solution has reached its capacity. If a few drops of test solution form a precipitate (white particles) in a small sample of the fixer, the fixer should be discarded.*

during the remainder of the fixing time. When using short fixing times, agitate for the entire time the print is in the tray.

Some fixers contain a hardening agent, such as alum, to toughen the emulsion and help prevent damage during processing. Today's print emulsions are more damage-resistant than those used in the past, so many photographers choose to use *nonhardening fixers.* The main reason for doing so is the effect on print washing — nonhardening fixer is easier to dissolve and wash out of the emulsion and paper base.

Washing aid. This is an optional step in the process, and in fact, is probably unnecessary with the short wash times specified for RC papers. With FB papers, however, a washing aid will make the fixer easier to wash out, greatly shortening wash times.

Washing. Fixer and its byproducts must be thoroughly removed from prints by washing. If they are not, the prints will eventually (sometimes in a matter of months) exhibit stains and yellowing.

Resin-coated papers have short wash times: Ilford recommends 2 minutes; Kodak suggests 4 minutes. Fiber-base is a different story: the typical washing time for double-weight FB paper is 60 minutes in running water. By placing the print in a tray of washing aid for a few minutes (times vary with the brand), washing time is shortened to 10 minutes. That represents a significant savings of both time and water.

Drying. As noted in Chapter 8, there are a number of drying methods, ranging from blotters to ferrotype tins to electrically heated devices. When a print must be ready quickly, RC paper can be squeegeed to remove excess water, and then dried with a hand-held hair dryer in a matter of minutes, **Figure 9-30.**

Because of the plastic coating, RC papers will dry without curling, even when hung on a line with a clothespin. If fiber-base paper is hung up to dry in the same way, it usually will curl badly. Paper that is blotter-dried, ferrotyped, or dried on a heated print dryer will usually come out acceptably flat. In

Figure 9-30. *A print made on RC paper can be dried quickly by using a squeegee to remove most of the surface water, and then a hand-held hair dryer to finish the job. The dryer's warm air (rather than "hot") setting should be used.*

many darkrooms, both RC and FB papers are placed on fiberglass screens for drying. Fiber-base prints should be placed facedown on the screen, and will usually dry with only a slight curling of the edges. A stack of dried prints can be flattened thoroughly by placing them under several heavy books for a day or so. A drymounting press can be used to flatten a print quickly with a combination of heat and pressure.

Stabilization prints

An alternative method of printing that permits rapid results is *stabilization printing.* Stabilization paper is exposed in the same way as regular photographic paper, but is processed with a special machine, **Figure 9-31.** The paper has developer incorporated into its emulsion. Inside the processing machine, the paper first is drawn through an *activator* to start the development process, then through a *stabilizer* to halt it. The process takes only seconds to produce a damp-dry

Figure 9-31. *Prints made on stabilization paper can be developed in seconds with a special processing machine. The prints will quickly begin to yellow and fade if they are not fixed and washed conventionally. (Porter's Camera Store)*

print. Because of the processing chemicals it contains, the print will yellow and fade in a matter of days. This can be prevented by fixing and washing the stabilization print in the same way you would a conventional print.

Evaluating the print

Your first straight print from a negative might be acceptable (possibly even excellent), but it is more likely to be a "proof" that you can evaluate for improvement. Most photographers make this initial evaluation from a still-wet print. The print is removed from the holding tray and the water is allowed to drain off. The print is placed in a clean spare tray so it can be carried away from the sink without dripping.

For proper evaluation, the print should be viewed under white light (normal room illumination) rather than safelight, **Figure 9-32.** This may be done in the darkroom, using the normal white light or a separate "inspection light." All paper and other light-sensitive materials must be safely stored, of course, before turning on the white light. The print also may be carried out of the darkroom to an adjacent lighted area, if preferred or more practical.

Figure 9-32. *Safelight is not adequate for evaluating a print, since all values will appear darker than they actually are. View the print under white light. Use either an inspection light, like the one shown here, or normal room light.*

First, look at the print as a whole. If your chosen exposure time is approximately correct, the print should exhibit the full range of tones that you saw in the negative (or on a well-made contact sheet). It should not give an immediate overall impression of being "too dark" or "too light," **Figure 9-33.**

The most critical area for judging proper exposure is the highlights, especially those that were not included in the area from which you made an exposure test strip. On a print, highlight areas may range from light gray to pure (paper) white. Unless the highlight is actually a light source (the sun or a lightbulb) or a specular reflection, it should *not* print as paper white. It should show at least a hint of texture or a slight shading of gray. A common example of a too-light highlight area in a print is the "bald sky." A blue, cloudless sky can easily be overexposed and print as a featureless white indistinguishable from the print border, **Figure 9-34.** This situation is usually too extreme for minor overall exposure adjustment, as described in the next paragraph. It calls for more intensive and localized exposure adjustment, or "burning in," which is covered later in this chapter.

If the significant highlight areas are too light, more exposure is needed. If they are too dark, less exposure should be given. The amount of added or subtracted exposure will depend upon the degree of change needed. One method that is often used is to think in terms of a *percentage* increase or decrease in exposure. If a fairly small adjustment appears to be needed (for example, to bring out just a bit more texture in the highlight), try a 10% change. This is easy to compute: just divide your original exposure

Figure 9-33. *Overall evaluation for exposure. A—Printed too light, exposure too short. B—Printed with full range of tones, exposure about right. C—Printed too dark, exposure too long.*

Figure 9-34. *As shown in this portion of a larger print, a "bald sky" will print paper white, just like the print border. Only light sources and specular highlights should print paper white. Giving the sky area sufficient additional exposure to make it light gray would overexpose the rest of the print. It calls for burning in, a technique for localized exposure.*

time by 10. Thus, if your original exposure time was 17 seconds, a 10% change would be 1.7 seconds. If you are using an electronic timer, you may be able to add or subtract precisely 1.7 seconds; with a mechanical timer, round the time to 2 seconds. Your new exposure times, to make the highlights a bit darker, would then be 19 seconds (17 + 2 = 19). Some photographers prefer to use the new exposure time to make a test print of just the highlight and surrounding area on a small piece of paper, rather than a full-size print. See **Figure 9-35.** This allows checking the result, and making additional adjustment if necessary, while conserving material. Once satisfied with the degree of change, they make another full-size print.

Remember that any exposure increase or decrease to change the highlights will also affect the mid-tones and shadows to the same degree. A change of 10, 15, or even 20% will usually not make the rest of the print unacceptably light or dark, but each print must be judged individually. If you find that an increase of more than 20% in exposure time is needed for highlight improvement, burning in would be the preferred method.

Once a satisfactory exposure time has been established and a new print made, the print's contrast can be evaluated, and adjusted as necessary. As was the case with exposure, the first step should be to look at the print overall to assess whether it is too flat or too contrasty. A *flat print* will have a generally gray appearance, with no areas of strong black or bright white. An *overly contrasty print* will be the opposite, with strong blacks and bright whites, but few gradations of tone in between. A print that is extremely contrasty is sometimes described as "chalk and soot." See **Figure 9-36.**

Examine the shadow areas of the print. Very deep shadows may be totally black and show no detail, but less-deep shadows should include at least a hint of texture and detail. Compare the corresponding area of the negative (which will be light, of course). If there is detail visible on the negative, it should also be visible in the print if the contrast is right. In general, if the shadow areas seem too light or weak-looking, change to a

Figure 9-35. *Using a small piece of paper for a test print allows you to compare the effects of different exposure times without using an entire sheet of photo paper. An 8″ × 10″ sheet of paper can be cut into four 4″ × 5″ pieces to make exposure tests. Some photographers use even smaller pieces for tests.*

Figure 9-36. *Overall evaluation for contrast. A—Flat, gray appearance, contrast too low. B—Average contrast, showing full range of tones. C—"Chalk and soot" appearance, contrast too high.*

higher contrast grade (paper or filter). If the shadows are too dark and featureless (when they should be showing detail), decrease the contrast grade.

To show the differences in appearance that result from increasing and decreasing contrast, **Figure 9-37** displays six prints made from the same negative. The negative was chosen because it prints well (exhibiting a full range of tones) with normal-contrast, or #2, filtration. The prints were made using #0, #1, #2, #3, #4, and #5 filtration on variable contrast paper. Prints made on contrast-graded papers would not match precisely

from grade to grade, but would show the same general progression of contrast. Some differences would also exist with filter sets from different manufacturers, or with the recommended dichroic filter settings on different enlarger color heads.

Filtration can affect the exposure times for prints. For example, Ilford specifies a doubling of exposure times (or opening up the enlarger lens one stop) with filters #4, #4 1/2, and #5. Less drastic adjustments of a few seconds may be necessary when changing from one grade to another (such as #2 to #1). You may wish to make test strips in such

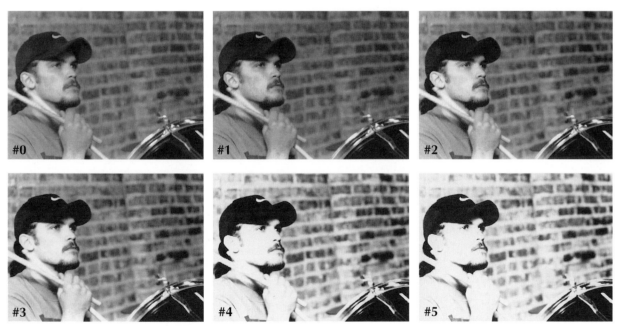

Figure 9-37. *The range of contrast differences attainable using variable contrast paper and filtration from very low (#0) to very high (#5). Filter sets are actually made with half-step increments, allowing even finer adjustment of print contrast.*

situations until you gain a "feel" for any needed time adjustments. Photographers who use the *minimum time for maximum black* method of exposure determination usually establish an MTMB for each contrast grade at the print size they make most often.

Improving the print

There are limitations to what can be done in "straight" printing, since adjustments in exposure time and contrast affect the *entire* print. In an ideal sense, you should be able to use a properly exposed and developed negative to generate an outstanding straight print. In reality, however, almost every print can be improved to some extent by using techniques that permit local adjustment of exposure and contrast. The opposite is also true: improperly used, these same techniques can turn an otherwise acceptable print into a reject.

Dodging and burning in for local exposure control

As noted in an earlier section, some highlight areas require extra exposure (often a considerable amount more) to prevent printing them as blank white paper. At the opposite extreme, some shadow areas may need decreased exposure to reveal the detail they contain.

The process of giving less exposure to a limited area of the print is called **dodging.** The opposite technique, used to provide exposure to part of the print, is called **burning in.** Some skilled darkroom workers use only their hands to block light (dodge) or to selectively apply light (burn in). Most dodging and burning in, however, is done using simple tools that are either purchased or homemade. See **Figure 9-38.**

Dodging might be considered slightly more difficult to master, since it must be done during the basic print exposure. A tool of the approximate shape of the area to be dodged is selected or made. It is then placed in the light path to "shade" the selected area of the paper during part of the exposure,

Figure 9-39. The tool is moved nearer to or farther from the paper to adjust size of the dodged area, and must be kept in slight but constant horizontal motion. This will prevent a noticeable edge between the dodged area and the rest of the print. The critical

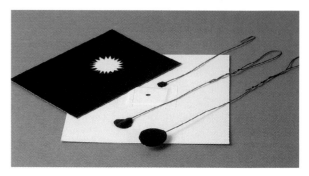

Figure 9-38. *Tools for dodging and burning can easily be made as needed. Thin, stiff wire with a small piece of opaque cardboard taped to the end makes a dodging tool, while an opaque card with a hole in it can be used for burning in. Dodgers can be made in a variety of sizes and shapes to suit specific needs. In the same way, holes of different sizes and shapes are used in cards for burning in.*

Figure 9-39. *To avoid a hard edge, the dodging tool must be in constant motion while it is in the light path. This will "feather" the edges of the dodged area to blend the different amounts of exposure. Motion will also prevent a white or gray line from the wire used to support the dodging tool.*

Figure 9-40. *Dodging one area of a photo (such as this prickly pear cactus) for too long will make it unnaturally light, so that it "jumps out" of the print at the viewer. A badly dodged print like this one can't be salvaged — a new print must be made.*

factor in dodging is *time*: too much will leave the dodged area unnaturally light, while not enough will leave the area too dark to reveal the desired detail. Depending upon the degree of lightening needed, dodging may be done for 10%, 20%, or more of the total exposure. Skill in dodging, and a sense of how long to dodge in a given situation, will develop with practice. As a general rule, dodging for too short a time is preferable to dodging too long, **Figure 9-40.**

Burning in is done by making one or more additional exposures of selected areas after the basic print exposure has been made. The basic tool for burning in is a card large enough to shadow the whole print, with a hole in it to direct light onto the

desired area. Holes may be varied in size and shape — many darkroom workers have a selection from which to choose for a specific task. White card stock that is thick enough to block light is preferable to black. The white card makes the projected image easier to see, so that the spot of light can be positioned more accurately. See **Figure 9-41.**

Moving the card closer to the lens or farther away will change the size of the spot of light projected onto the paper. This permits the light spot to be better matched to the area being burned in. Depending upon the size and shape of that area, a single large spot may be used for an "all-at-once" exposure, or a smaller spot may be used to "paint" light onto the paper in a series of smaller-area exposures. A small spot, for example, can be used to trace along an irregular edge, then the card can be raised to make the spot larger for exposing a larger adjoining area. To avoid a hard edge to the burned-in area, the spot of light must be kept in constant slight motion.

As in the case of dodging, skill in using burning tools comes with practice. So does judging the time that a given area should be burned in. In some instances, a few seconds

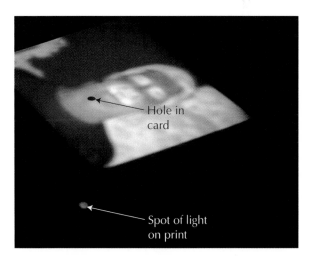

Figure 9-41. *By using an opaque white card to make a burning-in tool, the projected image can easily be seen atop the card. This aids in sizing and positioning the spot of light on the print area to be burned in.*

Figure 9-42. *Printing down. A—The too-light area in the left foreground is distracting, and pulls the eye away from the line of the stream and tree. B—Darkening the area with additional exposure, or "printing down," eliminates the distraction.*

will suffice to bring up the desired tone or texture. More often, however, a longer exposure period will be needed. At times, the exposure for burning in may equal or even exceed the basic exposure time.

While burning in is primarily used to improve the picture's highlight areas, it may be used to darken any tone (other than pure black, of course) that you feel will improve the print. In this context, the technique is referred to as *printing down* a part of the picture. Most often, printing down is used to de-emphasize a lighter area of a print that is distracting. **Figure 9-42** shows the effect of printing down such an area.

When burning in a large area (such as a bald sky) that will require a considerable

amount of exposure, the use of a low-number (#00 or #0) contrast filter will give more rapid results. Remember that variable contrast papers have two emulsions: one sensitive primarily to green light, the other relatively more sensitive to blue. The yellow low-contrast filters block blue light and permit mostly green light to reach the paper. This causes the highlight areas to be exposed more rapidly than if a normal or high-contrast filter were in place. The differing times needed to achieve the same tone with a #2 and a #00 filter are shown in **Figure 9-43.**

In addition to holes in a card, you can use a card's edge to control light when burning large areas, especially at the print margins. Sometimes, cutting the edge of a

Figure 9-43. *Effects of filtration when burning in highlights. A—In the straight print, with an exposure time of 8 seconds, the sky is bald and featureless. B—Burning in with #2 filter for an additional 8 seconds brings out sufficient tone and detail in the sky. C—The same effect is achieved more rapidly, with 5-seconds burning-in time, by using a low-contrast #00 filter.*

card into an irregular shape to "mask" an area (such as a horizon line) while burning is useful, as well.

Some excellent printers regularly burn in all four edges of their prints for a few seconds as the last step in exposure. The almost imperceptible darkening of the edges helps to confine the viewer's eye within the picture and also helps to visually separate the photo from its mounting board when mounted for display. The diagram in **Figure 9-44** shows how the edges are burned in on each side in turn, using the straight edge of a card. Note that the four corners receive a "double burn," making them slightly darker.

"Split-filter" printing.

Practitioners of *split-filter printing* base their method on the way that filters at the extremes of the set change the light reaching the paper. As described in the preceding paragraph, the lowest-contrast filters (#00 or #0) block blue light and allow green light to pass. The highest contrast (#4 1/2 or #5)

Burn in 1" to 2" from each edge

Overlap Overlap

Figure 9-44. *Using the straight edge of a card, each side of the print is burned in for a few seconds to slightly darken it. The card should be moved in a way that allows additional exposure for approximately 1"–2" inward from the edge. As shown, the four corners will receive double the amount of exposure due to overlap. As a result, the corners will be slightly darker.*

filters have the opposite effect: they block green light and pass blue. The filters between these extremes allow varying percentages of blue and green light to pass, depending upon their position in the series. The #2, or normal, filter allows the passage of approximately equal amounts of green and blue light.

There are two basic approaches to split-filter printing. One involves overall exposure through low and high filters in succession, the other uses different filters to expose different areas of the print for varying amounts of time.

In the *overall* approach, the low-contrast exposure controls the highlight values, while the high-contrast exposure controls the shadows. Some practitioners use only the two filters at the extremes; others maintain that any two filters can be used, so long as they are at least three grades apart. Determining the relative lengths of the two exposures requires some experimentation.

Even more experimentation may be needed for the second method, in which a number of different filters may be used. Typically, this method involves making an overall, or *base,* exposure with the normal filter, and then making additional exposures of specific areas with various filters to provide local control of contrast. Practitioners of this type of split-filter printing often develop a diagram on a work print or a tracing-paper overlay to show the filtration and exposure times for each area. See **Figure 9-45.**

These methods are dealt with in far greater detail in books devoted specifically to darkroom work with variable contrast papers.

Special techniques

Photographic printing is a creative and highly individual activity, open to almost endless variation to suit the printmaker's personal vision. Beyond the basics of exposure and contrast, there are numerous approaches that can be taken with technique, materials, or both. A sampling of these will be discussed in the following section.

Figure 9-45. *A marked-up work print or an overlay can serve as a "road map" when planning varying exposures and filtration.*

Use of different substrates

Several manufacturers offer printing papers with special finishes that can be suitable to different images. Papers are available in several colors (including metallic silver), as well as several different surface textures. At least one manufacturer offers a linen material bonded to a paper backing.

Liquid emulsions that can be painted onto various materials, **Figure 9-46,** provide numerous possibilities. The emulsion can be applied to different substrates such as wood, cloth, stone, glass, or various types and colors of paper. The major caution in selecting a substrate is its durability when wetted by processing solutions. Some substrates, such as watercolor papers, hold up well when immersed in developer and other solutions. Other papers, however, would fall apart when wet.

Application of the emulsion must be done with a brush or other applicator, making it difficult to achieve an evenly covered surface free of bubbles. On substrates that are not absorbent, such as glass, a coating of varnish must be applied first and allowed to dry. The varnish acts as a *subbing layer* that helps bond the emulsion to the surface.

After being allowed to dry thoroughly, the emulsion can be exposed by either contact or projection printing. The paint-on emulsions are equivalent to a Grade 2 paper in contrast. Test strips can be made by painting emulsion onto pieces of watercolor paper (or any other paper that will not fall apart when submerged in processing chemicals). With thick or irregularly shaped objects, focusing of the image must be done by measurement or the use of an identical (but not sensitized) object. For some objects, developing chemicals must be poured or brushed on. Despite these more complex preparation and processing steps, many photographers find the use of applied emulsions a worthwhile creative activity.

Changing image appearance

A number of physical and chemical operations can be performed to further alter

Figure 9-46. *A special liquid emulsion can be brushed or flowed onto paper, wood, metal, stone, glass, or other substrates. Although more difficult to work with than conventional printing papers, these emulsions can provide many creative opportunities.*

Figure 9-47. *An unusual effect can sometimes be achieved by printing through a piece of lace or other open-type fabric laid atop the paper.*

There are two types of screens: small ones that are sandwiched with the negative in the enlarger, and larger ones that are placed in contact with (laid over) the printing paper. The pattern of the smaller screens is enlarged along with the negative when projecting the image. Contact screens can produce a finer pattern, since they are not enlarged.

In addition to commercially available screens, photographers also use various other materials for effect. These include insect screening, open-weave fabric (even lace), and various translucent patterned materials, **Figure 9-47.** A diffused or *soft-focus effect* can be achieved by stretching a piece of fine black nylon stocking material over the lens. The effect is subtly different from soft focus attained when exposing the negative.

Vignetting is a technique that gives the central image a soft-edged shape that gradually shades to either white or black, **Figure 9-48.** It provides a somewhat "old-fashioned" look

the appearance of an image. The physical methods are applied at the time the print is exposed, while the chemical techniques are used after development.

Special effects screens can be used to give the image an overall texture or pattern.

A

B

Figure 9-48. *Vignetting. A—A vignette with a white surround is made by exposing through a hole of the appropriate size and shape in a mask. B—For a black surround, a mask is used to cover the image area and overexpose the surrounding area long enough to achieve maximum black.*

to the print, especially when the subject is one or more people and an oval vignette is used. An image vignetted out of a white background is made by cutting an opening of the desired size and shape in an opaque card to make a *mask*. The mask must be large enough to prevent light from striking any part of the paper except the vignetted area. To obtain the soft, gradual shading into the white background, move the card up and down slightly during the exposure.

For a vignette out of a black background, you will first expose the print for a white background, as just described. To expose for the black background, a second mask is needed. This mask is a piece of opaque card the same size and shape as the opening in the first mask. For manipulation, the second mask is taped to a piece of stiff wire about 6″ in length. Using the enlarger's red filter for viewing the projected image, position the second mask to cover the area printed in the first exposure. Remove the negative from the enlarger, move the red filter out of the light path, and make the second exposure. This exposure should be long enough to provide a good, strong black surrounding the vignetted area. (See "minimum time for maximum black," earlier in this chapter.) To avoid a white or gray line from the wire used to hold the mask, keep it in constant slight motion during the exposure, just as you would a dodging tool.

Distortion of an image is done by altering the plane of the surface upon which the image is being projected. Paper can be curved or forced into other shapes, with a resulting stretching or compression of the projected image. See **Figure 9-49.** Single-weight paper can be distorted more readily than double-weight or RC (medium-weight) paper.

A special application of image distortion is actually a method for correcting a common photographic problem, *converging verticals.* The problem — vertical elements that seem to come together as they recede from the viewer — is most noticeable when you tilt your camera upward to include the

full height of a building. This effect is suitable in some contexts, such as using strongly converging verticals to convey the "tallness" of a skyscraper or church steeple, **Figure 9-50.**

Most often, however, the converging lines are considered a defect or distraction in a photo. Large format camera users correct the problem before exposure, using the tilt and swing controls of their equipment (see Chapter 11). For 35mm photographers, there are two ways to control the problem when making the picture. They can move far enough back from the subject to minimize the convergence, or use a special tilt-shift

Figure 9-49. *Distortion of this print was done by curving the paper into a trough on the enlarger baseboard.*

Figure 9-50. *Strongly converging verticals can be used to emphasize the height of a skyscraper or similar subject, such as this church steeple.*

lens, **Figure 9-51.** Moving back (or using a lens with a shorter focal length) helps control the problem by making the image smaller, so that the camera doesn't have to be tilted upward. The tilt-shift lens permits some of the same corrective adjustments used by large format photographers.

For an existing image that exhibits converging verticals, some degree of correction is possible during printing by using a distortion technique. In this case, the print easel is tilted to compensate for the tilt of the camera at the time the original exposure was made. The tilt of the easel distorts the projected

image to make the vertical lines *diverge* (spread apart). This offsets the convergence of lines in the negative, returning them to the vertical. See **Figure 9-52.** Some experimentation will be necessary to determine how much the easel can be tilted without affecting focus. On some enlargers, the negative carrier can also be tilted, allowing a greater degree of correction. This technique will not work in all cases, but can often correct or minimize a convergence problem.

Toning is a chemical process used to change the color of a black-and-white print, or to intensify the print (essentially, to make the blacks a bit "blacker"). Most common toning colors are sepia (a yellowish-tan to brown color), blue, and the purplish tone that results from the use of selenium toner. Toners have also been developed that produce red, orange, yellow, or green colorations in the print.

Color toning is most effective when it fits the subject matter or mood of the photograph, **Figure 9-53.** *Blue toning* imparts a rather cold feeling, and is often effective with mountain landscapes, snow scenes, or seascapes. It can also be a good choice to convey the bleakness of some urban scenes.

Figure 9-51. *A tilt-shift lens allows a 35mm SLR to have some of the correction capabilities usually reserved for large format cameras equipped with tilts and other movements. (Canon USA, Inc.)*

Figure 9-52. *By tilting the printing easel and (if possible) the negative carrier, converging verticals can be corrected in the print. A—The straight print, showing the image as captured on the negative. B—The print resulting from tilting the printing easel to compensate for the converging lines.*

While *sepia toning* is most often employed to give an "old-fashioned" or "antiqued" appearance to a photograph, it can also be a good choice for some landscapes or for photos featuring weathered structures.

Prints to be color-toned must be fully fixed and washed. Some types of toners, such as the traditional sepia, require a two-step process. The print is first immersed in a bleaching solution until the black tones become a faint yellow-brown. After rinsing, the bleached print is placed in the toner and agitated until the desired range of tones is achieved. Other types of toner do not require the bleaching step, allowing toning with a single solution.

Toning can be selectively applied to only certain areas of the print, and more than one color of toner can be used on a print. To tone only a part of a print, you must begin with a print that is *dry*. Using rubber cement or artist's liquid frisket, create a mask by carefully painting over all the areas that you do *not* want to be toned. Let the masking material dry thoroughly. When the print is later immersed in the toner, the mask will prevent the solution from acting upon the areas it covers. After washing and drying the toned print, the masking material can be stripped off to reveal the untoned areas. See **Figure 9-54**. The same procedure can be used to apply different tones to different areas of the print. After the first toning, apply the mask to the areas affected by that toner. Repeat the toning with the second color. Variations can be created by allowing some areas of the print to be acted upon by both toners.

Special toning systems have been developed that combine toning solutions and color dyes. These systems make possible a wide variety of colorations and effects, depending upon the toner/dye combinations used. Detailed directions are included with the kits, **Figure 9-55.**

When performing toning work, special attention must be paid to ventilation and to protecting yourself from contact with the solutions. A number of toning chemicals produce gases with unpleasant odors; these gases are potentially dangerous in a confined space without sufficient ventilation. Some toning materials (particularly selenium) can be toxic if absorbed through

Figure 9-54. *Applying rubber cement or liquid frisket as a mask will permit toning of just a portion of the print. The toner will change the print color in all the unmasked parts of the image. Later, the mask is peeled off to reveal the untoned area. Careful application of the masking material is necessary to avoid ragged edges or pinholes that will allow the toner to reach the emulsion.*

Figure 9-53. *Color toning should be done to enhance the subject. A—This snow scene is strengthened by the coldness of the blue tone. B—Sepia toner or brown toner will work well with weathered wood and similar subjects.*

Figure 9-55. *Toning systems are available to permit multicolor toning and various special effects. (Berg Color Tone)*

the skin. **As a general safety procedure, always wear rubber gloves or use tongs to handle prints being toned. Wear goggles or safety glasses with side shields to protect the eyes against splashes.** Toning solutions will also stain clothing, so the use of a plastic or rubber apron is recommended.

Another process used to chemically alter prints is selective *bleaching.* A dilute solution of a reducing agent (bleaching chemical) is applied to areas of the print that you wish to lighten for emphasis or for better balancing of tones. See **Figure 9-56.** Farmer's Reducer is most commonly used for this work. It is prepared as two separate stock solutions, which are then mixed in small equal quantities for use. Although the mixed solution is used full-strength for overall reduction of too-dense negatives, it is diluted for use as a selective bleach. Usually, a 1:10 dilution (1 part of solution and 10 parts of water) is used, providing better control of the bleaching action. Dilution can be varied to speed up or slow down the work of the solution, if desired.

Bleaching must be done on a print that is damp. It can be performed on a print that has just been developed, fixed, and rinsed, or on a print that has been previously processed, washed, and dried. A dry print must be soaked in water for several minutes

before bleaching is attempted. The print is placed on a work surface, such as the bottom of a developing tray, and surface water removed by squeegeeing or blotting. A tray of water for rinsing and a tray of fixer to halt the bleaching action should be within reach.

Depending upon the size of the area to be bleached, applicators ranging from a fine-pointed brush to a cotton swab to a small piece of sponge may be used. Do not use a brush or other tool with metal that may come in contact with the bleach — a chemical reaction between the bleach and the metal can cause stains on the print.

Apply the bleach to the print in small quantities, being careful to avoid drips and runs into areas that you do not want lightened, **Figure 9-57.** Watch closely as you apply the solution, since the bleaching action can be quite rapid. When the degree of lightening is just short of what you want, place the print in the rinse. This will dilute the bleach enough to almost (but not completely) stop its action. Some bleaching will continue until the print is placed in the fixer. Fix and wash the print according to directions for the paper and fixer you are using. If the degree of bleaching is not sufficient, the process can be repeated. Although somewhat tedious and time-consuming, bleaching in stages is a good practice when first

Figure 9-56. *Bleaching selected areas of a print can help bring out details in shadows or provide emphasis to some highlights. A—Original print. B—Print after bleaching to brighten the breaking wave and bring out highlights in the large rock.*

Figure 9-57. *Careful application of small amounts of the bleach will help you control the process. Be careful to confine the solution to just the areas you want to bleach: the effect cannot be reversed.*

learning this technique. It prevents over-bleaching, which cannot be corrected. To lessen the frustration of losing a print to overbleaching, make several identical prints. If one is ruined, another is immediately available for a "second try."

Archival processing for image permanence

In the preceding discussion of toning, *selenium toner* was mentioned several times. While it is a commonly used color toner for prints, selenium plays an even more important role in ***archival processing*** — the method used to ensure that a photographic print will last for hundreds of years without deteriorating.

As noted earlier in this chapter, proper fixing and washing is vital to producing prints that do not quickly deteriorate. If a print is fixed for too short a time, unexposed silver halides in the emulsion will not be dissolved and removed. Later exposure to room light will cause darkening of the print. The fixer itself is the source of another problem: as it fixes the image in the emulsion, byproducts are formed that are difficult to dissolve. The problem becomes more severe if the fixing period is longer than recommended, or if the fixer is used beyond its

capacity. If these by-products are not removed by sufficient washing, the print will sooner or later exhibit stains or overall discoloration.

Archival processing is typically done for prints made on fiber-base paper. While using archival procedures with resin-coated papers does no harm, it is generally considered a waste of time and effort. Until enough testing is done to establish whether the plastic coating will be stable over the long term, RC papers cannot be considered archival.

Depending upon the type of fixer used, and the recommendations of the paper manufacturer, fixing time will be either 1 minute or 5–10 minutes. The 1 minute recommendation is from Ilford, and is based on the use of a rapid (ammonium thiosulfate) fixer diluted 1:3. Kodak's recommendation for the longer fixing time is based on using a sodium thiosulfate fixer diluted 1:7. When the longer fixing times are used, the two-bath fixing method is preferred. Fixing time is split between the two baths, with the first bath doing most of the fixing. As described earlier in the chapter, a new batch of fixer is mixed after the recommended number of prints have been processed. The first fixer bath is discarded; the second becomes the first, and the fresh fixer becomes the second.

To eliminate virtually all of the fixer and its byproducts from the prints, thorough washing is necessary. Traditional washing times for fiber-base paper are 60 minutes or more, but the use of a washing aid will greatly reduce the time needed for washing. The washing aid (also called a hypo clearing agent) acts on the residual hypo and its byproducts, making them easier to dissolve. The washing time is shortened to a period of from 10–30 minutes (depending on the manufacturer's recommendation). Ilford recommends an initial 5-minute wash, 10 minutes in the washing aid, and a final 5-minute wash. Kodak calls for a 1-minute water rinse, then soaking in washing aid for 2 minutes (single-weight paper) or 3 minutes (double-weight or premium-weight papers).

Single-weight paper is then washed for 10 minutes; double-weight for 20, or premium-weight for 30.

Selenium protective toning is most often done as part of the washing-aid step: the toner is mixed with the washing aid in a 1:20 or even greater (up to 1:40) dilution. In this very dilute form, the selenium will cause little or no color change in most papers. Instead, its primary role is *protective*. The selenium toner chemically changes the silver in the image to a more stable compound, silver selenide. If not treated with selenium (or the more expensive gold toner), the silver making up the image can literally tarnish from airborne contaminants such as sulfur gas. The image can yellow and gradually fade away, **Figure 9-58.**

Washing can be done with running water in a tray or specially designed washer, so long as the flow rate is sufficient for a

Figure 9-59. *Washers specifically designed for archival processing provide individual slots for each print. This helps to ensure thorough washing of prints.*

complete change of water every 5 minutes. In a tray or similar device, the prints should be kept moving in the water so that they do not stick together. The preferred method is a washer design that provides a separate slot for each print, **Figure 9-59.** This permits adequate water flow to both surfaces to carry away residual fixer.

To test the effectiveness of the washing time and washing method in removing fixer, a testing solution can be used. A drop of the test solution is placed on the border of the washed print (after blotting off excess water) and allowed to stand for 2 minutes. The presence of residual fixer in the paper is revealed by a yellowish stain. To determine whether the fixer residue is sufficiently low to be considered archival, the stain is compared to standard text patches, **Figure 9-60.** If the residual fixer level is too high, washing times need to be increased. Additional testing will establish the optimum washing time for your system.

Prints that have been archivally processed should also be mounted and/or stored under archival conditions. Storage boxes, mounting boards, and any other materials in contact with the prints must be acid-free. This subject will be covered in greater detail in Chapter 10.

Figure 9-58. *Prints that are not archivally processed will eventually deteriorate from residual fixer in the paper and exposure to acids in the air. This century-old view of the original Ferris Wheel is badly faded and shows both yellowing and brown stains. (Author's collection)*

Place a drop of
st solution on the area and allow it to
on the surface for 2 minutes. Then rinse
slution from the surface and compare the
with the sample patch below to estimate
fectiveness of your washing.

o test solution in a screw-cap or glass-stoppered
ottle away from strong light. Avoid contact of test
with hands, clothing, negatives, prints, or
loped photographic materials to prevent black stains.
approximately 28% acetic acid from glacial acetic
ute 3 parts of acid with 8 parts of water.

2

Figure 9-60. *The stain made on a washed print by the residual fixer test solution is compared to test patches in such reference works as the Kodak Black & White Darkroom Dataguide. The Dataguide includes the formula for making up a batch of the test solution.*

Questions for review

Please answer the following questions on a separate piece of paper. Do not write your answers in this book.

1. Explain the importance of having only one variable when making a comparison (choosing between alternatives).
2. The _____ developer combines the developing and fixing functions in a single tray.
3. What is the primary advantage of resin-coated papers, in comparison to fiber-base papers?
4. In a variable contrast paper, the green-sensitive part of the emulsion controls the _____-contrast response, while the _____-contrast response is governed by the blue-sensitive part of the emulsion.
5. To achieve intermediate contrast steps with contrast-graded papers, a different _____ can be used.

6. When using a dichroic colorhead for black-and-white printing, variable contrast values are set using the _____ controls.
 a. yellow, magenta, and cyan
 b. yellow and cyan
 c. magenta and cyan
 d. yellow and magenta
7. A _____ print is always the same size as the negative from which it was made.
8. With a properly made contact sheet, what important film exposure information can you find at a glance?
9. Which of the following is the most common method used to determine exposure time for projection print?
 a. print projection scale
 b. test strip
 c. minimum time for maximum black test
 d. print exposure meter
10. Describe the two-bath fixing method. What are its benefits?
11. Using a washing aid will shorten washing time for double-weight fiber-base paper from _____ minutes to _____ minutes.
12. What is meant when a black-and-white print is described as "flat?"
13. Providing extra exposure to a part of the print to darken it or bring out detail is called:
 a. spotting
 b. burning in
 c. dodging
 d. toning
14. By tilting the printing easel, some degree of correction for _____ is often possible.
15. The use of _____ toner in a highly dilute solution is an important step in archivally processing a fiber-base print.

Window mat:
A sheet of mat board with a hole or window cut in it to display and help protect a print. The mat is hinged to the mounting board.

Chapter 10

Finishing and Mounting

When you have finished reading this chapter, you will be able to:

⇒ Compare the benefits of various print-drying methods.

⇒ Correct scratches, spots, and other minor print defects.

⇒ Select an appropriate mounting material.

⇒ Identify the most suitable mounting method for a print.

⇒ Demonstrate the procedures for dry mounting a photographic print.

⇒ Describe the reasons for applying an overmat to the mounted print.

⇒ Discuss the reasons for using different types of overmat.

Something interesting happens when a photographic print is mounted, overmatted, and framed: it becomes "art." Whether or not a critic might agree to that label, the viewer's *perception* of a photo is different when it is presented in unmounted and mounted forms. The wide border formed by the mounting board and/or overmat eliminates distracting surroundings, helping the viewer concentrate on the photo itself. For this reason, fine art photographers prefer plain white or black mounts — colors and patterns tend to compete with the print for attention.

Mounting, matting, and framing are typically the final steps in preparing a print

for display. Before a print can be mounted, however, it must be dried and have any minor visual defects repaired. These operations are collectively termed *finishing.* Proper finishing — especially the elimination of small visual defects — is vital to the appearance of the mounted print.

Drying prints

Drying methods range from the simplicity and low cost of wooden clothespins and a piece of strong cord to the greater expense and complexity of a drying cabinet using a flow of filtered, heated air. Complex or simple, all the methods achieve the same result: a dried print. Some perform the drying in a shorter time, while others produce a flatter print or one with a glossier surface. The choice of method is usually a combination of expense, available space, and the photographer's personal preference. Ranging from simplest to most expensive, drying methods include:

- Hanging line and clips.
- Blotter rolls or books.
- Air-drying screens.
- Ferrotype plates.
- Heated drying units.

The use of a *hanging line and clips* is a time-honored method that is simple and

inexpensive. Many photographers stretch a length of wire or cord across their darkroom above the sink for hanging prints to dry. The prints are suspended from the wire by spring clips that can grip one corner of the paper. The traditional clip for this method is the wooden spring clothespin, which has an opening through the spring coil that allows it to be threaded onto the cord or wire, **Figure 10-1.** Wire is preferred over cord, since it can be stretched more tightly and will not sag under the weight of wet prints. A strong, thin, finely braided wire rope called *aircraft cable* is often used. The line should be suspended within easy reach, but high enough to avoid interfering with work at the sink.

This method is most effective for drying resin-coated (RC) printing papers, since those papers will air-dry with little or no curling. Fiber-base (FB) printing papers will tend to curl toward the emulsion side as they dry. When suspended by a single corner (as is commonly done with RC prints), they will usually curl severely. The solution to this problem (if line drying must be used) is shown in **Figure 10-2.** Two prints are placed back-to-back and clips attached to all four corners. The prints will curl somewhat at the edges, but will be manageably flat for mounting. Further flattening can be

Figure 10-2. *Curling of fiber-base paper when air-drying can be controlled by placing two wet prints back to back. The top corners are fastened with the wire-mounted clothespins, and two additional pins or clips are used to fasten the lower corners together. Since fiber-base papers curl toward the emulsion, placing the prints back-to-back makes the curling forces work against each other.*

Figure 10-1. *A length of wire or cord can be threaded through a number of wooden, spring clothespins, then stretched above the darkroom sink to hang prints for drying.*

achieved, if desired, by placing a stack of air-dried prints on a hard, smooth surface under several heavy books for a day or two.

Blotter rolls or *blotter books* have declined in popularity from the days when most photographers were printing on fiber-base paper, but they are still used to some extent. Both are made from thick, soft, absorbent paper: the roll consists of one long, continuous sheet, while the book has a number of separate pages bound together at one edge. Wet prints are placed between the book pages, or rolled up in the blotter roll. The blotter material literally soaks up excess water from the prints. Over a period of a

day or more, the water in the blotter and the prints evaporates. Dried prints are quite flat, since they were contained by the blotter material. Since RC papers do not absorb water, there is no point to using a blotter device to dry them.

For many photographers, air-drying prints on *fiberglass screens* is the preferred method. Framed screens can be purchased, or can be easily made from 1″ × 2″ lumber and screening material. Since the screens can be stacked, a fairly large number of prints can be dried in minimal space (an important consideration in many darkrooms). Fiberglass screening material is available in several widths, allowing units to be made in a size suited to the available space. Screens should be large enough to comfortably hold several prints in the sizes you most commonly make. A frame with an 18″ × 24″ screen surface, for example, is small enough to be easily handled, but will hold four 8″ × 10″ prints. The same frame could be used for two 11″ × 14″ prints, one 16″ × 20″, or up to ten 5″ × 7″ prints.

The fiberglass screening material is soft enough to prevent scratching the emulsion of the print. It does not absorb any residual chemicals, and can be easily cleaned if any dust or dirt accumulates. The open weave allows air to circulate around both sides of the print for even and relatively rapid drying. Generally, FB prints are placed on the screen emulsion-side down so that their own weight helps to minimize curling. See **Figure 10-3.** When air temperatures are high in the area where drying is taking place, however, fiber-base prints should be dried face up to avoid leaving screen imprints in the softened emulsion. Resin-coated prints are usually placed face up. Drying times, under average temperature and humidity conditions, are one-half hour or less for RC papers, and 6–10 hours for FB papers.

Printing paper usually will be available in both glossy or matte (flat, nonglossy) finishes, although a few fiber-base papers are made only with a glossy surface. In RC

papers, some manufacturers also offer an intermediate level of finish with a low luster, terming it "semi-matte" or "pearl." This finish is quite close in appearance to a glossy fiber-base paper that has been air-dried on a fiberglass screen. Photographers who print in both fiber-base and RC find this an advantage, especially when making trial prints on the less expensive and faster drying RC material.

A glossy resin-coated paper will air-dry with a glossy finish. To obtain a high gloss on a fiber-base paper, however, a *ferrotype plate* has traditionally been used. The ferrotype, also referred to as a "tin," is a sheet of metal with a shiny chrome finish. The washed print is laid face down on the ferrotype tin. A squeegee or a roller (called a *brayer*) is then used to remove as much excess water as possible from the print. The print can be left to air-dry on the tin, or the tin and print can be placed in an electrically heated dryer. When the print is dry, it will release from the ferrotype tin's surface.

Figure 10-3. *Fiber-base prints placed emulsion-side-down on fiberglass screens will dry with only a slight edge curl. Compare the FB print at right with the flatness of the RC print at left. An exception to the face-down placement is print drying in hot, humid weather. To avoid danger of impressing the screen texture in the softened emulsion, FB prints should be dried emulsion-side up. They will curl more noticeably when face up, however.*

There are two types of *heated drying units:* direct-heating and heated-air. The *direct-heating* units make use of an electric resistance heating element to warm a metal platen on which the print is placed. Only fiber-base prints can be dried on a direct-heating unit — the plastic coating of an RC print would melt from the heat and stick to the platen. Direct-heating dryers for use in home darkrooms are typically sized for one 11″ × 14″ or two 8″ × 10″ prints. They have a smooth, shiny metal plate surface for the emulsion side of the print, and an absorbent cloth material that is stretched over the back of the print and clamped into place. A ferro-type plate with prints can be placed in this type of unit for faster drying.

When larger quantities of prints must be dried rapidly, a variation is used. It has a large rotating drum covered by a continuous cloth belt. Prints are placed on the drum at one side and emerge dry at the opposite side. Drum dryers were once common in commercial studios and school darkrooms, but are now seldom used.

A *heated-air* dryer can be used for either fiber-base or resin-coated papers, although its greatest advantage is in speeding up drying for fiber-base prints. The dryer is simply a box fitted with guides to hold drying screens and a means of introducing a flow of warm air,. The warm air is usually filtered at the inlet to minimized dust and other airborne debris. It circulates around the prints on the screen racks to carry away moisture. Commercial units are normally used in schools and similar large darkrooms, but a heated-air dryer for home darkroom use can be constructed quite easily.

Fixing minor print defects

The best way to deal with spots and similar print problems is to avoid them in the first place. Regular cleaning of the dark-room and all equipment used to produce prints will minimize the amount of dust and other debris available to be attracted to your negatives. Careful handling of negatives at every stage (using cotton gloves where appropriate) will help avoid scratches and fingerprints, while use of an antistatic brush and a burst of compressed air will remove loose particles just before printing.

However, even with the greatest of care, you will often find a few white or black spots on your dried prints. A speck of dust that settled on the negative after it was already in the enlarger (or a particle of debris that stuck to the emulsion as the negative dried after development) will show up as a *white* spot, **Figure 10-4.** Damage to the negative in the form of a pinhole in the

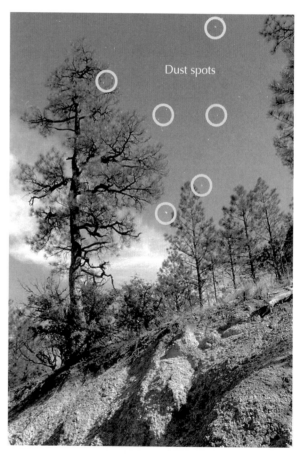

Figure 10-4. *Small white spots on the print are usually caused by dust particles on the negative. For a professional-looking print, they need to be "spotted" with a dye solution matching the color of the surrounding print. A clean darkroom and proper handling of negatives will minimize the number of spots on the print.*

emulsion or a scratch will reveal itself as a *dark mark*. Failure to repair these defects will lessen the visual effectiveness of your final print.

The two types of problems must be dealt with using different techniques. White spots have to be darkened to match the tone of the surrounding darker areas; dark spots must first be changed to white spots (by chemical bleaching or physical abrasion), and then darkened to suit.

Repairing light-colored defects

The traditional method of darkening light-colored defects to match their surroundings, called *spotting,* is tedious but not difficult to master. Although there are sets of marking pens or special pencils on the market for this procedure, the traditional materials are a fine-tipped brush and a liquid dye. Diluted dye is carefully applied to the spot to gradually darken it to match the surrounding print tone.

As shown in **Figure 10-5,** the full set of spotting tools (in addition to the dye and brush) includes a small supply of fresh water, a white plate or similar surface for diluting the dye, and several clean paper towels. Spotting dyes are made in a number of different shades or tones to better match the tone of the printing paper. The most-widely used spotting dyes are available in *sepia, brown,* or *olive* for use on warm-tone

Figure 10-5. *Tools for print spotting. A—Paper towel. B—Liquid dye. C—Container of water. D—Plate or mixing surface. E—Fine-tipped artist's brush.*

papers; *cold* for cold-tone papers, and *neutral* for general use.

When spotting a print, the easiest defects to repair are those in deep shadows; the most difficult are those located in areas of smooth lighter tones, such as skies. As might be expected, small defects are fairly easy to fix and larger spots are much harder. Probably the most challenging spotting task is fixing a line (such as a mark left by a hair or textile fiber) located in an area of cloudless sky on the print. The challenge comes from the way the dye must be applied. It cannot be stroked on like paint; instead, it must be built up as a series of dots or points to fill the defect.

To spot a print, follow this procedure:
1. Mix a drop of wetting solution (such as Photo-Flo) with a tablespoon or so of lukewarm water in a small container. The wetting solution will help the dye penetrate into the emulsion.
2. Using the brush, place a drop or two of the spotting dye on the plate.
3. Dip the brush in the water, then wipe it dry on the paper towel.
4. Select a spot on the print to be treated.
5. Dip the brush in the water to pick up a small amount of liquid.
6. Deposit the drop of liquid on the plate next to one of the spots of dye.
7. Blend a little water with some of the dye to make a very light gray solution, **Figure 10-6.**
8. Dry the brush on paper towel. Draw the brush across the paper so that the fine point is maintained at the tip.
9. Touch the brush to the light gray solution on the plate to pick up only a small amount of liquid.
10. Holding the brush perpendicular to the print surface, touch the tip very lightly to the spot, **Figure 10-7.** A very small amount of dye will be deposited.
11. Lightly blot the spot with a clean paper towel.

Figure 10-6. *Blend small amounts of water and dye until a light gray solution results. This solution will be applied to the spot on the print to build up the tone until it matches the surrounding area.*

Figure 10-7. *Lightly touch just the tip of the brush to the spot to deposit a small amount of dye. The procedure will usually need to be repeated several times to achieve the desired darkening of the spot.*

12. Examine the spot. It may be a bit darker, or it may show no perceptible change after the first application.

13. Continue to add dye to the spot (repeat steps 9–11) until the tone matches its surroundings.

14. Follow the same procedure for each of the light spots on the print. Often, it will be possible to work on several spots at the same time, speeding up the overall process.

15. When all spots have been repaired, set the print aside to dry for a few minutes before stacking it with others.

The greatest danger in spotting is applying too much dye and making the spot *darker* than the tone you are trying to match. Such a darker spot will stand out (especially in a sky or similar area of even tone) and be even more unsightly than the original white spot. It is sometimes possible to minimize the damage immediately after it occurs by "flooding" the spot with a large drop of water to dilute the dye. The result is seldom satisfactory, however.

To avoid the danger of darkening a spot too much, resist the temptation to try "matching" the surroundings in a single application. It is easy to misjudge and apply a spot of dye that is too dark, essentially

ruining the print. The only exception is white spots in areas of deep shadow, which often can be matched in one or two applications of almost undiluted dye. The gradual buildup of tone, as described earlier in this section, is a time-consuming process, especially if there are a number of spots to be treated. It is, however, the most sure and effective method of eliminating light spots.

Removing dark defects

Getting rid of a black spot or line is more complicated and slower than eliminating white spots, since it is a two-stage process. First, you must turn the dark spot into a white spot, then darken the white spot to match its surroundings.

The traditional method of removing a black spot, called *knifing*, involves mechanically scraping away the emulsion layer down to the baryta backing. It requires a very sharp blade and a steady hand to achieve good results — if scraping goes through the bartyta layer to the actual paper, the dye application will be hard to control. The exposed paper surface will absorb dye differently from the emulsion or the baryta layer, making it difficult to match both the color and the luster of the surrounding area.

A chemical method called *bleaching* can be used to eliminate the black marks without causing a mechanical change in the surface. Bleaching makes use of a *reducer* (a solvent for silver compounds) to literally dissolve the exposed silver grains. The result is a clear spot in the print emulsion that shows the underlying white bartya layer. The reducing action is stopped, or chemically neutralized, by a fixer.

Bleaching can be done by making up a small quantity of Farmer's Reducer and applying it to the black spot with a fine brush. The same fixer used for film and paper (ammonium thiosulfate) is applied to stop the reducing action. Commercially available spot-reducing kits eliminate the need to mix solutions. They are packaged as two small bottles: one of bleach and one of fixer. Even simpler is a pen system introduced in recent years. The first pen, loaded with bleach, is touched to the black spot. When the black coloration is gone, the second pen is used to apply fixer.

After the black blemish has been eliminated, by either mechanical or chemical means, a spotting dye must be applied to the resulting white spot. Careful dye application is needed to gradually build up the tone to the desired level.

Preparation for mounting

Once the minor defects have been corrected, prints are ready for mounting. Since most mounting processes involve a number of steps, many photographers prefer to accumulate a group of prints and mount them in a single session.

Two basic decisions must be made before starting the mounting process: you must select the mounting surface (or *substrate*) and determine which mounting method is appropriate to the situation. Photographers usually do not make these decisions each time they mount prints — they settle upon a basic substrate and method used for most work. Changes in substrate or method are then made as

necessary. For example, a photographer who normally dry mounts prints on acid-free mounting board might mount a print on a curved plastic surface, using spray adhesive, to meet a client's specific requirements.

Selecting a mounting surface

The vast majority of mounted photographic prints are placed on *board,* the general term for a stiff, paper-faced material that supports the print and keeps it flat for display. The two basic types are **mat board,** composed of two or more layers of cellulose fiber, and **foam board,** with a paper facing on a rigid core of plastic foam. See **Figure 10-8.**

When you select a mat board for mounting a photograph, there are four considerations that will influence your decision:

* Composition.
* Weight/thickness.
* Color.
* Size.

Mat composition

The most basic consideration is *composition* — the material from which the board is made. Composition of the board is important when *permanence* is a consideration. Common mat boards are made with

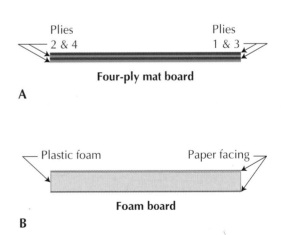

Figure 10-8. *Board for mounting. A—Mat board is made up of two or more layers, called plies, of cellulose fiber. B—Foam board has a core of rigid plastic foam with paper facing on each side.*

cellulose fibers derived from wood pulp, and are slightly acidic. Over time, the acids (in combination with airborne moisture and pollutants) can attack the photograph, causing it to yellow and deteriorate. If you are archivally processing your photographs, it would defeat the purpose of that processing to mount them on ordinary mat board. Products that are termed *museum board* or *conservation board* should be used. These are boards made with cellulose fibers that are acid-free. **Conservation board** is made with fibers derived from specially processed wood pulp, and is typically less expensive than **museum board,** which is made with fibers from cotton (another term used for such board is "rag board"). A board that is acid-free has a neutral pH (a scale that is used to determine acid/alkaline balance). Conservation boards and some museum boards are **buffered** (made slightly alkaline) to counter the long-term effects of weak airborne acids.

The choice of buffered or nonbuffered board will depend upon the material you are mounting. Black-and-white prints should be mounted on a buffered board to take advantage of the additional protection offered. Color prints, especially dye transfer prints, should be placed on nonbuffered board since the prints themselves contain acidic dyes. The dyes could react with the alkaline buffering and cause a color shift.

Foam board typically has an acid-free, buffered-paper facing on both sides. The core material is a chemically inert polystyrene foam.

Mat thickness

The *weight* or *thickness* of mat board is measured in the number of layers or plies that have been glued together. Boards are available with 1-, 2-, 4-, or 8-ply construction. Since plies are typically 1/64" in thickness, a 2-ply board would be 1/32" thick, a 4-ply would be 1/16", and an 8-ply, 1/8". Most mounting is done on either 2-ply or 4-ply boards to obtain sufficient rigidity. For

prints up to 8" × 10", a 2-ply board is stiff enough to stand alone for display; 4-ply should be used for larger items. If an overmat (also called a "window mat") will be used, a common combination is 2-ply for mounting and 4-ply for the overmat, **Figure 10-9.** Eight-ply board is sometimes used for mounting very large photos. Foam board is available in various thicknesses from 1/8" to 1/2" or more. It combines very high rigidity with light weight, and often is used for mounting mural-sized prints for such applications as trade show displays.

Mat color

Selecting the most appropriate mat *color* is somewhat a matter of personal taste, although there are traditional choices. Photographers working in black-and-white usually will mount their work on a white mat. If they use an overmat, it will normally be either white or black, depending upon the photo being displayed. For example, a high-key photo with its predominately white or light gray tones would be set off most dramatically by a black overmat; a dark, low-key photo might benefit from a white overmat. Various shades of gray are available, as are ivory and cream shades that work well with warm-toned papers.

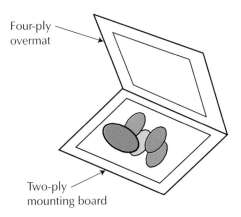

Four-ply overmat

Two-ply mounting board

Figure 10-9. *If a four-ply overmat is to be used, prints in most common sizes can be mounted on a two-ply board. The combination provides sufficient rigidity and protection for the print.*

For framed display in a home or office, a colored overmat may be selected. Many colors are available, **Figure 10-10.** With a black-and-white print, the mat color may be selected to match or complement a room's color scheme. If a color print is being displayed, mat color is often selected to emphasize or contrast with the dominant color in the photo. In addition to sheets of colored mat board that can be cut to size, mats with precut windows are available in many sizes and colors.

Mat size

One of the most important reasons for mounting and matting a print is to provide *visual isolation*, which removes distractions and allows the viewer to focus on the photo. To achieve this isolation, a relatively wide border is needed on all sides of the mounted print.

The usual rule of thumb is to make the *mat size* for a given print equal to the *next-larger* print size. Thus, an $8'' \times 10''$ print would be mounted on an $11'' \times 14''$ mat, an $11'' \times 14''$ print on a $16'' \times 20''$ mat, and so on. Proportionally larger mats may sometimes be used for dramatic effect, but proportionally smaller mats should be avoided. A mat that leaves a too-narrow border around the print is cramped looking and fails to provide the desired visual isolation. Prints that are not of typical proportions may be mounted on standard size mats, or may be effectively displayed on mats proportioned to their dimensions. See **Figure 10-11.**

Other substrates

In addition to the traditional boards, photos may be mounted for display on a wide variety of other substrates. Most of these substrates, however, will not provide

Rag Mat Museum Grade Conservation Board
100% Rag Core & Backing Paper, 100% Acid & Lignin-Free. All Components 100% Acid-Free, Buffered, pH 8.5 to 9.5. Thickness (.054-.058).

Figure 10-10. *Mat board is readily available in a rainbow of colors, as shown by this chart from one manufacturer. Precut window mats are also sold in a variety of colors and sizes. (Crescent Cardboard Co.)*

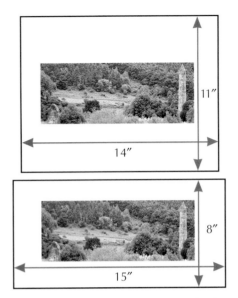

Figure 10-11. *A photo with nonstandard proportions, such as 4" × 11", can be effectively displayed with a standard 11" × 14" mat, or with a more proportional 8" × 15" mat.*

the permanence available from mounting on archival, acid-free boards.

For rigidity and strength, *composition board* is a good choice. Marketed under the trade name Masonite®, composition board has a hard, smooth finish that accepts most adhesives. It has good **dimensional stability** (will not expand or shrink excessively).

Rigidity and dimensional stability are also benefits of *glass* as a substrate. Methods of adhering the print to the surface limit the usefulness of glass; so does its fragility. *Plastic sheet materials*, whether clear or opaque, have the same benefits and drawbacks as glass (although they are less fragile).

Wood and *metal* have also been used as substrates. Like composition board, wood accepts most kinds of adhesives, but more preparation must normally be done to achieve a smooth mounting surface. If the wood has been treated with a color staining material, there is danger of the stain bleeding through and discoloring the photo. Most metals provide a smooth, hard, mounting surface, but can be used with only a limited number of adhesives. Oxidation of metals like steel or copper can discolor photos.

Selecting a mounting method

Just as your decision on a mounting material was governed by various considerations, your decision on a mounting *method* will be shaped by such factors as permanence, convenience, time and cost, and the availability of needed materials and equipment. A number of mounting methods are available, but they can be grouped into three categories:

- Edge or "loose" mounting.
- Cold-adhesive mounting.
- Heated-adhesive (dry) mounting.

Edge mounting

This approach to mounting is favored by museum curators and others concerned with maximum archival preservation of photos. *Edge mounting* is a loose-mounting approach in which the photographic print is held by its corners or by hinges made from easily removed acid-free paper tape.

Corners are available from commercial sources in polyester or paper form or can be easily formed from strips of acid-free paper. The polyester corners are self-adhesive; paper corners must be fastened to the mat board with acid-free tape or another archival adhesive. As shown in **Figure 10-12,** the four

Figure 10-12. *Corners of acid-free material hold a print firmly in position on the mat, but allow it to be removed when necessary. An overmat will cover the corners.*

corners are positioned and fastened to the mat, and then the print is slipped into place. The loose mounting allows the print to be removed and rematted if necessary. Corners are used when the print has a sufficiently wide border so that they can be concealed by the overmat.

There are two types of hinges formed from acid-free tape and used for archival mounting, **Figure 10-13.** Depending upon the size of the print, either two or three hinges are formed along the top edge. The hinging material can be removed, if necessary, without any danger of damaging the print.

The *"T" hinge* is formed by adhering a piece of tape to the back of the print with half its width extending above the edge. The print is then positioned on the mat and a second piece of tape is adhered to the extended part of the first piece and to the mat. This hinge is used when the edges of the print will be covered by an overmat.

If the edges will be exposed, a *"V" hinge* must be formed. The first piece of tape is positioned in the same way as the "T" hinge,

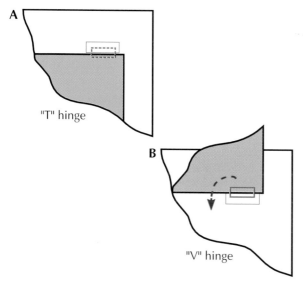

Figure 10-13. *Hinging methods. A—The "T" hinge is used when the photo edges will be covered by an overmat. B—The "V" hinge is folded down, then taped in place with the print face down. When the print is rotated face up, it will conceal the hinge.*

but the part of the tape extending above the print edge is then bent downward. Viewed from the end of the print, the tape forms an inverted V, with the point just below the print's top edge. The print is positioned on the mat, and then rotated or "flipped" along its top edge. The bent-over portions of the hinge "Vs" are dampened and adhered to the mat. For additional security, a second piece of tape is adhered to the mat over the first piece. The print is then folded down into position, hiding the hinges.

The major disadvantage of loose-mounting methods is that they leave the print free to expand or contract with changing humidity levels. This often results in some degree of curling or rippling of the print.

Cold-adhesive mounting

Adhesive mounting methods bind the print tightly to the substrate, and are generally considered permanent. The greatest advantage of the cold methods, as compared to heated-adhesive mounting (dry mounting), is convenience, particularly when only one or a few photos need to be mounted. There is no need to set up or prepare equipment, and the mounting usually can be done in a more limited amount of space.

There are essentially two methods of mounting with cold adhesives: those in which an adhesive is applied to the print or the mount by spraying, brushing, or a roll-on applicator, and pressure-sensitive adhesives that are supplied in sheet form or already applied to a substrate.

The oldest form of **brush-on adhesive** is *rubber cement,* which was applied to both the print and the substrate and allowed to dry until tacky. When the two surfaces were brought together, they bonded instantly and permanently. To permit better alignment, a slipsheet (a smooth, dry paper sheet to which the cement would not adhere) was normally placed between the surfaces and gradually withdrawn to allow bonding. Rubber cement bonding is no longer recommended, except for temporary

mounting of disposable prints. The solvent used in the cement often causes discoloration of the mounted material. A more acceptable form of brush-on material is a water-based acrylic adhesive that allows repositioning and alignment of the print. The print is not bonded to the substrate until pressure is applied with a roller or burnisher.

A *spray-on adhesive* can be applied quickly, but has one major drawback: it is messy to use. Adjacent areas must be protected from overspray, and good ventilation must be provided. Like rubber cement, the most common type of spray adhesive bonds almost instantly and requires precise positioning. A more expensive version of the adhesive is repositionable, allowing a print to be lifted from the substrate and its position adjusted. Removal and replacement can be done numerous times, if necessary.

Several types of *roll-on adhesive* applicators are marketed. Some apply an adhesive in tape form, others dispense evenly spaced dots of adhesive, still others roll on a wide strip of liquid adhesive, **Figure 10-14.** The liquid adhesive forms a

pressure-sensitive bond, allowing the photo to be repositioned until burnished down.

Pressure-sensitive adhesive material can be purchased in sheets or rolls. The material is cut to size, if necessary, and positioned between the print and mat board or other substrate. Pressure applied with a squeegee or roller activates the adhesive, forming a permanent bond. A special applicator used with one brand of adhesive material uses a hand-cranked roller system to apply pressure to materials up to 20″ wide.

Foam board with an already-applied adhesive can be purchased and used for *flush mounts* (those where the photo extends to the edge of the mount, with no border), **Figure 10-15.** To mount a photo, a sheet of protective paper is peeled away from the adhesive, and then the print is carefully aligned with the mount edges and pressed in place. Finally, the print is burnished to assure a good bond. Some photographers using this type of mount prefer to make the print slightly oversize, and then trim it after mounting to assure proper alignment with the mount edges.

Heated-adhesive (dry) mounting

The most widely used mounting method for photographs continues to be *dry*

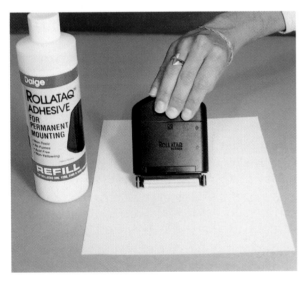

Figure 10-14. *An applicator that uses a roller to lay down a 2″ wide strip of adhesive on the back of the photograph. The adhesive is acid-free, and its bond does not become permanent until it is burnished down. (Daige Products, Inc.)*

Figure 10-15. *This print has been flush mounted on a piece of foam board with an already-applied adhesive. Some boards are manufactured using black foam; the white foam edges of this board were painted black for better appearance.*

mounting, a process that uses heat and pressure to bond the print to the substrate. The heat-activated adhesive material, called *mounting tissue,* is generally sold in sheet form, although rolls are available for large-volume users. Several varieties of mounting tissue are available for different applications. One type is intended strictly for use with porous materials, such as fiber-base paper; another for either porous or nonporous (such as RC paper) materials. Both of these form permanent bonds. A special archival mounting tissue allows *reversal* of the bonding action—reheating a mounted print will allow it to be removed from the mount without damage.

Most heated-adhesive mounting is done using a special dry-mount press. The press has an electrically heated platen that is clamped down on the print and substrate to apply both heat and pressure. Dry-mount presses come in a number of sizes, from small home units capable of mounting an 11″ × 14″ print to large commercial units able to accommodate material up to 52″ in width.

Although results will not always be as uniform as working with a dry-mount press, it is possible to do heated-adhesive mounting with a home laundry iron, **Figure 10-16.** Some experimentation with scrap materials should be done to establish the proper setting on the iron's temperature control. A temperature that is too high can damage a print (especially RC materials), while a too-low temperature will not melt the adhesive sufficiently for a good bond.

Positioning the print

No matter which mounting method you select, you must position your print carefully and accurately on the substrate to show it to best advantage. The most basic "rule" of print positioning is that the print's long axis should be parallel with the long axis of the mat board — if you have an 8″ × 10″ print, the 10″ side should be parallel with the 14″ side of the 11″× 14″ board. This is true whether you have a horizontal or a vertical print, **Figure 10-17.**

Figure 10-16. *By working carefully and experimenting to find the proper temperature, it is possible to successfully dry mount prints using a home laundry iron. The process is slower and less uniform than using a dry-mount press, however.*

There are two slightly different ways of positioning the print on the board, depending upon whether or not you plan to use a precut overmat ("window mat"). The preferred mounting method, used when the print will be displayed without an overmat (or with an overmat that is custom-cut), places the print at the *optical center* of the board. See **Figure 10-18.** This means that the print has equal amounts of space on either side, but *unequal* amounts above and below. The space below the print is somewhat greater than the space above. This positions the center of the print slightly higher than the center of the mounting board. Assuming that you are mounting a horizontal 8″ × 10″ print on an 11″ × 14″

Figure 10-17. *The print should be oriented so that its long side is parallel to the long side of the substrate on which it will be mounted. A—Horizontal print. B—Vertical print.*

board, the margins at each side would be 2", the bottom margin would be 1 3/4", and the top margin would be 1 1/4".

If you are using a precut window mat like those available from camera and art supply stores, the print position must match the window in the overmat. This generally requires the print to be centered on the mounting board at top and bottom as well as side to side. See **Figure 10-19.** As in the

preceding example, side margins would be 2", but both bottom and top margins would be 1 1/2". The opening in the precut mat is slightly smaller than 8" × 10", so that the edges of the mounted print will be hidden.

Mounting a print

As noted earlier, *dry mounting* using a heat-activated adhesive is the most widely used method of attaching a print to a substrate. For that reason, the following section will concentrate on the dry mounting method.

Materials and equipment needed

Although some substitutes can be used for reasons of cost or availability (such as a home laundry iron in place of the tacking iron and dry mount press), the recommended equipment and materials for dry mounting include:

- Dry-mount press.
- Tacking iron.
- Mounting board.
- Mounting tissue.
- Release paper.
- Print positioner or ruler.
- Print trimmer or art knife and steel rule.
- Clean board or paper for use in the press.

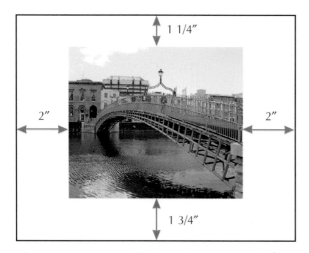

Figure 10-18. *Positioning the print at the optical center of the substrate. Side margins are equal, but the bottom margin is slightly wider than the top.*

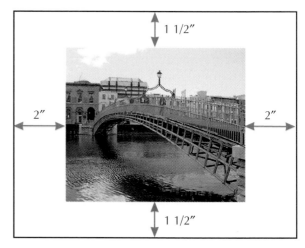

Figure 10-19. *When using a precut overmat, position the print at the actual (mathematical) center of the substrate. Side margins are equal, and so are the top and bottom margins.*

To avoid possible print contamination by skin oils, many photographers wear lint-free white cotton gloves whenever they handle photographic prints. Others find the gloves cumbersome; they minimize skin contact through handling prints by the edges and using a sheet of clean paper between their hand and the print surface (for example, when doing spotting).

The work area for print mounting should be a table or counter with an area large enough to hold the mounting press and other equipment, and still leave a clear surface area large enough for biggest mat board that will be used. A hard, easily cleaned surface such as a plastic laminate is preferred. The area should be well-lighted and have electrical outlets conveniently located for plugging in the mounting press and tacking iron.

Mounting procedure

Assemble all of the necessary materials in the work area, and turn on the press and tacking iron to preheat them. Follow directions from the mounting-tissue manufacturer when selecting heat settings. Be sure to use a tissue designed for the type of print (RC or fiber-base) you will be mounting.

Tack mounting tissue to the print

Adhering a sheet of mounting tissue to the print by *tacking* (melting a small area of the adhesive) will hold the materials in the proper alignment with each other for subsequent mounting steps. If you have several prints to be mounted, it is a good idea to perform such operations as tacking on all the prints before moving on to the next operation.

1. Lay the first print to be mounted, face down, on the work surface.

2. Align a single sheet of mounting tissue with the print. It will usually be slightly larger than the print; the excess will be trimmed off.

3. Place a small piece of *release paper* (a silicone-coated material to which

adhesive will not bond) over the area where you will use the tacking iron.

4. Touch the tacking iron's tip lightly to the release paper for a few seconds, moving it in a small circle. See **Figure 10-20.**

5. Set aside the tacking iron and lift the release paper. The mounting tissue should be adhered to the print in the area where the tacking iron was used. If the tissue did not bond, repeat the operation with slightly increased pressure and a longer heating time.

Repeat the procedure with the next print.

Trim the print to desired size

Prints are trimmed before mounting to remove the white borders and excess mounting tissue. Trimming is also used creatively for *cropping* the photo to change its size or proportions. Various trimming devices and methods are used, but the most common is a steel straightedge used with a sharp knife or a rotary cutter. See **Figure 10-21.**

1. Place the print face up on a cutting mat or piece of scrap board.

2. Align the straightedge for the first side to be trimmed. A straightedge with a nonslip backing can be held in place with hand pressure. For long cuts, or if

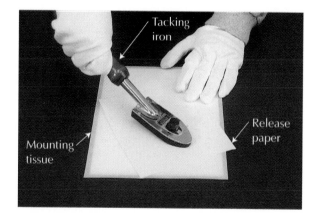

Figure 10-20. *Use the tacking iron to melt a small area of adhesive and bond the mounting tissue to the print. The release paper will keep melted adhesive from sticking to the tacking iron.*

Figure 10-21. *Cutting tools used with straightedge for print trimming. A—Artist's knife. B—Single-edge razor blade in holder. C—Rotary cutter.*

the straightedge does not have a nonslip backing, spring clamps should be used to hold the straightedge firmly in place.

3. In one smooth, nonstop motion, make the first cut, **Figure 10-22.**

4. Reposition the print to make the second cut at a right angle to the first. Be sure corners are square (form a 90° angle); if necessary, check using a drafting triangle.

5. Repeat the procedure to make the third and fourth cuts.

If you plan to crop your photo to a different size or proportion, it is usually best to first trim the four borders, assuring square

corners. Using the trimmed edges for reference will help keep the new cuts parallel and square.

Position print on the board

The trimmed print must be aligned so that its edges are parallel to the mat-board edges. It also must be properly centered on the board. This can be done by using a ruler and calculating the proper side, top, and bottom margins.

An easier and faster method for placing the print in the optical center of the board is to use a **print positioner,** as described in the following steps:

1. Place the print, face up, in the upper right corner of the mat board. Align the corners.

2. Lay the print positioner on the left side of the mat board, with the "T" head extending over the top edge of the board. Slide the positioner toward the bottom of the board until the lip of the "T" head rests against the top board edge.

3. The scale on the "T" head is a centering rule. Move the positioner left or right as necessary until there are equal distances shown from the print edge to the zero mark and the left edge of the board to the zero mark. See **Figure 10-23.** This establishes the side margins.

Figure 10-22. *When trimming prints, hold the cutting edge firmly against the straightedge and make the cut in one smooth movement to achieve a clean edge.*

Figure 10-23. *The centering scale is moved until the distance from 0 to the edge of the print is equal to the distance from 0 to the left edge of the mat board. In this example, the distance is 1 3/4", which will be the side margin amount.*

Figure 10-24. *After the side margins are established, the print is moved to the bottom edge of the mat board, then brought up against the body of the positioner.*

4. Holding the positioner firmly in place, move the print from the upper right corner to the intersection of the positioner's body and the lower edge of the mat board. See **Figure 10-24.**

5. The positioner body has two number scales: small and large. Look at the top edge of the print and determine where it aligns with the large number scale, **Figure 10-25A.**

6. Slide the print upward until its top edge aligns with the matching point on the small number scale, **Figure 10-25B.**

This establishes the top and bottom margins — the print is now properly positioned at the mat board's optical center.

7. Remove the print positioner, being careful not to change the position or alignment of the print.

Tack print to the board

This is a critical step, since any shift in photo alignment at this point will be difficult or impossible to correct. If undetected, it will only become apparent after the mounting has been completed.

1. With one hand holding the print firmly so it will not shift, use the other to lift up one corner of the photo.

2. Slip a small piece of release paper between the print and the mounting tissue, **Figure 10-26.**

3. Pick up the heated tacking iron, lift the print corner again, and carefully insert the iron.

4. Move the tacking iron in a small circle or arc on top of the release paper to bond a small area of the mounting tissue to the mat board. Be extremely careful not to shift or buckle the mounting tissue when moving the iron. See **Figure 10-27.**

Figure 10-25. *Establishing the top-margin distance. A—Identifying where the top of the print aligns with the large scale. B—The print is moved upward until its top aligns with the same number or mark on the small scale.*

Figure 10-26. *When tacking the print to the mat board, release paper must be used between the tacking iron and the mounting tissue to prevent transfer of adhesive to the iron.*

5. After removing the iron, maintain firm pressure on the print and check the tacked area. If there is not a good bond, repeat step 4. Once tacking has been completed successfully, there is no longer danger of shifting, so pressure on the print can be released.

If misalignment does occur because of print or tissue shifting, it is sometimes possible to carefully pull the tissue away from the board. The print may then be repositioned and tacked again. The danger in this instance is that damage to the board surface or the tissue will be embossed on the print in the mounting process.

Insert board in the press

All of the preceding activity leads up to the seconds or minutes that the material will be clamped between the platens of the mounting press. Temperature and time in the press will vary depending upon the substrate, the mounting tissue, and the size of the material being mounted.

1. Check the thermometer or "ready" light to be sure press temperature is correct for mounting, and then open the press (if closed to preheat).
2. Place special cover sheets, release paper, or clean brown kraft paper on the top and bottom of the mat board, **Figure 10-28.**
3. Carefully insert the material in the press and close the cover.
4. Allow the press to remain closed for the time recommended by the mounting tissue manufacturer.
5. Remove the mounted photo from the press and place it, face down, on a hard, smooth surface.

Figure 10-27. *The tacking iron is inserted between the print and the release paper so that only the mounting tissue is adhered to the board. Care must be taken to avoid buckling the tissue while tacking it in place.*

Figure 10-28. *Special cover sheets or clean kraft paper, as shown here, will protect the photo and substrate from foreign matter while in the press. Sometimes, a sheet of mat board is also placed between the top platen and the mounted item to slightly increase and evenly distribute pressure.*

Figure 10-29. *Once the mounted print has cooled, check the bond by flexing the board at opposite corners. All parts of the photo should remain tightly adhered to the substrate.*

6. "Rub out" the mount with your hands to help it cool and aid adhesion (some mounting tissues actually form their bond as they cool). A metal plate specifically made for this purpose can also be used.

Once the mounted print has cooled, test the adhesive bond by bending the board at opposite corners, **Figure 10-29.** If any part of the photo "pops" away from the board, repeat the heating cycle in the press.

Overmatting a print

In addition to mounting a print, many photographers also use an overmat with an opening, or window, cut in it to allow the print to show through. The overmat has two primary functions: *appearance* and *protection*.

The first of these is obvious, since the color (and sometimes texture and/or pattern) of the overmat can help to show the photo to best advantage. Protection, however, is equally important. When a mounted photo is framed and displayed behind glass or a plastic glazing material, the overmat provides spacing to prevent the photo from touching the glazing material. If an overmat is not used, moisture in the air can cause the emulsion to stick to the glass. Moisture can also cause the print to discolor and warp.

Overmat types

The most common form of overmat is one that has a beveled-edge rectangular opening that slightly overlaps the print borders. Variations on this are primarily in the shape of the opening, with circles and ovals often seen. Multiple-opening mats are widely used for displaying a collection of school or family-member portraits.

Double- or even triple-layer window mats are readily available in most framing and art supply stores, and special diecut shapes are growing in popularity. Custom framers often will create mats to meet customer desires by adhering various fabrics, papers, or other coverings to mat board.

A less common form of window mat is cut with an opening somewhat larger than the print. Sometimes referred to as a *reveal mat,* this larger version is most popular among fine-art photographers and museum curators.

The curators like this style of mat for its archival preservation quality — it protects the print like a standard window mat, but does not actually touch the print (minimizing sources of possible contamination or chemical reaction).

Fine art photographers also like the fact that it does not overlap the edges of the print, so the entire photo is revealed to the viewer. The reveal mat, if cut sufficiently oversize, also allows room for the photographer's signature, a title, and (where appropriate) edition numbering. See **Figure 10-30.**

Figure 10-30. *The reveal mat allows room below the photo for the title of the work, edition numbering (8/25 indicates that this print is the eighth in a total edition of 25), copyright date, and the photographer's signature.*

Cutting an overmat

Although precut mats are commercially available in standard print sizes and a number of colors, many photographers prefer to cut their own overmats. The major benefit of doing so is creative flexibility — there is no limit on size and position of the window or windows. It also permits them to match their archival-quality mounting boards with window mats of the same material (precut mats are not necessarily acid-free).

Cutting an overmat with a rectangular window is a fairly simple matter, and becomes even easier with practice. Elaborate cutting systems are on the market for those cutting mats in volume, but small quantities can be produced with only a few simple tools. The basic tool is a hand-held cutter with replaceable blades, **Figure 10-31.** The cutting depth and blade angle should be adjustable. Additional tools include a straightedge, a pair of large spring clamps to hold the straightedge in position, an artist's knife or single-edge razor blade, a ruler, and a pencil.

Before cutting a mat, several preparatory steps are needed. The board for the overmat should be cut to the same outside dimensions as the board on which the photo is mounted. A fresh blade should be installed in the cutter, if necessary, and the angle and depth adjusted. Windows in overmats are typically cut at a bevel of 45°. The blade depth should be just sufficient to cut through the mat board and lightly into the surface of the underlying cardboard or cutting mat. A too shallow cut will not free the window from the surrounding board; cutting too deep will produce a ragged or

Figure 10-31. *Hand-held mat cutters. A—A cutter like this one is suitable for use with a straightedge when cutting small numbers of mats. Blades should be easily replaceable, since clean cuts can be made only with a sharp blade. B—This cutting system includes a hand-held cutter, a base, and a peg-registered cutting guide that simplifies cutting of double overmats. (Porter's Camera Store)*

wavy cut as the blade digs into the underlying surface. Test the cutting depth on a mat scrap of the appropriate thickness.

Follow these steps:

1. Measure and note the distance from each mat edge to the corresponding photo edge.

2. Transfer these dimensions to the back side of the overmat (since windows are cut from the back). Use the straightedge and pencil to lightly draw the rectangle showing the size and position of the photo.

3. Adjust the measurements to allow for the type of window mat you will cut. If you will cut a reveal mat, make the rectangle 1/4″ larger on the top and sides, and 3/8″ larger on the bottom edge. For a mat that will overlap the print, make the rectangle 1/8″ or 3/16″ smaller than the print on all sides. See **Figure 10-32.** Make the adjusted rectangle with darker lines so it can be readily identified while cutting.

4. Set up the straightedge for the first cut. It should be positioned on the outside of the cutting line (when making a cut, the cutter blade is angled toward the straightedge).

Figure 10-33. *Cut each side of the window in one continuous motion. Start and finish just beyond the corner marks for cleanly cut corners.*

5. Start the first cut just outside the corner of your cutting line rectangle. Continue cutting in one smooth motion until the blade goes just past the other corner. See **Figure 10-33.**

6. Repeat steps 4 and 5 on the other three sides.

7. Remove the straightedge and carefully lift one edge of the mat. If the window was perfectly cut, it will remain on the cutting surface. Most often, however, at least one corner will not be cut through completely.

8. Supporting the window piece to avoid tearing the mat surface, turn the mat over so that it is face up. As shown in **Figure 10-34,** carefully insert an art knife or razor blade between the window piece and mat. Matching the 45° bevel, slowly and carefully cut through the

Figure 10-32. *After adjusting measurements, make the new lines darker so they stand out. These are the lines you will cut on.*

Figure 10-34. *If a corner is not cut all the way through, finish it with a sharp blade. Match the bevel and cut carefully.*

material to the corner. Repeat on other corners as necessary to free the window piece.

9. Lay the window mat over the mounted photo to check alignment. If it fits properly, hinge the overmat to the mount at the top with acid-free tape, as shown in **Figure 10-35.**

The same basic procedure can be used to cut multiple openings in a mat, or to cut slightly larger or smaller windows for double-matting. Oval and circular masks can be cut with the aid of a special swiveling cutter, **Figure 10-36.**

Figure 10-35. *The overmat should be hinged to the mount with a length of acid-free tape. This will hold the two in proper alignment.*

Figure 10-36. *Several manufacturers offer devices that allow you to cut oval or circular windows in overmats. This mat combines a semicircular cut with straight cuts. (Porter's Camera Store)*

Questions for review

Please answer the following questions on a separate piece of paper. Do not write your answers in this book.

1. Drying prints and eliminating _____ are referred to as "finishing".
2. What type of printing paper is best suited to the hanging-line-and-clip drying method? Why?
3. What are several advantages of fiber-glass-screen drying method?
4. Why are ferrotype plates used with fiber-base paper?
5. When spotting prints, why is it better to gradually build up a tone to match its surroundings than to try matching in a single dye application?
6. What must be done to eliminate a black spot on a print?
7. Describe the basic difference between museum board and conservation board.
8. Buffering is a process that is used to make mat board more _____.
 a. acid
 b. corrosive
 c. neutral
 d. alkaline

9. For a high-key photo, _____ would be a good color choice for the overmat.

10. An 11″ × 14″ print should normally be mounted on a mat that is at least _____ in size.

11. Which print mounting method is preferred for maximum archival protection of photos?
 a. rubber cement
 b. edge mounting
 c. cold-adhesive
 d. dry mounting

12. One advantage of using pressure-sensitive adhesives is the ability to _____ prints before they are burnished down.

13. Which type of adhesive material used in dry mounting permits reversal of the bonding action?
 a. tissue for porous materials
 b. tissue for nonporous materials
 c. archival tissue
 d. biodegradable tissue

14. A photo that is optically centered on the substrate has equal margins on the sides, but _____ above than below.

15. Why should an overmat be used when a photo is to be framed and covered with glass or rigid plastic?

Linhof/H.P. Marketing Corp.

Movements:
The adjustments (rise, fall, tilt, swing) that can be made to a large format camera to correct perspective and focus problems.

Chapter 11

Large Format Photography

When you have finished reading this chapter, you will be able to:

⇒ Identify the different types of large format cameras.

⇒ Describe the ways in which large format cameras differ from small format and medium format cameras.

⇒ List the advantages provided by large format photography.

⇒ Demonstrate the operation of a large format camera.

⇒ Explain the ways in which camera movements are used for control.

In one sense, every camera — regardless of size or complexity — can be termed a "view camera," since it produces a picture or *view* of the subject in front of its lens. To a photographer, however, "view camera" usually translates to "large format camera" (in fact, the terms are often used interchangeably).

A *view camera* can be defined as one that accepts individual sheets of film in sizes that range from 2 1/4″ × 3 1/4″ to 16″ × 20″, uses a ground-glass back for composition and focusing, and offers a variety of mechanical adjustments ("movements") for control of perspective and depth of field. These cameras also feature interchangeable lenses, usually mounted with a separate shutter on a board that locks into the front of the unit. In addition to the basic holders for individual or multiple sheets of film, view cameras often accept special backs to permit use with Polaroid® instant film, roll film, or digital-image capture (a *scanning back*).

View cameras do not offer features taken for granted by most 35mm camera users: autofocus, built-in light metering and automatic exposure, or motorized film advance. As a result, the photographic process is much slower and more deliberate — the small-camera user might easily shoot an entire roll of film in the time it takes a large format photographer to compose, focus, and expose a single picture. Large-format enthusiasts maintain that the benefits of the bigger negative, the camera control capabilities, and the ability to individually alter the exposure and processing of each sheet of film, far outweigh the drawbacks of the slower and more cumbersome equipment.

View camera types

There are two basic forms of view camera, the flatbed and the monorail. Of the two, the flatbed camera, **Figure 11-1,** has the longest history — crude versions were used for daguerreotype photography in the 1840s. By the time Matthew Brady and his "operators" were photographing the American Civil War in the early 1860s, appearance and functioning of the camera was similar to those used today.

Figure 11-1. *The flatbed view camera, or field camera, is sturdily constructed to permit use in location photography (often under adverse conditions). Some field cameras are all-metal in construction; others are of traditional wood and metal design. (Linhof/H.P. Marketing Corp.)*

The flatbed camera

The *flatbed camera* is often referred to as a "field camera," since its more compact and rugged construction makes it more suitable to use outside a studio setting than the monorail view camera. The flatbed camera is constructed of several major components:

- Bed, or base.
- Front standard.
- Bellows.
- Back standard.

The *bed* supports the two standards and includes a pair of rails along which one or both the standards can be moved. The base also has a socket for attaching the camera to a tripod. Typically, the bed is hinged, allowing the camera to be folded into a more compact unit for transportation in the field, **Figure 11-2.**

The *front standard* has a variety of functions, from holding the lens to making

Figure 11-2. *The bed of a field camera can be folded to form a compact and protected package for transportation in a camera bag or backpack. The camera shown here is actually a press camera, which is similar in most respects to the field camera but offers only a limited range of control movements. Because they are generally available on the used camera market at reasonable cost, press cameras provide the entry point to large format photography for many photographers.*

various movements for focusing and perspective control. The *lens* is usually attached to a separate *shutter mechanism,* which in turn is mounted on a *lensboard.* The lensboard is fitted into the front standard, **Figure 11-3.** The number of front standard movements

Figure 11-3. *The front standard provides a mounting for the lensboard, which holds the lens and shutter assembly. Various methods, such as rotating latches or sliding catches, hold the lensboard firmly in place on the standard.*

available for control will vary from camera to camera — more expensive models usually offer more movements. Basic movements are *tilt* (rotation around the horizontal axis) and *swing* (rotation around the vertical axis). The standard may also be able to *shift* (move from side to side) or *rise/fall* (move upward and downward). See **Figure 11-4.** To focus the camera, the front standard is moved back and forth along tracks on the bed.

A flexible, light-tight element called the *bellows* connects the front and back standards. The bellows is made from a stiff, pleated material that allows it to lengthen (extend) or shorten (contract or collapse) as the standards are moved.

Like the *front standard*, the back standard is multifunctional: it holds the ground glass used for focusing, accepts the film holders or backs, and may be capable of control movements. The *ground glass,* mounted in the film plane, permits precise through-the-lens focusing of the image. Ground glass focusing allows the effects of

any control movements to be viewed as they are made (although it takes some getting used to an image that is not only upside down, but reversed from left to right). When a film holder is inserted into the back standard, the ground glass is moved backward so that the sheet of film can take its place, retaining precise focus. The back standard of a field camera should offer both tilt and swing movements. Due to the construction of most such cameras, shift and rise/fall are usually not available. On 8″ × 10″ and larger field cameras, the back standard can usually be moved backward or forward along the bed rails. This allows focusing to be done by moving either standard.

Press camera

A *press camera* is a type of flatbed view camera once used extensively by newspaper and magazine photographers, **Figure 11-5.** Most commonly found in the 4″ × 5″ format, these cameras are often purchased from used-camera dealers by photographers

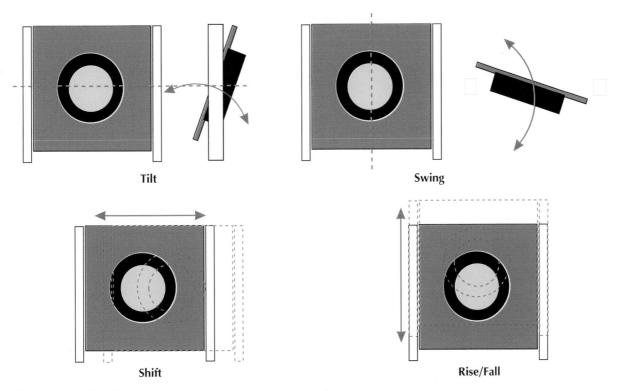

Tilt Swing

Shift Rise/Fall

Figure 11-4. *Basic movements for a view camera standard.*

Figure 11-5. *The press camera is similar in appearance to the field camera, but lacks the range of control movements the field camera typically provides. The shorter bellows of the press camera is also limiting, since it does not permit close-up work.*

seeking a relatively inexpensive entry to large format photography. They are ruggedly constructed and usually have adequate lenses, but lack the range of movements found on true field cameras. Typically, a press camera would be capable of only front rise and a limited tilt. The maximum length of the bellows is also a limitation. To obtain a life-size (1:1) close-up, bellows extension of twice the lens' focal length is needed. A field camera will typically provide such extension; a press camera bellows will not.

Banquet camera

A specialized view camera, typically producing a 12″ × 20″ negative, was the *banquet camera.* It was used to record such large gatherings as annual company dinners, civic receptions, or award banquets. Most popular in the first half of the Twentieth Century, they are essentially a collector's item today. Some landscape work has been done with such cameras by photographers who favor the somewhat "stretched" format.

Panoramic camera

Panoramic cameras that physically rotate to record a view of 180° or more on a long strip of film were popular as early as

1905 when Eastman Kodak introduced its Cirkut line. These cameras were driven by spring motors and were geared to slowly revolve while exposing the film through a narrow slit shutter. Panoramic photography has seen resurgence in recent years, with several manufacturers offering cameras. While the Cirkut and other older cameras used film up to 10″ in width, the new panoramic models are based on the readily available 120 (2 1/4″ wide) film size.

The monorail camera

Like the flatbed view camera, a monorail has front and back standards connected by a bellows. The difference is in the supporting structure: instead of a flat base, there is a single, usually tubular, rail that support the standards and has provision for mounting the camera on a tripod. See **Figure 11-6.**

Figure 11-6. *The monorail camera and the flatbed view camera differ in the way the standards are supported. Monorail cameras usually provide a complete range of control movements. The monorail type is used primarily for studio work. (Linhof/H.P. Marketing Corp)*

Since the design is less compact and harder to transport than a field camera, the monorail is most often used in studio settings.

The monorail approach allows a full range of movements for both the front and back standards: swing, tilt, shift, and rise/fall. For greater precision when setting movements, many monorail cameras have pointers moving across numerical scales. Monorail construction also permits the use of additional bellows sections to gain increased extension for extreme close-ups.

Wide-angle adaptations

In large format photography, lens-to-film plane distances are very short when using wide-angle lenses. For example, on a 4" × 5" camera, the most common wide-angle lens is the 90mm (comparable to the 28mm lens in a 35mm system). The focal length from the optical center of the lens to the film is thus slightly more than 3 1/2". A 75mm lens (equivalent to the 24mm in a 35mm system) cuts the distance even further, to just under 3". On many monorail cameras, the bellows cannot be compressed tightly enough to permit focusing with these lenses, much less allow corrections using swings and tilts.

Two solutions are available and are often used together. Special lensboards allow the lens to be recessed up to 1" or more into the front standard, while soft cloth bag bellows permit the standards to be moved much closer together than the standard pleated bellows. See **Figure 11-7.**

Why use a view camera?

With all the advances in 35mm films, lenses, and cameras in recent years, why would a photographer prefer to use such a cumbersome, slow, and apparently outmoded system as the view camera? A dedicated large format photographer would sum up the reasons in two words: *quality* and *control.*

Under comparable conditions, a large format negative will provide *image quality*

Figure 11-7. *Using a wide-angle lens on a monorail camera usually requires a recessed lensboard, and may call for substituting a bag bellows for the normal pleated bellows. A shorter rail may need to be substituted for the standard length.(Linhof/H.P. Marketing Corp)*

greatly superior to a 35mm negative when printed. The difference is one of scale: assume you are making 8" × 10" prints from a 4" × 5" negative and a matching 35mm negative. The two negatives are on the same type and speed of film, both are well-exposed, and both appear critically sharp under the loupe. As shown in **Figure 11-8,** when you make your print from the 4" × 5" negative, you will magnify it by a factor of two: every detail of your photo (including any defects) will be twice as large as it was on the negative. To make an 8" × 10" print from the 35mm negative, however, you will magnify it *eight* times.

Photographers working with 8" × 10" or larger negatives often will make *contact prints*, rather than enlargements. While making enlargements from negatives this size requires equipment that is both big and costly, the decision to make contact prints is usually an esthetic one. Since the negative is laid directly on the printing paper and no magnification is involved, the print will have a richness of detail, subtlety of tone, and degree of sharpness impossible to obtain by any other method.

Figure 11-8. *Negatives sizes and enlargement. A—A 4" × 5" negative must be magnified to only twice its original size when making an 8" × 10" print. B—A 35mm negative must be magnified eight times its original size when making an 8" × 10" print.*

Since the large format photographer is working with separate sheets of film, rather than a roll containing 24 or 36 images, a considerable deal of *creative control* is possible: exposure and processing decisions can be made individually. For example, when shooting a black-and-white photo of a lighted industrial scene at night (with its huge contrast range), the photographer could decide to overexpose the negative to capture shadow detail. She would then underdevelop the negative to "bring down" the overexposed highlights to a printable level. This individual treatment of a negative would be impossible if she were shooting roll film, since other subjects on the roll shot with normal exposure values would be adversely affected by the underdevelopment. The overexpose/underdevelop approach would work with roll film if the entire roll was devoted to the same subject — an approach that seldom is practical.

The Zone System of photographic control (as described in Chapter 4) was developed by Ansel Adams and Fred Archer essentially for use with the carefully exposed and individually processed negatives used in large format photography. Extension of the Zone System to use with roll film involved some compromises, when compared to its large format application.

With a large format camera, *control* of the final image is done through mechanical/optical means, as well as through exposure and processing adjustments. As described earlier, the standards holding the lens and the film can be moved independently in a variety of ways. They can pivot horizontally or vertically, and shift up, down, or from side to side. These adjustments, or movements, permit an infinite number of refinements to the focus or perspective of the image. Later in this chapter, the effects of the movements will be described and shown.

How a view camera is used

While there will be minor differences from camera model to camera model, the following general procedures are valid for setting up and operating view cameras as a class.

1. Set up a sturdy tripod in approximately the position where it will be used.

2. Remove the camera from its case or other carrying container, and secure it to the tripod, **Figure 11-9.**

3. Select the appropriate lens for the subject and setting, and mount the lensboard on the camera's front standard. Avoid touching the front or rear glass of the lens with bare hands — skin oils on the lens will degrade the image.

4. Open the shutter using the preview lever (on older lenses, this is done by setting the shutter speed to "T" for time). See **Figure 11-10.** Set the aperture to its widest opening.

5. Use the ground glass to make an initial check of image size and composition. It may be necessary to shield the ground glass from ambient light for sufficient visibility. If necessary, physically move the tripod and camera (remember that the ground glass image is not only upside down but reversed laterally).

Figure 11-9. *To provide the steadiest possible support, the camera must be securely mounted on a sturdy tripod. Using a system with quick-release mounting plates will simplify the mounting of the somewhat unwieldy camera on the tripod.*

Quick-release plate

6. Level the camera so tit is truly horizontal. There may be built-in bubble levels on the camera or the tripod head

Figure 11-10. *To admit light through the lens, it is set to its widest aperture and held open with a preview or time exposure setting.*

Bubble to right of center

A

Bubble centered

B

Figure 11-11. *Leveling the camera. A—Bubble indicates tilt in opposite direction (to left). B—Bubble centered in glass shows that camera is now level.*

for use in this operation, **Figure 11-11.** If there are no levels, use the edges of the ground glass (or ground glass grid, if one is present) to align with a vertical element in the scene.

7. Be sure that all movements are zeroed (neutral) to provide a reference point as you make image adjustments. In some cases, few or no adjustments may be needed other than focus; in others, extensive adjustments may be required. (For details and examples, see the following section, *Using camera movements for control.*)

8. Adjust image location (higher/lower, left/right) in the frame by using the shift and rise/fall movements — front or back—as necessary. See **Figure 11-12.**

Figure 11-12. *The difference in image position resulting from a rise/fall or shift adjustment can easily be checked on the ground glass.*

9. Adjust the size of an object in the image, using the back standard tilt or swing movements.

10. Adjust the plane of focus (if it is not parallel with the film plane) using the front standard tilt and swing movements.

11. Check the corners of the ground glass for vignetting (dark areas indicating light falloff) and correct if found. Use a magnifier, if necessary, to be sure image is critically focused and properly adjusted.

12. Determine what filtration, if any, might be needed for emphasis or correction (see Chapter 4).

13. Use a hand-held light meter to determine the proper exposure. Depending upon the situation, you may wish to use a 1° spotmeter, a standard reflected-light or ambient-light meter, or a flashmeter. Some newer view cameras have an

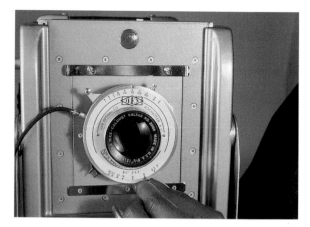

Figure 11-13. *The aperture and shutter speed are set as desired. Small apertures are often chosen to maximize depth of field.*

meter accessory that can make light readings off the ground glass. If an exposure choice is made that will require a change from normal film processing, make careful notes for later reference in the darkroom.

14. Set the desired aperture/shutter speed combination, **Figure 11-13.** Since subject movement is not normally a problem in large format work, the photographer is freed from shutter-speed restrictions and can select a small aperture for maximum depth of field.

15. Insert the film holder carefully to avoid disturbing any camera settings, **Figure 11-14.**

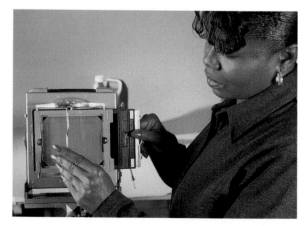

Figure 11-14. *The film holder should be placed in the camera back as gently as possible to prevent any change in focus or other adjustments.*

Slowly withdraw the dark slide from the front side of the holder.

16. If you have an older shutter with a cocking lever, it must be set before the shutter will function. After touching the camera (for removing the dark slide or setting the cocking lever) wait a few seconds for any vibrations to die down.

17. Press the cable release to trip the shutter, **Figure 11-15.** Using a cable release will help prevent any camera motion that could slightly blur the image.

18. Flip the dark slide over, so that the black-painted top faces the front of the camera. Replace the slide in the holder, **Figure 11-16.** The black paint indicates the film on that side has been used.

Black side out — after exposure

Figure 11-16. *To avoid accidental double exposures or wasting unexposed film, always follow the conventional practice for positioning film holder dark slides: face the silver side outward if the film is unexposed, and the black side outward if film has been exposed.*

19. Remove the film holder, rotate it so the side containing the unexposed film faces forward, and re-insert it in the camera.

20. Make another exposure at the same settings as a "backup," or bracket your first exposure with an altered shutter speed or aperture.

Using camera movements for control

The view camera is unique among photographic devices in the way that its individual components can be adjusted to achieve control over the way a subject is recorded on the film. The front and rear standards of the camera can typically be raised, lowered, shifted forward and back or side to side, and

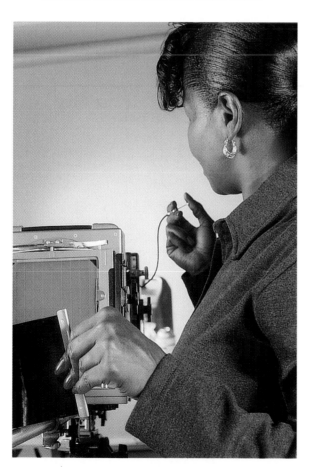

Figure 11-15. *Always use a cable release with a view camera. Pressing the shutter release directly with your finger can cause vibrations that affect the sharpness of the photo.*

rotated around their vertical and horizontal axes. Further, these changes or movements can be combined as needed t o achieve a certain result. For example, the front standard might be moved forward, raised, swung (rotated) several degrees to the right, and tilted forward, all for the same photo.

The degree to which some of these movements can be effectively used depends upon the *coverage* of the camera lens — the size of the **image circle** it projects when focused at infinity. At minimum, the diameter of the image circle must be slightly larger than the diagonal measurement of the film, to ensure that the entire area of the film will be exposed, **Figure 11-17A.** A larger image circle, **Figure 11-17B,** provides room for the camera movements to alter the portion of the scene that will be captured on the film.

Types of movements

As described briefly in an earlier section, there are four basic movements used with a view camera. These are rise/fall, shift, tilt, and swing.

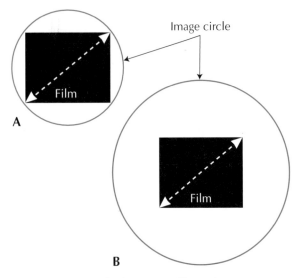

Figure 11-17. *The lens actually projects an image circle onto the film plane, but only the portion that falls on the film will register. A—The minimum image circle diameter must be slightly larger than the diagonal of the film. B—To allow effective use of camera movements, the image circle should be quite a bit bigger than the film.*

Rise and *fall* are vertical movements of the front or rear standard above or below the centered, or **neutral,** position. The most noticeable effect of using either the rise or fall is a change in the portion of the image circle that appears on the film. Possibly the easiest way to visualize this effect is to think of the film as a window frame, **Figure 11-18.** When the standard is at its neutral position, the subject is centered in the frame. The rise movement of the front standard slides the frame upward, so that the subject appears to be lower in the frame. The fall movement of the front standard moves the frame lower so that the subject appears higher. Since the image projected onto the film plane is upside down, rear-standard movements have the opposite effect: rise moves the window downward; fall moves it upward.

This positional change of the frame is the only effect of rear rise or fall. *Front* rise

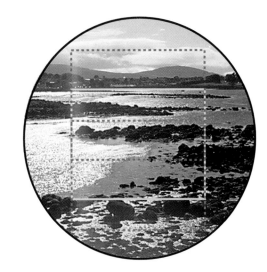

Figure 11-18. *The effects of the rise and fall movements. When the standard is into its neutral position, the subject is centered in the film frame (yellow rectangle). When the rise movement is used, the frame slides upward like a window to show a higher portion of the image circle (red rectangle). The fall movement slides the frame downward to show a lower portion of the circle (blue rectangle). Note that the subject does not move, but that its relative position inside the frame changes.*

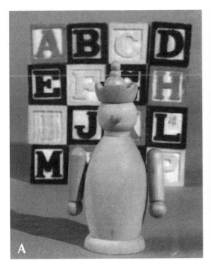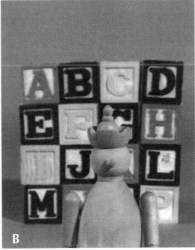

Figure 11-19. *Effects of front rise and fall movements. A—View with front standard in neutral position. B—Front rise changes both the subject position in the frame and the relationship of the objects. C—Front fall changes position and object relationships in the opposite direction.*

and fall, however, subtly change the alignment of the lens and subject. Rise provides a higher-angle view; fall, a lower-angle view. See **Figure 11-19.** Front rise can sometimes be used to minimize the *keystoning* (converging verticals) of vertical lines when photographing a building. Keystoning is caused by tilting the camera upward to include a building's upper portion. Sometimes it is possible to make the camera level and "straight on" with the building to keep lines vertical, then use the front standard rise to bring the top of the building into the frame, **Figure 11-20.** In more extreme cases, the tilt movement is used to straighten verticals.

Shifts are horizontal movements of the standards to the left or right of the neutral (centered) position. As shown in **Figure 11-21,** the shift effects in the horizontal plane correspond to those in the vertical plane with the rise and fall movements.

The *tilt* movement is a rotation of the front or rear standard around a horizontal axis. On monorail cameras, this axis is normally the centerline of the standard; on field cameras, the axis is located at the base of the standard. The effects of the tilting movement are the same for either arrangement.

Tilt is used both to change the shape of an object (correct or exaggerate convergence)

and to extend the range of acceptable focus (improve depth of field). Shape-changing is a function of the rear-standard tilt, which moves portions of the image projected on the ground glass closer to or farther from the center of the lens. Areas that are brought closer to the center of the lens appear larger;

Figure 11-20. *The rise movement of the front standard can sometimes be used to include upper portions of a building while avoiding converging verticals.*

Figure 11-21. *Differing effects of front and rear shifts. Compare the position of the figure's head and the letter blocks behind it in these views. A—Rear shift left changes only the subject position in the frame; front shift right changes the relationship of the foreground and background objects. B—Rear shift right changes only position; front shift left changes object relationships.*

those moved further away appear smaller. **Figure 11-22** demonstrates the effects on a rectangular object that is receding from the camera. In normal perspective (rear standard in the neutral position), the object appears to narrow as distance from the lens increases.

When the rear standard is tilted backward (bottom closer to the lens), the convergence is exaggerated: the near end of the object appears larger and the far end appears smaller. The opposite occurs when the rear standard is tilted forward (top closer to the lens). The

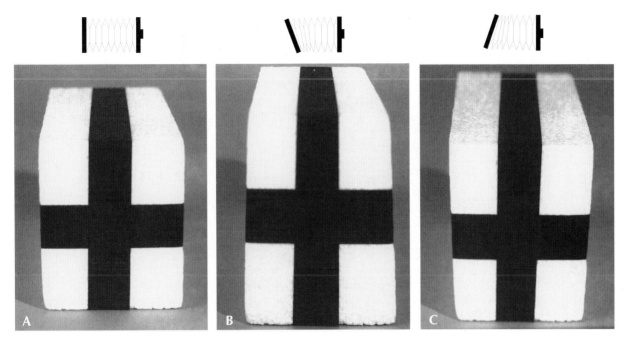

Figure 11-22. *Tilting the rear standard affects shape. A—With standard in neutral position, a rectangular object exhibits normal perspective. B—Tilting backward exaggerates the convergence of lines. C—Tilting forward corrects the convergence.*

convergence has now been corrected: the near end appears smaller and the far end appears larger, so the width of the object seems uniform for its entire length.

Tilting of the front standard is used to better align the plane of the lensboard with the plane of the subject to bring as much of the scene as possible into sharp focus. Normally, of course, the plane of sharp focus is parallel with the lens mounting and the film plane, **Figure 11-23.** This means that points of the subject along the plane of focus will be sharp, while those located closer to or farther from the camera will be less sharp. For most kinds of cameras, the relationship of the lens mounting and film plane are fixed and cannot be altered. The tilt movements of the view camera, however, make it possible to alter the relative positions of the lens, film plane, and subject plane.

If the subject plane is tilted at an angle to the camera, front and rear tilts can be used to achieve the normal parallel focusing relationship, **Figure 11-24.** If the planes cannot be made precisely parallel, tilts can still

be used to achieve the best possible focus by following the *Scheimpflug Principle.* The principle states that maximum sharpness of an image in a subject plane will be achieved when lines projected through the subject plane, the film plane, and the optical center of the lens meet at a common point. This is

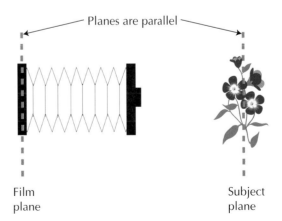

Figure 11-23. *All points along the subject plane will be in sharp focus, since that plane is parallel with the film plane. Points in front of or behind the subject plane will be less sharp, depending upon their distance.*

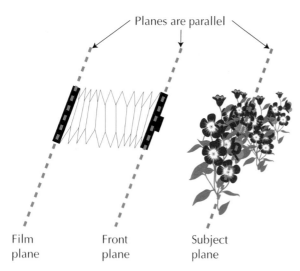

Figure 11-24. *The view camera's tilt movements allow the film plane and the plane of the front standard to be made parallel to the subject plane. Other types of cameras do not have this capability.*

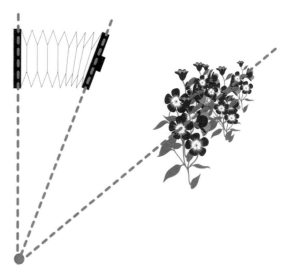

Figure 11-25. *The Scheimpflug Principle is demonstrated in this diagram, since the lines projected through the subject, lensboard, and film plane meet at a common point. Points along most of the subject plane will be in sharp focus.*

shown in **Figure 11-25.** With the lensboard tilted forward as shown, points along most of the subject plane will be in sharp focus, even though they are at different distances from the film plane. The arrangement shown in **Figure 11-26** complies with the Scheimpflug Principle, but also introduces correction for convergence: the rear standard is tilted backward to increase the apparent size of the foreground and decrease the apparent size of the background. The results of the Figure 11-26 arrangement are shown photographically in **Figure 11-27.**

As noted earlier, the effects of the rise/fall movements and the shift movements are the same except for horizontal and vertical orientation. In the same way, the effects of tilts and swings are identical except for the direction in which they take place. The Scheimpflug Principle operates in the same manner with planes converging horizontally as it does with vertical planes.

Once the uses of the four basic movements are understood and a certain amount

of practice has made the photographer more comfortable with the inverted and reversed ground glass image, large format photography should no longer be a mystery. The degree of control it permits over the final image is a strong argument for this approach to photography.

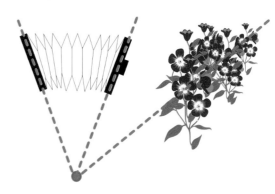

Figure 11-26. *Tilting the rear standard backward as shown will correct convergence in the subject at the same time sharp focus is being achieved by tilting the front standard.*

Figure 11-27. *The results achieved by using front and back tilts as shown in Figure 11-26. A—With standards in neutral position. B—With standards tilted for correction of focus and convergence.*

Questions for review

Please answer the following questions on a separate piece of paper. Do not write your answers in this book.

1. The field camera and the press camera are two examples of the _____ form of view camera.

2. List two features of view cameras, apart from size, that set them apart from most other cameras.

3. Which of the following is not a component of a view camera?
 a. front standard
 b. rear standard
 c. film advance lever
 d. bellows

4. A _____ bed allows the field camera to be folded compactly for transportation.

5. Briefly describe a bellows and its function as part of a view camera.

6. What is a drawback to using ground glass focusing?

7. What are the major differences between a press camera and a true field camera?

8. Why is the monorail type of view camera used most often in the studio, rather than in the field?

9. Which lens for use on a 4″ × 5″ camera is the equivalent of a 28mm lens for use on a 35mm camera?
 a. 50mm
 b 75mm
 c. 85mm
 d. 90mm

10. A large format photographer would use the words _____ and _____ to describe the primary reasons for using a view camera.

11. What type of print — contact or projection — is more likely to be made from an 8″ × 10″ or larger negative? Why?

12. To aid in making the setup truly horizontal, many view cameras have built-in _____.

13. List the four basic movements found on a view camera.

14. To correct convergence of lines in the subject, the rear standard can be _____.

15. To attain the best possible focus on a subject plane that is tilted at an angle to the camera, the large format photographer can make use of the _____ Principle.
 a. Sauerbraten
 b. Scheimpflug
 c. Schaumburg
 d. Saarbrucken

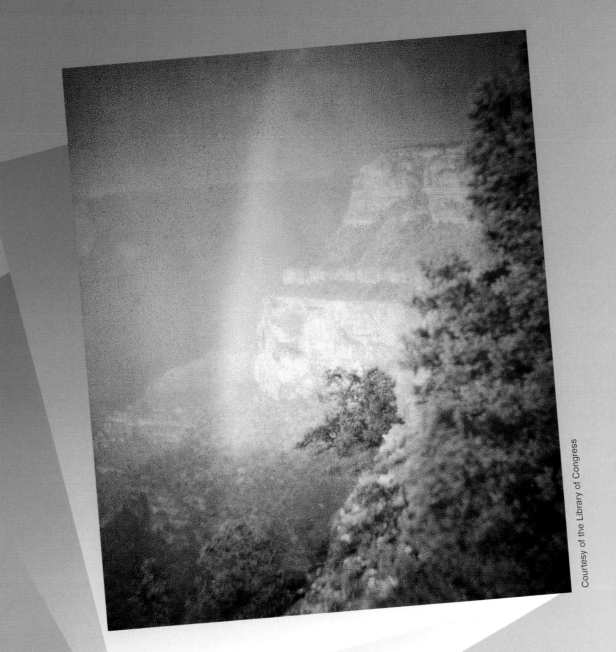

Autochrome process:
The first practical form of color
photography, introduced in 1907. It
used dyed grains of potato starch as
color filters.

Chapter 12

Color Photography

When you have finished reading this chapter, you will be able to:

- ⇒ Describe the differences between the additive and subtractive color systems and identify where they are used.
- ⇒ List the advantages and disadvantages of color negative and color positive (transparency) films.
- ⇒ Explain the importance of the color temperature of light to the appearance of colors on film.
- ⇒ Select the proper filters for different lighting conditions or special effects.
- ⇒ Describe the materials and procedures needed to develop color negative and positive film, and to make color prints.

Visualize circles of red, green, and blue light thrown onto a screen by three separate slide projectors. Now, adjust the images so that they overlap, and observe the changes that take place in the colors. As shown in **Figure 12-1**, the center area where all three circles overlap has no color —only the white of the screen. Where the red and the blue circles overlap, there's a wedge of magenta. Overlapping blue and green produce a wedge of cyan, while (surprisingly to many people) the overlap of green and red creates a yellow wedge.

In its essentials, you have just reproduced the first demonstration of color photography,

an event that took place almost one and one-half centuries ago! James Clerk Maxwell, a Scottish physicist and mathematician, theorized that it was possible to create any color from the proper combination of the primary colors of light: red, green, and blue. In 1861, he made use of the relatively new art of photography to demonstrate his point. Maxwell arranged to have positive black-and-white transparencies made through red, blue, and green filters. The processed

Figure 12-1. *Red, green, and blue (the additive primaries) can be used in various combinations to create any other color. Computer monitors use additive color for their displays.*

transparencies were placed in three projectors, with their matching color filters, and projected onto a screen. When the images were brought into register, a crude but recognizably full-color image resulted.

Maxwell's demonstration was an example of the *additive color process,* in which the primary colors combine to create all other colors. This process is in extensive use today — you see its effect every time you look at a television set or the monitor of your computer. Both the television screen and the monitor have inside surfaces covered with row upon row of tiny phosphorescent dots that glow red, green, or blue when struck by an electron beam. The combination of dots results in a glowing full-color image.

The first practical color photographic process was based on the same principle (minus the electron beam). The Autochrome additive-color process was introduced commercially in 1907. It used plates that were covered by a thin layer of tiny starch grains dyed red, green, and blue, which acted as filters during exposure. After processing, the same layer of starch grains provided the filtration necessary to allow viewing of the photograph in full color.

The basis of all color photography today, however, is the *subtractive color process.* It functions in just the opposite manner from additive color — instead of colors combining to create other colors, the subtractive process "takes away" some colors and allows others to be seen. The colors cyan, magenta, and yellow are called the *subtractive primaries.* On a color wheel, **Figure 12-2,** these subtractive primaries fall between the red, green, and blue additive primaries. Each of the subtractive primaries will absorb light of the color that is positioned opposite it on the color wheel (called its *complementary* color). It will reflect or transmit the colors on either side of its position. Thus, magenta will absorb green light and reflect or transmit blue and red; cyan will absorb red light and pass green and blue, and yellow will absorb blue and transmit red and green.

While additive color is visible only by means of transmitted light, subtractive color functions with either transmitted or reflected light. For example, if you mix yellow and magenta paints, the resulting color (seen in reflected light) will be red. The mixed paint is red to your eyes because the two of the three components of white light (which is made up of equal amounts of red, green, and blue light) have been absorbed. The yellow paint absorbs blue, while the magenta paint absorbs green. The remaining component, red, is reflected by both components, so you see the mixture as red.

Color negative film makes use of the filtering effect of the subtractive primaries on transmitted light. As described in Chapter 5, color negative film has three separate emulsion layers: one sensitive to blue light, the second to red light, and the third to green light. In the development process, cyan, magenta, and yellow dyes are formed in the three layers. When a color print is made, the white light from the

Figure 12-2. *The subtractive primaries—cyan, magenta, and yellow—are located between the additive primaries (red, green, and blue) on the color wheel. Colors opposite each other on the wheel, such as green and magenta, are called complementaries.*

enlarger is filtered through these dye layers. The varying combinations of the dye layers permit the colors of the original scene to be recorded on the red-sensitive, blue-sensitive, and green-sensitive emulsion layers of the photographic paper. **Figure 12-3** summarizes the effects of the different dye combinations on white light.

Types of color film

There are two basic types of color film on the market: "print film" that produces a negative from which positive prints can be made, and "slide film" that results in a positive transparency. A specialized form of color film is "instant" material that self-processes into a print in one minute or so.

Print films

If you are photographing polar bears in the Arctic, exotic orchids along the Equator, giant tortoises in the remote Galapagos, or the parade of humanity in New York's Times

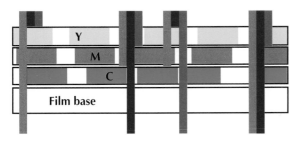

Figure 12-3. *Cyan, magenta, and yellow dyes in the layers of a color negative will act in various combinations to block or transmit the red, green, and blue wavelengths that make up white light. An example, at far left, is light striking an area of the negative where yellow and magenta layers contain an image. The yellow image will block blue and transmit red and green. The magenta image will block green and transmit red (it would also transmit the blue wavelengths, if those wavelengths hadn't already been subtracted by the yellow layer). Thus, only the red wavelengths of light will reach the printing paper in that area. Other dye combinations and their effects on various wavelengths are also shown.*

Square, chances are you can find a place reasonably nearby to buy an extra roll or two of film. And, almost certainly, that film would be print film, the most widely available form of color film.

Kodak, Fuji, Agfa, and a host of smaller producers have blanketed the world with their products, selling millions of rolls each year. The entire mass-market photographic industry, in fact, is built on supplying the cameras, print film, and developing services used by people taking snapshots of family events, children's activities, and vacation trips. Nine out of every ten rolls of film sold are color print film.

The popularity of print film is due in great part to the negative/positive format, which makes possible the rapid production of highly portable and easy-to-view prints. Unlike transparencies (slides) that must be projected in low light to be enjoyed, prints can be viewed easily under most lighting conditions and require no additional equipment. Multiple prints can be made directly from the negative, or even copied from the print itself. Prints can be mailed to friends or digitized on an inexpensive desktop scanner for e-mailing or posting on the World Wide Web.

Another factor in the popularity of print film is the ease and rapidity with which it can be processed. In all but the most remote areas, development and printing on a "next-day" basis is usually possible. In urban areas, "minilabs" in shopping malls, discount stores, and drugstores can develop and print film in an hour or less. See **Figure 12-4.** Multiple prints can be made easily at the time of original processing, and reprints (single or multiple copies) can be produced quickly and relatively inexpensively. In many locations, special "do-it-yourself" printing machines allow enlargements to be made from prints or negatives quickly and at relatively low cost.

The exposure characteristics of print film also contribute to its popularity. Color print film is manufactured in a range of speeds from ISO 50 to 1600, with ISO 100, 200, 400, and 800 almost universally

Figure 12-4. *Processing of color print film is readily available in cities and suburban areas. One-hour processing labs are located in many retail centers. (Walgreen Company)*

available. It has a wide exposure latitude, allowing acceptable prints to be made when underexposed by a stop or overexposed by two (or even three) stops. Corrections can be made in printing to overcome color casts caused by photographing under tungsten or fluorescent lights. This last characteristic, along with other printing adjustments, is one of the reasons why some professionals prefer to shoot print film. Tungsten-balanced print film is available, but is seldom used — correction by means of filters during shooting or by adjustment during printing is more convenient.

Transparency (reversal) films

Transparency (commonly referred to as "slide" or "reversal") film accounts for only a small fraction of the film market. It is used primarily by professional photographers and serious amateurs. Transparencies are first-generation color positive images, which means they provide the maximum in sharpness and contrast. Color *prints* are second-generation images (the negative is the first generation) and always suffer from some loss of sharpness and contrast during the printing process. Slow-speed (and thus fine-grained) films with ratings of ISO 25 and ISO 64 are available in transparency

form. ISO 64, 100, or 200 transparency film is relatively easy to find; ISO 25, 160, 400, or 1600 is more difficult. None of the manufacturers currently offers an ISO 800 reversal film.

The exposure and filtration choices made by the photographer are precisely recorded on transparency film, giving him or her greater control of the final image than using print film. This means, however, that transparency film is far less "forgiving" of mistakes — exposure variations of as little as one-half stop are detectable. Color casts, such as the green hue from fluorescent lighting, must be corrected at the time of exposure.

Since professional requirements for color reproduction are much more exacting than those of the consumer market, there are more emulsion choices offered in transparency film than in print film. In addition to the speeds noted previously and the basic division of emulsions balanced for daylight or tungsten, transparency films are available in a number of degrees of color saturation, from muted to highly intense (often within the same line or brand). Color reproduction and saturation also vary from brand-to-brand, giving the photographer a large number of "looks" from which to choose. She or he may prefer Brand A for its more intense reproduction of green shades when photographing landscapes, while choosing Brand B for portrait work because of its more accurate reproduction of skin tones.

Unlike the one-hour or overnight processing typically offered for print film, transparency processing is usually a 3- to 5-day procedure when done through retail outlets. Professionals, of course, will normally use a custom lab for both speed and quality reasons. Some professionals and serious amateurs process their own transparency film (the exception is Kodachrome, which uses a process different from all other transparency films, and must be done commercially).

Instant color films

Color films that develop in one minute were introduced by Polaroid Corporation in

the early 1960s. Like the earlier black-and-white instant films, these consisted of two layers that were peeled apart at the end of the developing period. One piece was the print; the other was discarded. Several varieties of color instant film continue to be offered by Polaroid today to meet the needs of both the consumer and professional markets.

Consumer market instant films appeal to those who do not wish to wait for processing and printing. Consumer instant color films today are generally variations on the SX-70 system introduced in 1972. The SX-70 camera produced a one-piece photograph with a clear top layer, **Figure 12-5.**

Professionals typically use instant-developing films (both color and black-and-white) to check lighting and studio setups. In advertising photography, the instant photo allows the photographer to show the client how the finished image will appear. This method allows considerable savings of time and effort, as well as the cost involved in reshooting at a later date. The peel-apart films can be exposed with conventional large format cameras by using a special film-holding back. One-piece films require a camera designed for their use.

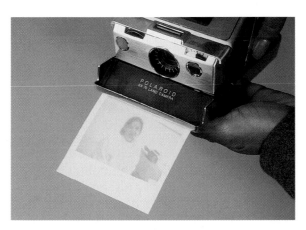

Figure 12-5. *The need for peeling apart layers of instant photographs was eliminated in 1972, when Polaroid introduced the SX-70 camera. It produced a one-piece photo that developed itself as the photographer watched. Later Polaroid cameras continued use of the one-piece film, which provided greater consumer convenience.*

Figure 12-6. *Emulsion transfers to watercolor paper or other materials are possible with the Polaroid peel-apart color films. The variables involved in the process create "one-of-a-kind" prints.*

Instant color films also have a number of uses in fine art photography. A number of photographers have chosen the material — especially in large format sheets — as their preferred medium. Polaroid film in the "peel-apart" form is used for making emulsion transfers in which the film's emulsion layer is adhered to watercolor paper or a similar substrate, **Figure 12-6.** One-piece films, such as the SX-70 or later Spectra, are often manipulated by distressing the developing emulsion with a stylus or similar tool pressed against the clear protective cover layer. More detailed information on alternative photographic processes using instant film will be provided in Chapter 14.

Emulsion types

There are two basic types of color film emulsions — those intended for use with electronic flash or daylight, and those balanced for use under tungsten lighting. The

term "tungsten" refers to the metal used for the glowing filament of incandescent bulbs, such as those used for normal room lighting. Sometimes, the two types are referred to as "outdoor" and "indoor" film, but most professionals use the terms *daylight-balanced* and *tungsten-balanced*.

Emulsions are matched to light sources that have a specific color temperature that is measured in **Kelvin units** (abbreviated K). In the Kelvin scale, higher numbers such as 5500K (average color temperature for noontime sunlight) indicate light sources that are nearer the blue end of the spectrum. Lower numbers like 3400K (typical for a tungsten photoflood bulb) indicate that the light source is nearer the red end of the spectrum. Thus, light with a higher color temperature is colder (more blue); lower-temperature light is warmer (more red). This is, of course, the exact opposite of how we normally think of temperature (*higher = hotter; lower = colder*).

Daylight-balanced

Daylight-balanced film, the most common type of emulsion, is optimized for use with natural daylight or the bright, blue-white light from an electronic flash.

If daylight-balanced film is properly exposed under natural- or artificial-light conditions with an approximate color temperature of 5500K (known as *photographic daylight*), colors in the resulting photographs will look "right" to the viewer. Exposing daylight film with artificial light sources such as photofloods or normal incandescent room lighting (table or ceiling lamps) can result in photos that have an overly warm yellow appearance, **Figure 12-7.** If you are using print (positive/negative) film, your finished prints may not show a yellow cast in the frames shot under tungsten light. Automatic printers used in minilabs or volume processors usually will correct the color balance of such prints. Transparency film balanced for daylight and exposed with incandescent (tungsten) lighting, however, will definitely have a yellow appearance.

Figure 12-7. *Transparency film that is daylight-balanced will take on an overall warm yellow cast when exposed with tungsten lighting. Color negative film can normally be corrected in printing to eliminate the yellow coloration.*

If you must expose all or part of a roll of daylight-balanced transparency film in a tungsten lighting situation, there are two practical methods that can be used. The first is to use special blue-colored photoflood lights. They are available in larger camera stores, and also can be ordered by mail from several sources. The second method is to place one of the 80-series filters on your lens. These are blue filters that subtract some of the yellow wavelengths of light before they reach the film. The 80B filter is used with standard photoflood lamps, which have a color temperature of 3400K. Household tungsten bulbs used in table and floor lamps have a somewhat warmer color temperature (3200K) and require an 80A filter. As is usually the case, placing a filter in the light

path requires an increase in exposure. Through-the-lens camera meters automatically compensate for a filter placed on the lens. If a hand-held meter is used instead, a manual adjustment must be made. With an 80A filter, you must open up two stops; an 80B requires an increase of 1 2/3 stops. Even though positive/negative films can be corrected in processing, more predictable results can be obtained by using an 80-series filter or blue photofloods.

Tungsten-balanced

Tungsten-balanced film is optimized for the warmer color temperatures of incandescent lighting. When properly exposed, this emulsion will correctly render colors exposed with tungsten light. Tungsten-balanced film is typically designated with a "T" in the film's name: Ektachrome 160T, Fujichrome 64T, and Scotchchrome 640T are examples. Tungsten-balanced film is sold primarily in transparency form, since positive/negative film is usually corrected in printing.

If a tungsten-balanced film is used outdoors or with an electronic flash as the light source, the resulting photograph will have a cold blue cast, **Figure 12-8.** As was discussed under daylight-balanced film, the color cast

is normally a problem with transparencies, rather than prints. The color cast can be eliminated by using a yellow-orange 85B filter to keep some of the blue light from reaching the film.

Using filters with color film

One use of filters — color balancing for daylight and tungsten emulsions — was discussed in the preceding paragraphs. Other uses of filters with color film include additional forms of color balancing, modification of the quantity or type of light reaching the film, and special effects.

Color-balancing fluorescent light

A special form of color balancing is attempting to compensate for the green or blue color cast produced on film exposed under fluorescent light. Fluorescent tubes emit a light that is deficient in red wavelengths and very high in green wavelengths. This causes daylight-balanced film to have a green coloration, **Figure 12-9,** and tungsten-balanced film, a blue cast.

The most common method of compensating for fluorescent lighting is the use of

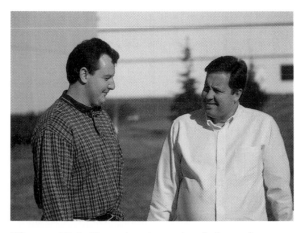

Figure 12-8. *Exposing tungsten-balanced transparency film under daylight conditions will result in an overall blue cast. A yellow-orange filter over the lens will correct the color balance.*

Figure 12-9. *Fluorescent lighting often will produce a green or blue coloration, especially on transparency film. Standard FL-series filters often will be sufficient to correct the problem, but more precise control can be achieved with color-compensating (CC) filters.*

Figure 12-10. *The standard filter used with daylight-balanced film under fluorescent lighting is the FL-D filter. The magenta filter blocks some of the excess green light emitted by the fluorescent tube.*

filters over the camera lens. Standard filters made for this purpose are designated as FL-D or FL-W (for daylight-balanced film) or as FL-B or FL-T (for tungsten-balanced film). The filter for daylight film has a magenta appearance, **Figure 12-10,** and blocks a portion of the green light; the yellow-orange filter for tungsten film blocks some of the blue light.

The standard filters will provide varying degrees of correction, depending upon the type of fluorescent tube that is emitting the light. They usually perform best with the mix of light wavelengths in the widely used "cool white" fluorescent tubes. Tubes designated as "warm white," "daylight," or other variations differ in the proportions of red, green, and blue wavelengths of light they produce.

More precise control can be achieved with combinations of color-compensating filters to match the wavelengths emitted by the particular type of tube. Color-compensating (CC) filters are manufactured in the additive primary (red, green, blue) and subtractive primary (cyan, magenta, yellow) colors, and in a range of densities from 0.10–0.50. These filters are typically designated by an abbreviation that indicates the type, density (without the decimal point, and color. Thus, a CC20Y is a yellow color-compensating filter with a density of 0.20. The CC30R is a red color-compensating filter with a density of 0.30. The filters are

made in thin, transparent gelatin sheets used in a holder placed over the lens.

Complicating the issue is the color response of different films — for the same light source, two different films usually will require different filter combinations. If you were shooting Kodak Ektachrome 200 in lighting from warm white fluorescent tubes, you would combine cyan (CC20C) and magenta (CC40M). If you switched to Kodachrome 200 under the same lighting, you would combine blue (CC40B) and cyan (CC05C) filters. Exposure compensation would differ, as well. With the cyan/magenta combination and Ektachrome, you would lose one full stop; with the blue/cyan combination and Kodachrome, the loss would be 1 1/3 stops. Film manufacturers produce tables showing the filtration needed for different light and film combinations, **Figure 12-11.**

Special-purpose filters

Beyond balancing the light's color, the *quality* of light or the *quantity* of light reaching the surface of the film can be altered by the use of special-purpose filters. Light quality is modified by the ultraviolet, polarizing, and warming/cooling filters, while neutral-density filters regulate the amount of light entering the lens.

Filters and Exposure Adjustments for KODAK Color Films

| Type of Lamp | Daylight-Balanced Films | | Daylight-Balanced Films | | Tungsten and Type L Films (3200 K) |
	VERICOLOR III Professional; EKTAPRESS Plus Professional; Pro; EKTACOLOR Pro 160; EKTAR Professional	EKTACHROME Professional, EKTACHROME, KODACHROME 25 Professional	KODACHROME 64 Professional	KODACHROME 200 Professional	VERICOLOR II Professional EKTACHROME Professional
Daylight	40R + 2/3 stop	50R + 1 stop	50R + 10M + 1 1/3 stops	30R + 2/3 stop	85B + 40M + 30Y + 1 2/3 stops
White	20C + 30M + 1 stop	40M + 2/3 stop	05C + 40M + 1 stop	10B + 05M + 2/3 stop	50R + 10M + 1 1/3 stops
Warm White	40B + 1 stop	20C + 40M + 1 stop	20B + 20M + 1 stop	40B + 05C + 1 1/3 stops	50M + 40Y + 1 stop
Warm White Deluxe	30B + 30C + 1 1/3 stops	30B + 30C + 1 1/3 stops	40B + 05C + 1 1/3 stops	10B + 50C + 1 1/3 stops	10R + 1/3 stop
Cool White	30M + 1 stop	40M + 10Y + 1 stop	40M + 10Y + 1 stop	20M + 1/3 stop	60R + 1 1/3 stops
Cool White Deluxe	20C + 10M + 1 stop	20C + 10M + 2/3 stop	05B + 10M + 2/3 stop	05B + 20C + 2/3 stop	20M + 40Y + 2/3 stop
Average Fluorescent*	10C + 20M + 2/3 stop	30M + 2/3 stop	05C + 30M + 1 stop	10B + 05C + 2/3 stop	50R + 1 stop

Figure 12-11. *Reference tables like this one help you select the right color-compensating filter combination for the type of fluorescent tube and the type of film being used.*
(Eastman Kodak Company)

Ultraviolet filters

The filter probably used by more photographers than any other is the virtually clear ***ultraviolet (UV) filter,*** commonly referred to as a *haze filter* or a *skylight filter*. In outdoor scenes, especially those with a distant horizon, short-wavelength ultraviolet radiation is scattered in the atmosphere. This creates a hazy appearance that hides distant detail. The UV filter "cuts through" the haze to reveal the detail.

Many photographers keep such a filter on their lens at all times for a reason other than its haze-decreasing value. The filter is considered protection for the surface of the lens from airborne grit, salt spray, bumps against hard objects, and similar hazards. The reasoning is that a damaged filter is easily and inexpensively replaced; damage to the glass or coated surface of the lens itself is costly to repair. Any filter placed in front of the lens will degrade the image to some extent, but many photographers consider the tradeoff of slight quality loss for better protection to be worthwhile. The compromise solution taken by other photographers is to leave the filter in place most of the time but remove it before shooting. This is practical for photographing landscapes or other subjects permitting time to remove the filter; it is quite impractical for action or street photography.

Polarizing filters

The ***polarizing filter*** is also common, and has several uses: deepening the color of a blue sky, improving the color saturation of natural objects by reducing glare, and reducing or eliminating reflections from glass, water, and similar surfaces.

Light becomes polarized when its waves all vibrate in the same plane, rather than vibrating in all directions perpendicular to the line of travel. Polarization occurs when light is reflected from a shiny surface at an angle of approximately 35°. A polarizing filter consists of a material in which tiny crystals are all oriented in a single direction.

Light striking the filter will either be transmitted or blocked, depending upon the orientation of the waves to the filter. If the light waves are oriented in the same direction as the crystals, they can pass through the filter. If they are oriented at a right angle (90°) to the crystals, transmission is blocked. See **Figure 12-12.**

In use, the polarizing filter (threaded onto the front of the lens or mounted in a special holder) is rotated to diminish or eliminate the reflection. The effect can be seen through the camera's viewfinder, permitting the photographer to judge the point of best effect. Reflections off water, glass, painted finishes, smooth leaves, and similar surfaces can be reduced by the use of a polarizing filter. Light reflected off bright metal surfaces (***specular reflection***) is not polarized, so the polarizing filter has no effect.

Darkening of a blue sky is achieved with the polarizing filter because a considerable percentage of sky light is polarized. The darker blue sky also allows cloud forms to show better. Maximum effectiveness of the polarizing filter on the blue sky occurs when

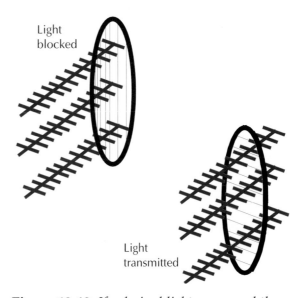

Figure 12-12. *If polarized light waves and the aligned crystals in the filter are at right angles to each other, the polarized light is blocked. If light waves and crystals are parallel, the polarized light is transmitted.*

Figure 12-13. *When the sunlight is coming from a direction at 90° to the axis of the camera lens, the polarizing filter will darken the blue of the sky and bring out cloud forms more strongly. A—Without polarizing filter. B—With filter.*

the sun is at a right angle to the axis of the camera lens, **Figure 12-13.**

Bright light from the sky will cause a glare from leaves and other surfaces that somewhat mutes or washes out their colors. Many photographers never notice this effect until they see the stronger, more saturated colors that become visible when using a polarizer to eliminate the glare.

When purchasing a polarizing filter, it is important to buy the type that is compatible with your camera. There are two types, the *linear polarizer* and the *circular polarizer.* ("Circular" refers to the way the crystals of the polarizing material are arranged, not to the shape of the filter. Both linear and circular polarizers are round in shape, since they must be rotated to achieve their effect.)

The type of polarizer selected is important because the *linear polarizer* cannot be used with autofocus cameras or with cameras that use a beam splitter as part of their exposure metering system. This means its use is restricted to many (but not all) older manual cameras.

The *circular polarizer* is more expensive to buy, but is compatible with autofocus systems and with beam-splitter exposure meters. This means it can be used with any type of camera.

Neutral-density filters

Reducing the quantity of light reaching the film, without altering the color of the light, is the special capability of the *neutral-density (ND) filter*. Most often, an ND filter is used to compensate for bright lighting conditions that would cause overexposure with a fast film. For example, assume you are at the beach on a brilliantly sunny day with ISO 1000 film in your camera. To avoid a distracting background, you need to shoot with a fairly large aperture (f/5.6) to minimize depth of field. Even at your fastest shutter speed of 1/1000 second, you would be seriously overexposing the scene — you need to "lose" three stops of light. The solution is a neutral-density filter with a density of 0.90, which reduces exposure by three stops. Some manufacturers would designate this filter by its density (ND0.9 or sometimes just ND.9); others use the *filter factor*, labeling it as an ND8X filter. See Chapter 4 for a discussion of filter factors and how they are calculated.

ND filters are most readily available with densities of 0.30 (one stop exposure reduction), 0.60 (two stops reduction) and 0.90 (three stops reduction). The filters also are available in 1/3-stop increments (0.10, 0.20, and so on) up to 1.0. Above that point, filter factors increase by powers of 10: a 2.0 density filter has a filter factor of 100 (6 2/3 stops reduction), while a 3.0 filter has a factor of 1000 and reduces exposure by ten stops. Filters can be used in combination to achieve other exposure reductions. For example, a 0.60

filter and a 0.90 filter, used together, will yield a five stop reduction in exposure (1.5 density).

Like other types of filters, ND filters are available in either the round, screw-in type or the square form used with a special holder. Filters with a given density that graduates to a clear background are made in a square or rectangular shape, **Figure 12-14.** They have particular application in landscape photography, where there is often a large difference in brightness between the sky and the foreground. To balance the exposure of the scene, the graduated neutral-density filter, or *"ND grad,"* is slid into its holder with the darker neutral-density portion at the top. It can then be adjusted so that the transition from darker to clear is positioned at the horizon. The camera is set to obtain proper exposure of the foreground area, with the ND filter reducing the sky exposure (usually by one or two stops) to avoid "burning it out." See **Figure 12-15.**

Figure 12-15. *Using a graduated neutral-density filter. A—The brightness range between the sky and foreground is excessive. Exposing for the trees causes the foreground to be correctly exposed, but the sky to be washed out and overexposed. B—Exposing for the sky has the opposite effect; the trees are considerably underexposed. C—The ND grad properly balances exposure of the foreground and the sky.*

Figure 12-14. *Graduated neutral-density filters fade from the full density value to clear, making them valuable when compensating for large differences in brightness between the background and foreground. The rectangular filters are more easily positioned than the round type.*

Special-effects filters

Filters for creating many kinds of special effects are sold in both the round screw-in and square holder types. Special-effects filters can be used to change color in all or part of a scene, to soften or diffuse an image, to duplicate the subject several times in the same photo, to add "star" rays to light sources, and to achieve many other creative variations.

Color-changing filters

In an earlier section, the use of filters to balance light for proper color representation was discussed. Color filters can also be used to *add* color to all or part of a scene. For example, the same yellow, orange, red, blue, and green filters used with black-and-white film to improve contrast or separate gray tones can be employed with color film to give a scene an overall color cast. A typical use might be a desert scene exposed through an orange or dark yellow filter, or a seascape shot with a blue filter.

In the same way that split neutral-density filters are used to reduce exposure of only a part of a scene, graduated color or *color-grad* filters can add color to part of the scene. A popular color-grad filter is one with a yellow-orange color that can be used to enhance the sky colors when photographing a sunrise or sunset. The same filter can be inverted to add warmth to a foreground (such as a beach scene) without affecting the color of the sky. Color-grad filters are made in many colors, and even in combinations of colors (such as red at one end and blue at the other).

A more subtle use of color filters is to *warm* or *cool* a scene. For example, if reflected skylight is giving shadow areas a cold, blue appearance, you could put a *warming filter* such as the yellowish 81B on your lens. The filter will absorb some of the blue light, warming up the scene. At the other extreme, you might be photographing a scene illuminated by the warm light of a campfire, and wish to make the coloration of the scene a bit less yellow. A *cooling filter* (such as the light blue 82A) will achieve the effect you want.

Diffusion filters

For portrait work or other applications, it is often desirable to have a slightly softened or diffused appearance, rather than the usually-preferred razor sharpness. *Diffusion filters* provide a look different from that of being slightly out of focus, although the difference is hard to define. A photo taken with a diffusion filter, **Figure 12-16,** presents the appearance of being shot through a light veiling of fog (in fact, a filter with a somewhat stronger effect is called a "fog filter"). The very slight softening of the image smoothes out small wrinkles and skin defects.

Diffusion filters are made with varying degrees of softening, sometimes in combination with a very light shade of color. A variation is the *center-spot filter,* which has a clear central area. A photo taken with this filter will exhibit normal sharpness in the center, but add diffusion to all other areas.

For years, photographers have created diffusion effects by such means as stretching a piece of sheer black nylon stocking material over the lens, or applying a thin smear of petroleum jelly to a UV or skylight filter. On a cool day, it is possible to make a "diffusion filter" by breathing on the filter or front

Figure 12-16. *An overall softening of the image is produced by a diffusion filter. This filter is often used for portrait work.*
(Cokin Filters/Minolta Corporation)

Figure 12-17. *Condensation on the lens can be used as a readily available diffusion filter. Breathing on the lens on a cool day will fog it for a short time.*

element of the lens, causing it to fog from condensation, **Figure 12-17.** The exposure must be made quickly, before the condensed moisture evaporates.

Image-modifying filters

In a strict sense, *all* filters are image modifiers, since their purpose is to change what appears on the film. For the purposes of this discussion, however, the term is being used to group various filters that have a more pronounced effect on the image than those previously discussed. Filter manufacturers offer many such filters, and are adding more all the time. Some of the more commonly used image modifiers include:

- **Star filters.** These filters have a grid of finely etched lines (a diffraction grating) that causes bright rays to extend from any small, intense light source in the

picture. Different gratings will produce "stars" with four, eight, or sixteen rays. See **Figure 12-18.**

- **Multiple-image filters.** Anywhere from two to as many as twenty-five repetitions of the image will be displayed. Patterns in which the images are arranged vary with the number of repetitions.

- **Blur filters.** Different degrees and patterns of blurring are offered to provide such effects as motion blur, zoom, rotation, or fog.

- **Double-exposure filter.** This device is an opaque mask that can be rotated to cover half of the lens at a time. In use, the first exposure is made with the mask in position over half the lens area. The mask is then rotated to cover the area first exposed, and the second exposure is made without advancing the film. The result is two nonoverlapping exposures on the same film frame, **Figure 12-19.** If overlapping exposures are desired, a different technique (not using this filter) must be employed. The use of intentional double exposure as a creative tool is discussed in Chapter 14.

Figure 12-18. *Star filters can add interest to photos that include bright points of light, such as this night view of New York City. (Cokin Filters/Minolta Corporation)*

Figure 12-19. *A simple mask is used by the double-exposure filter to permit exposing two nonoverlapping images on the same frame. A—First exposure, with mask covering half the frame. The mask is reversed to make the second exposure. B—The final double-exposed image. (Cokin Filters/Minolta Corporation)*

- **Split-field filter.** Designed to allow two zones of sharp focus (near and distant), this filter consists of a +2 close-up diopter that covers half the lens. It allows focusing simultaneously on an object approximately 18″ from the lens (through the close-up diopter), while focusing to infinity through the area of the lens not covered by the diopter. The visual effect is different from the "foreground-to-infinity-in-sharp-focus" effect that can be achieved using a wide-angle lens and small aperture.

Processing color film

Of the millions of rolls of color film exposed each year, all but a tiny fraction are developed and printed commercially. Few professional photographers do their own processing; they find it more efficient and economical to send their work to a custom lab. Amateur photographers generally do not have the interest or the knowledge necessary to develop and print their color film. They find it more convenient to drop off exposed rolls at the corner drugstore or a one-hour lab in the shopping mall.

A small minority of professionals and amateurs, however, prefer to develop their own color negatives or transparencies and to make their own color prints. They do their own work not to save money (mass-market photofinishers can do it cheaper), but to maintain control of their images through the entire process from exposure to final print or transparency.

Like black-and-white materials, color film can be processed in facilities ranging from a temporary darkroom set up in a bathroom to a fully equipped permanent darkroom. The basic equipment needed is the same for color or black-and-white, but some additional items (such as color printing filters) are needed for color work. The major differences between black-and-white and color darkroom work are more strict temperature control and the need to work in virtually total darkness when printing. For color film work, the developer must be regulated to remain within a range of ±1/4°F of the specified developing temperature. Color print developer has a bit more latitude — it must stay within a range of ±1°F of the specified temperature. Darkroom lighting for film processing is the same for color as for black-and-white if the film is processed in small light-tight tanks. Color printing, however, is usually done in total darkness because color paper is much more light-sensitive than black-and-white paper. While an extremely dim safelight (dark amber with

a 7 1/2 watt bulb) is permitted, most dark-room workers find it to be of little help and dispense with its use.

Developing color negative film

A number of processes have been used for developing color film over the years; the current one for negative film is designated by Kodak as the *C-41 process.* Other film manufacturers have their own designations (Fuji's process is CN-16; Afga's is AP-70), but the processes are essentially identical. This means that virtually any manufacturer's color negative film can be processed in any other manufacturer's chemistry. The exception is respooled motion-picture negative film sold by some mail-order processing businesses; it cannot be developed with the C-41-type processes.

Development of color negatives with the C-41 process is a 24 1/4 minute procedure (not counting the time needed to load the film in the developing tank or the 10–20 minute drying time). Processing kits contain the components of four different solutions that must be prepared: developer, bleach, fixer, and stabilizer. The kit manufacturer's directions for mixing and storing solutions should be followed closely. **Proper protective equipment (such as splash goggles and rubber gloves) must be worn and correct safety procedures observed.**

Following is the typical procedure for color negative development, using a small light-tight processing tank:

1. Place containers of mixed solutions in a water bath that is adjusted to bring solutions to 100°F (38°C) and maintain them at that temperature, **Figure 12-20.** To avoid overdevelopment or underdevelopment, the developer must be kept within a range of ±1/4°F from the target temperature — between 99.75°F and 100.25°F (37.6°C and 37.9°C). The other three solutions can be from 75°F to 105°F (24°C to 41°C), but keeping all solutions at approximately 100°F provides more consistent processing.

2. In total darkness, load the film onto the processing reel and place it in the developing tank. Once the light-tight lid is on the tank, the lights can be turned on again.

3. Use your darkroom thermometer to stir the developer to be sure it is at a uniform temperature. Check the temperature to be sure it is between 99.75°F and 100.25°F. If so, you can proceed with the developer step.

4. Fill the processing tank with developer and start your timer to begin the 3 1/4 minute developing period. Sharply rap the processing tank on a hard surface to dislodge bubbles ("air bells") from the film.

Figure 12-20. *To maintain the critical temperature for color development, a water bath is needed. A dedicated unit with thermostatic control can be used, or (as shown here) one can be improvised from a deep plastic dishpan or similar container.*

5. Agitate for 30 seconds, inverting the tank and turning it upright again once each second. Following agitation, set the tank in the waterbath to maintain temperature.

6. After 13 seconds in the waterbath, lift the tank from the water and agitate for 2 seconds.

7. Continue this sequence (13 seconds in the waterbath, then 2 seconds agitation) for the remainder of the developing time.

8. Ten seconds before the developing period ends, start pouring the developer from the tank back into its storage container (this "drain time" is considered part of the developing period). See **Figure 12-21.**

Figure 12-21. *The time needed to pour a solution from the developing tank into a storage container is figured into the time specified for each processing step.*

9. Fill the tank with the bleach solution and start the timer. Agitate for the first 30 seconds of the 6 1/2 minute bleach period.

10. For the remainder of the bleach time, follow a sequence of 25 seconds in the waterbath and 5 seconds of agitation.

11. Ten seconds before the end of the bleach period, start draining the solution into its storage container.

12. Fill the processing tank with water, then pour it out. Repeat the fill and empty cycle for a total wash time of 3 1/4 minutes.

13. Fill the tank with the fixer solution and start the timer. As you did with the bleach, agitate for the first 30 seconds of the 6 1/2 minute fixing period. Agitate 5 seconds of each 30.

14. Ten seconds before the end of the fixing period, start draining the solution into its storage container.

15. Perform the second wash in the same way as the first (Step 12).

16. Fill the tank with the stabilizer solution and start the timer. Agitate for the first 30 seconds of the 1 1/2 minute stabilization period.

17. When 10 seconds remain in the stabilization period, start draining the stabilizer into its storage container.

18. Open the tank and remove the film from the processing reel. Hang to dry for 10–20 minutes, preferably in a drying cabinet.

Developing color transparency film

Color transparency films are also called *reversal* films because the developing process first involves a negative stage, and then a reversal to a positive stage to produce the final image. With the exception of the Kodachrome films, all transparency films on the market today are developed using the Kodak E-6 process or equivalent processes

Figure 12-22. *Ektachrome transparency films are developed using the E-6 process, while Kodachrome requires the K-14 process, which is more complicated.*

from other manufacturers. Kodachrome films are developed by the more complex K-14 process, which must be done in commercial laboratories. See **Figure 12-22.**

Development of film with the E-6 process takes approximately one-half hour. The variables involved are the times for the two development stages, which depend upon solution temperatures. Recommended solution temperatures are between 96°F and 110°F (36°C and 43°C), compared to the precise 100°F (38°C) for the C-41 process. At the lowest temperature in that range, the first developer time is 7 3/4 minutes; at the highest, it is 4 minutes. Although the working range is wider, the actual temperature still must be carefully controlled — the selected development temperature should be maintained with an accuracy of ±1/2°F.

An E-6 developing kit once consisted of as many as six solutions. Today, most have four and some have three (as a result of combining actions). The typical kit includes a first developer, color developer, bleach/fix (often referred to as "blix"), and stabilizer.

While specific directions for E-6 processing are provided in each kit, a typical procedure for small-tank development follows:

1. As described in the color negative development procedure, place the containers of mixed chemicals in a waterbath. Bring them into the desired temperature range and hold them there.

2. Load the film on the processing reel in total darkness. Place it in the developing tank, install the light-tight cover, and turn on the light.

3. When the solution temperatures have stabilized at a point within the desired range, consult the manufacturer's time/temperature table to determine the proper first-developer and color-developer times.

4. Fill the processing tank with developer and start your timer to begin the developing period established in Step 3. Sharply rap the processing tank on a hard surface to dislodge any air bubbles from the film.

5. Agitate continuously for 30 seconds. At the end of that period, set the tank in the waterbath to maintain temperature. At 30-second intervals, agitate according to the kit directions (commonly for 5 seconds each time).

6. Ten seconds before the developing period ends, start pouring the developer from the tank back into its storage container. This "drain time" is considered part of the developing period.

7. Completely fill the tank with fresh water, and then empty it completely. Perform the fill/empty cycle three more times.

8. Fill the tank with the color developer and start the timer. Agitate at 30 second intervals, as described in the kit directions.

9. Ten seconds before the color-development period ends, begin pouring the solution back into its container.

10. Repeat the wash procedure described in Step 7.

11. Pour the blix (bleach/fix) solution into the tank and start the timer. During the 10-minute bleach/fix step, agitate at 30-second intervals.

12. Ten seconds before the bleach/fix period is completed, begin pouring the solution back into its container.

13. For the final wash, fill and empty the tank with fresh water six times, rather than the four used in preceding washes.

14. Pour the stabilizer solution into the tank and start the timer. This step is only 1 minute in length, with initial agitation as recommended by the manufacturer.

15. After 1 minute, pour out the stabilizer into its storage container. The processed film may now be dried, as described in the color negative procedure. NOTE: When wet, the film will have an almost opaque appearance. As it dries, it will become transparent.

In both the color negative and color transparency sections, the development method described was the manually agitated small-tank procedure. Developing methods that involve drums rotated by a motor for continuous agitation are used by many photographers. Some manufacturers offer a processor that combines tank rotation with a thermostatically-controlled waterbath for precise maintenance of solution temperatures. See **Figure 12-23.**

Making color prints

Most color prints are made from negatives, but excellent prints also are possible

Figure 12-23. *Drum processing for color film development permits very consistent control of temperatures and agitation. An electrically heated waterbath controlled by a thermostat keeps solutions at the desired temperature. (Jobo Fototechnic, Inc.)*

from color positive (transparency) originals with use of the proper materials and techniques. Color printing is somewhat more complex than black-and-white printing, mostly because you must deal with three emulsions instead of one.

Prints from negatives

A color negative has layers containing yellow, magenta, and cyan dye images. Yellow, magenta, and cyan are the complementary colors of the blue-, green-, and red-light wavelengths in the light that exposed the film after being reflected from the subject. To make a color print from the negative, filters must be placed in the light path during exposure. The filters control the amount of light of each color that reaches the corresponding emulsion layer of the paper.

The filters used may be the same color-compensating (CC) filters described in the discussion of shooting under fluorescent lights, or *color printing (CP) filters* made specifically for enlarging work. The type of filter used depends upon your enlarger. If the enlarger has a filter-holding drawer located between the light source and the negative, the acetate CP filters can be used, **Figure 12-24.** If filters must be positioned below the enlarger lens, CP filters should not be used. The more optically clear gelatin CC filters can be placed below the lens, since they will cause less deterioration of image quality. A third possibility is a *colorhead* for the enlarger. A colorhead has built-in filters that permit you to "dial in" the precise combination of filter values needed, **Figure 12-25.**

The printing light source should be a tungsten bulb or a tungsten-halogen lamp. Heat-absorbing glass and a UV filter (CP2B) are used below the lamp housing. The tungsten-halogen lamp is brighter than the standard bulb, but generates considerably more heat. This means the enlarger must be designed to dissipate the additional heat. Fluorescent ("cold light") sources are not suitable for color printing.

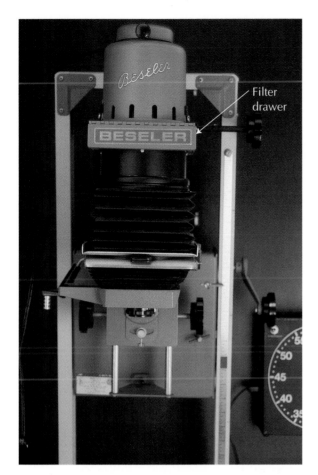

Figure 12-24. *Acetate color printing (CP) filters can be used in enlargers with a filter drawer located between the light source and the negative stage. If filters must be placed below the lens, the optically superior CC gelatin filters are preferred.*

The following description of a typical color printing session assumes the use of CP filters in the enlarger's filter drawer.

1. Establish the initial filter pack. You may use the suggested starting combination provided on the package of color printing paper, or use 50M + 50Y filters, or a combination you have established with a standard negative.

 A *standard negative* is a control device used to determine the filter pack needed to make an excellent print using your equipment, procedures, and usual printing paper. You can purchase a standard negative from Kodak or other sources, or you can make your own. The standard negative you make should be typical of the kind of photography you do, and should include both a standard 18% reflectance gray card and a person shown in sufficient close-up so that you can judge skin tones.

2. Set the enlarger to the height needed for your desired print size, and focus the image.

3. Turn off the darkroom lights. Place a sheet of color paper in the printing easel, along with a mask (cut from black cardboard) that allows you to expose one-fourth of the paper at a time. See **Figure 12-26.**

4. Make each of the four exposures for the same amount of time — 10 seconds — but change the lens aperture each time. Expose the first quarter of the paper at f/5.6, reposition the mask to a fresh area, and make the second exposure at f/8. Repeat the procedure for the two remaining quarters at f/11 and f/16.

5. Process the print, then squeegee off excess water and air-dry it with a portable hair dryer. (For accurate assessment of color, the print must be dry.)

6. Identify the quarter of the print that shows the best overall color. Next, look

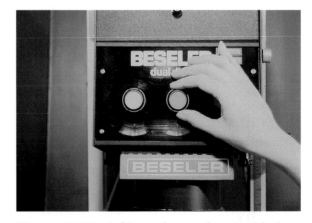

Figure 12-25. *A filter value can be set with the twist of a dial when a colorhead is installed on the enlarger. Depending upon the design, the colorhead may use actual color filters or dichroic interference filters.*

Figure 12-26. *An 8" × 10" piece of black card stock with one-quarter cut away is used as a mask for test exposures. The mask is flipped or rotated as necessary to place four different exposures on a single sheet of color printing paper.*

at flesh tones or critical colors that must be rendered accurately. Change the filter pack (see the following section) to correct any color casts in the print. If the print is too light overall (underexposed) or too dark overall (overexposed), adjust exposure time for the next print just as you would in black-and-white printing. It will probably be necessary to further adjust exposure time to match the filter pack. See **Figure 12-27.**

7. Make a full-size print from the negative at the selected aperture and time, using the new combination of filters.
8. Develop and dry the new print, then assess the color. If additional correction is needed, change the filter pack and exposure time.
9. You should have a satisfactory print by this stage, but if additional fine-tuning is needed, make another test.

Filter pack adjustments

When viewing a test print and determining what correction is needed, you must answer two questions:

- Which color is too strong? (Is the print too green? Too yellow? Too cyan?)
- How much change is needed? (A little? A fair amount? A lot?)

Make your color judgments by looking at critical areas of the print. A flesh tone will readily show color casts; so will a neutral-tone area such as a gray card.

The most difficult obstacle for many beginning color printers is learning to "think in reverse" when correcting color. An excess amount of a color in a print means that — although it seems contradictory — *more* light of that color must be transmitted to the emulsion. Like negative film, color printing paper has three emulsion layers. One layer is sensitive to red light, one to blue, and the third to green. When the exposed paper is

Color Filter Factors

Yellow	Factor	Magenta	Factor	Cyan	Factor	Red	Factor	Green	Factor	Blue	Factor
05Y	1.1	05M	1.2	05C	1.1	05R	1.2	05G	1.1	05B	1.1
10Y	1.1	10M	1.3	10C	1.2	10R	1.3	10G	1.2	10B	1.3
20Y	1.1	20M	1.5	20C	1.3	20R	1.5	20G	1.3	20B	1.6
30Y	1.1	30M	1.7	30C	1.4	30R	1.7	30G	1.4	30B	2.0
40Y	1.1	40M	1.9	40C	1.5	40R	1.9	40G	1.5	40B	2.4
50Y	1.1	50M	2.1	50C	1.6	50R	2.2	50G	1.7	50B	2.9

Figure 12-27. *A change in the filter pack (CP or CC) usually will require some adjustment of the next exposure. This table lists the filter factor (amount by which exposure must be multiplied) for each of the CP filters.*

developed, dye images are formed in the complementary colors: respectively, cyan, yellow, and magenta. When the print is viewed, the dyes act upon the light reflected back to the viewer so that the original colors are seen.

Adjustments to the filter pack are made by either adding or removing filters to increase the amount of a given color of light that reaches the emulsion. For example, if you determine that the print is too green, you must increase the amount of green light falling on the paper. To do this, you can subtract or reduce the density of the magenta filter. Magenta, the complementary color of green, blocks green light. If there is no magenta in the filter pack, you can add a green filter (if using CC filters) or add cyan and yellow filters (if using CP filters). The green filter will transmit green light; so will the cyan/yellow combination. See **Figure 12-28.** The additional green light will provide increased exposure to the green-sensitive layer of the paper. When the paper is developed, the magenta dye image will be more dense. This will remove the green cast by filtering out the green wavelengths in the light reflected back to the viewer.

Figure 12-28. *Increasing the amount of green light reaching the film can be done by adding a green filter, or by adding cyan and yellow filters. A—The green filter blocks red and blue light and passes green. B—The yellow filter blocks blue and passes green and red; the cyan filter blocks red and passes green. The combination blocks both red and blue, allowing only green light to pass through.*

Filter adjustments are not usually an "all or nothing" proposition. The amount of change needed determines whether the filtration should be changed a little or a great deal. For example, if the test print is only slightly "too green," the density of the magenta filter might be decreased by 0.10 (replacing a CP50M with a CP40M). If the print is "way too green," a CP50M might be replaced with a CP10M, a CP05M, or even removed entirely). When adding filters, of course, the units are increased instead of decreased. A CP05C and CP05Y would be used together to correct a slight green cast; CP10C and CP40Y could be combined for a more drastic color change.

If you are using CC filters, you can actually use filters made in all six of the colors. Color printing filters however, are manufactured in red, cyan, magenta, and yellow. If blue or green filtration is needed, it can be achieved by combining magenta and cyan (for blue) or cyan and yellow (for green). The CC filters are made in all six colors because no more than three filters should be combined below the lens to avoid degrading the image. Since the CP filters are located above the negative, and do not affect image sharpness, more than three filters can be combined. Eliminating blue and green filters in the CP set reduces cost without affecting usability.

Print processing

While it is possible to process color prints in trays, as done with black-and-white prints, it is less convenient because of the need to work in very dim safelight conditions or total darkness. Some color print paper is so light-sensitive that it can be fogged by the very low-intensity output of the LED on an electronic timer.

Most color print processing done in home darkrooms makes use of some form of the daylight drum system. Automatic processors, which are considerably more expensive, may be used for convenience or when processing larger quantities of prints.

Daylight drum systems make use of a light-tight plastic tube with provision for introducing measured amounts of developer and other processing chemicals, **Figure 12-29.** Their major advantages, compared to tray processing, are convenience, economical use of chemicals, and the ease of achieving consistent results. Drums are available from a number of manufacturers and are made in a range of sizes corresponding to print paper sizes. The most common drum size will hold one 8″ × 10″ print, two 5″ × 7″ prints, or four 4″ × 5″ prints.

Exposed paper is loaded into the drum in total darkness. Once the drum is capped, however, all subsequent steps can be carried out in normal room lighting. Agitation can be performed in a number of ways. The simplest is the manual method: merely rolling the tube to-and-fro on a countertop or using a lift-and-invert motion like that used with small-tank film processing. Several motorized agitation devices are available. The least expensive is a base that uses a friction wheel to rotate the drum, **Figure 12-30.** Some motor bases rotate continuously in one direction; others use a reciprocating motion. The most sophisticated motorized units include a thermostatically regulated waterbath. The bath keeps both the drum and containers of chemicals at the recommended temperature for consistent processing. As in film processing, control of temperature is especially critical during development — developer temperature should be controlled to within ±1°F.

Print-processing steps correspond to those used for black-and-white, and require approximately the same amount of time as RC papers. The major variable is development time, which can range from just over 2 minutes (at 100°F/38°C) to 19 minutes (at 66°F/19°C). At a typical developing temperature of 90°F/32°C, the time is 3 minutes. The typical sequence and times for print development would be:

1. Fill the drum with water (same temperature as developer) and prewet for 30 seconds.
2. Empty the drum and introduce a measured amount of developer. Agitate as directed by manufacturer of the processing kit.
3. Pour out the developer and pour in a measured quantity of stop bath. Agitate as directed.
4. Drain the stop bath after 30 seconds and introduce the bleach/fix. Agitate as directed during the bleach/fix step (1 to 1 1/2 minutes, depending upon temperature).

Figure 12-29. *Drums permit economical use of chemicals and aid in consistent processing of prints. (Jobo Fototechnic, Inc.)*

Figure 12-30. *A motor base provides consistent agitation for even print development. Several systems using daylight drums are on the market. (Regal-Arkay)*

5. Pour out the stop bath and begin the washing process. Washing may be done in the tube, or prints may be removed and washed in a tray. The wash period should be 2 minutes in total length, with water emptied and refilled four times.

6. Dry the prints. If a heated drying method is used, temperature must not be greater than 200°F (93°C) to avoid damaging the prints.

Automatic processors carry the exposed paper through a series of light-tight tanks containing the various chemicals. Some models are "dry-to-damp" types, turning out a washed print that must be dried outside the machine. The most sophisticated models are "dry-to-dry," ejecting a fully processed and dried print. See **Figure 12-31.**

Prints from transparencies

A transparency is a *color positive*. In order to obtain a print from a transparency, you must either create a copy of the slide on negative film (called an *internegative*) for printing, or use *reversal paper* which allows positive-to-positive printing.

Creating an internegative added time and cost to the process of making a print, but traditionally was the preferred method because it allowed better control of contrast than reversal printing. Improvements in

Figure 12-31. *"Dry-to-dry" processors handle all the steps of color print development, fixing, washing, and drying automatically. (Jobo Fototechnic, Inc.)*

reversal printing papers in recent years have virtually eliminated the contrast gain that was typical when making a print from a transparency. The improved quality and the greater convenience of reversal papers have greatly reduced the use of internegatives for printing.

A major difference in printing from a transparency to reversal paper, compared to printing from a negative to a positive paper, is how the amount of exposure affects the print. See **Figure 12-32.** In negative/positive situations (color or black-and-white), increasing exposure *darkens* the print, while decreasing exposure results in a lighter print. In a positive/positive (reversal) situation, however, the effects are just the opposite: increasing exposure *lightens* the print; decreasing exposure darkens it.

The same light sources and filters used for negative color can be employed for printing from color transparencies. In addition to the heat-absorbing glass and UV filter used with tungsten or tungsten-halogen lights, it may be necessary to insert a filter that absorbs infrared (IR) wavelengths. Some reversal papers are particularly sensitive to IR; the manufacturer's directions will specify the needed filter.

Following is a description of a typical printing session with a transparency and color reversal paper. It assumes the use of CP filters in the enlarger's filter drawer.

1. Select a transparency that is well-exposed and includes some neutral areas and flesh tones. The film should be the one you normally use. This will allow you to identify a standard filter pack that can be used as a starting point for all transparencies shot on that type of film.

2. Set the enlarger to the height needed for an 8" × 10" print size, and focus the image. Set the lens aperture to f/5.6.

3. Remove any filters (other than UV or IR corrections) from the drawer. The test print will be made with unfiltered white light.

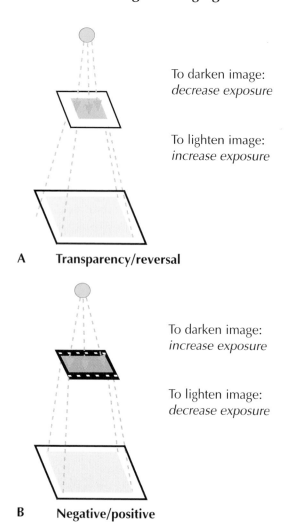

To darken image:
decrease exposure

To lighten image:
increase exposure

A Transparency/reversal

To darken image:
increase exposure

To lighten image:
decrease exposure

B Negative/positive

Figure 12-32. *Positive/positive vs negative/ positive printing. A—When printing from a transparency on reversal paper (positive/ positive), increased exposure will lighten the image. Shorter exposures result in darker images. B—When printing from a negative onto positive paper (negative/positive), increased exposure will darken the image. Shorter exposures result in lighter images.*

4. Turn off the darkroom lights. Place a sheet of reversal paper in the printing easel and expose it for 5 seconds.

5. Cover 1/3 of the paper with a piece of black card and make another 5-second exposure.

6. Slide the card so it covers 2/3 of the paper. Make a 10-second exposure.

7. Develop, wash, and dry the print. The sheet will show three distinct exposure areas ranging from 5 seconds (darkest) to 20 seconds (lightest).

8. Examine the print to identify the area that shows the best overall density. It is possible that the desired density will fall somewhere between two exposures, requiring an intermediate exposure time. For example, if the 5-second strip is too dark, and the 10-second strip is too light, a 6-, 7-, 8-, or 9-second exposure might be selected. Remember that values lighten as exposure time increases.

9. For color balance, compare the selected area of the print (the one nearest the desired density) with the original transparency. Look at midtones, neutral areas, and skin tones (if available) to identify which color is excessive in the print.

10. Select the filter of the matching *complementary* color. You may have to use a pair of filters to form the complementary color. For example, if the print is too blue, choose a yellow filter. If the print is too yellow, combine magenta and cyan filters (the equivalent of blue, which is not available in CP filters). Choose a filter density (0.05, 0.10, 0.20, etc.) based on whether the excess color needs a small amount of correction (0.05 or 0.10), or considerable correction (0.30 or more).

11. Make another test print, using the adjusted exposure time and selected filter pack. Develop and dry the print.

12. Evaluate color balance and overall density. If further changes in filtration are needed, add or subtract filters as necessary. See **Figure 12-33.**
Note that in correcting prints made from a transparency, filter use is just the *opposite* of correction made when printing from a negative. Instead of increasing exposure of a given wavelength of light, you are decreasing the exposure. When printing

Adjusting Filter Packs for Color Printing

If color is too	Subtract	or Add
red	yellow & magenta	cyan
green	yellow & cyan	magenta
blue	magenta & cyan	yellow
cyan	cyan	yellow & magenta
magenta	magenta	yellow & cyan
yellow	yellow	magenta & cyan

If color is too	Subtract	or Add
red	cyan	yellow & magenta
green	magenta	yellow & cyan
blue	yellow	magenta & cyan
cyan	yellow & magenta	cyan
magenta	yellow & cyan	magenta
yellow	magenta & cyan	yellow

Figure 12-33. *Filters are added or subtracted to adjust the color balance, based on the test print. Subtracting filters is usually preferable to adding them.*

from a negative, you add a filter matching the excess color or subtract the filter(s) of the complementary color. Printing from a transparency, however, requires adding the complementary color filter(s) or subtracting the matching color filter.

13. Once a satisfactory print is made, record the filter pack values. This pack can now be considered a standard, providing the starting point for all prints made from the same film type and speed. Ideally, you should identify a standard filter pack for each of the transparency films you use regularly.

Reversal print processing

The same equipment (drums or automatic processor) used to process color print paper can be used to process reversal paper, but the sequence of development steps is different. While color print processing is a five-step procedure (prewet, developer, stop bath, bleach/fix, wash), reversal processing requires a second developer and additional washing steps. The steps for processing reversal paper are:

- Prewet
- First developer
- Wash
- Color developer
- Wash
- Bleach/fix
- Wash
- Dry

Depending upon developer temperature, the entire process can take as long as 40 minutes or as little as 10 minutes. The preferred development temperature of 100°F (38°C) yields the shortest of those times.

Black-and-white prints from color originals

It is possible, and sometimes desirable, to make black-and-white prints from a color negative or transparency. A common reason for making such a print is for reproduction in a publication (such as an association newsletter or a simple brochure) that is not printed in color.

Using variable contrast paper and filters, it is possible to achieve a usable print from a color negative, **Figure 12-34.** The print will not be a true representation of the tones in the original, since normal black-and-white print papers are not sensitive to red light. Thus, red tones in the original will print too dark. Blue tones will be lighter than they appear in the original. Because of the orange mask used on color negative film, exposure times will be longer than for a comparable black-and-white negative.

To achieve a range of gray tones that corresponds to the colors of the original, a special paper (Kodak Panalure) is used. *Panalure*™ is a true panchromatic paper that is sensitive to the blue, green, *and* red wavelengths. Since it is sensitive to all the colors of light, no safelight can be used while exposing and processing the paper.

Figure 12-34. *The black-and-white print and color print were made from the same color negative. Note that the tonal relationships in the black-and-white print, made on variable contrast paper, differ from those in the color print. Red, especially, prints darker in relation to other colors.*

Development is done with the chemicals normally used for black-and-white print processing in trays, drums, or automatic processors.

To make prints from a positive transparency, you must first make a black-and-white negative. This can be done by contact printing (for a same-size negative) or by projection with an enlarger (for a larger negative). Once the new negative is developed, fixed, and dried, it can be used to make traditional black-and-white prints.

Questions for review

Please answer the following questions on a separate piece of paper. Do not write your answers in this book.

1. The system in which three primary colors combine to create all other colors (for example, on a television screen) is called the _____ color process.

2. Which are the primary colors in the subtractive color process? Where are they positioned, relative to the additive primaries on the color wheel?

3. Which of the following is *not* an advantage of the negative/positive system?
 a. ease of viewing finished pictures
 b. ability to rapidly produce multiple prints
 c. first-generation sharpness and contrast
 d. widely available, fast processing

4. _____ film is used primarily by professionals and serious amateurs.

5. Why does the use of transparency film give the photographer greater control over the final image?

6. What uses do professional photographers make of instant films?

7. Color temperatures are measured in _____ units.
 a. Celsius
 b. Kelvin
 c. Pfaltzgraf
 d. Fahrenheit

8. Describe two methods of balancing light to allow daylight film to be used with tungsten sources.

9. Why is film for use with incandescent light described as "tungsten-balanced"?

10. Which of the following filters would be the most useful in improving your photograph of a display in a shop window? Why?
 a. neutral-density
 b. color-compensating
 c. ultraviolet
 d. polarizing

11. A _____ filter is very useful in landscape photography to balance the relative brightness of sky and foreground.

12. Why is a diffusion filter often used when doing portrait photography?

13. Would it be true to state that saving money was the major reason why a photographer would decide to process her or his own film?

14. Which of the following processes is used to develop color negative film?
 a. C-41
 b. J-53
 c. E-6
 d. K-14

15. Color film development requires precise control of solution temperatures. The developer must be kept within a range of _____ °F of the specified developing temperature.

16. Which of the following types of filters should be used for color printing if the enlarger requires filters to be placed below the lens? Why?
 a. color-grad filters
 b. color compensating filters
 c. color printing filters
 d. neutral density filters

17. For color print processing in a home darkroom, the _____ system is most often used because it offers convenience, economy, and consistent results.

18. When printing on reversal paper from a transparency, increasing exposure will _____ the print.

Ambient light:
The light that already exists in a scene or space, without any additions being made. Ambient light can be natural or artificial.

Chapter 13

Artificial-Light Photography

When you have finished reading this chapter, you will be able to:

➡ Identify the types of artificial lighting used in photography.

➡ Explain the effect of the inverse square law on exposure made by artificial light.

➡ Describe the major types of portable flash equipment and how they are used.

➡ Apply the basic techniques of studio lighting for both portrait and product photography.

➡ Discuss the techniques for controlling light in the studio.

How long an exposure would you have to use to capture a photo of a black cat in a coal mine at midnight? What if the subject were a white rabbit, instead of the cat?

Since the description "in a coal mine at midnight" indicates a condition of total darkness, you wouldn't get a picture in either case, no matter how long you exposed the film. *Without light, you cannot capture a photographic image.*

As you may recall from an earlier chapter, the word "photography" was coined in the year 1839 by the English astronomer John Herschel, who combined the Greek roots *photos* (light) and *graphos* (drawing). Thus, some form of light is needed to produce a photograph.

If natural light from the sun is not available, you obviously must supply the necessary light to obtain a photograph. The "necessary light" can be amazingly small and dim — a tiny birthday candle would allow you to capture a picture of either the black cat or the white rabbit with a long-enough time exposure. See **Figure 13-1.** With a different type of artificial lighting — an electronic flash unit — you could expose your picture using a burst of intensely bright light lasting only a fraction of a second.

Figure 13-1. *A black cat in a coal mine at midnight (for practical reasons in this example, a small toy cat against a black velvet background) can be photographed by adding only a tiny amount of light and making a long time exposure. This photo was made on ISO 160 film with an exposure of 2 minutes at f/3.5. The light was from a small birthday candle.*

Types of artificial lighting

There are basically three types of artificial lighting that you will use as a photographer: ambient (room) lighting, portable (usually electronic flash) lighting, and studio lighting. Each has its advantages and drawbacks, especially in terms of the photographer's ability to exercise control. Ambient lighting is the least controllable; studio lighting the most.

Ambient lighting

The term *ambient lighting* can be defined as the lighting that already exists in a scene or space, without any additions being made. It may be natural or artificial lighting, or a combination of the two. In an outdoor setting, of course, the daytime ambient lighting typically will be natural light: direct, reflected, or diffused sunlight. At night, it might be natural (moonlight), artificial (street lamps), or a combination.

In the same way, ambient indoor (room) lighting can be natural (daylight from a window or skylight), artificial (electric lamps, candles, fire light), or a mixture. At night ambient , indoor light is almost always artificial (although moonlight streaming in through a window can been used with good dramatic effect).

The primary advantage of ambient lighting is *its very existence*: the photographer must provide little or no additional light to expose the film. It also can give a feeling or mood to the photograph that would be almost impossible to duplicate with portable flash or studio light sources, **Figure 13-2.** Using only ambient lighting also permits you to make photographs unobtrusively. This is an advantage when use of a flash would be objectionable (at some religious ceremonies or in theaters and similar settings), or would cause people to change their behavior because they became aware of the photographer.

Disadvantages of ambient lighting can be summed up in three words: brightness, direction, and color. The light falling on your

Figure 13-2. *Ambient lighting can help you capture a very specific feeling or mood for a photograph. It would be difficult, if not impossible, to duplicate this photo with studio or portable flash lighting. (Photodisc)*

subject may be too strong, causing harsh shadows and washing out highlight details. On the other hand, it could be too weak, providing low contrast and requiring long exposure at a wide aperture (with the resulting depth-of-field and subject- or camera-motion problems). Light direction can be a problem — strong backlighting can turn your subject into a silhouette, or bright overhead lighting can create unflattering deep pools of shadow in eye sockets or under the nose and chin. See **Figure 13-3.** When shooting in color, undesirable color casts can result from mismatched film and light types (as described in Chapter 12), or by light passing through a colored material such as a translucent lampshade or stained glass.

In terms of controlling the light reaching the film, ambient lighting is the most challenging. Sometimes, individual light sources such as table or floor lamps can be turned

Figure 13-3. *A strong overhead light source can place deep shadows under the nose and chin and in the eye sockets. This lighting is very unflattering to the subject, and should be avoided whenever possible.*

off or on to correct brightness problems. The light source or the subject may be able to be moved to better distribute the light, or a reflector can be used to soften harsh shadows. Some lighting color casts can be corrected or minimized with filters, or (if print film is used) in printing.

Portable (flash) lighting

The ability to bring your own source of light to the scene or subject you are photographing is a real advantage — it frees you from total dependence on ambient light. The earliest form of portable light for photography was *flash powder*, a finely ground form of the highly flammable metal magnesium. When ignited by a flame or spark, magnesium powder generates an instant burst of brilliant blue-white light. Since it was burned in an open tray-like device, flash

powder was a hazardous light source when used indoors. It also produced a thick cloud of white smoke, which had to dissipate before another exposure could be made.

Around 1930, a new form of portable lighting — the *flashbulb* — appeared on the scene. The earliest bulbs resembled household lightbulbs, complete with a screw-in base. Inside the glass bulb was a small filament coated with an easily ignited paste material, a quantity of fine aluminum wire or foil, and an oxygen-rich gas mixture to promote rapid burning. When an electrical current was passed through the filament, it ignited the paste, which in turn ignited the aluminum wire or foil.

The resulting flash of light was nearly as brilliant as the explosion of flash powder, but far safer since the reaction was contained inside the glass bulb. Over the next half-century, many different sizes and shapes of flashbulbs evolved, **Figure 13-4.** After the use of color film became common, most types of bulbs were available with a blue coating. This helped to correctly expose daylight-balanced films when shooting indoors under tungsten lights. For

Figure 13-4. *Flashbulbs were made in a variety of sizes, burning rates, and light intensities to meet different photographic needs. Screw-in bases were eventually replaced with quicker-to-change bayonet mounts in a number of forms. The multiple-flash cube and strip forms were used primarily with snapshot cameras. Flashbulbs are seldom used today, except in specialized situations. They have been supplanted by electronic flash units.*

convenience and greater speed when shooting frames in sequence, multiple-flash devices were introduced. These took the form of four-bulb *flashcubes* and strips (*"flipflash"* and *"flashbars"*) typically holding eight or ten bulbs. The flashcubes rotated after being fired, bringing a fresh bulb into position for the next picture. A simple snap-in mounting method made them easy to replace after the fourth flash. Early units required battery power to fire the flash; later, a mechanical triggering system was introduced. The flashbars had five bulbs to a side, firing in sequence as each frame was exposed. After the fifth flash, the bar was pulled out of its socket, turned end-for-end to bring five fresh bulbs into position, and replaced in the socket. Flipflash units were similar but had eight bulbs.

Complicated lighting setups with dozens of flashbulbs were created by some photographers to light large areas such as a sports arena or ballroom. The master of such setups was O. Winston Link, who made a career of photographing speeding trains at night with flash lighting.

In the 1950s, electronic flash began to take the place of the flashbulb as a convenient and reliable source of portable light. Today, electronic flash units are the primary source of portable artificial light for most photography. **Figure 13-5** shows the basic circuit used in electronic flash units. The principle of operation involves building up a strong electrical charge in a storage device called a ***capacitor.*** The source of electricity stored in the capacitor is usually some type of battery, although "plug-in" units for connection to 110 V household current may sometimes be used. When the camera's shutter release is pressed, a trigger circuit causes the accumulated electrical charge in the capacitor to discharge. An electrical pulse is released into a gas-filled flash tube, producing a burst of bright light synchronized with the opening of the camera shutter. The flash unit will then ***recycle*** (rebuild the capacitor's electrical charge).

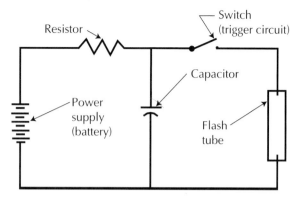

Figure 13-5. *Electronic flash units are all based on this simple circuit consisting of a power supply, an energy-storing capacitor, a flash tube, and a triggering circuit. The capacitor is charged (filled) with electrical energy by the power supply. When the camera's shutter release is pressed, the triggering circuit releases the energy stored in the capacitor to flow through the flash tube. Gas inside the tube is ionized, producing the brief but intense flash of light. Following discharge, the capacitor recharges, or fills with electrical energy, and is ready to be triggered again.*

The duration of the flash of light from an electronic unit is considerably shorter than the light burst produced by a flashbulb, and typically is measured in thousandths of a second. The short but very bright flash of light is usually sufficient to "freeze" motion of the subject, regardless of the shutter speed set on the camera.

The actual flash duration varies, depending upon the size and model of flash unit and the type of control: manual, sensor, or through-the-lens (TTL). Under manual control, flash duration to provide proper exposure is determined by dividing the distance from the flash to the subject by a ***guide number.*** This manufacturer-supplied number is based on the light output of the flash and the ISO rating of the film being used. The result of the calculation is the proper lens aperture for correct exposure. Most modern flash units eliminate the need for the calculation by using a built-in dial, **Figure 13-6.** Once the film speed is set, the distance-to-subject and corresponding f-stop

Figure 13-6. *A built-in dial on many flash units relieves the photographer of the need to calculate exposure using the flash guide number. By setting the ISO of the film being used, the photographer can then select the range that includes the flash-to-subject distance and read the proper f-stop for correct exposure.*

can be read directly. Manual flash provides a fixed-duration burst of light.

Both sensor-equipped and TTL flash units will shorten the length of the light burst to prevent overexposure. The sensor, **Figure 13-7,** is usually mounted on the body of the flash unit. It "reads" the light reflected from the subject and adjusts the amount of energy supplied to the flash tube by the capacitor. The TTL flash system performs the same function, but measures the amount of light reaching the film surface and uses that reading to control the length of the light burst. Both methods provide good control of exposure, but the TTL method is more precise.

For cameras using focal-plane shutters (virtually all 35mm cameras), flash exposures must be made at or below the

flash synchronization speed, often shortened to "sync speed." This is the speed at which the shutter is fully open — 1/60 second for most older cameras and 1/125 second or 1/250 second on newer models. Focal plane shutters actually involve two metal or cloth curtains that move horizontally or vertically in front of the film plane to provide an opening for light to strike the film. At the synch speed or lower, the first curtain moves

Figure 13-7. *The sensor used on a flash unit measures the amount of light reflected from the subject and shuts down the flash tube circuit when enough light has been emitted to achieve correct exposure. Some sensors can be removed from the flash and connected to it with a special extension cord. This can be useful when the flash is moved away from the camera; the sensor is mounted on or near the camera to measure light at the camera position.*

across or down to create an opening the full size of the film frame. At the end of the exposure time, the second curtain travels to close the opening. At faster shutter speeds, however, the second curtain starts to move while the first curtain is still opening. The effect is to create a narrow slit-like opening that moves horizontally or vertically across the film to admit light. At exposure times shorter than the sync speed, only a portion of the frame will be exposed when the flash unit fires. *Leaf shutters* built into the lens (like those found in many medium format cameras), will synchronize with flash at any speed, since a leaf shutter always opens fully.

Some cameras have a control used to select between two synchronization methods identified as *X synchronization* and *M synchronization.* The X-sync method is used with electronic flash, which reaches peak light output almost instantly, while

M-sync is used with flashbulbs, which take longer to reach peak output and provide that output for a longer time than electronic flash. M-synch fires the flashbulb shortly before the shutter is fully open.

Many of the cameras in the general consumer market today, from single-use models to SLR and digital models, have a built-in automatic flash, **Figure 13-8.** No calculations or settings are necessary, other than selecting the mode (flash/no flash). For cameras without a built-in flash, two methods of synchronizing the shutter release and flash trigger circuit are used: the sync terminal and the hot shoe. The *sync terminal* is a small socket in the camera body that accepts a special cord (a *pc cord*) connected to the flash. Electrical signals are carried through the pc cord, triggering the flash when the shutter release is pressed. The *hot shoe* is usually mounted on top of the SLR's pentaprism

Figure 13-8. *Flash connection methods. A—Built-in automatic flash is a feature of many of today's cameras. (Eastman Kodak Company) B—A sync socket allows the use of a connecting cord, making it easy to move the flash away from the lens axis for better control of shadows. C—The hot shoe is usually located on top of the camera, directly over the lens.*

housing, placing it directly above and in line with the camera lens. Electrical contacts on the hot shoe mate with those on the flash unit, triggering the flash when the shutter release is pressed.

Studio lighting

The greatest amount of control over lighting can be exercised in the studio. Lighting units can be added, removed, positioned and repositioned until the desired effect is achieved. Various accessories — including diffusers, reflectors, and items with such strange names as "snoots," "soft boxes," "flags," or "gobos" — can be used to control light intensity, direction, and coverage. Colored filters and cut-out patterns can be positioned in front of a lighting unit to alter the light being thrown on a background or the subject itself.

Light sources for studio use are typically either electronic or incandescent, although some photographers also make use of natural light (from a skylight or window) in the studio. *Incandescent lights,* commonly referred to as *hot lights* because of their heat output, are available in two forms. One is the *photoflood,* a glass bulb similar in construction to standard bulbs used in household lighting. These bulbs are constructed for high light output, however, and have a limited life measured in hours of operation. The No. 1 photoflood bulb is rated at 250 W; the No. 2 photoflood is a 500 W bulb. Both clear bulbs (for use with tungsten-balanced film), and blue-tinted bulbs (allowing the use of daylight-balanced film), are normally mounted in metal reflectors to direct and concentrate the light output, **Figure 13-9.** The advantages of hot lights are their relatively low cost and the ability they give the photographer to directly observe the light falling on the subject. These advantages are offset by the negative effect of their heat output on human subjects and certain types of products (such as ice cream or wax candles). In addition, the glowing tungsten filament that provides light also causes a

dark deposit to build up inside the bulb. As the service period lengthens, this deposit causes a decrease in light output.

The second form of "hot light" is the *tungsten-halogen bulb.* These small, bright bulbs have both a higher light output (typically 600 watts) and a longer life than photoflood bulbs. Various types are available. One type may be mounted, with an adapter, in the socket/reflector unit used for photofloods. Another type, **Figure 13-10,** is mounted in a fixture that is specifically designed for its use. Tungsten halogen lights (sometimes referred to as "quartz lights" because the outer envelope of the bulb is made from the mineral quartz rather than glass) are extremely bright and extremely hot. Care must be exercised with both types of incandescent lights to prevent contact with skin or flammable materials. Aside from the discomfort caused by heat, human

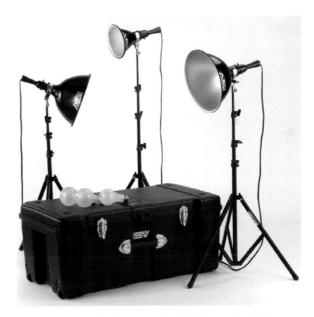

Figure 13-9. *Reflectors should be used with clear or blue-tinted photoflood bulbs to concentrate and give direction to their light output. Depending upon the bulb, rated operating life may be as short as three hours. The high operating temperature of the photoflood can cause painful burns if the glass is touched. The bulbs can also be a fire hazard when used near flammable materials. (Smith-Victor Corporation)*

Figure 13-10. *Specially designed fixtures are used with tungsten-halogen bulbs, which have a very high light and heat output. A protective screen (omitted here to show the bulb) is often used with this type of light. It decreases light output, but helps prevent accidental contact with the bulb. It also will contain the quartz envelope fragments if the bulb shatters.*

or animal subjects can literally be sunburned by prolonged exposure to tungsten-halogen lights. Unlike photofloods, tungsten-halogen bulbs do not darken with age, so their light output remains constant.

Electronic studio flash units overcome the problem of heat, since they are "on" for only a fraction a second for each exposure. Some photographers find them more difficult to use than incandescent lights, however, since the effects of lighting changes cannot be observed directly. Also, exposure readings cannot be made in the usual way with an in-camera or traditional hand-held reflective light meter.

Direct observation of lighting effects with electronic flash units is made possible by the use of *modeling lights.* These are small incandescent light sources that are built into the flash head, providing light that comes from the same direction as the flash. Modeling lights allow the photographer to observe the placement of shadows and highlights and to gain an overall assessment of the lighting setup. If a medium format or large format camera is being used, a more precise means of checking the actual lighting

effect is the use of an instant-film adapter (*Polaroid back*), **Figure 13-11.** The instant photo allows the photographer to see exactly how the light falls on the subject, so that any needed adjustments can be made.

Establishing proper exposure with electronic studio flash is most easily done by use of a *flash meter.* This meter allows the photographer to trigger the flash units and make an incident light reading from the subject's position. Separate flash meters are available, but the trend in recent years has been to combine the flash-reading function with the traditional reflected-light and incident-light capabilities of the hand-held meter to create an "all-in-one" instrument.

There are two types of electronic studio flash systems on the market: traditional and self-contained. The *traditional system* consists of a power pack that plugs into a wall outlet and several separate flash heads connected to the power pack by individual cables. The *self-contained unit,* often called a *monolight,* is a combination flash head/power supply. The units consist of a flash

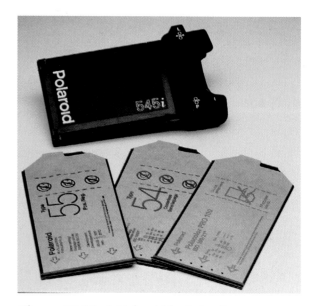

Figure 13-11. *A Polaroid back for the camera permits the use of instant film to quickly determine if studio flash units are properly placed, and what lighting changes might be needed. (Polaroid Corporation)*

tube and power supply combined into a single housing. Each unit plugs into a wall outlet. See **Figure 13-12.**

Mixed artificial and natural lighting

Some photographic situations involve a mixture of artificial and natural lighting. Indoor shots, whether in a studio or other location, may be illuminated to a greater or lesser extent by light from a window or skylight. Artificial light sources would normally be used in such situations to supplement the natural light. Outdoors, unless it is a dark and gloomy day or the subject is in deep shade, natural light will usually be the primary light source. Again, artificial light would be employed as a supplement or secondary source.

Most often, the supplementary light source will be a portable flash unit used at less than full power ("fill flash") to balance illumination on the subject by adding light to shadowed areas, **Figure 13-13.** In some cases, the situation is reversed, with the artificial source as the main light and the natural light as the secondary, or "fill," source. Using artificial light as the secondary is more common, however.

Lighting principles

A very basic principle affecting the photographer is often referred to as *light falloff.* Simply put, this means the farther the subject is from the light source, the less brightly it will be illuminated. Another way of stating the principle is "the further light must travel from the source, the weaker it will be."

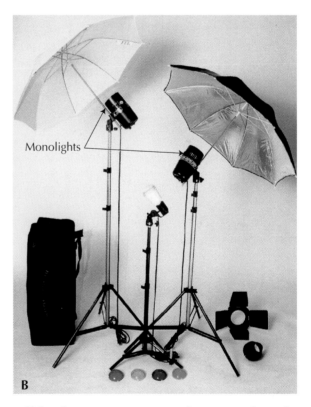

Monolights

A

B

Figure 13-12. *Electronic studio flash systems. A—A traditional system uses a central power pack, such as these examples, to which a number of separate flash heads can be connected. Power packs are available in different capacities to operate various lighting setups. Digital readouts make it easy to keep track of system status. (Sinar Bron Imaging). B—This studio system consists of self-contained lighting units (monolights) that combine the flash head and power pack in a single housing. (Porter's Camera Store)*

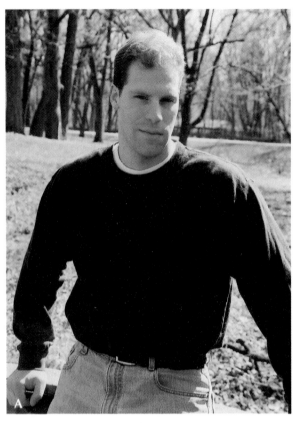

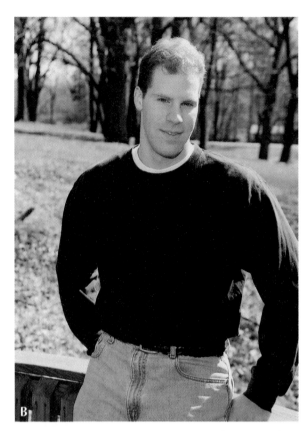

Figure 13-13. *Using fill flash to balance light. A—With strong sunlight falling on one side of the subject, lighting of the face is too harsh and contrasty. B—Fill flash was used to open up the shadows, resulting in a more pleasing and balanced lighting effect. (Ed Cayot)*

Inverse-square law

Actually, the amount of light falloff can be stated more scientifically using the ***inverse-square law:*** *the illumination provided by a point source of light will vary inversely as the square of the distance from the source.* What this means is that as light moves further away from its source, it spreads out to cover a larger area and thus provides weaker illumination. An illustration, **Figure 13-14,** will help to make the principle more clear.

At a distance of 1′ from the light source, a given amount of light will fall in a 1 sq. ft. area. If the distance from the source is doubled to 2′, the same amount of light will spread out to cover an area of 4 sq. ft. (the square of the distance, or $2 \times 2 = 4$). The light must cover four times as much area, and thus will only be one-fourth as intense.

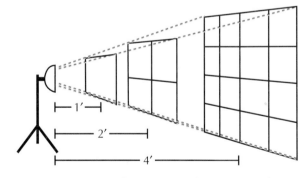

Figure 13-14. *Light intensity decreases as the distance from the source increases, since the light covers a larger area. As shown, a given amount of light falling on 1 sq. ft. area at a distance of 1′ from the source will spread out to cover an area of 4 sq. ft at a distance of 2′ from the source. At a distance of 4′ from the source, the same amount of light will cover an area of 16 sq. ft.*

Doubling the distance again, to 4', will spread the light over an area of 16 sq. ft. Light intensity 4' from the source is only 1/16 as strong as it was at 1'.

Since the amount of light reaching the film after reflecting from the subject is the vital factor in determining exposure, the practical importance of the inverse square law is obvious. When using portable flash illumination, the amount of light output governs how distant the subject may be to remain properly illuminated. In the studio, changing the distance of different lights from the subject is the typical method of balancing the lighting.

Color temperatures of light sources

Another lighting factor that must be considered is the *color temperature* of the light that will expose the film. When using black-and-white film, the color of the light generally is not an issue in terms of exposure: it can be effectively exposed in daylight, tungsten light, or even fluorescent light.

As described in Chapter 12, the color temperature of light plays a critical role in exposing color transparency film. Film balanced for 5500 K (*photographic daylight*) will take on a yellow or orange cast when exposed by 3200 K light from incandescent table lamps. Tungsten-balanced film for use in incandescent light will produce photos with a cold blue appearance when exposed with daylight or electronic flash.

The practical importance of color temperature is its effect on the photographer's choice of film and/or filters. To obtain the desired results, light source and film must be properly matched (or the light modified before it reaches the film).

Working with ambient light

The simplest ambient light situation is one that is restricted to a single type of light source, such as incandescent bulbs. With the proper type of film (or corrective filtration), color balance should not be a problem —

only exposure and light placement issues must be addressed.

Mixed types of ambient lighting can create problems, especially when exposing color transparency film. When dealing with two different types of light, such as incandescent and fluorescent sources, the practical but not always satisfactory solution is to determine which light source is dominant (or whether one type of light can be turned off). Once the dominant light source is identified, select the film balanced for that source or use a correction filter. The alternative solution is to use color negative film in mixed-light situations, since considerable correction can be done when making prints.

Working with flash

The introduction of a portable light source that was comparatively safe and easy to use greatly extended the creative possibilities for the average photographer. Flashbulbs and later, electronic flash, allowed the photographer to bring the light to the subject as needed instead of being dependent on daylight or room lighting. (The use of magnesium flash powder as a light source was primarily a tool for professionals. It was too cumbersome and dangerous for most amateurs.)

Types of flash units

As noted earlier in this chapter, the use of flashbulbs has been almost entirely supplanted by the electronic flash. Ease of use, greater light output, and rapid repeatability are among the advantages that have made the electronic flash popular.

Built-in flash units are found in most point-and-shoot and many consumer-level SLR cameras. While they are convenient for snapshot use, they are limited in capability for serious artificial light photography.

Self-contained flash units are available in a variety of sizes and types, but can be divided into two broad categories:
- smaller units designed for mounting on a camera's "hot shoe" or accessory shoe.

- larger, usually more powerful, units attached to the camera with a removable bracket.

The first type is widely used by amateur and professional photographers alike; the second type is primarily a professional tool. See **Figure 13-15.**

Shoe-mount flash units

Models are available from camera manufacturers and from *"third-party" equipment makers* (those whose units can be used with various camera brands). They vary in light output, physical size, mechanical design (typically with or without a tilting head), and degree of automated operation.

Light output is measured scientifically in *beam candlepower-seconds (BCPS)*, but from a practical photographic standpoint, the *guide number* is generally used. The guide number is calculated by the flash manufacturer and relates the light output to the ISO rating (or *speed*) of the film being used. As noted earlier, the proper flash exposure is determined by dividing the guide number by the flash-to-subject distance to yield the proper f-stop.

For comparison purposes, the guide number is typically stated for ISO 100 film—the higher the guide number, the more powerful the flash. For example, using a flash with a guide number of 66 and a subject-to-flash distance of 15′ would result in an aperture of f/4:

$$66 \div 15 = 4.4$$

If a more powerful flash is selected, the light output will permit use of a smaller aperture. At the same distance of 15′, a flash with a guide number of 120 would yield an aperture of f/8:

$$120 \div 15 = 8$$

Guide numbers will range, depending upon the manufacturer, from the low or mid-40s to as high as 150 for shoe-mount units; handle-mount flash units may have numbers as high as 200. All of the guide numbers noted thus far have been for distances measured in *feet*.

A

B

Figure 13-15. *Two basic types of flash units. A—Many small- to medium-size flash units, such as this one, are designed for mounting on the camera's hot shoe or similar camera-top locations. (Canon USA, Inc.) B—Large, powerful flashes used by wedding photographers, photojournalists, and other professionals, mount on a special bracket attached to the camera. (Sunpak/ToCAD America, Inc.)*

For distances in meters, the guide numbers are just under one-third those used for feet (1 m is equal to approximately 39", or a bit over 3'). Thus, a flash with a guide number of 66 for feet has a guide number of 20 when distances are measured in meters. Manufacturers' catalogs or advertisements often will list both numbers, such as *20/66* or *36/120.*

The physical size of most shoe-mount flashes does not vary greatly. Most are approximately 3" in width and from 4"–6" tall. Depth will vary from 2" to almost 4", depending upon the projection of the flash head.

The major mechanical difference in shoe-mount flash units is whether the flash head is fixed at a right angle to the body, or can be pivoted to point upward at an angle or even straight up. See **Figure 13-16.** The pivoting head provides greater flexibility, allowing the photographer to soften the light by bouncing it off the ceiling or another surface. While most shoe-mount flash units have a rectangular reflector, some are made with a round reflector like those used for flashbulbs. A variation is the ***ringlight flash,*** used for close-up and macro photography. The flashtube encircles the front of the lens, providing even, shadowless light. The flash body containing the electronic circuitry

mounts on the hot shoe and is connected with a flexible cable to the flashtube. At least one camera manufacturer offers a camera with a built-in ringlight for use in dental photography. See **Figure 13-17.**

In recent years, shoe-mount electronic flash units have be become highly sophisticated, with many automated features. The most fully-featured products are the ***dedicated flash units*** manufactured for use with specific camera models (or a range of models from one manufacturer). These units fully automate the process of flash photography, setting the proper aperture and shutter speed, and adjusting the duration of the flash by reading the light at the film plane. Because of the metering method they use, such dedicated units are often referred to as TTL (through-the-lens) flash systems, **Figure 13-18.** TTL exposure control is more precise than the ***sensor-type automatic flash control*** found on general use (and some dedicated) units. As noted earlier, these flash units control the duration of the flash by reading light reflected back from the subject to a sensor mounted on the flash body.

Dedicated flash units offer many other features, such as automatic fill-flash and compensation for different zoom-lens focal lengths. Features will vary from model to model and manufacturer to manufacturer;

0° 45° 90°

Figure 13-16. *Many shoe-mounted flash units are designed with a pivoting head that can point straight forward, straight up, or at one or more angles in between.*

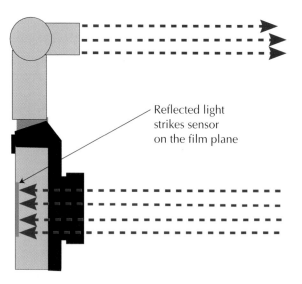

Figure 13-18. *For precise control of flash exposure, TTL flash units evaluate the amount of reflected light reaching the camera's film plane. Once sufficient light has fallen on the film plane sensor, the flash is cut off.*

Reflected light
strikes sensor
on the film plane

Figure 13-17. *Ringlight flashes provide even lighting for close-up work. A—A ringlight flash with the flash body mounted on the camera's hot shoe. (Porter's Camera Store) B—A specialized camera with a built-in ringlight flash, designed for dental photography. (Pentax)*

detailed manuals provide the needed information for using the flash effectively. Most third-party flash makers offer special modules that can be used to provide dedicated operation for some of their flash units.

Handle-mount flash units

Professional photographers who require high light output, durability, and the ability to use different types of power usually will select the larger handle-mount flash units, **Figure 13-19.** Handle-mount units are physically much larger than shoe-mount types,

Figure 13-19. *Many professionals use powerful handle-mount flash units like this one. The high light output permits photography under low-illumination conditions.*
(Sunpak/ToCAD America, Inc.)

and are connected to the camera with a sync cord. They are designed to be easily attached or detached from an L-shaped bracket fastened to the camera.

Wedding photographers, and photojournalists covering sports or breaking news stories, need power sources that can provide numerous full-power flashes. The power source must also permit fast recycling of the capacitor to avoid missed photo opportunities. Handle-mount flash units typically can be used with a number of power sources, ranging from multiple AAA batteries to household current supplied through a plug-in power cord and transformer. Many photographers consider the most practical power supply to be a belt-mounted *high-voltage power pack* that uses special rechargeable batteries, **Figure 13-20.** Spare charged batteries can be carried along and quickly substituted as needed. Power packs also can be used with many of the dedicated shoe-mount flashes.

Figure 13-20. *Power packs that have rechargeable batteries can be worn on the photographer's belt and provide a large number of full-power flashes. (Quantum Instruments, Inc.)*

Flash techniques

The flash method used by most amateur photographers — aiming the flash "straight on" at the subject from a position directly over or right next to the lens — almost guarantees an unflattering photograph. *Direct flash,* as it is called, creates a number of problems in the picture, including:

- Harsh, flat lighting.
- Unattractive shadows.
- "Burned-out" foreground details.
- "Red eye."

The only advantage of direct flash is ease and convenience of use: wherever you point your camera, the light will go as well. With the small built-in light source found on many cameras, of course, direct flash is the only choice (other than turning off the flash). For people interested primarily in taking snapshots of friends, family, pets, or vacation activities, the quality of the lighting is not usually an issue — from observing results of their own and friends' photography, they expect "flash pictures" to look that way.

One aspect of direct, on-camera flash *is* an issue — no one likes the *red eye* appearance caused by the light of the flash reflecting back from the retina of the subject, **Figure 13-21.**

Figure 13-21. *Red spots in place of the expected black pupils (red eye), result from the light of a flash reflecting off the retina at the back of the eye. Positioning of the flash immediately above or to one side of the lens is the cause, since the light bounces directly back to the lens and is recorded on the film.*

Red eye is most pronounced when the pupil of the eye is *dilated* (wide open), which occurs in dim light. Of course, this is precisely the situation in which flash is most likely to be used. Camera manufacturers have attempted to overcome the problem by introducing a *red-eye reduction* feature for built-in flash units. This is a series of short, low-power flashes that are made while the camera is autofocusing. The theory is that the short flashes will cause the subject's pupils to contract (close down to a smaller opening) before the main flash is triggered. Since the opening is smaller, less red light will be reflected back. The method works, to some extent. Red eye is usually reduced, but not eliminated.

Shoe-mount flash units do not have "red-eye reduction," but they can be used in a way that not only eliminates red eye, but overcomes the other problems of direct flash. The simplest method for improving results with an on-camera flash is to diffuse or soften the light it produces. *Diffusion* is accomplished by placing a translucent material — a piece of tracing paper, frosted plastic, or even a white handkerchief — over the flashtube. This will cause the light rays to scatter, eliminating the harshness of the light. Several types of translucent plastic diffusers are commercially available. The diffusion material lowers the light output, making an exposure adjustment necessary with manual flash. As a rough guide, assume you will have to open up one f-stop for each layer of diffusion material.

A second method is to remove the flash unit from the hot shoe and position it more effectively. By using a coiled sync cord, the flash can be moved a foot or more to one side of the camera, as well as being raised, **Figure 13-22.** Some photographers use a bracket like the one shown; others prefer to hold the flash in one hand and operate the camera with the other. This ***off-camera flash*** method will eliminate not only red eye, but troublesome flash reflections from eyeglasses, mirrors, and metal surfaces. The

Figure 13-22. *Moving the light source to one side of the camera and tilting it downward from a higher level will eliminate most of the problems encountered with direct on-camera flash. Be careful when aiming the light to cover your subject sufficiently. (Porter's Camera Store, Inc.)*

higher positioning of the light also throws shadows downward behind the subject and out of sight. Because the light is now striking the subject at an angle, instead of straight on, the flattening effect of direct flash is relieved. Depending upon the situation, the flash also may be slightly further away from the nearest subjects, making it less likely that they will be overexposed and "burned-out."

Light coverage can be a problem when using direct flash, especially with wide-angle or telephoto lenses. Most flashtubes project a cone of light that will evenly cover the subject with a lens as wide as 28mm. When a wider lens is used, such as a 24mm or a 20mm, severe light fall-off will be noticeable on the edges of the picture. Special wide-angle flash heads, or supplementary lenses slipped over the standard head, will spread the light for adequate coverage. When using a telephoto lens, the opposite problem occurs — the angle of light coverage from the flash is considerably wider than the

angle of view of the lens. As a result, much of the light is wasted, as well as being weakened by the distance it has to travel. A number of shoe-mount flashes have a "zoom" design that includes wide, normal, and telephoto settings. The telephoto setting concentrates the light into a narrower beam to minimize light fall-off with the more distant subject. Several types of flash projection devices are made to permit adequate lighting with longer telephoto lenses, **Figure 13-23.**

Bounce flash

A softer and more pleasing lighting effect is possible by using *bounce flash.* In this technique, the light reaches the subject only after being bounced off something else, such as a wall, a ceiling, or even a piece of white plastic or card stock. As shown in **Figure 13-24,** the light is directed at a light-colored surface and reflected to the subject, becoming much more diffused and even. This can be done with an on-camera flash that has a pivoting flash head, or by removing the flash from the hot shoe and physically tilting it to direct the light upward.

Figure 13-24. *Bounce flash can help light your subject evenly and avoid harsh shadows. When bouncing light off a surface, choose an aiming point about midway between your flash and the subject (remember the old principle, "the angle of incidence equals the angle of reflection"). If you are using a manually adjusted flash, remember to add together the distance from the flash unit to the ceiling and from the ceiling to the subject when determining exposure. If you use only the straight-line distance from the flash to the subject, you will underexpose the shot.*

Figure 13-23. *Special light-projection accessories, such as the Project-A-Flash, are made to attach to flash units when using telephoto lenses of 300mm or greater length. These devices are most often used in bird and small animal photography, where such long lenses are a necessity. (Tory Lepp Productions)*

Two important considerations in using bounce flash are the flash-to-subject distance and the color of the reflecting surface. Dedicated or automatic flashes will compensate for the greater distance the bounced light must travel, but users of manual flash units must take that factor into account. In addition to calculating the f-stop based on the increased distance, you must open up one or two stops to account for the loss of light due to scattering from the reflecting surface. The actual increase in exposure for bounce flash will be established through experience; for safety, bracket exposures when using this technique.

Beware of reflecting a color cast onto your subject by using a "bounce" surface that is strongly colored. A wall painted sunny yellow might be attractive on its own, but the yellow light that it reflects onto your subject could be highly unflattering to his or her skin tones. Very dark surfaces, especially

those with a rough finish (such as certain types of wood paneling), will absorb most of the light striking them, rather than reflecting light onto the subject.

When the benefits of bounce flash are desired but suitable reflective surfaces aren't available, you can provide your own surfaces, **Figure 13-25.** If an assistant or some form of

Figure 13-25. *Alternate methods of bouncing light from a flash. A—A large square of white card or a photo umbrella can be used to bounce light onto the subject. B—A bounce card will reflect most of the flash unit's light output toward the subject. A commercial version in plastic is available, but many photographers make their own with an index card and a rubber band or tape. (Porter's Camera Store)*

stand is available, a photographic umbrella (normally used in studio photography) or a piece of stiff white card several feet square can be used as a reflector. The reflective surface is positioned above and to one side of the camera and angled to reflect light on the subject. The flash unit is then reversed so it points at the reflective surface rather than the subject. When using manual flash, exposure adjustments must be made to compensate for distance and light scattering.

Another method, which has the benefit of simplicity and ease of use, is the *bounce card*. A small piece of white card stock is cut the width of the flash head and fastened in place with tape or a rubber band. The flash unit's tilt head is pointed straight up, and the card bent to extend over it at about a 45° angle. When the flash is triggered, most of the light bounces off the card in the direction of the subject. A version of the bounce card, made of rigid plastic, is available commercially.

A direct-flash technique with many of the benefits of bounce flash is known as **bare-bulb flash.** This method requires a special flash head without a reflector (or one from which the reflector can be removed), so that the light can spread in all directions. The result is a soft, even illumination that is a bit stronger than the light from a diffused flash. Because the light is emitted in a 360° circle from the flash, coverage is adequate for even extreme wide-angle ("fisheye") lenses.

Fill flash

A portable flash may be used effectively as a supplementary light source to illuminate areas that would otherwise be too deeply shadowed. It can also be used to bring out color and add some "sparkle" to a subject under dim, flat lighting conditions.

In the technique usually described as fill flash, the flash unit's output is balanced with the ambient light. Generally, the flash is set to provide approximately one-half the light that would be needed for proper flash exposure. This creates a lighting effect that is more subtle than using the full power of the flash as the primary light source. When fill

flash is properly used, the lighting of the subject will appear natural, rather than giving the appearance of a "flash picture."

Most photographers use fill flash for portraits and other outdoor situations involving people or animals. Two different lighting situations call for fill flash to create better photos. In one case, the photographer wishes to lower the contrast range of the subject. This situation might occur when bright sunlight strikes the subject from a high angle, creating deep shadows beneath the brim of a hat or in the eye sockets and beneath the nose and the chin. The fill flash will project enough light into the shadowed areas to soften them and reveal detail. The second situation is just the opposite — the subject is very evenly and softly lighted (such as a person in open shade), and the photographer wishes to add a hint of directional light to better model the features. Fill flash from a position to one side and slightly above the subject will add soft shadows that provide a more three-dimensional effect.

A similar use of fill flash is to enhance colors and shapes that have been muted and flattened by a dark overcast. When thick clouds obscure the sun, the resulting light is even, directionless, and fairly dim. Under such ambient light conditions, a photo taken of a normally bright and colorful subject, such as red berries or fall foliage, will be dull

and lifeless. Fill flash will brighten the colors and help separate the shapes of objects. The flash light will also provide small bright highlights on reflective surfaces, giving the picture life and sparkle. See **Figure 13-26.**

Cameras equipped with dedicated TTL flash units can generally be set to provide automatic fill flash, with no need for calculation. Units that control flash duration with a sensor, rather than the TTL method, can provide a semiautomatic fill flash. When controls have been properly set, the sensor will shut down the flash tube when the desired amount of light has reached the subject. Fill flash can also be achieved with manually-controlled flash units. Since fill-flash procedures vary from manufacturer to manufacturer, consult the owner's manual for specific directions.

Open flash
Most flash techniques rely upon *synchronization* to make sure the flash is triggered while the shutter is fully open. Open flash requires no synchronization, since the shutter is held wide open and the flash triggered manually one or more times. Obviously, this technique is most effective when there is little or no ambient light to cause additional exposure. For effect, flash and ambient light exposures may be combined. An example might be a faintly

Figure 13-26. *On a gray, overcast day, fill flash can bring colors to life and add depth and richness to a scene. A—Only ambient light was used to expose this scene. B—The same scene is much more interesting with the addition of fill-flash light.*

Figure 13-27. *Open flash provides many creative possibilities. In this scene, the shutter was left open long enough for the overall scene to be exposed by ambient light (the streaks in the sky are "star trails" resulting from the long exposure). A single flash provided proper exposure of the blooming yucca plants to give them prominence in the scene.*

moonlit landscape with a single feature, such as a tree or plant, that is given prominence by the use of flash exposure. See **Figure 13-27.**

The technique called **painting with light** is an open flash technique. It is typically used in large, dimly lighted spaces such as church interiors, or for exterior photos taken at night. The basic procedure for this technique is to open the camera lens by using the B (bulb) setting and a locking cable release, then illuminate the subject with a series of flashes. Care must be taken to avoid overlapping the different light bursts to prevent localized overexposure, and to avoid silhouetting the person holding the light against the illuminated background.

Often, this technique is easier to employ with an assistant, especially when the amount of ambient light makes it undesirable to leave the lens open between flashes. With the assistant handling the flash unit, the photographer can cover the lens while the flash is being repositioned. Verbal signals permit the lens to be uncovered just before the flash is triggered.

Calculating exposure is simple: even though multiple flash "pops" are being used, each part of the scene is lighted by a single flash (if you are careful to avoid overlap). Thus, the flash's guide number divided by the flash to subject distance will provide the correct f-stop. For even exposure, keep the flash-to-subject distance approximately the same for each separate flash.

Multiple flash

Lighting a large or complex subject can also be done through the use of *multiple* flash units. Since the entire scene is lighted at one time (unlike the painting-with-light technique), moving subjects can be captured. Photos of birds arriving at a nest, or small animals moving along a forest trail at night are often made using two or more flash units. The camera and flash units may be triggered manually, but often are controlled by a motion sensor or sound trigger.

Sometimes, two or more flash units may be physically connected with pc cords to fire simultaneously. A more reliable and flexible method of control than cord connections, however, is the use of **slave units.** These may be a small flash unit specifically designed for such use, or an adapter connected to a conventional electronic flash. In either case, the actuating device is a photoelectric cell that responds to the bright burst of light from the *master flash* that is connected to the camera. The photoelectric cell causes the slave unit flash to fire instantaneously. For more complex multiple flash situations, *radio slaves* are often used. These consist of a transmitter unit mounted on the camera, and receivers used to trigger the flash units. See **Figure 13-28.**

When portable flash is the primary source of light for a portrait, a more pleasing photo can be taken by using two or more flash units. One of these will be the **main light** and will provide the principal illumination. The second light, called the **fill light**, should be adjusted or positioned to provide about one-half as much light on the subject

Figure 13-28. *A radio slave system can be used to trigger multiple flash units at distances of up to 1600'. A—Transmitter unit that mounts on camera. B—Receiver used to trigger flash units. The LCD panels provide status information on the system, which can make use of multiple channels for sophisticated lighting setups. (LPA Design/Bogen Photo Corp.)*

as the main light (this topic will be explored more thoroughly in the studio lighting section). Additional units may be used for such tasks as lighting the background. Exposure calculations should be made based on the guide number and flash-to-subject distance of the main light.

Working with studio lighting

As described briefly in an earlier section of this chapter, studio lighting units may be either incandescent (*hot lights*) or electronic. Because of their differing color temperatures, the two types would not normally be used together. One possible situation in which the lighting types would be mixed would be to achieve a special effect, such as a warm-toned background lighted by an incandescent floodlight while the subject was lighted with electronic flash. A similar effect could be achieved more easily, however, by using

a *theatrical gel* (a sheet of transparent color material) on an electronic background light.

Each of the lighting types is further divided in two categories.

• Incandescent light sources can be conventional photoflood bulbs or tungsten-halogen units.

• Electronic sources may be part of a system consisting of lighting units connected to a separate power pack, or self-contained one-piece units.

Electronic units are often referred to incorrectly as *strobe lights* or just "strobes." A true *stroboscopic light* is an electronic unit that can emit flashes of light repeatedly and very rapidly. This makes it ideal for studying sequences of action, such as the operation of a machine or the motions of an athlete. Most electronic flash units used for either portable or studio work do not recycle rapidly enough to permit true stroboscopic photography.

Many photographers choose incandescent lighting when they first attempt studio photography. One reason for doing so is cost — the equipment investment for photoflood bulbs and reflectors is minimal. Tungsten-halogen units are somewhat more costly, but still represent a smaller cash outlay than is required for an electronic system. The second reason is, to borrow a term from the computer world, *WYSIWYG* (what you see is what you get). With hot lights, the photographer can see how the light falls on the subject or background. Shadow placement and relative brightness of light from each source can be observed easily, and the effects of changes studied. Exposure metering can be done with the in-camera meter or a conventional hand-held meter.

Electronic studio flash units eliminate *heat*, the major drawback of incandescent lights. They also allow changing the amount of light falling on the subject by increasing or decreasing the light output of the source, rather than by physically moving the source toward or away from the subject. These two factors are major reasons why most professionals prefer electronic lighting in the

studio. Additional advantages of electronic flash are compatibility with 5500K daylight-balanced film, and a steady light output that does not change as the unit ages.

Incandescent modeling lights are included in many electronic units to help the photographer assess lighting effects. The illumination they produce is considerably less bright than incandescent studio lights, but adequate for judging shadow placement and general lighting. For critical assessment of lighting, many professionals use an instant film back on their medium format or large format camera. The resulting print shows the exact lighting effect that will be obtained when the electronic flash units are triggered. Instant-film backs are not available for 35mm cameras, but some photographers use a separate instant-film camera to check lighting.

Lighting methods

Studio lighting can be as simple as a single light, or as complex as a setup involving three, four, or even more light sources. The important consideration is what effect you wish to achieve, not the number of lights you use. Many highly effective studio photographs, from portraits to still-life arrangements, have been made with a single light or just a light and a reflector, **Figure 13-29.**

Whether a lighting setup uses one light or several, the unit that provides the primary illumination of the subject is called the *main light* or *key light.* Depending upon the subject being lighted, the light may be positioned to the left or right of the camera, at an angle of a few degrees to more than 90° to the axis of the camera lens. See **Figure 13-30.** Since we are conditioned to outdoor (sky) lighting, in which the light strikes the subject from a high angle, the key light is usually raised to simulate that lighting. The light should strike the subject from an angle of 40°–65° above the horizontal.

Supplementary illumination is placed on the subject by the *fill light.* This light (or a reflector) softens dark shadows, decreasing the contrast range of the light reflected from the subject. The added light helps to reveal the

Figure 13-29. *This vase was lighted with a single key light located to the left of the camera at an angle of about 75° to the lens axis. The light was raised to simulate conventional sky light. To reveal some detail on the shadowed side of the vase and emphasize its rounded shape, a large white reflector was positioned just outside camera range to the right of the subject. This technique also works well with portrait subjects.*

desired degree of detail in shadow areas. As shown in **Figure 13-31,** the fill light is usually positioned on the opposite side of the camera from the key light, but is usually close to the axis of the lens. The fill light is set at approximately the same height as the camera. An important consideration in fill lighting is avoiding *conflicting shadows* that show light coming from two directions (an unnatural situation). The location or intensity of the fill light must be altered to prevent such shadows.

While "spill" from the key and/or fill light may illuminate the background, better control is achieved by using a separate *background light.* The primary purpose for using a background light is to provide sufficient visual separation between the subject and the background. This is especially important when a light-colored subject, or one with light edge areas, is placed against a light-colored background. The background should be lighted so that it will be slightly less bright than the subject, **Figure 13-32.**

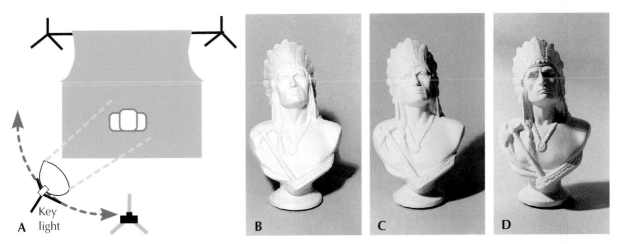

Figure 13-30. *The key light is the primary source of illumination falling on the subject. A—The key light may be located anywhere on the horizontal arc shown, and is usually directed downward onto the subject. B—Positioning the key light just slightly off the camera lens axis provides flat frontal lighting. C—Moving the key light to strike the subject at a 45° angle to the lens axis casts shadows that provide a greater degree of modeling of the features. D—With the light at an angle of 90°, a much more dramatic appearance results because one-half the subject's face is strongly shadowed.*

Usually, the light is placed low and behind the subject, so that it is directed upward onto the background material. This accomplishes two objectives: it hides the light source from the camera, and it gives the background a gradually shaded illumination. By slightly changing the tilt of the light source, or shifting it a bit from side to side, the intensity of the light behind the subject can be varied considerably. Sometimes, a colored theatrical gel over the light is used to tint the background; a patterned translucent material or

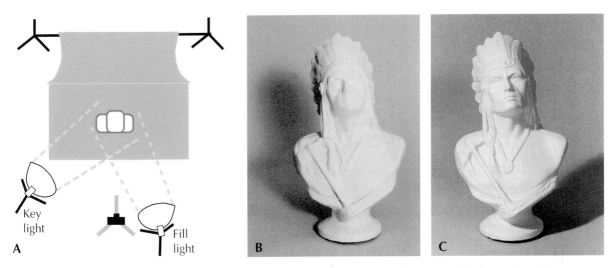

Figure 13-31. *The fill light supplements the key light. A—The fill light is usually located at the same height as the camera, on the side opposite the key light. B—Just the fill light is falling on the subject here. Its intensity must be sufficient to soften dark shadows cast by the key light, but not strong enough to create conflicting shadows. Positioning the fill light close to the lens axis helps avoid conflicting shadows. C—The combined effects of key and fill lights help to define the subject's features and avoid excessive contrast between highlight and shadow areas.*

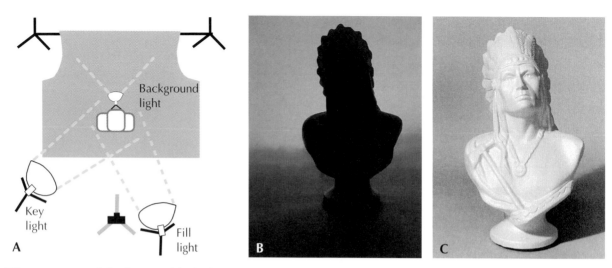

Figure 13-32. *A background light helps to separate a light-colored subject from a background that is also light-colored. A—The light is pointed upward at the background. B—Placing the background light low and behind the subject hides the light source from the camera. C—Lighting the background so it is somewhat less bright helps separate it from the subject.*

an opaque cutout may be placed in front of the light to project textures or shadows.

Some photographic situations require additional lighting for emphasis, dramatic effect, or other reasons. For example, an arrangement of several small products for publication in a catalog may need to have one of the products highlighted to emphasize it. This would be accomplished by using a small spotlight to place a tightly concen-

trated beam of light on that product. The difference in lighting intensity would make the product stand out.

In portrait photography, a ***hair light*** is often used both for dramatic effect and to help separate a dark-haired subject from a dark background. Also called an *accent light* or *rim light*, it is positioned behind and to one side of the subject to provide backlighting. **Figure 13-33** shows placement of such a

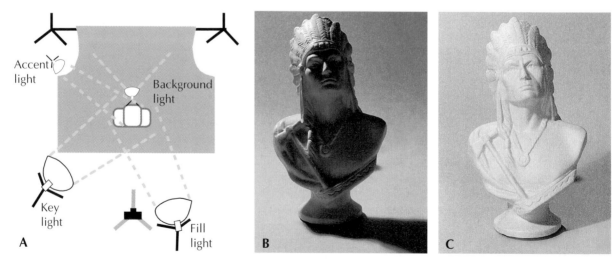

Figure 13-33. *Accent lighting can be used to emphasize certain features or parts of subjects. A—An accent light or hair light is placed behind the subject to provide backlighting. B—The rim light emphasizes the edges of the subject. Light falling directly on the camera lens must be avoided, or flare will result. C—Combined with other lights, the rim light creates dramatic emphasis.*

light. Care must be exercised to keep the light from shining into the camera lens, which would cause flare.

Controlling light

The *intensity,* or brightness, of the light falling on the subject can be varied in a number of ways. The most basic methods are increasing or decreasing the output of the light unit, or changing the distance of the light from the subject. Electronic studio flash units are available with different power output (watt/second) ratings; many also can be adjusted to change the light output over a range equivalent to several f-stops. The adjustability of such lights allows light output to be varied while leaving the lighting unit in one spot. When using hot (incandescent) lights, the most practical method of adjusting light intensity is by physically moving the lighting unit closer to, or farther

from, the subject. For example, a fill light might be positioned twice as far from the subject as the main light. If both lights had the same watt rating and were used in similar reflectors, the fill light falling on the subject would be only one-fourth the intensity of the main light.

The light's intensity may also be controlled by using devices such as snoots or grids, or a technique called feathering. The *snoot,* shown in **Figure 13-34,** is a tube placed on the front of a light to narrow its beam, producing a small spot of intense light. In portrait work, a snoot is often used to precisely direct the beam of the hair light. A *grid* is a frame with square or hexagonal openings that align the rays of light so they are more ordered and parallel. See **Figure 13-35.** This type of light adds sparkle

Figure 13-34. *A snoot is used over a light to narrow its beam. The result is a small, intense spot of light that can be used to emphasize a small subject or part of a larger one. (Norman Enterprises, Inc. Division of Photo Control Corporation)*

Figure 13-35. *To add sparkle to a scene, a grid with square or hexagonal openings is placed in front of a light. The openings align the light rays and make them more parallel. (Norman Enterprises, Inc. Division of Photo Control Corporation)*

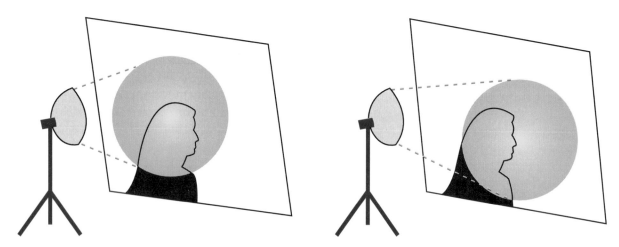

Figure 13-36. *Feathering light. A—The cone of light cast by a lamp is most intense in the center, and decreased in intensity toward the edges. B—Intensity of light on the subject can be varied by moving the light so illumination comes from the edge of the cone.*

to a scene through increased contrast. *Feathering* can sometimes be used to adjust the intensity of the light reaching the subject. When a cone of light is projected from a lighting unit, the intensity is greatest at the center and falls off toward the edges. In feathering, the light is adjusted so that the less intense outer edges of the light cone illuminate the subject. See **Figure 13-36.** A considerable range of light intensities can be obtained by using this technique.

The *quality* of light can be termed *hard* or *soft*, based on the type of shadows that are produced. Light from a small, bright source is *specular* (made up of parallel rays); light from a large source is *diffused* (made up of rays scattered at various angles). Thus, the light cast on the subject directly from a bulb or flash tube (a small source) will result in dark, well-defined shadows. It is termed **hard light.** When a translucent material is placed between the light and the subject, a large light source is created, resulting in shadows that are lighter and less defined. The light is then termed **soft light.** The difference between hard and soft light is shown in **Figure 13-37.**

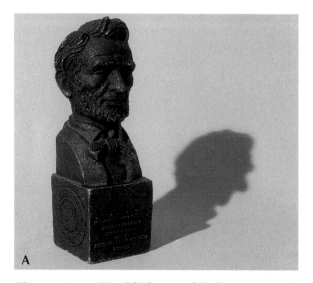
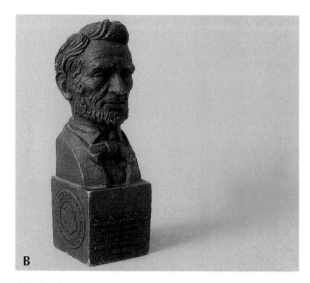

Figure 13-37. *Hard light vs soft light. A—Specular hard light from a small source creates dense, well-defined shadows. B—Diffused soft light from a large source lightens shadows and makes them less defined.*

Many different types of diffusers are available commercially, but photographers often create their own with translucent plastic panels, tracing vellum, or even white spun-glass material. For ease of use, the material is usually attached to a simple wooden or aluminum frame. A very popular lighting accessory, especially in studios doing product photography, is the *softbox*, **Figure 13-38.** This large source of diffused light consists of several lamps or electronic flash units mounted inside a reflective housing. A sheet of translucent material covers the side of the housing that faces the subject. A large softbox will provide soft, directionless light that seems to "wrap around" the subject.

Some subjects, such as highly reflective metal objects, are most effectively lighted by surrounding them with a "tent" of translucent material lighted from the outside. The camera lens is inserted through a hole in the tent.

In addition to the use of diffusion material between the light and the subject, soft light may be obtained by the indirect or bounced light method. A reflective material, such as a matte white panel or photographic umbrella,

will produce a soft, diffused light. Panels or umbrellas with a silver finish will produce a slightly harder, but still diffused, light.

Reflectors can be used in a more indirect way, as well. They can be placed opposite the key light, on the other side of the subject, to add illumination to the shadow area. When used in this way, the reflector gives results similar to a fill light. A piece of flat black card stock can be used in the same way, but with the *opposite* effect: it eliminates an unwanted reflection of light into shadow areas. This method is valuable when the object is to achieve a dramatic, high-contrast photo with dense black shadows.

Preventing light from falling in areas where it is not wanted is the function of the light-control devices known as barn doors and flags. *Barn doors* are hinged rectangular flaps, usually made of black-painted metal, that are attached to the front of a lighting unit, **Figure 13-39.** The barn doors can be

Figure 13-38. *A softbox produces a very diffused, directionless light that is ideal for many types of studio photography. Softboxes are made in a number of sizes; this one is more than 6′ in length. The size of such a light source is an advantage when photographing polished metal and other highly reflective subjects, since it creates a single large reflection. (Sinar Bron Imaging)*

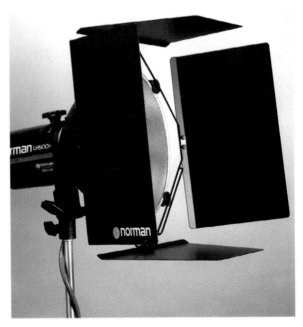

Figure 13-39. *Barn doors are metal flaps that can be adjusted to prevent light from falling in certain areas. They are usually attached to the lighting unit with a ring-type mount that allows the flaps to be rotated, as well as opened and closed. (Norman Enterprises, Inc. Division of Photo Control Corporation)*

adjusted to physically block a portion of the light being emitted. A common use is to prevent light from spilling beyond the subject onto a background. *Flags* are usually smaller in size, may be almost any shape, and are usually cut from black posterboard or stiff black paper. They may be attached to light stands, flexible arms, or other fixtures to block a portion of the light. A flag is often used to shade the camera lens when a lighting unit is pointed toward the camera (as when backlighting a subject). The lens must be shaded to prevent flare that would lower contrast of the photo. Flare can also cause internal lens reflections that would show up on the film.

A similar light control device is the *gobo,* a generic term for anything that "goes between" the light and the area where the light is intended to fall, **Figure 13-40.** A gobo

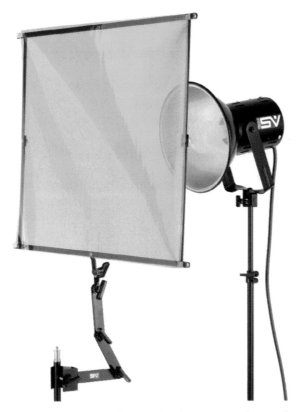

Figure 13-40. *A frame like this one can be used to hold a colored theatrical gel, a patterned material, or any other form of gobo in front of a light source. (Smith-Victor Corporation)*

might be a *theatrical gel* used to add overall color to the subject or the background, a transparent or translucent textured material (such as patterned glass or plastic), or a cardboard cutout designed to cast a recognizable shadow on the background. A widely used type of gobo is a cutout that places on the background a shadow representing a multipaned window. Three-dimensional objects, such as a real or artificial tree branch with leaves, are sometimes used as gobos.

Measuring light in the studio

Careful measurement of the light falling on the subject is important not only for establishing correct overall exposure, but also for determining the relative intensities of the key and fill lights. The method used to measure studio lighting depends upon the type of lighting units involved. Light from incandescent sources can be metered by using a camera's built-in meter or a hand-held meter. For overall exposure, a gray card can be placed in front of the subject, and a reflective meter reading taken. An incident-light meter reading, if preferred, can be made by holding the meter with its diffusing dome just in front of the subject. See **Figure 13-41.**

The brief burst of light from studio electronic flash units cannot be measured with conventional hand-held or in-camera meters; instead, a special hand-held *flashmeter* is used. The flashmeter is typically used to make an incident-light reading. It is held in front of the subject and the flash unit(s) triggered with a sync cord or electronic device. The light reading is usually given as the specific f-stop needed for proper exposure.

Establishing the lighting ratio

Achieving an effective balance among the various lighting elements is important in all types of studio photography. However, the concept of *lighting ratio* is most often discussed in the context of portrait photography. Simply put, the **lighting ratio** is a numeric expression of the relationship between the illumination of highlight and

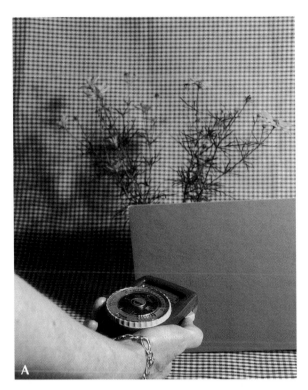
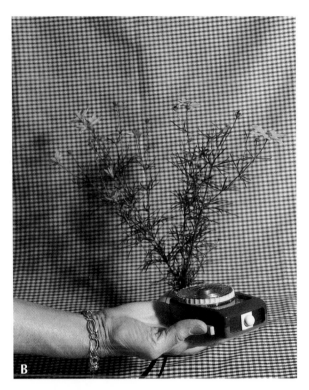

Figure 13-41. *Light readings for incandescent sources. A—A reflected-light reading is taken from a gray card at the subject's position. B—An incident-light reading is made at the subject's position.*

shadow areas of the subject's face. Put another way, the lighting ratio expresses the relative intensities of the key and fill lighting.

At one extreme, the ratio would be 1:1, meaning that the key light and the fill light were of equal intensity when measured at the subject position. At the other extreme, the ratio might be 64:1, an extreme contrast equal to a difference of six f-stops, or even higher. Thinking in terms of f-stops, a 2:1 ratio indicates that the key light is one stop brighter (i.e. twice as bright) than the fill light. A 4:1 ratio would be a two-stop difference, an 8:1 ratio, three stops, and so on.

Traditionally, the lighting ratio for portrait work is 3:1. This means that the highlight areas are three times (1.5 stops) brighter than the shadow areas. Or, it could be said that the fill light's illumination is one-third as bright as the illumination from the key light. Low-contrast lighting ratios of 2:1 or 3:1 are preferred for portraits of women because they are considered flattering to the subject, producing pleasing skin tones and

minimizing wrinkles and blemishes. Men are often photographed with a somewhat higher ratio of 4:1 or 5:1, while more dramatic "character" portraits may use ratios of 16:1 or even higher. **Figure 13-42** shows the effects of different lighting ratios on a single subject.

The method of using a light meter to establish lighting ratios differs slightly depending upon whether a reflective meter or incident meter is being used. The same basic techniques can be employed with a normal hand-held meter and incandescent lights, or with a flashmeter and electronic flash.

Reflective-reading method. Hold a gray card at the subject's position, with the gray surface pointed midway between the key light and the camera. Take a reading off the card and note the exposure reading (f-stop). Shift the card so its gray surface points directly at the camera. Shade the card as necessary so no illumination from the key light will strike it (you are making a fill-light-only reading). Note this reading, then determine the number of stops between the

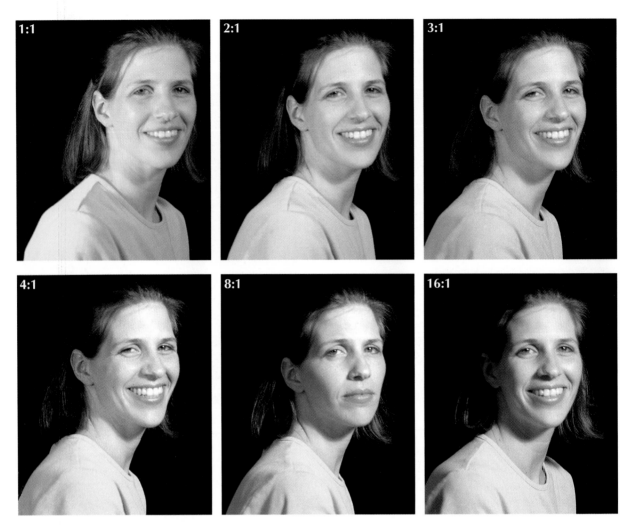

Figure 13-42. *Typical lighting ratios for portraiture. The lower ratios, 2:1 and 3:1, are preferred for portraits, especially with female subjects. As ratios become higher, the lighting becomes more dramatic.*

two readings. Refer to **Figure 13-43** to convert the difference in stops to a lighting ratio.

Incident-reading method. Hold the incident meter at the subject's position, aiming it directly at the key light. Note the exposure reading. Next, aim the meter at the camera. As described in the reflective method, shade the meter to prevent any key light falling on it, so you will obtain a reading from just the fill light. Note the second exposure reading, determine the number of stops difference, and use the chart to find the lighting ratio.

Typical lighting situations

Basic portrait lighting can be done with a single light source, a one-light-plus-reflector

Lighting Ratios

If the difference in f-stops is:	Then the lighting ratio is:
2/3	1.5:1
1	2:1
1 1/3	2.5:1
1 2/3	3:1
2	4:1
2 1/3	5:1
2 2/3	6:1
3	8:1
3 1/3	10:1
3 2/3	13:1
4	16:1

Figure 13-43. *This chart converts f-stop differences to lighting ratios.*

arrangement, or with two lights (key and fill). When using only one light, you must take care to avoid straight-on lighting that flattens out the subject's features. The light source should be raised above the subject's head level and tilted downward at an angle of 40°–65°. Shifting the light somewhat away from the axis of the lens, as shown in **Figure 13-44,** will provide some measure of sidelighting. This will cast shadows that bring out features and give the face a more rounded, three-dimensional appearance. Unless a dramatic, contrasty look is desired, the light source should be diffused to soften the shadows. Avoid moving the light too far to one side of the subject, since this would place half of the face in deep shadow.

If the key light must be placed in a position that deeply shadows one side of the face, a fill card (reflector) or second light must be used to add light to the shadowed area. This will lighten the shadows, lowering the overall contrast and revealing detail.

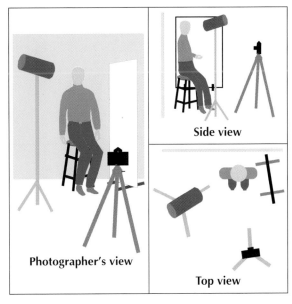

Figure 13-45. *A reflector can be used with a single-light setup to bounce additional illumination into shadowed areas. The position and angle of the reflector can be varied to alter the amount and direction of the bounced light. A reflector with a white matte surface will provide a soft light; a smooth-surfaced or metallic reflector will reflect a harder, more intense quality of light.*

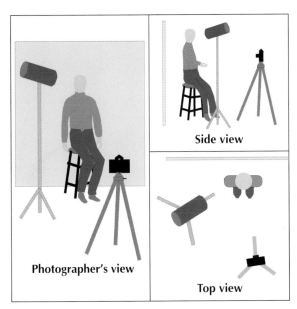

Figure 13-44. *In a single-light portrait setup, raise the light so it will shine downward at an angle of 40°–65°. Move the light somewhat to the side of the subject to bring out facial features and avoid flat lighting. Often, the light will be diffused to avoid casting dense shadows.*

Figure 13-45 shows how a reflector can be positioned in relation to the key light. Depending upon the angle of the key light and other factors, a large reflector can be placed standing upright on the opposite side of the subject, or propped at an angle. A reflective surface such as a white card can even be held by the subject (out of the camera's view) at an angle that will bounce light into the desired area.

A *two-light arrangement* is extensively used for portraits, since it offers considerable flexibility in creating different effects and lighting ratios. The key light is typically positioned in the same way as a single light — above and somewhat to the side of the subject. Depending upon whether a hard or soft light is desired for the photo, the key light may or may not be diffused. The fill light is usually located close to the camera position. See **Figure 13-46.** It may be positioned approximately at camera height, or

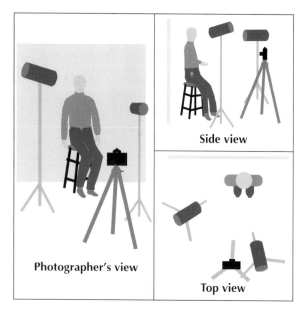

Side view

Photographer's view

Top view

Figure 13-46. *The two-light arrangement is popular because of its ease of use and the flexibility it provides. Different lighting effects and lighting ratios can be created by changing the relationships of the key and fill lights. Either can be moved to a different height or horizontal position, or moved closer to or farther away from the subject. Diffusers can be used on one or both lights to achieve hard light or soft light effects.*

somewhat higher, but is usually lower than the key light. Normally, the fill light will be diffused to provide a softer light. The lighting ratio is established by changing the amount of fill light reaching the subject. With incandescent lights, or with fixed-output electronic flash units, this must usually be done by moving the light closer to or farther from the subject. Variable-output electronic flash units allow the photographer to leave the lighting unit in one spot and adjust controls to deliver a greater or smaller amount of light.

Some portraits call for a *multiple light arrangement*; still life and product photographs also will frequently require the use of three or more lighting units. Adding a background light or a hair light can increase the impact of a traditional portrait, **Figure 13-47.**

For product photography, the key light may be a *softbox* or similar large diffused

source to provide a soft overall lighting effect. Additional accent lights and reflectors are then positioned as necessary to create shadows and highlights. See **Figure 13-48.**

Glassware, polished metal, and other reflective objects can be difficult to light, since they will act as mirrors showing the light source and surrounding objects (including the camera and photographer), **Figure 13-49.** It is possible, of course, and sometimes desirable, to eliminate reflections entirely. By placing an object on a translucent

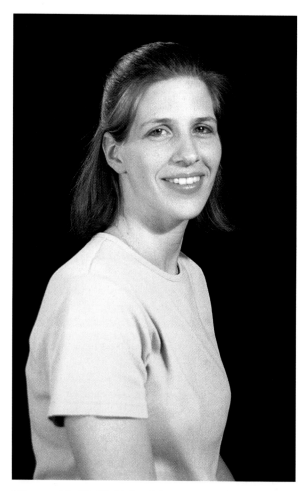

Figure 13-47. *To light this portrait, the photographer used three light sources: key, fill, and hair lights. The key light was positioned to the right of the camera and raised to direct light downward at about a 45° angle. The fill light was at head level and positioned to provide a 3:1 lighting ratio. A small spotlight provided rim lighting on the hair.*

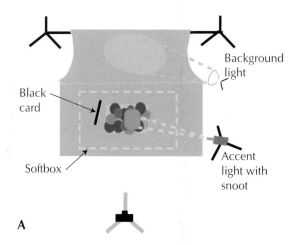

A

B

Figure 13-48. *A product shot using multiple light sources.* **A**—*Positioning a large softbox above the setup provided virtually directionless overall illumination. The product was given emphasis by lighting it with a small spotlight with a snoot. Positioning a black card opposite the accent light prevented lightening of the shadow areas due to reflection. A background light was placed low and directed through a colored gel.* **B**—*The final effect of the lighting setup.*

surface, **Figure 13-50,** then lighting it from both above and below, a very even and shadowless illumination can be achieved. This is shown in **Figure 13-51.** A similar method is *tenting* the subject by constructing a cone or shell of white translucent paper or plastic, with a small hole cut in one side for the camera lens. When light is thrown on the cone from the outside, a very diffused illumination

Figure 13-49. *Polished metal surfaces act as a mirror, showing undesirable reflections from the light source and objects in the studio. Note the reflection of the camera and the photographer in these silver-service pieces.*

Figure 13-50. *A shooting table is often used with small subjects. A combination of backgrounds, from solid to translucent to transparent allows different lighting approaches to be used, depending upon the subject. (Smith-Victor Corporation)*

Figure 13-51. *Lighting a subject from both above and below with very diffused light can eliminate both reflections and shadows. The resulting photo tends to have very little modeling, taking on a more two-dimensional quality than a picture that includes shadows and/or controlled reflections.*

of the subject is achieved. Although this lighting approach eliminates reflections, it tends to flatten the object — it doesn't convey surface texture or curvature very well.

Another approach, which is often used for photographing glass, is *indirect* or *transmitted* lighting. Light is bounced off the background and passes through the glass objects to the camera lens. Since no frontal light is striking the reflective glass surface, there are no reflections. Colored backgrounds, or color gels on the lights, can be used to good effect. See **Figure 13-52.**

The key to successfully portraying most reflective subjects, however, is *controlling* the reflection(s). Controlled reflections help to define the three-dimensional nature of the subject, convey its texture, and provide highlights that add visual interest. Control of reflections is usually done by a combination of light sources, reflectors, and black ("reflection-killing") materials.

Small, bright light sources will create small specular reflections, while large, diffused light sources will result in broader and less intense reflections. Distance of the light source from the reflective object can make a difference, as well. The closer the light source is to the object, the larger its reflection. To make the reflection pattern in

Figure 13-52. *Transmitted light can eliminate undesirable reflections when photographing glassware. A—Bouncing light off the seamless background material will both illuminate the glassware and create interesting shadow patterns. B—Using a color background behind the glassware or adding color theatrical gels to the lights can produce dramatic effects.*

the shiny surface more interesting, pieces of black paper or card stock may be strategically placed between the diffused light source and the object. This will break up the reflection into dark and bright areas. Usually, several experimental arrangements must be tried to find the best pattern.

Studio lighting is a subject complex enough that entire books have been written about it. Such books can provide a good grounding in the subject, and examples of different lighting treatments. The best way to learn lighting technique, however, is the same method used for learning most other aspects of photography: *practice* and *experimentation*. Use a systematic approach — start with a single key light and try various angles and distances or intensities until you are satisfied with it. Next, add a reflector and see the differences that result from placing it at various distances and angles. Replace the reflector with a fill light. Turn off the key light and experiment with various placements of the fill light. Turn the key light on again, and make any additional adjustments to the fill light. Use a light meter to determine lighting ratio, and experiment with different ratios by making changes to the fill light. As you make exposures of the subject with various lighting setups, make careful notes including a rough sketch of the light placement (with dimensions). After the film is developed and printed (or slides are processed) you will be able to check your notes to see the effects of the different arrangements. This will allow you to keep using successful techniques, and discard those that did not provide the desired results.

Questions for review

Please answer the following questions on a separate piece of paper. Do not write your answers in this book.

1. The most difficult-to-control form of artificial lighting is _____ lighting.

2. What kind of problem can result from bright overhead ambient lighting when a human subject is involved?

3. Why was the flashbulb considered a major improvement over flash powder for artificial light photography?

4. Electronic flash is based on the sudden release of electrical energy that is stored in a _____. The energy enters a gas-filled flashtube, producing a brilliant burst of light.

5. Duration of an electronic flash is typically measured in _____ of a second.
 a. tenths
 b. hundredths
 c. thousandths
 d. millionths

6. Photofloods and tungsten-halogen units are the two forms of _____ lighting, and are often referred to as "hot lights."

7. Why do some photographers find electronic studio flash more difficult to use than "hot lights?" List two methods of overcoming this problem.

8. Apply the inverse square law to determine the intensity of light in the following situation. If light covers an area of one square foot at a distance of one foot from the source, how many square feet would it cover at a distance of 16 feet?
 a. 32 sq. ft.
 b. 64 sq. ft.
 c. 128 sq. ft.
 d. 256 sq. ft.

9. Why are self-contained portable electronic flash units preferable to built-in flash?

10. To permit comparison of different units, the guide number for an electronic flash is typically stated for use with film rated at ISO _____.

11. Dedicated flash units that adjust flash duration by reading reflected light at the film plane are called _____ systems.

12. The lighting technique used to lighten shadow areas and reduce contrast when photographing outdoors is called _____.

 a. indirect flash
 b. fill flash
 c. open flash
 d. bounce flash

13. A _____ is a tube placed in front of a light source to narrow and direct its beam.

14. What is meant by the term, "lighting ratio?" What lighting ratio is traditionally used for portrait photography?

15. When photographing a polished metal object, would you use a small light source placed far from the object, or a large diffused source located close to the object? Why?

This portable lighting outfit consists of four tungsten-halogen fixtures with barn doors and other accessories. The outfit is suitable for portrait or product photography on location. (Smith-Victor)

Depth of field:
The size of the zone, from nearest to farthest, that is in acceptably sharp focus. It becomes greater as the aperture size decreases.

Chapter 14

Advanced and Special Techniques

When you have finished reading this chapter, you will be able to:

⇒ Identify the techniques used to stop action.

⇒ Compare the various types of closeup equipment and identify the most suitable use for each type.

⇒ Explain the method used for calculating exposure compensation when doing closeup photography.

⇒ Demonstrate the process of creating an image through intentional double exposure.

⇒ Describe the major types of nonsilver photographic printing processes.

Many photographers, especially those who do not depend upon the camera as a means of making a living, are content to achieve competence in one area and never venture beyond it. For example, a person might reach a high level of technical and artistic accomplishment in landscape photography or natural light portraiture or studio small-object (tabletop) work. Such photographers become so concentrated on their chosen area that they have little time for (and little or no interest in) other aspects of photographic activity.

Other photographers, however, take a broader view. They might have a strong interest in one area, such as closeup photography, but are continually working to acquire skills in other areas. While the dedicated closeup photographer might never achieve the same level of expertise in (for example) nonsilver printmaking methods, he or she has at least explored the possibilities. That exposure might lead to a deeper involvement, or to the conclusion that "it's not for me."

The preceding chapters of this book provided the information and techniques needed to achieve a basic level of photographic skill. This chapter goes beyond the basics to describe some advanced methods and a variety of special topics. The material is introductory in nature, and is intended to present an overview of those areas. For the student who wishes to explore one or more of these topics in greater depth, there is a wealth of material available in both print and electronic media.

Action photography

In the early days of photography, there was no such thing as an "action shot." Film emulsions were so slow that street scenes usually included no human figures: pedestrians strolling by the camera were moving too rapidly to register on the film. To be captured by the camera, a person had to remain in one spot for several seconds.

As film emulsions became more sensitive, and lens and shutter speeds improved,

Figure 14-1. *A shutter speed of 1/500 second, plus timing to catch the action at its peak, froze both the volleyball and the player in midair.*

the photographer's ability to include moving objects in pictures improved as well. Today's films and camera systems make it not only possible, but relatively simple, to "freeze" even the rapid action of a sports activity. See **Figure 14-1.**

Completely stopping motion isn't always desirable, however. To convey a sense of movement, it is often desirable to have some degree of motion blur in the photograph. The amount of blur may be very slight, **Figure 14-2,** or almost total, as shown in **Figure 14-3.**

Figure 14-2. *Using motion blur to convey movement. In this shot of a rodeo rider "biting the dust," the shutter speed was fast enough to preserve the instant of impact, but allowed some blurring of the bucking bronco's hooves and tail.*

Figure 14-3. *A slow shutter speed was used to blur the lights of this whirling carnival ride into colorful streaks that show its movement.*

Stopping action

When you seek to totally stop the movement of a subject, the relative motion of that subject will affect the shutter speed you select. This involves not only the speed at which the subject is moving, but the direction of movement in relation to the camera. In terms of the subject's speed of movement, the relationship is straightforward: stopping a sprinter requires a faster shutter speed than you would use to freeze the motion of a slowly strolling pedestrian.

Direction of movement also affects the choice of shutter speed. A subject moving directly toward the camera (whether that movement is fast or slow) can be stopped by a relatively slow shutter speed. A subject moving at an angle to the lens's axis, either toward or away from the camera, requires a higher shutter speed. If the movement is perpendicular to the lens's axis (i.e., across the field of view), a still faster shutter speed is needed. Under identical conditions, shutter speeds become twice as fast for each directional change. For example, if 1/125 second stops movement toward or away from the camera, 1/250 second would be needed to freeze a diagonal movement. Motion across the field of view would need 1/500 second. **Figure 14-4** is a table comparing the effects of distance and direction of movement on shutter speeds for some typical subjects.

Object in motion (or type of action)	Approximate speed		Distance from camera		Type of movement		
	(mph)	*(kph)*	*(feet)*	*(meters)*	*Toward/ away*	*Diagonal*	*Across*
• People walking	5	8	10–12	4	1/125	1/250	1/500
			25	8	1/60	1/125	1/250
			50	16	1/30	1/60	1/125
			100	33	1/15	1/30	1/60
• People jogging, skating, or bicycling • Children in active play	10	16	10–12	4	1/250	1/500	1/1000
			25	8	1/125	1/250	1/500
			50	16	1/60	1/125	1/250
			100	33	1/30	1/60	1/125
• Active sports • Animals (large) running • Vehicles on city streets	25	40	10–12	4	1/500	1/1000	1/2000
			25	8	1/250	1/500	1/1000
			50	16	1/125	1/250	1/500
			100	33	1/60	1/125	1/250
• Vehicles on highway	50	80	25	8	1/500	1/1000	1/2000
			50	16	1/250	1/500	1/1000
			100	33	1/125	1/250	1/500
			200	66	1/60	1/125	1/250
• Racing vehicles • Other fast-moving subjects	100	160	25	8	1/1000	1/2000	1/4000
			50	16	1/500	1/1000	1/2000
			100	33	1/250	1/500	1/1000
			200	66	1/125	1/250	1/500

NOTE: Shutter speeds listed are for 35mm cameras, based upon use of a normal (50mm) lens. For longer lenses, shutter speeds must be adjusted upward, moving to the next highest speed for each doubling of the focal length. Thus, 1/500 with a 50mm lens increases to 1/1000 for a 100mm lens, or 1/2000 for a 200mm lens.

Figure 14-4. *Shutter speeds needed to stop motion for some typical situations.*

A third factor is the distance of the subject from the camera — the closer the subject, the faster it will move across the lens's field of view, and the faster the shutter speed that will be needed to stop its motion. The most challenging combination is a fast-moving subject crossing the camera's field of view a few feet in front of the lens. At the opposite extreme, of course, is a slow-moving subject coming directly toward the camera, but a long distance away.

Complicating the issue is the focal length of the lens you use. As the focal length increases, the field of view narrows proportionately. If both a 100mm lens and a 200mm lens are focused on a bicycle rider 100′ away, the bicyclist would cross the field of view of the 200mm lens twice as fast, because the field of view of that lens is only half as wide. Using a longer lens also requires a faster shutter speed, since you are in effect closer to the subject. The shutter speed is doubled for each doubling of the focal length. If you selected a shutter speed of 1/125 second to stop the bicyclist's motion with the 100mm lens, you would have to use a speed of 1/250 second with the 200mm lens to achieve the same effect.

Even though today's most fully featured 35mm cameras offer shutter speeds as brief

as 1/8000 second, some action cannot be stopped by shutter speed alone. In some cases, the movement is too rapid even for a very fast shutter speed; in others, low light levels require slower shutter speeds (even with large apertures) for proper exposure. The solution, in these situations, is the use of electronic flash. The duration of the light burst from the flash tube is extremely short (between 1/10,000 second and 1/50,000 second), so that the subject is frozen into stillness.

Using flash to stop motion is most effective in conditions with low levels of ambient light, since the subject will be isolated against a dark background. When the level of ambient light is fairly high, ghost images can result. Although the flash serves as the main source of light and stops subject motion for an instant, the shutter remains open for 1/60 second (or 1/125 second, depending on sync speed). The blurred "ghost" is caused by ambient-light exposure of the moving subject during the time the shutter remains open. With older cameras, the blurred ambient light image is in front of the subject. This occurs because the flash exposure is made the instant the shutter opens. The subject continues to move, and is recorded on the film by ambient light until the shutter closes. Many newer cameras offer "rear-curtain synchronization" that delays the firing of the flash until the instant before the second curtain of the focal plane shutter begins to close. This places the "ghost image" behind the moving subject for a more natural appearance. Since sync speeds are higher with most new cameras, the shutter is open for a shorter duration, minimizing the ambient-light exposure.

Experienced action photographers, especially those covering sporting events, are often able to capture dramatic "stop action" photos without the use of flash or extremely high shutter speeds. They do so by catching their subject at the *peak of action,* an instant when motion slows dramatically to almost a stop. Probably the most familiar example of

catching the peak of motion is the image of a pole vaulter who seems to hang in midair, just above the bar. At that instant, the upward momentum of the athlete is briefly balanced with the pull of gravity — he or she has stopped moving upward, but hasn't yet begun moving downward. Similar situations occur in most sports: the football receiver leaping high to snag a pass, the soccer forward "heading" a ball, the home-run slugger's bat meeting the ball, the diver snapping arrow-straight out of a twist, the rodeo cowboy being whiplashed atop a bronco or a bull. See **Figure 14-5.**

The key to using the peak-of-action technique effectively is knowing the sport (and sometimes the individual player) well enough to anticipate *when* action will reach a peak. Some sports, such as the high jump or basketball, have action peaks that are fairly regular and predictable. Others, such as lacrosse or rodeo or racquetball, feature more random and unpredictable motion, making it more difficult to anticipate the peak of action. Good timing is vital, since the shutter must be released an instant before the peak of action takes place. This means that, if you wait to see the peak of action in

Figure 14-5. *Many sports offer opportunities to stop motion by timing the shot to capture the peak of the action. Even the violent motion of this rodeo bullriding event came to a virtual halt at times as it changed direction, allowing the photographer to effectively stop motion.*

your viewfinder, it is too late to press the shutter release — you'll miss the shot. It takes practice, plus knowledge of the sport, to perfect your timing.

Your chance of capturing the peak of action is improved by the careful use of the *motor drive* or *continuous film advance* feature found on most 35mm cameras today. Separate motor drives are available as accessories for older cameras. The battery-operated drive will keep advancing the film and making exposures as long as the shutter release is pressed. Many cameras will expose film at a rate of from 3–6 frames *per second,* which is both an advantage and a disadvantage. By using good timing and making exposures in short bursts of 3–4 frames, a photographer has a good chance of getting the exact shot he or she desires. With poor timing and too heavy a shutter finger, however, it's easy to "burn" an entire 36-exposure roll of film and still fail to capture a good action photo.

Obtaining sharp focus

Cameras with predictive autofocus and similar sophisticated focusing systems have made life simpler for sports, action, and wildlife photographers. Besides improving the percentage of well-focused shots, autofocus has freed the photographer from one task, allowing more attention to be paid to composition, timing, and other matters.

Some autofocus systems react too slowly for action photography; a photographer skilled in manual focusing can do the job faster and more effectively. A common situation in which manual focus is preferable to slow autofocus is one in which a moving object must be kept in focus to allow the shutter to be pressed at any time. Known as *follow focus,* this technique requires continuous small adjustments by the photographer to keep the subject sharp. An example would be "tracking" a goose or duck coming in for a landing on a body of water. By keeping the subject in sharp focus, the photographer can select the exact instant to release the shutter. (If the camera is equipped with a motor

drive, a number of exposures could be made during the landing.)

This type of focusing is usually done by judging the sharpness of the image on the viewfinder's ground glass, rather than using the split-image or microprism portions of the finder. Determining the amount of lens barrel rotation needed to keep the focus sharp requires practice. Visits to a city park will provide many subjects (birds, joggers, bicyclists, children, pets) that can be used to practice the follow-focus technique until it becomes virtually automatic. Much of the practice work can be done without film in the camera, since the object is to develop proper coordination and motor skills. Shooting an occasional practice roll of film will allow you to assess your technique.

Prefocusing on a specific spot is a useful technique when the action follows a regular pattern or route, as it does in baseball and most types of racing. All that is necessary is to select a particular location (for example, first base or the finish line of the track), sharply focus the camera there, and wait for your subject to reach that point, **Figure 14-6.** This method works best when it is possible to use a smaller f-stop for increased depth of field. To compensate for reaction time, the shutter release should be pressed just before the subject reaches the point of focus.

Another type of prefocusing is called *zone focusing,* since it covers a wider area. This makes it a good choice for activities that are less predictable, such as football, basketball, or soccer. The first step is to determine the pair of distances between which you wish to be able to capture action, such as 10' and 30'. The area of acceptable sharpness is approximately one-third in front of and two-thirds behind the actual point of focus. Thus, your point of focus should be one-third the distance between 10' and 30', or at approximately 17'. Once the camera is focused at that distance, the lens must be stopped down to an aperture that will provide acceptable sharpness from 10' to 30'. The camera's depth of field preview feature can

Figure 14-6. *Prefocusing on a specific spot allows you to capture a well-focused photograph when the subject reaches the point you have chosen. In this bicycle race shot, the prefocus spot was the area between the sewer grating and the orange paint marking.*

be used to observe the changes in depth of field as the lens is stopped down. Once the zone of focus is established, any action within that zone will be acceptably sharp.

A similar technique is to set the lens at its *hyperfocal distance*, the nearest point that will be in sharp focus when the lens is focused on infinity. This distance is different for each f-stop and each focal length. When a lens is set to its hyperfocal distance, everything from one-half that distance to infinity will be in sharp focus. To find the hyperfocal distance on a lens with a depth-of-field scale, first align the infinity symbol (∞) on the focusing mark. Note the distance (in feet or meters) shown above the mark for the

appropriate f-stop on the left-hand scale. This is the *hyperfocal distance*. Rotate the focusing ring until the hyperfocal distance is aligned with the focusing mark. The distance figure appearing above the appropriate f-stop on the left-hand scale will be one-half the hyperfocal distance. Everything from that point to infinity will be in focus.

Blurring for creative effect

Earlier, it was mentioned that some degree of blurring from subject movement is often used to help convey a sense of motion. Normally, blurring due to movement of the *camera* is considered much less desirable. Two types of blur induced by camera motion — panning and zooming — are often used creatively, however, to add visual interest.

In *panning*, the camera is moved in an arc as the subject passes, and the shutter release pressed at the desired point. The result is a sharply focused subject moving across a blurred background, strongly conveying the idea of rapid movement, **Figure 14-7.** Best results are obtained when the camera is moved smoothly at the same apparent speed as the subject. The panning movement must continue past the point where the shutter is released. A background close to the moving subject will streak more interestingly than a distant background.

Although most panning is done with a horizontally moving subject, vertical panning can be used to capture an ascending rocket

Figure 14-7. *Panning the camera along with the motion of the subject will produce a picture with a sharp subject and a streaked background.*

or a fast-climbing stunt plane at an air show. For either horizontal or vertical panning, a tripod-mounted camera results in smoother movement than can be obtained in hand-holding. This is especially true when a long lens is being used.

Zooming is usually done to impart motion to a photo of a stationary subject, but it also can be used with a moving object. The subject is centered in the viewfinder and sharply focused, and the camera's zoom lens is moved in or out during the exposure. Since a fairly long exposure time (1/15 second to 1/30 second is typical) *must* be used to allow zooming, tripod-mounting of the camera is a necessity. When properly done, a zoomed photo will have a center area that is in focus, and streaking outward from the center to the edges of the print. See **Figure 14-8.**

Closeup photography

The closeup photographer is able to open the door to a strange and often beautiful world. In that world, intricate shapes and structures emerge from everyday objects and common insects can take on the menacing appearance of prehistoric monsters. Exotic as the closeup world is, it has the advantage of being conveniently nearby. While a landscape photographer may have to travel thousands of miles to capture a chosen subject, the closeup photographer can find an almost endless supply of subjects literally in his or her backyard.

How close is close?

The term *closeup* is widely used by photographers, but has no specific meaning. To one person, a frame-filling shot of an elephant might be considered a closeup; to another, "closeup" might mean a twice-life-size portrait of a flea. For greater precision when discussing closeup photography, the terms *magnification* and *reproduction ratio* are commonly used. Although they present the information in different forms, both are methods of stating the size relationship

between the actual object and its image on film. The image size on the film is literally that — the physical measurement of the object's image on the negative or transparency (not the size on a print or projected slide).

Some people find the size relationship easiest to understand when stated as a **reproduction ratio,** such as 1:4. The numeral before the colon represents the *reproduction size,* or the size on film; the number after the colon represents the size of the *actual object.* In the case of a 1:4 ration, this means that the actual object is four times larger than its representation on film (or looking at it another way, the film image is one-fourth the size of the actual object). If the image on film is 1" long, then the "real thing" is 4" in length.

An example might be a ladybug that is 1/4" long. If the image of the insect on the film is also 1/4" long, the *reproduction ratio* would be 1:1 — the film image is said to be same size or *life size.* If the image of the insect on the film measures only 1/8", the reproduction ratio would be 1:2, or *half life-size.* Often, the film image will be larger than the real object. If the film image of the ladybug measures 1/2", it would be *twice as big* as the real insect, so the reproduction ratio would be stated as 2:1. See **Figure 14-9.**

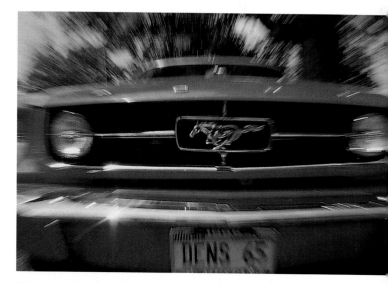

Figure 14-8. *Zooming in or out during a long exposure creates a very interesting, almost abstract effect and a strong feeling of motion.*

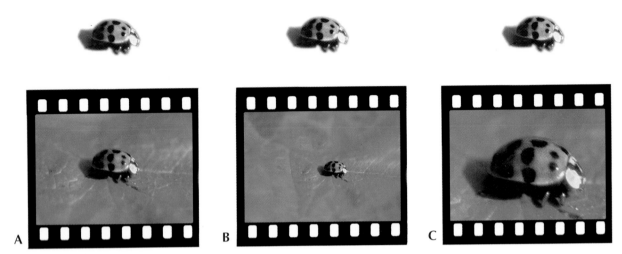

Figure 14-9. *Reproduction ratio. A—If the actual object and the image on film are the same size, the ratio is 1:1. B—If the film image is one-half the size of the actual object, the ratio is 1:2. C—A film image twice as large as the actual object has a reproduction ratio of 2:1.*

The ***magnification rate*** provides the same information as the reproduction ratio, but in a different form. Instead of describing the size relationship as 2:1, for example, it would be stated as 2×, or "two times life size." A 4× magnification would describe a film image four times larger than the actual object; 5.5× would be five-and-one-half times the actual object size, and so on. Reproduction at less than life size is represented by *fractional* magnification rates, such as 1/2× or 1/10×. The 1/2× magnification, of course, means that the film image is one-half the size of the actual object; 1/10× describes a film image one-tenth as large as the original.

As noted at the beginning of this section, the meaning of the term "closeup" is highly subjective. However, there are three ranges of magnification that can be used to better answer the question, "How close is close?" The lowest range of magnification extends from about 1/20× to 1× , or 1/20 life size to actual life size. Based on the 1″ × 1 1/2″ (24mm × 36mm) frame size of 35mm film, the original subjects would be from 20″ × 30″ down to 1″ × 1 1/2″ in size. This degree of magnification, which can be referred to as the ***closeup range***, is achieved by the use of lenses alone, without employing special techniques or accessory equipment. The upper part of the range (from 1/20× down to

about 1/6×) is achievable with normal-focusing lenses. See **Figure 14-10.** To obtain greater magnification, a *close-focusing lens* is needed. These lenses provide greater extension, so that sharp focus can be obtained on a subject that is closer to the lens. This permits a larger image to be projected onto

Figure 14-10. *A normal lens—in this case, a 300mm telephoto—can produce closeups in the range of 1/10× up to about 1/6×. The image of this Monarch butterfly is 1/4″ long on the film, or one-sixth the 1 1/2″ length of the living creature. An advantage of using longer focal length lenses is the greater lens-to-subject distance ("working room") they make possible. Increased distance makes the subject less likely to feel endangered and flee.*

the film. A close-focusing lens is often referred to as a *macro lens* (the term comes from the Greek word *makros*, which means "large").

A reproduction ratio of 1:1 (life size, or a magnification rate of 1×) is generally considered the borderline between the closeup range and the *macro photo range.* In the macro range, the film image is as large or larger (even *much* larger) than the actual object. Technically, the proper term for work in this range is *photomacrography*, but popular usage converted the word into the easier-to-pronounce macrophotography and eventually shortened it to just "macro." At approximately 25×, another borderline is passed, into the third range of magnification. This is the highly specialized realm of *photomicrography,* in which a microscope is used to achieve extremely high magnifications.

In the macro photo range, various types of accessories are used to increase the magnifying power of the camera's lens or accessories. Some of these devices move the lens further from the film, increasing its focal length and thus, the image size. Others place additional magnifying components in front of the lens, with the same effect on image size.

Ways of getting close

In the closeup range (up to life size), macro lenses provide the advantage of simplicity and ease of use. They also are versatile, since they can be used for normal photography as well as close-focusing situations. When first introduced for use on 35mm SLR cameras, macro lenses were available only in 50mm focal length and typically provided a "half life-size" (1:2) image. Today, macro capability is built into lenses of a number of fixed focal lengths, often providing 1:1 reproduction ratios. Zoom lenses, especially those with manual focus, frequently claim macro capability, but most provide only a 1:4 (one-quarter life-size) reproduction ratio. The majority of those lenses allow macro-focusing only at the long end of their zoom range; a few are close-focusing at the wide end, instead.

For magnifications greater than life-size, it is necessary to use other devices in combination with the camera lens. Depending upon the device or combination of devices, it is possible to photograph an object as much as 25 times life-size (25×). At such a magnification, a tiny insect only 1mm long would almost fill the 35mm film frame. Although such extreme magnification is possible, most photographers work at reproduction ratios of less than 10:1. The devices and methods used to get greater magnification include:

- **Closeup diopters.** Sometimes called "supplementary lenses" or "plus diopters," these magnifying devices simply screw onto the front of the camera lens. In effect, they shorten the focal length of the lens, and thus increase the image size on the film. Usually sold in sets of three and labeled as +1, +2, and +3 (or sometimes, +1, +2, +4), they can be used singly or in combination. See **Figure 14-11.** Magnifications made possible through the use of the closeup diopters are not dramatic: stacking the +1, +2, and +3 diopters on a 50mm lens will achieve a reproduction ratio of about 1:2; using the same combination on a longer lens (100mm, for example) will approach 1:1. The drawback to using these simple single-element lenses

Figure 14-11. *Closeup diopters are simple magnifying lenses that mount on the front of a regular lens. They are usually sold in sets of three, which can be used singly or in combination.*

is *degraded optical quality*. Sharpness of the image decreases dramatically when two or more diopters are stacked, and as magnification is increased by using longer lenses. Better results can be obtained by using the optically superior *two-element diopters* made by several camera manufacturers. The two-element lenses are corrected for chromatic and spherical aberrations to provide much sharper images. They can be used with any brand of lens with the appropriate filter size.

- **Extension tubes.** Much higher magnifications can be achieved by moving the lens farther away from the film plane. This is merely an extreme application of what happens in normal focusing of a lens: as you rotate the lens barrel (focusing ring), the optical elements physically move farther away or closer to the film plane. By moving the elements farther from the film (focusing closer), you are magnifying the image. Normal lens focusing may produce a movement, or lens extension, of 6mm or 7mm, but extension tubes can provide many times that. Unlike the closeup lenses that put additional optical elements in the light path, the tubes add only distance. Extension tubes come in various lengths, and are sometimes sold in sets, **Figure 14-12.** Different-length tubes can be coupled together to achieve the desired extension. To determine the extension needed for a desired magnification, multiply the focal length of the lens by the magnification. With the lens focused at infinity, adding an amount of extension equal to the focal length will produce a 1:1 reproduction ratio. Thus, to achieve a 3:1 ratio (3× magnification, or three times life-size) with a 50mm lens, couple together tubes for a total extension of 150mm, or about 6″. With short-focus lenses, *working distance* can be a problem when extension tubes are used — the lens-to-subject distance may be 1″ or less, blocking the

Figure 14-12. *Extension tubes move the lens farther from the film plane to increase magnification. Unlike closeup diopters, extension tubes do not degrade the image. (Porter's Camera Store)*

light. With long-focus lenses, a large amount of extension can cause vibration problems that destroy sharpness.

- **Bellows.** In effect, the bellows is a variable-length extension tube, with the camera attached to one end and a lens to the other. A gear and pinion arrangement allows the bellows to be extended or collapsed to achieve the desired extension. For proper balance and minimum vibration, the bellows unit (rather than the camera body) is mounted on the tripod head, **Figure 14-13.** A scale on

Figure 14-13. *A bellows unit is a valuable accessory for closeup work, but is better suited to studio use than field photography.*

the bed of the unit allows direct reading of the amount of extension. Due to its bulk and the fragility of the bellows, this device is more commonly used in studio work than in field photography.

- **Reversed lens.** One of the most effective methods of gaining higher magnifications is to mount a wide-angle or normal lens *backwards*, using an accessory called a *reversing ring.* This device has filter-mounting threads on one side, and a lens mount on the other. The reversed lens is attached to the adapter using the filter threads, and the lens mount is attached to the camera body, extension tubes, or a bellows. See **Figure 14-14.** The advantages of reverse-mounting are 1× or higher magnification (depending upon whether extension is used), better

Figure 14-14. *High magnification and better working distance are two benefits of mounting a lens in the reversed position. A reversing ring or a coupling ring can be used, depending upon the application.*

optical performance, and increased working distance. A similar technique involves use of a *coupling ring* to join the reversed lens to the front of a telephoto lens that is mounted on the camera. The coupling ring has filter threads on both sides, allowing the two lenses to be brought together. Magnification is found by dividing the focal length of the reversed lens into the focal length of the telephoto. A 28mm lens attached to a 300mm telephoto lens would provide a magnification of almost 11×.

Exposure and other problems

When a bellows, extension tubes, or coupled lenses are used for closeup work, the distance that light rays must travel from the lens to the film is increased. This means that less light will reach the film surface due to light falloff, making an exposure increase necessary. If you are using a modern camera with a built-in through-the-lens (TTL) meter, no compensation is needed — the meter reading will automatically adjust for the decreased light level. If your camera does not have a TTL meter, a corrected exposure must be calculated. Since this calculation is normally required for large format cameras that use a bellows for lens extension, it is referred to as the *bellows factor.* To determine the bellows factor, two figures are needed: the focal length of the lens and the total amount of extension (extension plus the focal length). Each figure is squared (multiplied by itself), then the total extension figure is divided by the focal length figure. The result is a factor by which the exposure is multiplied. For example, assume you have a 100mm lens. Adding 150mm of extension produces a total extension (with the lens focused at infinity) of 250mm. See **Figure 14-15.**

Square the focal length: $100 \times 100 = 10,000$

Square the total extension: $250 \times 250 = 62,500$

Divide: $62,500 \div 10,000 = 6.25$

Exposure (bellows) factor: 6.25

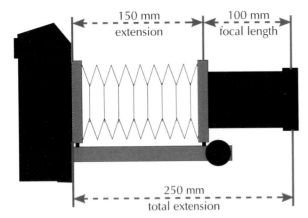

Figure 14-15. *To calculate bellows factor, you must know the focal length of the lens and the total amount of extension (including the lens's focal length). The bellows factor is used to adjust exposure for the light falloff resulting from the greater distance the light rays must travel to reach the film. Cameras with through-the-lens metering automatically compensate for this, eliminating the need for calculating bellows factor.*

Next, calculate exposure time. Assume your metered exposure for the subject (without compensation for extension) is 1/2 second at f/11. To calculate the correct exposure, multiply exposure time (converted to a decimal value, 0.5) by the bellows factor (6.25):

$$0.5 \times 6.25 = 3.125, \text{ or } 3\ 1/8 \text{ seconds}$$

Compensation for lens extension is usually done by adjusting exposure time, rather than aperture. Aside from the difficulty of determining the correct increase in aperture, "opening up" to change exposure would seriously decrease depth of field.

Depth of field

As you increase magnification, the portion of the subject that is in acceptably sharp focus at a given f-stop decreases. The *depth of field* — the distance in front of and behind the plane of focus that appears to be sharp — can shrink to a fraction of an inch or a few millimeters. For example, when photographing an object at one-half life size (0.5×), the distance from nearest to farthest sharp focus at f/8 is 3.2mm or approximately 1/4". When magnification is increased to twice life-size (2×), the depth of field at f/8 shrinks to 0.4mm or 16/1000". To increase the depth of field when doing closeup photography, you use the same solution you would in normal photographic situations: stopping down. By using smaller apertures such as f/16, f/22, or f/32 (depending upon your lens), you will obtain the greatest depth of field possible under the circumstances.

To obtain full advantage from the available depth of field, the camera should be aligned so that the film plane is parallel to the subject areas that must be in focus. An example would be two blossoms on a plant that you wish to have in equally sharp focus. If one blossom is 1/2" closer to the lens than the other, and your depth of field is only 1/2", focusing on either blossom (or midway between the two) would not be satisfactory — one or both blossoms wouldn't be sharp. The solution is to shift the camera angle, if possible, so that the two blossoms are approximately the same distance from the lens. Depth of field can then be used to keep the two equally sharp. See **Figure 14-16.**

One problem that can occur when using very small f-stops is some loss of sharpness due to *diffraction* (the bending of light rays around the edge of a very small opening). For this reason, the smallest aperture usually available on normal or long focal length lenses is f/22 or f/16. While results from individual lenses will vary in terms of sharpness, most closeup photographers consider the increased depth of field at f/16 or f/22 to be more important than a slight loss of sharpness due to diffraction.

When working with a depth of field measured in units as small as tenths of a millimeter or thousandths of a inch, critical focusing and elimination of all camera movement is essential. The basic requirement is a sturdy tripod or similar camera support. Using a cable release to operate the shutter and locking up the mirror (if the camera design permits) will help eliminate camera movement from vibration. Manual

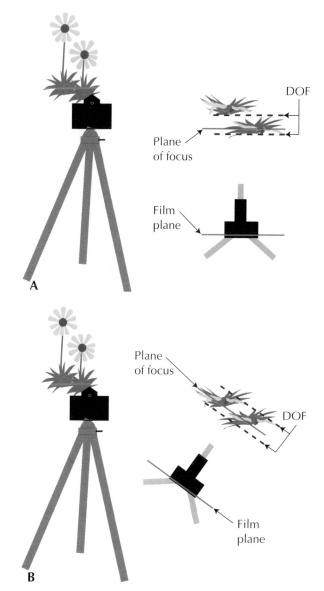

Figure 14-17. *A focusing rail is a very useful tool in closeup photography. It uses a gearing arrangement to allow camera movement in fine increments for precise focusing. Once focus is established, the carriage can be locked in place. Some focusing rails are available to permit side-to-side adjustment as well as forward-and-back movement. (Porter's Camera Store)*

Figure 14-16. *Aligning the film plane so it is parallel with the subject allows most effective use of depth of field. A—Film plane isn't parallel with the two blossoms, and depth of field isn't great enough to keep both sharp. B—Camera position has been changed so the two blossoms are at equal distances from the film plane. Depth of field is now sufficient to allow sharp focus on both blossoms.*

focusing is almost always necessary to get the desired fineness of focus in higher-magnification closeup photography.

A *focusing rail*, **Figure 14-17,** permits the camera to be moved toward or away from the subject in tiny increments to achieve precise focus. The base of the rail unit mounts to the tripod, while the camera is attached to the movable top slide. Movement is done with a fine-toothed rack-and-pinion gearing arrangement that can be locked into position after focus is set. Some focusing rail models have a second geared slide arranged at 90° to the first, permitting side-to-side adjustment. Although they are considered cumbersome for use in the field, better-quality bellows units incorporate a focusing rail.

If you are using lower magnification under conditions that permit hand-holding, a different technique can be employed. For example, if you are photographing flowers or insects at a 0.25× (1:4) magnification and using flash or bright sunlight as illumination, your depth of field at f/16 would be just over 3/4". The technique used in this situation by many nature photographers is to focus on the desired area of the subject, then use small body movements to "fine tune" the placement of the plane of focus, **Figure 14-18.** In cases where you must select

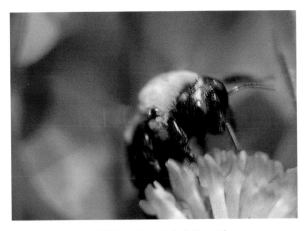

Figure 14-18. *When hand-holding the camera for lower-magnification photographs, such as this bumblebee taken at a 0.75×, the depth of field is sufficient to shift the plane of focus using body movement. Leaning slightly toward or away from the subject allows the area of acceptable sharpness to be moved forward or back.*

a shutter speed too low for normal hand-holding (such as 1/15 second), this same technique can be used with a monopod, beanbag, or other support that permits small-scale movements.

Working distance

Working distance is the amount of space between the front of the lens and the subject. A working distance that is too short affects closeup photographers in two areas: lighting and subject response. When the front of the lens is very close to the subject, it can block natural light and place the subject in shadow. Such short working room may also make it virtually impossible to place artificial light on the subject. Animals and insects have a "comfort zone" — moving closer than the invisible border of that zone will cause them to flee (or in rare cases, attack the intruder).

The key to working distance is the *focal length* of the lens: the longer the focal length, the farther you can be from the subject while retaining the same magnification. As shown in **Figure 14-19,** the distances are proportional. If you fill the frame with your subject using a 50mm lens at a lens-to-subject

distance of 6″, switching to a 100mm lens will allow you to double that distance to 12″ while keeping the same image size. A 200mm lens would increase the working distance to 24″; a 400mm lens, to 48″. If the image size is kept the same, and the same f-stop is used, there will be no change in depth of field when increasing focal length to gain working distance. If the same working distance is retained, but a longer focal length lens is substituted to increase image size, the depth of field will change in inverse proportion (doubling the focal length will reduce the depth of field by one-half).

A *tele-extender* can be used to increase working distance even more, although it requires an exposure increase. Adding a 2× extender to the 400mm lens in the preceding example would increase working distance to 96″ with the same image size. If the same 48″ working distance was retained, adding the tele-extender would double the size of the subject on film. In either case, the use of the tele-extender will make it necessary to open up two stops (or — to retain depth of field — use a shutter speed two steps slower).

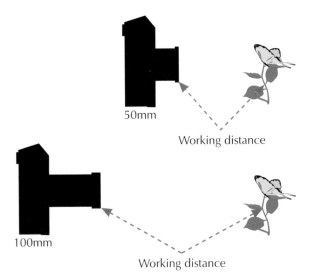

Figure 14-19. *Using a lens with a longer focal length permits you to gain working distance while keeping the subject image the same size. As shown, doubling the focal length of the lens permits doubling of the lens-to-subject distance.*

Lighting

Increased working distance makes it easier to light the subject for proper exposure. In some situations, natural light will be sufficient, although it may be necessary to redirect it with reflectors or diffuse it for more even distribution. More commonly, especially as magnifications increase or subject movement becomes a factor, electronic flash must be used. There are two types of flash generally used for closeup work, the ring flash and the self-contained unit normally mounted on a camera's hot shoe. The built-in flash found on point-and-shoot and some SLR cameras is not suitable for closeup work.

The ring flash, which surrounds the camera lens, provides a flat, shadowless, omnidirectional light that makes it most suitable for medical, dental, and various types of "record shot" closeup photography. Since the shadowless light from the ring flash provides no modeling to indicate depth, and is not like any natural lighting condition, this light source has found little favor among photographers who shoot nature subjects.

Closeup work with natural subjects shot in the field is usually done with small self-contained flash units that can be adjusted to provide light of the desired intensity and direction. Although they are designed for mounting on a camera's hot shoe, these flashes are more normally placed on an adjustable bracket for proper positioning. Some photographers prefer to use a single flash, positioned several inches above and just behind the front of the lens; others employ two flashes mounted on adjustable arms positioned several inches to either side and just above the level of the lens. One flash serves as the main light; the other as the fill light. See **Figure 14-20.**

The use of flash illumination allows hand-holding of the camera when photographing small animals or insects. The mobility of the subjects, and the photographer's need to quickly change positions

Figure 14-20. *The adjustable double flash bracket is a design favored by butterfly and insect photographers. It allows the use of traditional main-light/fill-light illumination. (Stroboframe)*

for the best composition, make hand-holding a virtual necessity. While a tripod is desirable in many closeup situations, it is far too slow and cumbersome for capturing active insects or small animals. The use of flash allows the photographer to "freeze" the subject as well as achieve a good exposure.

Motion of a different sort is a problem for those who concentrate on photographing flowers and other plants. Wind is usually a factor in this type of closeup work: even on a generally still day, a tiny gust can set the subject into motion at the most inopportune moment, **Figure 14-21.** While some flower photography uses motion blur to good effect, closeups are usually expected to be tack-sharp. The use of a flash can stop motion, just as it does with insect and small-animal subjects. Flash is most often used in lower-light situations, such as a heavily overcast day or flowers temporarily in deep shade.

Wildflower and plant photographers usually prefer to use natural light (sometimes with a reflector for "fill"). If the light level is sufficiently high, faster shutter speeds such as 1/250 second or 1/500 second can stop the subject's movement. With conditions requiring lower shutter speeds, two strategies are possible: waiting for a lull or blocking the breeze. Wind seldom blows steadily for more than a few seconds; it becomes stronger or weaker and sometimes stops entirely. By carefully

Figure 14-21. *Unpredictable gusts of wind can move flowers and plants. A—Motion blur caused by wind is a problem at slower shutter speeds. B—Waiting for a lull in the breeze will allow you to capture a sharp image.*

focusing a tripod-mounted camera and waiting patiently, the photographer can make an exposure during a lull when the subject briefly remains still. A more efficient method is to erect a windbreak that creates a zone of stillness around the subject. If an assistant is available, he or she can hold a sheet of posterboard or similar material upwind of the subject and just outside camera range. If you are working alone, a windbreak often can be improvised from a collapsible reflector, plastic sheeting, a trash bag ... even a jacket or other article of clothing.

When photographing animals or plants, be sure to behave in an environmentally responsible manner:

- Step, kneel, or lie down carefully when composing your shot — don't damage other plants while you are capturing your image.
- Don't "garden" by uprooting, pruning, or breaking plants to improve your field

of view. If necessary, use string to tie back intruding foliage or hold it out of camera range with your free hand while releasing the shutter.

- Avoid stressing animals — especially nesting birds — by approaching too closely or by making sudden movements or loud noises. Be careful to avoid attracting the attention of possible predators to a nest location.
- Don't leave behind evidence of your visit. Return a site, as nearly as possible, to the state in which you found it. Remove all your debris (film boxes, etc.) and as much as you can of the litter other individuals carelessly left behind.

Intentional double exposure

Unintentional double exposures were once a common occurrence — many a family album contains a snapshot in which Aunt

Harriet seems to be peering through the curtain of water at Niagara Falls, or a similar improbable composition. Before the introduction of mechanisms that both advanced the film and cocked the shutter for the next exposure, the two camera functions were separate. If the photographer forgot to advance to the next frame (by turning a knob or crank) after making an exposure, it was an easy matter to cock the shutter and make a second exposure on the same frame, **Figure 14-22.** The same effect could result from a different situation: removing a partly exposed roll of film from a camera

Figure 14-22. *Although unintentional double exposures sometimes provide interesting results, they more often ruin the two pictures that were accidentally combined. This photo is an unplanned combination of two scenes of children skating on a neighborhood pond: one vertical and one horizontal.*

(for example, to change film types), then later reinserting the partial roll and forgetting that some frames were already exposed.

Most of today's cameras, especially the SLRs, make it virtually impossible to double-expose a frame by mistake ... and often, difficult to do so intentionally! If you wish to intentionally make two or more exposures on one frame for artistic reasons, you will find that the difficulty of doing so depends on the camera model you are using. Some models have an electronic or mechanical feature that permits the shutter to be recocked without advancing the film. Many older cameras with mechanical film advance lock the shutter release until the advance lever is operated. To make a double exposure with such cameras, the common method is to take up any film slack with the rewind crank, then press the rewind release button (usually on the bottom of the camera). This permits you to operate the film advance lever and recock the shutter without actually advancing the film.

Planning the photo

To create an effective intentional double (or triple, quadruple, etc.) exposure, you need to plan for both the composition and the exposure. Multiple-exposure photographs may contain separate images or overlapping images; a different technique is used for each type.

To plan a photo where the images do not overlap, such as **Figure 14-23,** the first step is to identify the individual elements and their relative sizes and positions within the frame. Some photographers actually make a rough sketch to be used as a guide, while others just visualize the completed picture. Since the images will be made with a dark background and will not be overlapping, each can be normally metered and exposed. Often, all images will be given optimum exposure, but sometimes, one or more of them may be deliberately underexposed. The underexposed images will help to emphasize the importance of the image or images that are normally exposed.

Figure 14-23. *Making a multiple-exposure photo in which the images are not overlapped generally requires no exposure adjustment. The subjects are individually metered for proper exposure, and usually are shot against a dark background for uniform appearance. This approach allows size relationships to be changed, as shown here by the flowers and the watering can.*

A photo in which images overlap may be as simple as a ghostly figure appearing in a scene, or a montage of several layered images. Because the images overlap, some areas of the frame will receive more exposure than others, and could become seriously overexposed. Careful planning is needed to produce an effective and attractive multiple-exposure photo.

The rule of thumb for such photographic situations is that the proper exposure for the scene should be divided by the number of images that will be placed on the frame. In other words, if there will be four images, each should be given one-fourth the

exposure that would be needed for a single-image photograph. Begin by metering the subject that will occupy the largest portion of the frame, just as if it were the only image you were going to photograph. Assume that your meter reading is 1/60 second at f/8. If you are planning to use a total of two images, the proper exposure for *each* image should be one-half that reading. You would thus expose each of the images at 1/60 second at f/11. Since you are stopping down by one stop for each image, the total exposure will add up to 1/60 second at f/8. Calculating exposure for two images is relatively easy, but larger numbers of images become more complicated to figure. **Figure 14-24** is a table that will allow you to directly read the exposure decrease in f-stops needed for each image when combining various numbers of exposures in one frame.

A similar and somewhat simpler method can be used if your camera allows setting of an ISO rating for the film (rather than the automatic setting done by reading the DX coding on the cassette). You merely multiply the ISO rating of the film (for example, ISO 64) by the number of images to

Exposure Adjustment for Multiple Images

Total # of Images	# of Stops Decrease
2	1
3	1 1/2
4	2
6	2 1/2
8	3
12	3 1/2
16	4

Figure 14-24. *When combining multiple overlapping images, exposure must be decreased for each individual image to provide total proper exposure. To use this table, first establish the proper exposure for a single image (usually the image that will be largest in the final frame). Then, find in the left column the total number of images that will be combined in the frame. In the same row of the right column is the number of f-stops by which you must decrease exposure for each image.*

be combined. If you were planning a four-image multiple exposure, your new ISO setting would be 256 (64 × 4 = 256). The nearest ISO rating to 256 is 250 (1/3 stop faster than ISO 200).With the film speed reset to ISO 250, you can meter each image normally and expose it based on the meter reading. The exposures for the images in **Figure 14-25** were determined by this method. To return to single-exposure photography, remember to reset the film speed to the original value.

With either of these methods, the relative intensity of the different images will vary, even though the same exposure is used. The variation is caused by such factors as lightness or darkness of the individual subject, the background used, and the amount of overlap with other images in the frame. When making multiple exposure photos in color, still another variable is introduced: the creation of new shades and colors as images of different colors overlap. Experimenting and taking careful notes should help you determine some general procedures for your equipment, materials, and subject matter. You may then wish to try exposure variations to make some images more transparent (by underexposure) or more substantial (by overexposure). Zooming, panning, and the use of various types of special effects filters allow even more creative variations. All of the effects possible by multiple exposure, as well as other effects, can be created with a computer and image-editing software using a technique called *compositing*. This technique will be discussed in Chapter 16.

Copying techniques

Sometimes, one print or one slide is not enough. You may have misplaced a negative and need prints of a photo to send to several people, or you might need to convert a print to a slide for an audiovisual presentation, or you require a duplicate slide to submit to a contest or for publication. *Copying* make it possible to produce the necessary duplicates.

Flatwork

The traditional method of copying photographic prints, documents, and similar two-dimensional items (called *flatwork*) is to use a copystand, **Figure 14-26.** The *copystand* consists of a vertical column with an adjustable mount for the camera, a flat stage upon which the print or other item is placed, and usually, two arms holding lighting units.

To use the copystand, a camera is attached to the column mount, which is designed to hold it parallel to copy stage. Ideally, the camera will be equipped with a "flat field" lens that will eliminate distortion or softness of focus at the edges. For occasional copying, a normal camera lens is

Figure 14-25. *The film-speed method was used to determine exposures for this three-image multiple exposure photo. The film used was rated at ISO 100, so the camera's film speed control was set to ISO 320 (100 × 3). The individual images were then metered to determine correct exposure.*

Figure 14-26. *A copystand is a convenient tool for duplicating photographic prints or other documents, especially when a number of originals must be copied. This unit can be used with still or video cameras. Although a tripod and a pair of light sources can also be used for copying work, a dedicated copystand is more convenient and efficient for volume work.*
(IFF Repro-System/Bogen Photo Corp.)

usually sufficient. The item to be copied is centered on the stage and secured in place. Some stands use clamps, pins, or magnetic strips to hold the item flat; others depend on a clean sheet of glass laid over the print. Large professional units use a vacuum easel. The lights, typically arranged at a 45° vertical angle to the stage to provide even illumination and eliminate reflections, are turned on and the camera position is adjusted for size and focus. Exposure settings are made, and the shutter is tripped with a cable release or timer to eliminate vibration (if the camera has a mirror lockup feature, it should be used for the same reason).

If a copystand is not available, or if the original is too large for the copystand, a tripod and a pair of floodlights can be used. The original is fastened to a wall and evenly lighted, then copied with the tripod-mounted camera. A tripod with a reversible center column can be used as a form of copystand with originals placed on the floor. The tripod legs may interfere with light placement, however, and most photographers find the reversed-column arrangement awkward to use.

Film used for copy work depends on the type of subject matter. For black-and-white photographs, an ISO 100 film is typically used to retain the quality and tonal range of the original. Documents, such as letters, certificates, or drawings, can be copied with the same film, although some photographers prefer a slow-speed (ISO 50) film such as Kodak's Technical Pan, which produces a virtually grainless result. With black-and-white films, color filters can be used to eliminate stains or such problems as the overall yellowing of old photographs and paper documents. A yellow filter will lighten the yellowed appearance of an old photo, for example, while a red filter can "bring up" faded blue ink on a handwritten document.

If black-and-white originals are being copied with color transparency film to make slides for projection, the color temperature of the lighting is critical. If tungsten photoflood lamps are being used as a light source, a tungsten-balanced slide film should be used or a cooling filter (80A or 80B) placed over the lens to reproduce the material as black-and-white. If daylight balanced film is used, the slides will have a warm yellowish "sepia" appearance (which may be desirable if copying historical photos). Similarly, if electronic-flash units are providing the light, use a daylight-balanced film or an 85B warming filter with tungsten-balanced film to avoid a blue cast.

Color prints can be copied in the same way, using an ISO 100 color print film. Today, however, it is often easier (especially for only one or two prints) to use the photo

copying and enlarging kiosks found in most stores where film processing is done. These units, **Figure 14-27**, can accept prints, slides, negatives, and even digital files on disk and turn out copies or enlargements in a matter of minutes. The devices can produce sheets with multiple copies in various sizes, and even permit the user to perform limited manipulation (such as color or contrast adjustment) of the photo before the copy is made.

Slide duping

Photographers who enter competitions or who submit images for publication are understandably reluctant to send out their original slides, which could become damaged or lost. Instead, they send high-quality duplicate slides (typically referred to as *dupes*). The easiest but most costly method of obtaining quality duplicate slides is to have them made at a professional laboratory.

Many photographers, however, prefer the greater control and flexibility of making their own dupes. They not only retain physical control of the originals, but also are able to make desired adjustments such as color correction and cropping. Several types of slide-duplicating devices are available; most are in the form of a tube that attaches to the camera in place of the lens. At one end of the tube is a closeup lens; at the other, a slide holder covered with a light diffuser. See **Figure 14-28.** An electronic flash, photoflood, or even natural light can be used to provide the necessary illumination. Straight 1:1 copying of the slide is the only option with the least expensive models; better units permit cropping and enlarging portions of the image. Some degree of color correction is possible with filters.

The choice of film for making duplicates is limited by the fact that slides usually gain contrast when being copied. For this reason,

Figure 14-27. *Introduced in the late 1990s, free-standing kiosks at many photofinishing locations allow quick and relatively inexpensive copying and enlargement of photos. The machines typically accept originals in print, negative, slide, or digital form. (Eastman Kodak Company)*

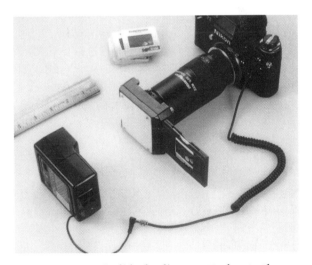

Figure 14-28. *A slide duplicator attaches to the camera in place of the lens and can be used to make an exact copy of the original slide. Some duplicators permit cropping and enlarging; others make straight same-size copies. (Porter's Camera Store)*

special low-contrast slide duplicating films are normally used. These films are supplied with thorough directions for using filters to adjust color balance, so that the dupes closely match the originals.

When only a few duplicates are to be made, especially if the originals are somewhat low in contrast, a conventional slow-speed (ISO 50 or less) slide film can often be used. Bracketing of exposures should produce acceptable results. If a somewhat lower-quality duplicate is acceptable for a given application, and a slide duplicator is not available, a projected image can be copied. If the slide projector and the camera are carefully aligned to prevent distortion, the slide can be projected on a piece of white posterboard or similar matte surface and photographed with a slow-speed slide film. The resulting duplicate's quality will not approach that of a dupe made by other methods, however.

Darkroom manipulation

In the darkroom, the possibilities for creative exploration are almost endless. Within the limited scope of this book, only a few of the more common techniques can be touched upon. Specialty books on darkroom work, combined with experimentation, will help you progress well beyond this introductory section.

Multiple image printing

Like multiple-exposure photography, *multiple-image printing* is a way of combining two or more subjects to create a new photograph. The multiple-image printer has greater flexibility in achieving a final image, however, since the multiple-exposure photograph has its elements fixed and essentially unchangeable once developed. The multiple-image printer can try many variations, making a variety of quick "test prints" to progressively refine the design.

Some multiple-image prints will have images that are totally separated from each other on a dark background; others will overlap to a slight degree, usually on a light background. Still others will overlap to a significant degree and may exhibit very complex layering effects.

The technique for creating separate images and slightly overlapped images is similar in many respects. The first negative is placed in the enlarger, sized and positioned as desired, and then focused. A test is made to determine correct exposure. The paper to be used for the final print is placed on the easel, and the first image is exposed. After the top edge is marked on the back of the print for correct orientation later, the exposed sheet is stored in a light-tight box.

A sheet of plain white paper is then placed in the easel and the first negative is projected onto it. The outlines of the image are traced on the paper for use in positioning subsequent images. For prints in which the images will be separate, this tracing can also be used to make a mask for subsequent printing.

The second negative is placed in the enlarger and the image projected on the easel containing the traced outline. Adjustments of size, position, and focus are made for the second negative, then that image is traced onto the paper, **Figure 14-29.** The tracing is removed from the easel and a sheet of photographic paper put in place. A test print is now made to determine proper exposure for the second image.

For printing of the second image, the technique used will depend upon the final appearance desired for the multiple print. If the images are to be separate, the tracing should be used to create a mask used to "block out" the first image. The previously exposed and stored sheet of photo paper is placed in the easel with the top edge oriented properly, and the mask aligned with the paper. As the second image is being exposed onto the paper, the mask is moved up and down very slightly to "feather" the junction of the first image and the dark background. A similar masking procedure

Figure 14-29. *Tracing the image of a projected negative onto plain white paper will record the relative positions of the final image's components. For nonoverlapping images, the traced outlines can be used to create the necessary masks.*

can be used, with careful planning, to print a number of separate images on one piece of photo paper.

If the images are to partly overlap, the tracing can be used as a basis for creating a reduced-sized opening, approximately the shape of the second image, in a large opaque card. This opening can be used in the same way as a "burning-in card" is employed. The image is projected through the hole in the card onto the paper, while the card is kept in limited up-and-down or horizontal motion to blend the image edges with the background. This technique works best if the first image printed includes a large blank area (such as an essentially cloudless sky), so that the second image will only partly overlap the first. In this case, the background is usually white or at least, a light gray (although some interesting effects can be achieved when overprinting areas of distinct clouds, **Figure 14-30**).

Several overlapping images sometimes can be printed in a single exposure by sandwiching the negatives in the carrier of the enlarger. The exposure for the combined negatives is determined with the normal test methods, and a print is exposed. If additional individual images (or combined images from sandwiched negatives) are to be printed, the exposed paper should be stored in a light-tight box and a tracing made on typing paper to aid in positioning of the subsequent images. The varied densities of the negatives used will result in an interesting mosaic of overexposed, underexposed, and normally exposed areas in the final print. See **Figure 14-31**.

Figure 14-30. *Although printing of a partly overlapped image is usually done on a plain or muted background, printing onto an area of strong pattern or tone like these clouds can create interesting multiple-image effects. Experimentation is necessary to achieve the right combination of images and the right exposure relationship.*

Figure 14-31. *Printing multiple overlapping images from individual or sandwiched negatives can result in interesting layered effects. A wide range of exposures will be recorded in the overlapping and nonoverlapping components due to their varied densities.*

Sabattier prints

It is possible to produce a print that displays a partial reversal of tones, producing effects that can be very dramatic. The **Sabattier effect**, named for a French photographer who first produced such prints in the 1860s, occurs when a print is briefly exposed to light part way through the developing process. An example of a print exhibiting the Sabattier effect, along with a conventional print from the same negative, is shown in **Figure 14-32.** The degree of tone reversal will vary for prints made from different negatives, or even for prints made from the same negatives but reexposed or developed differently.

Typically, the re-exposure of the print is done with a somewhat dim (for example, 25 W) bulb for a second or two about halfway through the development process. The bulb should be positioned 12″–18″ above the developer tray. Before turning on the bulb, agitation should cease and the developer/ paper movement allowed to stop. Experimentation should be done with varying re-exposure times, distances of the bulb above the tray, and the proportion of development time before and after the re-exposure.

The term *solarization* is often used incorrectly as a synonym for the Sabattier effect. **Solarization** is actually a result of extreme overexposure that causes a reversal of tones. A very bright object, such as the sun, can actually appear black in the print. In such extreme overexposure, the negative density increases to its maximum, and then actually decreases until the affected area is almost transparent. Ansel Adams deliberately produced such an effect in his 1939 photograph *The Black Sun*, made in California's Owens Valley. In the photo, the sun is a black disc surrounded by a bright corona, while the rest of the scene — trees, grass, and a small stream — appear slightly dark but otherwise have normal tonal relationships to each other. Even the reflection of the sun in the water exhibits a normal appearance.

High-contrast effects

Carrying contrast to an extreme, by virtually eliminating shades of gray in a print, can produce strikingly dramatic images. One popular high-contrast effect is *exaggerated grain*, which can be achieved by using a high-speed film that is typically pushed several stops to obtain a grainy negative. The print is then made on high-contrast paper (Grade 5 or the equivalent filter with VC paper). Grain can be exaggerated still further by increasing magnification — printing from only a small area of the negative. See **Figure 14-33.**

A film intended for use with graphic arts line copy, such as Kodak's Kodalith™, is often used creatively for various types of

Figure 14-32. *The Sabattier effect. A—This print was normally exposed and developed. B—To display the partial tone reversal of the Sabattier effect, this print was exposed to light for about 1/2 second halfway through the development process. Note the thin bright lines (called Mackie lines) along some edges of the subject in the upper-left quarter of the print. These lines dramatically enhance the contours of the subject. The Sabattier effect is highly variable, offering opportunities for experimentation with light intensity, exposure length, and development times.*

high-contrast prints. When properly exposed and processed in lithographic film developer, this film will produce a negative that has only dense black and completely clear areas. "Lith film," as it is often called, can be purchased in roll or sheet form, allowing it to be used for copy work, projection printing, or contact printing. A normal print can be photographed on lith film to produce a high-contrast negative; a normal negative can be projection- or contact-printed onto lith film to make film positive. If desired, the positive can be contact-printed in turn to produce a high-contrast negative. Prints made from lith film negatives (or positives) have no middle tones or shades of gray, only the extremes of black and white.

Posterization uses lith film to create a print with several distinct, flat shades of tone, rather than the continuous gradation of tone found in a normal print. A three-tone posterization is the most common, involving three lith-film negatives or "separations." One negative is underexposed, one normally exposed, and the third overexposed. The underexposed piece of film will emphasize the shadows; the overexposed piece, the highlights. The normal exposure will capture both shadow and middle-tone values.

The negatives are projection-printed individually onto the paper to make the final

Figure 14-33. *The mood of this night scene at a carnival is reinforced by the high contrast and exaggerated grain. The negative was exposed on ISO 400 film and pushed two stops in development. Printing of a relatively small area of the negative further exaggerated the grain.*

print. To produce a sharp print that looks "right," the three negatives must print in proper alignment or ***registration.*** A system involving locating pins in the enlarger's negative holder is normally used. The exposure for each of the three negatives is determined so that it will print as middle gray. Since some areas of the print will be exposed through one negative, others through two, and still others through all three, the print will exhibit three distinct tones: gray, darker gray, and black.

Antique and experimental techniques

In recent years, there has been a revival of interest in various alternate photographic techniques. Some are old methods that were once quite popular and then faded away as newer techniques that were easier, faster, or provided better results were introduced.

Others are experimental approaches that provide a distinct "look" that cannot be produced by conventional photo methods.

Photograms

The earliest of all forms of photography, the ***photogram*** is a picture made without the use of a camera. Some of the earliest images obtained by exposing a light-sensitive material were recorded by two English experimenters in about 1800. Humphry Davy and Thomas Wedgwood placed leaves and other opaque objects atop a sheet of leather or paper that had been coated with a solution of silver nitrate. When exposed to sunlight, the areas not protected by the opaque objects darkened; the protected areas remained white. In effect, they created a "reverse silhouette" with a white subject on a dark background.

The images produced by Davy and Wedgwood were not permanent. Continued exposure to light caused the white areas to darken, since no method of "fixing" (chemically dissolving unexposed silver compounds to prevent them from darkening) was then available.

Today's photograms, usually made on black-and-white printing paper, are developed and fixed to make them permanent. The basic technique is to place a sheet of paper, emulsion side up, on the base of an enlarger, then arrange objects upon it. The arranging can be done by safelight to obtain the desired placement. A mix of opaque and translucent objects can produce an image with a variety of tones, as shown in **Figure 14-34.** Exposure can be done with a low-wattage desk lamp or the enlarger. Experimentation with exposure times will be necessary to establish a basic exposure, which then can be varied for different effects.

Photogram kits that do not require the use of photographic chemicals are sold at science education stores, museum shops, and similar outlets. These kits are based on the cyanotype process (described later in this

Figure 14-34. *Although the photogram image is basically white on black, some variation of tones is possible when translucent objects are included. Different degrees of translucency (light transmission) will produce different shades of gray.*

chapter), and produce white images on a blue background. Exposure requires sunlight or a similar strong source, while developing is done in plain tap water.

Pinhole photography

The principle of the pinhole as an image-forming method was discovered in ancient times. By the 1700s — a century before photography was invented — artists were using the *camera obscura* as an aid in sketching scenes. The camera obscura was, in effect, a pinhole camera as big as a small room. The image passing through the pinhole was projected upon a wall or surface to which the artist's paper was fastened. The artist was then able to make a pencil tracing of the image. Later versions were smaller and more portable, but used the same basic principle.

Teachers often use the experience of making and photographing with a pinhole camera as an introduction for beginning photo classes. Such cameras are often sized to use 4″ × 5″ or 8″ × 10″ photographic paper as the light-sensitive medium. The same cameras can use sheet film; other designs

(usually adaptations of conventional cameras) allow the use of 35mm or 120-size roll film. See **Figure 14-35.**

Exposure times for pinhole photos are often lengthy, especially when using very small pinhole apertures (f/180 or f/360 are not uncommon) and slower films. For example, with a pinhole 0.018″ (0.44mm) in diameter and a pinhole-to-film distance of 6″ (152mm), the effective aperture would be f/346. At the nearest whole f-stop of 360, exposure time for ISO 100 film would be 15 seconds.

A major characteristic of the pinhole image is infinite depth of field — everything in the photo, from near to far, is recorded with the same degree of sharpness, **Figure 14-36.** Unfortunately, the degree of sharpness is not as acute as that obtained with a lens. For very small apertures, diffraction can further degrade image sharpness. Pinhole photographers, however, consider the slight softness to be a distinctive characteristic of the medium.

Figure 14-35. *A conventional 35mm or medium format camera can be adapted for pinhole use by modifying a spare body cap. A hole approximately 1/4″ in diameter is drilled through the center of a plastic body cap. Heavy-duty aluminum foil or very thin sheet brass or aluminum is then carefully pierced with a needle to create the pinhole. The foil or metal sheet is then fastened to the body cap, with the pinhole centered over the larger drilled hole. Since long exposures are almost always necessary, the camera must be mounted on a tripod.*

Figure 14-36. *This image of a tabletop scene was taken using the pinhole arrangement shown in Figure 14-35. The overall softness of the image is due to the size of the manually produced pinhole. Extremely tiny pinholes made in thin brass stock with a laser are available commercially, and produce somewhat sharper images.*

Infrared photography

Infrared (literally, *below red*) wavelengths of light are in the 700 nm–900 nm portion of the electromagnetic spectrum, and are not visible to the human eye. They can, however, be recorded on film that has the proper sensitivity, producing unusual photographs. This makes it possible to photograph subjects in virtually total darkness. For example, Arthur Fellig, the 1930s New York press photographer known as "Weegee," used a virtually invisible infrared flash and infrared film to photograph people in movie theater audiences.

Today, the majority of general infrared photography is done outdoors, using sunlight as the light source. Although infrared film is available in both color and black-and-white emulsions, most nonprofessionals who process their own film use black-and-white. Color infrared film is most widely used for scientific and technical photography.

In a well-exposed and printed black-and-white infrared photograph, sunlit grass and tree leaves will appear as bright, ghostly white, **Figure 14-37,** while a clear blue sky will be portrayed as very dark in tone. This

shift in tonality of grass and leaves occurs because of the chlorophyll they contain. The green chlorophyll absorbs most of the visible light that strikes it, but reflects most of the infrared wavelengths. Thus, the leaves and grass blades are bright reflective objects and appear white. Blue skies go dark for a different reason: lack of infrared wavelengths. Since there is little "light" to expose the infrared film, sky areas are dark due to underexposure (clouds, however, are shown as bright white).

To obtain the desired recording of infrared wavelengths on black-and-white film, a filter must be used to absorb unwanted blue and violet wavelengths of light. The strongest infrared effects are obtained with the visually opaque Wratten 87, 87C, or 88A filters. These can only be used with a stationary subject and tripod-mounted camera, however, since focusing cannot be done with the filter in place. You must first focus, and then mount the filter over the lens. More practical is the red Wratten 25 filter — although it darkens the finder image considerably, focusing through the filter is still

Figure 14-37. *Grass and leaves reflect almost all the infrared wavelengths, so that they are recorded on film as strongly lighted objects — in black-and-white prints, they glow brilliant white, while objects that reflect infrared less strongly, or shaded grass and leaves, are darker. This photo was taken using a Wratten 25 (red) filter to help block blue and violet wavelengths of light.*

possible. Figure 14-37 was taken using a red filter. A further difficulty in focusing is the slight difference between the point of visible-light focus and the point of infrared focus. Some lenses indicate the infrared focus position with a red dot, **Figure 14-38.** On such lenses, the image is focused normally, then the barrel is rotated slightly to align the focused distance with the red dot. With lenses that are not marked for corrected focus, try to use an aperture that will provide as much depth of field as possible to compensate. When relying upon depth of field for infrared focus, adjust the point of focus so the nearest critical object is at its sharpest.

Because infrared film is sensitive to such a wide spectrum, it must be handled in complete darkness from the time its packaging is opened until it has been developed and fixed. It must be loaded into the camera in a darkroom, changing bag, or other light-tight setting. To avoid possible fogging due to defective light seals, a camera loaded with infrared film should be kept out of direct sunlight as much as practical. When all exposures have been made on the roll, the film should be rewound into the canister, but the canister should not be removed until the camera can be opened in total darkness. If

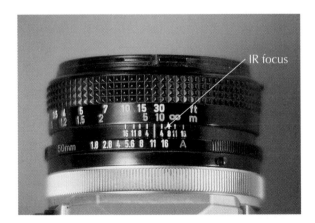

Figure 14-38. *Older manual-focus lenses often have a red dot marked on the barrel to provide corrected focusing for infrared film. The lens is focused normally, then rotated slightly more to align the focused distance with the red dot.*

the film will not be processed immediately, place the canister in an opaque plastic film can or seal it in an opaque black plastic bag.

Nonsilver processes

Not all photographic processes are based on the use of silver halides to produce a print. Some of the variant processes rely upon salts of metals other than silver (such as iron or platinum), while others are based upon colloidal materials that can be sensitized so they are hardened by exposure to light. *Nonsilver processes* provide the photographic printmaker with tremendous creative flexibility and can be pursued as a separate fine art specialty. The various processes will be described here in brief form as an introduction to this interesting area. For those interested in studying this area in greater depth, a number of books and specialty workshops are available.

Cyanotype process

The cyanotype was yet another discovery of Sir John Herschel, the English astronomer who had previously coined the term "photography" and discovered the method for "fixing" or making photographic images permanent. In 1842, Herschel found that a material sensitized by a solution containing an iron salt (today, ferric ammonium citrate is most commonly used) would darken when exposed to a strong light source. Placing opaque objects on the sensitized paper resulted in a *photogram,* with white images on the dark background. Contact printing from a photographic negative, however, provided a continuous tone print similar to a silver halide print, except the tones were blue instead of gray. See **Figure 14-39.**

The blue coloration on the **cyanotype** provided its name (from the Greek *cyanos,* for dark blue). Unlike the traditional negative-positive process, in which the latent silver image remains invisible until developed and fixed, the cyanotype is a *printing-out* process. As the exposure progresses, the image becomes visible on the paper. Printing is

Figure 14-39. *A contact print made from a photographic negative will produce a continuous-tone cyanotype print. Washing in water will "fix" the print and prevent darkening of unexposed areas.*

typically done using sunlight or an ultra-violet lamp and a contact-printing frame. The hinged back of the contact frame allows the print to be inspected periodically without moving the paper and negative out of register. Depending upon light intensity and the density of the negative, exposures usually can be measured in minutes. When the print has reached the desired intensity, it is removed from the frame and placed in a flowing water bath for several minutes. This washes out remaining unexposed salts to prevent later darkening on exposure to light. A brief soaking in a water bath to which a small amount of hydrogen peroxide has been added will help clear any remaining blue tint in highlight areas.

Because of the soaking steps following exposure, the substrate for a cyanotype must be carefully chosen. Watercolor paper, which retains its strength when wet, is commonly used; so are cotton and linen fabrics, **Figure 14-40.** Substrates are prepared for the cyanotype process by sizing with a brushed-on or sprayed-on starch. The sizing provides a smooth and less porous surface, so that the sensitizing solution will not sink in. Holding the sensitizing solution on the surface will provide a sharper and better-defined image. Sizing should not be applied to a cloth substrate (such as a tee shirt) that will be

washed repeatedly. The sizing would wash out, causing the image to be lost in whole or in part. Sensitizer allowed to soak into the fibers of the material will result in longer-lasting images in such situations.

The sensitizing material is made up as two stock solutions that are then combined immediately before being applied to the substrate. Solutions are available in kit form, or can be made up following formulas listed in photographic reference books. The sensitizer is applied to the substrate by brushing or soaking in a tray under subdued light (a darkroom safelight is acceptable). The material is then allowed to air-dry in a dark place; dried sensitized material should be stored in a light-tight box or bag. Sensitivity of the coating declines fairly quickly — the material should be exposed and processed within a day or two.

Van Dyke Brown process

Similar in printing and developing methods to the cyanotype, the *Van Dyke Brown process* produces prints with a rich brown color, **Figure 14-41.** This process is one of a number of alternative printing methods based upon the photosensitivity of certain iron compounds and their ability to

Figure 14-40. *Cyanotypes can be printed on fabric for textural interest or special effects. This turn-of-the-century summer scene was printed onto faded blue denim from two old glass-plate negatives. (Original images courtesy of the Kankakee County Historical Society)*

Figure 14-41. *The iron-based Van Dyke Brown process results in prints with a full tonal range rendered in shades of brown. This portrait of a young woman dates to the 1890s and was contact printed from a 4" × 5" glass-plate negative. (Original image courtesy of the Kankakee County Historical Society)*

reduce ions of silver to silver metal, thus forming an image. Among these processes are the very early *argentotype*, the later and more widely used *kallitype*, and a modern proprietary process called the *argyrotype*. Chemically similar methods are involved in making prints using compounds of the costly metals platinum and palladium. **Platinum prints**, in particular, are noted for a luminous quality obtainable with no other emulsion.

The sensitizing solution for Van Dyke Brown prints is available in kit form, or can be mixed from bulk chemicals. Various formulas can be found in books and on Internet sites devoted to alternative photographic processes. Most combine ferric ammonium citrate, tartaric acid, silver nitrate, and distilled water.

Warning: When working with photographic chemicals, follow proper chemical handling procedures and wear appropriate safety equipment, Figure 14-42. Silver nitrate, for example, is highly toxic.

Substrates for Van Dyke Brown prints are the same as those used for cyanotypes: watercolor papers or fabrics (cotton or linen) treated with starch sizing to control penetration of the sensitizer. See **Figure 14-43.** Sensitizer is applied with an inexpensive plastic-foam paintbrush or spread on the substrate with a glass rod (for a more even coating). Coating

Figure 14-42. *Appropriate personal protective gear is vital when working with chemicals. A plastic or rubber apron will prevent damage to clothing, while safety goggles or safety glasses with side shields will protect against chemical splashes. A full face shield also may be used. A dust mask (or respirator) will guard against inhaling chemical dusts. Rubber gloves should always be worn when working with chemicals that are considered toxic; many darkroom workers wear them whenever they work with chemicals.*

Figure 14-43. *A cloth substrate can make an interesting and unusual background for a cyanotype or Van Dyke Brown print. The negative of the World War I soldier was masked to eliminate the studio background, then printed by the Van Dyke Brown process on a small flag. The "period" feeling of the print is enhanced by fading of the flag's colors as a result of exposure to strong sunlight, the fixing chemicals, and a lengthy immersion in water. (Original image courtesy of the Kankakee County Historical Society)*

should be done in subdued light, and the paper or cloth hung up to dry in a dark room. The substrate must be thoroughly dry before printing, but should be exposed within one day after being sensitized. Light sensitivity of the material declines fairly rapidly, especially if humidity is high.

Contact prints from negatives are made in the same way as cyanotype prints. The negative and sensitized material are placed in a contact-printing frame and exposed to a light source (sun or lamp) that is strong in

ultraviolet wavelengths. A visible image — yellowish brown on a yellow background — is formed as exposure progresses. The lengthy exposures (up to 15 minutes in sunlight; 30 minutes under lamps) can be monitored by checking highlight areas for color. Since these are beneath the most dense portions of the negative, a printing frame that can be opened without disturbing register of the negative and paper is a necessity.

The print is developed for several minutes in running water. During this step, the brown color often will actually lighten somewhat as some of the sizing is dissolved by the washing action. To obtain the deep brown tones characteristic of this process, the print is next placed in a fixer (sodium thiosulfate) solution for 1 or 2 minutes. In addition to bringing out the full tonal range of the print, the fixer bath stabilizes the emulsion. Finally, the print is washed in running water for 10 minutes to remove residual fixer.

Gum bichromate process

This process is based on the same principle Niépce used in 1826 to capture the first permanent photographic image. That principle is the hardening of a sensitized colloid material when struck by light, forming an image that can be developed by dissolving away the material that was not exposed to light. Niépce used a type of asphaltic material that could be dissolved by a solvent called "oil of lavender." The *gum bichromate* process makes use of a mixture of potassium bichromate and gum arabic (a resin obtained from tropical trees), which can be dissolved by cold water.

A black or color pigment is typically added to the colloid to provide a visible image. The mixture is brushed onto the substrate, which must be a material able to withstand soaking in water. After the coating is dry, the print is made using the same contact method employed for cyanotypes and Van Dyke Brown prints. An exposure

time of 3–5 minutes is typical. The print is next placed in a cold water bath to dissolve the colloid material that was not hardened by exposure to light. A gentle spray of water can be used to speed the dissolving process. After washing, the print should be attached to a firm support to prevent curling as it dries.

Multiple-color prints can be made by repeating the process with colloid materials that have been tinted different colors, **Figure 14-44.** The print must be thoroughly dry before recoating, and a pin-register system may be necessary to align the images properly. Kits of materials for producing

Figure 14-44. *This multiple-color print was made using the Kwik-Print process, a commercially available version of the gum bichromate process. Careful masking and pin registration were necessary to position the image of the drought-struck vineyard in a "window" of the background map print. The map was printed in yellow and blue; the vineyard in red and yellow. Both were printed from film positives to create a final negative image for greater impact.*

gum bichromate prints are available commercially from several suppliers. Some kits include only black-tinted material for traditional black-and-white printing; others add red, yellow, and blue materials for multi-color printing.

Polaroid transfer

Very interesting prints ranging from single images that mimic watercolors to multiple image montages can be created by making transfers from exposed Polaroid films to substrates such as watercolor paper or fabric.

There are two different transfer processes in general use, image transfer and emulsion transfer. Both use Polaroid peel-apart (positive-negative) films such as Type 669, 559, 59, or 809 in sizes ranging from 3 1/4" × 4 1/4" to 8" × 10". Each process has its advantages and disadvantages: *Image transfer* is faster and involves fewer steps, but *emulsion transfer* provides a more finely detailed image, allows the image to be distorted or otherwise manipulated, and can be used with a wider range of substrates.

Exposing a sheet of Polaroid film for transfer by either process can be done in one of three ways:
- direct, "live" photography of a scene (or a print or other flatwork to be copied)
- slide copying, using a specialized unit that exposes 35mm slides onto Polaroid film.
- projection printing, using an enlarger to expose the film.

The use of a slide-copying unit is most common because of its convenience. See **Figure 14-45.** Some photographers prefer the spontaneity and immediacy of the live photography approach, although it is limiting when used with the image transfer method (in which the transfer must be made within 10–15 seconds of the start of development). It is more suited to emulsion transfer, which uses prints that have completely developed and dried.

Figure 14-45. *A dedicated slide-printing unit is the most common method of creating images for the image transfer or emulsion transfer processes. The unit accepts 35mm slides and projects them onto Polacolor film. Such units are particularly useful when doing image transfer work, since they can be set up on the same worktable used for preparing the substrate and making the transfers (Polaroid Corporation)*

Image transfer method

Although most commonly done with 3 1/4″ × 4 1/4″ or 4″ × 5″ film, this method is carried out by some photographers working with 8″ × 10″ materials. *Image transfer* is performed by peeling apart the negative and positive sheets of the Polacolor film within approximately 15 seconds of the time development begins. At that point in development, only a small portion of the image dyes have migrated to the positive; most remain in the negative.

The positive is set aside, and the negative is placed, dye-side down, on a previously prepared substrate (referred to as the *receptor*).

In this process, the receptor is usually a smooth-finish watercolor paper that has been soaked in water and squeegeed onto glass, a laminate countertop, or similar hard surface. A rubber roller (brayer) is then used to press the negative and damp receptor into close contact. Applying the proper amount of pressure when using the brayer will come with practice — too much will distort the image; too little will leave white spots where contact was insufficient.

After 2 minutes, the negative is carefully peeled away from the receptor. Usually, the best results are achieved by starting at one corner and pulling the material back diagonally. At times, some of the transferred material may lift away from the receptor. This can sometimes be dealt with by slightly reversing the peeling movement and burnishing down the lifted area through the negative. Some photographers consider irregularities caused by small areas lifting away to be a part of the distinctive "look" of this process. Repeating the transfer process several times with different images creates a montage, **Figure 14-46.** The completed transfer print should be allowed to air-dry thoroughly (gentle application of warm air from a hair dryer can speed the process). If the substrate has curled while drying, it can be flattened in a drymounting press.

Emulsion transfer method

In the *emulsion transfer* method, the fully-developed photo emulsion is separated from its backing and applied to a substrate. One of the major benefits of this method is a finished print that exhibits finer detail and more subtly rendered color than an image transfer print (which is made before development is fully completed). The emulsion transfer process allows the use of a wider variety of substrates, since the thin emulsion material will adhere to virtually any firm surface.

A Polacolor print that is to be used for an emulsion transfer must be fully developed and thoroughly dry (allow at least

Figure 14-46. *Image transfer was used to create this montage from four separate slides. The overlapped portions of the images indicate the order in which they were laid down. Partial lifting of the emulsion when the negative was peeled away left the irregularly shaped areas of cyan coloration.*

8 hours after development, or use a hair dryer to accelerate the process). To prevent the back coating of the print from dissolving, cover it with a sheet of self-adhesive vinyl paper. To free the emulsion from its backing, the print is placed face-up for 4 minutes in a tray of water heated to 160°F (71°C). The tray should be agitated to keep the print below the water's surface. At the end of the hot soaking time, the print is transferred to a tray filled with cold water.

The emulsion is loosened at one corner by pushing it toward the center, then carefully and slowly peeled away from the paper backing. The peeling should be done below the water's surface to help prevent tearing. The separated emulsion is reversed to float facedown, and the backing material is discarded. A sheet of Mylar® or clear acetate is slipped into the water and maneuvered

beneath the floating emulsion. The top corners of the emulsion are held to the acetate sheet with two fingers, and the acetate lifted in and out of the water until the emulsion lays smoothly. The holding and dipping process may be repeated three times, if necessary, with the acetate rotated 90° each time, to eliminate all wrinkles.

The emulsion is then applied to the substrate by inverting the acetate. Once the emulsion is positioned, the acetate sheet is carefully removed. The emulsion can be stretched or otherwise manipulated on the substrate, if desired, before it is burnished down. The burnishing is done with a soft rubber brayer, working from the center outward to remove air bubbles and excess water.

Questions for review

Please answer the following questions on a separate piece of paper. Do not write your answers in this book.

1. Explain what is meant by the statement, "In the early days of photography, there was no such thing as an 'action shot.'"
2. In action photography, the point at which motion slows almost to a stop is called the _____.
 a. decisive moment
 b sweet spot
 c. action key
 d. peak of action
3. When a reproduction ratio (such as 1:3) is given, the number *before* the colon represents the _____.
4. Today's macro lenses typically provide a magnification rate of _____.
 a. 2×
 b 1/2×
 c. 1×
 d. 4×
5. "Bellows factor" is used to determine a corrected _____ to compensate for lens extension.

6. In closeup photography, the amount of space between the front element of the lens and the subject is called _____.

7. Describe how to use film speed (ISO rating) to calculate exposure for a multiple-exposure photo in which exposures will overlap.

8. If a daylight-balanced color transparency film is used to copy black-and-white originals under tungsten lighting, a(n) _____ filter should be used to avoid reproducing the material as a warm, yellow cast.

9. A partial _____ of print tones is achieved by making use of the Sabattier effect.

10. "Lith film," when properly processed, will reproduce only _____ and _____ values.

11. A major characteristic of pinhole photography is _____ depth of field.
 a. infinite
 b shallow
 c. minimal
 d. very broad

12. Green plants appear bright white in prints on black-and-white infrared film. Why?

13. Which iron salt is commonly used today in the cyanotype process?

14. The hardening effect of light on certain sensitized colloids make possible the _____ photographic process.

15. Which of the two Polaroid transfer processes — image transfer or emulsion transfer — produces the greatest detail and most subtle colors?

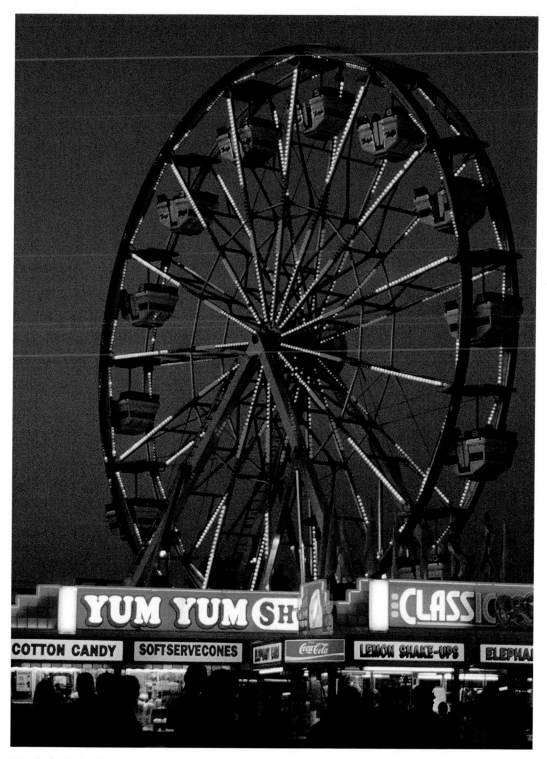

Brightly lighted structures such as this carnival Ferris Wheel stand out dramatically when photographed against the darkening sky just after sunset. Meter for the sky and bracket to provide a choice of exposures.

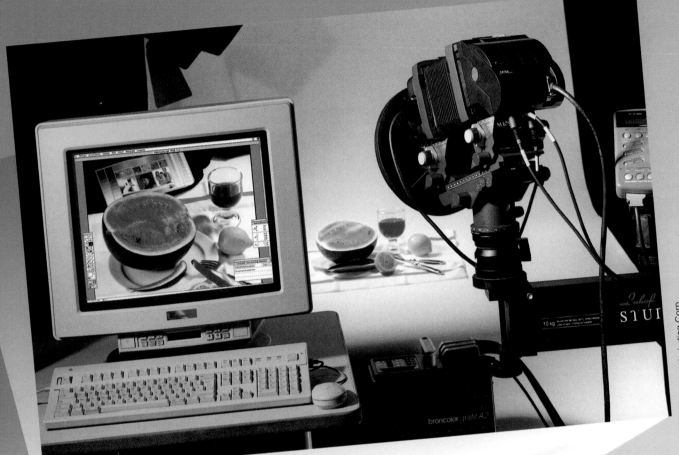

Digital back:
High-resolution capture device for studio use that attaches to a medium format or large format camera.

Chapter 15

Digital Image Capture

When you have finished reading this chapter, you will be able to:

➡ Describe the differences between the conventional chemical method of image capture and digital image capture.

➡ Explain the operation of a CCD array in capturing an image.

➡ Identify the major types of digital cameras.

➡ Discuss the major types of scanners and the advantages of each.

➡ Apply the basic techniques of digital image capture with a camera or scanner.

➡ Distinguish between the Photo CD and Picture CD formats.

On New Year's Day, 1900, a photographer capturing an image of children sledding on a snowy hill would have used a camera that recorded the scene on a strip of flexible material coated with an emulsion of light-sensitive silver halides.

On New Year's Day, 2000, the great-granddaughter of that photographer might have captured an image of a sledding scene on a similar (but much more light-sensitive) emulsion. However, chances would be almost as good that she captured the image using an array of millions of tiny solid-state sensors and stored it as a series of electronic pulses. In the late 1990s, digital cameras began to emerge as a serious alternative to conventional chemical-based photography.

Recording an image on film

For more than 150 years, photography has been an image-capture process that involved chemical changes in substances exposed to light. In the traditional photographic process, light rays reflected from the subject passed through a lens and struck a silver-based emulsion coated on a smooth (usually flexible plastic) film base. The latent image imprinted on the emulsion was made visible and permanent by chemical development and fixing.

The resulting image could be a negative or a positive, depending upon the type of film used. Positive (transparency) film, which involved an additional chemical reversal step, resulted in a projectable slide image. Negative (print) film produced a negative that could be used to create positive prints. These prints were made on a paper or plastic surface that had been coated with a light-sensitive emulsion similar to, but less sensitive than, the emulsion used for film. Light transmitted through the negative exposed the print emulsion to create a latent image. Development and fixing with the appropriate chemicals resulted in a positive image of the scene originally photographed. The traditional chemical-based photographic process is diagrammed in **Figure 15-1.**

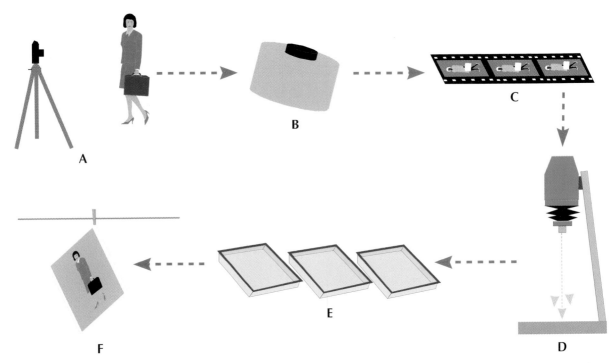

Figure 15-1. *The conventional, chemical-based process of capturing an image and creating a finished print has been used for more than 150 years. A—Film is exposed. B—Film negative is developed and fixed. C—Negative is washed and dried. D—Print is made by projection or contact method. E—Print is developed and fixed. F—Print is washed and dried.*

Recording an image digitally

The similarities between conventional and digital image capture end when the light rays reflected from the subject reach the camera's film plane. In a conventional camera, the light causes a latent image to form in the film emulsion. In a digital camera, the light rays strike thousands or millions of tiny sensors. These sensors may be *CCDs (Charge-Coupled Devices)* or *CMOS (Complementary Metal Oxide Semiconductors)*. CCDs are most widely used in digital camera applications. Recent improvements in CMOS image quality, coupled with lower cost and far lower power consumption, have made them an attractive alternative for camera manufacturers. Cameras with CMOS sensors make up a small but growing fraction of the available models.

Sensors are typically arranged in rows to form a grid or *area array.* A fairly common arrangement, an array of 1200 rows with 1800 sensors per row, adds up to almost 2.2 million

sensors). See **Figure 15-2.** Another arrangement, used strictly in cameras intended for studio work, is the *linear array* containing only one to three rows of CCDs. Studio cameras will be discussed later in this chapter.

The common term for an individual sensor in an array is *pixel,* an abbreviation of the term *picture element.* Cameras are often classified by the number of pixels contained in their sensor array. Thus, a camera with a three-million-pixel array is referred to as a "3 megapixel" camera (the Greek prefix "mega" is widely used to represent a quantity of a million). In most arrays, the individual pixels are square, but some manufacturers use rectangular or even octagonal (8-sided) pixels.

What happens when light strikes the array? A tiny electronic signal is generated by each CCD; the signal intensity varies depending upon the brightness of the light. This signal intensity is translated by the camera's programming (called *firmware*) into a shade or *level* of gray. How many *gray levels,* or

A

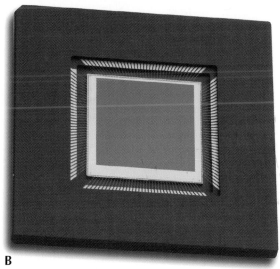

B

Figure 15-2. *The digital camera has an array of thousands or millions of tiny sensors that react to the light striking them by producing an electronic signal. A—A simplified diagram of a portion of an area array (pixel size is greatly exaggerated). B—This 16-megapixel array is used in a high-resolution studio digital camera. (Foveon, Inc.)*

Bit Depth	Exponent (Base of 2)	Shades of Gray
1	2^1	2
2	2^2	4
3	2^3	8
4	2^4	16
5	2^5	32
6	2^6	64
7	2^7	128
8	2^8	256

Figure 15-3. *Bit depth increases exponentially from a base of two. For example, a bit depth of four can display 16 shades of gray ($2 \times 2 \times 2 \times 2 = 16$), while a bit depth of five can display 32 shades ($2 \times 2 \times 2 \times 2 \times 2 = 32$).*

an 8-bit depth, a total of 256 shades of gray can be distinguished — a range equivalent to the number of gray values in a conventional black-and-white photographic print. Thus, to capture an image with an acceptable tonal range, the digital camera must have a grayscale bit depth of at least 8.

What about color? Actually, a digital camera is color-blind; it can distinguish only shades of gray. Color information is recorded by filtering the light striking the array to obtain three different grayscale channels: one for green, one for red, and one for blue. Each channel typically has a bit depth of 8, and thus can contain 256 levels of gray. The resulting image will have a bit depth of 24 (3×8), and will be able to reproduce up to 16.7 million different tones of color. See **Figure 15-4.** A 24-bit color depth is considered the minimum for good color reproduction. Most portable digital cameras produce images with a 24-bit color depth.

Bit Depth	Exponent (Base of 2)	Colors Displayed
8	2^8	256
16	2^{16}	64,000
24	2^{24}	16.7 million

Figure 15-4. *Bit depth for color images increases in the same way as grayscale bit depth, but the numbers become much larger because of the three color channels involved.*

steps between pure white and pure black, the camera will "see" is determined by the **bit depth** of the pixel.

Bit depth increases exponentially, as shown in **Figure 15-3.** Thus, a pixel with a bit depth of 1 can be used to distinguish only 2 shades: white and black. A 2-bit pixel, however, can handle 4 shades of gray; a 3-bit depth can capture 8 shades and so on. With

In cameras using area arrays, color filtering is done using either of two methods. The most common uses *filter decals* applied in a checkerboard pattern over individual pixels in the array, **Figure 15-5A.** There are usually twice as many green filters as red or blue filters, because human vision is most sensitive to the light values contained in the green channel of a color image. Some camera manufacturers use a prism to filter incoming light and direct the red, green, and blue wavelengths to separate arrays of sensors. See **Figure 15-5B.** When the image is reproduced on the computer screen or sent to a printer, software translates the various levels of gray in each channel back into color information for display.

Studio camera image capture

Portable or field-use cameras, like those described in the preceding section, are designed for exposures measured in fractions of a second, much like a conventional film camera. The short exposure times are necessary to permit capture of moving subjects and are used in a variety of lighting situations. The majority of portable cameras are equivalent in size to 35mm SLR or point-and-shoot cameras.

Cameras for studio work are designed to capture motionless subjects under controlled lighting conditions, and are typically equivalent to medium format or large format equipment. These cameras may use either an area array, or a linear array that functions much like the sensor array of a flatbed scanner or a photocopier. They require longer exposure times than the portable (often called "single-shot") cameras, but deliver an image of extremely high quality, **Figure 15-6.**

Studio cameras that employ an *area array* typically require three exposures to capture an image. A filter wheel mounted between the lens and the array rotates to position a different filter (red, green, or blue) in the light path for each exposure, **Figure 15-7.** Some cameras employ a fourth exposure, using the green filter a second time to increase the information recorded in the green channel. Because of the need to make multiple exposures, these cameras cannot be used to capture moving subjects in full color (some models allow a single-shot black-and-white image capture).

Another multiple-exposure method does away with the filter wheel. It uses fixed red, green, and blue filters and a small electric motor to precisely shift the array into alignment with the proper filter for each exposure. These cameras are typically able to be switched from multi-shot (3 or 4 exposure) to single-shot mode to permit action photography. In the single-shot mode, the array

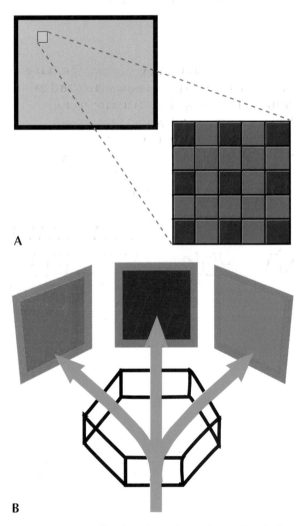

A

B

Figure 15-5. *Filtering for color values. A—Color decals applied to a single area array. Pixel size is greatly exaggerated. B—Using a prism to direct red, green, and blue wavelengths to individual arrays.*

Figure 15-6. *Studio digital cameras, with their large arrays, can capture high-quality images for use in catalog, magazine, or advertising illustrations. This photo was taken by a camera that uses three 2048 × 2048 sensor arrays with a total resolution of 12 megapixels. (Foveon, Inc. photo by Viktor Budnik)*

records 50 percent of the usual pixel resolution for the green channel, and 25 percent of the normal resolution for each of the other two (red and blue) channels. *Interpolation* (creation of new pixels by averaging the values of the surrounding existing pixels) is used to bring all three channels to full resolution. The resulting image is lower in quality than a multi-exposure image, but is adequate for many applications.

A few studio cameras use three separate arrays and a prism to provide single-shot capability with higher image quality. Since each array captures 100% of the normal resolution for its designated color, interpolation is not necessary.

Scanning backs

Studio capture devices called *scanning backs* make use of a trilinear array, rather than an area array. The *trilinear array* is a bar containing three rows of sensors that is moved across the image capture area. One row of sensors is filtered to capture red wavelengths, one is filtered for green, and the third is filtered for blue. See **Figure 15-8.**

Figure 15-7. *Filters for red, green, and blue wavelengths rotate into place for the three successive exposures in this studio digital camera. The green filter may be used twice (a fourth exposure) for improved color.*

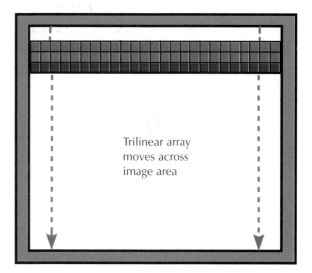

Trilinear array moves across image area

Figure 15-8. *Three rows of pixels, filtered for red, green, and blue wavelengths, are typically used in digital scanning backs. These cameras move the array in tiny increments across the entire image area. The scanning process requires exposures that are usually minutes in length.*

This permits image capture in a single pass as the bar is moved by an electric motor in tiny increments. Operation is much like the movement of the capture element in a flatbed scanner (thus the name, scanning back). Scanning backs are intended for attachment to medium format or large format cameras, capturing images that are the equivalent of the 6 cm × 6 cm or 4″ × 5″ film formats.

Because of the large formats, resolutions achieved with scanning backs are very high when compared with the resolutions possible from the smaller area arrays of portable cameras. For example, one scanning back built for use on 4″ × 5″ studio cameras has a resolution of 48 megapixels (6000 × 8000 pixels). Bit depth is also typically greater with the scanning backs: a pixel bit depth of 12 (36-bit color depth) is common; some scanning backs offer a pixel bit depth of 16 (48-bit color depth).

The tradeoff for the high resolution and increased bit depth is *reduced speed.* Exposure times with a scanning back are long — measured in minutes rather than fractions of a second. The long exposures, in turn, require a rock-solid camera mount (usually a heavy studio stand) and lighting that is constant in intensity and free from flicker. The long exposures also generate *heat,* which can cause **digital noise** (tiny light-colored spots especially noticeable in shadow areas) and **blooming** (a smearing or bleeding of some color pixels, especially red, into adjacent parts of the image). Various methods, ranging from fans to special electronic circuits, are used to regulate sensor temperatures.

Digital studio cameras must be connected to a computer for framing and focusing; the computer screen becomes the "ground glass." This arrangement also makes use of the computer's hard drive for image storage. See **Figure 15-9.**

Digital camera considerations

Photographers used to working with conventional 35mm SLR cameras will find

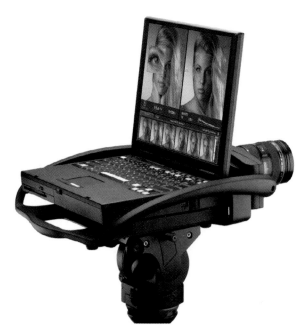

Figure 15-9. *Digital studio cameras use a computer screen as the "ground glass" for framing and focusing. This unique single-shot design attaches the lens and three CMOS imaging arrays directly to a laptop computer. Images are stored on the computer's hard drive. (Foveon, Inc.)*

both similarities and differences when they begin using a digital camera. Basic photographic skills, such as composition, are used identically in both conventional and digital photography. Most digital cameras offer fully automatic modes for exposure and focusing; many permit manual override of those functions.

The majority of portable digital cameras on the market today are essentially point-and-shoot models with either fixed single-focal-length lenses or short zoom lenses, **Figure 15-10.** Some models have auxiliary wide-angle and telephoto lenses that can be mounted on the fixed lens somewhat like filters. Cameras with interchangeable lenses (often digital adaptations of current professional-level SLRs) are found only at the high end of the price spectrum. See **Figure 15-11.**

Although many camera manufacturers list both optical and digital zoom ranges for their cameras, the digital zoom capability should be disregarded. Optical zooms are

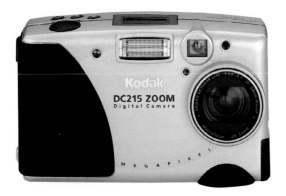

Figure 15-10. *Most digital cameras aimed at the general photography market are point-and-shoot models with a fixed single-focal-length lens or a short telephoto in the 2× to 3× range. Like their 35mm or APS counterparts, most feature full automation of both exposure and focus, but many also permit manual operation. This model has a 29mm–58mm optical zoom.*
(Eastman Kodak Company)

generally in the 2× or 3× range (equivalent to a 28mm–60mm or 35mm–105mm focal length); like those on conventional cameras, they allow you to "get closer" to a subject without degrading the image. Digital zoom, however-

er, merely selects a smaller portion of the image, increasing pixel size to provide a closer view. The process seriously degrades the quality of the image.

Since most CCD arrays used for digital capture are physically smaller than the 24mm × 36mm dimensions of a normal 35mm frame, the familiar lens focal lengths are subjected to a "telephoto effect." If the array is 0.66" in width, the image produced by a "normal" 50mm lens would provide a field of view equal to what you would expect to see from a lens with a focal length of between 90mm and 100mm. See **Figure 15-12.** Some cameras use a framing guide in the viewfinder, while more sophisticated models compensate optically to show the actual field of view in the viewfinder. A few cameramakers place a reducing lens assembly in the light path. This approach "squeezes down" the full image to the dimensions of the CCD, but reduces the effective aperture of the lens by as much as two f-stops. For medium format cameras, the use of sensors close to the normal 6 cm × 6 cm frame size avoids the telephoto effect.

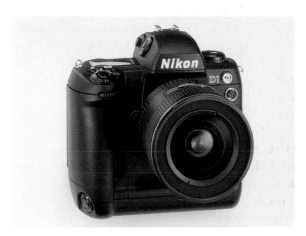

Figure 15-11. *Portable digital cameras used by professionals are sometimes built upon an existing professional-level 35mm camera body. Other manufacturers have developed specifically digital camera bodies that are similar in most operating respects to their professional-level 35mm SLR cameras. This Nikon D1 model has a 2.74-megapixel resolution and accepts the same lenses as conventional Nikon SLR cameras. (Nikon,Inc.)*

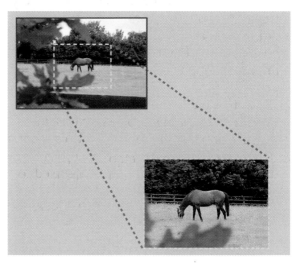

Figure 15-12. *An example of the "telephoto effect" that results from the smaller size of the CCD array in comparison to the normal 35mm full frame. With an array that is 0.66" wide—not quite half the 1.5" width of the 35mm frame—the field of view of a 50mm lens is reduced to the view of a lens with a focal length between 90mm and 100mm.*

A professional-level digital camera with a 6 megapixel CCD array of the same dimensions (24mm × 36mm) as the normal 35mm frame was introduced in 2001 by Pentax. This eliminates the telephoto effect, allowing the photographer to use lenses at familiar focal length. The digital SLR accepts all Pentax K-mount autofocus lenses. With an adapter, medium format lenses can also be mounted.

Viewfinders on digital cameras may be the familiar optical finder, a full-color liquid-crystal display (LCD), or both. See **Figure 15-13.** Less expensive models tend to have only optical finders; mid-range cameras may have either or both; higher-priced models usually have both types. While the LCD screen is an attractive feature (especially for checking a shot after you have taken it), it can be hard to see in bright sunlight and places a heavy drain on the camera batteries. Experienced photographers usually use the optical viewfinder and turn on the LCD display only to check a shot. Digital cameras display camera settings and status, such as battery life, on a separate monochrome LCD panel usually located on top of the camera.

Since these cameras do not use film, there is no "film speed" as such. However, the sensitivity of the CCD array is usually stated in its *ISO equivalent.* Entry-level

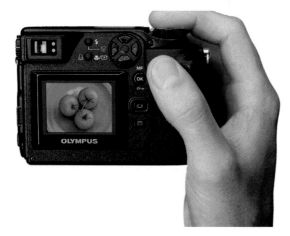

Figure 15-13. *Liquid-crystal-display viewfinders, in full color, are found on many of today's digital cameras. Most cameras also have the traditional optical viewfinder. (Olympus America, Inc.)*

portable cameras usually offer a single "speed," often the equivalent of ISO 100; more full-featured models may allow the photographer to select among several values. Some studio cameras offer a range of ISO equivalents, but many have a single value equivalent to ISO 50 or even less. Such a low sensitivity is not a problem under the studio conditions of controlled lighting and static subjects.

With a conventional camera, photographers use filters or film choices to adjust to different types of lighting. For example, you would select tungsten-balanced film (or a cooling filter) to adjust for the warmer light provided by incandescent bulbs, or add magenta filtration to offset the greenish cast of fluorescent lighting. Digital cameras adjust to different lighting conditions by setting a *white point.* This may be done manually by focusing on a white card under the specific lighting conditions that will be photographed. Many cameras set the white point automatically or with the press of a button. Some also allow you to select from a list of lighting conditions and types.

Shutter lag, a problem most often encountered with conventional point-and-shoot autofocus cameras in low light, can be a problem with digital cameras under similar conditions. Depending upon the camera and the shooting conditions, a second or two may pass between the time you press the shutter release and the time the shutter actually operates. Another type of delay is particular to digital cameras. This is the *refresh rate* — the time required to transfer the captured image to the camera's storage card or disk. Typically, this means a wait of a few seconds before you can make the next exposure. Some digital cameras have a *burst-mode* feature, which is the digital equivalent of a motor drive. Entry-level cameras may achieve this quick sequence capability by reducing the resolution of the images, however. Professional models use an internal storage buffer to hold burst-mode exposures at full-resolution

value. When the camera is taken out of burst mode, there is a delay as the images are transferred to the storage card or disk.

Digital camera resolution

As described earlier in this chapter, the resolution (fineness of visible detail in a captured image) of a digital camera is measured by the number of pixels recorded by its CCD or CMOS sensors. Thus, a camera with a 640 × 480 array will have a relatively low resolution of just over 300,000 pixels, while a camera with a 2048 × 1536 array will deliver a high-resolution image containing more than 3 million pixels.

In general terms, camera price and potential uses are determined by the size of the array. Excluding professional models, portable digital cameras can be classified as entry-level (basic), intermediate, or advanced.

Entry level models

These are the digital equivalent of the simplest point-and-shoot snapshot cameras. See **Figure 15-14.** Although they may have resolutions as high as 1 megapixel, most use 640 × 480 arrays. Optical viewfinders are more common than LCDs, although most newer models are being introduced with LCD displays. These cameras usually have a fixed single-focal-length lens equivalent to a moderate wide-angle SLR lens. Memory is built-in, limiting the number of photos that can be taken before downloading to a computer. The images produced by these cameras are best suited for low-resolution computer display on web pages or as e-mail attachments. Snapshot-quality 4″ × 6″ or smaller prints can be produced on an ink jet printer.

Intermediate models

More features and higher resolution set the intermediate models, **Figure 15-15,** apart from basic digital cameras. Resolution is typically 1 megapixel or greater, with some models offering as much as 2 megapixels. Zoom lenses are virtually standard, with most in the 2× range. Controls are more complex than in basic models, although most are easily selected with buttons or switches. An important addition is *removable memory* — storage cards or disks that can be filled with images and replaced to allow the photographer to keep on shooting. The images can then be downloaded from the storage device to a computer, and the card or disk can be used again. The higher resolution provided by intermediate models permits larger prints of acceptable quality to be made: up to 5″ × 7″ for 1-megapixel or higher cameras, and up to 8″ × 10″ for 2-megapixel models.

Figure 15-14. *Basic or entry-level digital cameras are useful for capturing images that will be displayed on a computer screen or printed as snapshots on an ink jet printer. (Olympus America, Inc.)*

Figure 15-15. *Intermediate level digital cameras offer more features and higher resolution than basic models. Most have a zoom lens and an LCD viewfinder. (Eastman Kodak Company)*

Advanced models

Digital camera models in this category have a minimum resolution of 2 megapixels; top-of-the line models will have 3 megapixels or more, often in a 2048 × 1536 CCD array. See **Figure 15-16.** Both 2× and 3× optical zooms are found in this category, with a strong trend toward the 3× configuration. Controls are more sophisticated than those on intermediate cameras, and include many of the same choices (shutter-priority vs aperture-priority exposure, a range of ISO equivalents, manual vs automatic exposure control) found on equivalent conventional cameras. Most have burst-mode capability and both optical and LCD viewfinders. The high resolution allows up to 8″ × 10″ prints from desktop printers; files saved at the highest resolution are suitable for reproduction (usually at smaller sizes) in books, magazines, or other printed products.

The line between advanced digital cameras and professional-level equipment is not sharply defined by resolution (2- and 3-megapixel arrays are common in both categories) or by degree of control and number of features. The most obvious distinction is SLR-style lens interchangeability (as noted earlier, some professional-level digital models are built around existing conventional SLR

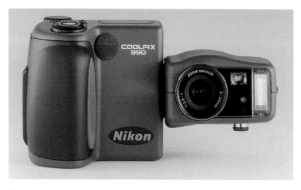

Figure 15-16. *Advanced digital cameras have many of the same features and capabilities found on sophisticated 35mm cameras. Some advanced models have a nontraditional appearance, including lenses that swivel or that can even be detached from the camera body. At the highest price/feature level, advanced camera models begin to blend into the professional category. (Nikon, Inc.)*

camera bodies and lenses). As in the case with conventional photo equipment, professional digital cameras are built more ruggedly and designed for heavier use than models intended for amateur photography.

Image storage and transfer

The sheer size of electronic files generated by a digital camera makes their storage and handling an important consideration for the photographer. For example, a color image captured by a 3-megapixel camera and saved at the highest resolution (2048 × 1536 pixels) would create a file size of almost 9.5 megabytes (Mb). *File size* is computed by first multiplying the dimensions in the pixel array (2048 × 1536 = 3,145,768), and then multiplying by the number of channels. If the image is black-and-white (and thus is comprised of only one channel) its file size would be 3,145,768 bytes. A color image, however, is made up of three channels, each of which is 3,145,768 bytes in size. Multiplying by 3 (for the red, green, and blue channels) yields the actual file size of 9,437,184 bytes. See **Figure 15-17.**

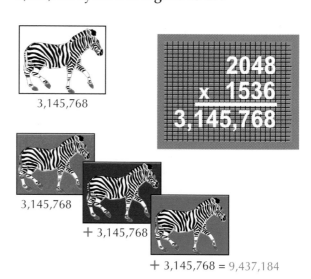

Figure 15-17. *At the highest resolution, a digital camera produces a monochrome (black-and-white) image file is the same size as the resolution of the array. A color image file has three times the number of pixels in the CCD array, since it consists of three channels (red, green, blue).*

Digital cameras allow files to be saved in a number of different *modes* or **file types**. Some of these, such as RAW or *TIFF* (Tagged Image File Format) retain the original size and all the original pixel data. Files may also be **compressed** to a smaller size to take up less storage space or to speed up transfer time. The most common compressed file type is the **JPEG** (Joint Photographic Experts Group) format, which can be used to reduce file size by a small or large amount. The JPEG compression method is **lossy,** which means that it discards some image information in the process of compressing the file. When the highest quality (least compression) is selected, the loss is minimal; more severe compression can seriously degrade image quality. Additional image information is lost every time a JPEG image is manipulated and resaved. **Lossless** compression methods, such as **LZW** (Lempel/Ziv/Welsh), do not discard image information but cannot reduce a file size as drastically as JPEG. The JPEG method is the only compression choice offered on many cameras.

Storage devices

The earliest digital cameras offered only internal (RAM) memory, but the majority of camera models today use some form of removable memory device. The need for such devices, which can be treated as a form of "digital film," arose from the continuing increase in camera resolution (and thus file size). The internal memory of a camera without a removable memory device could quickly become filled with image files. Shooting would then have to stop until the files were transferred to a computer.

A camera with a removable storage card or disk is more flexible. The removable memory device can be filled with image files and replaced with a fresh unit so that shooting can continue. The contents of the filled unit can be transferred to a computer's hard drive, and the card or disk readied for use again.

While there are a number of removable storage devices in use, the two most common are small, solid-state memory cards called **CompactFlash** and **SmartMedia,** which are slipped into a slot on the camera. See **Figure 15-18.**

- CompactFlash cards are available in capacities from 4 Mb to more than 500 Mb. There are two varieties of card: Type I is the original; Type II is somewhat thicker and has higher capacity for storage. Slots for Type II cards will also accept Type I cards, but not vice versa.

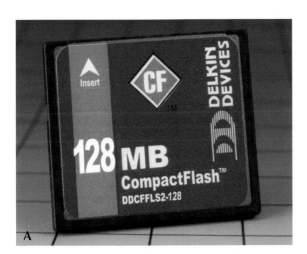

Figure 15-18. *Removable memory cards. A—The CompactFlash card packs large capacity in a small size. This card has a capacity of 128 Mb, but cards with capacities of up to 500 Mb are available. B—The SmartMedia card is smaller and thinner than the CompactFlash card, and generally offers smaller amounts of storage. This is a 64 Mb card. (Delkin Devices)*

- SmartMedia cards are smaller and thinner than CompactFlash cards, and are available with capacities of 8 Mb–128 Mb.

The drawback to using multiple CompactFlash or SmartMedia cards as you would rolls of film (for example, when traveling) is *cost:* buying several high-capacity memory cards could cost you as much or more than the camera in which they will be used.

Other types of removable memory include:

- The standard 3.5″ computer disk, which is limiting, since it holds only 1.4 Mb.
- The Memory Stick™, a removable memory device used in Sony cameras. Available in 4 Mb–64 Mb capacities.
- The Iomega Clik!™ drive, a device built into some cameras, that uses a rewritable 40Mb disk.
- The IBM Microdrive™, a high-capacity removable drive the size of a CompactFlash Type II card. It can store up to 1 *gigabyte* (1000Mb) of information on a tiny hard disk the diameter of a U.S. 25-cent coin.
- CD-R (recordable) disks in the 3.5″ size. The disk can be recorded upon only once, but relatively low cost for the disks makes the system feasible.

Transfer methods

Moving image files from the camera or a removable memory device to a computer hard drive is typically done through some form of wired connection. Newer cameras and computers can be connected together directly for fairly high-speed transfer through *USB* (Universal Serial Bus) ports.

A *memory-card reader,* **Figure 15-19,** is a widely used transfer device. It accepts either CompactFlash or SmartMedia cards (some brands have dual slots and can handle both types of cards) and connects to the computer. The transfer speed depends upon the type of connection available: parallel port (slow), USB (fast), SCSI (faster), or *FireWire*

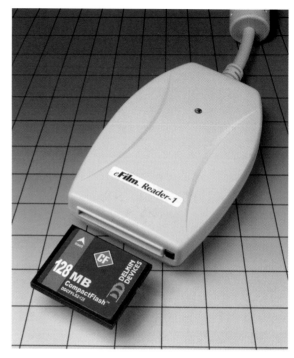

Figure 15-19. *Memory-card readers can transfer information from CompactFlash or SmartMedia cards to a computer's hard drive. Models are available for connection to USB, parallel, SCSI, or FireWire ports. (Delkin Devices)*

(fastest). If you have two memory cards, you can continue to use your camera while the images are being transferred. An alternative method for users of SmartMedia cards is the FlashPath™ device, an adapter the size of a standard 3.5″ computer disk. See **Figure 15-20.** The SmartMedia card is slipped into the FlashPath unit, which can then be inserted into the computer's standard 3.5″ disk drive to transfer images to the hard drive.

Until recently, photographers who used digital cameras to make a large number of exposures on location were forced to either invest in a number of memory cards or carry along a laptop computer to which images could be downloaded. A device called the Digital Wallet™ appears to solve the problem. The small unit, **Figure 15-21,** accepts memory cards and copies the image files to its onboard memory. With a capacity of 6 gigabytes, the device can store hundreds of high-resolution image files. After returning

Figure 15-20. *A special adapter allows SmartMedia cards to be read in a computer's standard 3.5" disk drive. A similar device is available for use with CompactFlash cards. (Delkin Devices)*

Figure 15-21. *Temporary storage of large image files while on location can be achieved with the Digital Wallet storage device. The battery-operated device, only 5 1/2" × 4" × 1 1/4" in size, can store up to 6 gigabytes of information. It eliminates the need to carry a quantity of memory cards or a laptop for downloading. Files can be transferred to a computer with a USB connection. (Minds@Work)*

from location, the photographer can download files from the Digital Wallet onto the computer hard drive.

A similar field storage device is part of a 35mm digital imaging system, **Figure 15-22.** The EFS-1 system is based on an electronic insert designed to fit several professional SLR camera models. The insert contains a 1.3 megapixel (1280 × 1024 pixel) CMOS array that will capture images in 36-bit color. Built-in flash memory will hold up to 24 high-resolution images.

The other two components of the system are a download device and a field storage

Figure 15-22. *The EFS-1 digital imaging system is designed to convert a professional-level 35mm SLR into a digital camera. A—The electronic film cartridge contains a 1.3-megapixel CMOS array. B—The cartridge is inserted in place of a film cassette for digital image capture (the camera can be used interchangeably for conventional and digital photography). An image download device and a field storage unit are part of the complete system. (Silicon Film Technologies, Inc.)*

unit. The camera insert containing captured images is placed in the download device, which can be connected to a computer with a USB cable. Alternatively, the device can plug into a memory card reader. For temporary storage during location shooting, the download device is plugged into a field storage unit called an (e)box.

Other image capture methods

In addition to digital cameras, there are a number of other methods of acquiring digital images. These include capturing still frames from video recordings; using a scanner to create digital files from transparencies, negatives, or prints; having photos scanned and placed on a Photo CD, and acquiring digital images by downloading from the Internet.

Still (single frame) video

Individual still frames from video cameras can be captured and converted to digital files, although their inherently low resolution makes them most suitable for use on Web pages or other screen displays.

With traditional analog video cameras, the easiest method of capturing still video images is with a video capture board built into the computer, or a separate "frame grabber." This is a device that connects to the video camera on one side and to a computer input port on the other. Conversion software allows motion video playback on the computer screen. When a desired picture appears, it can be captured as a still frame and saved as an image file for further processing.

Digital video cameras do not require the frame grabber device. They can be connected to the computer's video card via a USB port for playback. Individual video frames can be identified and saved as image files.

Scanners

Scanners are mechanical/optical devices used to convert transparencies, negatives, or

prints into digital form. There are three basic types: flatbed scanners, film (transparency and negative) scanners, and drum scanners.

Flatbed scanners

The most common, and generally least expensive, scanner type is the *flatbed*, **Figure 15-23.** Looking somewhat like a small photocopier, the flatbed can be used to scan artwork, printed material, some kinds of three-dimensional objects, or photos. With an adapter, some models can be used to scan transparencies.

Most flatbed scanners intended for home or small business use can handle originals up to 8.5″ × 11″ and some will scan an area as large as 8.5″ × 14″. More expensive units intended for professional use will accept originals up to 12″ × 17″ in size.

Resolution

The quality of an image produced by a scanner, like the output of a digital camera, is directly related to the *resolution* used for scanning: the higher the resolution, the more detailed the image will be. Functionally, the scanner resembles the studio digital cameras in which a linear CCD array moves across

Figure 15-23. *The flatbed scanner is a popular tool for capturing digital images. Able to fit on a corner of a desktop, the flatbed scanner can convert photo prints, artwork, and other flat material into digital image files. Some models also can scan transparencies or negatives. (Microtek)*

the image area. Resolution, measured in pixels per inch (ppi), is usually stated in a form such as 1200 × 2400. The first number is the number of sensors (pixels) per inch on the linear array; the second is the number of distinct "stops" per inch that a stepper motor will make as it moves the linear array down the length of the scanned material. See **Figure 15-24.** When describing the scanner's resolution, only the first number is typically used: such as a "1200 ppi scanner."

When dealing with scanner resolution, an important distinction is whether the stated resolution is optical or digital. *Optical resolution* is the actual pixels per inch count: 600, 1200, 2400, and so on. *Digital resolution* — the measurement used by some manufacturers for advertising purposes — is achieved by using software to interpolate additional pixels around those actually scanned. The higher resolution figure thus generated is misleading, since the scan is actually lower in quality than one scanned at the comparable optical resolution.

Scanning large originals at full resolution can create some very big file sizes. For example, an 8″ × 10″ print scanned on a flatbed with a 1200 × 2400 pixel resolution would result in a 23 Mb file for grayscale or 70 Mb file for color. In practical terms, scanning will often be done at lower resolutions, based on the intended use. If the image is to be used for a magazine, book, or similar printed product, a scan at 300 ppi would be sufficient, resulting in a color file size of 22 Mb. A scan done at 200 ppi (suitable for quality output on an ink jet printer) would have a file size of just under 10 Mb.

Other scanner considerations

In addition to resolution, the quality of a scanned image is affected by two other factors, color (bit) depth and dynamic range. As discussed in the section on digital cameras, *bit depth* is a measure of the number of shades of gray that a pixel can display. For an acceptable tonal range in the image, a bit depth of 8 (capable of displaying 256 shades of gray) is considered minimum.

The scanner records color information by filtering the three rows of sensors on the array to obtain three different grayscale channels: one for green, one for red, and one for blue. Each channel typically has a bit depth of 8, and thus can contain 256 levels of gray. The resulting image will have a bit depth of 24, and will be able to reproduce up to 16.7 million different tones (256 × 256 × 256). Software translates the shades of gray into color values for display. Most scanners have a color bit depth of 36; a growing number offer 42-bit color. With 36-bit or greater color depth, the number of different color tonalities is in the billions.

Dynamic range is the ability of a scanner to reproduce detail at the extremes of highlight and shadow (the darkest and brightest areas of the picture). This characteristic is measured on a logarithmic scale, with a maximum value of 4.0. A dynamic range of 3.0 would be considered minimal; most moderately priced scanners would be in the 3.2 or 3.3 range, and more expensive models might have a dynamic range of 3.4. The makers of most lower-priced flatbeds do not provide dynamic-range figures.

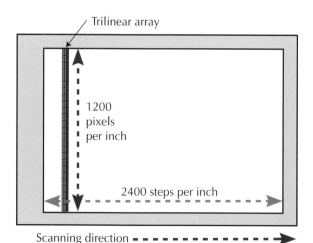

Figure 15-24. *The linear array of a flatbed scanner is parallel to the short side of the scanning area. Thus, a 1200 ppi array would actually have 10,200 sensors (for an 8.5″ wide scanning area). A motor would move the array down the length of the scanning area making 2400 stops per inch (a total of 26,400 for the full 11″ scanning area).*

The *speed* at which the machine scans an image and sends it to the computer may be minutes when scanning at higher resolutions. Aside from the scanning speed, the type of connection between the scanner and computer is a factor. As described in the cameras section of this chapter, the common connection types (from slowest to fastest), are parallel, USB, SCSI, and FireWire. For the photographer who scans small numbers of images, speed is not usually a major consideration. When a larger volume of scanning must be done, however, scan and data-transfer speeds become more important.

A number of flatbed models are capable of scanning transparent images (positive or negative) with the use of a ***transparency adapter,*** **Figure 15-25.** Some scanners include an adapter as standard; others offer it as an extra cost option. The adapter is necessary because transparency materials must be scanned with the use of *transmitted light,* rather than the *reflected light* used to scan prints and other

opaque originals. Best results when using a transparency adapter are obtained from medium format or large format transparencies. For the smaller areas presented by 35mm slides or negatives, the higher resolution of a film scanner will provide better results.

Scanning software

Specialized software is used to preview and adjust the characteristics of the image before the actual scan is made. Each scanner maker provides software with its equipment; scanning programs are also available from software developers. Such "third-party" programs are typically more sophisticated and offer more control than the manufacturer's software; they are usually used by professionals who deal with a large scanning volume.

The first step in scanning is the generation of a *preview image,* **Figure 15-26.** This shows the image as it would be scanned, and is used to determine what changes should be made in terms of cropping, contrast adjustment, and color correction. As a general practice, as much adjustment and correction as possible should be done *before* scanning, and then any necessary refinements made to the scanned image with graphics-editing software.

Figure 15-25. *A transparency adapter allows use of a flatbed scanner for digitizing negatives or transparencies. The adapter shines light through the transparent original onto the CCD sensors (prints and other opaque originals are scanned by reflecting light from their surface). Best results are obtained when scanning medium format or large format transparencies or negatives; 35mm slides or negatives are scanned more effectively using a film scanner. (Microtek)*

Figure 15-26. *Scanning software allows you to preview the image and make adjustments before scanning. The preview screen typically displays image resolution and size information, as well as the tools used for cropping and adjusting the image.*

Depending upon the scanning software used, different types of information will be displayed, and various tools for correction and adjustment will be available. Important information that is displayed (refer to Figure 15-26) includes the input or scanning resolution, the size of the original being scanned, and the desired output resolution and resulting image dimensions.

One very useful tool is the *histogram,* a graphic display of the number and distribution of tones in the image. **Figure 15-27A** is the histogram for a black-and-white photograph. The horizontal dimension, from 0 to 255, represents the 256 possible shades of gray in the 8-bit image. The "peaks and valleys" are representations of the actual number of pixels of each shade, from 0 (pure black) at left to 255 (pure white) at right. A photo with a full range of tones will show smaller numbers of pixels at the extremes and a large number distributed through the middle tones. For a color image, the software may display a single composite histogram, or separate histograms for the three color channels, as shown in **Figure 15-27B.**

If the histogram displays empty areas at either end (indicating no pixels at the lowest or highest values), the image can be adjusted to use the full tonal range. The small triangular indicators (called *sliders*) at either end can be positioned below the lowest and highest values shown on the histogram, **Figure 15-28.** This will reassign the values of the pixels, so that the darkest value will become 0 and the lightest, 255. All other pixel values in the image will be redistributed to provide a full tonal range. The effects of such changes can be viewed in the preview image. A more detailed discussion of the histogram will be found in Chapter 16.

The *Curves tool* is a very powerful means of adjusting contrast and color of an image before scanning. As initially displayed, it consists of a diagonal line across a grid with the 0 (pure black) point at lower left and the 255 (pure white) point at upper right. For color images, the composite (RGB) is displayed, with individual color channels selectable from a dropdown menu. **Figure 15-29** shows the initial display for a black-and-white image at left; at right, the curve has been adjusted into an "S" shape that will

Figure 15-27. *The histogram displays the tonal distribution of pixels in the image. A—The histogram display for a black-and-white image. B—Color-image histograms may be displayed as three separate channels, as shown here, or as a composite of the red, green, and blue channels.*

increase contrast in the photo. The contrast increase is achieved by redistributing pixel values to darken the shadows and lighten

the highlights. The curve is "locked" at its midpoint to prevent shifting the midtones. Mastering the use of curves takes more practice than working with the histogram, but provides very precise control. Chapter 16 will cover the use of curves in image manipulation and color adjustment.

The *Eyedropper tool* is still another means of adjusting the image before scanning. The dark eyedropper is used to sample the darkest desired tone in the image, setting its value as the **black point** (0). The light eyedropper is used in the same way to select the lightest desired value, which becomes the **white point** (255). See **Figure 15-30.** Once those points are set, the remaining values are distributed between them to achieve the full tonal range.

Some scanning software also offers a **Variations tool**, a display of small (thumbnail) images with the current preview in the center. Samples of various combinations of contrast and brightness changes are displayed around the preview, **Figure 15-31.** If one of these variations represents the desired appearance of the image, it can be selected before scanning.

Figure 15-28. *Adjusting the sliders to the first pixels at either end of the histogram will expand the tonal range of the image. The darkest pixel in the image will be given the value of 0 (pure black); the lightest, 255 (pure white).*

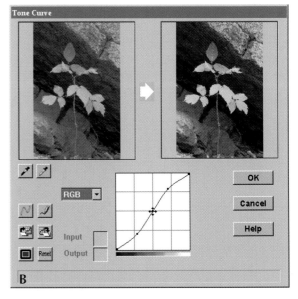

Figure 15-29. *The Curves tool. A—The initial Curves display, with a straight line running diagonally from 0 (pure black) at lower left to 255 (pure white) at upper right. B—The curve adjusted to increase image contrast. The middle tones are locked in place, and then the curve adjusted to make the blacks blacker and the whites whiter.*

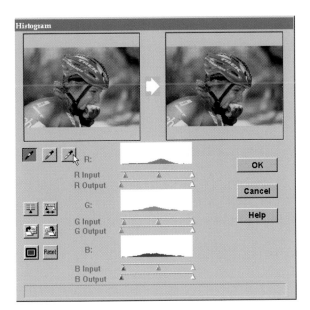

Figure 15-30. *The Eyedropper tool is used to set the black point and white point of an image, thus achieving full tonal range. The dark eyedropper has already been used to set the black point; the light eyedropper will be used next to set the white point.*

Once all image adjustment and cropping has been done, the scanner can be directed to process the image. The image will be scanned (usually requiring several minutes) and the digitized image file will be transferred to the

computer's hard drive. The file can then be opened and manipulated as desired using an image-editing program such as Adobe Photoshop®.

Film scanners

Higher resolution, a greater dynamic range, and the ability to work from *first generation* (original) materials are the primary reasons for using a film scanner, **Figure 15-32.** These small desktop units range from units that can handle only 35mm

A

B

Figure 15-32. *Film scanners. A—This model, offering 4000 ppi resolution, can scan 35mm slides or negatives, as well as APS film. (Polaroid Corporation) B—An important feature of this 35mm scanner is built-in software that automatically cleans up dust spots and scratches on the film. The 2700 ppi scanner can perform batch scans, a timesaver when a number of originals need to be digitized. (Nikon, Inc.)*

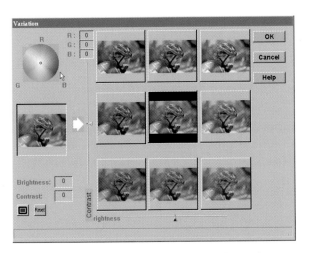

Figure 15-31. *The Variations tool allows the user to select the best among different versions of the preview. The choices include images with greater or less contrast, and different degrees of brightness.*

materials, to those capable of scanning medium or even large format transparencies or negatives. A number of manufacturers offer adapters for scanning APS film, and at least one film scanner on the market also permits the scanning of 4" × 6" prints.

Resolution available with film scanners starts at about 2400 ppi (double the typical flatbed resolution) and ranges upward to 4000 ppi. Dynamic range of these scanners is typically 3.4–3.6. In addition to the resolution and dynamic-range advantages, working with first-generation materials — transparencies and negatives — helps to achieve higher quality. Second-generation materials, such as prints made from a negative, inevitably suffer some quality loss. The software available with some scanners has a feature that eliminates dust spots and scratches during the scan, without affecting image sharpness. This feature can save considerable time that would otherwise have to be spent electronically "spotting out" small defects.

Film scanners, as a group, are more expensive than flatbeds, but provide far superior results from 35mm materials. Where space and budget permit, many photographers have both types: a flatbed for prints and large transparencies, and a film scanner for smaller-format originals. A number of film-scanner models can be equipped with a feeder to make scanning of multiple items more efficient.

Drum scanners

When scan quality is the major consideration, such as an image that will be enlarged drastically for use on a poster, or a photo that will be used in a full-page magazine advertisement, the use of a drum scanner is called for. See **Figure 15-33.**

These expensive, complex machines are typically found in prepress departments of large printing companies or in "service bureaus" that are used by publishing companies, advertising agencies, and commercial photographers. Drum scanners can be used to scan transparent or reflective materials of

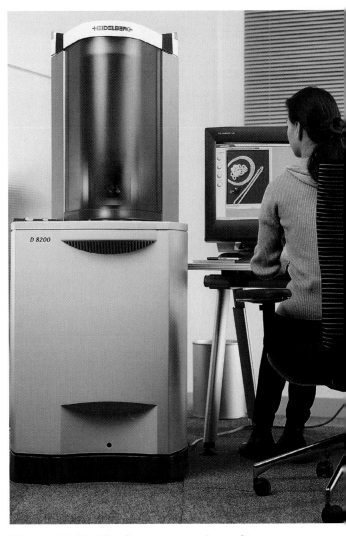

Figure 15-33. *The drum scanner is used to produce scans of the highest quality. Very skilled operators are needed to run the equipment. (Heidelberg)*

almost any size, so long as they can be mounted on the scanning drum. Books, mounted photos, or similar rigid materials cannot be handled on a drum scanner.

Images on disk

If you aren't yet ready to invest the time and money in doing your own scanning, you can still convert your images to digital form. At locations as convenient as the nearby one-hour photo developing lab, your local camera store, or a mail-order processor, you can have your pictures scanned onto a

CD. Simple software provided with the CD, or more sophisticated image-editing programs, will allow you to use your computer to perform such "digital darkroom" activities as cropping, changing contrast, adjusting color, or combining images.

Photo CD vs Picture CD

Since it was introduced by Kodak in the early 1990s, the *Photo CD*™ has been a standard method of obtaining digitized images from 35mm transparencies and negatives. See **Figure 15-34.** For a dollar or two per image, photos are scanned and stored at five different resolutions ranging from a level suitable only for screen display to one high enough to produce an acceptable 8″ × 10″ ink jet print. Most camera stores and the photofinishing departments of some discount or department stores accept orders for Photo CDs. They send the slides and negatives to be scanned to a service bureau, which will return the originals and the disk in a day or two. The disk will hold up to 100 images, but does not have to be filled in a single session. So long as room remains on the disk, new images can be added in batches over a period of time.

Photographers who shoot in film formats larger than 35mm, or who wish to make prints beyond 8″ × 10″ in size, use the ProPhoto CD. In addition to 35mm originals, medium format and 4″ × 5″ transparencies or negatives can be scanned (although the price per scan is considerably higher). In addition to the five resolutions offered on Photo CD, the ProPhoto CD includes a very high resolution that permits prints to be made at 16″ × 20″ or even 20″ × 30″ (depending upon the output device).

Kodak later introduced a product called the *Picture CD*™, that was developed in association with computer-chip manufacturer Intel. Aimed at the mass market of casual "snapshooters," this CD has been promoted as an additional step in the photofinishing process, **Figure 15-35.** For a few additional dollars at the time a roll of film is developed and printed, the images are scanned and placed on the Picture CD. An index print displays small "thumbnail" images of each picture on the disk for easy reference. Picture CD images are scanned at a single resolution that will produce photo-quality 4″ × 6″ prints on a desktop printer.

Figure 15-34. *The Photo CD can store up to 100 digitized images, each at five different resolutions. The highest resolution permits making photo-quality prints up to 8″ × 10″ in size.*

Figure 15-35. *The Picture CD is an inexpensive addition to the photofinishing process. Scans of the complete roll of film are done at the time of developing. The medium-resolution files are suitable for making snapshot-size prints or for display on monitors.*

Most mail-order photofinishers offer some form of digital-image product similar to Picture CD, and at least one provides a five-resolution disk comparable to the Photo CD. In addition, some one-hour labs have begun offering on-site scanning services. The scans typically are at resolutions suitable for 4″ × 6″ prints; some are high enough to make prints in a 5″ × 7″ size.

Images on-line

An area of tremendous growth in recent years has been Internet-based photofinishing and photo-sharing sites. These sites typically offer low-cost, mail-in photofinishing in combination with on-line albums displaying the images scanned from your film, **Figure 15-36.** The on-line albums may be publicly viewable, or can be restricted to viewing by you and persons you choose. You receive traditional prints, but also can download any or all of your images from the displayed album for printing or e-mailing.

Many photographers have their own World Wide Web pages to display their work, or post their images in on-line galleries maintained by organizations or individuals. For a beginning photographer, the Internet provides opportunities to see a wide variety of work by others as part of the learning process. Some of the on-line galleries encourage viewers to provide critiques of the posted images, which can help a photographer improve his or her work.

One negative aspect of posting on the Internet is the relative ease of downloading (copying) posted images, which can result in violations of the copyright laws. A typical example would be a photographer who downloaded several images from galleries or web pages, incorporated them into a montage or composited image, then sold the composite to a client. Unless the photographer received permission from the owners of the images, he or she has violated their copyrights (in effect, committed theft). One method being used by photographers to help protect digital images is the use of electronic watermarking, which embeds copyright information and the owner's identity in the digital file. This provides a basis for identifying and prosecuting copyright violators. The various aspects of copyright as related to photography are discussed in the appendix entitled *Copyright and the photographer.*

Figure 15-36. *On-line photofinishing businesses return finished prints and display scanned photos in "albums" that may be either private or public in nature. Images can be sent by e-mail or downloaded and printed.*

Questions for review

Please answer the following questions on a separate piece of paper. Do not write your answers in this book.

1. Conventional and digital cameras both use light rays passing through a lens to record an image. At what point in the picture-taking process do the two methods begin to differ?

2. A pixel with an 8-bit depth can represent a total of _____ shades of gray. Why is this number of gray values significant?

3. A camera's CCD array can distinguish only shades of gray. How does it capture color information from the scene being photographed?

4. What is a trilinear array?

5. Why is optical zoom more important to a camera user than digital zoom?

6. To adjust the digital camera to ambient lighting conditions, the _____ must be set either automatically or manually.

 a. ISO equivalent

 b. white point

 c. luminance factor

 d. black point

7. What does the availability of inter-changeable lenses tell you about a digital camera?

8. Image-compression methods that dis-card some information in the process of compressing the image file are described as _____.

9. Which type of removable media, the CompactFlash card or the SmartMedia card, offers the widest range of capacities?

10. When flatbed scanner resolution is given in the form 1200 × 2400, what do the two numbers mean?

11. Scanning software will usually display a _____ that shows the number and distri-bution of tones in the image.

12. What can the Curves tool be used for when preparing to scan an image?

13. What is the advantage to scanning from first-generation materials when using a film scanner?

14. Are the Photo CD and Picture CD just different names for the same product? Explain your answer.

15. How does electronic watermarking help protect an image from copyright violation?

Compositing:
The process of creating digital images by combining part or all of other images. Further manipulation may be done on the combined image.

Chapter 16

Digital Image Manipulation and Output

When you have finished reading this chapter, you will be able to:

→ Discuss the advantages and disadvantages of the "digital darkroom" vs. the conventional darkroom.

→ Distinguish between digital image processing and digital image manipulation.

→ Describe the general procedure for using image-editing software.

→ Apply digital darkroom techniques to adjust the size, contrast, and overall color balance of an image.

→ Explain how and why unsharp masking is used on digital images.

→ Describe the process of digital photo restoration.

→ Identify the major alternatives for digital image output.

In this age of digital imaging, it is possible to shoot a photo, process the image, and print a color enlargement in as little as five minutes. With a digital camera and an ink jet or dye sublimation printer (even the computer is optional), the photographer can capture an image with the camera, pop out the small memory card, and then insert the card directly into a reader slot on the printer. Minutes later, the finished print emerges. A number of sports and event photographers are using such capabilities to their business advantage: they often can have a photo of the rodeo performer's thrilling ride ready by the time the competition results are announced. See **Figure 16-1.**

This, of course, is an extreme application of the "digital darkroom" concept. For most photographers, the advantage of working digitally is not so much speed as it is creative control and convenience. Compared to a conventional darkroom, the space required by a computer, scanner, and printer is minimal (and *multipurpose,* since most people use the equipment to perform other tasks in addition to photo work). The convenience factor is a major advantage for many users. Unlike traditional darkroom work, the digital darkroom requires little setup time, and there is no need to set aside a block of time (typically several hours) to complete the work of printing, developing, fixing, washing, and drying prints.

It also offers much greater flexibility, since operations can be easily stopped and started. For example, work on a digital image can be halted, the results saved, and efforts resumed hours or even days later. In conventional darkroom work, operations must typically be carried through to completion in a single session. Conventional darkroom work usually means hours of standing in a darkened room; digital darkroom activities are carried out in room light from the comfort of a desk chair. For the

Figure 16-1. *A completely digital system permits the time lapse from image capture to finished print to be shortened to a matter of minutes. By the time the results of this rodeo barrel race are announced, a print of the last competitor's ride will be emerging from the photographer's printer. A number of photographers specializing in competitive event pictures of this type use a setup that tethers the digital camera to a computer with a cable. The image is downloaded to the hard drive, then sent to a printer for output. In another system, the camera's memory card is removed and slipped into the reader slot of a specially equipped printer. The image is printed from the card, without need for the computer.*

photographer with allergies or sensitivity to chemical fumes, the advantage of the digital darkroom is obvious.

On the other hand, processing in the digital darkroom doesn't have the same feeling as closing yourself up in the tiny world of the chemical darkroom, turning on some music, and working for hours that seem like minutes. It also requires learning a whole new set of skills and methods to achieve the results you are used to from the conventional darkroom (and it's even quicker and easier to produce really *bad* prints). In some contexts, digital imaging can raise ethical questions (depending

upon your view of photography as a truthful medium) as a result of inserting or removing elements from a picture. Actually, such manipulation has always been possible with the skilled use of traditional printing methods — it's just faster and easier to do with a computer and image-editing software.

Some photographers make a distinction between image processing and image manipulation. They consider *image processing* to consist of the electronic equivalents of the work typically done in the conventional darkroom: adjustment of exposure, color, and contrast; cropping the image, and dodging and burning. More extreme changes to the image, especially those that involve distortion, removal of particular elements from the photo, combining of elements from one or more other sources, or radical changes of color and tone, are considered *image manipulation.*

Using that distinction, processing activities could be classified as working in the *digital darkroom,* while manipulation could be characterized as working in the *digital studio.*

Image-editing software

The indispensable tool for either image processing or image manipulation is a software application referred to in general terms as an *editing program* or *image editor.* There are a number of such programs on the market, ranging from very simple ones that can be used for basic tasks to highly complex applications with an array of specialized features. See **Figure 16-2.**

Image-editing software is often *bundled* (included as an accessory item) with a digital camera or a scanner. Programs offered in this way tend toward the basic, but others provide an intermediate level of features. Kodak's Picture CD, promoted as an "add-on" to conventional processing, even includes a simple image editor on the CD containing the digitized photos.

Figure 16-2. *Image-editing software can range from the quite simple to the very complex. A—Corel Photo House is typical of the more basic editors, using buttons to display a number of preset functions and effects. B—Adobe Photoshop is considered the industry standard for image editing. It offers a great number of features, but requires investing considerable time and effort to learn to use it effectively.*

The procedure for using image-editing software, in general terms, includes:

1. Open an image for editing. This might be one already stored on the computer's hard drive, one imported from a CD, or the output of a scanner.
2. Perform basic image-processing actions, such as cropping or contrast adjustment.
3. Save the altered image file to preserve the changes.
4. Output the image to a printer.

Step 2 in the procedure, of course, is the complicated one. It may involve only a broad change or two, such as cropping the image or altering its overall brightness. At the opposite extreme, it could involve both broad changes and many smaller adjustments (from eliminating a scratch or spot to changing the color of a subject's eyes) to produce the desired result. *Note:* Experienced visual editors will normally make a copy of the image and use that copy to make changes. This preserves the original in its unchanged state for future use, if necessary.

Many different "tools" are available for performing actions on the image, **Figure 16-3.** They include painting and drawing tools, an eraser, color application tools, a "Rubber-Stamp" or cloning tool that can copy small portions of the image (very useful in eliminating dust spots or similar defects), and selection tools used to isolate part of an image for further processing.

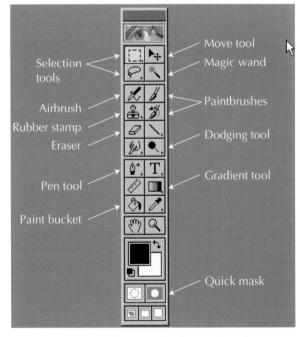

Figure 16-3. *Tools available for various image-editing functions are shown as icons on the toolbar, such as this one from Adobe Photoshop. A specific tool can be selected by clicking on its icon. The toolbar can be moved around the screen to suit individual user preferences.*

The tools are typically selected and applied by using the standard computer mouse, although a *graphics tablet and pen,* **Figure 16-4,** is favored by some users. The major advantage of the tablet and pen is more precise control of tools, especially when drawing or when retouching fine details. Adobe Photoshop and similar full-featured programs also allow the use of shortcut keys as an alternative to using a mouse and menu to perform many operations. *Shortcut keys* are typically individual keys or combinations of the **Ctrl** or **Alt** key (⌘ or **Option** key on a Macintosh) with a letter or numeral. For example, when using a brush on an image in Photoshop, the brush size can be changed with shortcut keys.] will change to the next larger brush; [will move to the next smaller. Using **Shift** plus] will select the last brush size/shape shown on the Brushes palette, while **Shift** plus [will select the first brush size/shape.

The image-editing window, **Figure 16-5,** varies in appearance somewhat from program to program, but almost always includes these features:

* a menu bar with drop-down menus across the top of the screen.

Figure 16-5. *The basic parts of an image-editing program screen. A—Menu bar with drop-down menus. B—Status or information bar. C—Workspace or editing area where the image is displayed. D—Toolbar displaying the available tools. E—Palettes used for specific displays.*

* a status or information bar across the bottom.
* a workspace or editing area where the image is displayed.
* a toolbar displaying the available tools.
* one or more palettes used for specific displays (such as color choices or brush sizes).

Working in the "digital darkroom"

As noted earlier, many photographers who are making the transition to digital imaging consider "digital darkroom" activities to be those equivalent to traditional printmaking processes. In the descriptions of techniques that follow, the tools, commands, and screen representations are from Adobe Photoshop. Although they may differ in name or appearance, the corresponding tools and commands of other image-editing programs accomplish similar results.

Cropping and flopping images

To bring out the best in an image, cropping is often necessary. For those who

Figure 16-4. *A special pen, used with a graphics tablet, allows precise control when working on images. It is particularly valuable when retouching fine details, or when using the brush, pencil, pen, or airbrush tools. (Wacom)*

scan their own images, cropping is often performed as part of the scanning process. Images from a CD, or those imported directly from a digital camera, will be full-frame — any cropping will need to be done with the image-editing software.

The *Rectangular Marquee* selection tool can be used to crop an image, **Figure 16-6.** After using a mouse click to select the tool from the toolbar, the user then clicks on one of the intended corners of the area to be cropped. By holding down the mouse button and dragging to the diagonally opposite corner, a rectangular frame of dashed lines will be visible. When the mouse button is released, the lines of the frame will appear to be in motion (this appearance is referred to by veteran Photoshop users as *"the marching ants"*). The border can be moved by clicking inside it and dragging it in the desired direction. It cannot be changed in size, however. If a different-size crop is needed, click *outside* the frame to delete it, then repeat the click-and-drag process to create a new frame. To perform the actual crop, select Crop from the Image drop-down menu.

A more flexible method is the use of the *Cropping* tool. Grouped with the selection Marquees on the toolbar (in the selection tool flyout), this tool is applied in the same way (click and drag), but can be adjusted in both size and orientation. Once the mouse button is released, the frame can be resized by selecting and dragging any of the four sides or corners. The image can be rotated, as well as cropped, by clicking outside the frame and dragging the mouse in the desired direction, **Figure 16-7.** The change is previewed on screen, making it easy to determine when the proper amount of rotation has been achieved. To perform the crop, the user can double-click inside the frame, or merely press the **Enter** key.

Sometimes, an image will look better if it is reversed left-to-right. In the conventional darkroom, this is done by *flopping the negative* (turning it upside down) before making the print. In the digital darkroom, it can be done with a single mouse click, **Figure 16-8.** In addition to the "flip horizontal" and "flip vertical" choices, it is possible to rotate the entire frame 90° to 180° (a different menu allows rotation in smaller increments).

Cleaning up the image

Despite the most careful cleaning of a negative before printing in the conventional

Figure 16-6. *Clicking and dragging create a frame ("Rectangular Marquee") to identify the desired crop. The frame can be moved, but not adjusted in size. If a different crop is desired, the frame is deleted and a new one created with the mouse.*

Figure 16-7. *The Cropping tool is versatile, since it allows both resizing and rotation of the frame. Rotation is achieved by clicking outside the frame and pulling it in the desired direction. This method is particularly useful for straightening crooked scans.*

Figure 16-8. *Flipping an image. A—A single mouse click on a drop-down menu can reverse an image vertically or horizontally. B—The image is reversed left-to-right.*

darkroom, at least a few small white dust spots are likely to turn up on the final print. These must be eliminated by the use of dye solutions and a very fine-pointed brush. The process, called *spotting,* is tedious and takes some practice to achieve acceptable results.

The digital darkroom makes the spotting task much easier, but careful cleaning is still necessary to minimize the problem. When scanning from prints, the glass of the flatbed scanner should be inspected and cleaned if necessary; negatives and slides should be dusted with a soft (preferably antistatic) brush before being inserted in the film scanner.

Spotting is done with the **Rubber-Stamp** tool, which basically is used to copy (*clone*) a small area of the image and place it over the white dust spot. The size of the copied area and the nature of the copied information (hard- or soft-edged and the degree of opacity) can be varied to suit the situation. The working size of the Rubber-Stamp tool is set by choosing a brush size from the Brushes palette; for spotting work, a fairly small soft-edged brush is normally used.

Figure 16-9 shows a portion of a scanned image that requires spotting. Only a portion of the full image is visible — all spotting work should be done with the image at the full-size (100%) setting. This allows you to see what the image will look like when printed, so that defects can be identified and corrected. Spotting should be done systematically, beginning at one of the image corners and proceeding in steps until the entire image has been processed. The

Figure 16-9. *Spotting is done with the image displayed at 100% (percentage is shown next to the filename at the top of the image display) to make defects visible. Only a portion of the image can be shown on the display at one time. The small, bright white spots that are visible are dust spots that must be eliminated by cloning. Size and position of the brush selected for the work is indicated by a small black circle. On the Brushes palette (upper-right side of the display), a black box surrounds the chosen brush.*

Page Up and **Page Down** keys allow you to step through the image vertically; combined with the **Ctrl** key, they allow horizontal stepping.

Eliminating a spot using the Rubber-Stamp tool involves several steps:

1. Position the cursor (brush-size circle) on an area near the spot to be removed. The area should be as close as possible in appearance to the spot's immediate surroundings. This will make the "cover-up" less obvious.

2. Hold down the **Alt** key (**Option** on a Mac) and click with the left mouse button. This selects the image pixels that will be copied.

3. Reposition the cursor over the spot and press the left mouse button. The white spot will be covered with the image information (pixels) you selected in step 2. If the spot is larger than the brush size, move the cursor and press the left mouse button again. Continue moving and clicking until the spot is eliminated. See **Figure 16-10.**

4. Larger areas can be covered by clicking and dragging (using the tool as a paintbrush), but the results are often an unsatisfactory patterned appearance. Moving and clicking to cover the defect with a series of smaller cloned spots gives better results.

A growing number of scanners offer a feature that automatically cleans up dust spots and scratches during the scanning process. This can be a real timesaver, especially if the original is in poor condition from improper storage.

Most image-editing programs offer a tool that automatically cleans up scans from images that exhibit a large number of such defects. In Photoshop, the tool is called the Dust and Scratches filter, **Figure 16-11.** This filter actually works by blurring pixels in small bright areas (which are usually dust spots or scratches), but can cause an undesirable softening of the entire image.

Two settings in the dialog box for the Dust and Scratches filter allow you to select the degree of change. The Radius setting determines the width of the defect that the program will identify as a spot or scratch. The larger the number, the more blurred the image will be. The Threshold setting sets the sensitivity of the filter — how much the

Figure 16-10. *After selecting an area from which to clone image information, the brush circle is placed over the spot. A mouse click will copy the selected image over the white spot. For large spots like the one at lower-left, the action is repeated several times.*

Figure 16-11. *The Dust and Scratches filter can clean up images with many small defects, but can also soften the image unacceptably. Experiment with different radius and threshold settings to see their effect before using the filter.*

color of the spot must differ from its surroundings to be considered a defect. If the setting is 1, the filter would consider everything a defect and blur the whole image; a value of 255 would have the opposite effect — no defects would be recognized and nothing would be changed. Checking the Preview box allows you to see the amount of blurring and spot elimination done at various settings. Because of its effect on image quality, this filter should be used only for images that show a very large number of defects. Although it can be tedious, cleaning up spots and scratches with the Rubber-Stamp tool will preserve the quality of the image.

Altering contrast

Altering the relationship of shadow and highlight, or *contrast*, within a photo is one of the basic operations of both the conventional and the digital darkroom. Whether made from a negative or a scan, a **straight print** (unaltered image) is seldom totally satisfactory. The tonal range may be *too narrow,* resulting in a flat and dull image, or *too wide,* producing a harsh and too-contrasty print.

In the conventional darkroom, the overall contrast of the print is adjusted by selecting a different grade of paper or a different filter (when using variable-contrast papers). For a flat image, a "harder" (higher-numbered) paper grade or filter is chosen; an overly-contrasty image would call for a "softer"(lower-numbered) paper or filter. Both papers and filters are limited in the contrast grades offered. Papers range from grade 0 (very soft) to grade 5 (very hard), while filters may be found in half-step increments from 00–5.

The digital darkroom, however, permits use of an infinite range of contrast alterations. There are two basic methods for changing contrast: the Brightness/Contrast tool, and the Curves tool. Both are accessed by clicking on the Image selection on the menu bar, then clicking on Adjust. This presents a drop-down menu with various

tools for adjusting the tones and colors of a image. The *Brightness/Contrast* tool is simple and easy to use: sliders allow adjustment of either brightness or contrast from 0 to 100 (increase) or 0 to –100 (decrease). Since sliders are difficult to adjust in small increments, however, control is not very precise.

The Curves tool, **Figure 16-12**, is more versatile. Its tone graph is initially presented as a straight diagonal line, representing the gradation from darkest value (at lower left) to brightest value (at upper right). Using the mouse, a graph curve can be constructed that is reflected by value changes in the image. If the Preview box is checked (the usual configuration), changes can be observed on the monitor as adjustments are made. To alter contrast using the Curves tool:

1. With the image open, select Curves from the drop-down menu.

2. Click on the midpoint of the diagonal line to anchor it at that point. A small black dot will appear at the center of the graph line. This locks the mid-tone values so that they will not shift when other areas of the line are adjusted.

Figure 16-12. *When the curves dialog is first opened, the tone curve is shown as a straight line. The lower-left end of the curve represents the shadow values; the upper-right end, highlights. Note that the Preview box is checked, so that changes made to the graph will be reflected in the image shown on the monitor.*

3. Click on the line at a point midway between the center and the lower-left corner, and then drag it a small distance diagonally down and to the right. Note that the line is now a curve from the midpoint to the lower-left corner. The line from the midpoint to the upper-right corner has assumed a matching (but opposite) curved shape, **Figure 16-13.** The image will have become more contrasty, with the tonal range extended. The degree of contrast change depends upon the distance the point was moved — the farther the line curves away from the diagonal, the greater the change.

4. To decrease contrast, the curve is moved in the opposite direction, curving upward from the lower left-corner to the midpoint and downward from the midpoint to the upper-right corner. The tonal range is decreased, "flattening" the image.

When working with a color image, contrast of the red, green, and blue color channels can be adjusted individually for greater control. The desired channel can be selected

Figure 16-13. *With the curve anchored in the middle, a change in the lower portion of the line is mirrored in the upper portion. This mildly S-curved line represents a moderate increase in the contrast of the image. If a color image is being adjusted, changes can be made independently to each of the three color channels.*

using the Channel box above the tone graph. *Composite* is the default; when it is displayed, contrast adjustments are applied to all three channels simultaneously.

Contrast also can be adjusted *locally* (in a selected area). Such a change might be made to bring up detail in the somewhat dark foreground of a landscape. This is equivalent to the conventional darkroom process of using different contrast filters to expose selected areas of a print. First, a selection (discussed later in this chapter) is made, then the contrast adjustment is carried out. The change will affect only the selected area.

Adjusting color

Working with color images, as compared to black-and-white images, can be considered three or four times as complicated, since color images consist of either three channels (red, blue, and green) or four (cyan, magenta, yellow, black). As described earlier in this text, the images displayed on your computer screen or television set are *RGB images:* all the colors you see are combinations of varying amounts of red, blue, and green light. On the screen, tiny *phosphor dots* of red, blue, and green glow when struck by a beam of electrons, transmitting the color. Red, green, and blue are referred to as the *additive primaries,* since their light is added together to make a color.

Images that are printed on paper or other opaque base material cannot depend on transmitted light to convey colors to the eye. Instead, they make use of reflected light. A different set of colors (cyan, magenta, and yellow) are used for printed images. Each color blocks, or subtracts, a specific color and reflects others. Yellow absorbs the blue wavelengths of light but reflects red and green, magenta absorbs green but reflects red and blue, while cyan absorbs red and reflects blue and green. For this reason, cyan, magenta, and yellow are called the *subtractive primaries.*

On the standard color wheel, the additive and subtractive primaries alternate and thus

are paired on opposite sides: red is opposite cyan, blue is opposite yellow, and green is opposite magenta. The colors in each pair are known as *complementary* colors.

Familiarity with the complementary-color pairs is important when correcting color images using the Curves tool. With Curves, adjustments can be made to the composite RGB curve, which affects the image as a whole, or to the individual color channels (providing much more precise control). **Figure 16-14** is a photo taken under industrial fluorescent lighting, which gave it an overall green color cast.

To correct the cast:

1. Display the Curves tool and switch to the green channel (since green is the problem color).

2. Hold down the **Alt** key and move the cursor (which appears as an Eyedropper tool) to an area where the color cast is most noticeable. A small circle will appear on the diagonal line of the tone graph. This indicates the graph location for the pixel values being sampled. Note the location.

3. Click on the graph at the point where the circle was shown, then drag the line to adjust the color. Since the object is to make the image less green, drag the line diagonally downward to the right. Observe the change in the image as you reduce green and increase its complementary color, magenta. (If you drag too far, you will see the image taking on a distinct magenta cast.)

4. After making the adjustment for the green cast, the image appears slightly too blue and cold. It can be warmed in tone by adjusting the blue curve to slightly increase the amount of yellow.

5. The changes in the green and blue curves have caused the image to darken somewhat. To lighten the entire image, switch to the composite (RGB) curve and pull diagonally up to the left on the midpoint of the curve, **Figure 16-15.**

A color correction method that doesn't offer control as precise as Curves, but is somewhat less complex to use, is the Color-Balance tool. It presents the three pairs of complementary colors, with a slider control for each pair. To make a color correction, the appropriate slider is moved toward the color that is to be increased, **Figure 16-16.** The color balance can be adjusted differently, if desired, in the image's shadows, midtones, and highlights.

Figure 16-14. *Fluorescent lighting has given this photo a strong green cast. Using the Curves tool, the green channel can be adjusted to correct the color.*

Figure 16-15. *To brighten the image, the composite curve is pulled slightly upward. The proper amount of adjustment can be judged by changes on the displayed image.*

Figure 16-16. *This photo, taken with incandescent light on daylight-balanced film, is much too yellow. The Color Balance tool can be used to add blue, effectively decreasing the yellow. The amount of decrease can be different in shadow, midtone, or highlight areas. Color Balance is quicker and easier to use than Curves, but control is less precise.*

The Hue/Saturation tool can be used to fine-tune colors in an image. It permits selection of any of the six primary colors in the image (red, green, blue, cyan, magenta, yellow) and adjustment of the hue, saturation, and brightness of the chosen color.

As shown in **Figure 16-17**, the hue slider can shift a given color toward its neighbors on the color wheel (the two colors that are its components). If the selected color is red, for example, sliding the control to the left will change the red values in the image to magenta; sliding to the right will change them to yellow. Such extreme shifts would seldom be made — more often, you would want to make the red just a bit more magenta or a bit more yellow. The Saturation slider changes the *intensity* (strength) of the color; the Lightness slider alters the overall brightness.

Converting color to shades of gray

For dramatic effect or other reasons, it is sometimes desirable to change a color image to a *monochrome* (single-color; typically, black-and-white) image. There are two basic ways to achieve this result:

- mode conversion to grayscale
- desaturation, or the removal of color.

When an image is converted from a color mode to *grayscale mode,* all the color information is thrown away. The three color channels (red, green, blue) are merged into a single grayscale channel. The major drawback to this form of conversion is that the resulting image is often somewhat flat and lacking in contrast (especially local contrast). The problem occurs because very different colors (some shades of red and green, for example) have very similar brightness

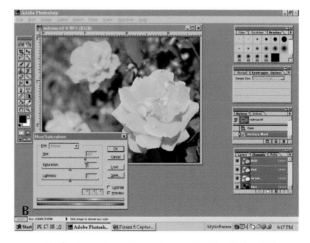

Figure 16-17. *The hue slider can be used to make dramatic shifts in color. A—Sliding to the left shifts the color of the red flower toward magenta (the original color is displayed in the small image on the History palette at right). B—Sliding the control to the right shifts the hue toward yellow.*

values. When converted from color to a shade of gray, similar brightness values make it difficult to distinguish a red flower from its background of green leaves. Further processing of the converted image using the Levels or Curves tools can improve the contrast.

An alternate conversion method that often gives better contrast is to review the color channels (which are displayed in grayscale) and select the one that looks best. With the desired channel selected, the Grayscale command will use the brightness values of that channel to make the conversion. **Figure 16-18** shows the results of the two conversion methods.

When the *Desaturate* command is used, **Figure 16-19,** color is removed from the image, and gray values are displayed. The image remains in the color mode, with the three color channels still intact. This increases the possibilities for image manipulation, such as adding areas of color or restoring some portions of the image to their original color values (see *Using special effects,* later in this chapter).

To desaturate only part of an image, so that some areas are gray and others in color, two different techniques may be used. A *selection* may be made to isolate the desired part of the image, and the Desaturate command applied to the selected area. Direct desaturation can be done with the *Sponge*

Figure 16-19. *When the Desaturate tool is used, the image displays gray values, but remains in a color mode. This image was desaturated, then the original color was restored to the left side to compare the color and gray values.*

tool. This tool, located with the Dodge and Burn tools on the toolbar, is applied like a paintbrush or eraser tool to the desired area. Opacity can be set to 100% to remove all color, or set to a lower value to leave a tint of the color in the area. See **Figure 16-20.**

"Burning in" and "dodging"

The processes of increasing exposure (*burning in*) or decreasing exposure (*dodging*) in specific print areas are familiar techniques to those who have worked in a

Original	**Grayscale**	**Grayscale from color channel**

Figure 16-18. *The grayscale command can result in a flat image (center) because of similar brightness values of different colors. Selecting the best color channel and converting it to grayscale (right) can provide better contrast.*

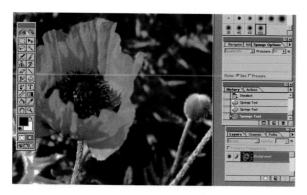

Figure 16-20. *The Sponge tool can "wipe away" color in selected areas for effect. Different opacity settings can alter the effect, leaving a tint of color in place. The Sponge tool was used, with a low opacity setting, on the stems at the right side of the poppy photograph.*

conventional darkroom. The techniques are described in some detail in Chapter 9.

In the digital darkroom, the same methods are used for local control of image brightness and darkness. The toolbar contains a Burn tool and a Dodge tool, which are used for the same purposes, and in much the same manner, as their conventional-darkroom counterparts.

Like the Color Balance tool, both the Dodge and Burn tools offer the option of being applied to the shadows, midtones, or highlights. The exposure can be controlled by typing in a value (from 1–100) or using a slider on the options palette, **Figure 16-21.** For those who use a pen and graphics tablet, the palette has check boxes to specify whether pen pressure will affect exposure or the size of the area being burned or dodged.

Once the Dodge or the Burn tool is selected, the size of the tool can be chosen from the Brushes palette. Typically, a soft-edged brush is used to help blend the effect with surrounding image areas; brush size depends upon the size of the area being dodged or burned. Change is cumulative — each pass over a given area will increase the darkening or lightening effect. For this reason, the exposure should be set to a low value (10 or less) and the effect built up gradually with multiple passes over the

desired area. As in the conventional dark-room, skill in using dodging and burning techniques will grow with practice.

The digital techniques, like their conventional counterparts of burning in and dodging, cannot create texture and detail where none is available. If highlight areas are "blown out" to pure white by over-exposure, burning in can do nothing more than create a featureless and unattractive gray tone. Similarly, dense black under-exposed shadow areas can be lightened, but will also be without any detail or texture.

Sharpening the image

One technique available in the digital darkroom that has no conventional dark-room counterpart is *sharpening,* which involves enhancing edge contrast to make the image appear more sharply focused. While it cannot correct an image that is badly out of focus, it can improve one that is slightly soft. The most common use for the sharpening technique, however, is overcoming the slight blurring that can occur when an image is resized, rotated, or otherwise processed digitally.

Sharpening is actually an optical illusion: it doesn't restore lost detail, but increases the

Figure 16-21. *Controls for the Dodge and Burn tools have the same options: adjusting the intensity of the effect on a scale of 1–100, and a choice of whether changes will be applied to the shadow, midtone, or highlight values. Pen pressure can be set to change exposure or tool size.*

difference in the color of adjacent pixels, especially along edges. This tricks the eye into seeing the image as more detailed and sharp. The technique must be used with care; *oversharpening* can give the image an unattractive, harsh, blotchy appearance. See **Figure 16-22.**

An image-editing program may offer several sharpening tools or *filters*. Photoshop, for example, lists four choices: Sharpen, Sharpen Edges, Sharpen More, and Unsharp Mask. Although it has the least-likely sounding name, the best of these tools — because of the control it offers — is Unsharp Mask. The other three choices are "all-or-nothing" in their approach, providing a set amount of sharpening (minimal in the case of Sharpen and Sharpen Edges, a considerably greater amount in Sharpen More).

The Unsharp Mask filter will create a slightly blurred copy of the image and use it as a mask (hence, *unsharp mask*) to determine which areas will be sharpened. As shown in **Figure 16-23**, the degree of sharpening can be controlled and previewed when using this filter. The chosen degree of sharpening is displayed on both the full-size screen image (for accurate judgment of the effect, the displayed image should be at 100%) and on a small detail view. By clicking on this detail view, you can compare the image before sharpening and with sharpening applied.

Three sliders —Amount, Radius, and Threshold — control the effect of the filter. (Values can also be entered from the keyboard.) *Amount* can be adjusted from 1%–500%, but most often, it will be set somewhere in the lower middle part of that range, from about 100%–200%. Higher values are typically used with larger images that will be reproduced on ink jet or dye

Figure 16-22. *Oversharpening can seriously degrade image quality. A—A properly sharpened image. B—The same image after being badly oversharpened.*

Figure 16-23. *The effect of different Unsharp Mask percentages can be viewed in both the large monitor image and in the small detail view that is part of the dialog box. Unsharp masking is the most effective sharpening method.*

sublimation printers; lower values on smaller images, especially if they will be reproduced by the halftone printing process (for example, in a magazine).

Radius settings can be varied from 0.1 pixel to 250 pixels. At the lower values, sharpening is confined mainly to edges within the image; settings of 5 pixels or lower are normally used. The *Threshold* setting identifies how much different in brightness level two pixels must be before sharpening will be applied. The adjustment range is 1–255, with the number of pixels affected decreasing as the setting increases. A typical starting point for Threshold settings would be 3–4.

Artistic combination and manipulation

Beyond the basic image adjustments and techniques of the digital darkroom, the photographer enters the realm of image manipulation. The basic areas of manipulation include removing or adding picture elements; altering the shape, color, texture, or

other visible attribute of the subject; changing the relationship of elements in the picture, and combining elements from two or more pictures into a single image. Only a general overview of image manipulation can be presented in the space available here. If you wish to explore this area in greater depth, there are numerous books available on various aspects of digital imaging, especially on the use of Photoshop and similar image-editing programs.

Selecting parts of images

A basic skill for any photographer who will be doing image manipulation is mastering the use of selection tools to choose one element of an image. Once selected, that element is *isolated,* so that it can be manipulated (rotated, changed in color, etc.) without affecting other portions of the image. The selected element can be copied, repositioned within the image, or moved to another image.

Selection tools

There are a number of types of selection tools, ranging from the simple Marquees (rectangular/square, elliptical/circular) to the Lasso and Pen tools, to the Magic Wand. See **Figure 16-24.**

Marquee. The Marquee tools are quick and easy to use when the area being selected is a simple rectangular or circular shape. All

Figure 16-24. *Image-editing software typically offers the choice of several selection tools.*

are used with a "click and drag" technique —
clicking with the mouse at the point of origin,
dragging to the final size and shape, and then
releasing the mouse button. (Refer to Figure
16-6.) To constrain the Rectangular Marquee
to a square selection, or the Elliptical Marquee
to a circle, hold down the **Shift** key while
selecting. Holding down the **Alt** (**Option** on a
Mac) key will radiate the selection outward
from a center point. The rectangular/square
marquee can be used for cropping an image;
the elliptical/circular one cannot.

Lasso. This tool allows you to select
irregular shapes by using the mouse or a pen
and graphics tablet to "draw" around the
desired outline. There are actually three lasso
tools, each using a slightly different selection
technique. The basic *Lasso* tool is a freehand
drawing tool used to trace as closely as possi-
ble around the desired outline, **Figure 16-25.**
After the initial click, the mouse button is
held down until tracing is completed back to
the point of origin. When the button is
released, the familiar "marching ants" selec-
tion outline appears. The *Magnetic Lasso*
tool works in a similar fashion, but doesn't
require holding down the mouse button after
the initial click. The shape is traced with the
mouse, just as you would with the basic
Lasso tool; when the origin point is reached,
the selection appears. This tool works best
when selecting shapes with well-defined

edges, since it distinguishes differences in
color or brightness. The *Polygon Lasso* tool
is useful for making fairly precise selections
that have straight edges. It is used by clicking
on the origin, then stretching the visible line
(a method called *rubberbanding*) to the point
where the edge changes direction. Clicking
sets an anchor point for the first line seg-
ment; the line is then stretched to the next
direction change and another point is placed.
The process continues until the entire shape
has been defined with points and lines.
Although curved portions of a selection can
be defined by using many short straight-line
segments, such shapes are better selected
using the *Pen* tool.

Pen. The most precise and sophisticated
of the selection tools, the pen is used to
define a *path,* which can then be edited and
altered as necessary. Like the Polygon Lasso
tool described in the last section, the *Pen*
tool uses a "connect-the-dots" technique.
The difference, however, is in the nature of
the points set by clicking the mouse: points
set by the Pen tool have *handles* that can be
used to curve the line segment between
them. This allows the selection of curved
shapes, **Figure 16-26.** In addition to the basic

Figure 16-26. *Handles on the points set by the
Pen tool can be used to fit the line to curved
shapes. (Leonard Rue Enterprises)*

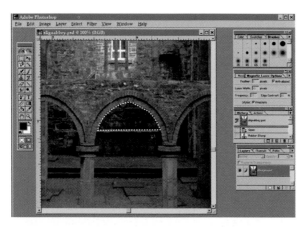

Figure 16-25. *Lasso tools can be used to make a
selection by drawing around the area you want
to isolate.*

Pen tool, you may select the Magnetic Pen tool or the Freeform Pen tool. The *Magnetic Pen* tool operates in much the same way as the Magnetic Lasso: clicking to set an origin point, then moving the mouse around the desired outline. Clicking again on the origin point will define the completed path. The *Freeform Pen* tool is similar in operation, but requires you to hold down the mouse button after clicking on the origin point. After the path has been traced, releasing the mouse button will automatically set the points and connecting line segments. Once the path is complete and has been adjusted to its final contour, it can be turned into a selection. There are a number of methods of doing so, but the simplest is to click on the "convert-path-to-selection" icon at the bottom of the Paths palette, **Figure 16-27.**

Magic Wand. If the area to be selected is quite uniform in color and that color is different from adjacent image areas, the *Magic Wand* tool can often be used to make a quick selection. An example would be a product photo made against a white studio background. The magic wand can be used to select the background so that it can be deleted and a scene or other background substituted. The selection is made by choosing the Magic Wand tool and clicking

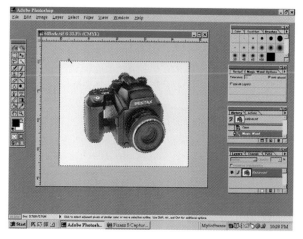

Figure 16-28. *The Magic Wand tool can quickly select areas of similar brightness, such as the background of this product photo taken with a white seamless backdrop. Adjusting the Tolerance setting can change the number of pixels selected. (Pentax)*

in the desired area, **Figure 16-28.** The sensitivity of the Magic Wand — which image pixels it will select — is determined by the Tolerance setting on the Magic Wand Options palette. The Wand makes its selection based on the brightness value (0–255) of the chosen pixel. The Tolerance setting determines how many levels above and below the chosen one will be selected. For example, if the chosen pixel value was 200 and the Tolerance was set at 25, all adjacent pixels with values between 175 and 225 would be selected.

Refining selections with Quick Mask

Even the most careful and precise selection often will need some "touch-up" work along the edges. This is done most easily using the Quick Mask overlay, which allows you to add to or delete areas of the selection.

Clicking on the Quick Mask icon at the bottom of the toolbar will generate a translucent (50% opacity) red mask that covers all the area outside the selection. If preferred, the overlay can be reversed, or *inverted*, to cover the selection instead. By selecting a brush size, and the foreground color, new areas can be painted onto the mask to refine

Figure 16-27. *A path can be converted to a selection with a single click of the mouse. (National Pork Producers Council)*

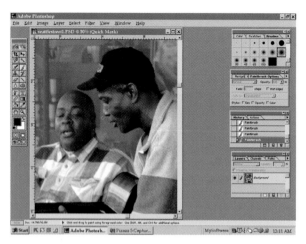

Figure 16-29. *A selection can be refined with the Quick Mask overlay by painting in additional mask areas or erasing part of the mask.*

the selection, **Figure 16-29.** If the background color is selected instead, the brush can be used to erase the red mask in chosen areas. To check the effect of mask changes on the actual selection, you can toggle back and forth between the Quick Mask and the selection outline by clicking on the respective icons.

Working with layered images

One of the most attractive features of the more sophisticated image-editing programs is the ability to create image layers. These *layers* can be thought of as separate transparent sheets attached to the base image. By placing different elements of the image on separate layers, those elements can be worked on independently, without affecting the rest of the image. Material on a layer can be used to totally block out the corresponding image area on layers below it, or may be *ghosted back* (lowered in opacity) to allow the underlying material to show through to a greater or lesser degree. Two identical layers can be blended together for various effects, including overall darkening or lightening of the image. This blending technique is often used to bring out detail in an overexposed (too light) image.

When an image from a scanner, digital camera, or CD is first opened in the

image-editing program, it will be on a single layer called the *background layer.* If only the common digital darkroom tasks are to be performed on the image, the single background layer may be sufficient.

The background layer and any layers added to the image will appear on the Layers palette, **Figure 16-30.** Each layer is a separate item on the palette, and can be displayed on the monitor by itself, or combined with other layers. In multiple-layer documents, the visibility of each layer is indicated by an *eye icon* to the far left of the item. Clicking on the icon turns layer visibility on and off. Changes to a layer can only be made when that layer is the *active layer,* indicated by the layer name being highlighted and showing a *brush icon* immediately to its left.

Layers can be added or deleted. They also can be moved to a different position within the stack of items shown on the layers palette (as new layers are added, they are placed on top of the stack). New layer creation is discussed in the next section. A layer (with all its included image information) can be deleted by dragging the item to the trashcan shown at the bottom of the

Figure 16-30. *All layers created for an image are shown as items on the Layers palette. Note the eye icons to the left of the items, showing that all three layers are currently visible on the monitor. The green highlighting and brush icon show that Layer 2 is currently active; any changes to the image will be made on that layer.*

palette. Layers can be moved by dragging them upward or downward in the stack, They also can be relocated using the Arrange commands from the Layers menu. The Bring-to-Front and Send-to-Back commands move the selected layer to the top or bottom of the stack, respectively (the background layer is always at the bottom, so the Send-to-Back command places the moved layer just above it). Two other commands move a selected layer upward or downward in the stack, one item at a time. They are Bring Forward and Send Backward.

Creating new layers

The background layer alone is adequate for simple adjustments, but for more complex manipulation of an image, additional layers are a necessity. New layers can be created in a number of ways. To open a new blank layer, click on the Create-New-Layer icon at the bottom of the Layers palette, or select New Layer from the Layer drop-down menu.

When you have made a selection of part of an image and wish to place it on a separate layer, select New Layer from the Layer drop-down menu. Among the menu choices will be Layer via Cut and Layer via Copy.

Both choices copy the selection to a new layer, but they differ greatly in their effect on the original image layer. Layer via Cut will leave a blank area behind when the new layer is created. On a background layer, the "hole" will be white; on other layers, the opening will be transparent. Layer via Copy is exactly that: the selection is copied onto the new layer but the original remains intact. See **Figure 16-31.**

A selection can also be placed on a new layer in a *different* image, a common technique when creating a composite (described in the next section). There are two different methods for moving a selection to a different image: cut-and-paste and dragging.

Cut-and-paste. Click on the selection, then select Cut or Copy from the Edit menu (shortcut keys are **Ctrl X** and **Ctrl C,** respectively). Open the destination image, and then click on Paste from the Edit Menu or use the shortcut keys, **Ctrl V.** The selection will be placed on a new layer in the destination image.

Dragging. Both images must be open on the monitor. Select the Move tool from the toolbar, and then click on the selection and drag it to the destination image. The selection will be placed on a new layer in the

Figure 16-31. *A selection can be placed on a new layer by either cutting (left) or copying (right). When the new layer is created, the selection occupies the same position as it did on the original layer — they have been moved in these examples to show the effect on the original layer of cutting or copying.*

Figure 16-32. *Dragging with the Move tool is an easy method of copying a selection from one image to another. The cut-and-paste or copy-and-paste techniques can also be used.*

destination image. See **Figure 16-32.** Existing layers can also be copied from one image to another by dragging. Again, both images must be open on the monitor. Click on the origin image to make it active, and then click on the desired layer thumbnail on the Layers palette. Drag the layer to the destination image, releasing the mouse button when a black border appears around the destination image window.

Combining images

The ability to select part of one image and make it part of another is the key to creating *composites* (combined images). Sometimes these combinations are strictly utilitarian, such as placing several product shots on a common background. Often, however, they are created for an artistic purpose, resulting in images ranging from the clearly fantastic to what have been called "believable lies" — scenes that *might* have been captured with a camera. See **Figure 16-33.**

When creating a composite, the *order* of the image layers is important, since each layer will obscure some portion (or all) of the layers below it. New layers are created with a transparent background. When an image is placed on the new layer, only the image area will obscure the layer below: the

transparent background will allow the rest to be visible. See **Figure 16-34.** At times, it is desirable to have the image on the lower layer "show through" the image on the upper layer. The upper layer image can be made more or less transparent by changing its opacity, using a slider control on the Layers palette. **Figure 16-35** shows the varying effects possible.

In addition to changing opacity, you can make many other adjustments or changes to the image on a given layer without affecting the other layers. As described in the Digital Darkroom portion of this chapter, you can adjust the contrast, color, orientation, and other characteristics of the image. It is also possible to erase portions of the image, add to the image, or apply various special effects.

Erasing. By choosing the Eraser tool from the toolbar, you can selectively "wipe out" portions of an image. On the background layer, the opaque (usually white) background color will show through after erasing; other layers will erase to a transparent background. Like most image-editing tools, the Eraser is available with a number of options. It can be used like a paintbrush, with any of the hard-edged or soft-edged

Figure 16-33. *This composite illustration was built from five separate elements: the head, pepper, fragments of pepper, "rocket," and sky background. Additional layers were used to create the cloud of vapor and the blurred pepper and rocket images that indicate movement.*

brush sizes chosen from the Brushes palette; like a pencil, with only hard-edged sizes, or like an airbrush, which can provide very soft edge transitions. Also available is a square block eraser, which provides a clean, hard edge. All but the block eraser can be varied in opacity, allowing only partial erasure of the pixels. This can be useful for fading effects, or for blending overlapping images.

Adding to an image. A variety of tools and techniques can be used to add to an image. The Rubber-Stamp tool, if carefully used, can extend the edges of an image to cover a larger area. This is especially useful when the area to be extended is patterned or has a distinct texture (for example, grass or massed flowers). Areas of solid color can be added using the Paintbrush tool or the Airbrush tool (better where gradations of color are required). To select a color in the image for matching, the Eyedropper tool is used, **Figure 16-36.** The sampled color becomes the foreground color that will be applied by the drawing tool.

A portion of the image can be selected and copied, then moved to the desired area. When positioned and altered, if necessary, (erasing extra image areas, for example) the

Figure 16-34. *In a composite illustration, the image on a layer will obscure areas on the layer or layers below it. A—The background layer. B—The upper layer. C—The two-layer composite.*

Figure 16-35. *The amount of "show through" from the lower layer can be varied by changing the opacity of the upper layer. A—An opacity of 75%. B—An opacity of 45%.*

Figure 16-36. *The Eyedropper tool is used to select a color from the image for application by the Paintbrush, Airbrush, and other tools. The selected color (in this case, a red-orange) becomes the new foreground color. To revert to the default foreground color (black) click on the small black and white squares below the foreground color display.*

new layer can be merged with the layer from which it was copied. This will allow treating it as a single unit for later manipulation. The Layer drop-down menu offers several choices for multilayer images:

- **Merge Down.** Selecting this option will merge the active (highlighted) layer with the one immediately below it.

- **Merge Visible.** A number of layers can be merged with this option. All layers that are currently visible (showing the eye icon) will be merged.

- **Flatten.** This choice merges all layers into one. Flattening is the first step in converting the file from its native Photoshop format to a different format that does not support layers. Conversion to these formats, such as *TIFF* (Tagged Image File Format) or *EPS* (Encapsulated PostScript), is necessary for inserting the file into a page-layout program. Flattening should not be done until all adjustments and changes have been made to the image. Although further changes can be made to the flattened image, the flexibility of separate layers has been lost.

Applying special effects. The Edit drop-down menu provides access to a number of tools for changing the size, shape, and orientation of an image or a selection. The Transform section of that menu offers tools for scaling the image to a larger or smaller size, rotating it a set or specified number of degrees, skewing or distorting it in different directions, or altering its perspective. See **Figure 16-37.** Transformations cannot be applied to the entire background layer, but can be done to selections made on the background layer. To apply a transformation to the entire background layer, make a background copy by using the Duplicate Layer command from the Layer menu. The original background layer can then be discarded, and any desired transformations can be made on the background copy.

Changes ranging from very mild to very wild also can be applied to all or part of an image by the use of *filters*, **Figure 16-38.** A large number of these are included with Photoshop and other high-end image-editing programs; many more are available as *plug-ins* from software companies specializing in graphic applications. The

Figure 16-37. *The Perspective tool is useful for correcting such problems as converging verticals. It can also be used, however, to distort a selected part of an image for effect, as in the case of this pillared facade.*

Figure 16-38. *A sampling of filter effects. A—The original image before filtering. B—Motion Blur was applied to just the foot, leg, and pedal. C—The Rough Pastels filter. D—The Mosaic filter. E—The Graphic Pen filter. F—The Emboss filter. G—The Find Edges filter. H—The Texturizer (burlap) filter. I—The Neon Glow filter.*

more dramatic filters, which radically alter the appearance of the image, often are best applied to full images to serve as a background. Applying them to only part of an image, however, can make a strong visual statement, **Figure 16-39.**

Colorizing monochrome images. A black-and-white image, while striking by itself, can sometimes be made even more dramatic by the addition of color. The

process of hand-coloring black-and-white conventional prints with oils or pencils achieves a distinctive look that can be duplicated with digital techniques. Another approach makes use of a strategically placed spot or two of vivid color in a monochrome image. This technique periodically becomes popular in advertising work, is used widely in both print and video, and then falls out of favor again.

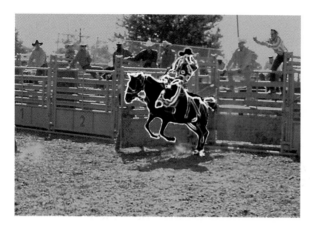

Figure 16-39. *The "neon cowboy" image was created by selecting the rodeo rider and horse and applying the Glowing Edges filter. The rest of the scene was shifted in hue and lowered in saturation to further emphasize the cowboy.*

To achieve either effect digitally, the image must be in a color mode. If the original is a grayscale image, it should be converted to RGB mode. An image that is already in color can be desaturated (as described earlier in this chapter) to display grayscale values while remaining in a color mode.

If you want to mimic the appearance of a hand-colored photograph, avoid highly saturated colors and apply colors at low opacity settings, as shown in **Figure 16-40.** The most effective coloration of this type is actually closer to *tinting* rather than applying solid color. This allows the details of the photograph to show through the color. An alternative approach is to use solid, saturated colors in some areas (such as clothing) and leave others (such as skin tones) in grayscale. This produces an interesting effect that is part photographic and part painting.

Another method useful for adding color to a monochrome image is the use of Photoshop's *History Brush* tool. This tool allows you to "paint in" details from the full-color version of an image, resulting in a grayscale image with spots of the original color. To use this technique most dramatically, select a single element — preferably with a strong color — to which you want to draw the viewer's attention. See **Figure 16-41.**

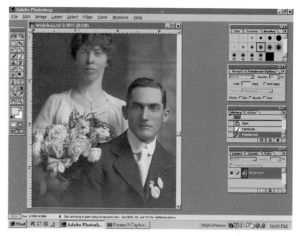

Figure 16-40. *The look of a hand-colored black-and-white image can be achieved by using the Paintbrush or Airbrush tools to apply color in selected areas. A low opacity of 30% was selected on the Paintbrush options palette. This provides a soft tinting effect that lets the image details show through.*

Figure 16-41. *The red hue of the rowboat and the bright magenta of the foreground flower stand out from this monochrome image, drawing the eye of the viewer. The History Brush was used to "paint in" these elements from the original color image.*

Sometimes, applying an *overall* color can make an image stronger or help it communicate a period feeling. This is similar to the chemical toning that has been done for years in conventional darkrooms. Digital toning can be done quite easily with the Hue/Saturation tool in the Image drop-down menu. By clicking on the Colorize check box, you will then be able to use the Hue slider to cycle through the entire color wheel to find the desired color. The Saturation and Lightness sliders can be used to refine the appearance of the image on the monitor. **Figure 16-42** shows examples of both period and modern images that have been colorized.

Combining type with photos. You can overlay type on a photo, or arrange type so that photos shows through the letters. In the first case, the type is added to the image as a layer. It can be treated like any other layer, with the color, opacity, and other characteristics changed as necessary. With the use of a white or light-colored type, the opacity of the type layer can be adjusted to allow the underlying image to show through to a greater or lesser degree.

To fill type with a background image, various methods may be used. One that works well is creating a *character mask,* which results in letters that are on a color background and filled with the desired image. To create a character mask, follow these steps:

1. Open the image that you wish to have fill the letters. Note the dimensions of the image.

2. Open a new, blank image with the same dimensions. Before opening it, set the background color in the toolbar to the desired hue (this will be the color that surrounds the type).

3. Make your photo image the active image again, then select the Type outline tool from the toolbar.

Figure 16-42. *Applying overall color to a monochrome image is similar to the chemical color toning done in a conventional darkroom. A—The sepia tone is appropriate for this image of a girl taken in the late 1800s. (Kankakee County Historical Society) B—For this night scene at a steel mill, a deep blue tone was chosen to enhance the strong contrast and suit the nature of the subject.*

Figure 16-43. *The word to be filled with an image is typed into the Type Tool dialog box. The typeface, type size, and other characteristics (such as "kerning," or the space between letters) are specified in this box. Once OK is clicked, the type outline will appear on the background image, where its position and size can be refined.*

4. When the Type Tool dialog box appears, select the desired typeface and point size. Key in the word or letters you wish to have appear in the final image. They will appear in a window at the bottom of the dialog box. See **Figure 16-43.**

5. Click OK, and the type will appear in outline form over the photo image. Position the type as desired, and (if necessary) use the Scaling tool to resize it.

6. Press and hold the **Ctrl** key, then click on the type and drag it to the open image with the color background.

7. Release the **Ctrl** key and mouse buttons. The photo-filled type will appear on the color background, **Figure 16-44.** If necessary, use the Move tool to position it.

Photo restoration

Old, faded, damaged images can be restored to "like new" condition with digital imaging techniques. **Figure 16-45** shows a century-old snapshot that has been poorly treated: it shows multiple emulsion cracks, dirt spots, and missing pieces in the border. It has also faded and yellowed in the years since it was printed.

When attempting to restore an image like this one, the first and most important step is to *make a copy of the original,* and do all your work on the copy. This will preserve the original image in case it is necessary to start over with a fresh copy.

Correct the faded and yellowed appearance, and then make large repairs (replacing missing pieces and fixing major emulsion cracks). Next, make small or critical repairs (such as cracks or scratches across the subject's face), and then move on to eliminating dust spots and small stains. Finally, adjust

Figure 16-44. *The finished image, with the Changing of the Guard at Buckingham Palace filling the letters of the word LONDON. Letters with heavy thick strokes work best with this technique, since they provide enough space to see the important elements of the photograph.*

Figure 16-45. *The years were not kind to this snapshot taken almost a century ago. It has yellowed, faded, and been subjected to rough handling that caused numerous cracks in the emulsion, a missing corner, and other border damage.*

Figure 16-46. *Converting the image to grayscale, after minor contrast and brightness adjustments to the green channel, improved the faded appearance and eliminated the yellowing.*

overall and local contrast as necessary, carefully inspect the entire image for any missed defects, and sharpen as needed.

Correcting fading and yellowing. Open the Channels palette and check the red, green, and blue channels. In this case, the green channel appeared to have the best overall contrast and sharpness. After some minor adjustments with the Levels and Curves tools, the image was converted from RGB mode to Grayscale, using the green channel brightness values. See **Figure 16-46.**

This removes the yellow cast and remedies the fading to some extent.

Making large repairs. By making a selection from an undamaged border area and using the cut-and-paste technique, the missing border pieces are covered over, then blended in where necessary using the Blur and Rubber-Stamp tools. The Rubber-Stamp is also the major tool for eliminating the emulsion cracks. **Figure 16-47** shows the image after major repairs were completed. The sky area is somewhat blotchy because of the large amount of cloning necessary to repair the many emulsion cracks. It will be

Figure 16-47. *The Rubber-Stamp tool was used to "clone out" the emulsion cracks and eliminate stains and dirt spots. Repair of the damaged borders was done by cutting and pasting selections from undamaged areas. Note the blotchy sky resulting from the crack removal. Areas of smooth tone, such as a cloudless sky, are difficult to work with. A gradient fill from light to dark will be applied to even out the tones in the final image.*

smoothed by making a selection and then applying a gradient fill.

Making critical repairs. Slow and careful use of the Rubber-Stamp tool (set to a small, soft-edged brush size) is needed to smoothly repair the cracks crossing the subject's face, **Figure 16-48.** The work should be done at high magnification (300% in this case) for the greatest visibility and control.

Figure 16-48. *Making repairs to areas of skin tone must be done carefully to ensure smooth transitions. A very small soft-edged brush (indicated by the crosshair precision cursor) should be used for cloning out defects like the emulsion cracks shown here. Because of the high magnification, the image appears somewhat fuzzy. (The original is slightly soft in focus.) The large white area on the front of the man's hat appeared at first to be a badge of some sort, but close examination of the original photo showed it to actually be an area of emulsion separation. Thus, it will be eliminated in the final image.*

After making the repairs to the face, the entire image should be carefully checked and spotted at 100% magnification.

Adjust contrast and sharpen. A slight deepening of the shadow tones, using the Curves tool, added some "snap" to the image. The Burn tool was used to somewhat darken the distant hills and the man's shirt; the Dodge tool opened up the foreground shadows a bit. Finally, a 100% Unsharp Mask was applied. The final result is shown in **Figure 16-49.**

Figure 16-49. *The finished image is a considerable improvement over the battered and yellowed original shown in Figure 16-45. The final steps involved some contrast and tonal adjustments, and the application of the Unsharp Mask filter to compensate for the slight softening caused by the image-editing process. The smooth gradation of the sky upward from the horizon was achieved with a gradient fill to eliminate the blotchiness visible in Figure 16-47.*

Restoration of older color prints makes use of many of the same tools and techniques. Because of the color shifts and fading common to prints made a number of years ago (especially in the 1950s and 1960s), working with color originals is more complex than black-and-white restoration work. When working on an old color print, the

Color Balance tool and the Hue/Saturation tool will come into considerable use. Experimentation and practice (especially when working with individual color channels) will permit you to become proficient in color-photo restoration.

Image output alternatives

Once you have gone to all the work of capturing and processing a digital image, it's natural to want to share that image with others. There are many ways of doing so, ranging from posting the image on a web site to displaying it on a computer monitor or in an "electronic frame" to making physical prints to actually converting the image to film form.

Electronic display

Once a photo has been scanned, it can easily be displayed in a number of electronic venues. Many photographers use a favorite image as the "wallpaper" on their computer monitor, **Figure 16-50,** or put together a series of images to display as the screen saver when the computer is inactive. A number of businesses, including Eastman

Figure 16-50. *One means of displaying digital images is the "wallpaper" on the computer desktop. This is the author's desktop, with an image he calls "The Door into Summer." Digital images can also be displayed as a screen saver.*

Kodak, have promoted the idea of "photo-sharing" sites where pictures can be posted for the enjoyment of friends and family. A similar approach, aimed at more serious photographers, is the *on-line gallery.* These sites are maintained by organizations or schools, and sometimes are restricted in access to members of the organization. Others are available for public viewing. Many photographers, both amateur and professional, maintain a personal *web site* to display their work. These might range from a simple single page with an image or two to an elaborate professionally developed site displaying numerous images, information about them, and biographical/personal data about the photographer.

An outgrowth of the rapid increase in the number of consumer-level digital cameras in use was the introduction of the *electronic frame,* **Figure 16-51.** This device displays digital images in much the same way that conventional picture frames display physical photographs. One major

Figure 16-51. *A number of digital images can be stored and displayed in an electronic frame, an LCD display small enough to fit on a desktop or bookshelf. In addition to accepting memory cards from a digital camera, the frame can be connected directly to a computer for access to a larger number of images. (Digi-Frame, Inc.)*

difference is that a conventional frame is designed to show a single picture (or an arrangement of individual prints), while the electronic frame can display a changing series of images.

Even the traditional slide projector has its electronic equivalent, the *LCD projector.* When connected to a computer, the device can be used to display digital images on a large screen for group viewing. Although it is not much larger physically than the familiar slide projector, the electronic version is considerably more costly, with a price tag in the thousands of dollars. For this reason, most of the units currently in use belong to businesses, schools, or large organizations.

Film conversion

A high-quality digital image can be converted from electronic to conventional film form, using a device called a *film recorder.* The recorder transfers the visual information from the digital image to physical film using a beam of light to precisely expose the film. The exposed film (transparency or negative) then is conventionally developed.

Digital-to-film conversions are typically done for two different purposes:

- Producing physical 35mm slides of digitally manipulated or enhanced images for projection with a traditional slide projector. This use is primarily for business meetings or similar large-audience presentations.

- Creating a conventional film image (usually in negative form and often in large format) for use in making fine art prints or similar products. The film conversion allows the artist to explore the freedom of digital image creation while retaining the characteristics of the traditional photographic print.

Few individuals make the large investment involved in purchasing their own film recorder; most often, the electronic files are sent to a *service bureau* to do the conversion. Costs range from a few dollars to tens of

dollars per image, depending upon film format and whether fast turnaround ("rush service") is needed. The standard service time is 48 hours for customers located in the same metropolitan area as the service bureau; greater distances mean longer service times or require additional-cost overnight delivery service.

Printers

The most widely used output method for digital photographs is the *printer*, a device that translates digital data into tiny dots of color to simulate the appearance of a continuous-tone photographic print. Although there are at least five different types of color printers on the market, only two — the ink jet and the dye sublimation printer — are used for serious photographic output. Two of the remaining types, the solid ink printer and the thermal wax printer, are primarily used for graphic-arts proofs and similar commercial uses (such as package-design mockups or sample advertising layouts). The fifth type, the color laser printer, produces color images that are acceptable for many business presentation applications, but cannot approach the output quality of the ink jet or "dye sub" printers.

Ink jet printers

Without the *ink jet printer* as a relatively low-cost device for producing photo-quality images, digital photography might have suffered the same fate as the disc camera or other formats that died soon after they were born. At best, the digital camera might have carved out a niche market like Polaroid instant photography.

Originally intended to provide color printing capability to home computers for such applications as word processing and simple art programs, the ink jet printer was well-established by the time digital cameras came on the scene. Even earlier, photographers and graphic designers had begun experimenting with the ink jet printer as an output device for scanned and digitally

processed photographs. In the early 1990s, the French term *giclée* (meaning spray or squirt) was adopted among fine art photographers to characterize the prints they were producing on high-quality commercial ink jet printers.

Several printer manufacturers identified the emerging consumer market for photo-quality reproduction and began producing papers with a weight and coated finish that provided a photographic-paper look and feel, **Figure 16-52.** The coated paper also overcame one of the initial drawbacks of the ink jet medium: *ink spread.* The ink jet image is formed by very small droplets of dye-based liquid ink that are sprayed onto the paper. The ink droplets soak into the surface of uncoated papers, producing a soft image with flat color. Coated papers resist the spread of

Figure 16-52. *Coated papers for photo reproduction allow ink jet printers to produce output that rivals traditional photographic prints. Paper weight and finish are very similar to conventional resin-coated photographic paper. (Epson America, Inc.)*

ink droplets; they retain their shape and color brilliance as they bond to the paper surface. The high gloss of the paper reinforces the "photo-like" appearance. Today, there are more than a dozen different brands of photo-quality ink jet paper on the market. They are offered in glossy and matte finishes, and in a variety of sizes from 4" × 6" to 11" × 14". In addition, there are many specialized paper products: postcards and notecards, greeting cards, portfolio covers, business cards and labels, heat transfer papers for decorating clothing, and transparent films for overhead projectors and other uses.

Ink jet printers come in two basic sizes for desktop use: letter-size and wide-format. The letter-size printer, **Figure 16-53,** accepts standard 8 1/2" × 11" paper (although photographers still refer to the output as "an eight by ten," most photo papers for ink jet printing are the standard letter-size). Some of these printers also accept legal-size (8 1/2" × 14") paper, which would allow full-frame 8" × 12" prints, but photo-quality paper is not offered in that size.

The wide-format printer will accept paper up to 13" wide, allowing the photographer to make 11" × 14" or larger prints. Some wide-format printers can handle paper up to 44" in length (this feature was originally designed for printing banners). Paper in rolls, and special roll-holder accessories, are available. The roll paper can be used for printing panoramic images, or for the production of multiple prints.

Paper in roll form is also used with the large-format ink jets that produce large fine-art prints, posters, banners, billboard sheets, and similar products. These units, normally operated by commercial printing houses or service bureaus, accept paper and other media as much as 6' in width, with virtually no length restriction. See **Figure 16-54.**

Another distinction between printers is the number of ink colors that they print. Originally, all ink jets used a four-ink set (the traditional CMYK, or cyan, magenta, yellow, and black). As color photo printing became more popular, however, manufacturers introduced the six-ink set, with a light magenta and a light cyan added. The two light inks are intended to produce smoother tonal gradations and thus better color.

Figure 16-53. *Since most photographers turn out digital prints in approximately the traditional 8" × 10" format, letter-size ink jet printers are the most common. Most accept standard 8 1/2" × 11" paper, and the majority of photo-quality papers are made in that size. (Epson America, Inc.)*

Figure 16-54. *For big images, such as posters, banners, or large fine art prints, special large format ink jet printers are available. Because of the volume required to make them cost-effective, such units are normally operated by specialized service bureaus or commercial printing companies. (Roland DGA)*

Photographers who work in black-and-white tend to favor the four-color printers as producing a better monochrome print. A continuing issue is the problem of producing a true neutral gray — when printing with the four ink colors, prints often exhibit a slightly green or magenta tone. One way that the problem can be solved is by dedicating a printer to monochrome work and using a special *quad-tone ink set.* These ink sets, available from several specialty manufacturers, consist of black and three grays, rather than CMYK. Those who choose to stay with CMYK often can find an acceptable combination of inks, paper, and printer setting through experimentation.

Two drawbacks to the ink jet printer are the cost of consumables (ink cartridges and paper) and the problem of image fading. Most printer manufacturers maintain that their equipment provides the best results with their own ink cartridges and papers. However, *OEM* (original equipment manufacturer) consumables are fairly expensive — an average operating cost of $1 or more per 8″ × 10″ print is common. Many photographers experiment with different paper brands to find those that give them the best results, but tend to stay with the manufacturer's inks. For this reason, there are relatively few "third-party" inks available. There are several refill kit products on the market that promise lower ink cost, but many users have found them unsatisfactory for either print quality or mechanical reasons. At least one manufacturer offers a continuous inking system that draws from large, refillable ink containers. Such a system is most attractive to persons who produce prints in larger quantities.

The archival issue. The question of print permanence, or *archival quality,* has long been a concern of photographers using ink jet printers. While properly processed conventional photographic prints (especially black-and-white) can be stored or displayed for many decades without showing noticeable fading, some ink jet prints have begun losing color in a matter of months. This has been a particular problem with the output of six-color printers — the light magenta and light cyan inks seem particularly prone to fading. Researchers have found that displayed prints exposed to ultraviolet light rays and high humidity are the most quickly and severely affected. Under less humid conditions and lower exposure to UV light, prints deteriorate much more slowly and may not show fading for years. To help protect prints from environmental conditions (especially humidity), some photographers use a laminating press, **Figure 16-55,** to seal them in plastic.

Epson, a major manufacturer of ink jet printers, has introduced models, **Figure 16-56,** that use an ink and paper combination the company claims will achieve print life comparable to or exceeding conventional photo prints. The inks use solid pigments, ground extremely fine, rather than the usual color dyes, and the papers have a coating compatible with the pigmented inks. The company says that both the pigment-based ink and its

Figure 16-55. *To help preserve ink jet prints, some photographers seal them in laminating film. Films are available in both clear gloss or matte finish. (Hunt Corporation)*

Figure 16-56. *The manufacturer claims a print life of up to 200 years with the ink and paper combination developed for this professional-grade ink jet printer. Some consumer-grade printers from this manufacturer use a similar system and project print longevity of 10 years or more. (Epson America, Inc.)*

matching paper must be used to obtain the full measure of print permanence. If the components are used separately (with other inks or papers), the print longevity will be greater than average, but not the maximum claimed.

The ink cartridges used on the new Epson printers solve another problem that has plagued ink jet users — the ability to switch ink cartridges before they are empty. This is a particular advantage when a cartridge is low on ink (especially one of the three inks in the color cartridge) and a number of prints must be made. Rather than ruining a print by running out of ink part way through printing, a full cartridge can be installed. Later, the nearly empty one can be put back in the printer to finish it with less critical jobs. In previous models, removing an ink cartridge caused the printer's ink-level sensor to reset, generating false readings when it was reinstalled. The new ink cartridges contain a microchip that keeps accurate record of the ink level.

Photographers with serious concern about the longevity of their ink jet prints have long used special pigment-based archival ink

sets available from specialty manufacturers. Typically, these inks are paired with acid-free papers to maximize the lifespan of the prints. In addition to concern about their work being preserved for future generations, these photographers are motivated by an ethical concern. They maintain that a museum or individual purchasing one of their works has a right to expect it will not deteriorate in a short period of time and thus lose both its artistic and monetary value.

Dye sublimation printers

Archival quality and brilliant color have always been a selling point for *dye sublimation printers;* the drawback has been the high cost (typically several thousand dollars). However, that appears to be changing: the first dye-sublimation printer for under $1000 has been introduced. See **Figure 16-57.** The printer will make 8″ × 10″ or smaller prints at a per-sheet operating cost of less than $2, the manufacturer claims.

"Dye-sub" printers, as they are commonly called, work on a thermal principle. A print head with thousands of tiny, precisely controlled heating elements works in conjunction with a wide plastic transfer ribbon carrying solid CMYK dyes. The print head causes the dyes to *sublimate* (change state from a solid to a vapor) and deposit as tiny color spots on a specially coated paper. Variations in color intensity and coverage are achieved by temperature control of the heating elements — the hotter the element, the more color is vaporized and deposited. The vapor deposits blend to produce an extremely smooth image without visible dot structure, very similar to a continuous-tone photographic print. Dye sublimation images are not subject to fading like those from most ink jet printers.

An additional advantage of the dye sublimation printer, in comparison to the ink jet printer, is printing speed. A typical consumer-grade ink jet printer might take as long as five minutes to print a high-resolution 8″ × 10″, while the dye sublimation print is produced in less than half that time.

Figure 16-57. *The dye sublimation printer offers the advantages of printing speed, smooth and brilliant color, and archival quality. The P-400 printer is the first moderately-priced professional-grade printer in this category. Per-print operating costs are somewhat higher than ink jets, but printing speed is considerably faster. (Olympus America, Inc.)*

Questions for review

Please answer the following questions on a separate piece of paper. Do not write your answers in this book.

1. Give at least two advantages of the digital darkroom compared to a conventional darkroom.

2. Would you associate the term "digital darkroom" with the activities of image processing or of image manipulation, as they are described in this chapter? Why?

3. The software used to alter and refine digital images is called a(n)_____ program.
 a. scanning
 b. digitizing
 c. image editing
 d. image processing

4. For more efficient program operation, you can use _____ instead of a mouse and menu choices.

5. Name the two tools used to crop photos. Which is more useful, and why?

6. Describe the operation of the process that is the digital equivalent of spotting a print.

7. Which of the following is not a technique for converting a color image to a grayscale image?
 a. straight mode conversion
 b. mode conversion using a color channel
 c. desaturation
 d. color stripping

8. Discuss why the statement "sharpening restores lost detail to an image" is incorrect.

9. What is the most important advantage of making a selection, in terms of image manipulation?

10. Which of the following is the best tool for making a selection that includes both straight-line and curved elements?
 a. Elliptical/Circular Marquee tool
 b. Polygon Lasso tool
 c. Pen tool
 d. Magic Wand

11. How would you copy a selection from one image to another?

12. Material on one layer normally hides material directly beneath it on a lower layer. To allow the lower-layer material to show through, you must decrease the _____ of the upper layer.

13. If you desaturate a color image and reduce it to shades of gray, what tool can you use to restore some areas to their original color?

14. Why was the existence of the ink jet printer important to the growth of digital photography?

15. What ethical issue regarding ink jet prints is a continuing concern for photographers?

Low key:
A photograph containing mostly dark tones; few light tones or whites will be present.

Appendix 1

Sources of Information and Materials

Books

There are literally thousands of books dealing with the various aspects of photography. The following list is just a sampling of those the author has found useful and instructive. Many are currently available from bookstores or directly from the publisher. Some older books that are out-of-print have been included because of the value of the information they contain. Copies of out-of-print volumes can often be located through book search firms or by searching on the Internet.

Basics

Adams, Ansel. *The Camera.* Boston: Little, Brown and Company, 1980 (paperback edition, 1996).

——— *The Print.* Boston: Little, Brown and Company, 1983 (paperback edition, 1995).

——— *The Negative.* Boston: Little, Brown and Company, 1981 (paperback edition, 1995).

Freeman, Michael. *The 35mm Handbook.* Philadelphia: Running Press, 1985.

Grimm, Tom, and Grimm, Michele. *The Basic Book of Photography.* New York: Penguin Books, 1997.

Hedgecoe, John. *The Book of Photography.* New York: Alfred A. Knopf, 1979.

Jacobs, Mark, and Kokrda, Ken. *Photography in Focus.* Chicago: National Textbook Company, 1986.

Suess, Bernhard. *Mastering Black-And-White Photography.* New York: Allworth Press, 1995.

Sussman, Aaron. *The Amateur Photographer's Handbook.* New York: Thomas Y. Crowell, 1973.

Vestal, David. *The Craft of Photography.* New York: Harper & Row, 1975.

Darkroom

Anchell, Stephen. *The Darkroom Cookbook.* Boston: Focal Press, 1994.

Bartlett, Larry, and Tarrant, Jon. *Black and White Photographic Printing Workshop.* Rochester, New York: Silver Pixel Press, 1996.

Curtin, Dennis, and DeMaio, Joe. *The Darkroom Handbook.* New York: Van Nostrand Reinhold, 1979.

Kodak Workshop Series. *Color Printing Techniques.* Rochester, New York: Eastman Kodak Company, 1981.

Langford, Michael. *The Darkroom Handbook.* New York: Alfred A. Knopf, 1989.

Schaub, George. *Black and White Printing.* New York: Amphoto, 1991.

Vestal, David. *The Art of Black and White Enlarging*. New York: Harper & Row, 1984.

Digital Darkroom

Blatner, David, and Fraser, Bruce. *Real World Photoshop 6*. Berkeley, California: Peachpit Press, 2001.

Evening, Martin. *Adobe Photoshop 6.0 for Photographers*. Boston: Focal Press, 2001.

Schaub, George. *The Digital Darkroom*. Rochester, New York: Silver Pixel Press, 1999.

Guides and Handbooks

Adams, Ansel. Examples: *The Making of 40 Photographs*. Boston: Little, Brown and Company, 1989.

Burian, Peter K., and Caputo, Robert. *National Geographic Photography Field Guide*. Washington, DC: National Geographic Society, 1999.

Hedgecoe, John. *The Photographer's Handbook*. New York: Alfred A. Knopf, 1996.

Hicks, Roger, and Schultz, Frances. *The Black and White Handbook*. Devon, England: David & Charles, 1997.

Kodak Pocket Guide to 35mm Photography. New York: Simon & Schuster, 1989.

Neubart, Jack. *The Photographer's Guide to Exposure*. New York: Amphoto, 1988.

Newhall, Beaumont. *The History of Photography*. New York: The Museum of Modern Art, 1964.

Photographer's Market, Writer's Digest Press, Cincinnati, Ohio. (issued annually)

Stroebel, Leslie; Compton, John; Current, Ira; and Zakia, Richard. *Basic Photographic Materials and Processes*. Boston: Focal Press, 2000.

Stroebel, Leslie, and Zakia, Richard. *The Focal Encyclopedia of Photography*. Boston: Focal Press, 1993.

Lighting

Brown, Alan; Braun, Joe; and Grondin, Tim. *Lighting Secrets for the Professional Photographer*. Cincinnati, Ohio: Writer's Digest Books, 1990.

Helprin, Ben. *Petersen's Guide to Photo Lighting Techniques*. Los Angeles: Petersen Publishing, 1973.

Kerr, Norman. *Technique of Photographic Lighting*. New York: Amphoto, 1979.

Outdoor and Nature

Collett, John, and Collett, David. *Black and White Landscape Photography*. Buffalo, New York: Amherst Media, 1999.

Davies, Paul Harcourt. *The Complete Guide to Close-up and Macro Photography*. Devon, England: David & Charles, 1998.

Hill, Martha, and Wolfe, Art. *The Art of Photographing Nature*. New York: Crown Publishers, 1993.

Lepp, George. *Beyond the Basics: Innovative Techniques for Nature Photography*. Los Osos, California: Lepp and Associates, 1993.

Rue, Leonard Lee. *How I Photograph Wildlife and Nature*. New York: W.W. Norton, 1984.

Shaw, John. *Closeups in Nature*. New York: Amphoto, 1987.

Specialized Topics

Burnett, Laurence, and Burnett, Janet. *The Picture Framer's Handbook*. New York: Clarkson N. Potter, 1973.

Gibbons, Bob, and Wilson, Peter. *Night & Low-light Photography*. London: Cassell, 1993.

Hedgecoe, John. *Practical Portrait Photography*. New York: Simon & Schuster, 1987.

Jacobs, Lou. *Selling Stock Photography*. New York: Amphoto, 1992.

LaHue, Kalton, and Bailey, Joseph. *Architectural Photography*. Los Angeles, Petersen Publishing, 1973.

Marx, Kathryn. *Photography for the Art Market.* New York: Amphoto, 1988.

McCartney, Susan. *Travel Photography.* New York: Allworth Press, 1992.

McQuilkin, Robert. *How To Photograph Sports and Action.* Tucson, Arizona: HP Books, 1982.

Neubart, Jack. *Industrial Photography.* New York: Amphoto, 1989.

Pendleton, Bruce. *Creative Still Life Photography,* Englewood Cliffs, New Jersey: Prentice-Hall, 1982.

Schaub, George. *Shooting for Stock.* New York: Amphoto, 1987.

Simmons, Steve. *Using the View Camera.* New York: Amphoto, 1987.

Taylor, Adrian. *Photographing Assignments on Location.* New York: Amphoto, 1987.

Visualization and Composition

Grill, Tom, and Scanlon, Mark. *Photographic Composition.* New York: Amphoto, 1990.

Patterson, Freeman. *Photography and the Art of Seeing.* Toronto: Key Porter Books, 1985.

Smith, Bill. *Designing a Photograph.* New York: Amphoto, 1985.

Zone System

Davis, Phil. *Beyond the Zone System.* Boston: Focal Press, 1993.

Picker, Fred. *The Fine Print.* New York: Amphoto, 1975.

White, Minor. *Zone System Manual.* Dobbs Ferry, New York: Morgan and Morgan, 1972.

Periodicals

Although the number of general photography magazines has declined in recent years, new periodicals have been launched in areas such as digital photography.

Outdoor Photographer
12121 Wilshire Blvd., Suite 1200
Los Angeles, CA 90025
www.outdoorphotographer.com

PC Photo
12121 Wilshire Blvd., Suite 1200
Los Angeles, CA 90025
www.pcphotomag.com

PEI (Photo>Electronic Imaging)
229 Peachtree Street NE, Suite 2200, International Tower
Atlanta, GA 30303
www.peimag.com

Petersen's Photographic
437 Madison Avenue
New York, NY 10022
www.photographic.com

Photo Techniques (formerly *Darkroom and Creative Camera*)
6000 W. Touhy Avenue
Niles, IL 60714
www.phototechmag.com

Popular Photography
1633 Broadway
New York, NY 10019
www.popphoto.com

Shutterbug
5211 S. Washington Avenue
Titusville, FL 32780
www.shutterbug.net

View Camera Magazine
P.O. Box 2328
Corrales, NM 87048
www.viewcamera.com

Organizations

Photography organizations range from large national and international groups to local camera clubs, and include many associations for people with specialized interests. Some have specific requirements for admission, but many are open to anyone with an interest in their subject area.

ASMP (American Society of Media
 Photographers)
 150 N. Second Street
 Philadelphia, PA 19106
 www.asmp.org

IAPP (International Association of
 Panoramic Photographers)
 P.O. Box 6550
 Ellicott City, MD 21042
 www.panphoto.com

IFPA (International Fire Photographers
 Association)
 P.O. Box 8337
 Rolling Meadows, IL 60008
 www.firephotographers.com/ifpa

NANPA (North American Nature
 Photography Association)
 10200 West 44th Avenue, Suite 304
 Wheat Ridge, CO 80033
 www.nanpa.org

NPPA (National Press Photographers
 Association)
 3200 Croasdaile Drive
 Durham, NC 27705
 www.nppa.org

PPA (Professional Photographers of
 America)
 229 Peachtree Street NE, Suite 2200,
 International Tower
 Atlanta, GA 30303
 www.ppa.com

PSA (Photographic Society of America)
 3000 United Founders Blvd., Suite 103
 Oklahoma City, OK 73112
 www.psa-photo.org

SPE (Society for Photographic Education)
 110 Art Building
 Miami University
 Oxford, OH 45056
 www.spenational.org

Workshops and Short Courses

Almost every community has a high school, college, or other institution that offers at least basic photography instruction.

For advanced and specialized instruction, photographers often enroll in workshops or short courses lasting from one day to a week or more. The following list is only a sampling — photography magazines carry advertisements for dozens of educational programs.

Maine Photo Workshops
 P.O. Box 200, 2 Central Street
 Rockport, ME 04856
 www.theworkshops.com/photoworkshops/

Palm Beach Workshops
 Palm Beach Photographic Centre
 55 Northeast Second Avenue
 Delray Beach, FL 33444
 www.workshop.org

Rocky Mountain School of Photography
 210 N. Higgins Ave., Suite 101
 Missoula, MT 59802
 www.rmsp.com

The Great American Photography Weekend
 160 Whirlaway Trail
 Corbin, KY 40701
 www.gapweb.com

The Santa Fe Workshops
 P.O. Box 9916
 Santa Fe, NM 87504
 www.sfworkshop.com

Web Sites

With the astounding growth of the Internet and the World Wide Web, locating information or specific products has become far easier than it was only a decade ago. NOTE: The addresses in this list (URLs or "Universal Resource Locators" in computer jargon) were current at the time this book was published, but may have changed. If the address does not take you to the desired location, use a search engine to try locating the company or organization name.

General Photo Information Sites

These sites offer a variety of resources, including links to many other photo-related sites.

Bengt's Photo Page:
 w1.541.telia.com/~u54105795/

FstopPhoto.com:
 www.fstopphoto.com/

George Eastman House: *www.eastman.org*

Photonet: *www.photo.net*

PhotoForum (Rochester Institute of Technology):
 www.rit.edu/~andpph/photoforum.html

Specialized Sites

Following are only a few of the special-interest sites to be found on the Web.

Alternative processes:
 www.collodion.org
 www.mikeware.demon.co.uk/

Alternative processes FAQ:
 duke.usask.ca/~holtsg/photo/faq.html

Infrared photography (FAQ):
 www.mat.uc.pt/~rps/photos/FAQ_IR.html

Pinhole photography:
 www.pinhole.org

Subminature photography:
 www.subclub.org
 www.greenspun.com/bboard/q-and-a.tcl? topic=Minox%20Photography

Equipment and Film Manufacturers' Sites

Agfa: *www.agfanet.com*

Beseler: *www.beseler-photo.com*

Bogen/Manfrotto: *www.bogenphoto.com*

Canon: *www.usa.canon.com*

Epson: *www.epson.com*

Fuji: *www.fujifilm.com*

Hasselblad: *www.hasselbladusa.com*

Ilford: *www.ilford.com*

Jobo Fototechnic: *www.jobo-usa.com*

Kodak: *www.kodak.com*

L.L. Rue: *www.rue.com*

Leica: *www.leica-camera.com*

Minolta: *www.minoltausa.com*

Nikon: *www.nikonusa.com*

Olympus: *www.olympusamerica.com*

Pentax: *www.pentax.com*

Polaroid: *www.polaroid.com*

Porter's Camera Store: *www.porters.com*

Rollei Fototechnik: *www.rolleifoto.com*

Sinar-Bron: *www.sinarbron.com/*

Smith-Victor:
 www.techexpo.com/firms/smithvic.html

Tamron: *www.tamron.com*

Tiffen: *www.tiffen.com*

Tokina: *www.thkphoto.com*

Tory Lepp Productions:
 www.leppphoto.com/Project-A-Flash/

Vivitar: *www.vivitar.com*

Organization Sites

(See Organization listings)

Specialty Materials, Products, and Services

Local photography stores or the large national mail-order firms are able to supply most everyday equipment and materials needs. Supplies for alternative processes, camera repair tools, or labs that offer obsolete film processes are more difficult to find. This list consists of some firms that meet specialized needs.

Alternative processes materials:

Photographers' Formulary, Inc.
 P.O. Box 950
 Condon, MT 59826
 www.photoformulary.com

Bostick & Sullivan
 P.O. Box 16639
 Santa Fe, NM 87505
 www.bostick-sullivan.com

Archival supplies:

Light Impressions
P.O. Box 22708
Rochester, NY 14692
www.lightimpressions.com

Franklin Photo Products
3702 W. Sample Street, Suite 1103
South Bend, IN 46619
www.franklinphoto.com

Camera repair tools and materials:

Fargo Enterprises, Inc.
301 County Airport Road, #105
Vacaville, CA 95696
www.fargo-ent.com

Ed Romney
P.O. Box 806
Williamsburg, NM 87942
www.edromney.com

Color toners:

Berg Color Tone
1041 S. Carroll Street
Hampstead, MD 21074
www.bergcolortone.com

Discontinued film formats:

Film for Classics
Box 486
Honeoye Falls, NY 14472
www.filmforclassics.com

Liquid photo emulsion:

Rockland Colloid
Box 376
Piermont, NY 10968
www.rockaloid.com

Obsolete developing processes:

Rocky Mountain Film Lab
560 Geneva Street
Aurora, CO 80010
www.rockymountainfilm.com

Film Rescue International
P.O. Box 44
Fortuna, ND 58844
or Box 428
Indian Head
Saskatchewan, Canada SOG 2K0
www.filmrescue.com

Pinhole cameras and supplies:

Pinhole Resource
Star Route 15, Box 1355
San Lorenzo, NM 88041
www.pinholeresource.com

Bender Photographic, Inc.
19691 Beaver Valley Road
Leavenworth, WA 98826
www.benderphoto.com

Prints from slides:

The Slide Printer
P.O. Box 9506
Denver, CO 80209

Appendix 2

Buying a Used Camera or Other Photo Equipment

Buying used photo equipment can be the key to getting the most value for the money you spend, if you shop carefully and knowledgeably. Most photographic equipment is well made and will have a long useful life if it has not been abused. With the steady flow of new models (and even new camera categories, such as digital) coming onto the market, there is usually a plentiful supply of "trade-ins" available for purchase.

What type of used camera should you look for? That depends on your photographic interests and needs. An experienced amateur photographer may be seeking an upgrade to a model with better autofocus capabilities or more sophisticated metering modes, while a student will likely have more basic needs. Course requirements and student budgets usually dictate that a "first serious camera" will be a fairly basic manual model, or at least a model with the capability of being used in the manual mode. Since this book is intended for school use, the following material will concentrate on the type of equipment a student might purchase.

Sources of used equipment

The traditional place to purchase used equipment has been the *local camera store.* These stores often purchase used equipment outright from individuals, or accept the equipment as a "trade-in" on newer or more sophisticated camera gear. National or regional chain camera stores, often located in shopping malls, are much less likely to have used equipment available. Equipment that is taken in trade is typically sent to the chain's headquarters and sold through its outlet store or stores.

Advantages to purchasing from a local camera store are the ability to inspect and handle the equipment, dealing with a (usually) knowledgeable salesperson who may even know the history of the equipment, and a warranty or similar buyer-protection on the equipment. Disadvantages are a somewhat limited selection of merchandise, and a price that might be higher than other sources selling the same item.

Other local possibilities include *newspaper classified ads, notices posted on community or school bulletin boards, yard sales,* and *flea markets.* Purchases from individuals who advertise can be a bargain if the owner is willing to negotiate. Equipment offered at yard sales or flea markets often can be bought for a fraction of the "camera store" price, but the danger of losing money by purchasing defective or damaged goods is fairly high.

Regional photo shows or "swap meets" are also a possibility for those living in or near

large cities. These events, featuring a number of dealers, are typically held on a monthly or quarterly basis in suburban hotel meeting rooms or similar surroundings. The major advantages of these events is the ability to examine comparable items from a number of different dealers. Bargaining on the price is often possible, and many dealers offer some form of warranty.

Equipment can also be purchased by *mail order, over the Internet,* or at *auctions* (actual or electronic). Large camera shops specializing in mail-order sales of both new and used equipment advertise heavily in photography magazines. Many of them also maintain "electronic stores" on the World Wide Web. The advantages of buying from such dealers are selection and price; the disadvantage is that you are making a purchase "sight unseen." Purchasing items at auction — whether you are physically present or bidding over the Internet — can result in a great bargain. However, it is also possible to pay more than the item's value if you do not know the "going price," or if you get caught up in competition with other bidders. Internet auction sites usually offer (for a small fee) some type of escrow service that will hold your payment until you have had an opportunity to examine and approve your purchase.

Checking out used merchandise

As a general rule, beware of an item that shows signs of severe wear or such damage as deep scratches or major dents. These indications (especially severe wear in such areas as the lens mount) signal heavy use, possibly by a professional. Although professional photographers usually follow a regular schedule of equipment cleaning and maintenance, the amount of wear resulting from constant use shortens the remaining useful life. The need for costly repairs will occur more quickly than with a less-heavily-used item.

Age of the equipment can be a factor, in combination with wear. A camera that is

20 years old is more likely to have wear-related problems than a comparably used 10-year-old model. However, many older camera models are ruggedly made and still function well, especially if they have seen only moderate use.

Some dealers will have a *CLA* (clean/lubricate/adjust) performed on a used camera body before offering it for sale. While such merchandise will typically have a higher price tag than a similar model that has not had a CLA, it is usually worth the added cost.

Camera bodies

To check out a camera body, first perform a thorough visual inspection. Look at the condition of the finish to assess the state of wear. Some degree of "brassing" (bare metal showing through the painted finish) is acceptable, especially on corners and edges, if the body otherwise appears to be in good condition. Major dents or deep scratches can indicate that the equipment was dropped or otherwise suffered a severe impact. Damage might have been done to delicate internal components, and misalignment of the camera back could permit light leaks.

Check for any missing or broken external parts, such as levers, knobs, or covers. Carefully examine all screws used in fastening body parts together. Missing screws or fasteners with damaged heads may indicate inept attempts at repair. Open the battery compartment and check for signs of corrosion or corrosion damage to the battery contacts. A number of older camera models were designed to use "button-cell" batteries that contained mercury. Such batteries are no longer sold in the United States due to environmental concerns. Alternative batteries and adapters to permit use of environmentally acceptable batteries with the correct voltage (to ensure proper meter operation) are available.

Open the camera back and check the cleanliness of the film compartment. Dust or sand in the compartment could indicate poor seals and use under adverse conditions.

Watch for scratches or rough spots on the film guide rails, and for any type of visible defect (such as a crease or wrinkle) on the shutter curtain. Check the condition of the foam-rubber light seals usually found at either end of the film compartment. If they are crumbling or gummy, they will need to be replaced. Remove the lens or body cap, and inspect the mirror and mirror box area. The mirror should be clean and have no visible blemishes.

Methodically check all the functions of the camera, beginning with the film advance (it should be smooth and noiseless). With the camera back open, operate the shutter release and observe the shutter operation at various speeds. Listen to the sound of the shutter at different speeds; changes in sound should be appropriate to the selected speed. Look at the camera from the front (with the lens or lens cap off) and be sure that the mirror is "flipping up" properly when the shutter release is pressed. If the camera has a mirror lockup function, operate it while observing the mirror. Operate the self-timer, if the camera has one.

Close the camera back and operate the shutter a number of times while observing the film counter to see if it advances properly (some cameras require film to be installed before the counter will function). Viewing ports or windows covering the film counter, ISO setting, or other indicators should be clear and undamaged. Attach a lens, and check the operation of the camera's metering system display in the viewfinder.

Most cameras manufactured in recent years have liquid crystal display (LCD) panels that show the status of camera controls and various functions. The display should be sufficiently bright to read in normal light, and the numerals and icons should be crisp and easy to distinguish. Operate all the camera functions while observing the LCD to be sure the display is functioning properly.

If possible, attach a flash unit to the hot shoe to check its functioning. The pc socket, if present, should be checked as well.

Grading system. Most major dealers in used equipment have a grading scale that is used to describe camera appearance/condition. Some dealers grade items with a set of descriptive words ranging from *mint* (like-new condition), through several grades of *excellent* (excellent +, excellent, excellent –), to *good* (some finish wear, but optically and mechanically sound). Grades below *good* will exhibit greater finish wear and may have mechanical or optical flaws.

Many of the mail-order dealers who have full- or multi-page advertisements in photography magazines use a numerical scale ranging from 10 downward. Definitions of both the numerical and word grades vary from dealer to dealer; most advertisements include an explanation of the grading scale used. When comparing similar items (such as a particular camera model) offered by different dealers, be sure to check the grading explanations to be sure they *are* comparable.

Lenses

A thorough visual check should include the lens body; all markings, controls, and fasteners, and the front and rear glass elements. If the lens has a built-in hood, check its functioning. A removable hood should be mounted and dismounted, while filter threads should be examined closely for damage. An appropriate-size filter should be used to check the threads.

The front lens element should not show severe scratches; slight abrasions ("cleaning marks") are usually acceptable, since they do not affect optical quality. The levers protruding from the rear of the lens should show no signs of damage and should operate smoothly. The aperture blades should be free of any visible oil, which can form a gummy residue that prevents proper functioning.

Check the lens for internal problems. Shake the lens gently and listen for rattling that could indicate loose fasteners or elements. Hold the lens up to a bright light and

look through it. A few specks of dust or dirt inside the lens should not affect its optical quality; larger quantities should be cause for rejection. Avoid a lens with any indication of fungus growth — a web-like pattern visible inside the lens. To check for fungus, look through the lens at a brightly lighted surface (not the light source itself).

Mount the lens on the camera and check for any looseness ("play") in the mount. Operate the focus ring while looking through the viewfinder. The focus control should operate smoothly and bring the scene into focus easily. Check the operation of the aperture ring, which should have detectable "click stops" for each aperture (and intermediate positions, on many lenses). If the camera has a depth-of-field preview function, operate the aperture ring with the preview lever or button engaged. This will allow you to observe aperture changes through the viewfinder.

If the lens is a variable focus (zoom) type, operate the zooming ring. It should move smoothly without being excessively loose or stiff. Excessive stiffness could make the lens hard to operate; a too-loose zoom control could allow "zoom creep" (failure to hold the desired focal length, especially when pointed downward). A feeling of roughness or grinding when the zoom ring is operated indicates grit in the mechanism. Costly repairs would sooner-or-later be needed.

Darkroom equipment

As the popularity of digital photography and the "digital darkroom" continues to grow, the photographer who wishes to set up a traditional chemical darkroom will find many bargains in used equipment. Glassware, trays, storage containers, and other small items can easily be inspected visually for defects. Mechanical or electrical/mechanical items such as timers and enlargers require a more detailed inspection.

Timers, whether electromechanical or digital, should be connected to an electrical outlet to be checked for proper operation.

Check each of the timing, display, and other functions (such as a buzzer) to be sure they work as intended. Connect an enlarger or a table lamp to the appropriate timer outlet and operate the timer. The bulb in the enlarger or lamp should be turned on at the beginning of the timing cycle and turned off at the end of the cycle.

An enlarger is a device with both electrical and mechanical components. After checking the line cord and plug for insulation wear or other damage, connect it to an electrical outlet. Operate the on-off switch (usually located on the line cord) to be sure the enlarger lamp functions properly. If the lamp does not light when the switch is turned on, it may be burned out. Replace it with a bulb that is known to be good. If the lamp still does not light, either the switch or the lamp circuit may be defective.

If possible, turn off the room lights to identify any light leaks from the enlarger. Carefully inspect the bellows for light leaks caused by cracks or tears in the fabric. Use the focus knob to extend and compress the bellows during your inspection.

Inspect the enlarger carefully for mechanical damage, missing parts, or loose fasteners. Operate the crank or other method of raising and lowering the enlarger head on the support column. Movement should be easy and smooth, with no binding of the parts or vibration. Check the locking mechanism (if one is present) to be sure it holds the head at the desired height.

Open the lamp housing and look carefully at the condensing lenses, which concentrate the light beam. They should not be chipped or cracked. Dismount the enlarging lens and inspect it. The glass lens elements should be free of scratches, and the aperture ring should operate smoothly (it may or may not have "click-stops" for each aperture). Look through the lens to observe the iris diaphragm as you rotate the aperture ring. The iris should open and close smoothly.

Remount the lens, and insert a negative in the negative carrier. Turn out the room

lights, and bring the image into focus (a sheet of white paper on the baseboard will make it easier to see the image). Check the focusing mechanism for ease of use. It should move smoothly and allow fine control for precise focusing. There should be no play in the mechanism.

The old adage, "you get what you pay for" doesn't necessarily apply when buying photo equipment. If you shop patiently, carefully, and knowledgeably for used equipment, you can often get far greater value for your money than buying new items. For the photographer on a limited budget, this can mean the ability to buy a more fully featured camera body, a better quality lens, or an additional lens.

Appendix 3

Copyright and the Photographer

If you hold the copyright to a photograph, you literally own *the right to determine who can make copies*. Although some people consider the issue of copyright to be confusing and intimidating, it really can be boiled down to that single issue: ownership of a piece of artistic property, and the ability to control its use.

How do you go about obtaining a copyright to a photograph (or a painting, or a poem, or a piece of music)? The basic way to do so is to *create* it: snap the photo, paint the picture, write the poem or song. You don't have to do anything else (not even fill out a form) — you automatically hold the copyright to a work that you create.

Are there exceptions? Of course: laws nearly always have exceptions. The major exception is described in three words: "work for hire." If you are an employee who takes photographs as part of your job, the copyright to those photographs belongs to your employer, not to you. An example would be photographs of products taken for use in a catalog or sales brochure.

A self-employed photographer can agree (for financial or other business reasons) that a job will be done on a work-for-hire basis. The client becomes the copyright holder.

Copyright can also be obtained by means of a *copyright transfer* — usually in the form of an outright purchase from the original copyright holder. The collections of photos sold on CD for use in advertising and similar applications were assembled by purchasing the copyrights from the photographers.

Copyright notice

If copyright is automatic from the time a work is created, why are many photographs published with a notice of copyright (such as *©2002 Joe Shutterbug*)? The same form of notice is often rubber-stamped onto the back of prints or printed on slide mounts.

Before 1989, when U.S. copyright laws were changed to conform with international usage, such a notice was required on any published photo. The notice established ownership and protected the photographer's rights in case of infringement (illegal use of the image). Today, the use of the notice is strongly recommended as a means of discouraging possible infringement. If a person makes illegal use of a work that bears a copyright notice, he or she will not be able to use the defense of "innocent infringement" (meaning that he or she did not realize the work was protected by copyright).

The copyright notice consists of three parts: the symbol © (alternatively, the word "Copyright" or the abbreviation "Copr." can be used), the year of first publication (or creation), and the name of the copyright holder.

The copyright holder's name can be spelled out ("Joe Shutterbug"), abbreviated ("JS"), or replaced by a known alternative designation ("Joe's Photo Studio").

Length of copyright

Under the copyright law in effect up until December 31, 1977, a work could be protected for a total of only 56 years — 28 years from the first publication, plus a 28-year renewal period. At the end of that time, it entered the *public domain*, where it could be freely used by anyone.

Since January 1, 1978, the term of copyright has been greatly lengthened. Works created after that date are covered by copyright from their creation until 70 years after the death of the copyright holder.

Registration of copyright

Registering the work with the U.S. Copyright Office (a part of the Library of Congress) is not required to obtain copyright protection. It does, however, establish a public record of the copyright ownership. If infringement of the copyright occurs, it must be registered before an infringement suit can be filed in court. Registration may be obtained for both published and unpublished works.

To register a work, you must complete a form, pay a fee ($30 currently), and supply two copies of the item being registered. The form, fee, and copies should be sent as a single package to:

Library of Congress
Copyright Office
101 Independence Avenue, S.E.
Washington, DC 20559-6000

Copyright Basics, a detailed explanation of the copyright law, can be downloaded from the Copyright Office web site: *www.lcweb.loc.gov/copyright/circs/circ1.html.* The web site of the American Society of Media Photographers (*www.asmp.org*) offers explanatory material on copyright as it applies to photographers.

How Does Copyright Benefit the Photographer?

If you shoot only family events or display your work only in camera club competitions, then the existence of the copyright law has little or no effect on your life. But what if you are the only person with a camera on the scene of a major news event? Suddenly, your photographs could become items of considerable monetary value. More realistically, you may be a serious photographer who wishes to make a continuing income from your work. In either situation, the copyright law will help you reap the benefit of your work in both the short and long term.

Copyright law allows you to *license* (grant permission for a fee) the use of a photo to another person or organization. Licenses may be restricted in many ways — by geographical area, by number of uses, by time period, or even by market segment. For example, you might license a given photo to a magazine for one-time use to illustrate an article, to a poster publisher, and to a greeting card company. If the card company distributes its products only in a several-state region, you could also license the same photo to other card companies operating in different areas.

Unless there is a compelling reason (usually monetary) to do so, most photographers try to avoid selling "all rights" to an image. This means that the buyer becomes the owner of the copyright, and the photographer no longer has any proprietary interest. Such a sale might occur in the case of the photographer who has the only pictures of a major news event: various national media might try to outbid each other for the rights.

In more typical circumstances, however, a photographer would have to weigh the possible income from multiple licenses over

a period of time against the lump sum of an all-rights sale. NOTE: The American Society of Media Photographers warns its members to carefully read all contracts and purchase orders from potential clients before signing, to be sure that the document does not include a copyright transfer.

As noted earlier, copyright law also protects the photographer from illegal use of her or his work. If someone uses a work without proper licensing or permission, that person can be sued for copyright infringement by the photographer. Such a suit can seek both *monetary damages* (the sum the photographer claims was lost due to infringement) and *punitive damages* (a sum sought as punishment).

Technical Vocabulary

A comprehensive glossary of photographic and digital imaging terms would, of course, fill an entire volume. The following list is intended to provide definitions of the basic terms used every day by professionals. It includes those terms highlighted in *bold italic* (and generally defined in context) in the chapters. Other terms that would be useful in communicating photographic or digital information also have been included.

A

Absorbed: Descriptive term for light that is "soaked up" by the subject and not reflected.

Abstractionism: A school of photographic thought that was dedicated to selecting or "abstracting" one characteristic or element of a subject and making it the main focus of the image.

Achromatic lens: A lens designed to minimize or eliminate chromatic aberration by combining a convex lens of crown glass and a concave lens made from flint glass.

Active autofocus: Focusing system in which a beam of infrared light is emitted to bounce off the subject. The system times the interval between the departing and returning burst of light, calculates the distance, and focuses the camera to that distance.

Active layer: The layer to which changes will be made. Active-layer status is indicated by the layer name being highlighted and showing a brush icon immediately to its left.

Additive color process: Color-reproduction method used with transmitted light (as on television screens or computer monitors). Red, blue, and green wavelengths of light (the additive primaries) interact to create all other colors.

Additive primaries: The colors red, green, and blue.

Advanced Photo System (APS): A film and camera system developed jointly by a group of major film and camera manufacturers and introduced in the mid-1990s.

Agitation: A regular cycle of movement of a processing tray or developing tank to set up an ebb-and-flow of solution over the print or film. This constantly exposes the emulsion to fresh solution to ensure even development.

Air bells: Bubbles that cling to the film surface and interfere with development, leaving behind dark round spots or mottling on the film.

Aircraft cable: A strong, thin, finely braided wire rope often used in darkrooms as a hanging line for print drying.

Ambient lighting: The lighting that already exists in a scene or space, without any additions being made. Ambient lighting can be from natural sources, artificial sources, or a mixture of the two.

Ambrotype: A glass negative placed over a black backing material that changed the appearance of the negative into a positive so that it resembled a daguerreotype.

Anastigmatic lens: Lens designed to overcome the lens aberration called astigmatism.

Antihalation layer: The bottommost layer of film, located on the back side of the base. This layer prevents light rays from being reflected back through the base and emulsion. Without this layer, reflected light could form halos (halation) around bright objects in the photograph.

Aperture: Term used to describe the size of the opening, through which light passes to expose the film inside the camera.

Aplanatic lens: A convex lens with a different curvature on each side, designed to correct spherical aberration.

Apochromatic lens: A lens corrected to provide precise convergence of the primary wavelengths of light to eliminate chromatic aberration.

Archival print washer: A plastic or steel washing device designed for virtually total removal of fixer residues to help ensure long print life.

Archival processing: Fixing and washing procedures used to ensure that a photographic print will last for hundreds of years without deteriorating. Archival processing is typically done only for prints made on fiber-base paper.

Archival quality: Term applied to photographic prints (conventional or digital) that are processed with the intent of achieving very long life.

Area array: A grid made up of rows and columns of electronic sensors.

Aspheric lens: A lens with surfaces that are not a section of a sphere, designed to overcome the lens aberration called curvature of field.

Astigmatism: The inability of a lens to bring horizontal and vertical lines in the subject into sharp focus at the same time.

Autochrome process: The first practical form of color photography, introduced in 1907. Fine grains of colored potato starch were applied to a plate, then the plate was coated with an emulsion. After exposure and development, it produced a viewable color image.

Automatic processors: Color print-development systems that carry the exposed paper through a series of light-tight tanks containing the various chemicals. Some models are "dry-to-damp" types, turning out a washed print that must be dried outside the machine. The most sophisticated models are "dry-to-dry," ejecting a fully processed and dried print.

Averaged reading: A light reading made by pointing the meter at the main subject. Most often, the scene will include a range of tones, from those that reflect a great deal of light (*highlights*) to those that reflect little or no light (*shadows*). The meter reading will fall somewhere in the middle, averaging out the reflected light.

B

Back standard: Multifunctional component of a view camera that holds the ground glass used for focusing, accepts the filmholders or backs, and may be capable of control movements.

Background layer: The initial layer set up when an image from a scanner, digital camera, or CD is first opened in the image-editing program.

Background light: Separate light used in studio photography specifically to provide sufficient visual separation between the subject and the background.

Backlighted: Descriptive term for a subject that has most of the light coming from behind it.

Ballhead: A very flexible camera support with a camera platform attached to a highly polished metal sphere contained in a housing. When the locking lever is released, the ball can be rotated 360° and tilted through an arc of 180°, providing quick and infinitely adjustable positioning.

Banquet camera: A specialized view camera, typically producing a 12″ × 20″ negative, that was used to record large gatherings.

Bare bulb flash: Method of using a flash without a reflector, so that the light can spread in all directions. The result is a soft, even illumination.

Barn doors: Hinged rectangular flaps attached to the front of a lighting unit, that can be adjusted to physically block a portion of the light being emitted.

Barrel distortion: An optical distortion in which a rectangular image has outward-bulging sides.

Base: The support material of film and photographic paper that carries the emulsion and various special-purpose coatings.

Beam candlepower-seconds (BCPS): Unit used for scientific calculation of electronic flash light output. See *Guide number.*

Beanbag: A small pillow-shaped cloth bag filled with dry beans or rice that will conform to the shape of the camera or lens and provide a solid support on a table, fence, or similar surface.

Bed: The base of a large-format field camera, upon which the standards containing the lensboard and filmholder are mounted.

Bellows: In effect, a variable-length extension tube, with the camera attached to one end and a lens to the other. A gear and pinion arrangement extends or collapses the bellows to achieve the desired extension.

Bellows factor: Calculation used in large-format photography to determine a corrected exposure, based on focal length of the lens and the amount of bellows extension.

Between-the-lens shutter: Light-control device that is part of the lens assembly. See *Focal plane shutter.*

Bit depth: A numeric expression of the number of shades of gray a pixel is capable of displaying.

Black point: In scanning, the tone selected as the desired darkest value (0) for the image.

Bleaching: Lightening selected areas of the print for emphasis or for better balancing of tones. A dilute solution of a reducing agent (bleaching chemical) is used.

Blooming: In a digital photo, the smearing or bleeding of some color pixels, especially red, into adjacent parts of the image.

Blotter book: Volume with pages of thick, soft, absorbent paper bound together at one edge. It is used to soak up excess water from fiber-base prints.

Blotter roll: A long continuous sheet of thick, soft absorbent paper in which wet fiber-base prints are rolled to soak up excess water.

Blue-sensitive films: The earliest types of film. They responded only to wavelengths in the blue/violet/ultraviolet end of the spectrum.

Blur filter: Special-effects filter available in different degrees and patterns of blurring, such as motion blur, zoom, or rotation.

Borderless easel: A type of easel that permits printing an image out to the paper's edge.

Bounce flash: A method of softening and diffusing flash light reaching the subject by first bouncing it off a wall, a ceiling, or even a piece of white plastic or card stock.

Brightness/contrast tool: A simple and easy to use tool that allows adjustment of either brightness or contrast of an image.

Brush-on adhesive: Liquid material used to adhere a print to a substrate.

Buffered: Descriptive term for mounting boards that are made slightly alkaline to counter the long-term effects of weak airborne acids.

Built-in flash unit: Small artificial-light source found in most point-and-shoot and many consumer-level SLR cameras.

Bundled: Term used to describe software included as an accessory item when a scanner, camera, or computer is purchased.

Burning in: A technique that involves making one or more additional exposures of selected areas after the basic print exposure has been made. It is primarily used to darken and bring out detail in the picture's highlight areas.

Burst mode: The digital equivalent of a motor drive, allowing several exposures to be made in quick succession.

C

C-41 process: The current Kodak designation for its negative-film development process. Other film manufacturers have their own designations (CN-16 for Fuji, AP-70 for Afga), but the processes are essentially identical.

Cable release: A stiff wire, inside a flexible sleeve, that is used to manually press the shutter release without causing vibration.

Cadmium sulfide cell (CdS) meters: Light meters that use a cell which changes its *electrical resistance* based on the intensity of light striking it. The increase or decrease changes current flow, which is translated into exposure values shown on a scale or a display.

Calotype: An early version of the negative/positive system that used treated paper as the negative material.

Camera: A light-tight box with a closable hole at one side and a light-receptive material on the opposite inside surface.

Camera angle: Any of the different points of view (such as "high-angle" or "low-angle") that can be used to vary a picture's composition and visual impact.

Camera lucida: A tracing aid consisting of a prism mounted on a stand that projected a scene at a right angle onto a piece of paper.

Camera obscura: Literally meaning "dark chamber," the camera obscura was an enclosed space with a pinhole opening (later a lens) on one side that projected an image of the scene outside onto a movable screen or wall, where it could be traced onto paper or canvas.

Camera shake: The involuntary movement of the camera during exposure, causing a blurred picture.

Camera technique: Using a camera and its capabilities to greatest advantage to obtain photos that are technically correct and esthetically pleasing.

Capacitor: A device capable of storing an electrical charge. The capacitor is a vital element of the electronic flash.

Capacity: The amount of material a photographic chemical can process before it becomes exhausted.

Cassette: A light-tight metal or plastic container holding enough film (usually 35mm) for as few as 10 or as many as 40 exposures.

CCDs (Charge-Coupled Devices): Electronic sensors widely used in the image capture arrays of digital cameras.

Celluloid: See *Cellulose nitrate.*

Cellulose acetate: A more stable type of plastic than flammable cellulose nitrate. It began to be used as a film base in the 1920s, but did not become widely adopted until the 1950s.

Cellulose nitrate: One of the earliest plastics, it was used as the clear base for early roll films. Also known as celluloid, it was highly flammable and was replaced by the more stable cellulose acetate.

Center of interest: A single element of the photo to which all the other elements of the picture will relate. Without such a center of interest, or with more than one emphasized element, the photo does not send a clear message to the viewer.

Center spot filter: A special-effects filter that provides normal sharpness in the center, but adds diffusion to all other areas.

Characteristic curve: An S-shaped graph that serves as a "snapshot" of a given film's reaction to light. It shows the relationship between exposure and density increase.

Character mask: An image-editing technique that results in letters on a color background that are filled with a desired image.

Chromatic aberration: An optical problem in which different wavelengths (colors) of light focus at slightly different distances behind the lens.

Chromogenic film: A type of black-and-white film that produces an essentially grainless image composed of dyes, rather than silver.

Circles of confusion: Points in front of or behind the plane of focus will appear as small circles on the film, and become larger as the distance of the originating point from the plane of focus increases. Size of the circles determines sharpness of the image on the film.

Circular polarizer: A polarizing filter with the crystals of polarizing material arranged in a circular pattern. This type of polarizer will not interfere with autofocus systems. See *Linear polarizer.*

Clearing time: The time it takes for a piece of exposed but undeveloped film to turn from opaque to clear when immersed in fixer. Doubling the clearing time establishes the proper length of fixing time for film.

Closeup diopters: Magnifying devices that simply screw onto the front of the camera lens. They shorten the focal length of the lens, and thus increase the image size on the film. Sometimes called *supplementary lenses* or *plus diopters.*

CMOS (Complementary Metal Oxide Semiconductors): Electronic sensors being used in the image-capture arrays of a growing number of digital cameras. They are less costly to make and consume less power than the more widely used CCD sensors.

CMYK images: Images using the subtractive color system, intended for reflected light applications such as printing.

Cold-light head: An enlarger light source that consists of a grid of fluorescent tubes emitting a soft nondirectional light. The light is usually further diffused before passing through the negative.

Collodion: A basic emulsion ingredient of the wet-plate process, consisting of cellulose nitrate dissolved in ether and alcohol. A halogen salt such as potassium iodide also is dissolved in the mixture.

Color-grad filter: A filter with a colored portion that gradually fades to clear. These filters are used to add color to part of the scene.

Colorhead: An enlarger light source with built-in filters that permit "dialing in" the precise combination of filter values needed.

Color printing (CP) filters: Acetate filters made specifically for enlarging work.

Color sensitivity: The way a film responds to the different colors (wavelengths) of light.

Color wheel: A visual representation of the relationship of the additive and subtractive primary colors. The cyan, magenta, and yellow subtractive primaries fall between the

red, green, and blue additive primaries. Each of the primaries will absorb light of the color that is positioned opposite it on the wheel (called its *complementary* color). It will reflect or transmit the colors on either side of its position.

Coma: A lens aberration that occurs when light rays not parallel to the lens axis create a series of overlapping circles of decreasing size. These circles gives the appearance of a comet with a tail, (thus the name *coma*).

CompactFlash: A small, solid-state memory card, available in capacities from 4 Mb to more than 500 Mb, which is slipped into a slot on the camera.

Compensating enlarging timers: Sophisticated timing systems that monitor any voltage fluctuations and make necessary adjustments in exposure time.

Complementary color: See *Color wheel.*

Composites: Images created by combining part or all of other images.

Composition: The process of selecting and arranging the elements of a photograph to achieve a desired effect.

Compositional elements: The basic components used for effectively composing photographs. The traditional compositional elements consist of point, line, shape or pattern, balance, emphasis, and contrast.

Compound lens: A combination of convex and concave lenses designed to overcome optical problems, called *aberrations*, that result in blurred, color-distorted, or shape-distorted images.

Compressed file: One that has been converted to a format that allows it to be saved in a smaller size to take up less storage space or to speed up transfer time.

Concave: A lens shape that is curved inward.

Condenser enlarger: Photographic enlarger that passes light through a condensing lens to make it directional and focus it on the plane where the negative is held. This bright, focused beam of light permits relatively short exposure times, and provides a sharp and somewhat contrasty image.

Conservation board: Acid-free mounting board made with fibers derived from specially processed wood pulp.

Contact print: A same-size print made by exposing a negative that is physically laid on top of the photographic paper.

Contact sheet: A form of one-sheet proof containing same-size prints of an entire roll of either 35mm or 120-film negatives.

Continuous tone: Descriptive term for a conventional photographic print, in which tones blend smoothly into one another. Used in contrast to *halftone,* which describes prints broken up into dot patterns for printing-press reproduction.

Contrast: The relationship of shadow and highlight within a photo. Also, a noticeable difference (such as size) between adjacent elements of a composition.

Contrast filters: Filters made in deep shades of color (red, blue, green). Each of these filters will transmit light of its own color, but absorb light of the other two colors. Their major use is to help differentiate between colors when they are rendered as gray shades on black-and-white film.

Contrasty print: One with strong blacks and bright whites, but few gradations of tone in between. An overly contrasty print is sometimes described as "chalk and soot."

Converge: To come together, as in light rays passing through a convex lens.

Convergence: A compositional problem in which parts of the image come together in an undesirable way.

Converging verticals: Distortion in which vertical elements (such as the sides of a tall building) seem to come together as they recede from the viewer. This effect is suitable in some contexts, such as using strongly converging verticals to convey the "tallness" of skyscraper.

Convex: A lens shape that is curved outward.

Cooling filter: A light blue filter used to make the coloration of a scene a bit less yellow.

Copystand: A device consisting of a vertical column with an adjustable mount for the camera, a flat stage upon which the item to be copied is placed, and usually two arms holding lighting units.

Corners: See *Mounting corners.*

Countdown timers: Darkroom timing devices that are set for the total period, and then count down to zero. Digital models show minutes and seconds on an LCD (liquid crystal display).

Coupled rangefinder: A camera focusing device that is mechanically connected to the lens, so the subject is brought into focus as the split or overlapped images are aligned.

Coupling ring: An accessory with filter threads on both sides permitting a reversed lens to be connected to a lens mounted on the camera.

Covering power: The circular area that is "seen" by a lens. In an enlarging lens, the circular area must be large enough to fully cover the size of the negative being printed. A lens for a large format camera should have sufficient covering power (project a large enough image circle) to permit the use of camera movements (rise, fall, swing, and tilt) for image adjustment.

Cropping tool: In an image-editing program, a specialized tool that permits adjustment of the selection outline and precise rotation of the image before cropping.

Cross processing: A color development technique in which negative film is processed in developer designed for transparency film, or vice versa. Unusual and often striking shifts in color result.

Curvature of field: A failure of light rays to focus at a common point. The projected image will either be in focus at the center and out-of-focus at the edges, or vice versa (depending on which focal point is chosen).

Curves tool: A powerful means of adjusting contrast and color of an image. Available in both scanning and image editing software.

Cyanotype: A *printing-out* process (one in which the image actually becomes visible as the exposure progresses) that produces a dark blue image.

D

Daguerreotype: The first widely available form of permanent photograph, in which the image was recorded on a silver plate. Each daguerreotype was "one of a kind," a direct positive image.

Dark slide: The opaque, movable lid of a sheet film holder, which is withdrawn to make an exposure.

Daylight drum system: A print processing system that makes use of a light-tight plastic tube with provision for introducing measured amounts of developer and other chemicals.

Daylight-balanced film: An emulsion optimized for use with natural daylight or the bright, blue-white light from an electronic flash.

Dedicated flash unit: A flash unit manufactured for use with a specific camera model (or a range of models from one manufacturer). See *TTL (through the lens) flash.*

Density: The darkness, or light-blocking ability, of the developed photographic image.

Depth of field: The size of the zone of acceptably sharp focus. It becomes greater as the aperture size decreases, and shrinks as aperture size increases.

Depth-of-field preview: A desirable camera feature that allows the photographer to see the scene at the desired aperture and assess the actual depth of field.

Depth of focus: The distance that the film can move toward or away from the lens without the image losing sharpness.

Desaturate: To remove color from all or part of an image, displaying gray values instead. The image remains in the color mode, with the three color channels still intact.

Developer: A powerful reducing agent that converts silver halides to metallic silver to turn a latent image into a visible image.

Developing-out paper: A photographic paper that requires the use of a developer to bring out the latent image.

Developing reels: Plastic or stainless steel devices onto which film is threaded for small tank processing.

Diaphragm: A variable-aperture device (also called an *iris*) that consists of an assembly of thin, overlapping metal blades.

Dichroic filter head: A color-printing head for the enlarger that permits the photographer to "dial in" the desired values of yellow, magenta, and cyan filtration. The head also can be used for printing with variable contrast black-and-white paper.

Diffraction: The bending of light rays around the edge of a very small opening, which can affect image sharpness.

Diffused light: Light that is reflected in many directions and has a soft, unfocused quality.

Diffusion enlarger: A type of enlarger that produces a soft, unfocused, nondirectional light by passing it through a frosted diffusing panel or by reflecting it repeatedly off the walls of a mixing chamber. The diffusion enlarger requires longer exposure times and produces a print that is somewhat softer in contrast than one made on a condenser enlarger.

Diffusion filter: A filter that provides a slightly softened look. Different degrees of diffusion are available.

Digital backs: Digital capture devices attached to large format or medium format cameras in place of the traditional film holder. The devices contain very large arrays of charge-couple devices, or CCDs to capture light from the subject, resulting in a high-quality image rivaling traditional film.

Digital noise: Tiny light-colored spots especially noticeable in shadow areas of a scan or image capture.

Digital resolution: A means of expressing scanner resolution that is used by some manufacturers for advertising purposes. It is achieved by using software to interpolate additional pixels around those actually scanned.

Dimensional stability: A mounting material's ability to retain its original dimensions and not expand or shrink excessively.

Direct flash: Aiming the flash "straight on" at the subject from a position directly over or right next to the lens.

Direct-reading meters: Meters that provide a reading in the form of a specific f-stop/ shutter speed combination.

Discharge: Light emission that results when a high-voltage current is passed through a tube filled with xenon, an inert gas that emits a short and very intense burst of light.

Distortion: A change in the shape of a rectangular image projected by a lens. It is one of the several effects related to spherical aberration. Also, the stretching or compression of an image achieved by altering the plane of the surface upon which it is being projected.

Diverge: To be spread apart, as in light rays passing through a concave lens.

Documentation: Pictures taken "for the record," rather than for an artistic purpose.

Dodging: A printing technique used to reduce local exposure by placing an opaque tool in the light path to "shade" the selected area during part of the print exposure.

Double-exposure filter: A device with an opaque mask that can be rotated to cover one-half the lens at a time, allowing two nonoverlapping exposures on the same film frame.

Double-weight: The thicker of the two weights available in fiber-base printing papers.

Drop-in loading: A feature of Advanced Photo System cameras that allows the consumer to merely open a film door on the camera and insert the cassette. The film is then automatically loaded and advanced to the first frame.

Drum system: A mechanical system used for print development. The drums are rotated by a motor to provide consistent agitation and even development. Only small amounts of chemicals are used for each print, and most development is done in room lighting.

Dry darkroom: One that is set up in a room without a water supply. Finished prints are normally accumulated in a tray of water and taken to a laundry room or bathroom for washing.

Dry-mount press: Device with a heated platen that can be clamped down to adhere a print to its mounting board.

Dry mounting: A process that uses heat and pressure to bond a print to the substrate.

Dry plate process: A method of producing a glass plate with a gelatin based photosensitive emulsion. Unlike the wet-plate collodion process, dry plates could be prepared and stored for months before being exposed, and development could be delayed until convenient.

Dry side: The area of a darkroom that contains the enlarger, counter space for such equipment as a paper trimmer, and storage for photographic paper and other materials and tools that must be kept dry.

Dupe: Common term for a high-quality duplicate transparency.

Dye sublimation printer: A printer containing a print head with thousands of tiny, precisely controlled heating elements. The print head works in conjunction with a wide plastic transfer ribbon carrying solid CMYK dyes. The print head causes the dyes to vaporize (sublimate) and deposit as tiny color spots on a specially coated paper. The vapor deposits blend to produce an extremely smooth image without visible dot structure, very similar to a continuous-tone photographic print. Dye sublimation images are archival.

Dynamic range: The ability of a scanner to reproduce detail at the extremes of highlight and shadow (the darkest and brightest areas of the picture). This characteristic is measured on a logarithmic scale, with a maximum value of 4.0.

E

E-6 process: Kodak's designation for its development process for all color transparency films except Kodachrome.

Edge mounting: A loose mounting approach in which the photographic print is held by its corners or by hinges made from easily removed acid-free paper tape.

Editing program: See **Image editing program**.

Electronic flash: The primary source of portable artificial light for photography. A strong electrical charge is built up in a storage device called a capacitor, then released into a gas-filled flash tube, producing a burst of bright light synchronized with the opening of the camera shutter.

Electronic frame: Device with an LCD screen that displays digital images in much the same way that conventional picture frames display physical photographs.

Electronic remote control cord: The electronic equivalent of a manual cable release that allows operating the shutter of newer cameras without causing vibration.

Electronic studio flash units: Larger, more powerful versions of the standard portable electronic flash. They are available as a *traditional studio flash system*, with a central power pack connected to separate flash heads, or as *monolights*, which are independent units combining the flash head and power supply.

Emphasis: A compositional tool is used to make some element of a picture stand out and capture the viewer's attention.

Emulsion: A thin coat of clear gelatin in which silver halide crystals are suspended.

Emulsion transfer: An alternative photographic process in which a fully-developed Polaroid photo emulsion is separated from its backing and applied to a substrate.

ENG (Electronic News Gathering): The use of video cameras to record news events for television broadcast.

Enlargement: A photographic print made by passing a beam of light through a negative and a lens and projecting it onto the photographic paper.

EPS: Encapsulated PostScript file format.

Equivalent exposures: Different combinations of shutter speed and aperture that are equal in exposure value.

Exclusion: Selectively framing to eliminate unwanted elements in the photo. Exclusion is sometimes referred to as "cropping in the camera."

Exhausted: Term used to describe a chemical solution that has exceeded its processing capacity or otherwise become ineffective.

Extension tubes: Glassless cylinders that move the lens farther away from the film plane to achieve high magnifications. They come in various lengths, and can be coupled together to achieve the desired extension.

Extra-fine-grain developer: A low-energy type of developer that tends to work slowly and produces a finer grain by preventing the formation of clumps caused by the overlapping of silver grains.

Eyedropper tool: A color sampling device used in both scanning and image-editing software. See **Black point** and **White point**.

F

f-stops: The numbers (5.6, 8, 11, 16, and so on) used to designate apertures of a lens. The f-numbers themselves are calculated by dividing the focal length of the lens by the diameter of the aperture. An f-stop can be thought of as a fraction: f/8 is an aperture 1/8 the focal length of the lens.

Fall: View camera movement in which the front or rear standard is adjusted downward from the neutral position.

Fast lens: A lens that has a large maximum aperture, giving it great light-gathering power.

Feathering: Technique in which the light source is adjusted so that the less intense outer edges of the light cone illuminate the subject. In an image-editing program, *feathering* is a means of softening edges of a selection to allow smooth combining of images.

Ferrotype: Formal name for the popular "tintype" process, in which a wet collodion emulsion was applied to a thin iron plate that had been painted with a black or brown enamel.

Ferrotyping: A procedure (seldom used today) for achieving an ultra-high gloss on a photographic print. The wet print is placed face-down on a highly-polished metal plate and a roller used to press out as much moisture as possible. When the print is dry, it will release from the ferrotype plate.

Fiberglass screens: Framed units used for air-drying prints. The screening material is soft enough to prevent scratching the emulsion of the print, does not absorb any residual chemicals, and can be easily cleaned if any dust or dirt accumulates. The open weave allows air to circulate around both sides of the print for even and relatively rapid drying.

Field camera: A large format camera, more compact and rugged than the rail-type studio camera, which is used for outdoor or other location work The front portion of the camera's flat bed can be folded upward to protect the retracted bellows and lens during transport.

File size: The amount of information recorded for a given image, usually expressed in kilobytes or megabytes (1 kilobyte = 1024 bytes; 1 megabyte = 1024 kilobytes or 1,048,576 bytes).

File type: Formats or methods of encoding an electronic file so that it can be recognized by different computers and applications.

Fill flash: Technique in which the flash unit's output is balanced with the ambient light. When fill flash is properly used, the lighting of the subject will appear natural, rather than give the appearance of a "flash picture."

Fill light: Studio light used to place supplementary illumination on the subject to soften dark shadows, decreasing the contrast range of the light reflected from the subject.

Film base plus fog: The minimal density of a clear film area, such as the strip between frames. The tiny amount of density is caused by the processing chemicals (rather than light). Also, a short, horizontal section at the left end of the characteristic curve.

Film cassette opener: A tool that is hooked over one of the crimped-on ends of the cassette, then used with a prying motion.

Film clips: Wood, metal, or plastic spring-loaded devices used to hang film for drying after development.

Film frame: The working space within which the picture is composed. All the compositional elements are employed in relation to the frame.

Film holder: A light-tight device that rigidly supports the film sheet. It is inserted in the camera and opened to permit an exposure to be made.

Film plane: The horizontal plane in the camera where the film is located and the light rays are focused. Also called the *focal plane.*

Film recorder: A device used to convert a high-quality digital image from electronic to conventional film form. The exposed film (transparency or negative) then is conventionally developed.

Film speed: The film's sensitivity to light — the higher the film speed, the less light is needed to create a latent image on the emulsion.

Filter decals: Transparent color overlays applied in a checkerboard pattern over individual sensors in a CCD array. There are usually twice as many green filters as red or blue filters, because human vision is most sensitive to the light values contained in the green channel of a color image.

Filter drawer: A holder for inexpensive acetate or gelatin filters for either color printing or variable-contrast black-and-white printing. Highest quality is obtained when filters are positioned between the light source and the negative, since the light is modified without optically degrading the projected image.

Filter factor: Exposure compensation made necessary by the amount of transmitted light lost passing through a filter.

Filters: Light-modifying or image-altering materials placed over the lens of a camera or an enlarger. In an image-editing program, filters are special features that can be applied to images to change aspects of their appearance. Some make only minor alterations; others perform radical change.

Finishing: Drying a print and repairing any minor visual defects prior to mounting.

FireWire: A very fast method for data transfer between cameras, scanners, and other computer-connected devices.

Firmware: The built-in program found in a digital camera or similar device.

Fish-eye lens: A lens with an angle of view greater than 180°. Such a lens produces a round image with considerable spherical distortion.

Fixer: A powerful silver solvent. It dissolves the unexposed silver halide particles and allows them to be washed away, making the developed image permanent.

Fixing: The chemical process of treating a developed photographic image to prevent further darkening of the silver by exposure to light.

Flags: Shapes cut from black posterboard or stiff black paper and attached to light stands or

other fixtures to block light (for example, to shade the camera lens).

Flare: The effect of stray light bouncing around inside the lens housing, causing decreased contrast, or even a severe "washed out" appearance that mimics overexposure.

Flash meter: A meter that can make an exposure reading for electronic-flash units.

Flash powder: A fine powdered form of the highly flammable metal magnesium, the earliest form of portable light for photography.

Flash synchronization speed: The speed at which a focal plane shutter is fully open — 1/60 second for most older cameras. Newer cameras offer higher synchronization speeds.

Flashbar: A multiple-flash device with five bulbs on each side, once widely used on simple consumer cameras. It was turned end-for-end to use bulbs six through ten.

Flashbulb: A glass bulb containing a small filament coated with an easily ignited paste material, a quantity of fine aluminum wire or foil, and an oxygen-rich gas mixture to promote rapid burning.

Flashcube: A multiple-flash device with four bulbs, once widely used on simple consumer cameras.

Flat field lens: A special type of lens, used for copying, that is designed to eliminate distortion or softness of focus at the edges.

Flat print: A low-contrast print with a generally gray appearance, and no areas of strong black or bright white.

Flatbed camera: See *Field camera.*

Flatten: Command in an image-editing program that merges all layers of an image into one. Flattening is done to convert the file from its native Photoshop format to a different format for insertion into a page layout program. Flattening should not be done until all adjustments and changes have been made to the image.

Flatwork: Prints, documents, and similar two-dimensional items to be copied photographically using a copystand.

Flipflash: A multiple-flash device with four bulbs on each side, once widely used on simple consumer cameras. It was flipped over to use the fifth through eighth bulbs.

Flopping the negative: Turning the negative upside down to reverse the orientation of the subject matter before making a conventional print.

Fluorescent light source: One in which a discharge of electrical energy causes a gas (usually mercury vapor) to emit ultraviolet radiation. This radiation, in turn, causes a coating inside the glass tube to glow and emit light.

Flush mount: Display method in which the photo extends to the edge of the mount, with no border.

Foam board: Mounting material made with a paper facing on a rigid core of plastic foam.

Focal length: The distance from the optical center of a lens to the point where the light rays converge (the film plane) when the lens is focused at infinity.

Focal plane shutter: Light-control device located in the camera body, just in front of the film. See *Between-the-lens shutter.*

Focal point: The common point at which converging light rays meet.

Focus lock: A feature of some autofocus cameras that allows the photographer to select the subject to focus upon, then hold that focus while recomposing the picture.

Focusing aids: Features in a camera's viewfinder designed to simplify the task of focusing. There are two major types of focusing aids, the split prism and the microprism.

Focusing mark: A mark (usually a short line or a dot) on a manual focus lens that is used to determine the distance from the camera to the subject. Numbers on a distance scale align with the mark to show — in feet or meters — the distance to the subject being focused upon.

Focusing rail: A tripod-mounted accessory that permits the camera to be moved toward or away from the subject in tiny increments with a fine-toothed rack-and-pinion gearing set.

Follow focus: A technique in which the photographer makes continuous small adjustments to keep a moving object sharp so that the shutter can be pressed at any time.

Formal balance: A composition that consists of matched halves; dividing the frame vertically or horizontally in the middle would produce two "mirror images."

Four-blade easel: This easel has four independently adjustable spring-steel blades that allow infinite variation of print size and proportion.

Freeform pen tool: A variation of the basic pen tool with some automatic features.

Frequency: A measure of the number of electro-magnetic waves (cycles) passing a given point in one second.

Front standard: Component of a view camera that has variety of functions, from holding the lens to making various movements for focusing and perspective control.

Full-frame print: A print made without cropping. A full-frame print from a 35mm negative on an 8″ × 10″ sheet would result in an image approximately 6 1/2″ × 9 1/2″.

G

Gearhead: A variation of the pan-tilt head that uses gears rotated with cranks or knobs to achieve precision movement.

Gel: See *Theatrical gel.*

General purpose paper developers: Developers usable with most papers to produce prints that have a neutral black tone, or a "cold" (blue-black) tone. Sometimes referred to as "universal" paper developers.

Giclée: A French term (meaning spray or squirt) adopted in the early 1990s by fine-art photographers to characterize the prints they were producing on high-quality commercial ink jet printers.

Glossy finish: The smooth, shiny surface favored by many photographers for printing papers. It helps convey the full range of tones available in the photo, especially strong, deep blacks.

Gobo: A generic term for any light-control device or material (such as textured glass or a colored gel) that "goes between" the light and the area where the light is intended to fall.

Graduated ND filter: A square or rectangular filter with a neutral density value that gradually fades to clear. It is often used to compensate for a large difference in brightness between the sky and the foreground. Also called an "ND grad."

Grain: The clumps of metallic silver visible on the film or print.

Grain focuser: A critical focusing device placed on the enlarging easel. A small section of the image will be reflected from the focuser's mirror to a magnifying eyepiece. The enlarger's focus control is adjusted until the image is as sharp as possible.

Graphics editing software: See *Image editing program.*

Graphics tablet and pen: A pointing and selection device. When moved on the tablet surface, the pen acts like a mouse, but is capable of much more precise control of tools when drawing or when retouching fine details. Tablets range in size from 4″ × 6″ to 12″ × 18″.

Gray card: A standard reference value of *middle gray,* equivalent to a tone that reflects 18% of the light that falls upon it. A gray card is often used to take light readings under studio conditions.

Gray levels: The distinct "steps" between pure white and pure black.

Grayscale mode: A mode in which all picture information is conveyed by up to 256 shades of gray.

Grid: Light modifier with square or hexagonal openings that align the rays of light so that they are more ordered and parallel. The grid adds sparkle to a scene through increased contrast.

Ground fault circuit interrupter (GFCI): An electrical safety device required for any outlet in a location with water (such as a darkroom). It will instantly cut off electrical power if a dangerous current flow (short to ground) develops.

Ground glass: A plain focusing surface used on large format and TLR cameras.

Ground glass focusing: A method that requires the photographer to make a judgment of when the image is in sharp focus.

Guide number: A manufacturer-supplied number based on the light output of the flash and the ISO rating of the film, used to manually determine lens aperture to be used for proper exposure.

Gum bichromate process: A printing process based on the hardening of a sensitized colloid material when struck by light, forming an image that can be developed by dissolving away the unexposed material. Gum bichromate printing makes use of a mixture of potassium bichromate and gum arabic (a resin obtained from tropical trees), which can be dissolved by cold water.

H

Hair light: In portrait photography, a small light often used both for dramatic effect and to help separate a dark-haired subject from a dark background. Also called an *accent light* or *rim light.*

Halftone process: A reproduction method in which continuous photographic tones are broken up into dot patterns to permit printing in newspapers, magazines, or similar publications.

Hanging line and clips: Traditional method of air-drying prints by suspending them over a darkroom sink.

Hard light: Light cast on the subject directly from a small source, resulting in dark, well-defined shadows.

Heated print drying units: Direct-heating units use an electric resistance heating element to warm a metal platen on which a fiber-base print is placed. Heated-air dryers are simply a box with a means of introducing a flow of warmed air, fitted with guides to hold drying screens. They can be used for either fiber-base or resin-coated papers.

Hertz: The unit of measure for frequency (1 cycle per second = 1 Hz).

High-acutance developers: Solutions that provide an impression of greater image sharpness by concentrating development in the layer of silver in the uppermost portion of the emulsion.

High-contrast: Description of a photo with a wide subject brightness range (an extensive range of gray tones, with deep black shadows and brilliant — but probably featureless — white highlights).

High-contrast developers: Solutions designed for use with high-contrast ("lith") films that are developed to show only black-and-white values, with no middle tones.

High-contrast prints: Prints made from a negative that has only dense black and completely clear areas.

High-energy developer: A rapid developer that produces somewhat less contrast increase and finer grain than processing in a general purpose developer for a longer time. Also called a *speed-enhancing developer.*

High key: A photograph in which shades of white or light tones predominate. Few or no dark tones will be present.

High-voltage power pack: Belt-mounted power supply for flash units that uses special rechargeable batteries. Such units are used by event photographers who shoot large numbers of flash exposures.

Histogram: A graphic display, available through scanning or image editing software, that shows the number and distribution of tones in the image.

History Brush tool: In an image-editing program, a tool that allows the user to paint details from an earlier version of an image onto the current image version. Often used to create a grayscale image with spots of the original color.

Hot lights: See *Incandescent light source.*

Hot shoe: Flash mounting terminal often located on top of an SLR's pentaprism housing. Electrical contacts on the hot shoe mate with those on the flash unit, triggering the flash when the shutter release is pressed.

Hyperfocal distance: The nearest point that will be in sharp focus when the lens is focused on infinity. This distance is different for each f-stop and each focal length. If the lens is set to the hyperfocal distance, focus will be sharp from one-half that distance to infinity.

Hypo: Shortened name for hyposulfite of soda, the first effective fixing agent used to make photographic images permanent. Now called *sodium thiosulfate.*

I

Illustration: General term for a photograph or artwork used to reinforce written information in books, magazines, newspapers, and brochures.

Image circle: The physical size of the image projected on the film plane when a lens is focused at infinity. On a view camera, the image circle must be large enough to permit camera movements to alter the portion of the scene that will be captured on the film.

Image editing program: A software application considered the indispensable tool for either image processing or image manipulation. Software on the market ranges from very simple programs that can be used for basic tasks to highly complex applications with an array of specialized features. Also referred to as an *image editor.*

Image manipulation: Changes to an image more extreme than those done in image processing, including distortion, removal of particular elements from the photo, combining of elements from one or more other sources, or radical changes of color and tone.

Image processing: Changes to images that are the electronic equivalents of the work typically done in the conventional darkroom: adjust-

ment of exposure, color and contrast; cropping the image, and dodging and burning.

Image transfer: An alternative photographic process in which dyes from a partly-developed Polaroid photo negative are applied to a substrate.

In focus: Term for an image that is at maximum sharpness.

Incandescent light source: One that consists of a metal element with high electrical resistance inside a sealed glass container or bulb. When an electric current is passed through the element, resistance causes it to heat rapidly to the point where it glows white-hot and emits light.

Incident light reading: One that measures the light that is falling on the subject.

Inclusion: Deciding what to include in the frame is an important concept in composition.

Indicator stop bath: An alkaline solution used to stop film development. The solution's normally yellow color begins changing to purple as it nears its capacity.

Indirect lighting: A reflection-free approach, often used for photographing glass, in which all light is bounced off the background and passes through the glass objects to the camera lens. Also called *transmitted lighting.*

Infinity focus: Adjusting focus so that the farthest visible subject is sharp.

Informal balance: A compositional method that provides a feeling of visual balance, but not the "mirror image" effect of formal balance.

Infrared: Wavelengths that are longer than 700nm, so they are below red (infra means "below") on the spectrum.

Infrared films: Films sensitized with dyes to reproduce light beyond the red end of the spectrum. Since these emulsions are also very blue-sensitive, they are usually shot with a deep red filter to absorb blue and ultraviolet wavelengths of light.

Ink jet printer: Output device that produces documents ranging from letters to photo quality images by depositing a fine spray of tiny ink dots on paper.

Integral tri-pack film: The common form of subtractive color film, consisting of three separate emulsion layers (the "tri-pack"). One is sensitive to blue light, the second to red light, and the third to green light.

Intensifier: Processing chemical used to darken the weak image of an underexposed or underdeveloped negative, making it more printable.

Intensity: Term used to describe the brightness of the light falling on a subject.

Intentional double exposure: A technique in which a photographer consciously makes two or more exposures on one frame. Shutter speed or aperture adjustments must be made to avoid overexposure.

International Standards Organization (ISO): A body that publishes standard sets of requirements to ensure uniformity of such items as film speeds.

Internegative: A copy of a color slide on negative film, used to make color enlargements.

Interpolation: In scanning or image-editing applications, the creation of new image pixels by averaging the values of the surrounding existing pixels.

Inverse square law: Scientific formula for calculating the amount of light falloff: *the illumination provided by a point source of light will vary inversely as the square of the distance from the source.*

Inversion tanks: Film processing containers that have spillproof caps, allowing them to be physically turned upside down (inverted) at intervals to agitate the chemicals.

ISO equivalent: The sensitivity of the CCD array, stated in terms of film speeds, such as ISO 100.

ISO identifier: The two-part film speed rating shown on packages, such as ISO 100/21°. It consists of the arithmetical rating previously used by the American Standards Association and a logarithmic rating based on the German DIN system that was used in Europe.

J

Jena glass: German optical glass that includes the elements boron, barium, and phosphorus. It is used in anastigmatic lenses, which correct the aberration known as astigmatism.

JPEG: The most common compressed file format, developed by the Joint Photographic Experts Group. It can be used to reduce file size by a small or large amount.

K

K-14 process: The development process for Kodachrome color transparency film. It is

more complex than the E-6 process used for other color transparency films, and must be done in commercial laboratories.

Kelvin units: Scale used to express the specific color temperature of a light source. Light with higher color temperatures is colder (more blue); lower temperature light is warmer (more red).

Key light: In studio photography, the unit that provides the primary illumination of the subject. Also called the *main light.*

Kinescopes: Recordings made by photographing the image on a television cathode ray tube. The method was supplanted by the introduction of videotape recording.

Kink marks: Dark, arc-shaped marks indicate that the film (usually medium format) was bent sharply, or kinked, during loading on the processing reel.

Knifing: The traditional method of removing a black spot from a print by using a very sharp knife blade to scrape the emulsion layer down to the baryta backing. A spotting dye is then applied to match the surrounding print tone.

L

Large format: Descriptive term for a camera that is used to expose individual sheets of film, most commonly in 4″ × 5″ or 8″ × 10″ sizes.

Lasso tool: A freehand selection tool used to trace as closely as possible around the desired outline when making a selection for image processing or manipulation.

Latent image: A photographic image that will not become visible until developing chemicals are used to bring it out and make it permanent.

Layers: Feature found in more sophisticated image editing programs, in which different elements of the image are placed on separate layers (like transparent overlay sheets). Elements on a given layer can be worked on independently, without affecting the rest of the image.

LCD: Abbreviation for *Liquid Crystal Display,* a device widely used in modern cameras to display information about control settings and camera functions. On digital cameras, the LCD can be used as a viewfinder and also allows review of images after exposure.

LCD projector: The electronic equivalent of the traditional slide projector. When connected to a computer, the device can be used to display digital images on a large screen.

Leader: The end of film, extending from the cassette's light trap, that is threaded into the camera's film-transport system.

Leading lines: Pictorial elements that draw the viewer's eye from one area of the photo to another.

Leaf shutter: A shutter constructed with over-lapping plates (similar to the aperture diaphragm) and built into the lens. Leaf shutters are used by many medium format cameras.

Lens: A piece of glass or other transparent material with curved surfaces that forms an image by focusing rays of light. A modern photographic lens is made up of several individual lenses or *elements.*

Lensboard: On a view camera, the fixture upon which the lens and shutter mechanism are mounted. The lensboard is fitted into the front standard.

Light: A form of electromagnetic radiation, or radiant energy, that is visible to the human eye.

Light falloff: The loss of light intensity with increasing distance from the source. See *Inverse square law.*

Light sensitivity: The "speed" of film; how readily it responds to light.

Light trap: Strips of felt material lining a slit in the film cassette to protect the film inside from accidental exposure. Also, the baffled opening that allows processing chemicals to be poured into and out of the developing tank without exposing the film to light.

Light-trapped: Term describing arrangements designed to prevent light from entering the darkroom.

Lighting ratio: A numeric expression of the relationship between the illumination of highlight and shadow areas of the subject's face. It expresses the relative intensities of the key and fill lighting.

Line: Compositional elements that typically draws the viewer's eye along its length, making it a useful tool for directing attention.

Linear array: Image-capture arrangement consisting of a long array containing only one to three rows of CCDs. Linear arrays are used in scanning-back cameras for studio work, and in flatbed scanners.

Linear polarizer: A polarizing filter that can interfere with autofocus systems. See *Circular polarizer.*

Liquid emulsions: Light-sensitive solutions that can be painted onto various materials to make them a substrate for photographic printing.

Lithographic film: A high-contrast material that produces an image without graduated tones: the film is either black or clear. Sometimes referred to as "lith film."

Lossless: Descriptive term for a type of file compression (such as Lempel/Ziv/Welsh or LZW) that does do not discard image information when compressing a file.

Lossy: Descriptive term for a type of file compression (such as JPEG) that discards some image information in the process of compressing the file.

Low-contrast: Description of a photo showing a compressed subject brightness range (a limited range of gray tones, without strong blacks or whites).

Low key: A photograph containing mostly dark tones; few light tones or whites will be present.

Luminances: Percentages of reflected light.

M

M synchronization: Flash-synchronization method used with flashbulbs, which take longer to reach peak output and provide that output for a longer time than electronic flash. M-synch fires the flashbulb shortly before the shutter is fully open.

Macro: Shortened form of macro-focusing lens, usually applied to one that can focus more closely than a typical lens of the same focal length. Derived from the Greek word *makros*, meaning large.

Macro photo range: Term used to describe photography in which the film image is as large or larger (even *much* larger) than the actual object.

Magic Wand tool: A tool, in some image-editing programs, that can be used to make a quick selection if the area to be selected is quite uniform in color and that color is different from adjacent image areas.

Magnetic Lasso tool: Variation of the basic Lasso tool that simplifies the selection process.

Magnetic Pen tool: Variation of the basic Pen tool that simplifies the selection process.

Magnification rate: A method of expressing size relationships. It provides the same information as the reproduction ratio, but in a differ-ent form. Instead of describing the size relationship as 2:1, for example, it would be stated as 2×, or "two times life size." See *Reproduction ratio.*

Main light: See *Key light.*

"Marching ants:" Photoshop-user term for a selection outline composed of small moving line segments, indicating that it is active.

Mat board: A mounting material composed of two or more layers of cellulose fiber. See *Window mat.*

Matte finish: A printing paper surface with a flatter, softer appearance than glossy paper. It is suited to subjects where a subtler, narrower range of tones is being conveyed.

Measuring cup: A container, graduated in volume units, for measurement of solution quantities in the darkroom.

Medium format: Descriptive term for a type of camera that uses 2 1/4" wide (120- or 220-size) roll film. Medium format cameras produce negatives in one or more of four different formats: 6cm × 4.5cm, 6cm × 6cm, 6 cm × 7cm, or 6cm × 9cm.

Medium-weight: The term used to describe the normal thickness of resin-coated printing papers.

Megapixel cameras: Portable digital cameras incorporating CCD arrays containing in excess of a million sensors to instantly capture images with moderately high resolution.

Memory-card reader: A transfer device that accepts CompactFlash or SmartMedia cards and connects to the computer.

Meniscus lens: The first lens developed specifically as a *camera lens.* It eliminated much of the distortion that was a problem with the biconvex lens.

Microprism: A focusing aid made up of small diamond-shaped elements that "break up" the image when it is out of focus. As the image is brought into focus, it becomes smooth and whole.

Mid-roll film change: A feature of the Advanced Photo System that allows a partly exposed cassette of film to be removed from the camera. When the partly exposed cassette is inserted in the camera again, it will be automatically advanced to the next unexposed frame.

Minimum time for maximum black: The shortest exposure time necessary to produce the

deepest possible black when making a straight, normal-contrast print of a well-exposed negative.

Mirror lockup: A feature of some cameras that eliminates possible vibration caused by the viewing mirror flipping up out of the light path when the shutter is pressed. A control manually moves the mirror out of the way and locks it in place.

Modeling lights: Small incandescent light sources built into an electronic flash head. They allow the photographer to observe the placement of shadows and highlights and to gain an over-all assessment of the lighting setup.

Monobath developer: A unique type of processing chemical that permits single-tray processing, since developing and fixing is done automatically in the same tray. Monobaths are designed for use with resin-coated papers that have an incorporated developer.

Monochrome: Single-color. When referring to film, black-and-white negative/positive film is usually meant.

Monolights: See *Electronic studio flash units.*

Monopod: A single-legged device that combines camera support with good mobility. A mono-pod usually has three to four nesting sections, allowing it to extend to 5' or more for use and collapse down to about 18" for storage.

Monorail: Large format studio camera design with a single, usually tubular, rail that supports the front and back standards and connecting bellows.

Motor drive: A battery-operated drive that will keep advancing the film and making exposures as long as the shutter release is pressed.

Mounting corners: Polyester or acid-free paper display accessories used in the edge-mounting method.

Mounting tissue: Heat-activated adhesive material, generally in sheet form, that is used in the drymounting process.

Multiple image filter: One that provides anywhere from 2 to as many as 25 repetitions of the image. Patterns in which the images are arranged vary with the number of repetitions.

Multiple light arrangement: The use of three or more lighting units, a common technique in still-life and product photography.

Multiple-image printing: A darkroom technique in which two or more subjects are combined to create a new photograph.

Multiple-size easel: Printing easel with preset openings for four common print sizes. One side has an 8" × 10" opening, while the other side has openings for 5" × 7", 3 1/2" × 5", and 2 1/2" × 3 1/4".

Museum board: Acid-free archival mounting board made with fibers from cotton. It is also called "rag board."

N

Nanometer: The unit of measure for wavelength, which is equal to one-billionth of a meter (0.000000001m = 1nm).

Naturalistic photography: A photographic philosophy that grew up in opposition to the sentimental nineteenth century pictorialist movement. Its adherents believed in "straight" photography that attempted to show natural subjects in their actual surroundings.

"ND grad" filter: See *Graduated ND filter.*

Negative ventilation system: A ventilation method that uses an exhaust fan on the wet side to draw air through the darkroom from intake vents on the dry side. A disadvantage of this system is that it creates a slightly lower air pressure inside the darkroom, so that dust and lint particles can be drawn in through small cracks.

Negative/positive film: The most popular form of film, which produces a negative original that is then used to make a positive print.

Negative/positive system: The basis of chemical-based photographic printing, in which the original is a negative (reversed) image that can be used to print any number of duplicate positive images.

Neutral density (ND) filter: A filter that reduces the quantity of light reaching the film, without altering the color of the light.

Neutral position: On a view camera, the normal or centered location of the front and rear standards.

Nonhardening fixer: A fixer that does not contain a chemical to toughen print emulsion. Such chemicals makes fixer harder to dissolve and wash out of the emulsion and paper base.

Noninversion tanks: Film processing containers that are intended to remain upright. Most are agitated by inserting a thermometer or other device into the hub of the developing reel and rotating it.

Nonsilver processes: Photographic processes that rely upon salts of metals other than silver (such as iron or platinum), or are based upon colloidal materials that can be sensitized so they are hardened by exposure to light.

O

OEM (Original Equipment Manufacturer): In photographic-equipment terms, the makers of complete camera, lens, and accessory systems. See *"Third-party" equipment makers.*

Off-camera flash: Removing the flash unit from the hot shoe and positioning it above and to one side of the camera to eliminate red eye, eyeglass reflections, and some shadow problems.

On-line gallery: Internet sites for photo display maintained by organizations or schools. Some are restricted in access to members of the organization; others are available for public viewing.

Open flash: Technique in which the camera's shutter is held wide open and the flash triggered manually one or more times.

Optical resolution: The actual pixels per inch resolution provided by a scanner.

Orthochromatic: Term for "red-blind" film emulsion that responds to both blue and green light, but is not exposed by the red wavelengths of light.

Overmat: See *Window mat.*

Oversharpening: Applying a sharpening filter at too high an intensity, giving the image an unattractive, harsh, blotchy appearance.

Oxidation: A chemical change in a solution (especially a developer) as a result of exposure to oxygen in the air. Oxidation causes the developer to lose effectiveness.

P

Painting with light: A flash technique used in large, dimly lighted spaces such as church interiors, or for exterior photos taken at night. The camera shutter is held open, and the flash is moved around to illuminate different sections of the subject.

Pan head: A camera support that usually allows moving the camera in two axes — tilting forward/backward, and panning from side-to-side.

Pan-tilt head: A three-axis camera support that allows tilting from side-to-side, tilting forward and back, and panning from side-to-side. Controls permit individual adjustment and locking in each axis.

Panalure: A true panchromatic paper used to achieve a range of gray tones that corresponds to the colors of the original.

Panchromatic: Term for a film emulsion that responds with adequate sensitivity to all colors of light.

Panning: Moving the camera along with an object crossing the field of view. It helps convey speed and movement by streaking the background behind a sharply focused moving subject.

Panoramic camera: Type of camera that physically rotates to record a view of 180° or more on a long strip of film.

Paper safe: A light-tight box used for storage of unexposed photo paper in the darkroom.

Parallax correction marks: Viewfinder guides that allow the photographer to compensate for the offset image.

Parallax error: A mismatch in what the photographer sees through the viewfinder and what the camera's taking lens actually sees. The slight difference in what is "seen" can result in cutting off part of a subject.

Passive autofocus: A focusing system that evaluates incoming light and makes focusing adjustments automatically.

Path: A line or closed figure, defined with the image editor's pen tool, which can then be edited and altered as necessary. A closed figure can be converted to a selection.

Pattern: A compositional element made by multiple objects, A pattern may consist of repetition of identical shapes, or may have elements alternating or varying in either shape or size.

pc cord: Cable that carries an electrical signal to trigger an electronic flash when the camera's shutter release is pressed.

Peak of action: The instant when motion slows dramatically to almost a stop.

Pen tool: A precision tool for defining paths and making selections in an image-editing program. The pen sets points that can be used to make curved line segments.

Pentaprism: A five-sided prism that corrects the inverted and reversed image for viewing through the camera's eyepiece.

Permissible circle of confusion: The largest diameter circle that will be seen as a point, and thus will appear to be sharp at normal print-viewing distance.

Personal web site: A location on the World Wide Web maintained by an individual. Many photographers, both amateur and professional, use such a web site to display their work.

Phosphor dots: Tiny red, blue, and green spots on a TV screen or monitor. They glow when struck by a beam of electrons, transmitting the color.

Photochromascope: A device for viewing an early form of color photography, in which three color separation negatives were exposed then used to make positives that recreated the full-color original scene.

Photoelectric light meter: One that uses electrical changes caused by different light intensities to indicate various levels of illumination. These indications, in turn, can be used to determine the exposure needed for a scene.

Photoflood: A bulb similar in appearance to standard bulbs, but constructed for high light output. Photofloods have a limited life, measured in hours of operation. They are available in clear glass for use with tungsten-balanced film, or with a blue tint for use with daylight-balanced film.

Photogram: A stencil-like photographic image created by placing opaque objects on treated paper that is then exposed to light.

Photojournalists: Photographers who specialize in news and feature coverage.

Photomicrography: A highly specialized field in which a microscope is used to achieve extremely high magnifications.

Photon: A particle of light.

Pictorialism: A nineteenth century photographic movement that created photographs conveying sentimental or morally instructive themes in an attempt to resemble the popular taste in painting.

Pincushion distortion: An optical distortion in which a rectangular image has sides that are pushed inward.

Pinhole camera: A photographic device with a very tiny fixed aperture. To regulate exposure, the opening is left uncovered for varying amounts of time.

Pixel: Abbreviation of the term *picture element*. Digital cameras are often classified by the number of pixels contained in their CCD array.

Plane of focus: The single plane of a scene that technically can be in sharp focus; parts of the scene closer to or further from the camera will be progressively more out of focus.

Platinum prints: Photographic prints with a particularly luminous quality, made on paper coated with a platinum-based emulsion rather than a silver-based emulsion.

Plug-ins: Filters and special-purpose programs from software companies specializing in graphic applications. They extend the capabilities of the image-editing software.

Point: Compositional element that is a single object, typically small in size, that attracts the eye. It may serve as the center of interest or focal point of a composition, or it may be a distraction, pulling the eye away from a more important object.

Point source enlarger: A specialized type of condenser enlarger that uses a small and very bright incandescent lightbulb to produce very sharp and contrasty images.

Polarized light: Light waves that become lined up in a single plane after reflecting from a shiny nonmetallic surface like glass or water.

Polarizing filter: A photographic filter that is used to deepen the color of a blue sky, improve the color saturation of natural objects by reducing glare, and reduce or eliminate reflections from glass, water, and similar surfaces.

Polaroid back: An instant-film adapter for large format cameras. The instant photo allows the photographer to see exactly how the light falls on the subject, so that any needed adjustments can be made.

Polygon Lasso tool: A variation of the basic Lasso tool that is useful for making fairly precise selections that have straight edges.

Positive ventilation system: A ventilation system that places a fan on the dry side of the darkroom and blows fresh air into the room. The air exits through vents on the wet side. The system creates a slight positive air pressure that helps keep the darkroom more dust-free.

Posterization: Technique that creates a print with several distinct, flat shades of tone, rather than the continuous gradation of tone found in a normal print.

Predictive autofocus: Focusing method that continually calculates speed and direction of a fast-moving subject and makes adjustments to assure that the focus will be precise at the instant the exposure is made.

Prefocusing: The technique of focusing on a specific spot and waiting for the subject to reach that point.

Press camera: Large format camera, similar in appearance to a field camera, that was used by photojournalists before the widespread adoption of the 35mm SLR.

Pressure-sensitive adhesive material: Sheets or rolls coated with a material that is activated by applying pressure with a squeegee or roller.

Preview image: Display that shows an image as it would be scanned. The preview can be used to determine what changes should be made in terms of cropping, contrast adjustment, and color correction.

Prewetting: Filling the developing tank with water and agitating for one minute to soak the film emulsion and improve developing uniformity.

Primary color: See *Color wheel.*

Prime lens: A lens with a fixed focal length (contrasted to a variable focal length, or zoom, lens).

Print exposure meter: An electronic darkroom aide that can be calibrated and used to determine the exposure time for a negative.

Print flattener: A solution in which prints are soaked to counteract their tendency to curl as they dry.

Print positioner: A T-shaped guide used to position the print in the optical center of the mounting board.

Print trays: Plastic or metal trays used to process photographic prints. Tray sizes are designated by the largest standard print they can hold: 5″ × 7″, 8″ × 10″, 11″ × 14″, and so on.

Printer: General term for an electromechanical device that translates digital data into incredibly tiny dots of color to simulate the appearance of a continuous-tone photographic print.

Printing down: A technique used to de-emphasize a lighter area of a print that is distracting by darkening it with additional exposure.

Printing easel: A device used to hold the printing paper flat and in the desired position during exposure.

Printing-out paper: A photographic paper upon which the image appears without the use of a developer.

Projection print: An enlarged version of the photographic negative, made by projecting the image through an enlarger lens onto the photographic paper.

Projection-print scale: A plastic sheet printed with wedges of varying density and times in seconds, that is laid on top of a sheet of photo paper on the enlarging easel. A test print of the image from the negative is printed through it, and the wedge that looks most well-exposed indicates the proper exposure time.

Pull processing: Intentional underdevelopment of the film, usually employed in situations where the film has been overexposed by one or more stops.

Push processing: Rating a film at a higher speed (i.e. 400 instead of 100), to permit shooting in low-light conditions, then adjusting development to compensate for the underexposure.

Q

Quad-tone ink set: A set of inks used with a dedicated ink jet printer for black-and-white reproduction. Available from several specialty manufacturers, these ink sets consist of black and three grays, rather than CMYK.

Quick Mask: In an image-editing program, a translucent red mask placed over an image, covering all the area outside the selection. The Paintbrush, Airbrush, Pencil, and Eraser tools can be used to alter the mask and refine the selection.

Quick-release system: A special mounting plate fastened to the camera that mates with a latching mechanism attached to the tripod head.

R

Rangefinder camera: A type of camera that is focused by means of bringing together two overlapping images seen in a separate viewing window. Since viewing is not done through the camera lens, there is no need for a movable mirror, allowing simpler construction and quieter operation.

Reciprocity failure: When very long or very short exposures are being made, the time/light intensity relationship doesn't remain constant; film manufacturers provide information on the time or aperture changes needed to compensate for reciprocity failure. Also called *reciprocity law failure.*

Reciprocity law: A description of the relationship of light intensity and time on exposure.

Rectangular marquee: In an image-editing program, a selection tool that is often used to crop an image.

Recycle time: Interval needed to rebuild the electrical charge in a flash unit's capacitor.

Red eye: Problem that is caused by the light of the flash reflecting back from the retina of the subject's eye.

Reducer: Processing solution that dissolves away some of the silver to lighten the very dense negatives that result from overexposure or overdevelopment.

Reflected light: Rays from a light source that bounce off an object and pass through the camera lens to be focused on the film plane.

Reflected light reading: A meter reading of light that has bounced off a subject.

Refraction: The bending of light rays that takes place in a lens because of the differing densities of glass and air.

Refresh rate: The time required to transfer the captured image from a digital camera's memory to the storage card or disk. It can result in a wait of a few seconds between exposures.

Relative aperture: The difference in the size of opening that a given stop represents at various focal lengths.

Release paper: A silicone-coated material to which adhesive will not bond, used to prevent mounting tissue from sticking to a tacking iron.

Removable memory: Storage cards or disks that can be filled with images and replaced with a fresh one. The images can then be downloaded to a computer, and the card or disk used again.

Replenisher: Concentrated solution periodically added to a prepared developer to maintain normal strength (and thus, developing times).

Reproduction ratio: A numeric expression of size relationships, such as 1:4. The numeral before the colon represents the *reproduction size*, or the size on film; the number after the colon represents the size of the *actual object*. See *Magnification rate.*

Reticulation: Wrinkling or cracking of the film emulsion resulting from a wide swing in processing-solution temperatures.

Retrofocus lens: A wide-angle lens design that combines negative and positive lens elements to "stretch" the light path within the lens. This provides sufficient back focus (distance from the rear element of the lens to the film plane) for mirror clearance, while maintaining the focal length of the lens. Also called an "inverted telephoto lens."

Reversal film: A color film that results in a reversed or positive final image (transparency or slide).

Reversal paper: A color printing paper that allows prints to be made directly from film positives (color transparencies).

Reversing ring: An accessory with filter-mounting threads on one side and a lens mount on the other, allowing a lens to be mounted backward for greater magnification.

RGB images: Images created in the additive color system, intended for use on monitors, TV screens and other transmitted light applications.

Ringaround: A panel of nine developed negatives or prints of the same subject showing all possible combinations of exposure and development.

Ringlight flash: A flashtube that encircles the front of the camera lens, providing even, shadowless light for closeup and macro photography.

Rise: View camera movement in which the front or rear standard is adjusted downward from the neutral position.

Roll film: A strip of film taped at one end to an opaque paper backing and rolled up with the paper. Roll film is used in medium format cameras.

Roll-on adhesive: Liquid or tape mounting materials applied with a special applicator. The liquid adhesive forms a pressure-sensitive bond, allowing the photo to be repositioned until burnished down.

Royalty: A percentage of the sale price paid to the author of a book, photograph, or other intellectual property by the publisher or stock-photo agency.

Royalty-free image collections: Groups of photos based on specific themes (business, medicine, etc.) that are packaged on CDs and sold outright to the end-user.

Rubberbanding: A method used in image editing and drawing programs. An initial point is established with a mouse click. Mouse movement then produces a visible line that stretches. When the termination point for the line is identified, it is set with a mouse click.

Rubber-Stamp tool: An image-editing tool basically used to copy (*clone*) a small area of a digital image and place it over a dust spot or other defect. The size of the copied area and the nature of the copied information (hard- or

soft-edged and the degree of opacity) can be varied to suit the situation.

Rule of thirds: A compositional device that divides the frame into thirds, both horizontally and vertically. The four intersections created by the crossing lines are considered the most effective spots to position the center of interest.

S

Sabattier effect: A partial reversal of tones that occurs when a print is briefly exposed to light part way through the developing process.

Scanners: Mechanical/optical devices used to convert transparencies, negatives, or prints into digital form.

Scanning backs: Studio capture devices that make use of a trilinear array, rather than an area array.

Scheimpflug Principle. A principle relating to obtaining the best possible focus when using a view camera. It states that maximum sharpness of an image in a subject plane will be achieved when lines projected through the subject plane, the film plane, and the optical center of the lens meet at a common point.

SCSI (Small Computer Systems Interface): A fast data-transfer method requiring installation of a special circuit board in the computer. Film scanners often require a SCSI connection.

Selective focus: A technique that uses a shallow depth of field to throw the background out of focus, drawing attention to the main subject.

Selenium cell meters: Meters with a photosensitive cell that generates a tiny electrical current whenever it is struck by light. The current is used to move a pointer across a scale to indicate an exposure value.

Selenium protective toning: Process in which prints are immersed in a very dilute solution of selenium toner mixed with a washing aid. The selenium solution causes little or no color change in most papers, but chemically changes the silver in the image to a more stable compound, silver selenide.

Self-contained flash units: Flash units available in a variety of sizes and types, either for mounting on the camera's hot shoe, or on a separate bracket.

Semi-matte finish: A printing paper surface midway in luster between glossy and matte.

Sensitivity specks: Impurities believed to play the important role of focal points or sites for the formation of the silver clumps making up the latent (undeveloped) photographic image.

Sensor-type automatic flash: Flash units that control duration of the flash by reading light reflected back from the subject to a sensor mounted on the flash body.

Separate viewfinder: A viewing window, used on simple cameras and rangefinder models, that does not present a "through the lens" view of the subject. Another form of separate viewfinder is used on twin-lens reflex (TLR) cameras, which have one lens for viewing and focusing and another for taking the photo.

Service bureau: A business specializing in electronic-to-film conversions and other forms of output (such as wide-format or fine-art ink jet printing) for photographers and graphic artists.

Shape: An individual object that is a strong compositional element.

Sharpening: In image editing, use of a built-in filter that enhances edge contrast to make an image appear more sharply focused. Intensity of the effect is adjustable.

Shelf life: The length of time that a chemical will retain its effectiveness.

Shift: View camera movement involving a side-to-side displacement of the front or rear standard.

Shoe-mount flash unit: Portable electronic flash that mounts on a camera's hot shoe.

Shortcut key: An individual key or combination of keys used to perform many operations as an alternative to a mouse and menu.

Shoulder: The right end, or high-density portion, of the characteristic curve, representing the highlights of a scene.

Shoulder stock: A rifle-like camera support that is widely used by nature photographers to "track" their target and steady the camera during exposure.

Shutter: Device that opens and closes to control the flow of light to the film. The shutter regulates light by the length of time it remains open.

Shutter lag: The interval between the time the photographer presses the shutter release and the time the shutter actually operates.

Silver halide salt: A light-sensitive chemical compound used as a key ingredient of photographic emulsions.

Silver print: Term used by fine art photographers and museum curators to describe black-and-white photographic prints.

Simple camera: The most basic form of camera, requiring no user adjustment for focus or exposure. Also called a "point and shoot" camera.

Single lens reflex (SLR): A camera in which the same lens is used for focusing and for taking the picture. A mirror reflects an image onto a viewing screen for focusing, but swings up out of the way when the shutter release is pressed.

Single-size easel: A type favored by darkroom workers who normally print on a particular size of paper, such as 8" × 10" or 5" × 7". An equal-sized border is placed on all four sides.

Single-use camera: A camera designed to be returned to the manufacturer for film processing. Prints and negatives are returned to the user; the camera materials are recycled.

Single-weight: The thinner of the two weights available in fiber-base printing papers.

Slave units: Flash units containing a photoelectric cell that responds to the bright burst of light from a master flash that is connected to the camera. The photoelectric cell causes the slave-unit flash to fire instantaneously.

Small format cameras: Those that use films in 35mm size or smaller.

SmartMedia: Removable memory card for digital cameras, available with capacities of 8 Mb–128 Mb.

Snoot: A tubular light modifier attached to a light source to direct a spot of intense light at the desired area of the subject.

Softbox: A large source of diffused light that consists of several lamps or electronic flash units mounted inside a reflective housing and covered with translucent material.

Soft focus: A technique used primarily in portrait photography to help mask minor blemishes and wrinkles. The effect is different in quality from the unsharpness caused by imprecise focusing.

Soft-focus effect: Diffusion added during printing by stretching a piece of fine black nylon stocking material over the enlarger lens. The effect is subtly different from soft focus attained when exposing the negative.

Soft-focus filters: Special filters that help achieve the soft-focus look. They are offered in several degrees of softness.

Soft light: Light cast on the subject from a large, diffused light source, resulting in shadows that are light and less well-defined.

Solarization: The result of extreme overexposure that causes a reversal of tones. In such extreme overexposure, the negative density increases to its maximum, and then actually decreases until the affected area is almost transparent.

Solutions: Liquid or powdered chemicals dissolved in water and used to process film or photographic paper.

Special effects filters: Optical accessories used to enhance, distort, or otherwise affect the image captured on film.

Special effects screens: Patterned sheets that can be used to give an image an overall texture. Screens for both projection and contact use are available.

Specular reflections: Bright spots of light "bounced back" from smooth polished surfaces. The rays are reflected in an orderly and concentrated manner.

Spherical aberration: Optical problem in which the light rays entering the outer edges of a lens are bent more sharply than those entering closer to the center. The result is an overall softness of focus, or "fuzziness," of the image.

Split-field filter: A filter designed to allow two zones of sharp focus (near and distant) at the same time.

Split-filter printing: The practice of using two or more filters, with different contrasts, for either overall printing or for local contrast correction. In the *overall* approach, a low-contrast exposure controls the highlight values, while a high-contrast exposure is used to control the shadows.

Split-prism: A focusing aid divided in two by a horizontal line. When the images in the upper and lower halves of the prism are aligned, the subject is in focus.

Sponge tool: A image-editing tool that can be applied like a paintbrush or eraser tool to a desired area, with opacity set to remove all color, or to leave a tint of the color. The sponge tool can also be used to increase color saturation of an area.

Spot meter: A device used to take reflected-light readings from very tiny areas and distant subjects. The spot meter has an angle of view as narrow as 1°.

Spotting: In conventional darkroom work, the process of hiding small white dust spots or scratches on a print using dye solutions and a very fine-pointed brush.

Spray-on adhesive: Liquid mounting adhesive in an aerosol or pump-type dispenser.

Sprockets: Toothed wheels in a 35mm camera's film transport system that engage the perforations (holes) along the two film edges. This method provides a very positive, slip-free method of film advance.

Stabilization printing: An alternative method of printing that permits rapid results using developer-incorporated paper and a special machine for processing. Stabilization paper prints will yellow and fade in a matter of days unless they are fixed and washed in the same way as a conventional print.

Standard negative: A control device used to determine the filter pack needed to make an excellent print.

Star filter: A diffraction grating with a grid of finely etched lines that cause bright rays to extend from any small, intense light source in the picture. Different gratings will produce "stars" with 4, 8, or 16 rays.

Stereoscope: A handheld device used to view pairs of photographs, giving the viewer the illusion of depth (three-dimensional space).

Stock photography: Libraries of images in many subject areas that are made available for publication in advertisements, books, or magazines on a "per-use" fee basis.

Stock solution: Concentrated chemical prepared by mixing a powder or liquid with water. It will be further diluted to form a working solution.

Stop bath: An acidic solution used to neutralize and halt the action of a film or paper developer.

Stopping down: Decreasing the size of the lens opening (aperture). This may be done to control exposure, or to increase depth of field.

Straight print: An unaltered image made in either the conventional or digital darkroom.

Straight-line section: The middle-density portion of the characteristic curve, where the density/exposure relationship is most nearly proportional.

Stringpod: A variation on the monopod that is inexpensive and easily made from strong string, a bolt that fits the camera's tripod socket, and a heavy nut or washer.

Strobe light: Term often used incorrectly to describe an electronic flash unit.

Stroboscopic: Descriptive term for the firing of an electronic flash in rapid sequence while the camera's shutter remains open, resulting in a series of "stop-action" images on a single frame of film.

Subbing layer: A very thin coating of pure gelatin that helps bond the emulsion to the base.

Subject blur: Out-of-focus condition that occurs when a subject is moving too fast for the selected shutter speed to stop its motion.

Subject brightness range (SBR): Luminances present in the scene, from brightest to darkest, expressed in stops. Some scenes may have a wider SBR, from Zone 0 to X and actually beyond, but most will have a narrower range of three to seven stops.

Sublimate: Scientific term for a change of state from solid to gas, without an intermediate liquid state.

Subminiature cameras: Small cameras that use 9.5mm or 16mm film. Also called "spy" cameras.

Substrate: The support onto which the emulsion layer of a printing paper is coated.

Subtractive color process: Color reproduction method used with reflected light, in which the subtractive primaries (cyan, magenta, and yellow) subtract or block specific colors from the white light that is used to view the image. Cyan absorbs red light and passes blue and green; magenta absorbs green and passes blue and red; yellow absorbs blue and passes red and green.

Subtractive primaries: The colors cyan, magenta, and yellow.

Supercoat: The very thin, tough topmost layer of the film. Its primary purpose is to protect the emulsion from abrasion during exposure and processing.

Supplementary lenses: See *Closeup diopters*.

Surfactant: An ingredient of the film's supercoat that promotes absorption of processing chemicals to help ensure even development.

Surge marks: Streaks of uneven development resulting from developer flowing back and forth through the sprocket holes of the film due to excessive agitation.

Swing: View camera movement involving rotation of the front or rear standard around the vertical axis.

Symmetrical lens: A lens that consists of two groups of lens elements with the lens diaphragm placed between them. A symmetrical lens is used to correct for distortion.

Sync terminal: A small socket in the camera body that accepts a special cord, called a pc cord, used to trigger a separate electronic flash.

T

"T" hinge: Mounting method used when the edges of the print will be covered by an overmat. It involves adhering a piece of tape to the back of the print with half its width extending above the edge. The print is then positioned on the mat, and a second piece of tape is adhered to the extended part of the first piece and the mat.

Tabular grains: A thinner and flatter form of silver halide grains, developed to allow an increase in film speed without a corresponding increase in visible grain.

Tacking: Adhering a sheet of mounting tissue to the print by using a tacking iron to melt a small area of the adhesive. Tacking holds the materials in the proper alignment for mounting.

Tele-extender: A diverging (negative) lens that is mounted between the camera body and a telephoto lens to increase focal length. Tele-extenders are usually available in two different degrees of magnification, 2× or 1.4×.

Telephoto lens: The true telephoto lens has a *front-focusing* design that shortens the light path, making a larger image possible at the film plane with less physical distance between the front lens element and the film. The point from which the distance to the film plane is measured to determine focal length is actually located out in the space in front of the first lens element group.

Tempering bath: A container of water in which containers of processing solutions can be immersed and held at the desired temperature.

Tenting: A lighting method (often used for small, highly reflective subjects) in which the subject is surrounded by a cone or shell of white translucent paper or plastic, with a small hole cut in one side for the camera lens. Lighting is done from outside the cone, resulting in a very diffused illumination and the elimination of unwanted reflections.

Test strip: A narrow print made with a series of exposures at regularly spaced intervals. The method identifies the proper exposure time for the full print.

Theatrical gel: A thin, transparent sheet of material used to add color to studio lighting.

Thermometer: Instrument used to measure temperatures of darkroom chemicals to ensure consistent processing.

"Third-party" equipment makers: Those whose products, such as lenses or flash units, can be used with various camera brands. See *OEM (Original Equipment Manufacturer).*

Through-the-lens viewing system: Composing and focusing method in which the viewfinder image is the scene viewed through the camera's taking lens.

TIFF: Tagged Image File Format.

Tilt: View camera movement in which the front and rear standards rotate around the horizontal axis.

Tinting: Application of soft, translucent color, especially to give a "hand-colored" look to a black-and-white image.

Tintype: See *Ferrotype.*

Toe: The low-density, or shadow, portion of the characteristic curve. The sharply curved line indicates that density is increasing at a faster rate than exposure.

Toning: A chemical process used to intensify shadow values or change the color of a black-and-white print.

Traditional studio flash system: See *Electronic studio flash units.*

Transmitted light: Light rays that reach the eye after passing through a clear or translucent substance (such as air or glass).

Transparency adapter: An accessory that allows flatbed scanners to process transparencies. The adapter is necessary because transparency materials must be scanned with the use of transmitted light, rather than the reflected light used to scan prints and other opaque originals.

Tray siphon: A print-washing tool that clips to a water tray to provide a steady, continuous flow of fresh water.

Trilinear array: In a scanner or scanning back, a bar containing three rows of sensors that is moved across the image capture area. One row of sensors is filtered to capture red wavelengths; one is filtered for green, and the third is filtered for blue.

Tripod: A sturdy three-legged camera support. Independently adjustable legs allow it to be firmly set in place on almost any kind of terrain. When mounted atop the tripod, the camera can be adjusted to the desired orientation and locked in position, allowing long exposures with little danger of camera movement.

Tripod head: Any of the devices that attach to tripod legs to allow mounting and positioning of a camera.

TTL (through the lens) flash: Units that fully automate the process of flash photography, setting the proper aperture and shutter speed and adjusting (by reading the light at the film plane) the duration of the flash.

Tungsten-balanced film: An emulsion optimized for the warmer (red/yellow) color temperatures of incandescent lighting.

Tungsten-halogen bulbs: Small, extremely bright bulbs with a higher light output and a longer life than photoflood bulbs. They are sometimes referred to as "quartz lights" because the outer envelope of the bulb is made from the mineral quartz rather than glass.

Twin lens reflex (TLR): A camera with two lenses, positioned one above the other. The lower lens is the "taking lens" which actually admits light to the film, while the upper lens is used for focusing.

Two-bath fixing: An archival processing method in which prints are fixed for half of the total time in each bath. Most of the fixing occurs in the first bath, so the second will reach exhaustion much more slowly. When the first bath is exhausted, it is discarded. The second bath then becomes the first, and a fresh batch of fixer becomes the second bath.

Two-blade easel: An easel with two adjustable blades that can be moved to use different paper sizes or proportions. The major disadvantage of this easel is that paper must always be positioned against stops in its upper left corner.

Two-element diopters: Screw-on close-up diopters (lenses) that are corrected for chromatic and spherical aberrations to provide much sharper images than single-element diopters.

Two-light arrangement: Lighting technique often used for portraits, with a key and a fill light.

U

Ultraviolet: Wavelengths of light that are shorter than 400nm, and thus are "beyond violet."

Ultraviolet (UV) filter: A filter that "cuts through" haze (ultraviolet radiation scattered in the atmosphere) to reveal distant detail.

USB: A fast data-transfer connection (Universal Serial Bus) supplied with most computers.

V

"V" hinge: Mounting method used if the print edges will be exposed. Tape is positioned in the same way as used for a "T" hinge, but the part of the tape extending above the print edge is bent downward to form an inverted V, with the point just below the print's top edge. The print is positioned on the mat and the bent-over portions of the hinge "Vs" are dampened and adhered. They will be hidden behind the print.

Vacuum easel: A paper-holding device that makes use of a perforated mat or baseboard attached to a small vacuum pump. When a sheet of paper is placed on the mat, it is sucked tight against the surface to hold it in place.

Van Dyke Brown process: A nonsilver photographic process that produces prints with a rich brown color.

Variable contrast (VC) filters: Enlarging filters in as many as 12 grades, which provide the black-and-white printer with great flexibility.

Variable contrast paper: Black-and-white printing paper that uses enlarger filters to obtain different degrees of contrast. First introduced by Ilford in England in the 1940s.

Variable focus lens: See *Zoom lens.*

Variations tool: In scanning and image-editing software, a display of small (thumbnail) images showing the effects of various contrast and brightness changes.

Vertical slot processor: A space saving print development system that takes up only about as much sink space as a single tray. The processor has two to five narrow vertical tanks to hold developer, stop bath, fixer, and other solutions.

View camera: A camera that accepts individual sheets of film, uses a ground-glass back for composition and focusing, and offers a variety of mechanical adjustments ("movements") for control of perspective and depth of field.

Vignetting: A printing technique that gives the central image a soft-edged shape that gradually fades to either white or black.

Visible spectrum: The portion of the electromagnetic spectrum that can be seen by the human eye. It consists of waves with frequencies ranging from about 400nm to about 70 nm.

Visualization: A technique in which the photographer controls how the final product will appear to the viewer, by first seeing that desired final result in his or her own mind.

W

Warming filter: A yellowish filter that will absorb some of the blue light, warming the scene.

Washing aid: Chemical solution used to make residual fixer easier and faster to wash away.

Waterhouse stops: An aperture-control method, used on some early cameras, that consisted of brass plates, each containing one precisely-sized hole. The selected plate was slipped into a slit cut in the lens barrel.

Wavelength: The distance from the crest of one electromagnetic wave to the crest of the next.

Web site: A specific location on the World Wide Web, accessed through the Internet. A web site may be as simple as a personal page with text and a photo or two or as elaborate as multipage company or commercial sites.

Wet side: The area of a darkroom that includes the processing sink, chemical storage, and solution mixing equipment.

Wet-plate collodion process: Photographic system, introduced in the mid-19th century, in which a glass plate was coated with a liquid emulsion. Exposure and development had to be done while the emulsion was still wet.

Wetting agent: Material normally used as a final rinse before the film is hung to dry. It helps prevent water spots from forming on the developed film as it dries.

White point: In scanning, the tone selected as the desired lightest value (255) in the image. Also, a value set by a digital camera to adjust for different lighting conditions.

Wide-angle lens: A lens with an angle of view from about 55° to as much as 180° and focal lengths ranging from about 35mm down to 8mm.

Window clamp: A support that allows the camera to be firmly attached to a vehicle window that is partly open. Before shooting, the vehicle engine must be shut off to eliminate vibration.

Window mat: A sheet of mat board with a hole or window cut in it to display a print. The window mat is hinged to the mounting board and helps protect the print providing a small air space between it and the glass of the frame.

Working distance: The amount of space between the front of the lens and the subject.

Working solution: Short-lived photographic chemical prepared by diluting a stock solution.

X

X synchronization: Flash synchronization method used with electronic flash, which reaches peak light output almost instantly.

Z

Zone focusing: A method of prefocusing on an area, making use of depth of field to provide acceptable sharpness for action within that area.

Zone System: A photographic method designed to produce consistent, predictable results through careful control of exposure, development, and printing. As devised by Ansel Adams and Fred Archer in 1939, the system uses a 10-step scale of image values (tones) from pure black to pure white to allow precise description and control.

Zoom lens: A lens with a variable focal length, allowing the photographer to change composition without physically changing lenses or position.

Zoom range: Classification of a variable focus lens by the spread from its shortest focal length to its longest focal length (such as 100mm–300mm).

Zooming: Moving the camera's zoom lens in or out during the exposure, usually done to impart a sense of motion to a photo of a stationary subject.

Index

D